The Artist's
HANDBOOK

The Artist's
HANDBOOK

Ray Smith

DK Publishing

LONDON, NEW YORK,
MUNICH, MELBOURNE, DELHI

REVISED EDITION
Project Editor Barbara Dixon
US Editor Jennifer Siklós
Art Editor Kelly Meyer
Project Art Editor Caroline Hill
Senior Editor Caroline Hunt
Senior Art Editor Mandy Earey
Managing Editors Maxine Lewis and Julie Oughton
Managing Art Editor Heather McCarry
Art Director Carole Ash
Category Publisher Andrew Heritage
Production Joanna Bull
DTP Designer Mike Grigoletti
Picture Research Anna Grapes
Picture Librarian Richard Dabb
Scientific Adviser Alun Foster

Every effort has been made to make sure that the information contained in this book is complete and accurate. Whenever harmful substances are being used, the reader is referred to the Health and Safety feature on pp.370-71. Neither the author nor the publisher can accept any legal responsibility for personal injury that may arise from handling any artists' materials. Readers are strongly advised to seek medical attention if an accident occurs.

First published in the United States in 1987 by Knopf

00 01 02 03 04 05 10 9 8 7 6 5 4 3 2 1

Revised edition published in 2003 by
DK Publishing, Inc.
375 Hudson Street,
New York, NY 10014

Library of Congress Cataloging-in-Publication Data
Smith,Ray, 1949-
 The artist's handbook / Ray Smith.
 p. cm.
 Includes index.
 ISBN 0-7894-9336-5 (alk. paper)
 1. Art--Technique. 2. Artist's materials. I. Title.
 N7430.S54 2003
 702'.8--dc21
 2002041583

Color reproduction by GRB, Italy
Printed and bound in Spain by Artes Gráficas Toledo, S.A.U.

See our complete product line at www.dk.com

Contents

Introduction

MOST ARTISTS CAN REMEMBER THE THRILL, at whatever age or stage in their lives, when they encountered the materials of their craft for the first time. There was something memorable about the particular shapes, smells, and colors of those hog hair brushes and oil paints, for example, and a sense of anticipation at the possibilities and opportunities they might bring. The excitement was generally tinged with some apprehension about what could actually be achieved with these new materials.

In this handbook, I have tried to convey something of the pleasure and excitement that the materials and techniques of art can generate. I have concentrated for the most part on two-dimensional work, including drawing, painting, printmaking, and digital image manipulation. But the book is also wide-ranging in its scope, encompassing many areas of the applied arts, including traditional areas such as stained glass or ceramic tiles and more recent materials such as laminates and vinyl. In each of these subject areas, I have tried to begin right at the beginning, but also to be as comprehensive as possible within the limitations of the available space. Along with my artist colleagues and friends, I have found that much experience of working with particular materials can help to distill information and make it accessible. So I can say, for example, that there are simply two basic ways of using paint; either transparently or opaquely. Once this basic practical concept is understood, all the infinite permutations about degrees of transparency or opacity, or the implications of painting in layers can then be more fully explored.

Such techniques can also be explored in relation to our developing knowledge of how artists in the past achieved their effects. Much of this had previously been simply speculative, but in more recent years, scientific analysis in the conservation departments of major museums has been able to reveal

precisely how a painting has been made. Such information does not mean we have to paint like old masters. It can help to generate ideas for contemporary practice using materials that were unavailable in the past. Many of these new materials are discussed here for the first time.

In the years since the first edition of *The Artist's Handbook*, perhaps the most significant change has been in the development of the personal computer. Computer literacy is becoming universal and the technology has had a major impact on art practice. I have explored some of the ways in which computers are useful tools for artists, not only in terms of the preliminary development of artworks that are realized in other media, but also in the creation of autonomous digital artworks.

There have, in recent years, been further developments in the broadening of the scope and accessibility of art. Galleries and museums continue to provide exciting venues for exhibitions and installations, but increasingly, significant works are commissioned and installed outside the gallery system. Artists have become more positive about recognizing and developing opportunities of their own. There is a thread that runs through the new edition of this book, which is designed to be of practical use in this respect. It is that artists who have skills in a particular medium that may not seem appropriate for one context can begin to see how these skills may be readily transferred to another medium that is. This opens up new possibilities and gives an artist the flexibility to work more successfully in a changing climate.

During the research and preparation of material for this new edition and the development of the book itself, I have been given a great deal of practical help and advice by numerous artists, experts, colleagues, and friends. I would like to thank them all for their generous support.

Ray Smith

MATERIALS

MANY OF THE RAW MATERIALS ASSOCIATED WITH THE paints and mediums that artists use today are the same as those that were used centuries ago. The natural earths still provide permanent pigments as they did to our earliest ancestors. We have become used to the refined products of the petroleum industries, which can offer clean and lightfast colors, for example. But fortunately, we can still marvel at the crisp and velvety richness in the marks that a simple stick of charcoal can provide.

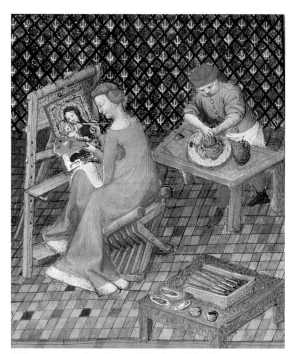

15th-century page from Boccacio's De Claris Mulieribus (ca. 1362)

This early 15th-century illumination on vellum is taken from a French copy of Boccaccio's "De Claris Mulieribus," a book of short biographies of famous women, and shows the artist at work on a gilded devotional panel. To her right, an assistant is grinding pigment. It could well be the expensive lapis lazuli providing ultramarine blue for the final layer of color on the Virgin's robes. She is holding a palette in which the colors have been laid out in a way that suggests a head, with two dark eyes, a white nose, and a red mouth. Behind the artist is a table with the colors laid out in shells—a common practice at this time.

Pigments

Painting is the art of distributing pigment over the surface of a support and, as such, the particles of pigment, which provide the colors for the work, are the single most important component in any consideration of the painting process.

The appearance of the pigment can be modified by the nature of the binding medium in which the particles are suspended and which attaches them to the support, by the nature of the support itself or of the ground to which it adheres, and by the variable action of the light.

Yellow and red ocher

Vermilion

Raw and burnt umber

Ultramarine
(lapis lazuli)

Pigment characteristics

A pigment is solid material in the form of small, separate particles. In their dry state, these particles exist in two main structural forms: as aggregates, in which primary particles or crystals are joined at the crystal faces, and as agglomerates, which are looser structures of aggregates.

Particle size and shape

The size and shape of the pigment particles affect the appearance of the paint—large particles tend to produce a matte, grainy texture—as well as properties such as lightfastness, opacity, consistency, flow, and brushability. In addition, particle size can affect stability: the smaller the particles, the slower the rate of settling for a given specific gravity in a liquid paint. In practice, this precludes certain coarse pigments from being used in acrylic emulsions, for instance (see p.203). Particle size can be finely adjusted for optimum effects by modern industrial methods.

Different pigments have very different particle characteristics (depending on their chemical group), so that natural Vermilion from the mineral cinnabar displays crystal fragments, while the artificial variety shows hexagonal grains and prisms. Lamp Black shows minute, rounded particles, while Bone (Ivory) Black exhibits irregular, coarse grains.

Wetting and dispersion

Before the pigment can be applied or manipulated, it must be dispersed in a binding medium. A paint should consist of a complete and continuous suspension of pigment in the vehicle or binding medium. A perfectly dispersed pigment is one in which each particle is separately and closely wetted with a completely enveloping film of medium.

Pigment particles are insoluble in the medium in which they are employed. The process of dispersion involves breaking down the agglomerates, but does not normally break down the aggregates; it is the size of these that determines whether the color is coarse or fine. For proper dispersion, the color and the medium must be ground together.

In the past, when artists prepared their own color, this was done by hand using a muller and slab. Colors prepared in this way were generally unstable and separated rapidly in storage, requiring redispersion before being used again. The process of dispersion has now largely been taken over by the artists' colormen who can ensure uniform and complete dispersion, and precisely control the medium content to a much greater degree than the artist at home. However, there is still a place for the craft of preparing one's own colors, especially for media such as egg tempera.

Oil absorption

The oil absorption of a pigment is the minimum amount of linseed oil that can be worked into a given weight of pigment (4oz/100g) so as just to form a coherent paste. This varies considerably from pigment to pigment and depends on the way the oil penetrates the pigment mass —the gaps between particles and irregularities in the individual particles—to form a complete coating. Such a paste is puttylike in appearance and the amount of oil or medium used to bring it to this state bears no resemblance to the amount necessary to make it workable for the artist. A number of factors determine oil absorption, including particle shape, the specific gravity of the pigment, and the fact that variations in the volume of 4oz (100g) can be considerable for different pigments. Thus, although the oil absorption of a pigment can be a useful guide if you are making your own colors, it should be treated cautiously as a guide to structuring a painting for optimum durability (see also p.172).

Color

The color of a pigment depends on its absorption of light (see *Color*, p.345). For example, yellow pigment absorbs most of the blue-violet light and reflects green and red light. This combination of green and red light rays produces the yellow color effect. The groups of atoms responsible for the pigment color are known as chromophores; secondary groups, which intensify color, are known as auxochromes.

Opacity

Light rays passing from one transparent medium to another are bent, or refracted, at varying angles. This property is quoted as the refractive index relative to air. The opacity of a color will be greater the higher the refractive index, i.e., the greater the difference between the indices of the pigment and the medium.

The Color Index

The only designation that as near as possible defines the composition of a pigment is its Color Index name; for example, Phthalocyanine Blue is Pigment Blue 15. The Color Index is compiled by the Society of Dyers and Colorists and is an internationally recognized designation.

Conversely, the transparency of a color is increased the smaller the difference between the refractive indices. An example is chalk, which has a refractive index of 1.57. Chalk in oil gives a whitish-gray transparent coating because the oil has a refractive index of 1.48. Water has a much lower refractive index at 1.33 and, since the difference between the refractive indices is that much greater than for oil, chalk in a glue solution is considerably more opaque, with good hiding power— as used in gesso, for instance (see p.59).

Lightfastness

The lightfastness, or permanence, of a pigment is its resistance to change on exposure to light (especially ultraviolet light). This depends on the chemical nature of the pigment, its concentration, and the medium in which it is employed. In watercolor, for instance, the concentration of pigment is less than in oil, so the paint film is generally thinner. In addition, the water-based medium itself offers less protection to the pigment than an oil medium. Therefore, pigments in watercolor are less permanent than in oil, so it is important to protect a watercolor from exposure to direct light.

Many pigments that are extremely lightfast in full strength lose lightfastness when they are reduced in tints with white.

Lightfastness standards Artists' color manufacturers usually give an arbitrary rating to their colors, but

there may be little relationship between the ratings of different manufacturers. Sometimes the classification may be related to a standard such as the "blue wool scale," in which eight numbered patterns of dyed cloth fade in an approximately geometric order. Each standard takes twice as long to fade as the one below it, so a pigment classified as 8 would be 128 times as fast as one rated 1. This remains the most commonly used standard employed by manufacturers and usually refers to pigments bound in an air-drying alkyd medium (see p.35).

In 1977, a subcommittee comprising manufacturers, artists, conservators, and other interested parties was set up within the American Society for Testing and Materials (ASTM) to establish performance standards for artists' colors. There are now four quality standards—D4302 relating to Artists' Oil, Resin-oil and Alkyds, D5067 Artists' Watercolor, D5098 Artists' Acrylic Emulsion Paints, and D5724 Gouache Paints. All the standards include lightfastness. A number of methods of testing are specified. With the exception of watercolor, all involve reducing the strength of the color with white and exposing the sample to a measured amount of light either by accelerated xenon arc exposure, fluorescent tube, or daylight (Arizona or Florida are the established exposure sites).

The degree of fading (color change), if any, is measured spectro-photometrically and the standard requires correlated results from two test methods. Pigments are rated I, II, III, etc. according to the degree of change. Only those rated I and II are considered to be acceptable as artists' colors. This standard is now generally accepted by artists and artists' colormen and has led to a reconsideration of the quality of some traditional colors. For example, Alizarin Crimson is rated III.

Inorganic pigments

Inorganic pigments are made up of chemical elements other than carbon, although simple carbon compounds—such as carbonates—are often regarded as inorganic. There are three kinds of inorganic pigment: earth, mineral, and synthetic.

Earth pigments
These include the natural products of the weathering of iron and manganese ores and feldspartic rock (which contains aluminum and silicon).

Ochers These are aluminum silicate clays tinted with ferric hydroxides. French ochers are cleaner in tone and less transparent than the Italian "siennas." Heating turns the ferric hydroxide into iron oxides, giving red to reddish brown pigments. Red ochers such as Caput Mortuum and Venetian Red can also be formed by natural dehydration.

Iron oxide

Umbers These are also aluminum silicate clays, containing 45–55 percent iron oxide and 8–16 percent manganese oxide. The best quality comes from Cyprus and is a warm, reddish-brown color. North Italian and German umbers are lighter in tone. Roasting turns the raw earth a reddish-brown to make Burnt Umber.

Other earth colors Terre Verte comprises platelike silicates containing iron oxide. The burnt variety is a red-brown color. Vandyke Brown is a brown earth of variable composition, so it is not reliably stable. It is partly organic.

Mineral pigments
Several pigments important to early painters occurred naturally as minerals.

Cinnabar (vermilion) This bright orange-red was known in China in prehistoric times and is synthesized from mercury and sulfur. It is now virtually unobtainable due to toxicity problems in the manufacture of the pigment.

Lapis lazuli (ultramarine) This natural blue was first used as a pigment in the sixth century. Artificial ultramarine was first prepared in France in the early 1800s.

White minerals China clay, chalk, gypsum, and barytes are transparent in oils, but they are important pigments in grounds and for gesso.

Synthetic (manufactured), inorganic pigments
These pigments do not occur naturally, but are manufactured. A large number of new mixed-metal oxides are available, including nickel titanates and cobalt-nickel mixtures.

Whites White Lead (basic lead carbonate) was first manufactured in the fourth century B.C. There are restrictions on its use due to its toxicity. Zinc White (zinc oxide) was introduced in 1834, Titanium White (titanium dioxide) in 1918.

Yellows and reds Naples Yellow (lead antimoniate) was introduced in the 1700s, and has now largely been replaced. Treated grades of lead chromates (and molybdates) offered a relatively inexpensive opaque yellow, but are virtually unavailable due to their toxicity. Cadmium sulfide and selenide pigments have been available since 1910 and offer an alternative range of opaque yellow to red pigments that are relatively safe in normal use.

Blues Prussian Blue, discovered accidentally in 1704, has now largely been replaced by the synthetic, organic Phthalocyanine Blue. Other popular synthetic mineral pigments first introduced in the 1800s are Cobalt Blue and Cerulean Blue.

Greens Cobalt Green is an oxide of cobalt mixed with zinc. Anhydrous chromium oxide along with its hydrated form, Viridian, became available in 1850.

Lapis lazuli

Natural organic pigments

Organic pigments are those made up of compounds of carbon. Those derived from natural sources may be either animal or vegetable in origin. Many occur as dyes, which are soluble, and these must be rendered insoluble for use as pigments. This is achieved in a process known as "laking," whereby the dye is precipitated onto an inert pigment or substrate.

A red pigment of vegetable origin that is still used today is Madder Lake, made from alizarin and purpurin dyes that are extracted from the root of the madder plant. Carmine, familiar in Europe since the mid-1500s, is obtained from the cochineal insect. Gamboge, the gum resin from the *Garcinia* tree, is still used as a watercolor pigment, though it has poor lightfastness.

Obsolete natural organic pigments include the following:
- Indian Yellow—manufactured from the urine of cows fed on mango leaves

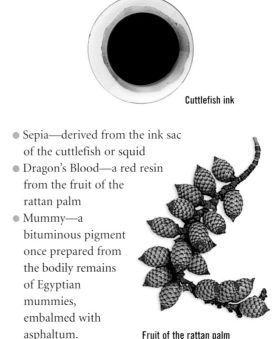

Cuttlefish ink

Fruit of the rattan palm

- Sepia—derived from the ink sac of the cuttlefish or squid
- Dragon's Blood—a red resin from the fruit of the rattan palm
- Mummy—a bituminous pigment once prepared from the bodily remains of Egyptian mummies, embalmed with asphaltum.

Synthetic organic pigments

This important group of pigments are complex compounds of carbon that do not occur naturally, but are instead manufactured in the laboratory.

Permanent, synthetic organic pigments have been available since 1935 when Phthalocyanine Blue and Green were invented. These are comparatively cheap to produce and are very lightfast and extremely strong. Recent pigments of similar fastness are the Quinacridones, Isoindolinones, Dioxazine, and many of the azo-type pigments (see p.13).

With the exception of Alizarin and Indigo, these synthetic pigments are unrelated to the natural dyes. Early synthetic pigments produced from coal-tar had poor lightfastness, but these have been replaced by pigments from petroleum chemicals and many are extremely lightfast.

Characteristics of synthetic organic pigments

Organic pigments are of three kinds:
- Insoluble dyestuffs
- Lakes—pigments made by precipitating or fixing a soluble dye upon an inert pigment or substrate
- Toners—metal salts of organic dyestuffs.

These are synthetically produced by various chemical reactions involving substances known as "intermediates," which react to form a colored dyestuff. Four kinds of reactions occur:

1 Intermediate A + Intermediate B = Insoluble dyestuff
2 Intermediate A + Intermediate B = Soluble dyestuff
3 Soluble dyestuff + precipitant + base = Lake
4 Soluble dyestuff + precipitant = Toner.

Most modern, synthetic organic pigments are brighter, stronger, and more flexible than traditional pigments. However, there are many commercially available products that, although similar in appearance and chemical structure, have very different performance characteristics. Pigments Yellow 12 and Yellow 13, for example, look almost identical; they are both diarylide pigments, but whereas the former has very poor lightfastness, the latter has medium-to-good lightfastness. If you rely on color manufacturers for your paints,

you must insist on an exact chemical kind of pigment, the lightfastness of which is marked on the product in accordance with a recognized standard.

Manufacturers buy their synthetic organic pigments from chemical companies whose main customers are industrial paint, plastics, and printing-ink manufacturers. The pigment products are designed to satisfy their requirements and not those of the artists' colormen—who represent a tiny percentage of the market. Printing-ink manufacturers want brighter colors but are not generally concerned with lightfastness. The automotive industry, on the other hand, demands durable, lightfast pigments and they subject them to extremely vigorous testing procedures. Pigments that withstand such tests must be extremely weather- and lightfast, and it is from this range that artists should select their pigments.

Permanence Although chemists can be reasonably sure of the permanence of any synthetic organic pigment, only time can really confirm this. They have not, like the natural earth colors, existed for millions of years.

Wetting and dispersion It is possible to make your own painting media using synthetic organic pigments, but this can prove difficult because the pigments in powder form are light and fluffy compared to the older, denser pigments. The pigments are chemicals and, although most are not toxic, a mask should be worn to prevent the inhalation of pigment dust. The fine powder creates a dust that literally "gets into everything," so an enclosed working area with a ventilation system is advisable. (See p.370 for information on working safely.)

A recent innovation are the Ciba-patented "IRGALITE Granules" that are designed to be low-dusting

without having an adverse impact on dispersion or time to disperse. These are designed primarily for the ink industry, but could be useful for artists.

Grinding modern synthetic pigments with a binding medium in the traditional way is not an efficient way of dispersing them. Some manufacturers supply pigments in paste form as aqueous dispersions, or dispersed in vinyl or acrylic resins. These predispersed forms can provide a more convenient basis for making certain painting media, since the binding mediums, extenders, and reducing components only need to be stirred in. However, most pigment manufacturers will only sell, at a high premium, small amounts of pigment, so the process is not economical.

Color Color strength depends to a large extent on the size of the pigment particles. Among the synthetic pigments, the individual particle size is generally between 0.05 and 0.5 microns although, sold as pigment powder in aggregated form, the size of the aggregate might be between 5 and 100 microns. Where opacity is required, a little color strength is sacrificed for a larger particle, and where transparency is required, a very small particle size is obtained.

If the color strength peaked at the same particle size as for lightfastness, it would be relatively simple to make a permanently bright pigment, but this is generally not the case, and manufacturers have to establish a compromise between color strength and lightfastness. High-value lightfast pigments that are ground too small can have their lightfast properties destroyed completely.

Pigment purity Manufacturers use a number of techniques to control particle size aside from simple grinding and milling operations. They sometimes add dyestuff to stop crystals from growing, or they heat the pigments in order

to sharpen and strengthen the crystals and to enhance light-reflecting qualities.

The high-quality pigments are generally sold as pure pigments but others are sold with resins, dyestuffs, or other additives adhering to them, and you may not know precisely what you are getting, especially if you buy a lower-grade product.

Kinds of synthetic organic pigment
There are, broadly speaking, two main classes of synthetic organic pigments—classical and nonclassical. The pigments used in artists' colors come from both classes.

Classical pigments Classical pigments are those for which the basic chemical structures have been known for many years, are produced in bulk relatively cheaply, and are used in areas that do not demand great light- and weatherfastness (e.g., printing inks, decorative paints). Examples are the simple mono- and dis-azo pigments and the copper phthalocyanines, though the latter are also used in much more demanding applications.

The azos The common characteristic of the classical azo pigments is that they all contain at least one "azo" group, in which two nitrogen atoms are linked (—N=N—) to join two separate chemical entities—an aromatic amine and a coupling component. Mono-azo pigment molecules contain one azo group and dis-azos contain two.

The chemical reactions that occur in the manufacturing process tend to produce small particle (sub-pigmentary) sizes that need some form of "after-treatment" to make them grow to a pigmentary size, so they reflect and refract light more efficiently, appearing brighter and stronger. This after-treatment usually only involves heating the aqueous pigment slurry, but additives may also be incorporated at this stage (see pp.40–41).

Common use is made of resin additives, particularly those resins derived from pine rosin. This helps the pigment to disperse in the ink or paint system and enhances optical effects such as gloss, transparency, and hue.

Azo pigments are usually forms of yellow, orange, or red. The actual color obtained depends on:
- The structure of the aromatic amine
- The structure of the coupling component
- The kind of crystal obtained.

Common mono-azo pigments are Pigment Yellow 1, Pigment Orange 5 (see pp.16–29), and Pigment Red 57:1.

Pigment Red 57:1 molecule

The major use of Pigment Red 57:1 is for the magenta shade in three-color printing (see p.347). Here, a metal (calcium) is added to fix, or "lake," the acidic groups in the amine and coupling component, producing an insoluble pigment. Without the addition of the metal, the product would be a soluble dyestuff and would "bleed" in the ink or paint.

Increased color strength in yellows can be obtained from dis-azos, in which the molecular weight of a mono-azo yellow pigment is effectively doubled. Commonly-used examples are Pigment Yellows 12, 13, and 14. These are produced in large tonnages for the printing-ink industry.

Copper phthalocyanine molecule

The phthalocyanines Blue and green pigments have been dominated by copper phthalocyanines since their accidental discovery in Scotland in 1928. Copper phthalocyanine is a "classical" pigment in that it is produced from cheap, readily available, raw materials, but its properties are such that it could also be classified with the expensive, "nonclassical" pigments. Thus, not only can it be used in cheap printing inks and paints, but also in areas demanding high heat stability and high light- and weatherfastness. These excellent properties are due to the very stable nature of the phthalocyanine crystal, in which the individual molecules are packed together closely.

The chemical structure of synthetic copper phthalocyanine is based on a ring system (called a porphin) that has parallels in nature—for example, chlorophyll, the light-absorbing green pigment in plants (that contains magnesium rather than copper), and hemoglobin, the red chromoprotein of blood (in which the metal is iron).

Various forms of copper phthalocyanine exist, the most common being the reddish blue α and the greenish blue β forms, used extensively by artists as a very strong Prussian Blue. These can be interchanged or mixed to give the desired color shade by a variety of chemical techniques such as solvent treatment, grinding with added salts, or dissolving in strong acid

and reprecipitating ("acid pasting"). Although of the same chemical constitution, the α form is less stable than the β form (to which it tends to revert in organic solvents), but can be stabilized by incorporating special additives.

Green pigments are obtained from copper phthalocyanine by reacting with chlorine and/or bromine. The brightest green (PG 7) is obtained when virtually all the outer ring hydrogen atoms of copper phthalocyanine have been replaced by chlorine. This green is more intense and clearer colorwise than the traditional Viridian. The yellowest green (PG 36) is produced when a mixture of chlorine and bromine is used.

Nonclassical pigments Nonclassical pigments are those whose chemical structures, while known, are more varying, complex, and difficult to obtain, are manufactured in small quantities, and are used in areas demanding a high performance level of, for example, thermal stability (e.g., in plastics) and light-/weatherfastness (e.g., in automotive paints).

Since the 1950s, considerable research and development has gone into producing new chromophores as pigment. Some have been developed from an already known chemical structure, while others have emanated from entirely new chemical entities. All are characterized by their very good applicational properties and their relative expense to manufacture compared to the classical pigments. All of them need "conditioning" before use (e.g., grinding, solvent treatment, or heating under pressure). The nonclassical pigments are divided into groups according to their chemical structure.

New azo pigments The properties of the azo pigments (see above) have been improved in two ways:
1 By doubling the molecular weight to give the "azo condensation

pigments" (e.g., Pigment Red 166), which have improved bleed properties and lightfastness.

2 By incorporating suitable amide groups (—CO—NH—), allowing increased hydrogen bonding, to give the benzimidazolone pigments (e.g., Pigment Yellow 156) that have greater stability and insolubility.

Azomethine metal complexes
These highly durable pigments, used mainly in metallic car paints, are based on the azomethine group (—CH=N—) rather than the azo (—N=N—) group (see above).

Quinacridones These red to violet pigments (e.g., Pigment Violet 19) are commonly used in artists' paints and have outstanding lightfastness. Their structure is polycyclic, each molecule consisting of a number of six-membered rings joined in a straight line. As with the phthalocyanines, the quinacridones exist in several different forms, the properties of commercial products depending on the form of after-treatment given to the crude product.

Anthraquinones The main use of anthraquinones is in vat dyestuffs for the coloration of textile fibers, but several are used as pigments for high-grade paint and plastic applications. The anthraquinone molecule is usually doubled up to increase the molecular weight and reduce solubility. Examples include Pigment Red 177 and Pigment Yellow 23. Various other ways of connecting two anthraquinone molecules give indanthrones (blue), flavanthrones (yellow), pyranthrones (orange), and anthanthrones (red). All are expensive, difficult to manufacture, and only used where the particular shade obtained cannot be produced by other means.

Thioindigo Indigo has been used as a deep blue coloring agent for fabrics for thousands of years.

Substitution of the nitrogen atoms in the indigo molecule with sulfur gives red to violet thioindigo pigments. The use of these in high-grade paints is decreasing, due to environmental problems associated with sulfur during manufacture. Pigment Red 88 is a thioindigo.

Perylenes These are high-grade, polycyclic, red pigments that offer high weatherfastness and are used in automotive paints. The pigments are based on the structure shown here, where X may be oxygen, as in Pigment Red 224, or nitrogen, as in Pigment Red 88 and Pigment Red 190.

Perylene molecule

Isoindolines Many new pigments, generally yellow, have recently been introduced based on the isoindoline system.

Isoindolines molecule

Examples include the tetrachloroisoindolinones, such as Pigment Yellow 110. These have outstanding light- and heatfastness properties, making them suitable for use in high-temperature plastic formulations (e.g., for colored window frames) and fibers, as well as paints.

Dioxazines This is another polycyclic class of pigments, useful in most applicational areas including artists' paints where durability is necessary. The major commercial product is Pigment Violet 23.

Dioxopyrrolopyrroles New, high-quality pigments based on a novel chemical structure occur only rarely nowadays. One such group is the red pigments based on a surprisingly simple structure, 1,4-dioxopyrrolo (3,4-pyrrole) (D.P.P.).

D.P.P. molecule (example)

These pigments offer fantastic heat stability, high coloring strength and hiding power, and excellent light- and weatherfastness. They have dominated the high-quality red pigments, especially for automotive paints, in the same way that the copper phthalocyanines have dominated the blues.

Conclusion In recent years, the range of bright, permanent colors has been greatly enhanced.

For stable, lightfast blue and green pigments, copper phthalocyanine and its derivatives are unsurpassed and, due to the size of manufacturing operations, their cheapness is unlikely to be matched by any other pigment. In the yellow to red pigment area, no such monopoly exists, and research constantly uncovers new structures that offer slight improvements over existing ones. The simple azo pigments have been supplemented with more durable azo condensation pigments (from Ciba Speciality Chemicals) and benzimidazolone azo pigments (from Clariant). The variety of polycyclic, high-quality pigments (from Ciba Speciality Chemicals) offers new horizons in gloss, brightness, strength, thermal stability, and lightfastness.

Pigment charts

The following pages contain details of reliable pigments that are generally available to the artist in various forms. I have excluded pigments that are very highly poisonous or that show very poor lightfastness, as well as any of historical interest that are now not generally used. Instead, I have listed many synthetic organic pigments, since the pigment industry is now producing more permanent and reliable colors that the artists' colormen can use with confidence. Because most dependable artists' paint manufacturers now put the Color Index name and number on their products, I have included these in the pigment information, with a description of each color.

Permanence
Some less lightfast, synthetic organic pigments are found in students' color ranges and similar areas where permanence may not be important. These may have other qualities that make them worth using, but if you are concerned about permanence, you should avoid using the following:

PIGMENT	Alternative names	Chemical type	Chemical composition/formula	Color Index name	Color description
Arylamide Yellow 10G	Arylide Yellow, Hansa Yellow	Azo		Pigment Yellow 3	Bright greenish yellow
Arylide Yellow RN	Arylamide Yellow	Monoazo		Pigment Yellow 65	Bright red shade yellow
Azomethine Yellow	Green Gold	Azomethine copper complex		Pigment Yellow 129	Greenish yellow
Nickel Azo Yellow		Monoazo, nickel complex		Pigment Yellow 150	Yellow
Nickel Dioxime Yellow		Dioxime		Pigment Yellow 153	Midshade yellow
Benzimidazolone Yellow		Benzimida-zolone		Pigment Yellow 154	Bright yellow
Benzimidazolone Yellow	Greenish yellow			Pigment Yellow 175	Greenish yellow
Bismuth Vanadate	Bismuth Yellow, Vanadium Yellow	Bismuth vanadate	(not available)	Pigment Yellow 184	Bright yellow

Arylamide Yellow G (PY 1) (borderline)
Benzidine Yellow (PY 13)
Dinitraniline Orange (PO 5)
Tartrazine Yellow (PY 100)
Benzidine Orange (PO 13)
Lithol Red (PR 49)
Lithol Rubine (PR 57)
Magenta Lake (PV 1)
Basic Violet I (PV 3)
Basic Violet II (PV 2)
Basic Violet IV (PV 4)
Pigment Green B (PG 8)

Toxicity ratings

The classifications used in the charts are based on those intended for the guidance of artists' color manufacturers, where large quantities of toxic chemicals may often be involved. The risk for an artist using small amounts of color is therefore very small.

Class A
Nonhazardous.
Class B
Relatively harmless—casual contact represents a negligible hazard.
Class C
Very low toxic hazard—some precaution necessary when handling.
Class D
Defined physiological hazard—appropriate precautions necessary.

Permanence	Oil absorption	Opacity	Tinting strength	Toxicity	Applications	Origin/comment
BS1006 7 ASTM II	32	Semi-transparent	Good	B	Oil color, watercolor, acrylic. May bleed in plastic, lacquer solvents; stable to 302°F (150°C).	1911: one of the first azo pigments to be accepted as an artist's pigment.
BS1006 8 ASTM I	30–40	Semi-transparent	Good	A	Oil color, watercolor, acrylic. Stable to 302°F (150°C). May bleed in NC solvents, xylene.	Used as a more lightfast alternative to Pigment Yellow 1.
BS1006 7–8 ASTM I	49	Transparent	Average	C	Oil color, watercolor, acrylic. Stable to 356°F (180°C). Good solvent resistance.	
BS1006 8 ASTM I	35–40	Semi-transparent	Relatively weak	C	Oil color, watercolor.	
BS1006 7–8 ASTM I	50	Transparent	Average	C	Watercolor.	Suitable as lightfast replacement for Indian Yellow, Gamboge.
BS1006 8 ASTM I	60	Semi-opaque	Average	A		Relatively new pigment, may be found in acrylics.
BS1006 7–8 ASTM I	70	Semi-opaque	Average	A	Oil color, acrylic.	Relatively new pigment, may be found in acrylics.
BS1006 8 ASTM I	30	Opaque	Average	A	Watercolor, acrylic.	New pigment. Alternative to cadmiums for opacity.

PIGMENT	Alternative names	Chemical type	Chemical composition/formula	Color Index name	Color description
Cadmium Yellow		Inorganic	Cadmium zinc sulfide CdS	Pigment Yellow 35	Green shade yellow to red shade yellow
Aureolin	Cobalt Yellow	Inorganic	Potassium cobaltinitrate $2K_3(Co(NO_2)_6).3H_2O$	Pigment Yellow 40	Midshade yellow
Naples Yellow	Lead Antimoniate, Antimony Yellow	Inorganic	Lead antimoniate $Pb_3(SbO_4)_2\ Pb(Sb)_3)_2$	Pigment Yellow 41	Greenish yellow to reddish yellow
Nickel Titanate	Titanium Yellow	Inorganic	Mixed oxides of antimony, nickel, and titanium	Pigment Yellow 53	Greenish yellow
Arylamide Yellow GX	Arylide Yellow GX, Hansa Yellow GX	Azo		Pigment Yellow 73	Midshade yellow
Diarylide Yellow		Disazo		Pigment Yellow 83	Reddish yellow
Isoindolinone Yellow	Tetracholoro-isoindolinone			Pigment Yellow 109/110	Greenish yellow to reddish yellow
Flavanthrone Yellow	Anthraquinone			Pigment Yellow 112/24	Reddish yellow
Azo Condensation Yellow	Chromophytal Yellow 8GN (Ciba-Geigy)	Azo condensation	(not available)	Pigment Yellow 128	Bright transparent yellow

Permanence	Oil absorption	Opacity	Tinting strength	Toxicity	Applications	Origin/comment
BS1006 7 ASTM I	17–21	Opaque	Good	B/C*	Oil color, watercolor, acrylic. Under damp conditions, chemical fading can occur due to oxidation of sulfate. Acid soluble; stable in most organic solvents.	Made by roasting cadmium oxide or carbonate with sulfur, or by precipitation from solutions of cadmium salts. Greenish yellow shades may be cadmium zinc sulfide PY 35. Often used coprecipitated with barium sulfate as Cadmium Lithopone PY 37:1. *Soluble cadmium levels below 1 part per million not considered toxic in normal usage.
BS1006 6 ASTM II		Transparent	Weak	C*	Oil color, watercolor. Not heat stable, decomposed by acid and alkali.	1848: made by reacting acidified cobaltous nitrate with potassium nitrate. *Soluble cobalt may have chronic toxic effects.
BS1006 7–8 ASTM I	10–15	Opaque	Weak	D*	Oil color, fresco, ceramics, glass. Stable in organic solvents, decomposed by acids.	High-temperature calcination of oxides of lead and antimony or reactions of metal salts. Naples Yellow is often a mixture of pigments based on White Lead or titanium dioxide. *Lead and antimony poisoning.
BS1006 8 ASTM I	15	Opaque	Weak	B	Oil color, acrylic. Stable to 1,774°F (950°C).	Made by calcining antimony, nickel, and titanium oxides at high temperatures. Substitute for Barium Chromate (Lemon Yellow).
BS1006 7 ASTM I	35–50	Semi-transparent	Good	B	Oil color, watercolor, acrylic. Not suitable in lacquer solvents, xylene.	Introduced as a more lightfast pigment with similar hue to Arylamide Yellow G.
BS1006 7 ASTM I	57	Transparent	Good	B	Oil color, watercolor. Stable to 392°F (200°C); stable to most solvents.	
BS1006 7–8 ASTM I	31–42	Semi-transparent	Good	B	Oil color, alkyd.	A permanent color, but not very often used because of its high cost and somewhat chalky appearance.
BS1006 6* ASTM I	35	Transparent	Good	B	Oil color, plastics. Heat stable to 500°F (260°C); insoluble in most organic solvents.	1901: originally known as Vat Yellow 1. Although one of the earliest of the vat dyestuffs offering greater lightfastness in an organic yellow, it has not become a popular artists' pigment. *Darkens in full strength; 7–8 in very pale tints.
BS1006 7–8	41	Transparent	Average	A*	Oil color, acrylic. Stable to 356°F (180°C); good solvent resistance.	More permanent alternative to Aureolin, Indian Yellow. *No known toxic effects.

PIGMENT	Alternative names	Chemical type	Chemical composition/formula	Color Index name	Color description
Benzimidazolone Orange		Benzimida-zolone		Pigment Orange 36	Red shade orange
Quinacridone Orange	Quinacridone Gold	Quinacridone		Pigment Orange 48	Yellow shade orange
Benzimidazolone Orange		Benzimida-zolone		Pigment Orange 62	Orange
Perinone Orange	Anthraquinonoid Orange	Organic		Pigment Orange 43	Orange
(no common name)	Irgazin Orange 3GL (Ciba-Geigy)	Isoindo-linone	(not available)	Pigment Orange 66	Reddish orange
Quinacridone Magenta		Quinacridone		Pigment Red 122	Bright blue shade red
Perylene Red		Perylene		Pigment Red 149	Bluish red
Quinacridone Maroon	Quinacridone Burnt Orange	Mixed-phase quinacridone	See Pigment Orange 48	Pigment Red 206	Dull maroon
Pyrrole Red		Diketopyrrol-opyrrole	Di-chlorinated PR 255	Pigment Red 254	Bright red
Pyrrole Red Light	Pyrrole Scarlet	Diketopyrrol-opyrrole		Pigment Red 255	Yellow shade red
Quinacridone Red	Permanent Rose	Organic		Pigment Violet 19	Bluish red
Permanent Crimson	Naphthol Crimson, Red F4RH, Naphthol AS-TR*	Organic		Pigment Red 7	Blue-red

Permanence	Oil absorption	Opacity	Tinting strength	Toxicity	Applications	Origin/comment
ASTM I	72	Transparent	Average	A	Good solvent resistance, except possibly alcohols.	Relatively new pigment, mainly found in acrylics.
BS1006 7–8 ASTM I	40–50	Transparent	Moderate	A	Oil color, acrylic.	Found as single pigment in acrylics and found in traditional ranges to produce lightfast, transparent greens, such as Olive and Sap Green.
BS1006 8 ASTM I	65	Transparent	Average	A	Acrylic. Stable up to 356°F (180°C).	
BS1006 7–8 ASTM I	48	Semi-opaque	Good	B	Stable to 392°F (200°C); stable to most solvents.	1924: originally known as Vat Orange 7. Relatively new pigment in the artists' field, more often found in acrylic colors than traditional ranges.
BS1006 7–8	37	Opaque	Average	A*	Oil color, acrylic (no known current user). Stable to 392°F (200°C).	Possibly useful as a permanent mid-orange, otherwise obtainable only by mixtures or use of cadmiums. *No known toxic effects.
BS1006 7–8 ASTM I	65	Transparent	Average	A	Oil color, watercolor, acrylic.	Largely replacing PV 19 in the red violet area.
BS1006 7–8 ASTM I	40-50	Semi-transparent	Average	A	Oil color, watercolor, acrylic. Stable to 392°F (200°C).	Largely replacing the lower lightfast azo reds.
BS1006 7–8 ASTM I	40	Transparent	Average	A	Acrylic. Appearing in more traditional media.	Alternative to the alizarin-based brown madder.
BS1006 ASTM I	44	Opaque	Very good	A	Oil color, watercolor, acrylic.	
ASTM I	40	Opaque	Very good	A	Oil color, watercolor. acrylic.	Relatively recently introduced alternative to lower lightfast azos.
BS1006 7–8 ASTM I	60-80	Transparent	Good*	B	Oil color, watercolor, acrylic. Very useful for mixing, giving bright oranges with yellows and violets with blues.	β-form known as Quinacridone Violet, often found in artists' colors as Permanent Magenta. *Usually considerably reduced in commercial colors due to its high cost.
BS1006 7–8 ASTM I	40	Semi-transparent	Good	B	Poor solvent resistance. One of the more stable of the azo pigments, commonly found in acrylics as Permanent Crimson.	1921: *Naphthol AS-TR description commonly used in the US only describes one of the coupling components. Check C.I. number of pigment; Naphthol descriptions can be misleading as several different pigments of varying lightfastness may be found under the same description.

PIGMENT	Alternative names	Chemical type	Chemical composition/formula	Color Index name	Color description
Rose Madder (genuine)	Madder Lake, Pink Madder	Natural Lake		Natural Red 9	Pale pink to crimson
Alizarin Crimson	Madder Lake	Organic Lake	Metal complex of alizarin; color depends on metal salts present: aluminum = red, calcium = bluish red, iron = marron. See Rose Madder for molecular composition.	Pigment Red 83	Blue-red
Cadmium Red		Inorganic	Cadmium sulfoselenide $CdS.xCdSe$	Pigment Red 108	Orange-red to deep red (becomes redder the more selenide is present)
Permanent Red FGR	Naphthol AS-D	Organic		Pigment Red 112	Bright red
Azo Condensation Red	Chromophthal Red BRN (Ciba-Geigy)	Azo condensation	(not available)	Pigment Red 144	Midshade red
Brominated Anthranthrone				Pigment Red 168	Bright yellowish red
Naphthol Carbamide	Naphthol Crimson	Organic		Pigment Red 160	Blue-red
Anthraquinonone Red	Anthraquinoid			Pigment Red 177	Blue shade red
Naphthol Red	Naphthol Red AS, B.O.N. Arylamide	Organic		Pigment Red 170	Yellowish red
Perylene Red	Perylene			Pigment Red 190	
Quinacridone Red		Organic		Pigment Red 207/209	Yellower red than PV 19

Permanence	Oil absorption	Opacity	Tinting strength	Toxicity	Applications	Origin/comment
BS1006 6 ASTM II	80	Transparent	Weak	B	Oil color, watercolor.	Alizarin Lake prepared by extraction of dye from madder root with alum, followed by precipitation with alkali onto an aluminum hydroxide base.
BS1006 7* ASTM II	76	Transparent	Fairly good**	B	Oil color glazes, watercolor. Should not be used reduced with white.	1826: Alizarin extracted from Madder, 1888–9: synthetic dyestuff (Perkin). *Half strength: 5. **Usually not used in tint because of poor lightfastness.
BS1006 7 ASTM I	17–21	Opaque	Good	B/C*	Oil color, watercolor, acrylic. Acid soluble; stable to most organic solvents.	*Soluble Cadmium levels are usually controlled to below 1000ppm. This is not considered toxic under normal usage. Its use may be restricted.
BS1006 7–8	54	Semi-transparent	Good	B	Oil color, acrylic.	
BS1006 7–8	55	Semi-transparent	Average	A*	Oil color, acrylic (no known current user). Stable to 356°F (180°C).	*No known toxic effects.
BS1006 7–8 ASTM I (acrylic), II (oil)	74	Semi-transparent	Good	B	Oil color, acrylic. Soluble in xylene, insoluble in acetone, alcohol, and toluene. Stable to 752°F (400°C).	1913: as Vat Orange 3. Prepared by bromination of anthranthone, or ring closure in sullfuric acid of [1,1'-binaphthalene-]-8,8'-dicarboxylic acid. More useful in acrylics than oils, due to its greater fastness.
BS1006 7–8 ASTM I (acrylic), II (oil)	65	Semi-transparent	Good	B	Oil color, acrylic.	Used commercially in printing inks, where lightfastness is not so critical.
BS1006 7–8	55	Transparent	Good	B	Oil color.	Possible replacement for Alizarin Crimson.
BS1006 7 ASTM I	70	Reasonably opaque	Good	B	Oil color, watercolor, acrylic.	Useful in oils because it does not bleed through white and is resistant to fading with Flake White.
BS1006 7–8 ASTM I	32	Transparent	Very good	B	Oil color, acrylic. Stable to 842°F (450°C).	Other similar pigments: PR 224: bluer shade but yellow undertone. PR 179: dull yellowish red (Perylene Vermilion).
BS1006 8 ASTM I	60	Transparent	Average	B	Oil color, acrylic.	Recently introduced Quinacridone pigments becoming established in traditional media.

PIGMENT	Alternative names	Chemical type	Chemical composition/formula	Color Index name	Color description
Cobalt Violet		Inorganic	$CO_3(PO_4)_2.8H_2O$ pink $CO_3(PO_4)_2.4H_2O$ deep violet $CO_3(PO_4)_2$ violet	Pigment Violet 14	Red- to blue-violet
Ultramarine Violet	Ultramarine Pink	Inorganic	Polysulfide of sodium alumino-silicate (complex structure)	Pigment Violet 15	Pink or violet
Manganese Violet	Permanent Mauve	Inorganic	$Mn'''NH_4P_2O_7$ Manganese ammonium pyrophosphate	Pigment Violet 16	Violet
Quinacridone Magenta	Quinacridone Violet, Permanent Magenta	Organic		Pigment Violet 19 (β-form)	Transparent red-violet
Dioxazine Violet	Dioxazine Purple, Carbazole Violet	Organic		Pigment Violet 23	Blue-violet
Phthalocyanine Blue	Often marketed under manufacturer's brand name.	Organic	See p.14	Pigment Blue 15	Bright greenish blue to reddish blue
Prussian Blue	Iron Blue, Milori Blue, Bronze Blue	Inorganic	$MFe'''[Fe'''(CN)_6].xH_2O.$ $M = K$, Na or NH_4 Alkali ferri ferrocyanide	Pigment Blue 27	Blue
Cobalt Chromite Blue	Cerulean Blue, Chromium, Cobalt Turquoise	Inorganic	$Co(Al,Cr)_2O_4$	Pigment Blue 36	Green shade blue
Cobalt Silicate Blue	Cobalt Blue Deep	Inorganic	Co_2SiO_4	Pigment Blue 73	Deep navy
Cobalt Zinc Silicate	Cobalt Blue Deep	Inorganic	$(Co,Zn)_2SiO_4$	Pigment Blue 74	Deep blue
Brominated Phthalocyanine		Phthalo-cyanine	Brominated copper phthalocyanine	Pigment Blue 36	Yellow shade green
Chromium Titanate		Inorganic	Mixed oxide of chromium antimony and titanium	Pigment Blue 24	Yellowish brown
Cobalt Blue	Kings Blue	Inorganic	$CoO.Al_2O_3$. Blue. $4CoO.3Al_2O_3$. Green. Cobaltous aluminate	Pigment Blue 28	Green blue to blue

Permanence	Oil absorption	Opacity	Tinting strength	Toxicity	Applications	Origin/comment
BS1006 7–8 ASTM I	10	Semi-opaque	Good	C*	Oil color, watercolor, acrylic, ceramics.	*Cobalt can have chronic toxic effects if swallowed.
BS1006 7–8	35	Semi-transparent	Relatively weak	B	Oil color, watercolor, acrylic. Bleached by acidic mediums.	Prepared from Ultramarine Blue by heating with ammonium chloride or chlorine and hydrochloric acid.
ASTM I	25	Semi-transparent	Weak	C*	Oil color, watercolor. Heat sensitive.	Often used as a substitute for Cobalt Violet in students' grades. *Manganese can have chronic toxic effects.
BS1006 7–8 ASTM I	68	Transparent	Good	B	Oil color, watercolor, acrylic. Used as a tinting color for violets or for glazing.	(See Quinacridone Red.)
BS1006 7–8 ASTM I	40–60	Transparent	Very good	B	Oil color, watercolor, acrylic.	Due to its high fastness, rapidly becoming a standard violet pigment, replacing the less fast lake pigments.
BS1006 7–8 ASTM I	40–50	Transparent	Very good	B	Oil color, acrylic. Good resistance to solvents and chemicals in certain forms; stable to 302°F (150°C).	Tends to flocculate unless treated; most modern forms are resistant to flocculation.
BS1006 7–8 ASTM I	35	Transparent	Good	C	Oil color, watercolor.	Although still popular as a "traditional" color, it has largely been replaced by Phthalocyanine Blue.
BS1006 8 ASTM I	15–40	Opaque	Weak	B	Oil color, watercolor, acrylic. Now common in US-manufactured products.	Alternative to the traditional PB 35 Cobalt stannate, which is becoming less available. Greener shades are found in Cobalt Turquoise, Teal Blue.
BS1006 8	25–30	Semi-transparent	Relatively weak	C	Oil color, watercolor.	Deeper blue than the traditional PB 28 Cobalt aluminate. Not widely available.
BS1006 8	25–30	Transparent	Relatively weak	C	Oil color, watercolor.	Similar to PB 73.
BS1006 7–8 ASTM I	24	Transparent	Very good	B	Oil color, watercolor, acrylic. Useful for producing bright yellow greens with yellows.	Yellower alternative to the more common PG 7, in which the Cl atoms are partially replaced by Br.
BS1006 8	25	Opaque	Weak	B	Oil color, watercolor, acrylic.	Useful base color for Naples Yellow substitutes.
BS1006 7–8 ASTM I	20–30	Semi-transparent	Relatively weak	C	Oil color, watercolor, acrylic, ceramics.	Various, e.g., high-temperature calcination of mixture of oxides of cobalt and aluminum.

PIGMENT	Alternative names	Chemical type	Chemical composition/formula	Color Index name	Color description
Ultramarine Blue		Inorganic	Complex polysulfide of sodium alumino-silicate	Pigment Blue 29	Green blue to reddish blue
Manganese Blue		Inorganic	Mixed crystal: 11 percent barium manganate $BaMnO_4$, 89 percent barium sulfate $BaSO_4$	Pigment Blue 33	Bright greenish blue
Cerulean Blue		Inorganic	$CoO.SnO$ cobaltous stannate. Commercial product usually 18 percent CoO, 50 percent SnO_2, 32 percent $CaSO_4$	Pigment Blue 35	Greenish blue
Indanthrone Blue	Indanthrene Blue	Anthra-quinonoid		Pigment Blue 60	Violet blue
Phthalocyanine Green		Organic	Chlorinated copper phthalocyanine	Pigment Green 7	Bright blue green
Oxide of Chromium	Chromium Oxide Green	Inorganic	Cr_2O_3 Chromium sesquioxide	Pigment Green 17	Dullish yellow green to green
Viridian	Hydrated Chromium Oxide, Guignets Green	Inorganic	$Cr_2O(OH)_4$ or mixture $Cr_4O_3(OH)_6$ and $Cr_4O(OH)_{10}$ with 0.5–10 percent boric acid	Pigment Green 18	Green to bluish green
Cobalt Green		Inorganic	Oxides of cobalt and zinc $CoO.ZnO$	Pigment Green 19	Pale to dark yellowish green
Terre Verte	Green Earth	Inorganic (natural)	Alkali-aluminum-magnesium-ferrous silicate of varying composition	Pigment Green 23	Bluish gray-green to olive
Nickel Azo Yellow	Green Gold	Organic nickel complex		Pigment Green 10	Greenish yellow
Light Green Oxide	Cobalt Titanate Green	Inorganic	Oxides of cobalt, titanium, and other metals, e.g., nickel Co_2TiO_4	Pigment Green 50	Bright green

Permanence	Oil absorption	Opacity	Tinting strength	Toxicity	Applications	Origin/comment
BS1006 8 ASTM I	25–40	Semi-transparent	Good	B	Oil color, watercolor, acrylic. Stable to 572°F (300°C).	1822: synthetic equivalent of lapis lazuli. Fusion of Glauber's salt, soda ash, kaolin, sulfur, carbon, kieselguhr.
BS1006 7 ASTM I	30	Transparent	Weak	C*	Oil color, watercolor, acrylic.	Unique hue, but not widely used. *Ingestion may result in barium poisoning.
BS1006 7 ASTM I	15–25	Semi-transparent	Weak	B	Oil color, watercolor, acrylic, ceramics.	Often substituted, particularly in student's grades, by a mixture of Phthalocyanine Blue and Green with Titanium White.
BS1006 7–8 ASTM I	37	Transparent	Very good	B	Oil color, acrylic.	Possible substitute for Indigo (usually mixtures have replaced the natural color).
BS1006 7–8 ASTM I	35	Transparent	Very good	B	Oil color, watercolor, acrylic. Stable to 302°F (150°C); stable to most chemicals.	1935: prepared by chlorination of copper phthalocyanine under catalytic conditions. A yellow shade, PG 36, is obtained by replacing some of the chlorine with bromine.
BS1006 8 ASTM I	15	Opaque	Weak	B	Oil color, watercolor. Stable to 1,652°F (900°C); insoluble in most solvents.	Prepared by reduction of potassium dichromate at high temperatures.
BS1006 7 ASTM I	90	Transparent	Relatively weak	B	Oil color, watercolor, "traditional" glazing color.	Often used in mixtures with Cadmium Yellow to get Cadmium Green, or Zinc Yellow to get Permanent Green. Phthalocyanine Green is often used as a substitute.
BS1006 7–8 ASTM I	20	Semi-transparent	Weak	C	Oil color, watercolor, acrylic.	Difficult to match by mixing. A recently-introduced variety found in acrylic colors also contains chromium oxide.
BS1006 7–8 ASTM I	20–30	Transparent	Very weak	B	Oil color, watercolor.	Used as artists' color since Roman times. Becomes red on heating, making Burnt Green Earth.
BS1006 7–8 ASTM I	47	Semi-transparent	Very good	C	Oil color, acrylic. Bleeds in organic solvents.	1905: not a very popular color. Unique shade, but of little artistic value.
BS1006 8 ASTM I	20	Opaque	Reasonable	B	Ceramics. Stable above 1,832°F (1,000°C); insoluble in most solvents.	Produced by high-temperature calcination of a mixture of metal oxides. Recently introduced pigment, more common in acrylics than traditional ranges. Also available in turquoise.

PIGMENT	Alternative names	Chemical type	Chemical composition/formula	Color Index name	Color description
Raw Sienna, Burnt Sienna		Inorganic	$FeO(OH)$ containing alumino-silicates and magnesium dioxide (0.6–1.5 percent)	Pigment Brown 7	Bright yellowish brown (Raw) Bright reddish brown (Burnt)
Yellow Ocher	Natural Hydrated Iron Oxide	Inorganic	$FeO(OH).nH_2O$	Pigment Yellow 43	Yellow to orange yellow
Light Red (yellower), Indian Red (bluer), Venetian Red	Red Iron Oxide, Red Ocher	Inorganic	Ferric oxide Fe_2O_3	Pigment Red 102	Yellow red to deep bluish red
Raw Umber, Burnt Umber		Inorganic	$FeO(OH)$ containing manganese dioxide	Pigment Brown 7	Greenish brown to reddish brown
Mars Black	Black Iron Oxide	Inorganic	$FeO.Fe_2O_3$	Pigment Black 11	Bluish gray to black
Ivory Black	Bone Black	Inorganic	10 percent carbon, 78 percent calcium phosphate, 8 percent calcium carbonate	Pigment Black 9	Black with brownish undertone
Lamp Black	Vegetable Black Carbon Black	Inorganic	Almost pure carbon	Pigment Black 6/7	Black with bluish undertone (P BK 6), brownish undertone (P BK 7)
Zinc White		Inorganic	Zinc Oxide ZnO	Pigment White 4	Bluish white
Titanium White		Inorganic	Titanium Dioxide TiO. Two crystalline forms: Rutile and Anatese (bluer, tends to chalk due to UV absorption)	Pigment White 6	Bluish white
Flake White		Inorganic	Basic lead carbonate $PbCO_3.Pb(OH)_2$	Pigment White 1	Slightly yellowish white

Permanence	Oil absorption	Opacity	Tinting strength	Toxicity	Applications	Origin/comment
BS1006 8 ASTM I	60–80	Transparent	Variable	B	All media.	Occurs in Northern Italy; similar but less transparent Siennas in US. Burnt Sienna usually calcined Raw Sienna. More transparent varieties of Raw Sienna are often classed as PY 43.
BS1006 8 ASTM I	30–35*	Opaque	Good	B	All media. Reddens above 212°F (100°C); soluble in acid.	Synthetic substitute PY 42 found in some colors, particularly acrylics. Synthetic pigment tends to be brighter, stronger, and more opaque. *Naturals may be higher.
BS1006 8 ASTM I	15–30	Variable	Good	B	All media.	Synthetic iron oxides (PR 101) are gradually replacing naturally occurring ones due to greater tinting strength and cleanness. When mixed with white, Light Red forms salmon pinks and Indian Red forms rose pinks.
BS1006 8 ASTM I	40–50	Transparent	Good	B	All media.	Occurs in Italy, Cyprus. Redder shades produced by roasting in open hearth furnace.
BS1006 8 ASTM I	15	Semi-opaque	Relatively weak	B	Oil color (not popular), acrylic. Insoluble in organic solvents; stable to 302°F (150°C).	Oxidation of ferrous hydroxide followed by calcination. Common black for acrylics, the fine particle size of other blacks causing stability problems.
BS1006 8 ASTM I	50	Transparent*	Relatively weak	B	Oil color, watercolor.	Carbonizing animal bones (originally ivory, hence the name). *Optically, all blacks are opaque by definition.
BS1006 8 ASTM I	80–100	Opaque	Good	B	All media. Tends to retard drying in oil colors; insoluble in organic solvents.	Lamp Black is more common than the purer and more intense Carbon Black (P BL 7). The latter tends to give glossy watercolors, but is often used in extended products where its greater intensity does not produce a gray.
BS1006 8 ASTM I	20	Semi-opaque	Reasonable	B	Oil color, watercolor. Unsuitable in acidic media.	1751 (commercially produced in 1850): burning zinc at 572°F (300°C).
BS1006 8 ASTM I	18–22	Opaque	Highest tint-resistant white	B	All media.	A replacement for Flake White. Early pigment did have problems with film strength and was always used with zinc oxide. Modern pigments have been produced with greater film stability.
BS1006 7 ASTM I	10–15	Opaque	Good tint resistance	D*	Oil color. Stable to 446°F (230°C).	Despite its toxicity, it is still the most popular oil color white due more to its reputation than its chemical properties. Modern Flake White does not react in the same way as the old stack process white. *Lead poisoning (accumulative).

Oils

THE NATURAL OILS USED IN OIL PAINTING ARE obtained from the seeds and nuts of certain plants. They are referred to as vegetable oils and classified as drying, semidrying, or nondrying oils, according to their ability to dry under normal conditions when applied in a thin film. Of these, only the first two are commonly used in painting.

Plant odors are due in nearly every case to essential oils. These differ from fatty (vegetable) oils by evaporating rapidly without leaving residue. For the artist, the most important essential oil is turpentine. It is extensively used in a number of ways, in particular as a diluent (see p.39) to reduce the consistency of oil paint and to facilitate its manipulation on the canvas.

Vegetable oils

These are the oils used for grinding paints and in painting mediums. The main ones are linseed oil, which is a drying oil, and safflower, sunflower, and poppy seed oils, which are all semidrying. The latter are normally paler and have less tendency to yellow. Linseed oil is extracted from the ripe seeds of the flax plant *Linum usitatissimum.* Safflower oil comes from the safflower plant *Carthamus tinctorius,* which is an annual herb native to the Himalayan foothills. Sunflower oil is extracted from the sunflower *Nechanthus annus,* while poppy oil comes from the opium poppy *Papaver sonniferum.* Walnut or nut oil, from the maturing kernels of the walnut tree *Juglans regia,* was used extensively in the past, being particularly

Opium poppy seeds

favored for its drying and nonyellowing properties. Light colors were nearly always ground in it. Nowadays, it has gone out of favor because, unless it is used fresh, it quickly goes rancid with a strong, disagreeable smell.

The oils do not dry by evaporation, but form dry, solid films by absorbing oxygen from the air. The complex reactions that occur during the drying process change the chemical and physical properties of the oil and, once it has dried, the oil film cannot be returned to its original liquid state.

The drying oils serve four purposes:
- They protect the pigment particles by binding them in an enveloping film
- They comprise the medium in which oil colors can be applied
- They act as an adhesive, in that they attach the pigment to the ground
- They contribute to the visual effect of the painting by bringing out the depth and tone of the color.

Composition of vegetable oils
Vegetable oils have the same chemical characteristics as fats and belong to the chemical compounds known as esters. They are composed of triglycerides of fatty acids along with small percentages of natural impurities that are largely removed by refining processes.

Some acids commonly found in vegetable oils are:
- Stearic acid
- Oleic acid
- Linoleic acid
- Linolenic acid.
It is linolenic acid that imparts the greater drying properties of linseed oil, but also the after-yellowing.

All of these fatty acids contain carbon atoms and are known as C_{18} fatty acids, but they differ in the way the carbons are bonded together. The drying properties of the oil depend on the number of carbon-carbon double bonds (C=C). Stearic acid contains no double bonds and is termed saturated; it is nondrying. Linolenic acid, on the other hand,

contains three double bonds, which accounts for the superior drying properties of linseed oil.

Processing of vegetable oils

Oil is extracted from the seed by pressure. Modern oils are usually hot-pressed with the aid of steam, but cold-pressed oils are available, and some claim they are superior. The oil may be further processed to remove impurities. This can be done by natural settlement, by washing, or by chemical means such as acid- or alkali-refining.

Oils contain free fatty acids that act as wetting agents, a high level of fatty acid aiding dispersion of pigments. Alkali-refining decreases the acidity and makes pigment dispersion more difficult but produces a paler oil. Unfortunately, the acid-refining makes the oil very reactive with some pigments, causing thickening, and so is seldom used by artists.

Kinds of vegetable oils

The classification of vegetable oils depends on their processing method. There are three main kinds:

Polymerized oil (stand oil) The viscosity of an oil can be increased by heating to a predetermined temperature, in the absence of air, until the required viscosity is reached. The oil undergoes a molecular change that polymerizes it. Such an oil is known as stand oil. Stand linseed oil is a particularly useful oil in painting mediums. When thinned with turpentine or paint thinner it gives excellent flow and leveling properties to oil paint. These qualities cannot be achieved with a raw oil. Stand oil is slowdrying because polymerization has taken place without oxidation but, when dry, it yellows less and is more flexible than raw oil. Metallic soaps may be added to increase the drying rate of the oil; lead, manganese, and cobalt are commonly used. Such driers accelerate the autoxidation process, but their addition must be

carefully controlled, because too much can produce wrinkling and cracking of the oil film.

Stand oil The oil has a viscous, molasseslike consistency.

Sunbleached and sunthickened oils These oils have undergone polymerization with oxidation, so they dry faster than stand oils. Sunbleached and sunthickened oils have been used by artists for centuries. The method of producing them is to shake up the oil with an equal amount of water and to expose it to the sunlight in loosely covered flat trays. The oil and water are mixed thoroughly every day for a week and then left for a few weeks until the required viscosity is reached. The oil is then filtered and separated from the water when it is ready for use. The bleaching action of the sun is said to have only a temporary effect, the color of the oil deepening when it dries and hardens later. The sun merely bleaches out the fugitive plant coloring material and does not affect the yellowing that occurs with age.

Boiled oils and blown oils Boiled oils, oils heated in the presence of driers, have caused deterioration of paintings in the past and are not recommended. If using them to speed drying, they should be used cautiously. Blown oils, polymerized by heating in the presence of air, are sometimes used as alternatives to sunprocessed oils, if sun is in short supply. These give faster drying times than stand oils, which are heated in the

absence of air, but otherwise have similar properties.

The drying process of the oil film

The drying process determines the best way to apply the oil color to enhance durability. Once applied, the paint absorbs oxygen from the air and changes from the liquid state to a solid film. In this complex process, known as "autoxidative polymerization," molecules of oil become linked together to form a polymeric structure.

As well as absorbing oxygen, and therefore increasing weight, the oil film releases volatile by-products that must be allowed to escape if the film is to dry properly. So, to ensure a sound structure to the painting, the artist must apply the "fat-over-lean" principle, in which each superimposed layer of paint has slightly more oil (fat) in it than the layer beneath. Each layer must be allowed to dry before more paint is applied, and the painting must not be varnished too soon. This is discussed in detail in *Oil Paints* (see p.197).

The main drying stages in a film of linseed oil are:
- A small change in consistency
- A marked change, from a liquid to a firm gel
- A further small change in consistency as the gel hardens.

Other changes occur with aging, and these depend on the kind of light to which the film is subjected:
- Diffuse light—slow hardening, relatively little decomposition, and some yellowing
- Ultraviolet light—rapid hardening and embrittlement, followed by severe deterioration
- Sunshine—fairly rapid hardening with embrittlement and severe decomposition
- Darkness—slow softening and considerable yellowing.

When it has dried hard, the film is a crosslinked, three-dimensional structure. If aged under normal conditions, the film continues to harden and becomes less flexible.

Oleoresins

Other plant-derived products are used by the artist. Oleoresins—or "balsams," as they are also known—are the thick liquid exudations from coniferous trees. They are a mixture of volatile (or "essential") oils and resins. Certain species of pine produce an oleoresin from which the volatile oil turpentine and the resin colophony or rosin are distilled. Oleoresins have been used in their natural state in painting mediums, though their use is now largely of only historical interest.

Uses of oleoresins

Oleoresins are said to give lustrous, flowing properties to oil paint. Venice and Strasbourg turpentine (see below) have in particular been used extensively in the past in oil painting mediums and egg tempera emulsions.

In my opinion, the addition of natural resinous material to an oil paint film will undermine its structure and resilience and, if more than very small quantities are added to the painting medium, the resulting paint film can be soluble in the solvent used when varnishing —with possibly disastrous results.

Kinds of oleoresins

Oleoresins should not be confused with the term "oleoresinous," which is used to describe varnishes and mediums made from cooked mixtures of hard resins and vegetable oils (i.e., a manufactured combination of oil and resin). There are four main kinds of oleoresins:

Venice turpentine Obtained from the larch *Larix Europea* or *Larix decidua,* this is a viscous, yellow liquid from which resin acids cannot be crystallized and in this respect it differs from common turpentine. It is soluble in alcohol, ether, acetone, and turpentine, but only partially soluble in petroleum hydrocarbons. When purified, it no longer shows its natural tendency to darken a painting and produce cracks, but when mixed with a fixed oil or an oil of petroleum, it is very cohesive.

Strasbourg turpentine From the white fir *Abies pectinata,* this is paler than Venice turpentine and very difficult to obtain. It is said to have protective qualities, locking up pigments, such as Verdigris, that are prone to decomposition. However, such qualities are not generally required with modern pigments.

Canada balsam Said to resemble Strasbourg turpentine, Canada balsam is relatively pure and valuable for its transparency and its high refractive index (see p.10).

Copaiba balsam Of variable composition and viscosity, copaiba balsam consists largely of free acid resins and so has a high acid value. Picture restorers once used it for regenerating turbid or blanching oil paintings. Since it was impossible to remove all traces of the copaiba (which displays excessive darkening and shrinkage), it is now avoided, though it is still sometimes used with aqueous ammonia as a picture cleaner.

Essential oils

The volatile oils discussed above are also known as essential oils and can be obtained from many plants. Many essential oils are mixtures containing volatile constituents with nonvolatile matter carried over by distillation. They are colorless or yellow liquids when freshly prepared, but often darken on exposure to air and light, producing resinous materials. It is for this reason that turpentine, for instance, should be kept in a dark or sleeved bottle and that, as it is used, the level in the bottle should be maintained by filling it with clean glass beads or something similar. This keeps the air content in the bottle to a minimum.

The essential oils are mainly used as diluents, but some are used as preservatives, to deter mold, as odorants, to retard the drying of oil paints, and to mask unpleasant smells in paint formulations.

Composition

The composition of essential oils is complex, the principal characteristics being mainly due to the presence of hydrocarbons and alcohols. The composition of an oil can vary considerably according to source. For example, English lavender oil may contain 10 percent esters, while the same plant in France may yield 35 percent. Essential oils are extracted in various ways, including simple expression and fermentation. Most of the commonly used oils are distilled by water or steam.

Kinds of essential oils

There are six main essential oils of interest to artists:

Turpentine oil Turpentine oil is distilled from the oleoresinous exudation of various pine trees. The oleoresin is known as crude turpentine, the nonvolatile residue is rosin, or colophony (see p. 32).

Common sources of turpentine oil are the Yellow Pine (*Pinus palustrus*) in the US, the Maritime Pine (*Pinus pinaster*) from France and Portugal, and the Scotch Pine (*Pinus sylvestris*) from Russia. The best turpentine is obtained by aqueous distillation. The inferior, steam-distilled product made from roots, logs, or stumps is known as wood turpentine. The toxicity of turpentine varies with its constituents and its source; the main constituent is pinene. Redistillation, or "rectification," is often employed to remove any resinous components.

Turpentine oil can be bought as "pure gum spirits of turpentine," "oil of turpentine," "rectified turpentine," or merely "distilled turpentine." It is used to thin oil color, as a solvent to make resin varnishes like dammar varnish, as an ingredient in a number of painting mediums, and in many other ways in painting and conservation.

Maritime pine

Spike-lavender oil Distilled from a particular variety of lavender, *Lavandula spica*, spike-lavender oil is a complex mixture of linalol, cineole, d-pinene, d-camphene, and camphor. It was used extensively in the past as a diluent (see p.39), though it is a less volatile solvent than turpentine and can take several days to evaporate. In the 1600s, it was recommended that a little spike-lavender oil, added to white and blue pigments ground in poppy oil, would prevent the colors from fading. It has also been used in soft resin varnishes, as a solvent for wax, and as an alternative diluent for artists who dislike the smell of turpentine or who get headaches from it.

A wax/oil-of-spike medium can be used with oil paints where a matte appearance is desirable. Some tempera recipes, such as egg-yolk and linseed oil tempera medium, recommend the use of spike oil.

Clove oil Distilled from the buds and stems of *Eugenia carophyllata*, clove oil has antiseptic properties and may be found as both a preservative and odorant in water-based paints.

Clove oil has also been used as a retardant to the drying of oil paints, allowing work to be carried over to the next day. However, some claim it can be harmful if used in this way, because it has a strong solvent effect on existing paint layers and causes blackening.

Cloves

Lemon oil Lemon oil is simply expressed from the fresh peel by squeezing. It is one of the most complex of the essential oils, containing, among other things, α-pinene, β-pinene, camphene,

and β-phellandrene. It is sometimes added as a reodorant in solvents, as is orange oil.

Lemon peel

Pine oil Pine oil is a volatile oil obtained from the needles and young shoots of many coniferous plants. It contains several terpenes, d-pinene, dipentene, and sylvestrene. It is used to delay the drying of oils and can be added to casein paints or gum tempera emulsions as a preservative and/or odorant.

Pine needles

Thyme oil Obtained from the common thyme plant, *Thymus vulgaris*, thyme oil contains 20 percent thymol, which is used as a preservative in some watercolors and as a disinfectant on backing cardboard in framed drawings, to inhibit the growth of mold.

Thyme

Resins

Resins are obtained naturally from the secretions of certain living or, in the case of fossil resins, dead trees. They are used in the preparation of varnishes for finished paintings, and in oil painting mediums, although they tend to darken more than oil and are generally less durable. Synthetically produced resins are now also widely used.

Resins are hard, glassy, noncrystalline solids with an amorphous structure. They soften when heated, melting to a sticky fluid, and burning with a smoky flame. They are insoluble in water but partially or completely soluble in organic solvents (see p.38). In this respect, they should not be confused with "gums"—also exudations from plants but soluble in water (see p.36).

Natural resins

With the exception of shellac (see below), natural resins are obtained by exposure to the atmosphere, by evaporation, oxidation, or by the polymerization of oleoresins (see p.32). The two main kinds of natural resins—soft and hard—each have their own specific characteristics.

Soft resins
Soft, or "recent," resins are obtained from living, rather than fossilized, trees. These are also known as spirit-varnish resins since they are soluble in alcohol and hydrocarbons.

Dammar Dammar resin is the only natural soft resin that is of real interest to artists. In its purest forms, it is regarded as the best of the soft resins to use as a varnish, for which it is usually dissolved in turpentine (see *Making dammar varnish*, p.176). Like all natural resins, it will discolor eventually, resulting in the "gallery tone" (golden, "antique" look) in paintings. This may happen in around 50 years, or earlier, if impure forms of the resin are used. Dammar can also become less soluble with age, so strong solvents may be needed for its removal. It is often used in oil painting mediums where it can give lustrousness to color and can accelerate the drying time of the paint (only when thinned with turpentine rather than paint thinner), but this is not recommended, except in the smallest quantities.

Mastic Mastic resin is soluble in turpentine, alcohol, and aromatic hydrocarbons, has good brushing properties, and has been used as a varnish for finished paintings, but it yellows strongly and darkens with aging. It is no longer used in oil painting mediums. The "megilp," used with disastrous consequences by 19th-century artists in particular, was a mixture of linseed oil and mastic varnish.

Sandarac Sandarac resin has similar properties to mastic but is harder. It has been used, dissolved in alcohol, as a retouching varnish, but it is extremely brittle and becomes dark and red with age.

Shellac Shellac is not strictly speaking a resin. It is a resinous material secreted by a stick insect onto certain trees. The dried resin is often highly colored and may be bleached for some purposes.

Shellac is normally dissolved in alcohol and used for furniture restoration, metal lacquers, etc. It is not soluble in turpentine, a fact that has made it useful in the past as a sizing medium. It has also been used to reduce the absorbency of gesso panels, as a pastel fixative, and an isolating layer in tempera painting. It may be rendered soluble in water by treating it with alkali, and has been used in this way as a binder in drawing inks.

Hard resins
The hard, or "fossil," resins are often known as "copals" (misleading, since soft copals, such as manilla, are found in spirit varnishes). They are the fossilized exudations of decomposed trees dug up from the ground. Such resins are almost insoluble in oils and organic solvents, and can only be rendered oil-soluble by heating or "running," when they combine with hot drying oils to form oil varnishes. These "run" copals became the basis for most general-purpose varnishes outside the art materials' industry. They have always been unsuitable for artists' purposes because they darken and crack with age. They are now practically unobtainable and have been replaced by the synthetic alkyd resins used in the art materials' industry.

Synthetic resins

Many of the natural resins have been replaced by synthetically produced alternatives. These provide a wide range of applications in areas of particular interest to artists, including finishing systems or surface coatings for external artworks. Among the thermoplastic resins are the acrylic polymers, which have proved central to the development of binding materials for acrylic painting.

Oil-soluble, phenolic resins These are usually based on a mixture of linseed and tuna oil. Varnishes containing phenolics are somewhat yellow, but useful where a heat-resistant finish is needed, or for exterior use. They are used as the core material in laminates.

Oil-modified, alkyd resins Alkyd resins are insoluble in hydrocarbon solvents. As such, they are unsuitable as film formers and require the addition of an oil to convert them to oleoresinous media for surface coatings. The oils used in the manufacturing process may be linseed or a semidrying oil such as safflower or soya (see p.30). The latter form paler resins and are used for artists' mediums. Those most likely to be encountered by the artist require the addition of driers (see p.40) and then form air-drying finishes.

Epoxy resins Epoxy resins are very stable and generally used with other resins as surface coatings.

Polyamide resins The polyamides have extremely good adhesion and are used in collapsible tube coatings and as curing agents for epoxy resins. They are also incorporated into decorative finishes to give "nondrip" properties.

Unsaturated polyester resins These were originally developed for laminating applications and have only recently found use as surface-coating resins.

Polyurethanes More correctly called polyisocyanates, these coatings are used in wood and metal finishes.

The so-called polyurethane decorative paints are in fact urethane oils or urethane alkyds.

Nitrocellulose Cellulose ethers are used as thickeners in water-based paints. Cellulose nitrate (nitrocellulose) is used as a binder and its properties are controlled by plasticizers and solvents.

Thermoplastic resins

Thermoplastic (linear polymer) resins are those that soften under heat and dissolve. They include the acrylic polymers that provide the binding medium for artists' acrylic colors (see p.203).

Very soft resins may soften under the heat of handling and pick up dirt or, if the resins are too hard, they may create a brittle paint film. The resins are made from chemicals known as monomers—normally mobile liquids that are subjected to a chemical change known as polymerization. The hardness of the resin is controlled by the choice of chemical ingredients that are polymerized. Different polymerization techniques produce resins with different properties.

Polyvinyl chloride (PVC) This has poor heat/light stability and is brittle, so it has to be plasticized. It is of little use to artists except as the main constituent of hot melt compounds such as "vinamold," which are used for mold-making.

Polyvinyl acetate (PVA) This is the vehicle for PVA adhesives and paints that represent the cheaper end of the polymer paint market (see p.203). The resin has much greater light stability than PVC, for instance, and is more flexible, though it often requires the addition of plasticizers, which can have limited stability. The PVA film consequently has a tendency to embrittle with time and to be less permanent than the acrylic resins.

PVA is used as an adhesive medium in some schools and universities, where it is also often mixed with powder paint to give a durable paint film. If it is branded as "washable" PVA, it may be Polyvinyl Alcohol, which is resoluble.

Acrylic polymers Acrylic esters can be produced with differing degrees of flexibility—for example, polyethyl acrylate is very flexible, polymethyl methacrylate is harder. By producing mixed polymers known as copolymers, the properties can be adjusted without need for the addition of plasticizers. They are therefore more stable than PVA.

Acrylic copolymers are the most useful to the artist and are used in both solution and dispersion form. It is in the dispersion form that polymer resins are most commonly encountered, when they are known as "polymer emulsions."

Solution polymers are often used by restorers and may also be found in varnishes as paint thinner solutions of poly isobutyl methacrylate.

Polymer emulsions These are particles of polymer suspended in water, which dry by evaporation. Acrylic emulsions tend to be alkaline, so they cannot be used with alkali-sensitive pigments.

Polymer emulsions are probably the most stable of all artists' mediums because once they are dry on the finished painting, no further chemical change takes place.

Glues, Starches, and Gums

IN ADDITION TO DRYING OILS, OTHER NATURAL binders are water-soluble materials of animal origin, such as glue, gelatine, and casein (proteins) and of vegetable origin, such as starch, dextrin, and gums (carbohydrates).

These form colloidal dispersions in water that range from liquids to gels. Colloids have a particle size intermediate between a suspension and a solution. They are widely used for sizes, adhesives, and binders for watercolors.

Proteins and carbohydrates

Proteins are the complex group of compounds that make up an important part of animal matter. The proteins encountered by the artist are principally used for sizing or as binders. Certain carbohydrates are used as binders, thickeners, or plasticizers in watercolor paints.

Proteins

These are long-chain polymers of amino acids and are an important part of animal matter. The artist may encounter them as albumens in egg yolk, globulins in egg white, collagen in animal glues, isinglass from fish, and phosphoproteins in casein.

Glue and gelatine

Glue is an organic, colloidal substance obtained by boiling animal matter (skin and bone) and then drying the solution. Its composition varies according to its source. Gelatine is simply a more purified form of glue. For artists, a high gel strength is required. Gelatine is most commonly used in preparation of size for canvas.

The preparation of glue size by soaking the size in water and heating in a double boiler is discussed on p.58.

Casein

Casein is a complex mixture of proteins, derived from the curd of milk. It is precipitated from the milk by the addition of acid and is sold as a powder. It swells on addition of water and only goes into solution on addition of alkali. It is soaked overnight in a solution of ammonia. Casein is used in dry powder adhesives. It has been popular as a binder for waterproof poster colors and has been used as an emulsifying agent in oil in water emulsions. It is sometimes used as a binder in gesso grounds, but is more brittle than conventional glue-based gesso.

Carbohydrates

Carbohydrates, or saccharides, are also natural products that find use as water-based binders. Sugar has been used as a plasticizer in watercolor paints, as has sorbitol. Sodium alginate is used as a thickener for some watercolors, and starch is used to make adhesive pastes and, in the form of dextrin, as a binder for certain pigments in watercolors. Gums are used as thickeners, binders, and stabilizers in watercolors and for binders in pastels.

Starch

Starch in the form of dextrin, which is prepared by heating acidified starch, is used as a binder for poster color, gouache, and occasionally watercolors. Starch is also used for sizing paper. On aging, starch solutions become less soluble and this is prevented by dextrinization. Corn and potato starches are commonly used in making dextrins. Dextrin is a cheap alternative to gum arabic and is sometimes used when pigments are reactive to gums. Cold-water-soluble dextrin has good stability.

Gum arabic

Gum arabic comes from certain species of acacia tree and varies considerably in quality. The most commonly used is Gum Kordofan. It is a seasonal product and its properties vary according to the time of harvest. Early gums are usually hard and difficult to dissolve. The gum is usually made into a 30–40 percent solution for preparing watercolors.

Gum tragacanth

A traditional binder for soft pastels and for dispersing vitreous enamel colors, gum tragacanth is also used as a stabilizer in watercolors because it forms a stronger gel than gum arabic.

Rabbit skin glue

Gum arabic

Waxes

WAXES ARE MAINLY ESTERS OF HIGHER FATTY acids and fatty alcohols, often containing free acids, alcohols, and hydrocarbons. They are all inert, permanent, and durable, provided that they are protected from mechanical damage and excessive heat. Wax is very resistant to permeation by moisture and has been used for centuries as a protective coating for wood, stone, plaster, and fabric. All waxes melt at a lower temperature than the boiling point of water.

Uses of waxes

The most common uses of waxes are as protective coatings, as matting agents in certain varnishes, as the binding material for wax crayons and oil pastels (these also contain animal fats), as components in pencil and crayon manufacture, and in wax-resistant painting methods. They are used as stabilizers in oil paint, and adhesives in wax-resin compounds used in conservation, as components in wax emulsions for tempera painting, in modeling materials, and as the binding medium for encaustic painting. These uses are detailed in the relevant sections of this book.

Kinds of waxes

The main waxes used by artists are beeswax, carnauba wax, and several kinds of paraffin waxes. In addition, candelilla wax is sometimes used as a slightly softer alternative to carnauba wax.

Beeswax Beeswax is the most important wax for artists' use. It is naturally yellow, though wax from newly built honeycombs is said to be white. Pure, refined, yellow beeswax, which is subsequently bleached by exposure to the sun in flat, shallow trays, is claimed to be superior to that which has been factory bleached, as this may change the chemical composition of the wax and make it soft and greasy. Beeswax should not be heated much over its natural melting point of around 145°F (63°C), otherwise it will darken. Beeswax gives a soft film and so is used in conjunction with resins, in varnishes, and in

Beeswax

blends with carnauba wax—for example, in encaustic painting (see page 223)—to give a harder film.

Carnauba wax This wax occurs as a coating on the leaves of the Brazilian palm, *Copernicia cerifera*. It is a hard, brittle wax with a melting point of around 185°F (85°C), more resistant to marking than beeswax, and also

Carnauba wax

more durable. Its main use is in coatings, where it is generally found in mixtures with beeswax.

Paraffin waxes The paraffin, or hydrocarbon, waxes are particularly stable. Their hardness can be controlled depending on the molecular weight, and a wide range of melting points can be obtained. This enables manufacturers to have a great deal of control over the particular kind of wax to suit a particular product. For modeling materials, waxes are required that soften on touch, so relatively low-melting point waxes are used here. For wax crayons, a wax that softened on touch would be inappropriate, so a harder wax is used, but not one so hard that it requires a very high temperature to melt it during the manufacturing process. Wax crayons and oil pastels are generally made from hydrocarbon waxes, though the latter incorporate a non-drying oil like tallow that renders them less durable than, for instance, linseed oil-based pigment, but gives them better adhesion to the support than pure wax crayons. Provided that the pigmentation levels are adequate, the wax components, being inert, are acceptably permanent.

Candelilla wax Candelilla wax is the exudation from the Mexican plant *Pedilanthus pevonis*. It is mainly comprised of paraffinic hydrocarbons and has a melting point of between 133–158°F (56–70°C), a little lower than that of carnauba wax for which it is a somewhat inferior substitute.

Solvents

A SOLVENT IS ANY LIQUID IN WHICH A SOLID CAN be dispersed to form a solution. Solubility depends on electrical properties and molecular size, small molecules being more readily soluble than large ones. Molecules are electrically neutral because their positive and negative charges are balanced. If the arrangement of charges is symmetrical, the molecule is called "nonpolar," if it is not symmetrical, it is "polar." In general, nonpolar materials are soluble in nonpolar solvents and polar materials are soluble in polar solvents. Glucose, for example, is soluble in water; cellulose, which is made up of glucose units, is insoluble in water. However, if cellulose is made more polar by conversion to carboxymethyl cellulose, it becomes water-soluble.

Solvents are important for their ability to render a solid substance, such as glue or resin, into a stable solution that allows the solid to be freely spread and manipulated on the support while the solvent then evaporates without leaving a residue. Possibly more important, is the use of solvents as thinners. These are used to decrease the viscosity of a paint or varnish and allow it to be spread thinly. A resin may be dissolved in one solvent and thinned with another.

In a paint formulation, it may be necessary to add more than one solvent to obtain the required properties of the paint. The correct combination is known as "solvent balance," and is determined by experimentation. A solvent does not need to be compatible with the solute at all concentrations.

Using solvents

Water is the most common and by far the safest solvent, and it is universally used in art practice. Historically it has been associated with egg tempera and watercolor and more recently with acrylics and the water-soluble oil colors that are coming onto the market. As far as possible, there has been a move away from volatile organic solvents, because they can be harmful to individuals and to the environment.

Water as a solvent

High levels of soluble salts present in untreated water can have very damaging effects on watercolors, inks, and acrylics, so distilled water is used in their manufacture. This is not necessary when diluting watercolors or acrylics, however, although manufacturers do recommend it for diluting inks. Distilled water should be used in tempera emulsions.

Solvent properties
The usefulness of a solvent is determined by these six major properties:

Solvent power This is the ability of the solvent to disperse the solute. Solvent power can be measured in various ways:
- The Kauri-Butanol value (or KB)—this is the amount of a kauri resin-in-butanol solution needed to turn a given quantity of the solvent being tested cloudy, or turbid
- The Aniline-point—this is the temperature at which turbidity occurs in a mixture of the solvent and aniline, a colorless, oily liquid.

Boiling point This is the temperature at which the solvent evaporates. A pure liquid of single chemical composition has a characteristic boiling point. A mixture, such as paint thinner, has a boiling range, because different constituents evaporate at different temperatures. This is normally known as the "distillation range" (which is stated as the initial boiling point, the distillation of given percentages, the dry point, and the final end point).

Evaporation rate Of particular interest to artists, this is a measure of the rate at which a volatile solvent leaves the paint or varnish

film. It is especially important for a film that dries solely by solvent evaporation. Evaporation rates are comparative; butyl acetate is usually taken as a standard and given a figure of 100, so that xylene at 68 evaporates slower and ethyl alcohol at 203 evaporates considerably faster.

Flash point/flammability This is the temperature at which the vapor given off by the liquid will ignite if a source of ignition is present. This is mainly important for the safe handling of the solvent.

Toxicity Volatile materials may readily enter the body by inhalation. They may also have toxic effects if in contact with the skin. Toxicity varies, but many solvents have narcotic effects and should only be used with adequate ventilation. If necessary, organic solvent vapor respirators should be worn, particularly if spraying. Barrier creams should also be used. See p.370 for information on working safely.

Odor This may be characteristic of the solvent itself or it may be due to impurities. The odor of paint thinner, for example, is due to the presence of aromatic hydrocarbons. So-called odorless solvents have these removed, but the solvent power is thereby reduced and they may not be as tolerant of resin addition.

Kinds of solvents
The nonaqueous solvents used by artists may be divided into seven groups:

Terpene solvents These are the oldest solvents in use in the paint industry. They have already been discussed under oleoresins and essential oils (see p.32) and they include turpentine, dipentene, and pine oil. Turpentine is used to make resin varnishes such as dammar varnish. Dipentene and pine oil are used to retard skinning,

the latter can also be used as an antifoam agent and has some anti-bacterial action.

Hydrocarbon (nonpolar) solvents These have largely replaced the terpenes as the most common solvents used in surface coatings. The commercial hydrocarbon solvents, obtained by the distillation of petroleum, are usually mixtures of closely-related compounds. Hydrocarbon solvents fall into three classes:
- Aliphatic: These are straight, open-chain hydrocarbons, commonly known as paraffins (but not to be confused with paraffin burning oil, which is a mixture of petroleum hydrocarbons). They include gasoline, paraffin, petroleum jelly, and wax. Paint thinner is a mixture of aliphatic and aromatic hydrocarbons
- Naphthenic: These are cyclic hydrocarbons—compounds that contain closed rings rather than open chain molecules. Odorless solvents may contain high proportions of naphthenes if aromatics have been converted by hydrogenation
- Aromatic: These are cyclic hydrocarbons that contain a benzene ring. Examples are toluene and xylene, which have been commonly used in conservation.

Oxygenated (polar) solvents These are better solvents for the polar

film-forming materials such as shellac, cellulose esters, urea/formaldehyde (U/F) and melamine/formaldehyde (M/F) resins, and the vinyl resins.

Alcohols Examples of alcohols are methanol (CH_3OH), ethanol (C_2H_5OH), isopropanol ($CH_3 CH_2(OH) CH_3$), and butanol ($CH_3 CH_2 CH_2 OH$).
These may be encountered by the artist as solvents for shellac, mastic, and for dewaxing dammar resins (see p.34). Methyl acetate is ethyl alcohol containing up to 4 percent methanol and may be used as a solvent for polyvinyl acetate in charcoal fixatives.

Esters These have characteristic odors. Possibly the best known is amyl acetate—the "pear drop" smell in adhesives and nail polish. Of particular interest to the artist are ethyl acetate and butyl acetate, which are found in aerosol fixatives and cellulose lacquers. They are highly flammable and narcotic.

Ketones Ketones such as acetone are often used by restorers for removing varnishes that are no longer soluble in hydrocarbons. Paint thinner is usually used as a diluent in this case.
Acetone has a wide range of uses. As well as being the principal constituent in most commercial paint removers, it mixes well in all proportions with water, oils, and many other solvents. This makes it a particularly useful ingredient in solvent mixtures.

Glycol ethers This group of solvents, which includes 1-ethoxyethanol (cellosolve), may be found in specialist lacquers based in natural resins, nitrocellulose, and synthetic resins. They should be avoided if possible unless conditions can be carefully controlled, because they are readily absorbed through the skin, producing irreversible toxicological effects.

Additives

A NUMBER OF INGREDIENTS ARE INVOLVED IN the preparation of paints, varnishes, painting mediums, and other artists' materials that are not discussed in the preceding pages. These include preservatives, plasticizers, driers, surfactants, extenders, and thickeners. Driers tend only to be used in oil paints and oil painting mediums and varnishes. These additives are also discussed elsewhere in the appropriate sections of the book.

The use of additives

The additives described below are commonly used by the commercial artists' material manufacturers who need to maintain a consistent product with an appropriate shelf life. With the possible exception of certain driers, and the use of ox gall as a surfactant, they are not generally used by individual artists.

Preservatives

Preservatives are added to watercolor and acrylic paints and mediums to prevent the surface effect of mold growth and the spread of bacteria within the paint. Certain bacteria can affect the stability of the paint, especially in watercolor, where the gum content can be attacked, causing a thinning of the paint.

Traditionally, camphor, thymol, eugenol, phenol, and formaldehyde have been used as antiseptics and disinfectants. Phenol and formaldehyde, which were used extensively in watercolor paints, are extremely toxic, and restrictions on the levels allowed are severe.

With the increased awareness of the health risks involved in the use of preservatives, manufacturers are trying to find alternatives that are as effective as traditional ones, but at much lower concentrations. These have been replaced by PCMC and PCMX in educational products and isothiazolone derivatives in acrylics and watercolor.

However, chemical hazards information is expanding at an ever-increasing rate and some of these alternatives are now classified as skin sensitizers, in particular the isothiazolone blend commonly known as MIT/CMIT. Fortunately,

at the moment some isothiazolones are acceptable, as are formaldehyde donors with low levels of formaldehyde release. These and preservatives permitted in foodstuffs and cosmetics will be found in modern art materials.

Pigments vary in the amount of preservative required. Blacks, for example, need high concentrations of preservative, possibly because their absorption of heat helps to incubate bacteria. Some mediums, such as gum tragacanth, are more prone to mold than others, so colors that incorporate it as a thickener will require more preservative.

Another consideration is the reactivity of certain pigments to preservatives. Quinacridones, for example, and some aluminum-based lakes, cannot be used with phenol for this reason, so formaldehyde tends to be used instead.

All preservatives are classified as dangerous substances under US legislation and may be toxic, harmful, or irritant.

Plasticizers

Plasticizers are added to binding materials to give flexibility to a paint film. In watercolor, glycerine, or glycerol, is the most common plasticizer, with sorbitol being used in the cheaper grades. A tube watercolor requires more glycerine than a pan color (see p.128). Glycerine is also used in poster or gouache colors, where the thicker paint film requires more flexibility.

Chemical plasticizers, such as dibutyl phthalate, are used in alkyds, celluloses, and certain synthetic resins such as PVA. The acrylics are generally internally plasticized by the incorporation of softer polymers. This makes for a more permanently flexible paint film.

Driers

Driers, or siccatives, are incorporated into certain oil colors, oil painting mediums, and some varnishes. They are generally metallic salts from lead, cobalt, or manganese. They can be characterized as surface driers (cobalt) or through driers (lead). The former dry at the surface first, leaving a soft film underneath; the latter dry through the film from the inside. In the manufacture of oil colors, a single drier can be used, but in the manufacture of varnish or mediums, a balance of surface and through driers is generally incorporated for even drying. Manufacturers consider that a

brushed-out oil film should be touch dry within 2–14 days. Particularly slow-drying pigments are modified with driers to come within this accepted drying range.

Driers are usually only used in painting mediums when working with thin paint, as in a glaze. A combination of lead, cobalt, and calcium is generally used, the latter not being a drier in itself but preventing bloom in transparent films. Nowadays, the toxic lead, with its darkening effect, tends to be replaced by cerium and zirconium.

The use of driers in varnishes is dying out, because the modern ketone or acrylic-based varnishes dry by evaporation and not by oxidation.

Surfactants

Surfactants, or surface active agents, are added to lower the surface tension at an interface between two surfaces (such as that between the pigment and the binding medium or the liquid paint and the paint support). The action of a surfactant causes changes in properties, such as wetting, emulsification, detergency, and foaming. Wetting agents are used in watercolor, oil, and acrylic paints as an aid to pigment dispersion and in watercolor especially to give good flowing-out characteristics.

Some pigments are difficult to wet and more than one wetting agent is needed. But even those that are easy to wet will have a wetting agent added to alter the surface tension so as to improve flow and control the wash. Wetting agents such as ox gall are also used to create certain marbling effects.

The surfactants used as wetting agents for oil colors serve a second purpose, replacing the acidity of the alkali-refined oil used in pigment grinding. This improves the wetting-out characteristics reduced during the refining process.

The surfactants most commonly used in artists' paints are:
- Alkylaryl sulfonates, such as sodium dodecyl benzene sulfonate, used in emulsion polymerization (see p.35) and as a wetting and dispersing agent in watercolors
- Ether sulfates, including sodium lauryl ether sulfate, also used for emulsion polymerization
- Sulfo succinates, such as sodium di-octyl sulfosuccinate, used as a wetting and dispersing agent in watercolors and acrylics
- Alkylphenol ethoxylates, such as nonylphenol ethoxylate, used as a wetting agent and an emulsifier
- Alcohol ethoxylates, such as fatty acid ethoxylate, used as a dispersing agent in oil colors and a wetting agent in acrylics
- Polyethylene glycol stearate—used as a wetting agent to help disperse the pigment in wax crayons.

Other substances include the polycarboxylates, used as pigment dispersants and in emulsions. Mineral oil-based surfactants are used as antifoams in emulsions, and the condensation products of formaldehyde and naphthalene sulfonates are commonly used in cheaper water-based color. In powder form, they are also used in powder colors and color blocks.

Aside from those mentioned above, the main wetting agent in artists' watercolor is ox gall. That sold to artists is only about 0.4 percent ox gall in solution, but even one drop of this added to the color, to the water, or to the mixed wash is enough to improve flow.

Extenders

Extenders are used to control the pigment strength and consistency of those colors that are naturally too strong to be used as they are. Phthalocyanine Blue, for instance, has up to 50 percent extender added before use. Commonly used extenders include precipitated chalks, magnesium carbonate, alumina hydrate (for transparent colors), blanc fixe, and china clay (see p.172). They are used in acrylic and oil paints, and also in opaque watercolors—but only if they are absolutely essential, since they produce a white coloration and do not give such a bright, transparent wash.

Thickeners

These are used in oil, acrylic, and watercolor to "body" the paint, give it more stability in the tube, and produce a tube-consistency color. Some pigments give a thin solution when mixed in watercolor, so they need to be thickened. The coarser natural earths would separate in the tube if thickeners were not added. Aluminum stearates are used in artists'-quality oil paints in proportions of up to 2 percent, but are only effective with certain pigments. The alternatives are hydrogenated castor oil derivatives that are predominantly used in second-quality tube colors. Other modern silicates or swelling clays modified for oil dispersion are used in limited quantities. Waxes are also used, but are softened by the later application of solvents. In acrylic paints, polyacrylate or cellulosic products are used as thickeners.

Watercolor paints that need to be transparent cannot be bodied in the same way as oil paints. For watercolor, gum tragacanth is used and also starch or dextrin. In addition, swelling clays like bentone are used. Thickeners are not generally used in pan colors.

Other additives

In addition to the above, acrylic paints may also contain:
- Antifreeze, added to protect consignments of paint during transit. This does not affect the paint properties. The most common is propylene glycol
- Coalescing solvents, which lower the minimum film-forming temperature of acrylic emulsions. Aromatic glycols, such as phenoxy ethanol, are used
- Antifoam agents—these prevent the foaming that acrylic emulsions sometimes exhibit. They are mineral oil-based substances.

SUPPORTS
AND GROUNDS

Wpainting are the topics that inform this part of the
handbook. Over the centuries, painters have turned to all
kinds of supports for their activities, including stone,
glass, wood, and canvas. It is worth noting the comments
on the deterioration of supports and grounds in the
Conservation section (see p.328), as some of the pitfalls
can then be avoided when you are preparing supports.

Las Meninas *(ca. 1656)*, Diego Velázquez

In *Las Meninas*, Velazquez turns around the conventions of
the subject in a painting, so that as spectators we become the
sitters for the painter. We are the King and Queen of Spain,
being observed by the Infanta Margarita with her "Meninas,"
or Maids of Honour, on each side, together with Velázquez
himself and members of the court. This device allows us to
see the canvas support on the stretcher frame, to the left
of the painting. The wood and canvas seem almost prosaic
compared to the complex world of illusion that they support.

Rigid Supports

THE SUPPORT IS THE STRUCTURE TO WHICH the paint and ground layers of a painting adhere. It can be either rigid, such as wood or aluminum, or flexible, like paper or canvas. If the paint film is to remain intact, the support must have good dimensional stability and durability.

The main advantage of using a truly rigid or inflexible support is that it induces no strain at all into the paint layers. Therefore,

you need only concern yourself with the movement of the paint film itself, rather than with the movement of both paint film and support. This reduces the risk of cracking and allows for more freedom in the handling of paint and a greater latitude as far as the rules of painting are concerned. It also allows you to use painting media like egg tempera or casein, which are often considered too brittle to use on flexible supports.

Natural wood

The advantage of a rigid support is a relative one where wood is concerned, as the main defect of natural wood is its tendency to shrink, expand, and distort as it loses and absorbs moisture in the atmosphere. There are two main kinds of wood:

- Softwoods—mainly conifers in the gymnosperm group. These have long cells, often contain a great deal of resin, and can deteriorate rapidly

- Hardwoods—the broadleaved trees. These can be deciduous or evergreen, and they belong to the angiosperm group. They have shorter fibers than the softwoods, but they are more durable and resistant to wet rot.

Wood for artists' panels generally comes from the temperate or tropical hardwoods, though some softwoods are occasionally used.

The seasoning process

The danger of shrinkage and distortion is lessened by seasoning, a process whereby the moisture content of the wood is reduced to the same level as the atmosphere surrounding it. There are two methods:

- Air-drying, in which the planks are stacked horizontally with thin sticks between them to allow the natural and free movement of air around the whole piece
- Kiln-drying, where the wood is subjected to steam heating, which removes the moisture more rapidly but is said to be less effective in the long term than air-drying.

Wood has an extremely variable structure, and the moisture absorbence can vary within a single

plank of wood, due to differences between early wood and late wood, sapwood and heartwood, and the direction of the grain.

Cutting wood

Most wood is plain sawed—that is, the planks are cut "through and through" the log. However, logs sawed in this way show a marked tendency to distort. Radially-sawed planks, on the other hand, are the most stable.

The old method of radial or "quarter sawing" produced the best planks, but a great deal of waste, because the edge of each plank has to be squared off. Nowadays, the quarter-sawed log represents the most commercially viable compromise. Quarter-sawed planks should always be used in the construction of panels for painting.

Modern quarter-sawed

The effect of the grain in the plank With plain-sawed wood (top) the end grain is comparatively oblique to the surface of the plank. This makes the possibility of movement much greater than with quarter-sawed wood (above).

Using secondhand wood

Since the natural process of seasoning can take years, some painters prefer to make panels from old, secondhand wood, provided that it is worm- and rot-free. However, even well seasoned wood will move and, although movement along the grain is virtually negligible, movement across it can be quite dramatic. Radial checks or cracks can develop and are one of the most common problems with old panels. The effect of all this can be very destructive if the movement of the wood causes cracking of the brittle paint film (see *Conservation and Framing*, pp.327–43). However, the paint film will probably not be entirely inflexible and the wood may be considerably more mellow and less vigorous than new, unseasoned wood, especially if kept at a reasonably constant temperature and humidity.

Bowing and cupping The surface of a plank may bow along the grain (above) and cup across it (top), causing distortion in the shape of the panel.

History of painting on wood

A wide variety of wood was used in the past. Egyptian paintings on cedar panels are well preserved, and panels were almost universal in Italy until the 1300s.

In his book *Il Libro dell'Arte*, 15th-century artist Cennini recommended poplar, which was widely used, along with linden and willow. Other woods used included lime, beech, chestnut, and walnut. In Holland and other areas of northern Europe, oak was

particularly favored for its strength and resistance to the damp climate.

A survey of 1,100 early Renaissance paintings from Europe has shown that 560 Flemish and 80 German panel paintings used oak panels as supports. An oak panel used by Van Eyck, which is well coated on the back with gesso glue and tow and covered with black varnish, has been found to be immune from woodworm and perfectly preserved.

Among other woods that were less available to Renaissance artists is mahogany, which can be recommended in every respect. It is extremely durable, has medium to good working qualities, small moisture content, and is of medium price, though it should always come from a sustainable managed source. Another good all-around wood is cedar and, in particular, the Western red cedar.

Technique

Making panels

There are various ways of joining planks of wood together to make panels. Tongue-and-groove or zigzag joints can be cut, or wooden dowels and butterfly keys used to join one panel to another. The planks can be clamped after gluing with a proprietary wood adhesive. In the past, a glue made from cheese and lime was used, and examples of planks bonded in this way remain strong to this day.

Cennini recommended planing the panel to degrease it, covering knot holes with sawdust and glue, and covering nails (in old panels) with tinfoil before preparing the panel for painting.

Well-seasoned, quarter-sawed planks are best, but if you have to use plain-sawed planks (see p.43), the direction of the curve of the grain of the wood should be alternated to prevent large sections of the panel from cupping.

Matching the direction of the grain
If at all possible, use well-seasoned, quarter-sawed planks, joined so that edges match—core edge to core edge, outer edge to outer edge (as shown).

outer edge to
outer edge

core edge
to core edge

Strengthening the panel At the joint between two planks, the greater the contact area the better—a zigzag cut (above) has a larger surface area than a tongue-and-groove joint (top).

Using additional strengtheners Planks can be joined together with wooden dowels (above), or butterfly keys (top), which are inserted at the rear of the panel.

Manmade wooden supports

There is an increasing range of wood-based panels on the market that have a high degree of dimensional stability and are suitable rigid supports for painting. They do tend to be heavy, however, and in some cases the inclusion of acidic elements may cause deterioration in the long term.

Plywood

Plywood panels consist of a central wooden core sandwiched between a number of thin layers of wood that are glued together. These laminations, or plys, add to a panel's strength but not necessarily to its stability, since there is more in-built tension in a panel with many layers. Fewer laminations are said to make the panel more susceptible to moisture and insect attack.

Of the various woods used to make plywood, poplar and birch are among the most common. The best plywood is W.B.P. (Weather and Boil Proof), in which the glue used is based on phenolic resin. An upgraded W.B.P. plywood for marine or outdoor use is known as marine ply. Such panels are often made purely of mahogany and are thus extremely durable. A birch ply gives a good, fine-grain structure that takes priming well. All sizing and priming should be done on both sides of the panel and on the edges so as to keep the whole sheet stable.

The advantage of plywood is that its construction makes it reasonably stable, rigid, and unlikely to split since the direction of the grain of each layer is at right angles to the one beneath.

Blockboard

Blockboard is made of narrow, parallel softwood or, less commonly, hardwood strips glued edge to edge and faced, like ply, with a thin veneer. In "three-ply" construction, the inner core is only covered by one outer layer on each side. In "five-ply," there are two skins on each side of the blockboard core. Such panels would be the most suitable for artists' purposes because they are more durable and extremely rigid. Unfortunately, the quality of blockboard is very variable.

Chipboard

Chipboard is a dense material made of chips of wood compressed into rigid panels with synthetic resin glues. It is commonly used as a substrate for laminates in furniture-making and, in high-density forms, as a flooring material. The latter would be better for artists' supports, since they have a more uniform consistency and are very stable. Chipboard is heavy and large boards may be difficult to maneuver.

Composite panels

These are among the most stable of the rigid supports available to artists. They are made from wood that is reduced to a pulp and then reconstituted with various synthetic resin-type adhesives.

Hardboard The homogenous structure of hardboard is said to be more stable than solid wood, plywood, or blockboard. It is made by hot pressing steam-exploded wood fibers with some resin, and relies mainly on the lignin that is naturally present in the wood to cement the particles together. It is commonly available in ⅛in and ¼in (3mm and 6mm) thicknesses. Large hardboard panels must be glued to a rigid framework, but smaller sizes can be used with no additional reinforcement.

Hardboard panels have one smooth and one meshlike surface; both of which can be used to paint on. The smooth side should be degreased but not sanded, as this may cause irregular swelling of the surface when size or water-based primer is applied.

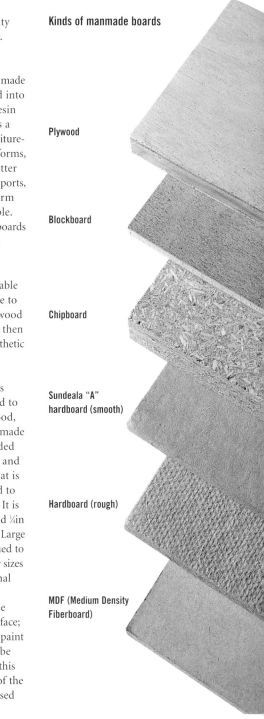

Kinds of manmade boards

Plywood

Blockboard

Chipboard

Sundeala "A" hardboard (smooth)

Hardboard (rough)

MDF (Medium Density Fiberboard)

Medium-density boards A number of medium-density fiberboards, such as "Medite," are available. Their process of manufacture is similar to that of hardboard, but they use resins as binders. Pulped wood fibers are steam-forced into a narrow gap between rotating rollers and sprayed with resin, which disperses into the wet fibers as they begin to dry. They have smooth front and back finishes and are among the most stable boards available. These boards, which used urea-formaldehyde resins in their manufacture, now have a reduced level of formaldehyde emission and are classified as Class A boards. Medite ZF is a zero-formaldehyde board in which a polyurethane resin is used as a binder. Artists may prefer to use this formaldehyde-free product for health and safety reasons or the external grade "Medex," which has more resin added for strength and durability.

Although fiberboard panels have excellent moisture resistance, their edges are much more absorbent than their surfaces, so these should be well sealed.

The medium hardboards, such as those produced by Sundeala, are rigid and light and have been extensively used by artists. The grade "A," which has some resistance to water absorption, is the board recommended for artists' use. These boards have a less hard and glossy face side than standard dense hardboard. This surface, combined with some degree of porosity, gives a size or primer an acceptable key.

Other rigid supports

There are many alternative supports to wooden panels. Copper, for example, became widely used as a support for painting from around the 1500s. Sheet metal, including steel, can be heavy, and sheet aluminum is an alternative.

During the 1900s, developments for the aeronautical and railroad industries produced honeycomb aluminum panels that combine dimensional stability with durability and lightness. They provide an excellent support for painting, for works in vinyl, or large-scale photographic artworks.

Honeycomb aluminum panels
These are considerably lighter than plywood, yet strong and dimensionally stable. They provide a practical support for painting that needs no additional strengtheners or supports. If the boards are degreased and sanded, they will accept conventional artists' primers.

A proprietary titanium-pigmented, oil-modified, alkyd resin primer is a durable primer for both the aluminum- and glass fibre-reinforced plastic (G.R.P.)-faced panels. Alternatively, the aluminum-faced board can be directly covered with two coats of acrylic primer. If a fabric texture is required, they can be covered with a lightweight, loosely-woven cloth, bonded on with any of the proprietary adhesives recommended by the manufacturers, and subsequently primed.

Honeycomb aluminum panels are also used extensively in the conservation departments of many museums as backing boards for old panel paintings.

Sheet aluminum
Although the honeycomb panels described above offer the best aluminum surface for painting, some painters may wish to work

Honeycomb aluminum
The samples above show a G.R.P.-faced honeycomb aluminum panel on top of an aluminum-faced one with the panels primed with a titanium-pigmented, oil-modified alkyd resin primer on the right.

on sheet aluminum. This needs to be properly prepared.

The first stage is to degrease it using paint thinner, methyl acetate, or a proprietary oil-removing fluid. This is washed off and the panel left to dry. Avoid using alkali cleaners such as ammonia-based ones, which can damage aluminum.

The degreased panel should then be given an acid wash with dilute phosphoric acid, or rubbed down well with emery paper, to give it a good key. A very thin coat of self-etching primer is then applied. This gives an excellent bond between metal and subsequent coatings. A red oxide primer is satisfactory for internal use; the more durable zinc tetroxychromate etch primer is recommended for external use. Two coats of oil painting primer should then give a satisfactory painting surface.

An alternative method is to use a two-part polyurethane undercoating within 24 hours of applying the soft etch coat. The "A" component of polyurethane coatings consists of saturated polyester resins. The "B" component consists of isocyanate resins, either aromatic or aliphatic. (The latter should be used in white pigments because they are less yellowing.) The first coat should be thinned with 15 percent thinners and a full-strength coat applied between 6 and 24 hours later. Rub down the dried polyurethane with wet and dry abrasive paper to give a good key.

Fiberglass
Fiberglass in flat board film is not a common support for panel painting; artists generally use it to mold low-relief constructions.

The advent of the honeycomb aluminum boards with fiberglass-reinforced plastic faces (see opposite page) has provided a new, light, rigid support that can be satisfactorily primed for artists' purposes. The surface should first be degreased and sanded with wet and dry abrasive paper, then coated with a proprietary fiberglass primer. This evaporates rapidly and slightly softens the surface so that it can receive the primer. A conventional oil/resin-based artists' white primer will take satisfactorily to the surface.

Alternatively, use the polyurethane coating described in the above section. Such coatings contain curing agents that react with hydroxyl groups in the fiberglass gel coat and this makes for a very durable bond. Fiberglass is known to degrade in UV light, so it must be protected from sunlight.

Steel
Mild steel should first be sandblasted to remove all traces of rust. A coat of zinc phosphate primer is followed by a layer of high-build epoxy or micaceous oxide paint, then a two-pack polyurethane finish for external use.

Alternatively, it can be zinc-metal sprayed after sandblasting and given a low-build epoxy primer before the finish coat. Galvanized steel requires a mordant wash before being primed and painted.

Copper
Copper is soft, so it dents and bends easily. It has a high coefficient of expansion and this can give problems for paint adhesion, although it is very stable when kept indoors. Copper is prepared for priming by thoroughly abrading with 180–200 emery paper, after which the White Lead in oil, or titanium in oil-modified alkyd, can be applied directly.

It has been suggested that a stippling technique is used to apply the first thin coat of primer. Each subsequent coat should be allowed to dry thoroughly until completely hard before the next coat is applied. Dull the primer surface slightly by abrasion with emery paper before painting.

Kinds of rigid supports

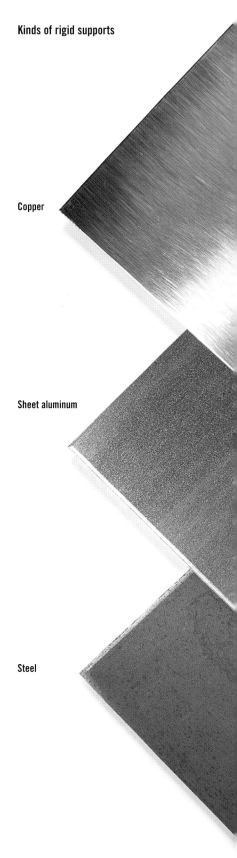

Copper

Sheet aluminum

Steel

Flexible Supports

IT MIGHT BE IN THE LONG-TERM INTERESTS OF their work for artists to paint on rigid supports, but there is something about the quality of paper and the flexibility of canvas that makes them irresistible. For large paintings, it is more convenient to work on a stretched canvas.

Paper

The wide range of surface types and textures, and the different weights, sizes, and tints of papers currently available from all over the world, provide artists with an enormous resource. This may at first seem overwhelming but it soon rationalizes itself into some kind of order.

Raw materials

The basic raw material in paper is cellulose fiber, which comes from a wide variety of plant sources. The plant fibers are reduced to a pulp, and certain potentially harmful substances removed before they are felted together in sheet form as paper.

Different plant fibers have very different characteristics that affect the quality and appearance of the paper. In the West, the best artists' papers have traditionally been made from linen rags. The linen fiber is said to be stronger than cotton or any of the alternative plant fibers but, nowadays, pure linen paper with its characteristic natural flax color is very rarely found. Cotton is now used by most paper manufacturers. Whereas, in the past, cotton was used in such forms as shirt cuttings or other offcuts from clothing manufacturers, or even old "debuttoned" cotton clothing, the introduction of manmade fibers such as nylon and rayon into cotton fabric has made the use of rag impracticable, since these artificial fibers produce unacceptable clear specks in a sheet of paper.

Nowadays, cotton linters are used. These are the fibers left on the seed after the longer 1–2½in (2–6cm) fibers used for making yarns have been taken off. They can vary in length from approximately ½–¼in (2–6mm), depending on whether they come as first cut (longest) to fourth cut (shortest). The longer the fiber, the stronger the paper. The best linters come from the southern United States or from Egypt and are usually bought in by paper manufacturers in bleached sheet form (as is wood pulp). The bleach has been thoroughly washed out by this time but, to check for impurities, some manufacturers subject sheets from each new batch to fading tests using xenon lamps.

The other common raw material is wood pulp. This has not been recommended in the past as a suitable material for artists' paper, since it contains harmful yellowing materials such as lignin. But, with the advent of photographic paper production, wood pulps needed to be developed that were considerably more pure than before and, nowadays, the so-called wood-free papers made from chemical wood pulp are not far behind cotton papers in permanence, with some respectable, high-purity, wood-pulp watercolor papers (such as "Bockingford") on the market. For some watercolor papers, a mixture of cotton linters with the clean, longer-fibered spinning waste from cotton mills is used. There are also some manufacturers of handmade papers who used flax/cotton mixtures in their pulps.

For Oriental papers, a wide range of plant fibers is used, ranging from the short-fibered "gampi" (*Wickstroemia shikokiana*), which gives a thin, transparent paper with a fine, smooth finish, to the longer-fibered, stronger "mitsumata" (*Edgeworthia papyrifera*) paper. The Oriental papers are sized using vegetable sizes that are made from pulp vegetables and subsequently stored in pots underground.

The manufacturing process

Water plays a large part in the manufacture of paper and it is for this reason that many established paper mills are located by a natural water supply. River water from limestone hills is very pure and requires only mechanical filtration before use.

The pulping process The sheets of cotton linters or wood pulp are put into hydropulpers with water and blended for 10 minutes to produce a slurry of fiber and water. This is pumped into storage towers and then through refiners—conical-shaped machines with a fixed outer cone that has metal bars on its inside surface. An inner cone rotates and can move in and out so that the distance between the rotating bars on the outside surface and the fixed bars inside the outer cone can be carefully controlled. The fiber-and-

water slurry passes between the bars and is treated lightly or heavily according to the type of end product required. The refining process controls the length of the fiber and the extent to which each fiber is split into individual fibrils. These tiny strands that are teased off each main fiber join with those on other fibers to give strength to the paper.

For handmade papers, the pulping and refining stages are combined and "Hollander" beaters are used to beat the pulp and to modify the fibers. The refining process can be more closely controlled in this way.

Internal sizing From the refining machine, the pulp goes to storage chests and, from there, via a large pump and continuous internal sizing, to the papermaking machine. At the large pump stage, there is 99 percent water and 1 percent pulp. For the internal sizing that is mixed in with the pulp, the better manufacturers use a synthetic size with a neutral pH. The new size is alkyl ketene dimer, which avoids the harmful effects of the old rosin/alum sizings. This is known as alkaline sizing or neutral sizing, because it is carried out in the absence of alum. The sizing, which is based on a fatty material derived from tallow, relies for its effect on a chemical reaction with the cellulose in the fiber.

The alkyl ketene dimer molecule has two main components—one end attracts water and the other attracts oil. The watery end attaches to the cellulose by hydrogen bonding—the cellulose being naturally hydrophilic —while the fatty end leaves a spot on the cellulose that is water-repellent. The degree of water repellence can be varied according to the intended use. Whereas a conventional size puts a waterproof layer down onto the support, the alkyl ketene dimer size gives a sizing effect without blocking the pores or the porosity of the fibers.

The internal sizing controls the absorbency of the sheet and gives a controlled pickup of gelatine when the paper is tub-sized after being formed. On a moldmade paper with only internal sizing, a watercolor wash will generally be absorbed and fixed into the paper and will not be readily adjustable as with a surface-sized sheet.

On handmade papers, most of which are internally sized, the internal sizing is far stronger than that on the machine- and moldmade papers, where further surface sizing is required.

Moldmade papers Artists' moldmade watercolor and printmaking papers are made on a slower-moving cylinder mold machine. Here, the fiber and water are pumped into a vat in which a large cylinder mold revolves. The sleeve or mold cover is made of thin wire mesh that, through a gravitational suction effect, draws up the pulp from the vat. Here, the fibers arrange themselves in a more random order on the mesh, which gives the sheet great strength and even stretching properties in each direction. The moldmade paper is therefore far more dimensionally stable than the machinemade sheet. Handmade paper in which the fibers show no direction at all is the best in this respect.

The deckled edge of the paper is formed naturally on each edge of the roll, but artificially at right angles by the use of a terylene tape that indents the paper to provide a tearing bar when the roll is made into sheets. The paper is carried away through a press section on a woollen felt or blanket, which gives the paper its characteristic grain. For rough paper, a coarse base weave is used for the felt, with a lot of texture and very little nap. For cold-pressed (CP) paper, a more spongy, teased-up felt is used with more nap. The paper and felt go through a press section that mechanically squeezes water out.

Moldmade paper

Fabriano Artistico
HP wove 200gsm

Saunders Waterford
CP wove 300gsm

Arches Aquarelle
rough wove 300gsm

Handmade paper

Two Rivers Watercolor
white handmade wove
410gsm

Khadi handmade
Gunny rough 210gsm

Japanese paper

Kawasake off-white
laid 29gsm

Hosho sized white
laid 73gsm

Printing paper

Bockingford inkjet
190gsm

Somerset velvet
radiant white 250gsm

Tinted paper

Bockingford 300gsm
oatmeal

Bockingford
300gsm blue

Subsequently, the paper—still with a 65 percent water content—goes around steam-heated drying cylinders on an open mesh that holds the paper in contact with the cylinders and the rest of the water is removed.

Cylinder mold machine making paper at St. Cuthbert's Mill in Somerset, England

Tub sizing for watercolor paper
In the next stage, the sheet is totally immersed in a warm solution of gelatine. This is the surface-sizing process that enables watercolor paper to stand up to a number of washes and manipulations.

The paper picks up its own weight in gelatine before going through squeeze rollers to remove excess liquid and, subsequently, through steam-heated drying cylinders. The surface-sizing pickup on the cylinder mold machine, with its total immersion process, is far greater than that which can be had on the large commercial machine, but it does not compare with the true tub sizing that handmade papers were given in the past. Unsized papers were immersed in gelatine that was allowed to soak thoroughly into each sheet of paper before the paper was squeezed, left to stand for 12 hours, and air-dried for a week. The front of the sheet could be identified by holding it up to the light and reading the watermark. On moldmade paper, the "front" of the paper is the "felt" side because this has the most consistent texture, but in practice both sides of a gelatine-sized watercolor paper can be used because there is little difference between them.

Traditional moldmade printmaking papers are not surface-sized, though the new inkjet printmaking papers do have a surface coating.

Hot-pressed paper For moldmade paper, the HP (hot-pressed) surface is obtained by passing the paper through calender rollers that control the thickness and finish of the paper. For handmade papers, a system known as plate glazing has been in use for the last 100 years. Individual sheets of paper are interleaved between sheets of zinc and passed between heavy rollers. A combination of pressure and slippage produces the characteristic smooth surface.

The characteristics of paper
The three standard descriptions for Western drawing and watercolor paper have been identified as:
● Rough
● CP (cold-pressed)
● HP (hot-pressed or smooth paper)
Within these categories there is a wide range of surface textures provided by different manufacturers who use different types of felt and different finishing treatments. There are HP papers of a glassy smoothness and those that come close to a CP surface. Some rough papers are characterized by such a uniformity of texture that they look like sections of an endlessly repeating textured wallpaper. Others have a much more varied and random-looking texture.

There are equivalent descriptions for printmaking papers, so that Rough would be "Textured," CP would be "Velvet," and HP would be "Satin."

Absorbency The nature of the paper is determined not just by its texture, but by its degree of absorbency. "Waterleaf" paper has no sizing and is held together merely by the fibers themselves. Such papers are commonly used in relief printing. Other papers have very little size and are known as "soft" papers. These are also particularly important in printmaking, which requires some absorbency in the paper.

The internally or neutrally sized papers have been mentioned, as has the process of gelatine tub or surface-sizing. Many handmade papers for watercolor and drawing are now only internally sized using the new neutral sizing mentioned on p.49. This is adequate for most watercolor manipulations, except for the use of masking fluid, which can pull off the surface of the paper when it is rubbed off. If masking fluid is to be used extensively in a painting, a paper with a gelatine surface sizing is more appropriate.

The watercolor artist generally requires such a paper. Some artists, like Emil Nolde and Jackson Pollock, on the other hand, found the very absorbent Japanese mulberry papers particularly suited to direct, one-stroke painting methods.

Weight The grammage or weight of the paper is now universally measured in grams per square meter (gsm or gm^2) and can range from 12 for a Japanese mulberry paper, to 640 for a heavy watercolor board. On the cylinder moldmade paper, the weight is controlled by the ratio of fiber to water at the wet end of the machine and, in addition, by the speed at which the machine is run.

pH neutrality Artists'-quality pure "rag" or chemical wood-pulp papers should have a neutral pH reading of around 7. The normal addition of calcium carbonate as a buffering chemical to absorb atmospheric acidity means that, in practice, the pH is usually between 7 and 9.

Reputable papermakers are careful to ensure the purity of the cellulose fiber. It is what is added to the fiber that can cause impermanence and this is why the old rosin/alum internal sizings are avoided in favor of the newer neutral ones.

Laid/Wove "Laid" refers to the horizontal and vertical pattern of lines created by the wire mesh

of the mold on which the pulp is lifted. The chain lines are those that are furthest apart (often vertical) and the laid lines at right angles are the fine lines that are close together. A woven mesh, looking more like canvas, was created to provide a more uniform overall texture. This is known as "wove."

High-quality papers for ink-jet printing The manufacturers of moldmade watercolor and printmaking papers are recognizing the need for paper of the same quality for artists, printmakers, and photographers, who wish to make limited edition prints using ink-jet printers. Whereas the rapid fading of the nonlightfast inks used in this process used to be a major problem for artists wishing to make durable prints, now products such as the new Lysonic Archival Inks have enabled artists to become more confident about the permanence of their work. Paper

manufacturers are applying coatings to one or both sides of their traditionally made papers to prevent the sinking in of the inks and to give good ink-jet receptivity.

Pigmented paper

Unfortunately, many of the commonly available colored drawing papers are not of reasonable quality, being colored with dyes that quickly fade. There is a need for high-quality, pigmented, acid-free, all-rag paper that is colored by adding lightfast pigments at the pulp stage. A greater range of reliable tinted papers would provide excellent supports for pastel painting, and for work in chalk, charcoal, and gouache.

There are some reliable tinted papers available such as those in the Bockingford range, but there are few that offer deeper tones. For this it is necessary to color a sheet of white paper yourself.

Methods of tinting paper It is not too difficult to tint a sheet of white paper, though the effect looks somewhat different from an internally pigmented sheet. It is advisable to stretch paper (see below) before wet toning. There are a number of wet methods, but the simplest is to lay a uniform watercolor or thin acrylic wash over the whole sheet (see p.137). Watercolor is only recommended where dry work, such as pastel drawing, is to be superimposed, because there may be a pickup of the background color with painting. This depends on the absorbency of the paper. A transparent acrylic wash is my preferred option, as it is effectively insoluble when dry and you can work freely on top of it using most drawing or painting media. A transparent wash will give the depth of tone required but will still allow the white paper to "illuminate" the background color. You can dry-tint paper by rubbing pigment powder into the surface.

Technique
How to stretch paper

Paper can be stretched on almost any flat, clean, nonabsorbent surface, from a sheet of laminate to a sealed wooden drawing board or a piece of thick glass. The surface needs to be larger all around than the sheet of paper.

1 Thoroughly dampen the paper on both sides by laying it in a bath of cold water. Allow the excess water to drain off.

2 Cut four strips of brown gummed tape. Lay the wet paper on a board and sponge off excess water from the center so that it lies flat.

3 Wet one strip of gummed paper at a time, using a damp but not too wet sponge.

4 Stick the tape firmly along one edge of the paper and repeat for each of the other three edges.

5 Sponge off any excess water and leave the paper to dry in a warm room.

Canvas

The term "canvas" applies to all types of stretched fabric traditionally used for artists' supports, including linen, cotton, and manmade materials such as polyester. Silk, hemp, and jute have also been used in the past. Canvas has been a popular support since the 1400s and remains so today, despite the fact that it needs more careful and time-consuming preparation than most other materials.

Linen

Linen is made from the fibers of the flax plant (*Linum usitatissimum*). The variety used for its fibers has a long, relatively unbranched stem compared to that used for linseed oil, which is shorter, with a branched stem and larger seeds. Textile flax is grown all over the world, with Russia the major producer. The best flax in the Western world is said to come from a 124-mile (200-km) wide band of country stretching from lower Normandy through Picardy to Flanders and up into Holland, where there is a great flax-growing tradition.

The growing period is around 100 days, with the flax being sown from the end of March and harvested from July to August. The flax is pulled, rather than cut, so as to take full advantage of the long fibers that run into the roots of the plant. The plant ripens from green through yellow to dark green or brown, and the best fibers are obtained from the plant when it is yellow.

Flax plant

The manufacturing process Once the seeds have been removed—a process known as "rippling"—the flax is "retted" i.e., allowed to decompose so that the pectins that bind the fibers together are broken down. In ground or "dew" retting, the flax is left in the fields to decompose naturally by the action of the dew and the warm sun—which takes between 3 and 6 weeks. In water retting, the flax is soaked in tanks of warm water at 98°F (37°C) for 3 to 5 days. After drying for between 8 and 14 days in "stooks," the flax is "scutched," which is a process of separating the fiber from the waste woody matter known as "shiv" or "shive." In scutching, the straw is passed through wooden breaker rollers and then rubbed and beaten by steel turbine blades. This produces long fibers of flax known as "line flax," with fibers of between 2–3ft (60–90cm) in length, and short fibers or "tow," which are between 4–6in (10–5cm) in length. The flax is then combed or "hackled" to separate the line from the tow flax and to ensure that the long fibers are parallel to each other. It also eliminates any further waste matter. The linen fiber is then drafted or pulled several times until a rove is formed that is wound onto bobbins —the rove is a very fine sliver of flax fiber with a slight twist in it. It is the rove that is spun into yarn.

Textural variations There are two spinning methods: wet spinning and dry spinning, and these greatly affect the nature of the woven linen surfaces. Both line flax and tow flax can be either wet spun or dry spun. The wet spinning process, in which the rove is soaked in warm water (140–158°F/60–70°C) during spinning, softens the pectins that are found between the shorter (¼–2¼in/6–60mm) ultimate fibers (fibrils) within the fiber itself. These ultimates slide and twist with the pulling and twisting action of the spinning process to produce a strong, sleek, and lustrous yarn. The dry-spinning process produces a rougher yarn. Dry-spun line flax is less fuzzy than dry-spun tow.

Many permutations can be obtained during weaving by using different yarns for the warp—the yarns stretched along the length of the linen, and for the weft—the yarns that are laid across the fabric. For artist's linen, which relies on the stability of the product, the warp and the weft should be made from the same yarn. The strongest and most durable linen is that which employs wet-spun line for both warp and weft. This has a smooth, "hard" surface with no fuzz, the texture being dictated by the thickness or weight of the yarn.

During weaving, the warp thread is held at considerable tension. The interlaced weft thread is not so taut. When the warp is relaxed, it "crimps," which makes it considerably more distensible than the weft if the canvas is stretched in its loom-state form. In order to get rid of the crimp and to straighten out the yarn, linen should be put through a "decrimping" stage. It should be stretched, wetted, and allowed to dry. It should then be taken off the stretchers and subsequently restretched prior to the application of size and/or priming. This is well worth the trouble because it provides a much

more dimensionally stable cloth that, on its second stretching, will have a more even tension all around. It also somewhat counteracts the "stress-relaxation" factor that applies to linen. This effect is one in which the stretched linen will naturally relax its tension unless there is something to counteract it. The phenomenon is not so apparent with oil painting, in which the contracting oil film counteracts the slackening of the linen, but it is quite noticeable when painting with acrylic on linen.

Cotton

The use of cotton as a textile support in painting has only been widespread since the 1930s. Although it is not as popular as the traditional linen, a good-quality cotton canvas provides a perfectly acceptable surface on which to paint. Cotton comes mostly from two species of cotton plant—*Gossypium hirsutum* and *Gossypium barbadense*. The plants are cultivated annually on a 175–225-day cycle and reach a height of between 10in (25cm) and 6ft (2m). The cotton fibers are seed hair fibers that are revealed as downy hairs when the boll or seed pod splits open. Unlike the long ("bast") fibers of the flax plant, which are connected together by pectins in the stalk, the cotton fibers have merely to be mechanically separated from the seeds by "ginning" and then compressed into bales before spinning and weaving.

The best cotton is Sea Island cotton from the United States, which has the longest fibers or

Cotton ball

"staples" of between 1½–2in (40–55mm). An average medium staple such as that produced in the USA would be between 1–1⅛in (25–30mm).

The manufacturing process The best cotton canvas is "loom-state" canvas, which is untreated by any of the finishes to which most fabrics for domestic and industrial purposes are subjected. Such treatments are known as resin finishing (though the products used are not exclusively resins) and give the crease- and shrink-resistant qualities to natural fibers that enable them to compete with synthetic fibers.

The two main methods of treating natural fibers are, firstly, to deposit chemicals by polycondensation on the fiber and, secondly, to use a chemical that actually reacts with the cellulose of the fiber. A gain in crease recovery and dimensional stability is coupled with an increase in the brittleness of the fiber and a loss of tensile strength and abrasion resistance. Though these deteriorations are counteracted by the further use of chemicals, they still suggest both physical and chemical reasons for avoiding painting on treated fabrics.

Grades of cotton The weight of the canvas is important and this is measured in terms of ounces per square yard or grams per square meter. The most common good-quality cotton for artists' use is cotton duck at 12oz (410gsm) or 15oz (510gsm), though it is possible to go down to 10oz (340gsm) and get a reasonable weave. Below this the canvas is of scenic quality, i.e., it is used for making "flats" for theater sets, and it has a much looser weave. To stiffen it and add weight, manufacturers often use sized yarn coated with starch or some proprietary paste that is difficult to identify and, for this reason, it should be avoided.

Kinds of linen and cotton

Fine grade linen

Coarse grade linen

410gsm (12oz) cotton

510gsm (15oz) cotton

Removing bulges in cotton canvas

Cotton does not exhibit very good elastic recovery, which can make it difficult to remove bumps and bulges in a canvas. In the studio, however, the artist will risk dealing with minor bulges by very slightly dampening the back of the canvas with water, so that the bump is pulled out.

Cotton versus linen

It has been claimed that cotton is vastly inferior to linen and that any artist who values performance should avoid the use of cotton canvas. There is, in fact, very little evidence to support this. It is certainly the case that the flax fiber used to make linen is longer and stronger than the cotton fiber, that linen exhibits more dimensional stability and less deformability per unit force than cotton, and that an artist having to choose between the two might opt for best-quality loom-state linen as his first choice. But the fact is that a good-quality 12–15oz loom-state cotton duck canvas is a perfectly acceptable support for permanent painting. It is unfortunate that manufacturers of prepared canvases have used greatly inferior cotton fabric in their second-grade products. This has had the effect of widening the apparent gap in quality between linen and cotton, presenting an unfavorable impression of the latter that is undeserved and discouraging many artists from trying it for themselves.

Chemical and physical comparisons

The similarities between cotton and linen are marked. The simplest fundamental unit of each material is identical. Chemically, they are both composed of cellulose.

$$CH_2OH$$
$$CH—O$$
$$CH \qquad CH–O–$$
$$CH—CH$$
$$OH—OH$$

Cellulose molecule

Cotton and linen have similar wet and dry strength and rapid moisture absorption. Where the fibers differ most is in the orientation of the cellulose crystallites. The higher orientation in the flax fiber makes it much stronger and smoother, but these advantages are offset by its greater sensitivity to abrasion. This sensitivity is even greater when the linen is wet.

Texture and strength

In the plain-weave fabric used by artists, linen and cotton show very different surface textures; the linen texture is very characteristic and more varied than the cotton one, depending on the weight and tightness of the weave and the length of fibers used for the yarn. Cotton provides a more uniform texture that, in the artists' quality grades, is more tightly woven because it is heavier.

A lightweight cotton canvas is not as strong as a lightweight linen one. However, linen is generally used in much lighter weight than cotton, so that a heavyweight cotton duck of 12–15oz, for example, is probably as durable as linen. Indeed, it has been shown that thicker yarns, such as are found in cotton, degrade more slowly than thinner ones.

Degradation

The degradation rates of cotton on exposure to light are in fact slower than those of linen, though, in a painting in which the textile is covered with opaque pigment and with its back to a wall, most of the degradation is thermal and the reactions that occur are in relation to the ambient conditions in the room (see *Conservation*, p.331).

Other flexible supports

Various flexible supports such as parchment, vellum, and leather made from the skins of animals have been used in the past, but are now no longer in common use. There are, however, new synthetic materials such as polyester sailcloth, which demonstrate excellent properties.

Polyester fabric

A number of synthetic fabrics have been used in the manufacture of artists' canvases, including polypropylene, nylon, and polyester. Of these, polyester has proved the most suitable, having superior paint-adhesion qualities. It comes in a wide range of weights from 20gsm to 540gsm and, although normal widths are only 90cm (36in), 2m (6ft) widths can be obtained from sailcloth manufacturers. Polyester sailcloth, which is all plain weave, is woven extremely densely and this produces a very stiff material. After weaving, the cloth is heat-set, which makes each yarn shrink irreversibly, producing a tighter and more dimensionally stable cloth. Such fabrics are resin-coated when used as sails, but for artists' supports, they should be used untreated.

Characteristics of polyester

Polyester fabric has qualities that are lacking in either linen or cotton. Firstly, it has far greater durability than linen or cotton, with a strong resistance to acid attack. Secondly, it absorbs very little moisture, with 0.4 percent water at 65 percent relative humidity compared to 12 percent for linen. Thirdly, polyester has exceptionally good dimensional stability. And, fourthly, it has good elastic recovery.

A highly inextensible flexible support (one that will not stretch out of shape) is best for painting and, in this respect, polyester is greatly superior to traditional supports. It is stretch-resistant but remains flexible. This is a desirable

characteristic, since there is less strain involved for a stiff material like polyester than there is on a less stiff one like linen or cotton in arriving at the level of tautness required for a painting support. The effect of this is to induce a smaller strain into the paint layers and for less stress to build up within the glue size or oil layers

when the relative humidity falls.

The only factor that has deterred artists' materials manufacturers from using polyester fabrics for flexible supports is that the texture of polyester weave is unlike that of more traditional supports. Some fabrics have a surface "fuzz" that could prove helpful in adhesion for thickly worked, impacted painting

but that can be sanded down between primings for a smoother finish.

Stretching polyester Polyester can be stretched in the same way as linen and cotton canvas, though it is suggested that the staples are attached closer together and that the fabric is pulled two ways before being stapled (see p.56).

Preparing flexible supports

The aim of stretching canvas is to produce a taut support with even tension in which the warp and weft yarns remain parallel with the bars of the stretcher frame. The rigidity of the frame is an important factor in the mechanical structure of a painting made on a flexible support. Modern stretcher frames are generally machinemade. They have mitered corners with slot and tenon joints that can be expanded by the use of wedges known as "keys." Stretchers are generally made of

softwood in varying widths and thicknesses, depending on the size of the painting. The face side of a stretcher piece is beveled to prevent the inner edge of the frame from creating "ridge" lines in the painting.

Conservation departments in museums tend to use much stouter stretcher pieces than artists. Large frames are mortised in the middle to take cross bars. These reduce the possibility of bowing or warping when the frame is under tension.

Problems with stretcher frames

There are three main problems encountered when using conventional stretcher frames: stress, cracking, and contraction.

Stress The main disadvantage of conventional stretcher frames is the strain they impose on the canvas. Although the edge of the frame is generally planed down somewhat, the yarn is still distorted and the canvas subjected to concentrated stress as it is turned around the angles of the stretcher edge.

Prolonged stress leads to the splitting of the canvas along the edge, the tacking margin becomes separated from the painting, and the edges of the canvas have to be lined. The conservation departments of museums are full of paintings that have become damaged in this way.

The tacks or staples that secure the canvas aggravate the condition by imposing further focal points of stress. Thick staples are better than tacks in this respect and these

should be attached very close together along the stretcher frame. Redesigning the stretcher frame in the way shown here would greatly increase the life of the canvas, although the picture frame would need to have a modified and deeper rebate in order to accommodate the new style of stretcher.

Distributing stress evenly The problem of stress can be solved by giving the stretcher piece a completely rounded profile. This eliminates the maximum distortion of the yarn around a right angle, instead distributing the stress evenly around the curve.

Cracking Conventional stretchers encourage the imposition of forces in the corners that run at 45 degrees to the stretcher bars. If the canvas is stretched too tightly, these forces result in the ultimate cracking of the paint film. This can be seen in many old paintings, where the crack pattern runs at 45 degrees to the right angles of the stretchers, becoming less severe toward the center of the painting. The problem is reduced by stretching the corners less tightly.

Contraction When a painting with a heavy layer of glue size is subjected to a very dry environment, it tends to shrink. The rigid design of the stretcher does not allow for contraction, so the painting may develop tensions and subsequently crack.

This problem can be lessened by ensuring that the glue size used on canvas is not too strong (see p.58) and by applying it warm.

Preparation How to assemble a stretcher frame and stretch canvas

Most artists buy rolls of unprimed canvas of suitable weight and commercially prepared stretchers and put together their paintings by hand. You must ensure that the stretcher pieces are solid enough for the size of the painting and incorporate a cross bar for additional support if necessary.

1 Assemble the stretchers and then cut the canvas around the perimeter of the stretcher frame.

2 Apply three staples in the middle of one of the longest sides.

3 Apply three staples on the side across from (and subsequently in the middle of the other two sides). Apply a temporary staple at each corner.

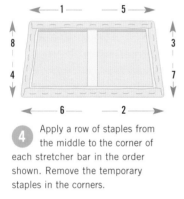

4 Apply a row of staples from the middle to the corner of each stretcher bar in the order shown. Remove the temporary staples in the corners.

5 Make two folds in the canvas at each corner, pull one fold over the other, and staple the canvas to the frame. This maintains even tension right up to the corners.

6 Tap in the stretcher frame keys the correct way around, making sure that the angle of the grain on the keys is not parallel to the stretcher bar.

Preparation

De-acidifying a canvas

It has already been suggested that a linen canvas should be "decrimped" by stretching and wetting, allowing it to dry, then restretching before priming (see p.52). Another useful process, which research at the Courtauld Institute in London, England, has shown to at least double the life of the fabric, is to de-acidify it.

There are proprietary de-acidifying products available, but these are expensive on large canvases. A simple alternative is to brush, spray, or soak the canvas with solutions of calcium hydroxide or magnesium bicarbonate. These are nontoxic, readily available, and easy to prepare.

Using calcium hydroxide
Shake up 2g of fresh calcium hydroxide in 1¾ pints (1 liter) of distilled water and allow it to settle. Then decant or filter the clear solution. It will last for about a week in a tightly stoppered glass or plastic container.

Using magnesium carbonate
Mix 9g of magnesium hydroxide—or (not so good) 1.5g light magnesium carbonate (laboratory grade)—with part of 1¾ pints (1 liter) of distilled water, and pour it into a soda syphon. Add the rest of the water and shake the syphon. Discharge two bulbs of carbon dioxide into the mixture, and shake vigorously every five minutes for about an hour. Transfer the solution to a glass bottle and filter it before use.

Preparation

Priming a canvas

After a canvas has been stretched, it must be primed. It is important that the canvas is prepared in this order because if it were primed before being stretched, the priming layer would introduce an additional strain that would increase in dry conditions.

By priming an already stretched canvas, on the other hand, the priming itself will not be affected and the strain in a typical painting will be limited to around 0.2 percent. The priming process for oil painting supports can be divided into two stages: glue sizing and the application of the ground (see opposite page).

Preparation Glue sizing a canvas

Glue sizing (see p.58) a canvas is said to protect it from the harmful oxidizing effects of the oils in the priming or paint layers. However, the oil content of an oil ground is only about 12 percent, so it should not be a major problem. In any event, linen degrades by oxidation in light or dark conditions and there is no evidence to suggest that glue sizing retards this degradation significantly. It has been claimed that glue sizing prevents the ground from coming through to the back of the linen, as if that were a bad thing. In fact, it may well be a useful method of enabling the ground to adhere well to the support.

The temperature of the size

During the 1800s, when artists' colormen took over the preparation of linen supports from the artists themselves, they applied sizing as a cold gel that created an effective surface sealer and enabled the Lead White and chalk primers to be very thin. However, if the painting became damp, the priming—with the painting on top—just popped off the glue size layer.

Commentators have maintained that sizing should be applied cold or just warm, rather than hot, so as to ensure that it does not penetrate the fibers of the canvas. Again, there is insufficient data to establish that the application of hot size is damaging. Indeed, there are times where the behavior of the size can be seen to compensate for changes undergone by the canvas as the humidity varies. As humidity increases, the size relaxes and swells so that, when the canvas shrinks at a relative humidity (RH) of about 85 percent, glue size within the fibers begins to counteract this tension.

Contraction

The major problem with size in a painting, however, is in dry conditions (which are more common than wet ones). If there is a lot of size on the canvas, so that it is able to operate as a distinct layer, it becomes by far the most powerful factor in the system. In such conditions, the canvas is relaxed, the size layer extremely tense, and the paint layer only slightly tense. The result is that the contracting size layer pulls at the canvas and the paint, forcing cracks and the peeling of the paint layer. Such problems are clearly noticeable in a large number of 19th-century

Sizing a canvas Apply the warm size to the canvas with a decorator's bristle brush.

paintings. (See also p.59, where a possible alternative to glue size is also discussed.) The answer is to use as little size as possible and to apply it hot.

Polyester fabrics require no size at all with an oil priming, since such fabrics are stable to acids and alkalis.

Preparation

Protecting canvases from the back

Anything that prevents the back of the canvas coming into contact with dirt will considerably reduce its rate of degradation. A double layer of canvas from the 1800s, in which the lower layer has a priming facing out, has shown the protected linen to be far less degraded than contemporary conventional supports. A tight-weave polyester cloth can be stretched on the frame and linen canvas stretched over it.

A backboard helps prevent accidental damage. It should not have any holes in it, as they help transmit irregularly any changes in humidity—the mystique about

Using a backboard A backboard made from hardboard, or even acid-free cardboard, will protect the back of the canvas by helping to stabilize the environment around a painting. Attach with tacks or staples.

"letting the painting breathe" is nonsense. Enclosing the canvas completely would provide the best protection but, since glazing interferes with appreciation, a coat of varnish is used to protect the face of the canvas from dirt.

Tension and flexibility

The different materials used to prime canvas may react differently to aging and to the support itself, causing problems of tension and flexibility.

- Oil grounds become very brittle, but they do not develop the same kinds of tension as glue size (see above).
- Soft acrylic grounds on fabric are not in themselves too flexible to use for oil painting, but they leave the structure itself too flexible for the oil film. They may be a more suitable ground for oil painting on a more rigid, sailcloth-type, polyester fabric. See p.61 for details of grounds suitable for flexible supports.

Grounds

A CANVAS OR WOODEN PANEL GENERALLY requires a preparatory coating or priming before painting. This is the ground. For an oil painting on panel, this might be a layer of glue size and a thick coat of gesso. For an acrylic painting on canvas, it may simply be a coat of an acrylic emulsion primer. Different techniques and painting media require different grounds. These are outlined below and detailed in the various painting media sections.

The ground performs three principal functions: firstly, it isolates the support from potentially damaging ingredients in the paint. This is particularly important in oil painting, where an excess of oil seeping from the paint into the fibers of the canvas is said to oxidize and embrittle the cellulose in them and cause their disintegration. The seriousness of this problem has, however, been largely over-estimated in the past.

Secondly, the ground provides a surface that will accept the paint and allow it adequate adhesion. The surface must have a degree of tooth to allow it to accept the paint, and a degree of absorbency. For oil painting, a ground that is too absorbent can soak up much of the oil from the paint, leaving a brittle film of paint that is liable to crumble. If the ground is completely nonabsorbent, however, the paint film will probably peel off.

Finally, in transparent and semi-transparent painting techniques, the ground enhances the colors of the painting by providing a white reflective background. This illustrates the need to use permanent materials in the pigmented ground. If an artist used cheap household emulsion as a primer, and made a painting using transparent glazes that relied on the white of the ground, the ground would discolor within a few years, leaving a dull, yellowing painting.

Size and gesso

This type of ground consists of a layer of glue size and a layer of "gesso." Gesso is the Italian for gypsum and gesso is a mixture of gypsum and glue size that forms the actual surface on which a painting is made. For centuries, artists have also used chalk with glue size to make the equivalent of a "gesso" surface, so in this book I have used the term "gesso" to cover both true gesso grounds and

also chalk/glue grounds. There are various methods of mixing and applying the ground. I have described a standard modern method based on traditional practice. A size and gesso ground is commonly used for egg tempera and oil painting on rigid supports, but should not be used on flexible supports because it is too brittle. See p.61 for alternative grounds.

Preparation **The glue size**

Glue size is made by mixing dry glue with water. Glues made from rabbit skin or other animal skin, or hide, are generally recommended for size and gesso ground. Rabbit-skin glue is flexible and dries out with relatively little tension. The more refined gelatine can also be used but is thought to be less effective and more brittle.

The ratio of dry glue to water is a crucial factor in determining the strength of the size. Too strong a size

Preparing the size
Dry granules of rabbit-skin glue are soaked in water and heated gently in a double boiler.

will produce great tension and cracking; too dilute a size will produce a weak, soft film. A more porous support will require a stronger solution than a less porous one. I use around 3oz per 1¼ pints (75–80g per liter) for panel. If used as an isolating layer on canvas, a weaker solution of 1½oz per 1¼ pints (30–35g per liter) is used.

The glue is allowed to swell in cold water overnight. The mixture is then gently heated in a double boiler until it is hot (it should not be boiled, because this impairs the strength of the size).

Applying the glue size

Apply the size to the front, back, and edges of a wooden panel. The first coat should be slightly thinned down and subsequent layers applied at full strength. Use a bristle brush and allow each coat to dry before applying the gesso (see p.60).

Glue size on flexible supports

Although size and gesso ground should not be used on flexible supports, glue size is often used as an isolating layer on cotton or linen canvas, but does not need to be as strong as for rigid supports. Glue size has been shown to be responsible for much of the mechanical damage (cracking) that oil paintings on flexible supports often display. This is due to the changes in stiffness that the glue layer undergoes in relation to changes in relative humidity. Glue size remains, however, the most common method of isolating the oils in paint and in the ground from the canvas. It should be diluted in a thin solution of around 1½oz per 1¼ pints (35g per liter) and applied reasonably hot, as recent research has shown that it may do less damage to the paint film if it is absorbed within the fibers of the canvas.

Sodium carboxymethylcellulose as an alternative to glue size

One alternative to traditional glue size is carboxymethylcellulose (CMC), which has been used for some time in the textile industry as a warp size. CMC is a cellulose ether, produced by reacting alkali cellulose with sodium monochloroacetate. It is available as a whitish powder or granulate that dissolves in water to form a clear, viscous solution. It can be obtained in a wide range of viscosities, but for textile sizing, a relatively low viscosity type is generally used. Refined CMC forms a flexible film that is resistant to oils and organic solvents. It is also physiologically inert.

Applying a chemically compatible sizing to the cellulose fibers of the cotton or linen canvas alleviates the problems associated with traditional glue sizing. Any expansion that occurs with changes in relative humidity will take place at a similar rate between the cellulose size and the canvas, so avoiding cracking.

Although, like glue size, the coating will stiffen the canvas, this is not at the expense of flexibility—the cellulose does not shed or crack as glue size might do in certain dry conditions. If you begin with around an 8 percent solution in cold water, the material may well be too viscous to use: simply dilute it with more water until it can be brushed onto the canvas. It should be stirred and left to swell, after which it can be stirred again before being applied with a stiff brush. Two coats may be applied. As with glue size, no priming should be applied until the cellulose size is completely dry.

Most wallpaper pastes use CMC, and these can be satisfactorily used if the material is difficult to obtain. The fingertip test is a good method for assessing whether the canvas has been properly sized. Before sizing, you will feel the individual fibers sticking out of the surface of the material. After sizing, the canvas feels smoother.

Preparation

Preparing the gesso

The gesso layer provides the background color and texture on which the painting is made.

Gesso is made by pouring hot glue size gradually into dry whiting or precipitated chalk and stirring until the mixture has a light, creamy consistency.

With practice, you should get a feel for when the mixture is just right. It is left for a few minutes, to allow trapped air to surface, before being applied. You can also make up the mixture by adding chalk to the glue as shown.

Adding the chalk Spoon the chalk into the glue size and stir vigorously.

Pigments and other additives in the gesso

The huge number of varying recipes for gesso all basically consist of inert white pigments bound in aqueous glue solution, but a wide range of other ingredients has been suggested. The two main factors that should determine your choice are whiteness and texture.

You must first decide how important it is for the board to be a brilliant white. For thin, transparent coatings that rely for their effect on the whiteness of the ground, this is an important factor, so a certain amount of white pigment can be added. Titanium White is to be recommended for its opacity. I combine one part with nine parts dry whiting or precipitated chalk, which bulk out the gesso and give it other working qualities.

The second consideration when choosing the ingredients for your gesso is the texture of the ground. If a very smooth ground is required, traditional red or white bole or clay can be mixed with the chalk. China clay or kaolin is an almost identical clay that can be used for the same effect. If a rough ground with a great deal of tooth is required, powdered pumice, sand, marble grit, or limestone dust are all acceptable ingredients.

You can experiment with mixtures and create grounds that suit your own requirements. Since these additives are inert, they have no chemical effect on the subsequent paint film and, provided that they are well bound in the gesso and to the rigid support, they will remain reliably permanent. (They can of course be added to acrylic emulsion primers.)

Technique
Applying the gesso

The number of coats of gesso that are applied is a question of personal preference, but it should create a smooth, even surface of brilliant whiteness. Artists generally apply between three and seven layers. The absorbency of the ground is increased with the thickness of the gesso layer as is the tension created by the size. It has been suggested that the upper layers of the gesso be bound more weakly than the lower ones in order to avoid the worst effects of the inherent tension in the film.

To minimize the risk of warping, the ground should be applied to both sides of a panel and also to the edges (not so much care needs to be taken with the back).

Sealing the gesso ground
The gesso described above is absorbent, and for some techniques it will need sealing in some degree to lessen its absorbency. A completely absorbent ground will soak up all the oil from an oil color, leaving the pigment dusty, dry, and much too weakly bound to be permanent. Among the sealers that can be used thinly and on rigid supports are diluted glue size and synthetic resin dispersions.

The sealer should not be resoluble in the solvent that is used to thin superimposed layers of oil paint.

1 Build up the thickness of the gesso ground by allowing each coat to dry before adding more layers.

2 Allow the gesso to dry thoroughly and, using wet and dry paper or an orbital sander, abrade it to a smooth, level surface.

Technique Using traditional size and gesso ground

In the 1400s, Cennini recommended how to prepare a gesso panel very much as described here, though the Italians tended to use gypsum (plaster of Paris) instead of chalk. Cennini's method uses two types of gesso:
- *Gesso grosso* This is made by grinding plaster of Paris in glue size. A single coat is applied with a spatula.
- *Gesso sottile* Here, the plaster of Paris is soaked in water for a month—the mix being stirred every day before being ground, squeezed of water, and added to hot, but not boiling, size. A number of coats are applied at right angles to each other.

Technique Using a cloth covering

Cennini recommends covering the sized panel with thin strips of linen. These should be soaked in size, then laid and smoothed over the panel, which is generally done over the joins between individual planks to minimize the risk of cracking. Covering the whole panel with small pieces of cloth was said to avoid the stress that a continuous piece might put on the panel by contraction. In practice, if a lightweight, loosely woven linen is used, there is little danger of this. With a gesso priming, the cloth is not visible in the finished panel. With a panel more thinly primed with a modern acrylic or oil-modified, alkyd resin primer, the texture of the cloth will be an integral part of the look of the panel, so a continuous piece of fabric must be used. If the backing panel is a rigid piece of composite board, such as hardboard or fiberboard, there is no danger of cracking.

Some commentators argue that cloth adds an extra and largely unnecessary element to a panel, with risks of defects such as blistering. But, provided that the cloth is lightweight enough, there is very little risk of such changes. However, a panel can be perfectly well prepared without fabric—especially today, with the wide range of manmade, wooden supports that are available (see pp.45–46).

Other kinds of grounds

There are currently two main kinds of primer made by reputable artists' material manufacturers. The water-based acrylic primers are used on canvas for acrylic color and on panel for acrylic or oil color. The oil-painting primers for canvas are generally based on pigmented, oil-modified alkyd resins. They are soluble in paint thinner and should be used with care.

Traditional emulsion ground

A proportion of linseed oil (at least 25 percent by weight), added drop by drop to a hot gesso mix and stirred in vigorously, produces an emulsified mixture. The resulting ground is far less absorbent than the aqueous gesso described above, and also more flexible. Though it shows a tendency to yellow and may become more brittle in time, it is a perfectly acceptable ground, especially for rigid supports and opaque painting methods (which conceal it).

Traditional oil ground

This is a traditional method of preparing a rigid support with a nonabsorbent oil ground on a rigid panel. The panel is first coated with linseed oil and allowed to dry before it is coated in White Lead ground in linseed oil. When dry—which may take a number of days—the ground is abraded. The process is repeated with long gaps for drying each time. The resulting coating is hard and thin.

White Lead in oil is still favored by some painters, but it is usually applied over a coat of glue size. Two coats are usually satisfactory and each should be allowed to dry thoroughly before overpainting. The panels are usually left for 6 months before painting. The reason is that applying fresh, wet oil paint on a half-dry oil ground causes serious problems of cracking and nonadhesion.

Modern "oil" grounds

Given the toxicity associated with the use of White lead, the White Lead in oil primer can be acceptably replaced by the primer produced by a number of artists' materials manufacturers, which is made from titanium dioxide in oil-modified, alkyd resin. The synthetic resin medium is extremely durable and non-yellowing. It should be allowed to dry thoroughly between coats but does so in a much shorter time than the linseed-oil-based equivalent. As with other primers, the edges and back of the panel should be painted to prevent moisture absorption and warping. Unlike the White Lead in oil primers, they can be applied directly (provided that the panel is clean and free from grease), but textile supports are generally given one or two coats of thin glue or cellulose size first.

Other synthetic resin-based grounds

The so-called "acrylic gesso primers" are not gesso at all but pigmented acrylic-resin dispersions. As such, they are nonyellowing and noncracking and give good adhesion to most surfaces without the need for a preliminary coat of glue size. They are extremely flexible and are appropriate on canvas for use with acrylics. They can be used as primers for oil painting on rigid supports, but they are too flexible to use as primings on canvas for oil painting —the film of oil paint would be less flexible than the ground and would therefore be extremely vulnerable.

There are more rigid, self-cross-linking acrylic resins that provide suitable dispersions in primers or oil painting on canvas, but these are difficult to obtain. The proprietary acrylic primers can be given extra tooth by small additions of inert fillers like powdered pumice or marble dust. Such modifications are fine as long as the resin can still form a coherent film that does not crack.

The acrylic dispersions (called emulsions) that bind the white pigment powder are available in non-pigmented form as acrylic mediums. These have the characteristic milky appearance of resin dispersions and dry transparent. They can be used directly as primers for flexible or rigid supports when the artist wishes to use the color of the linen or wood as part of the painting scheme.

Household paints as primers

Most water-based emulsion paints for house decoration are based on vinyl resins and these have been used as primers by artists needing a fairly absorbent ground. In addition, there are now acrylic-based, semi-gloss paints that are said to be far more durable than the alkyd-based ones and which some artists have used (after abrading the dry surfaces to give it key) for semi- or nonabsorbent grounds. Artists have also used commercial, oil-based, white matte undercoats as priming coats over glue size for oil painting. Although the manufacturers of these paints may be using the same basic oils or resins that are used by the manufacturers of artists' materials, they are working to a specification that requires a maximum life of only 10 years. Certainly, in the recent past, a lot of colophony or rosin was added to house paints and commercial coatings. If used by artists, these would eventually lead to serious discoloration and embrittlement of the paint film. Such coatings are safer on rigid supports, and when an opaque painting technique is employed where the colors do not ultimately rely on the whiteness of the ground.

DRAWING

Drawing is one of the most immediate and accessible forms of artistic expression. Using the simplest of materials—a piece of chalk, or a pencil on a scrap of paper—you can make a visual note, record a look, an idea, or an impression, and catch an atmosphere in just a few moments. Whatever the nature or medium of an artist's work, drawing invariably lies at the heart of it.

Self-Portrait with Spectacles (1771), Jean-Baptiste-Siméon Chardin

Chardin's self-portrait

This drawing, made just four years before Chardin's death, is one of the great pastel studies and its quality is a result of years of painting experience and self-understanding. Chardin shows himself just as he is, with turban tied with a blue ribbon, his pink scarf, and his spectacles perched on the end of his nose. He is under no illusion about how he looks, but he has made a dignified and compelling self-portrait in which we see exactly what Chardin sees. There is an alert, enquiring mind at work here, and one that captures, quite remarkably, the full dimensionality of the subject.

Pencil

THE SO-CALLED "LEAD" PENCIL IS, IN FACT, made from graphite. This material used to be called "black lead," thus "black lead pencil," which became shortened to "lead pencil." Graphite is a form of natural carbon, created, like coal, by the pressure of the earth on the decaying forests of prehistory. Coal is formed by pressure alone, but a combination of pressure and heat recrystallizes the amorphous carbon into platelike crystals of graphite. These are weakly bound between layers, which gives graphite its smoothness.

The most common form of naturally-occurring graphite is the amorphous, or shale, kind, which is crystalline but crumbly, and so not suitable for direct use as a drawing medium. Solid graphite was discovered in Cumbria, England, around 1500, and then mined for three centuries. Its main use was in the arms industry, in making molds for cannonballs.

Solid graphite This material was first used for making cannonball molds. Being volcanic, it remained unaffected by the heat of the molten metal.

The history of the graphite pencil

The English mine where graphite in lump form was initially discovered was unique, and the material became very expensive. A thriving black market developed that smuggled large quantities abroad. Solid graphite was found to have excellent markmaking characteristics, and pieces of graphite wrapped in sheepskin were used as a drawing medium.

The first wood-encased pencils

Throughout the 1600s, pencil manufacture developed very little. Pencils were made from graphite sawed into thin sheets. A sheet was wedged into a channeled groove in a piece of wood, and the graphite was scored along the top edge of the groove and then broken off. Another piece of wood was glued onto it. This "square" pencil was then rounded with a plane.

In the late 1700s, Napoleon urged his scientists to come up with an alternative to the graphite from Cumbria and, in 1795, a French chemist named N.J.C. Conté discovered a method of mixing amorphous graphite with clay and firing the mixture at high temperatures to form an artificial lump. This is the basis for the manufacturing of leads today.

Materials How modern pencils are made

The purest and best graphite contains the highest carbon content. Very pure forms with 98–99 percent carbon come from Sri Lanka, but sources are worldwide, ranging from Mexico to Korea. Graphite is micronized to a very fine powder before being supplied to pencil manufacturers. The degree of hardness or softness of the pencil lead depends on the proportion of clay to graphite used: the more clay, the harder the pencil lead will be. The clay has two functions: to hold the mix together before it is fired and, once fired, to act as a rigid matrix, or carrier, to hold the graphite in place.

The lead manufacturing process

The clays in pencil leads are ball clays from various deposits. These are essentially silicates, colloidal in particle size and nature. The clay is mixed with water to make a slurry and charged into a ball mill that grinds down the particle size of the graphite and provides an intimate mixture (thoroughly mixed compound). The water is removed by evaporation, resulting in graphite clay solids called "cake." The cake is ground into a fine powder, a known amount of water is added, and the solid mass is hammered into a billet or cylinder about 15in (37.5cm) long and 6–7in (15–17.5cm) in diameter. A vacuum pressure system sucks the remaining air out and a ram-head drives the mass in an extrusion press from which the material gets squeezed out like spaghetti through a die-head. This material is chopped into pencil-lead lengths and dried to remove water. The structure now has a number of holes previously occupied by the water. The leads are then fired at about 1,832°F (1,000°C), allowing the clay to soften, lose its chemically combined water, and fuse with adjacent clay particles to form a structure. It is a matter of skill to fire it to just the right point.

At this stage, the leads would be too scratchy to write with, so they are impregnated with molten wax—chosen for its texture when solid, in case the hardness or softness of the pencil needs adjusting. As the leads are immersed in a wax bath, bubbles of air show the wax displacing the space that the water had occupied during the extrusion process. Finally, excess wax is spun off.

The wooden casing of the pencil

The first tailor-made wood for pencils was cedar from Florida, taken from old railroad ties, well seasoned with oil and steam from the trains. This was used in the 1930s. Subsequently, Kenyan cedar was used, shipped in planks, sawed into slats, and placed in pressure chambers for impregnation with an oil emulsion. This provided lubrication, enabling the wood to give a neat cut when the pencil was sharpened.

Pencil manufacturing All aspects of pencil manufacturing are fully automated. Here, the pencils are being stamped and pointed.

Materials

Pencil sizes and shapes

Although most pencils come in a standard 7in (17.5cm) length, the shape and diameter of the lead and outer casing vary. Aside from the flat, rectangular, carpenter's kind, pencils are usually hexagonal or round. A pencil with a thin casing can be used for occasional pieces of work, but working with it for any length of time tends to fatigue the hand.

The hexagonal pencil

This sits firmly cradled in the hand with the index finger on one face and the thumb and middle finger on two others. This gives a firm grip suitable for writing or close line work.

The round pencil

For flexibility on the point or side of the core, a round pencil is more suitable because it can be rolled fractionally to any position rather than only through 60 degrees as with hexagonal kinds.

The widest (⅙in/4mm) cores are mostly used in colored pencils or in very soft graphite ones, where the edge of the lead is as important as the point. In a standard graphite pencil, kept sharp and used for writing or drawing, only about 5–10 percent of the core is used, so a thinner core is preferable.

Obtaining an even effect

When shading large areas of even tone, use the flat side that develops on the pencil's core. With your hand pressure constant, you can produce an even shade. But rolling the pencil so that an edge of the flat (with much less surface area) is in contact with the paper, even if your hand weight stays constant, will result in a streak. In practice, you are unlikely to roll the pencil in your fingers during constant shading, but this is why it is possible to have problems with continuous pencil tones.

Materials Kinds of graphite pencils

The most commonly available pencils are the standard hexagonal 7in (17.5cm) kind with a 2mm-diameter round, graphite strip or lead encased in wood. Round versions are slightly less common. Some manufacturers offer a range of thicker lead, wood-encased drawing pencils, up to 4mm or 5.7mm. Others make a range of round or hexagonal "pure" graphite crayons, 7mm, 8mm, or 12mm in diameter. Mechanical lead holder pencils are also sold; these carry leads in a range from 0.3mm to 2mm.

The graphite strip that does the drawing is basically the same product in each case. A "thin to fat" range of 0.3mm to 12mm and degrees of hardness to softness of 7H to 8B means you can carry out a wide range of manipulations and techniques.

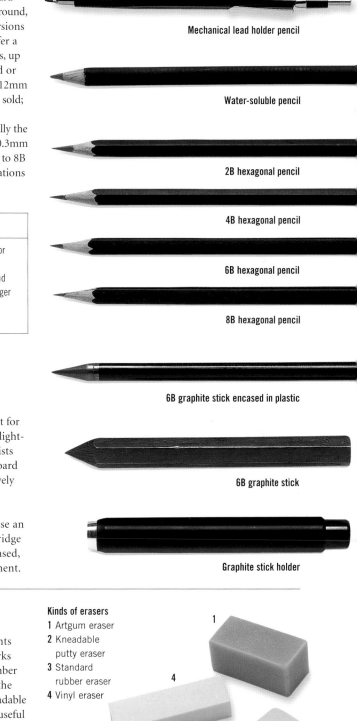

Mechanical lead holder pencil

Water-soluble pencil

2B hexagonal pencil

4B hexagonal pencil

6B hexagonal pencil

8B hexagonal pencil

6B graphite stick encased in plastic

6B graphite stick

Graphite stick holder

Sharpening pencils

Pencils are best sharpened with a sharp blade (utility knife or modeling knife). Although pencil sharpeners are extremely efficient at first, the blade becomes blunt fairly rapidly and artists tend not to replace or sharpen it. The action is no longer smooth; invariably the pencil lead breaks or the wood is not shaved away smoothly.

Materials

Supports for pencil drawing

White or cream paper is the most common support for most kinds of pure pencil drawing, though other light-toned colored papers may also be used. Some artists make underdrawings in pencil for paintings on board or canvas. Matte polyester drafting film is a relatively new support, with a surface that is particularly receptive to graphite.

For permanent drawings on white paper, choose an acid-free, pure rag paper; even high-quality cartridge paper will yellow with age. If not accidentally erased, graphite marks are, in themselves, totally permanent.

Materials Erasers

One of the aspects of pencil drawing that accounts for its popularity with artists is the fact that marks can easily be erased and redrawn. There are a number of proprietary erasers on the market, including the conventional rubber variety, the soft putty or kneadable eraser, the artgum eraser, and, probably the most useful of all, the plastic or vinyl eraser. White ones are used for pencil work and are highly efficient. They are firm-textured but do not remove the paper surface. They can easily be cut into sections for precise work.

Kinds of erasers
1 Artgum eraser
2 Kneadable putty eraser
3 Standard rubber eraser
4 Vinyl eraser

Pencil line techniques

Pencil is permanent, and yet adjustable in a way that other drawing materials are not. The artist has enormous control over the pencil line since it can be worked, erased, and reworked. It can have a soft, velvety quality or a crisp sharpness. It is capable, on the one hand, of great subtlety and delicacy and of great boldness and vigor on the other. Pencil is an economical, efficient, and tidy medium.

Technique The quality of the pencil line

Simple wavy lines made with two different kinds of graphite lead on smooth or rough paper demonstrate some of the basic aspects of pencil line work. The fluency of a simple pencil line has the steely and velvety immediacy that is characteristic of this graphite medium. On smooth paper, the pencil line is smooth and consistent. On rough paper, the graphite is only picked up on the raised grain of the paper, and this gives a textured look to the line. Variation in the pressure applied by the hand on the pencil allows the line to have tonal variation along its length. This subtle aspect of line quality marks out the graphite pencil from other more tonally uniform media such as ink. It enables the artist to give indications of tone in a simple line drawing by making the tone of the line deeper where contrasting tones abut in the subject, and lightening the tone of the line where adjacent tones are similar.

**6B graphite stick
smooth paper**
The smooth paper encourages fluency and even distribution of tone along the length of the line, and the edges are well defined.

**6B graphite stick
rough paper**
Hand pressure on the lead has been adjusted from heavy to light as the line is drawn, creating a ribbonlike, almost three-dimensional effect.

**Soft, flat lead sketching pencil
smooth paper**
The wide side of this rectangular cross section lead on smooth paper creates a line that has a strong liquid form.

**Soft, flat lead sketching pencil
rough paper**
The same marks on rough paper give a much more rugged feel, with the grain of the paper giving a rich, textured look.

Technique
Different approaches to line quality

For the first sketch portrait (on the left), I used a mechanical pencil with a 0.5mm B lead. For the portrait on the right, I used a standard, unsharpened, HB pencil. Both images are drawn directly from life with no erasing. The style of drawing for the portrait on the left arises not only from the concentration and intensity associated with the process of drawing someone from life, but also from the fact that there is a consistency in the nature and width of line with the mechanical pencil.

Mechanical pencil 0.5mm B lead Do not show more than about a millimeter of lead, or it will snap off when you draw.

Unsharpened HB pencil The rounded-off lead gives the portrait a softer, more tentative feel.

The pencil as sketching medium for line work
Small-scale pencil figure studies drawn from life, such as the one below, made simply by looking at and drawing the subject without erasing, are an excellent means of coming to terms with an image that you might later want to work on on a larger scale or in another medium.

Small-scale pencil sketch A good reference for a larger-scale work.

Controlling the quality of the line
The choice of pencil plays an important part in determining the quality of the line. In quick, small-scale, sketchbook drawings where you wish to work in an immediate way, a sharpened hard to medium pencil (H, HB, or B) is very suitable, while a pencil in the soft range (3B to 7B) produces a deep, thick, velvety line. Whichever pencil is used, the graphite line can vary considerably in tone along its length and has a quality of warmth that is hard to find in other media.

Using a tonally varied line This sketchbook drawing was made with a 4B pencil. The same drawing made in uniform-tone pen and ink would be flatter and less complex in feel.

Pencil tone techniques

There are several methods of building up the appearance of tone in pencil drawing. The techniques rely on the nature of the support for their particular quality. Three of the most popular and effective methods—cross-hatching, shading, and shading and rubbing—are shown in these examples. Other linear methods include closely following the contours of an image with tightly drawn parallel lines.

Cross-hatching

Cross-hatching uses intact pencil lines running in two or more directions. The rougher the surface, the more the regularity of the cross-hatching is broken up. Only on smooth paper is the crisp mark of each line retained. Cross-hatching is made less mechanical by a rough surface, which incorporates the marks into it. It is a standard method of tonal drawing in which each additional series of hatched lines deepens the tone in a particular area.

Shading

A simple method of building tone, this can be done using the natural movement of the arm or wrist, the elbow acting as the pivot on the drawing board. The sample below shows a patch of close, one-way shading. On rough paper, the grain turns the shading into a uniform area of halftone where the graphite adheres to the ridges of the paper, but the indented areas are left white. On smooth paper, a more uniform area of tone would be seen.

Shading and rubbing

Rubbing either cross-hatching or one-way shading with a finger or a paper stump will smudge and soften it. White, indented areas on rough paper can become filled with a soft, pale gray tone. In general, the thinner the lead used, the finer the tone will be; so you would see big differences between a graphite stick and a mechanical pencil. Further drawing and softening will build up a full range of tones, and the use of an eraser will pick out highlights.

Cross-hatching Crisscross lines with a 0.5mm lead in a mechanical pencil.

One-way shading Lines drawn closely at the same angle.

One-way shading As left, but modified by being rubbed with the finger.

Creating tones in pencil For the first two examples, a 0.5mm B lead was used on smooth and on rough paper. The third is drawn with a graphite stick on rough paper.

Mechanical pencil B lead smooth HP paper The 0.5mm lead allows for fine shading, and the dimensionality of the leaves is established with subtle gradations of tone.

Mechanical pencil B lead rough paper image softened with paper stump Similar to the drawing left, but on rough paper, and has been softened with a paper stump. This deepens, blends, and softens the tones.

Graphite stick rough paper Here, the drawing is made with the larger, 4B graphite stick; the image has a rougher, chunkier feel in which the grain of the paper provides texture.

Technique
Highly resolved drawings

This drawing of the face of Mary from Michelangelo's *Pietà* of 1501 requires a consistency of technique to allow the particular quality of the polished marble in the original sculpture to be expressed.

The whole drawing has been shaded on the diagonal using a 4B pencil. It follows the natural wrist movement of a right-handed artist (bottom left to top right). The drawing has been softened in places by gentle rubbing with the fingertips or with a paper stump or cotton swab. The highlights have been carefully picked out with a vinyl eraser.

In this kind of drawing, the marks made by the pencil have a consistency that makes them serve the image instead of being necessarily expressive in their own terms. The pencil is used to create the impression of the smooth, solid marble of the sculpture and this allows the image itself to speak directly to the viewer.

Shading on the diagonal The carefully drawn pencil shading aims to emphasize the quiet composure and dignity of Mary's expression.

Technique
Tonal drawing with lines

This tree study on pure rag paper illustrates some fairly unconventional shading techniques. A series of long or short, vigorous, upward strokes was made with two flat-lead drawing pencils—a soft 4B and a hard H. As the marks were gradually built up and superimposed, a fully rounded form emerged. The flat edges of these pencils make broad, tapering, axlike marks. Turned around 90 degrees, they provide sharp, thin marks for the impression of detail.

Shading techniques The vigorous sense of upward growth is emphasized by the nature and direction of the pencil lines.

Technique Pencil drawing with a colored wash

A pencil drawing can be used as a kind of *grisaille*, or monochromatic underpainting, over which transparent watercolor or acrylic paints are laid to provide color. Working in this way is like color-tinting a black-and-white photograph, and produces a kind of period feel. In *grisaille* underpainting, the tones are generally lighter than they appear in the finished work (in order to give dark, transparent pigments real depth in shadows). But in this example, the picture was made as a fully worked drawing with a complete range of tones before color was applied.

Tinting effects A fully dimensional pencil drawing was tinted by spraying thin, transparent acrylic color through masking film stencils with an airbrush. Some handpainting was done with a sable brush.

Technique
Using small objects as models for pencil work in tone

Objects such as the egg cup below provide useful models for developing an awareness of tonal values. One well-tried method of assessing tonal variation is to half close the eyes when looking at the subject. This has the effect of minimizing detail and showing broad tonal variation. In this drawing, the rounded egg shape has a full range of tones from dark to light. This has been achieved by working carefully over the image in diagonal shading, gradually building up the depth of tone required. The most important aspect of this technique is not to shade too heavily when you begin, but to build the tones up gradually.

Tonal values Careful shading gradually builds up the image.

Technique
Pencil drawing with other media work in tone

This portrait shows the successful integration of two very different drawing media. The eyes, nose, mouth, ear, and basic shape of the head have been drawn with an HB or B pencil. The marks for eyebrows, nostril, and line of the mouth have all been pushed more firmly into the paper. Other lines are lighter, but each has an assurance that comes of knowing precisely what the pencil is doing at each stage. Thick black and pale gray oil pastels have also been used. The juxtaposition of pencil and pastel creates a fully resolved work in which one complements the other.

Ray Smith (1980), DAVID NASH

Technique Drawing with an eraser

Working with an eraser is of course generally combined with conventional pencil drawing. Erasers can also be used as drawing instruments themselves, as a means of working on line or tone quality in a drawing, or even by working into an area of continuous tone laid down on the paper, as the sole means of creating an image (see example, below). This technique is a satisfying method of working with tone in broad, bold shapes.

Once the uniform tone is laid down on the paper, the overall shape of the image is picked out with the eraser and then any large areas of light tone are erased with bold strokes. Highlights are picked out and other light areas suggested by partial erasure. Stroking the eraser gently across the tone will smudge it slightly; careful use of this effect can subtly suggest the mid to dark tones.

Nude study with an eraser This drawing was made entirely with a vinyl eraser out of a uniform gray tone laid with the side of a 6B graphite stick over white cartridge paper.

All-purpose Pencil

THE ALL-PURPOSE WAX PENCIL (known under various trade names) was originally designed for marking plastic, china, metal, or glass surfaces that could not be marked with a normal pencil. It is also well known for marking photographic contact sheets or strips of color transparencies in plastic wallets. But the all-purpose pencil is also an original and effective drawing instrument and can be used with good effects on paper.

The pencil, which varies slightly from one manufacturer to another, is rich in wax with a small amount of filler and high pigmentation. The wax gives it a soft, almost sticky touch on the paper, and it can be used to make pale, soft tones or deep, velvety ones. The effect is similar to that of oil pastel and can be used for the overlaid and scraped-off effects characteristic of that medium (see p.83), but the easily sharpened, all-purpose pencil is a more precise medium.

Technique Line work in all-purpose pencil

Strong, chunky line work is a feature of the all-purpose pencil medium; once made, marks are permanent and cannot be erased, so drawings have to be made directly and with no adjustments. For this reason, it is a useful medium for direct observation drawing practice.

As well as deeply pigmented black lines, softer toned lines can be made. The pencil can feel its way around a form in a more tentative, exploratory way, making more fragmented lines.

Rapid sketch All-purpose pencil is a speedy medium, ideal for drawing quickly and directly. Subjects like children may require you to work speedily. Here, the essential features of the baby's face were recorded rapidly in just a few moments.

Soft-toned sketchbook line drawing The work on the left was made directly, with no alterations, beginning with the model's right eye and working outward from the features.

Increased tonal variations In the drawing (right) of the same model, there is more tonal variation in the line work itself. The effect is to create a gentler, somewhat softer image.

Technique Tone work in all-purpose pencil

Softly blended tonal effects can be obtained by progressively heavier shading. It is possible to soften tones by rubbing with your finger as in graphite pencil work, but note that you have to rub hard and the drawing may smear. Most artists find it easier to rely on the grain of the paper for halftone effects. Fine shading, using a very sensitive touch on the paper surface, creates an effective range of tones. Just "grazing" the paper with the pencil leaves a mark. With this technique, pushing up with the middle finger (to prevent too deep a tone from emerging too quickly) is just as important as pushing down with the index finger. As the pencil is sharpened and gradually used up, and your fingers get closer to the tip, the wax becomes warmer, stickier, heavier, and slightly less controllable in the light tones.

Using the pencil purely tonally Very few lines are used in this drawing. Different densities of the all-purpose pencil produce the tones.

Working on mid-toned paper

Using both black and white all-purpose pencils on a mid-toned ground further increases the tonal range of the medium; the white providing highlights and the black the dark tones. Halftone effects can be achieved by setting black-and-white lines against the middle tone of the paper.

Drawing on brown, mid-toned paper The raking sidelight, casting shadows across the massive old stone wall, creates a texture that is ideally suited to drawing on a mid-toned ground. Using just the white pencil for the highlights and the black pencil for the shadows, a full range of tones is suggested. The texture of the paper provides a tonal matrix in the shadows and emphasizes that of the stone itself. The slightly sticky waxy pencil has a tactile quality that makes it uniquely enjoyable to use. This is a very economical method of drawing a tonal image.

Colored Pencil

IN THE PAST, MANUFACTURED COLORED PENCILS often failed to come up to the standards of permanence to be found in other drawing and painting media. Some manufacturers used fugitive pigments in certain areas of the spectrum, in particular the reds, sacrificing permanence for short-term brightness. This might have suited artists whose work was created for reproduction, but it did no favors for those who wished to create more permanent and unique works of art.

Happily, since the first edition of this book, one of the most reputable manufacturers has taken on this issue and made a major commitment to lightfastness throughout the range of colors. For the first time, pigment names and Color Index details have been listed for each pencil, the pigment mixtures used for specific colors have been identified, and a full list of lightfastness results has been published. As a consequence, a unique drawing medium, with its particular soft-toned, grainy quality, can now be taken up more seriously by artists wishing to make a relatively permanent work of art.

Colored pencils are generally available in a standard form and as water-soluble pencils. The standard form is soluble in paint thinner, as this dissolves the wax in the pigment stick. This may be used for particular effects, but it is much safer to use the water-soluble variety for pencil and wash-type effects. At the time of press, water-soluble pencils do not come in the same permanent range as standard ones, but I imagine it is only a matter of time before permanent sets of these pencils are produced.

The character of colored pencil

Colored pencils are manufactured in the same way as graphite ones (see pp.63–64), except that the leads are not fired in a kiln since this would destroy the pigments. Instead, the mixture comprises pigment, a filler (chalk, talcum, or kaolin), and a binding material (usually a cellulose gum like hydroxypropyl methylcellulose).

As with graphite pencils, the pigment sticks are immersed in molten wax to give them their drawing properties. Very stringent consumer rules apply in the manufacturing of pencils that are liable to be chewed or sucked by children, and this means that pigments containing traces of soluble heavy metals cannot be used. This discounts the chromes and cadmiums and even naturally occurring earth pigments that could contain toxic heavy metals.

In general, the lightfast iron oxides are used for the earth colors, and for the greens and blues, newer, permanent, synthetic organic pigments such as Phthalocyanine Blue and Green are used. Among the current reds, Brominated Anthranthrone and Anthraquinone Red give better permanence than pigments previously used. Manufacturers have chosen less lightfast red/purples that look bright in the box, but that are somewhat fugitive, especially in tints. I recommend using crayons at full pigment strength. Be wary of the red/purples unless you are sure of the pigment.

Technique Colored pencil effects

Many different effects can be made using colored pencils. Used without a solvent, they are characterized, however deep the tones, by a softness arising from the effect of the grain of the paper on the medium. Even on hot-pressed (HP) papers, the pencils leave tiny white indentations that the pigment has failed to fill. This acts as an overall "softener," especially on mid- to light-toned areas.

Using a solvent
Skilful use of water or turpentine (depending on the kind of pencil) can fill white areas left in the paper with the characteristic "watercolor" look, while retaining the shading.

Optical color mixing
The most outstanding feature of the medium is its use in subtle optical color mixing. Colors are not, of course, mixed before being applied to the support, but combine optically on the support itself, when shaded diagonally next to each other or overlaid with various cross-hatching techniques. Because the tip can be sharpened to a fine point, transitions between colors or tones can be subtly controlled.

Choosing the support
Colored pencils are very sensitive to the surface of the support, and marks on cold-pressed (CP) paper look different to those on smooth HP paper. For permanence, a well-sized white, pure rag drawing paper is best, and an HP surface allows the most subtle manipulations.

Colored pencil techniques

Colored pencils can produce a broad range of effects from soft, light-toned sketching to highly resolved drawings with a full range of tones.

There are several different ways of using them to apply color to paper. These include both wet and dry methods of application.

Technique

Using water-soluble colored pencils

The effect of a "drawn and painted" image is very satisfying. With water-soluble pencils, this is quick to achieve. The effect of water-soluble pencils used dry is slightly softer than that of regular colored pencils—they deposit their pigment a little more easily on the paper.

To obtain the "watercolor" look, paint over the pencil work using clean water and either a damp or very wet sable brush, depending on the effect you want (see below). The best technique is to paint over the marks quickly and confidently. This way, the colors do not become too mixed and muddy and the original pencil marks are retained. Of course, the characteristic "dry" colored pencil appearance is totally changed, but it is replaced with something equally interesting, especially on textured paper. If the brush is too wet, the color can disappear completely. And if you overwork the surface, the optical effect will be destroyed.

1 Paint over the pencil marks quickly with a wet brush, but make sure not to overwork the color.

2 For more precise details, use less water on the brush.

Finished drawing This small study was completed in a matter of moments, but it demonstrates the immediacy and freshness of water-soluble pencils.

Overlaying tones

The lilies are drawn with the new, lightfast, colored pencils on cold-pressed (CP) paper. The medium that is often associated with a relatively light tonal range is further softened by the texture of the paper. The tones are built up by overlaying areas of shading using darker toned versions of similar colors. The final stage is to work over areas of the drawing using pencils of lighter tone. So, for example, once the vase has been shaded in blue and lilac, it is then gone over again with the white pencil. This does not make it look white, but has the effect of blending the colors and pulling the image together.

Blending colors A carefully worked, "dry" application study.

Technique Shading and combining colors

For the series of exercises shown below, designed to demonstrate the properties of dry and water-soluble colored pencils, a simple "house" shape was used, with three faces showing—to represent light, middle, and dark tones. For shading up to the sharp edges, a ruler acted as a "stop." Two kinds of Arches paper were used—a smooth HP and a fine-grain CP paper.

Examples of shading and combining colors

1 Regular "one-way" shading on smooth paper. The pencil lines are visible on the smooth surface. The range of tones from light to dark can be clearly seen.

2 The same image as **1** has had clean water applied with a brush. This gives the characteristic half-drawn, half-painted look of water-soluble colored pencils.

3 A green color has been shaded over the original blue. The effect is subtle, but it demonstrates how a more interesting effect may be had by simply adding a further color in an adjacent harmony.

4 The same image as **2** but with clean water applied with a brush.

5 Here, simple cross-hatching at right angles has been used to build up the tones using a single (blue) color.

6 Similar cross-hatching to **5** has been applied with red superimposed over the blue.

7, 8, 9, 10, 11, & 12 The same images as the six above have been drawn on CP paper. The shading has been applied in just the same way as on the smooth paper, but on this surface the texture of the paper gives it a quite different feel, producing a distinctive granulated look. This characteristic look is retained where clean water is applied (**8** and **10**), and where enough of the original texture remains to give it a unique look.

There is a limit to the number of times you can overlay colors using colored pencils. For best results, do not use more than two or three overlays.

Technique

Creating overall smooth tones in colored pencil

Working and reworking areas of even tone can be a long process since the technique involves very gradually depositing more color on the paper.

In the example on the right, worked up from a photograph, parallel diagonal shading was used in two colors—a blue and a green/blue—to build up a smooth, continuous, graded tone. A tone like this will probably need to be worked over at least twice. It is important not to press too hard on the pencil but to deepen the shading by degrees. Using the natural backward-and-forward motion of the arm, you can work speedily, fractionally rotating the shaft of the pencil in your fingers all the time, to find the best shading edge and make the tip flatter or sharper as required.

Shading with two colors

Working with two colors in this way gives a drawing qualities that it would not have if it were monochromatic. There is an added depth and richness of texture in which subtle shifts in color modulate the uniformity of the

"Splash!" drawing with graded tone background Derived from a photograph, the outline of the splash was traced onto CP paper and the drawing built up by shading from the top left to the bottom right.

surface and enliven it. This effect can be seen in the water behind the "splash" itself. Its depth of tone and color takes the drawing far beyond the pastel tones often associated with colored pencil work. Despite this, it still retains the softness that characterizes the medium.

Retaining white areas

For part of the watersplash and the many tiny drips to remain white, the paper had to be kept free of pencil marks in those areas.

An equivalent to masking fluid for colored pencil has yet to be invented, and it is almost impossible to remove unwanted marks with an eraser. However, it is remarkable how the hand and the eye begin to coordinate as if on "automatic pilot" when shading quickly, the crayon stopping each time at the very edge of the area to be left white. And where the eye perceives gaps or inconsistencies in the uniformity of the tone, the pencil moves almost automatically to fill them.

Technique

Drawing onto wet paper

Interesting effects can be obtained by drawing directly with water-soluble colored pencils onto paper that has already been dampened with clean water. This technique usually works best for rapid sketches that are made in one go while the paper is still wet. Some manufacturers make water-soluble colored crayons, which are slightly softer and fatter than water-soluble colored pencils, but can be used in a similar way (see underwater drawing, far right).

Drawing with water-soluble colored pencil Because the paper has to be very wet for this technique, it is best to work on stretched paper or on a block of watercolor paper with sealed edges. The water has the effect of saturating the color, making a rich, velvety line. The color bleeds into the damp ground, creating soft "watercolor" wash effects around the line work.

Drawing with water-soluble colored crayons These crayons tend to be slightly more soluble than water-soluble colored pencils and flow more easily into the damp paper.

Soft Pastels

ALTHOUGH WEAKLY BOUND PIGMENT HAD BEEN used to color drawings as early as the 15th and 16th centuries, it was not until the 1700s that the art of pastel painting came into its own. The portraits and drawings of the Venetian artist Rosalba Carriera were extremely successful, and soon artists such as Maurice-Quentin de la Tour and Jean-Baptiste-Siméon Chardin were exploiting the possibilities of the medium. The most celebrated pastel painter remains Edgar Degas who, in addition to making works with pure, dry pigment sticks, experimented successfully with mixed media effects.

A pastel painting has the most vulnerable of all painted or drawn surfaces. Although its "dusty" look is what gives pastel work its particular character, it must be protected almost as soon as it is completed if it is to remain permanent (see below).

Pastel drawing materials

Soft pastels are dry crayons made from powdered pigment, weakly bound in a solution of gum tragacanth or methyl cellulose. They usually contain a preservative, and sometimes a fungicide. A wide range of soft pastels is supplied, in different grades—hard, medium, or soft (the most traditional), and different shapes—thin or fat, square or cylindrical. Pastels can be bought separately, or in boxed sets of selected colors. The wood-encased, pastel pencils are slightly harder than the conventional sticks and not so popular with artists who specialize in pastels.

Color ranges and pigments
Because much of the art of pastel painting lies in laying down the precise tones of the colors required, the greater the number of shades in the pastel box, the better. One French manufacturer offers 552 shades in the handmade artists' range but, for most purposes, 50–100 shades are enough.

The most reputable artists' colormen supply colors of specified pigments—if you buy "Viridian," for instance, you know you are using a permanent pigment. Others merely supply crayons with romantically descriptive names that give no indication of the nature or permanence of the pigment. Pastels can also vary in softness within what should be a consistent range since different pigments require different strengths of binding solution, from very weak (Raw Umber) to strong (Alizarin Red). Although this can vary between pigment batches, some manufacturers do not pay enough attention to it.

Pastel fixatives
With a lightly drawn piece of work, just blowing on it is enough to remove much of the color, so fixatives can be extremely useful. Modern proprietary fixatives are solutions of polyvinyl acetate resin (PVA) in methyl acetate. They are as effective as any of the older shellac-based fixatives. Although casein/ammonia/alcohol kinds are said not to increase the saturation of pastel colors, in fact, any fixative changes the appearance of a painting. With a PVA fixative, the resin coats the surface or is absorbed by the pigment, changing its refractive index and giving a darker, more transparent look; some pigments are more liable than others to change in this way.

However, if a pastel work is well mounted, framed behind glass, and sealed into its frame, there is no reason why it should be any less permanent than if it is left unfixed. Clean the glass of a framed work with a damp cloth; a dry one can cause static electricity to build up, attracting pigment particles to the underside of the glass.

Different forms of soft pastels
1 Round sticks
2 Square stick
3 Wood-encased pastel pencil

Materials Supports and grounds

Pastel works well on sized 100 percent rag, neutral pH watercolor, or drawing paper. It takes easily to CP paper or rough surfaces, can also be used on HP paper, but does not adhere to shiny surfaces like coated papers. As long as there is some tooth to which the pigment can cling, it will lodge fairly permanently, provided that it is not scuffed. Pastels can be used on almost any other surface that has a slight roughness and the ability to pick up the pigment. Such surfaces include hardboard or cardboard coated or overlaid with butter muslin, then primed.

Toned grounds

While natural rag papers for watercolor are generally white, a wash of color—watercolor, size or cellulose paste paint, tempera, thin acrylic, or even lightfast inks—provides the toned ground that pastellists prefer. There are colored papers made for pastel painting. They come in a range of soft colors, especially in cream through dull ocher to brown, blue, and green/grays, and a group ranging from pale gray through to black. Between the opaque marks made by the pastels, a colored ground provides a network of warm or cool tones.

Sizing for pastel papers

The amount and kind of sizing used in rag papers varies considerably between brands. Some are well sized, which gives the surface an underlying hardness to which pastels readily respond. Others are less well sized and more absorbent; their fibers begin to loosen when pastel is worked into the paper and the paper may "rub up" annoyingly during drawing. However, this does not happen with commercial, colored, pastel paper and is easily overcome with pure rag watercolor paper by giving an extra coat of glue size.

Flocked papers

Velour, or flocked, papers are sheets of thin paper with a coating of powdered cloth, giving a velvety appearance. They come in a wide range of colors. Although their color lightfastness and structural permanence are difficult to establish, they have a unique surface for pastel. It enables you to make smooth, velvety lines, or soft, uniform tones. With most other papers, the pastel has to be laid on and rubbed in to make an overall tone, but here, the paper seems almost to do its own rubbing in when the pastel is laid on.

Papers for soft pastel work

Ingres paper

Canson paper

Canson paper

100 percent rag
drawing paper

Fine sandpaper

Velour (flocked)
paper

Technique

Adding texture to a paper

If you are resizing or coloring a paper, you can give it extra tooth by sifting an inert pigment such as pumice powder or marble dust over the wet surface. The result is like fine sandpaper that holds the pigment well, producing rich, vibrant colors. Alternatively, you can obtain large sheets of very fine sandpaper from glass paper manufacturers. These have an overall uniformity of texture and can be overpainted with gouache or a thin acrylic before you draw on them, to provide an alternative to the natural pale yellow/gray.

1 Coat the sheet of paper with warm size, cellulose paste, or acrylic medium.

2 Using a fine sieve, immediately scatter pumice powder or marble dust over the surface.

Caring for pastel drawings

Pastels should always be kept in dry conditions to prevent them from being attacked by mold. Various precautions have been proposed, including framing them with an absorbent cardboard backing sheet, impregnated with a 25 percent disinfecting solution of thymol, and placing a waxed sheet between that and the backing board. Pastels bound with cellulose are not as prone to mold as those made with natural gums. Generally, the best way of taking care of pastel drawings is to get them framed behind glass as soon after making them as possible.

Soft pastel working methods

Pastel work has a particular soft, matte quality. When you draw a pastel stick over a paper or other support with a degree of "tooth," the pigment crumbles, lodging in the fibers of the paper or in the surface coating. A certain amount of pigment dust in the atmosphere, on the floor, and on your hands and clothes, is inevitable, so choose nontoxic pigments for pastels (see *Pigment Charts*, pp.16–29).

Technique Line effects

The examples below show the effect of making pastel lines on different kinds of supports, from fine sandpaper and velour paper to paper with a painted ground. What characterizes the pastel line is a rich matte quality. The strokes have an immediacy that is unique among the drawing media. You are effectively looking at pigment in a pure form.

Fine sandpaper The pastel lodges firmly in the abrasive texture of fine sandpaper.

Velour paper The smooth texture of velour paper provides a contrast to the rich, dusty lines of pastel.

Gouache wash An opaque Yellow Ocher gouache background gives a good key to the pastel.

Burnt Sienna wash The lines of pastel seem to float against this transparent, Burnt Sienna wash.

Technique Color and tone effects

Gently shading one color over another and rubbing with a paper stump (see p.96) produces a mixture of the two colors. This is a common pastel technique and particularly useful where, for example, a pure color needs to be dulled or reduced in key.

Blue and red makes violet In the samples above, the blue and red are shown separately and then overlaid. Both rows are on rough paper, but in the bottom row they have been rubbed with a paper stump. The blending of the colors is very different in each case.

Linear shading effect

To make a transition between two different colors or tones on the paper, try a linear shading effect with the strokes of the two colors interlacing so that one appears to blend into the other.

Blending A strip of nine colors, from brown through orange to pink, are drawn vertically and blended at the fold with a paper stump. After each blend, the stump must be cleaned by wiping or sharpening.

Technique Cross-hatching and overlaying pastel colors

You can experiment with the effects that can be created by overlaying and blending colors. You can see from the examples below how the surface texture of the support can affect the appearance of the cross-hatching. This is much less apparent when the ground color has been rubbed into the paper. There is a limit to how many colors can be overlaid. Using a binding or fixing medium on each layer of paint also alters the color.

Cross-hatching effects
Color effects can be created by cross-hatching over rubbed grounds—a pure use of color with no further blending other than that created by the eye.

Two-color hatching Orange/red hatching over a green ground.

Four-color hatching More complex hatching on a cool red ground.

Pure four-color hatching Here, the colors are hatched with no blending.

Hatching blended with the index finger This gives overall color, but contains the marks of the grid.

Overlaying colors
If you draw into pastel pigment with a new color, the purity of the overlaid color is retained, but there is a limit to the amount of pigment the support will take.

Overlaid color Color laid on a rubbed pastel ground.

Different effects Color laid on a nonrubbed ground.

Adding a binding or fixing medium
To use a binding or fixing medium, brush cellulose paste or PVA over each layer of pastel. This gives a rich, saturated look to the color.

Colors fixed Red over orange hatching, with cellulose paste or PVA emulsion brushed over each layer.

Putting technique into practice This sketch employs the techniques shown above. In the sky, a "green" blue and a "yellow" blue were cross-hatched and rubbed before diagonal strokes of "yellow" blue were overlaid. The same technique was used on the castle entrance, where orange/yellows and cool reds were used. The adjacent harmonies of colors in these areas is set against the juxtaposition of complementary colors within the composition.

Technique Using pastel for tonal portraits

Pastel lends itself particularly well to portraits, and can give them a softness and immediacy that other media lack. In the conventional portrait drawing below, the ground is a flecked blue/green paper that contrasts effectively with the warm pinks of the pastel fleshtones. This contrast is emphasized by the use of blue/green pastels in the blankets indicated around the figure and hands.

Building up the pastel portrait

The technique is straightforward. First, the basic position of the features was faintly indicated with pencil or pastel. Then, using the background paper color as a guide to the middle to dark tonal range, highlights were drawn on the forehead with a white pastel. Subsequently, the lightest pink and yellow tints were touched in around the highlights and the whole area of the forehead modeled in this way.

Then a clean paper stump was used to blend adjacent tones and to work the pastel into the paper, producing the smoothly modulated surface.

Using pastels in this way is an excellent method of practicing tonal gradation and, although pastels generally work best in the middle to light range of tones, an impression of the full tonal range can be effectively demonstrated.

The drawing was worked downward from the forehead, using the same method of laying in adjacent tones and subsequently blending them with the stump for the eyes, nose, and mouth. Working from top to bottom helped prevent the drawing from being smudged.

Once the image was defined, it was reworked by adjusting colors and tones, reblending, adding the darkest touches, and re-adding the highlights. A putty eraser was used for minor adjustments and to erase smudges on the surrounding paper.

The pastel palette Just ten pastels ranging from pink to dark brown were used to produce a full range of tones.

Touching in the lightest tints

Blending adjacent tones Beginning in the center of each highlight, the stump was used with gentle, circular, rubbing movements.

Portrait in pastel Babies are often best drawn when they are fast asleep. The cool green paper here acts as a contrast to the warm flesh tones of the baby.

Technique Drawing landscapes in soft pastel

The warm orange paper used for the landscape below contrasts with the blue/greens of the drawing. To avoid smudging, the image was worked from the top down. To help suggest aerial perspective, the drawing was carried out in horizontal tonal bands, becoming progressively darker down the paper. It is much easier to control a range of tones by working across one band at a time, at least initially, than to build up the image randomly.

For the distant hills, blue shading was overlaid with pink, then rubbed with the fingers. For the trees, touches of color were applied in soft, circular movements that were repeated with a paper stump, working from the outside of the tree in. Blue was used with green for the distant trees while, for the closer ones, the second color was brown. The sunlit fields were drawn with white, pink, or yellow/green pastels. The darker tones were added and worked in with the paper stump.

Preliminary drawing The study has the urgency and immediacy of a more rapidly drawn sketch.

Finished drawing The larger, more carefully drawn version picks out the pattern of the hedgerows without losing the sweep of the fields and the overarching sky.

Technique

Direct drawing methods

Another approach to working with soft pastels is to use them directly, with no rubbing or blending techniques.

Drawing on sandpaper
This drawing was built up from a series of direct stabs of short pastel lines that exploit the deep, rich colors that sandpaper or similar supports give to pastels. The lit area incorporates a range of yellow and orange pigments with touches of mauve, brown, and blue, while the areas in shadow include deep blue,

High-key color on sandpaper
The texture of sandpaper means it holds pastel pigment well, creating rich tones and deep colors.

violet, purple, mauve, and brown. An object that is essentially a block of white stone is transformed into a mass of color that relies for its

effect on the complementary yellow and violet. The monochromatic background helps to bring the object forward.

Oil Pastels

Most oil pastels are made from mixtures of pigment, hydrocarbon waxes, and animal fat. In a sense, oil pastels are more similar to wax crayons than to soft pastels.

The better brands of oil pastel contain more pigment and are more flexible than wax crayons, which also have a certain hardness. However, their malleability changes with the temperature, and anyone working with the remains of a stick of oil pastel in hot hands will know about its tendency to "putty." The stick becomes harder to control and more color is deposited on the drawing surface than when the stick is cool.

Being largely wax-based, oil pastels do not undergo any of the changes during the drying process that occur with a medium like oil paint. The material's appearance remains unaltered unless it is rubbed with paint thinner, which dissolves it, or it is subjected to severe heat, which melts it.

The nature of oil pastels allows you to create effects that are different from those of other drawing media. However, they are too vulnerable to be recommended for permanent work. It would be more common to use them in work designed for reproduction or as a preliminary material for digital imagery.

Using oil pastels

The oil pastel surface can be manipulated in various different ways, such as in textural and scraped effects, where different colors are superimposed on each other and scraped back to reveal colored images. Interesting color combinations can be created with gentle shading; burnishing the color (rubbing with a fingernail) gives it a more saturated look, while combining it with watercolor or acrylic paint exploits the "wax resist" technique (see also p.152). Turpentine or paint thinner can be used as a solvent for oil pastel, although organic solvents, even in small quantities, should be used with extreme care and then only with careful precautions (see p.370).

Technique Superimposed and adjacent color mixes

By shading one clean color over another, you will create a third color. The appearance of this third color will be governed by the amount of pressure you use when shading and whether you subsequently "burnish" the color by rubbing it with a burnisher or with the back of your fingernail.

1 The texture of the paper is clearly shown when shading with oil pastel. The green is visible where the two colors overlap.

2 In this version of the same swatch, the colors were rubbed down with the back of the fingernail.

3 In this cross-hatching, shading colors are laid in adjacent rows at right angles to each other. This is as drawn with the oil pastels.

4 This version of **3** has been rubbed down as in **2**.

5 Here, the oil pastel has been scraped off with a flat blade to leave a residual image on the surface of the paper.

Technique "Scratchboard" or "s'graffito" effects

This technique, which works well on smooth paper, involves laying a uniform, bright, light-toned color (burnished with a fingernail) over the whole picture area, applying black over the top, then, using a scratchboard cutter or any metal object such as a screwdriver or the tip of a blade, scratching through the black to reveal the color beneath. You can achieve a range of effects (see *S'graffito effects*, p.191), from delicate tracery with fine line work to the removal of large areas of tone with wide-edged scrapers. The surface is very "pliant" and easy to work.

Project Trees

Each of these images has been made in the same way, but one of them has been made on smooth paper and the other on rough paper. First, a frame of masking tape is laid around the edges of the paper. Pale blue oil pastel is shaded over the whole drawing and rubbed in with the back of a fingernail. The whole area is shaded over again with black oil pastel. The drawings are made by scraping off the black oil pastel to reveal the tree shape. The masking tape is peeled off to leave clean edges. The texture of the rough paper means some detail is lost, but it gives an animated quality to the image. On smooth paper, the image is sharper, with more of a "woodcut" feel.

1 Cover the paper surface with a light-toned oil pastel.

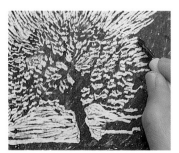

2 Cover this with a layer of black oil pastel.

3 Using a knife or screwdriver, scrape out the image.

Tree 1 Using the scratchboard technique, the image was made on smooth paper.

Tree 2 Here, the same image has been made on rough paper.

Technique

Incorporating a line drawing

The basic technique of superimposing a dark color over a lighter color and scraping off can be adapted by making a black line drawing first. Shade the lighter oil pastel on top of the drawing, then superimpose the black. When the whole surface is scraped off, the black line drawing is again revealed, incorporated into the overall color of the background.

Portrait drawing in pink ground Here, a rugged line drawing in black oil pastel is made on smooth white paper. The whole drawing is then shaded over with pink and subsequently black and then scraped back with a blade. The integration of the image with the slightly textured ground on the smooth surface of the paper gives a particular feel to the work.

Technique Scraping back on rough paper

On textured paper, superimposed layers of oil pastel conceal the colors beneath by only "taking" on the ridges of the paper surface (to which the previous coats have also attached). As more coats are built up, the troughs between the ridges gradually fill with color. When you scrape the surface with a blade, the superimposed layers of color are pushed into the troughs surrounding the ridges, while the ridges themselves are taken back to the first color layer, creating lively, variegated color and texture.

This technique can be used well in combination with watercolor or acrylic paint, where the "wax resist" effect means that the paint only takes to the areas of paper not covered by the oil pastel (see p.152).

The rich, saturated color and texture effects that can be obtained by using this technique on rough paper can be seen below. Work like this cannot be guaranteed to be permanent, since manufacturers of oil pastels do not generally identify the permanence of the pigments or other ingredients.

Using the scraping back technique The black outline of the rhinoceros was filled in with blue/gray. The background was filled with yellow, then the whole picture was covered with warm brown, then black. The whole area was scraped with a blade held at a shallow angle. The heavily textured, rich surface seems appropriate to the subject.

Technique Oil pastel used with watercolor or acrylic

Using the wax resist principle (see p.152), oil pastel can be used in conjunction with water-color to provide an underlying texture for an area of tone or color, usually on rough-grain paper. The watercolor only takes to the paper on the areas not covered by the pastel.

A single coat of acrylic can also be used to advantage with oil pastels. For instance, you can shade over a rough ground with a light-colored oil pastel and then give a coat of dark acrylic color (with a half-and-half consistency). You can then scrape out an image from the wet acrylic.

In the drawing of the chapel below, the rough paper is first shaded entirely with a yellow oil pastel. The whole area is then painted over with blue acrylic. The shape of the sky is then created by scraping the wet paint off that area with a knife blade. Next, the outline drawing is made into the still-wet paint using a very small screwdriver or a wooden stick with a sharpened "chisel" end.

1 Using a yellow oil pastel, shade the entire surface of the paper.

2 Brush a layer of blue acrylic paint mixed with a little water over the oil pastel rapidly.

3 Turn the paper upside down and scrape the paint off to create the sky texture.

4 Use a chisel-shaped, wooden stick to scrape off the paint and make the lines of the drawing.

Finished drawing The chapel.

Chalk and Conté Crayon

T HERE IS A LONG TRADITION OF WORKING
with both black and white chalk or pastels
on mid-toned paper in gray or other colors.
It is an economical way of working. You
can express mid-to-light tones with a
white crayon and mid-to-dark tones with
a black crayon, leaving the ground for the
middle tones. In many respects, it parallels
monochromatic methods of painting.

The black-and-white technique appears
throughout the history of art. Tintoretto
uses it in figure studies characterized by
their massive fluency and where the white
chalk is used only for the highlights. Van
Dyck makes more refined figure drawings
where the contours have a limpid fluency
and the shadows define the form with a
gentle touch. Red and brown crayons are

*A Small Oak Branch
with a Spray of
Dyer's Greenweed*
(ca. 1510),
LEONARDO DA VINCI
This beautifully-
observed drawing,
which has a rich
dimensionality,
demonstrates the
economy of working
on a warm pale to
mid-toned ground
using red chalk
heightened with
white. The drawing
is as immediate
today as it was
500 years ago.

equally traditional and have been, as they
still are, used extensively for landscape,
portrait, and figure work.

Traditional colors

The red ochers, or iron oxide reds, have always
been freely available as permanent, natural
coloring matter. The "sinopie," or underdrawings
for frescoes, came to be known by that name after
the red oxide pigment known as sinopia, which
was used for this purpose (see *Mural Painting Buon
Fresco*, p.278). When used for drawing, this rich,
warm color has a very pleasing quality; red chalk
or conté crayons have also been widely used. The
term "sanguine" simply designates the particular
red/brown terracotta color. (For an example of a
drawing incorporating sanguine crayon, see p.88.)

Other colored crayons of a similar kind are
sepia (warm brown) and bister (cool brown).
These take their name from brown pigments
obtained from the ink sac of the squid or
cuttlefish (sepia), or from the soot of burned
beechwood (bister). In fact, more lightfast
pigments are now used in the manufacturing
of crayons with these names.

Selection of conté crayons

Black

White

Sepia

Bister

Sanguine

Technique Drawing "à trois couleurs"

This technique uses three chalk or conté crayon colors—sanguine, black, and white—to create a drawing that goes quite some way toward being a full-color image. The most regular use of the technique is in portrait drawing. Broadly speaking, the sanguine defines the face and features, the white is used for highlights on forehead, nose, cheeks, chin, and neck, and the black is often used for the hair and possibly for special detailing around the eyes and eyebrows. Artists like Bernini or François Le Moine used the crayons in this way, but others, like Watteau and Greuze, made more use of the black crayon for shading and definition on the face itself. Although there are, of course, no hard and fast rules, the color combination seems a successful and enduring one. This technique can be used to some effect in landscape drawing as well as in portraits.

Low-key portrait on gray paper

In this portrait of a girl drawn on mid-gray paper, the sanguine was used for the face itself, with the rest of the head being drawn in black. A paper stump (see p.96) was used to blend tones and, to some extent, to blend the actual pigments. The dark tones around the eyes and below the nose and lips are mixtures of sanguine and black. The only pure white touches are the reflections in the pupils.

Achieving a low-key effect The dark effect, with lighter tones only on the forehead, bridge of the nose, and cheeks, gives a sense of intimacy and immediacy.

Black-and-white techniques

Working with black and white conté crayons on a mid- or mid-to-dark-toned ground shows how direct and economical a method it is. Black and white crayons can be used not only to make large, bold drawings that have great immediacy, but also for carefully composed works with more fully resolved detail. The white crayon produces highlights of great luminosity on a colored paper.

Technique Working on mid-gray paper

When using a mid-gray paper, tones and forms can be established very quickly. In the example, right, a paper stump was used for occasional softening of the pigment where the tones blend into the gray paper and out to the black. This can be seen at most of the tonal "intersections" in the drawing and on both sides of the nose and at each side of the face. The hair was left as an almost uniform gray tone made with broad strokes of the flat side of the crayons; a few diagonal lines made with a sharp edge indicate the way the hair falls onto the forehead. The subject is looking directly at the artist/spectator. The straight look is emphasized by the use of the white crayon only on the face itself, giving a particular form to its features, and also by the fact that the eyes have been drawn with slightly more detail than the rest, especially the iris and pupil with its bright highlight. This gives a sense of direct engagement with the subject.

Portrait on a mid-gray paper Although the portrait has quite a finished appearance, it is in fact somewhat loosely drawn, demonstrating the economy of the technique.

Technique

Working on mid-to dark-toned paper

For this drawing, a mid-toned opaque blue acrylic was painted over a stretched sheet of white HP watercolor paper and left to dry.

The white conté crayon is used exclusively for the highlights and the black crayon for the dark tones. The combination of the overall blue ground and the eye of the spectator completes the intermediate tones. This method of drawing allows you to make what appears to be a relatively detailed work with the most economical means.

At the horizon, the crayon is softened with a paper stump to give an impression of depth, and using bolder and more vigorous strokes of the crayon as the drawing moves into the foreground enhances the sense of perspective.

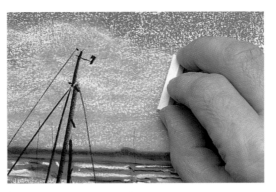

1 Use white conté crayon for the highlights in the drawing.

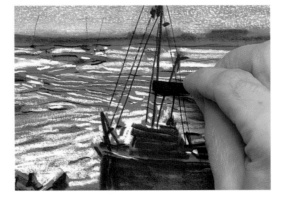

2 Use black conté crayon for all the dark tones.

Finished drawing Picking out the highlights in white chalk, where the sun reflects off the mudflats and boats, and the shadows in black, gives all the information needed for the impression of a complete image.

Technique Working on mid-toned grounds

Here, a warm brown ground provides the overall mid-toned background color for the drawing. The white conté crayon is used for the mid-to-light tones and the black crayon for the mid-to-dark tones. The light tones of the petals retain freshness by being drawn in white and then softened with a stump for the less bright tones.

The petals would lose their lightness and fragility if their deeper tones were made by mixing the black and white crayons together. The paper stump is rubbed on the side of the black crayon and then onto the drawing to deepen the tone of the background around the ends of the petals. This helps to give the flower more dimensionality.

Black-and-white techniques on mid-toned ground
The petals are drawn in white on a warm brown ground, and then softened with a stump. Black conté crayon is used for the mid-to-dark tones.

Thomas Gainsborough

The economy of black and white chalk
This sketch shows the economy and richness of black and white chalk used on a mid-toned paper. The low evening light is defined with sweeps of white that outline the head of the cow against the sky. Touches of white suggest the back of the cow in the water, reflections in the water, and highlights in the tree bark. Fluent strokes of the black chalk reinforce all the dark-toned areas. For all its sketchiness, the whole image has a sense of completeness and an air of repose.

Landscape with Cattle at a Watering Place
(ca. 1770), THOMAS GAINSBOROUGH

Charcoal

CHARCOAL IS ONE OF THE OLDEST DRAWING materials, produced by firing willow, vine, or other twigs at high temperatures in airtight containers. This carbonizes the wood, but leaves each stick whole and ready for use as a drawing medium. Cennino Cennini described the technique in the 1400s: slips of willow were tied in bundles, sealed in earthenware pots, placed in the local baker's oven, and left overnight until they were very black. He pointed out the importance of timing: overfiring produces a crayon that splits into pieces with use. Two centuries later, Volpato described how pieces of wood were crammed into an iron tube that was then sealed with hot ashes, made red-hot, then plunged into water to cool off.

Early writings suggest that charcoal was used as a means of drawing out images for panel painting or fresco. Now, although it is still considered a suitable medium for drawing out an image prior to painting, charcoal is used as an expressive medium in its own right.

The Renaissance painters found charcoal useful because they could easily modify an image during the drawing stage by erasing parts of it with feathers. Once the drawing was satisfactory, it was worked over with brush, pen, or silver stile, and any remaining charcoal was then brushed away.

Manufacture and equipment

Nowadays, willow for artist's charcoal is grown in organized plantations and harvested annually during the winter months. The most common species, *Salix triandra*, provides the standard sticks of charcoal for drawing. The 7ft (2.1m) Triandra willow rod tapers naturally to produce thick, medium, and thin sticks. Another species, the Osier willow (*S. viminalis*), is harvested every two years and provides a thicker stick for large-scale work.

Once the cut willow rods have been sorted, they are bundled into wads and boiled in water for nine hours to soften the bark. This is then stripped off in a revolving machine, and the willow dried in the open air. The sticks are tied into bundles, sawed into standard lengths, and packed into iron firing boxes.

The boxes are filled with sand on a vibrating table, to prevent air from getting to them while in the kiln—the sticks shrink considerably during firing and the sand takes up the space. After preheating to dry them out, the sticks are fired in a kiln for several hours at a high temperature. Twenty-four hours later, they are cool enough to be packed. (If the charcoal is removed from the sand too early, it may spontaneously combust.)

The harvesting of the willow The crop is harvested annually in mid-November from the willow beds in West Sedgemoor in Somerset, England.

Buff willows on the drying wires Following boiling and the stripping of the bark, the willow rods are laid onto drying wires for several days.

Cutting and packing The dry rods are tied in bundles and cut to size. They are then packed tightly into iron firing boxes before being fired in kilns.

Materials Different forms of charcoal

Charcoal comes in various forms and is made from different kinds of wood. The fine texture of willow is perfectly suited to making charcoal sticks. For easel-sized drawings, twigs ranging in diameter from around 4mm to 10mm are most commonly used, but for very large-scale work, scene-painter's charcoal is available in larger sizes.

Vine charcoal

Thin willow charcoal

Medium willow charcoal

Thick willow charcoal

Charcoal pencil

Compressed charcoal

This is not true charcoal, but is made from Lamp Black pigment, mixed with a binder and then compressed into square or round sticks. It also comes in pencil form. Compared to willow charcoal, compressed charcoal is dense and heavy and produces deep, rich, velvety blacks. It is not suitable as a preliminary drawing medium for oil painting because it cannot be brushed off so easily and would blacken the colors of the underpainting. But as a drawing medium in its own right, it is unequaled for rich, black lines and soft, dark tones. Like willow charcoal, it can be manipulated on the paper with fingers or a paper stump.

Making oil charcoal

Oil charcoal gives a clean, deep black line without the charcoal crumbling as much or leaving as much powder on the drawing as plain charcoal. To make it, soak charcoal in a vegetable drying oil such as linseed oil (I use stand oil thinned with turpentine). Put small pieces of charcoal into a small cylindrical container that can be completely sealed. Just cover them with the drying oil. It can take some time for the oil to soak into the charcoal and it is never fully absorbed, so leave the charcoal in the sealed container and use it when you need to. Just wipe off the excess oil on a paper towel before use.

Materials

Fixatives for charcoal

In the past, charcoal fixatives were dilute solutions of shellac, mastic, or colophony in alcohol. See p.370 for information on working safely.

Modern proprietary fixatives
Sold in pressurized cans, modern fixatives are polyvinyl acetate solutions in a quickly evaporating, acetate solvent. They work well on small drawings, but if you are doing large-scale work, such as murals, the cans are expensive and the product may not always provide as much protection as is required.

Acrylic emulsion as a fixative
As an alternative, two or three coats of an acrylic emulsion, applied with a spray gun, provide a permanent sealed surface. This holds the charcoal in its original state and is not affected by scuffing. Allow the acrylic to dry between each spraying. Dilute the emulsion with around 10 percent water before spraying. (A PVA emulsion can also be used but this may tend to yellow in time.)

I have found this acceptable on canvas, although acrylic polymer emulsions, when used on their own, can remain relatively soft when dry and could attract dirt and dust. It is best to glaze (frame behind glass) a drawing on paper.

Materials

Supports for charcoal drawing

Charcoal may be used on any number of different supports. In fact, one of the particular qualities of charcoal is its adaptability to different surfaces. It requires a certain key to the surface to be held effectively, so practically the only unsuitable supports are the very smooth-coated papers favored for illustration work. Otherwise, you can use it on canvas or panel or any of the acid-free papers with a Rough, CP, or HP surface.

Charcoal line techniques

Charcoal is a fast, direct, and responsive drawing medium. It is also one of the least inhibiting, since by nature it encourages a broad and unfussy approach. Charcoal gives a soft or strong quality of line that is unsurpassed for its flexibility and expressiveness, and reflects more than any other the confidence and fluency, the care and hesitation, the forcefulness or timidity of the artist's intention.

Technique

Drawing with willow charcoal

The quality and feel of a charcoal line is determined by the method of application. Holding the charcoal between thumb and forefinger and pulling the stick down, the paper gives a fluid, controlled line, but the charcoal is prone to snap or crumble under pressure. Pushing a mark up the paper, however, produces a deeper, stronger line that can give a solid effect to a drawing. When drawing on smooth paper, the rich black line with its velvety softness can be used to your advantage. The line is consistent and unbroken by any texture in the paper. With charcoal more than with almost any other medium, the vigor or subtlety of markmaking is immediately expressed in the resulting drawing. Drawing on rough paper creates different effects (see below, left).

On smooth HP Waterford paper For the drawing above, I cut a piece of charcoal along its length, giving it a semi-circular cross section and enabling me to make the thin lines along the bird's beak and elsewhere as well as the thicker, stubbier lines at the front and down the wings. The rapidly made lines give a sense of movement to the image.

A similar image on Rough paper This drawing demonstrates how the texture of the paper has a significant impact on the way the drawing looks. This is a rougher image in which the texture of the paper gives the work a tonal quality.

Applying a tonal wash Using no more than clean water and a soft (sable) brush, you can apply a tonal wash to a charcoal drawing. The charcoal dissolves partially in the water as the brush is applied and you can adjust the depth of tone as you work. Once the drawing is dry, it can be fixed normally.

Henri Matisse

"Ghost" lines

Partially erasing charcoal lines with the fingers during the drawing process leaves "ghost" images, recording how the final image was made. The result is that a few simple, black lines arise out of an intensive process of drawing and redrawing. Nowhere is this more successful than in work by Henri Matisse—all the preliminary observation work gives an authority to the clarity of line that emerges. Here, the plump tension of the figure is given softness and buoyancy by the grays beneath.

Reclining Nude with Arm Behind Head
(1937), HENRI MATISSE

Technique Using charcoal attached to a cane

This method of using charcoal, favored by Renaissance painters, gives a new perspective on drawing. The piece of charcoal—secured to the end of a length of cane—seems so far away that the drawing almost seems to develop on its own.

The technique involves holding the cane in one hand, with your thumb and forefinger extended along the shaft, the other fingers pushing the cane against your forearm to balance and control it. For extra control, you can steady the end of the cane with the thumb of your nondrawing hand. The marks produced have a soft, tentative quality, and, although fluffy and insubstantial in themselves, they can combine to create an image with a strong sense of form. The method can be used for drawing on walls and ceilings, or on paper or canvas laid on the floor.

Manipulating charcoal attached to a cane The photograph of Matisse in his studio shows clearly how you can work on a large scale using charcoal on a long cane. The distance between the artist and the artwork enables a useful perspective on the work to be maintained during the process of drawing.

Securing the charcoal
1 Split the end of the cane with two cuts at right angles.
2 Open out the end and insert the charcoal.
3 Secure with tape wound around the cane.

Charcoal tone techniques

Subtle and well-developed tonal effects can be created with charcoal in a variety of ways. Charcoal lends itself beautifully to the use of the grain of the paper for building tone—the charcoal stick often being used on its side to cover an area quickly. In the same way, it can be used on thin paper laid over grainy wood or sandpaper (known as frottage method) for other textured effects. Smooth tonal gradations can be achieved when charcoal lines or tones are softened and lightened by rubbing and smudging with a finger or a paper stump. And highlights can be picked out of charcoal with an eraser—putty or vinyl. The deep-toned softness of compressed charcoal is ideal for rendering tones; a paper stump can actually be used as a drawing instrument when loaded with powdered, compressed charcoal (see *Using a paper stump*, p.96).

Technique
Using the paper's texture

Thin sticks of willow charcoal applied in small, circular movements on a rough-grain paper create a continuous half-tone effect. You can vary the lightness and darkness according to how much pressure you apply to the stick. It is an efficient way of covering a fairly large area with tone—much faster, for instance, than doing a similarly precise work with either paint or pencil. If you are right-handed, work from left to right to avoid smudging, and make any final adjustments by resting your hand against a maulstick or brush handle to keep it off the drawing.

Tonal drawing on textured paper (detail) This drawing is entirely tonal, with no linear work. The grain of the paper and hand pressure provide all the tones.

Technique
Tonal effects from rubbing in

Comparatively smooth papers may be used for rubbing in tones, but make sure the paper has just enough tooth to retain the charcoal powder in its interstices; if the surface is too smooth, the charcoal simply slips off it. Highlights can be picked out with an eraser, which can also be used to generally "clean up" the drawing.

As a contrast to using the grain of the paper for tone, perfectly smooth gradations can be made after drawing or shading with the charcoal by rubbing it into the paper with the fingers.

Smooth tones on HP paper (detail) A drawing like this could be used as a solid, monochromatic "underpainting" for transparent color washes that would build the image into a full-color painting.

Technique Using a paper stump

A paper stump or smaller tortillon can be made of rolled paper, felt, or leather. Stumps are used for spreading charcoal on the paper to create blended or graded tones. They can also act as drawing instruments. Rub the end of the stump along a stick of compressed charcoal so that it picks up some black pigment, and then rub this over the paper. Light or dark tones are produced according to how much charcoal you pick up and how hard you press. For the very lightest tones, use a barely discolored stump.

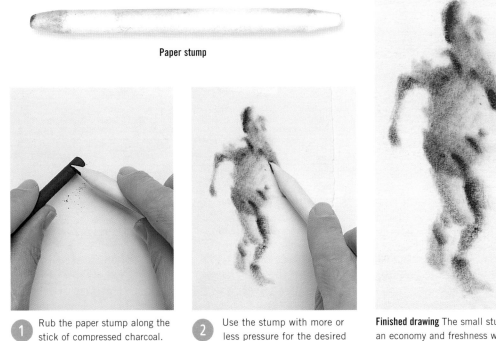

Paper stump

1 Rub the paper stump along the stick of compressed charcoal.

2 Use the stump with more or less pressure for the desired tone of the drawing.

Finished drawing The small study has an economy and freshness without any unnecessary detail.

Technique

Working and reworking an image

Repeated working and erasing on a tonal drawing allows you to progress beyond a mere "surface" treatment to a point where the interaction between the paper surface and the charcoal becomes more intensive. Such a drawing can be seen as the sum of many superimposed erasings, each of which leaves its mark on the paper and adds a softness and richness to the succeeding layer, while the final marks merely underline the essential features of the drawing. With such work, the image is often lost and rediscovered several times during the drawing process. Overworking may cause loss of freshness.

Highly worked portrait study A continual process of rubbing (with fingers and paper stump), redrawing, erasing (with a rubber eraser), and reworking can be used to build a fully developed drawing.

Silverpoint

SILVERPOINT IS THE ART OF DRAWING WITH A silver wire, held in a mechanical pencil or other holder, on coated paper or board. There is a delicate clarity about this medium that is unique among the drawing media. Silverpoint is readily available and requires little preparation.

A new silverpoint drawing is gray/blue in color. In time, the silver darkens to brown. This tarnishing effect gives silverpoint drawings their characteristic appearance. The line remains permanent (it needs no fixing) and unaffected by light. Furthermore, there is a velvety, but resistant, feel to the action of drawing in this medium that differentiates it from graphite pencil drawings (to which it looks most similar). Silverpoint feels more like a form of painting; each line cannot be erased and adds to the cumulative effect of the whole.

Materials and preparation

Preparation

Preparing the paper

Stretch smooth, acid-free, watercolor or drawing paper and coat it with Zinc White gouache or watercolor. Silverpoint deposits its fine line clearly on this surface. One or two thin coats of gouache are enough—if too thick, it may crack. Above all, the coating should be even.

1 Thin gouache to the consistency of cream and apply with parallel strokes of a wide, flat brush.

2 Once it is completely dry, begin drawing with the silverpoint.

Materials Supports for silverpoint

Paper with a special surface for silverpoint is available, but tends not to be permanent. Making your own surface by coating paper with white gouache is much more satisfactory (see left). Subtly colored, tinted grounds may be made by tinting the gouache. These can provide a particular background to a drawing, or give a surface that will take painted white highlights.

Other coatings have been used, including bone dust, gypsum, and chalk, usually mixed with glue size. All give a slight tooth that holds the silver. Silverpoint can also be used for underdrawing on glue-sized, gesso-primed panels.

Technique

How to use silverpoint

Before starting work, round off the end of the silver wire (see below). A wire cut with pliers and used directly is too sharp—it may cut through and break up the surface. Continuous drawing creates a flat on the rounded end of the wire, producing relatively broad strokes. Use the edge of the flat for thinner marks.

Silverpoint is probably at its best in fairly small-scale, finely crafted works with delicate cross-hatching, slowly worked up to the required depth of tone. Increasing hand pressure deepens the tone somewhat—although the deepest silverpoint tone is more like a mid-tone in most other drawing media.

Silverpoint wire in holder

Abrading the point of the wire
Round off the end of the silver wire on fine emery paper. This helps to achieve smooth marks.

Silverpoint techniques

Technique

Fine line drawing

Silverpoint can be used to draw a network of tiny lines that may be built up into fully rounded images where the light and shade are transcribed reasonably accurately. Each line remains visibly part of the whole network.

In a drawing like the portrait below, the tiny cross-hatched lines follow the contours of the face. Many of the lines do not follow the natural movement of the hand on the pivot of the elbow or wrist, so it is important to try to sustain a natural fluency or lightness of line all over. This can be done with practice by changing the drawing position of the hand, or by turning the drawing on its side, or upside down.

Use of shading There is a timeless quality about the marks made by silverpoint, especially when the blue/gray has oxidized toward a more sepia color. The generally careful way in which one applies the shading in a silverpoint drawing tends to give it a kind of dignity. In this case, this is helped by the pensive expression.

Technique Looser drawing

In contrast to the accurate style of the portrait (below, left), a much more loosely worked approach with silverpoint can be adopted. A 0.8mm wire was used for the example below, where an interlocking network of small patches of cross-hatching combine to represent a quiet scene.

In addition to the shading of small areas, there is shading on a larger scale, which follows particular patterns of movement through the drawing. Behind the temple, for example, along the first hedgelike backdrop of trees, the shading describes an overall area from the left, dropping down behind the temple along and up to the right in a "swathe." The lawn in front of the temple and the lake were finished with horizontal shading, which gives a solid base to the movement of the drawing.

Rotating the point of the wire By moving the "pencil" around so that the edge of the flat was in contrast with the paper, thinner, sharper lines were made to counterpoint and offset the texture of the broad ones.

Scratchboard

THE SCRATCHBOARD TECHNIQUE IS A FORM OF s'graffito (see p.191). Sharp tools are used to scratch away the smooth, black surface of a specially coated board, revealing a layer of white clay or chalk. Dramatic black-and-white images are created.

Scratchboard enjoyed a popularity among graphic artists during the first half of the 1900s because it enabled halftone effects to be created with line. These reproduced very well in newspapers and newsprint magazines where the quality of reproduction was generally mediocre. Among the works created for advertising were some that displayed virtuoso techniques in the skilful manipulation of line thickness, having an almost photographic realism. Scratchboard remains a unique and expressive medium in its own right, and can be used to make drawings that are not necessarily designed for reproduction.

Materials and tools

Materials

The scratchboard support

Images are created by scraping lines and tones out of black scratchboard, or out of black areas applied to white scratchboard. The board is manufactured industrially and has a smooth, chalk-based surface, providing whites of great clarity. The black surface has a semi-matte sheen that picks up any grease marks from the fingers. Parts not being worked on should, therefore, be protected from fingermarks by a clean sheet of paper. The board must be dry before you start work (important if you have applied Indian ink to the white board) because damp board will crumble when cut and will not produce crisp lines. Always keep scratchboard flat —it easily cracks if bent—by taping it onto a piece of plywood.

Simple lines are easy to produce. As far as tone is concerned, whether you are starting with a white or a black board, the standard approach is first to establish the large white or black areas, then to fill in the middle tones by various cross-hatching, shading, or stippling techniques. Fine detail can be achieved in this way.

On the other hand, scratchboard responds equally well to a vigorous, more "expressionist" approach, where the work can have the look of a rough-hewn woodcut or linocut.

Working on white board

Although a board with a black surface is thought to be the normal starting point for scratchboard work, many devotees prefer to work on a white board, coating it with black Indian ink only where there are shapes to be scraped out. Thus a combination of scratching and ink drawing can be used. The white surface is an excellent support for pen or brushwork; it has just the right amount of hardness and absorbency for crisp, fluent strokes.

To apply black ink to a white board, use a flat, soft-hair brush for a thin, even coating. Do not brush the ink too much or the ground will soften. Use a small, sable brush for outlines. When the ink is dry, pick out the details and highlights with cutters. If you make any mistakes, these can be scratched away or painted over, left to dry, and then redrawn.

Materials

Scratchboard tools

There are three basic kinds of conventional cutter (see below) that fit into pen-nib holders. Less conventional tools—from pins and needles to staples and utility knives —can create different effects. Whatever you choose, it must be sharp—use an oilstone to sharpen tools; if the precision of the scraped mark is lost, work progresses more slowly. You can also use engravers' tools, such as chisel-edged cutters with a row of teeth that create cross-hatched areas of tone very rapidly, or sections of hacksaw or fretsaw blade.

Diamond-shaped cutter Has flat or curved edges.

Knife-blade cutter Probably the most versatile of the tools.

Gouge (scoop-shaped cutter)

Scratchboard techniques

Technique Using a diamond-shaped cutter

You can make fine lines with the points of the flat and curved diamond-shaped tools. If you hold the tool like a spade and use it with a rapid digging action, you can create stipple effects. Pull the side of the flat across the board for thick, straight, wedge-shaped cuts, or down the board for thinner, slightly curved ones. The curved cutter makes similar, but less angular cuts.

Stipple effect Grasp the tool firmly so the handle is beneath your palm and use it at a relatively steep angle to the board.

Marks made with diamond-shaped tool

Technique Using a knife-blade cutter

You can use the point of the utility knife-type cutter to draw very fine lines, making carefully controlled manipulations and extremely detailed effects possible. As you work around the cutting edge, you can also make progressively broader lines. With practice, you can vary the width of a line in a single stroke by gradually lessening the angle of the blade to the scratchboard.

Producing a thickening line If you reduce the angle of the cutter to the board while making the cut, a gradually thickening line is formed.

Marks made with knife-blade tool

Technique Using a gouge

Held and used like a trowel, this tool makes tapering, scooplike marks of varying size depending on the pressure you apply. If you hold it vertically and pull it down the board, it will create long, firm, rectangular cuts. Or it is possible to make similar cuts at a diagonal using sideways movements of the gouge. If you use the tool too vigorously, however, it may push too deeply into the board.

Making "scoop-shaped" marks Hold the gouge like a trowel and use it with a shoveling action to make marks for texture effects.

Marks made with gouge

Technique Creating multiple line effects

A strip of staple gun staples makes an unusual cutter. Pull it across the board several times for an effect that would be very difficult to achieve with single lines. This is a rapid way of building up an all-over texture.

Overlapping wavy line texture

Complex straight line texture

Technique Linear techniques in context

The versatility and immediacy of this medium, from rapidly made, fluent line drawings to more complex, closely worked studies, can be seen in the following examples. The images on this page are all made on black scratchboard, while those on the following page are made on selectively inked, white board.

Pure line work

One of the simplest, most satisfying, most effective, and yet most difficult techniques is to draw directly from a model onto scratchboard. With this kind of line work, no second attempts are possible. In the example (right), the starting point was the girl's right eye. From here, the simple outline drawing developed to the rest of the features, the outline of the head itself, then the arms and body.

Simple, direct portrait A thin, white line taken out of dense, matte black has an illuminated quality that is unique to scratchboard.

Texture, vitality, and dimension

The recreation below of an image from the 1950s demonstrates the strong graphic quality of the scratchboard medium. It shows how texture and tone can be simply and effectively indicated, with the "white" shirt of the boy and the mid-toned (striped) dress of the girl. The boy's pants are partially in shadow and partially in the sun, and this is achieved with the use of thin parallel lines of shading. Similar shadows can be seen in the foreground grass and more distant hedgerows. The diagonal lines in the mid-part of the sky lead up to the pointing arm of the girl, and this takes the eye onto the plane on the top left of the picture. This movement, along with that of the two birds below the plane, helps to make the image more lively.

Impact of line direction

In this sketch, practically all the marks made by the "knife-blade" cutter (with the exception of the "S" shapes on the balconies) are vertical or near vertical, but they vary in width according to the level of detail. So the stage backcloths are drawn with chunky, vertical lines while the skirts of the chorus girls incorporate much finer ones. This sharply contrasted image gives a sense of the stage being flooded with artificial light within the dark surrounds of the theater. These dramatic lighting effects are typical of the medium.

Indicating texture and tone Scratchboard has a strong graphic quality.

Using line direction for special effects Chunky and fine lines add emphasis and light.

Lines and cross-hatching

In this ballroom scene, a flat-edged, diamond-shaped cutter was used with freehand lines and irregular cross-hatching to create an effect of light and shade. Thin downstrokes, used in places over the horizontal/diagonal hatching on the dance floor, indicate the reflections of figures. Long, thicker, diagonal strokes were used to show the reflection of the spotlight on the floor.

Lights and reflections The diagonal strokes used for the spotlight reflections trail off along the same line as the spotlight itself.

Technique

Using scratchboard to make preliminary designs

The directness and simplicity of the scratchboard medium lends itself well to making small, expressive images that may be scaled-up for use in other media.

Small preliminary image This was drawn in the process of creating imagery for a large-scale ceramic tile mural.

Technique

Working quickly on white board

For a shape defined against white, like the parrot and branch (right), it is easier to paint the shape in black ink and then draw in the details with a cutter. For the distant landscape, pen and ink was worked over with a cutter for a halftone effect; brush and ink was used for the foreground.

Parrot drawing on white board This relatively simple drawing would have taken considerably longer to make on black board.

Technique Working on a more precise and detailed image

It makes sense to use the white version of scratchboard if very large areas of your image are going to be white. The technique is simply to paint the board with black, shellac-based, waterproof drawing ink in the areas that are going to be worked on, leaving the rest of the board white. You should wait until the ink is completely dry before starting to scratch the image out of it. Here, the shape of the zebra has been painted in black ink and subsequently scraped back to show the characteristic markings. The surrounding area is clean, white, and unmarked. If the image had been made on black scratchboard, the background would have taken a considerable time to scrape back and would not have looked as clean.

Using white board The delicate cutting is appropriate to the image.

Technique

Creating a silhouette effect on white board

The combination of ink and white board used in this drawing means there are no cut-marks in the white areas. The shape of the coastline was first traced onto white board and then drawn in with a round sable brush and black ink. When this was completely dry, it was worked with a knife-blade cutter. Cutting into the edges of the black defined the line of the breakwater, the boats, and the people, and helped to sustain the appearance of the whole image being cut back from black.

Creating a silhouette effect The effect of the setting sun means the image is almost a silhouette, so few marks were needed to indicate the shoreline forms.

Pen and Ink

DESPITE THE HUGE RANGE OF INK DRAWING MATERIALS now available to artists, the basic aspects of pen and ink work remain the same as they have always been. The mark of the pen is a direct, unequivocal statement in line that, once set down, is fixed and permanent. Although there are erasers for ink, a pen line is not generally modified and adjusted in the way that a pencil line can be. It is a once-and-for-all technique in which there can be only one chance to make the pen line come alive. It directly reflects the artist's approach to his subject, be it tentative or confident, nervous or fluent. So it is interesting to note that the advice of 15th-century Italian artist Cennini to would-be Renaissance artists was only to begin working in pen and ink after at least one year spent drawing in charcoal and metal point.

Study of a Seated Actor *(ca. 1630)*, REMBRANDT VAN RIJN
There is an easy fluency about this expressive drawing that exactly captures the actor's confidence.

Materials and equipment

Materials Pens

The nature of the mark made by a pen is determined by the nib type and its ink supply. As well as traditional quill or reed pens and a wide range of steel nibs, there is a wide and expanding range of drawing pens, including various sophisticated technical pens with tubular nibs that make lines of established width. These are primarily designed for technical drawing, but provide the artist with a useful drawing tool. Among the technical pens are also those that feed ink at a constant rate to more traditional nibs.

The range of roller-tip or ballpoint pens is constantly being expanded and upgraded in relation to line width and ink flow. There is also an increasing range of self-inking pens with various kinds of nylon, acrylic, wool, or polyester fiber tip—the so-called felt-tip pens. These are made

with water- or spirit-based inks, and although the latter are claimed to be more permanent, the dyes that provide the colors are generally extremely fugitive, so it is probably best to avoid them—at least in the brighter color ranges—if you want to make a permanent work.

Different nibs and their marks
Some nibs, especially steel ones, are very flexible and allow you to make a line of varying width. A nib with a broad point uses more ink than one with a fine point, so the length of line you can produce with one dip in the ink is an important consideration.

The technical pens make lines of uniform width. They have to be held at a much steeper angle to the paper than traditional steel drawing pens. Reed pens provide a soft, chunky line; mapping pens produce a sharp, scratchy line. The extraordinary

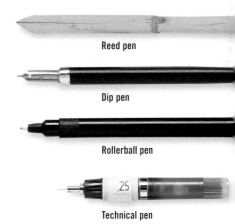

Reed pen

Dip pen

Rollerball pen

Technical pen

lightness of a quill pen makes the artist particularly aware of the point of contact between nib and paper. Among the fiber-tip pens, the "chisel" tip provides a sharper, more angular italic-style line, while the "bullet" tip gives a rounder, more uniform line. These pens can be used with the drawing board held vertically; other pens cannot.

Materials Inks

Aside from black and white drawing inks, which are pigmented rather than based on soluble dyes, some of the brighter colors may be fugitive. There are now wider ranges of pigmented colored inks. They claim high levels of lightfastness for most of the colors, with excellent permanence in red, blue, and green, and only slightly less in the yellows.

These inks are transparent and very pure in color, so you can mix particular colors with great accuracy, or control them by glazing with overlaid color. The introduction of these inks may well result in artists producing more work in full color in this medium rather than in the traditional black or sepia.

Ink dropper This is useful for applying just the right amount of ink to a nib.

Materials Supports

The traditional support for pen and ink drawing is sized paper. Paper that is too absorbent will make the edges of a pen line bleed, losing its crispness. HP rag paper provides a permanent support that can be used for most pen and ink manipulations, especially if it is stretched. Other smooth papers with coated surfaces are prepared by manufacturers with pen and ink work in mind. These are often mounted on board to avoid the need for stretching. They make fine surfaces for the work, but can be of doubtful permanence.

Technique
Using diluted ink

There is a significant alteration in the nature and appearance of marks made with diluted ink, compared to similar ones made with undiluted ink.

Here, the ink was progressively diluted in four stages, and wavy lines similar to the way those below were drawn. The marks were made with a reed pen (top) and a natural goose quill (bottom).

Technique The quality of the ink line

The tonal variations possible within a single line and the particular expressiveness of the diluted ink line (see above) are aspects of pen and ink work that are often overlooked.

The ink lines below show the great variety of line quality produced by different nibs on both dry and damp paper. The CP surface, although sized, is still fairly absorbent, and there is bleeding along the edges of the lines, though the characteristic look of each nib clearly emerges.

The three script pens included in the examples offer exciting alternatives to the more standard artists' drawing nibs. The round nib comes in several different widths and is excellent for making thick, strong lines. The square version gives lines a particular ribbonlike quality, with fluid variations within the thickness of a particular line.

1 Natural goose quill
2 Natural reed
3 Technical pen
4 Script round
5 Script flat
6 Script pointed
7 Gillot drawing
8 Mapping pen

Wavy lines drawn with eight different pens on stretched CP rag paper

Pen and ink techniques

Technique Line techniques

One of the most positive aspects of traditional pen and ink drawing is its immediacy—a tentative approach will be reflected in a delicate, tenuous line and a bolder, more assured approach with increased pressure on the nib will produce stronger, thicker lines. The particular quality of the line will have much to do with the specific pen itself.

Fine line marker The relatively new, permanent, fine line markers, which have a fiber end encased in a steel tube, are very effective drawing pens. They come in a range of line widths from around 0.1mm to 1.0mm. A study from the life room demonstrates the clarity and effectiveness of this pen as a recording medium. Working in this way, you make a commitment to the line as you draw it, because you cannot erase it. The width of the tip here is 0.5mm. This gives a softness to the drawing at this scale.

Commercial fine line pen Two small sketchbook drawings, made with the same direct commitment to the line and with no preliminary drawing out in pencil, use a more liquid, commercial, fine line pen. Here the line is considerably thinner, giving a crisper but more tenuous look to the drawing.

Comparing marker and drawing nib The first sketch (woman in bikini) is drawn with the same pen as the life room study above, while the second (man reading) has been drawn with a regular steel drawing nib. The difference between the two is striking. In the first, there is an almost complete continuity of thickness in the line, while in the second, the flexibility of the nib gives a thinner or thicker quality to the line throughout the drawing.

Comparing felt-tip pen and ballpoint pen Both of these sketches feel their way around the form, as in each case a mark made is a mark permanently committed. But the difference in line quality between the two is very noticeable —the felt-tip pen (top) gives a relatively thicker line, but one that has a more transparent feel. The ballpoint pen (bottom) has a thinner line but a more viscous feel, since it makes a slightly thicker deposit from time to time along the line.

Using a very wet support

Try thoroughly wetting the paper before beginning the drawing, rather than merely dampening it. This gives you somewhat less control over the finished appearance. Chance plays some part in determining the success of the technique, since you can never be sure exactly how and where the ink will run. On the other hand, it is just this freedom of the ink that gives work of this kind its appeal.

Drawing onto wet paper This rapidly made sketch shows the effect of working directly with undiluted drawing ink onto paper that has been dampened or more thoroughly wetted in advance. This technique has the effect of incorporating the line of the pen into the very fabric of the paper, since the ink is diluted and diffuses into the surrounding area.

Variable line with black brushwork

A bold, direct use of pen, brush, and undiluted ink is an economical way of creating dramatic effects of light and shade. Areas of solid black counterpoint the lines of the pen.

Juxtaposing lines with an area of black The fluent pen line that defines the figures and details their expressions is offset by a solid background, which pushes the figures forward as if into a spotlight.

Technique

Choosing nibs for different effects

Combining a fine line with a chunkier one in the same drawing is often the solution to a problem of expression—possibly when you need to "separate" the subject and background.

A technical pen will give you a fine line of uniform width. However, if you pull the pen very rapidly across the paper, it deposits the ink in a series of tiny dots and dashes. These lighter, broken lines can be used to modulate areas of tone.

Other pens have their own particular characteristics in this respect. For the kind of pen where you are supplying the ink, one way of modulating the tone is simply to dilute the ink according to the depth of tone required.

Using a homemade quill pen

A series of long or short lines in a range of three or four tones of black ink can follow the contours of a face, and gradually build up an image with form and volume. The eye naturally travels from line to line around the head, giving a lively effect.

Cutting a quill pen

It is relatively straightforward to cut a natural goose quill into the shape of a nib:

- With a utility knife, cut off the tip of the quill using an oblique cut.
- Take out a flat scoop along the underside of the quill.
- Make a central slit in the nib.
- Shape the nib on either side of the slit.
- Insert a small, S-shaped strip of metal to act as the ink reservoir.

Building contours Portrait drawn with a goose quill cut with a wide, flat end.

Using a reed pen

The nature of the contact between pen and paper is quite different between the hard, flexible, steel nib, the horny, flexible quill, and the less flexible but straightforward, less scratchy touch of the reed pen. The reed pen has a broadness of feel and a solidity that makes its contact with the paper a natural and satisfactory one. In some ways, it is similar in feel to a felt-tip pen, though the latter is more uniform and less resilient.

The reed pen makes a mark that reflects its natural, chunky appearance. It does not lend itself to oversophisticated techniques; the most successful drawings are those that rely on its plain, short strokes—there is a strict limit to the amount of ink the reed pen can hold. Vincent Van Gogh was possibly the most outstanding exponent of reed pen drawing, and his works in the medium have a clarity and intensity that is unparalleled. Short, smooth lines are characteristic of the reed pen.

Vincent Van Gogh

Reed pen drawing

The short, stubby strokes of the reed pen correlate perfectly with the stubble of the recently cut corn. Van Gogh creates a landscape that appears to recede effortlessly through foreground, middle ground, and distance in a long, seamless, and rich pattern to the far outlines of the busy town where the factory chimneys smoke ceaselessly. This is a world like that in illustrations in the early medieval books of hours in which a whole season and a whole lifetime seem to be subsumed. The decision to use a reed pen gives credibility and a kind of truthfulness to the markmaking that allows us to participate in this world unreservedly.

Arles, View from the Wheat Fields (1888), VINCENT VAN GOGH

Using a round-nib script pen

The script pen nibs give a smooth, rich line. Those with circular ends and an attachment to act as a reservoir for the ink can be very satisfying to use—they give a line with a relatively constant width and give a chunky quality to a drawing. Using them, you can make simple, bold studies, like this one of a boy sketching. Working at this scale, you can give just enough of an idea of the subject without going into detail, and yet give a real sense of the image.

Simple sketch using round-nib script pen Working with a line thickness like the one shown here will inevitably simplify your drawing.

Using a pointed-nib script pen

The pointed script nibs with two slits allow you to make a line that opens right out or closes up, depending on the particular effect you require. In this drawing, the soft shapes of the dogs' heads, ears, and mouths lend themselves perfectly to a style of line drawing in which the variable thickness of the line adds a velvety quality to the image.

Pointed nib used for variable line thickness This style requires a lot of practice, but can become fluent and expressive.

Brush and Ink

IT IS IMPOSSIBLE TO THINK OF BRUSH DRAWING WITHOUT CALLING to mind the Chinese and Japanese traditions in the medium. Oriental brush drawing, whether purely calligraphic or more representational, is a traditional art, rooted in centuries of discipline and practice. In the finest examples, a combination of technical virtuosity and a deep understanding of the nature of the subject matter is found.

Over the centuries, handbooks in China and Japan have charted practically every stroke that it is possible to make, with every position of the brush. Oriental brush drawing has at its core an overriding preoccupation with the nature of the line itself. In the West, where representation has taken a different course, there is no such "academic" tradition of precise brush handling, speed, and pressure of stroke; the brush has tended to have a more workmanlike role in "filling in," adjusting, and manipulating, rather than as the highly tuned instrument that only has one chance to make its mark.

Tiger *(1986)*, WANG DONGLING
An extraordinary fluency and control characterizes the best examples of Oriental calligraphy. The complexity of some of the "one-stroke" characters makes their perfection remarkable to anyone who practices brushwork.

Oriental and Western techniques

Brush drawing is the handwriting of the artist and reflects—possibly more than any other medium—the artist's character and decision. The reason for this lies in the responsiveness of the charged brush to pressure and movement from its manipulator. In the West, wherever a brush has been used directly, and by a great artist, its marks can have just as much life and appropriateness as in Oriental works. Over the last one hundred years or so, artists from the West have been increasingly aware of Oriental brushwork and have incorporated many of the traditional techniques in their own work. It is beyond the scope of this handbook to deal in depth with such a complex discipline, but some of its main aspects and techniques, especially those concerning the handling of the brush, are incorporated in this section.

Technique

Holding the brush

The huge variety of brushes available (see pp.119–21) is largely responsible for the versatility of brush drawings as an art medium. Brushes range from fine-pointed sables to coarse, hemplike bamboo brushes, and the nature of the brush dictates to a large extent the nature of the mark. The way in which the brush is held also gives the mark a special character.

Artists have developed their own methods of holding the brush for particular manipulations, and some have devised whole schemes inspired by Oriental methods. Through the various holds, pressures, and movements, a language of brush drawing is created that is articulated by the entire body.

The Western way
In the West, there is an automatic tendency to hold the brush like a pen, at an angle with the handle resting beside, or just below, the knuckle of the first finger. With this grip, the fingers are usually clamped together and move in unison, encouraging a one-directional stroke.

The Eastern way
In Oriental brushwork, the brush is held vertically and the support is horizontal. The thumb and middle finger provide a firm, central grip that can be moved multi-directionally by the action of all the fingers. The brush is held away from

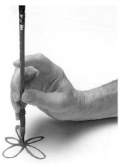

Level wrist
The wrist rests on the paper. While the right hand is drawing, the left rests flat on the table.

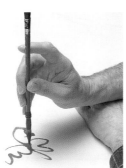

Pillowed wrist
A slightly raised wrist position, in which the wrist rests on the back of the flat left hand.

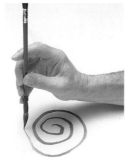

Raised wrist
Here, the elbow rests on the table and the forearm is raised.

Suspended wrist
Wrist and elbow are held above the table. This is used when standing, for large-scale work.

the palm, and the tips of the fingers do most of the holding and moving, giving firm but sensitive control. The main considerations that determine the look of the stroke are:
● Tightness of grip
● Position of the fingers
● Position of the wrist and arm
● Pressure on the hairs
● Speed of the stroke.
A tight hold gives stronger, firmer strokes; a looser hold gives more suppleness. There are three basic positions of the fingers on the handle —low, middle, and high. The brush moves more freely and sensitively in the high position than in the low one, where the movement is more restrained. The distance of the hand from the support provides another set of variables, with four main positions outlined by the Chinese calligrapher Chiang Yee (see above). The width of the stroke is determined by pressure on the tip of the hairs. The three main pressures produce fine, middle, and heavy-width strokes.

In the West, artists often use the whole of the brush up to the ferrule for certain manipulations. This is rare in the East—at least in calligraphy, where up to half the length of the hairs may be used, but where the very tip is the most important part, with the rest of the hairs acting as the ink reservoir.

Inks, brushes, and supports

The same immediacy in the markmaking characterizes brush and ink drawing whether made with Western or Oriental brushes, inks, and paper. It is important, therefore, to use good-quality brushes, to get to know the feel of different kinds of paper, and to experiment with various dilutions of ink.

Materials

Brush drawing media

Although Oriental stick ink and Indian ink are the most popular and traditional media for brush drawing, any painting medium can be used, including watercolor, acrylic, and even oils, depending on the support.

Oriental stick ink
In the East, the traditional brush drawing medium is Chinese or Indian ink in stick form. This has been made for over two thousand years. It consists of Lamp Black pigment (derived from the imperfect combustion of pinewood or oil in small, earthenware lamps), mixed with glue and scented with musk, camphor, or rosewater. The sifted, ground soot is mixed into warm size made from a mixture of fish glue and parchment size. This forms paste balls that are heated, shaped into sticks, and then hammered. Perfume is incorporated, and the material pressed into wooden molds, then dried, cleaned, and polished. The favored color is a blue or violet-black. Pure black, brown, and yellowish black are also seen.

Indian and other inks
Nowadays, Indian inks are generally carbon pigment suspensions in shellac or in a synthetic resin-based binding material, though some proprietary liquid Indian inks are made from Chinese sticks. Various other inks can be used for brush drawing. Sepia, prepared from the ink sac of the squid or cuttlefish, enjoyed a vogue in European brush drawing from the end of the 1700s.

Materials Brushes for linework

The dilution of the ink or other medium, the kind of paper or support used, and whether it is wet, damp, or dry, the kind of the brush used, and the amount of ink on the brush all contribute to the infinite variety of effects that can be created with brush drawing. The examples below were made with Western brushes.

1 Hold a fine-pointed sable vertically with the hand resting on the smooth paper as you travel down with the brush stroke. This allows an extremely narrow and consistent stroke to be made.

2 The same with a chisel-ended, sable striper.

3 Half-inch, oxhair, wash brush with undiluted ink. Drawn rapidly, the ink only takes on the raised grain of the paper.

4 The same with diluted ink on rough paper.

5, 6, & 7 One-inch, nylon flat on smooth paper. The stroke is made three times without refilling the brush. The effect is very different each time as a more halftone quality emerges from the drier brush.

8 Spiral with fine-pointed sable on dry paper.

9 The same on wet paper.

10 Simple brushstroke on dry paper with large sable.

11 The same on wet paper.

12 A linear brushstroke on dry paper and the same on wet paper. The effect of dampening the paper is to produce a very different feel to the line in each case.

Materials Supports for brush drawing

Paper or silk is the traditional support, but other canvas or panel supports may also be used.

The virtues of Oriental papers

Japanese and Chinese papers (see p.48) come into their own for brush drawing. They are generally thinner and more absorbent than Western papers, so there is a close relationship between brush, ink, and paper. Brushmarks are absorbed and become an integral part of the fabric of the paper rather than "sitting" on its surface, as with heavier-sized Western papers (see opposite page, top left).

Oriental papers give each stroke a remarkable form and clarity. They seem to retain the action of the stroke in a way that Western papers do not, particularly in direct drawing. Where a drawing is built up in washes of different tones, the more solid Western rag papers are better.

Technique Using different papers

A fat, pointed Chinese brush in a plastic enlarging holder attached to a bamboo handle was used for a series of brushstrokes on several different Oriental papers (see opposite page, top). The responsiveness of the papers to nuances of pressure and speed of line was noticeable. A momentary hesitation deposited more ink, leaving a denser tone. When the brush was slightly undercharged with ink, the edge of the line broke up, giving an expressive "dry brush" look. With diluted ink and an overcharged brush, flooding and bleeding occurred at the edges. The "palm tree" symbol drawn with a less wet brush, for example, gave a drier, grainier, and more expressive image than some of the shapes made with a fully charged brush.

Simple marks on Oriental papers

1 Sekishu shi white laid
2 Gifu shoji white laid
3 Kawasaki off-white laid
4 Kozo shi toned laid

Absorbing excess water

Diluted ink gives a softer, gray effect. But if the brush is too wet, the edge of the stroke will bleed. With the thinner papers, a sheet of absorbent paper placed below the sheet being painted on absorbs the excess fluid.

Using a smooth-coated paper

Similar strokes made with the same brush on smooth cartridge paper showed a different character to those on the thinner, absorbent Oriental papers. The crisper edges, though they can have an effective clarity, are somehow more separate from the action of the paint within the lines. The ink has a tendency to sit on top of the paper rather than being absorbed into it.

Translucent paper On this thin, translucent paper, the strokes of the brush are satisfyingly absorbed into the paper, creating a sense that the image is an integral part of the material quality of the paper and not just something painted on top of it.

Smooth paper Marks are more crisp-edged than on Oriental papers.

Technique

Working on smooth and textured papers

The character of a brush line drawing is directed by the nature of the brush and of the support. These two drawings were made with the same brush—a round, pointed sable—on two different surfaces, a smooth paper and a grainy paper. The drawings were made rapidly with simple, bold strokes—a style with a high failure rate. In the second example, the hardness of line of the first is broken up and softened by the effect of the grain of the paper. To get this effect, the brush should be dipped in the ink then partially wiped off with an absorbent tissue before drawing.

Smooth paper Direct line on smooth paper.

Grainy paper Direct line on grainy paper.

Technique

Using a fine brush line on smooth paper

This brush line drawing was made using the point of a small, round, sable brush. You can be forgiven for thinking that it is a pen drawing. The quality of the line varies between tentative and fluent. The latter can be seen in the wavy scribble indicating the left side of the boy second from the left.

Fine lines A pointed sable can make lines as fine as those made with a pen.

Brush drawing techniques

The expressive character of the single outline, brush drawing has been recognized and exploited by artists for centuries. The Egyptian drawings (right) were made on limestone flakes with red or red and black ink, probably using brushes made from reeds. The fluent and amusing drawing of the stonemason is a credible, witty characterization. There is some red ink underdrawing with suitably bold, black ink lines drawn on top.

In the more fully worked but still very two-dimensional drawing of a monkey in a tree, the brushstrokes have been overlaid to establish a depth of tone and a strong sense of formal patterning.

Egyptian ink drawing

These two small ink-on-limestone drawings were made in Egypt between 1310 and 1080 B.C.

Technique

Drawing brush and ink studies from life

This simple line study is made with a round sable and undiluted drawing ink. It is taken from life, directly onto the paper with no preliminary drawing—it is a question of looking and drawing. This means there is no going back on a mark once made, and that one's concentration is intense for the few minutes it takes to get the image down. This concentration seems very much part of the resulting images when they work. It also means that out of a large number of drawings, you may only find one or two that are worth saving.

Nude

Technique

Using two tones of ink, one large brush

With a large mop brush and black ink, the hedge can be indicated very rapidly. The ink is then diluted and the figures of the girls can be drawn swiftly with just a few strokes. The paler tone of the figure on the left gives an indication that the light is partially reaching her. The drawing would be much less interesting if the girls were simply black silhouettes in the same tone as the hedge.

Two girls by a hedge

Technique
Rapid brushwork

The energy associated with an image—here, that of birds in flight—can be expressed in the brushwork that is used to create it. It is virtually impossible to make this kind of drawing without reference to a photograph or other image that allows you to reflect on the shape and movement of the bird before making the drawing. These are small-scale works, but can be scaled up and recreated as a way of focusing on the energy and fluency of the brushstroke.

Technique Dry brushwork

Dry brushwork is a method of drawing that allows you to create halftones by keeping the brush relatively dry as you work and using the grain on the surface of the paper to pick up the color. For detailed work like this, you have to be fairly methodical in building up the drawing, and so the process is generally a very careful one.

Building a background With the sunlight picking out the plants in the foreground and the deep-toned, dense foliage as a backdrop, this is an ideal image for dry brushwork. The texture of the background can be carefully built up, leaving the plant as an almost white silhouette. The drawing is made with small, careful strokes of a sable brush on a CP surface.

Halftone effect The Iris looks like a fully dimensional study of the flower, but there is very little tonal contrast in the paint itself. The appearance of tonal variation is a result of the amount of white paper that is visible at any point in the drawing.

Other Drawing Techniques

Drawing is often viewed as a small-scale, intimate activity. Many contemporary artists, however, have made drawn works on a massive scale. Such works might fill the available wall space in a gallery or they may be external works. In many cases, they incorporate materials directly from nature. In fact, the sophisticated drawing products of the artists' materials manufacturers are so well packaged and marketed that this may obscure the fact that their raw materials are largely natural.

For artists whose work arises out of a direct involvement with the natural world, materials found on site, rather than the manufactured product, often provide the basis for work made in the landscape or later in the studio or gallery. Mud, sand, twigs, leaves, water, berry juices, and lumps of chalk have all been used. In addition, the actions of the sun, wind, and rain have all been called upon as a means of modifying, or even creating work.

Large-scale drawing in the gallery

One kind of large-scale drawing is that illustrated, for instance, by the wall drawing of Sol LeWitt. In this type of work, the concept is critical, since the drawing itself can be made by others to the artist's plan.

Sol LeWitt says: "The artist conceives and plans the wall drawing. It is realized by draftsmen. (The artist can act as his own draftsman.) The plan (written, spoken, or a drawing) is interpreted by the draftsman." Such a scheme allows for the draftsman's own decisions, interpretations, contributions, and errors, but the work itself remains that of the artist. "The wall drawing is the artist's art, as long as the plan is not violated."

During the last 30 years or so, Sol LeWitt has created hundreds of large-scale wall drawings in galleries around the world. More recent works include large wave-form shapes in matte and glossy black paint, and others that show massive illusionistic and brightly colored architectural forms.

Sol LeWitt

The qualities of wall drawings

Large wall drawings like the one shown have geometry and order and often utilize the whole of the available space. Sol LeWitt's wall drawings often use not just one wall but the whole of the gallery wall space. The effect of this is to entirely transform the nature and feel of the interior. Here, the wall drawing creates a powerful structure that becomes almost three-dimensional in its effect, as if the spectator is looking through the framework of the grid to a further space beyond it.

Installation Jul–Sept (1989), Sol LeWitt

Technique
Scaling-up wall drawings

Drawings can be made on a small scale and then enlarged on the walls of a gallery or elsewhere. This transformation can be a means of focusing on the graphic essence of the original drawing, or of celebrating its fluency or another quality. But it can also create a visual impact that the original context would not have provided. The "scaling-up" can be done in a number of ways: by projection, using the grid method, or simply freehand and using different materials for the scaled-up work to those used in the original drawings.

Large-scale versions of brush and ink drawings A series of rapidly made brush and ink drawings was photographed and projected onto the studio walls. Pieces of torn matte black paper were stuck to the walls and ceiling to correspond with the images.

Using natural materials

A number of artists have incorporated the actions of the elements in their work.

Rain often makes its mark on a work by chance, but there are artists, such as American painter Julian Schnabel, who have made whole suites of drawings based on the action of rain on charcoal or watercolor. Others have used the sun's rays to make drawings. British artist Roger Ackling uses a powerful magnifying glass to concentrate light from the sun, burning images into pieces of driftwood. He feels the slow, careful method of working that this entails is perfectly suited to his temperament.

There are artists who make drawings in the landscape itself and whose work is documented in various ways before being washed away by the rain or tide, or blown away in the wind. German artist Joseph Beuys, for instance, made a series of drawings in smooth sand with a stick. On a larger scale, New York artist Walter de Maria has made drawings by leaving motorcycle tracks in the desert sands.

Many different approaches are adopted by artists who use natural materials as their drawing medium. The materials may be taken directly from the subjects they represent or used entirely separately.

Technique Working with mud or water

Some artists use mud or water to make works. Such works are discussed here as drawings, for although they are not drawings in the conventional sense, they nevertheless have the immediacy and indeed, for all their scale, the intimacy of the direct and personal form of markmaking that is traditionally associated with drawing.

In the mud and water works of Richard Long (see p.116), there is a concern not to recreate the external appearance of something perceived, but to allow the nature of the medium itself to be seen and understood in a startlingly vivid way. This arises out of the artist's understanding of the materials and his interaction with them. The mud drawings are worked by hand within the matrix of a circle or other universal form, or confined to the effect created by a splash thrown against or poured down a gallery wall. Long creates works that are not representational in a traditional sense, but are startlingly real in themselves. Their presence in the gallery is of a very different order to that of a work in acrylic paint, for example. The dusty matteness of the mud speaks directly of itself and of the landscape from which it is taken. The works have that clarity that comes of the natural material being taken out of its natural context and placed within the geometric order of the white gallery space. But this is no mere juxtaposition. The works transform the space, evoking a world quite separate from that of the gallery and its urban context. There is nothing placid or laid-back about them, however; these are strong and active works.

Working on a large scale

The power and presence of the water or mud works described on p.115 can be seen in "White Water Circle" of 1994 (below). This is a work on a massive scale and yet it has a lightness and an immediacy that allows it to float, buzzing with energy, in the space between gallery floor and ceiling. Its energy comes directly from the energy of its making, in which every rapid gesture of the artist's hand is visible throughout the work. Within the mud circle, the interwoven marks of the fingers create a dense and urgent latticework. The texture of the fingermarks gives an impression of depth from a distance, though from close-up their effect is to reinforce

the flatness of the wall. The arcs of splashed mud around the perimeter of the circle reflect the movement from bucket to wall in a symmetry around the circle and bring the eye into the central focus of the work.

As with all the mud pieces, the gallery floor is cleaned of all the mud and water that is deposited while the work is made. This is an essential component of the work. The presence of these works relies to some extent on the fact that while our general associations with mud might be earthbound, these works are lifted out of the horizontal plane—they are highly sophisticated and their immediacy is contained within the rectangle of the gallery space.

Richard Long making "River Avon Mud Arc" *(2000).* This photograph of the artist at work gives a real sense of the energy that goes into the making of the works and that is contained within them.

White Water Circle *(1994),* RICHARD LONG
The trajectories of the mud splashes around the edges of the circle directly reflect the movement of mud from container to wall and combine to give a sense of motion to the whole work.

Working on a small scale

In size, "Rock Drawing" is at the other end of the scale from "White Water Circle." It is an intimate work in which the artist has taken a pencil rubbing from a piece of slate. But, as with the larger wall work, this small drawing has a similar sense of contained energy. Here, the marks of the pencil show the vigorous and consistent arc of the shading. It is clear that this has been done with some commitment and it gives an underlying strength

to the work. The marks reveal a surface that has the look of a lava flow. As such it could represent something on a much larger scale. From this point of view, we are reminded of Leonardo's dictum that in the form of a small piece of rock we see the larger contours of the mountain itself.

Rock Drawing *(2002),* RICHARD LONG
This small drawing recording the surface of a piece of slate evokes a form of landscape on a far larger scale.

Technique Using materials related to the subject

Certain artists work on a smaller scale, on paper, incorporating natural materials found on site and related to what is being drawn. Among them is the English sculptor David Nash. His "Ash Dome" drawing is made with leaf mold taken from the site of the ash dome sculpture (see p.322). "Sheep Spaces" uses conventional drawing materials—graphite stick, gray pastel, and chalk —for the rocks, while the actual "sheep spaces," where

sheep rub themselves in the ground in the shelter of the rocks, are rubbed into the drawing with material from the ground itself. Grass has also been rubbed into the drawing. This goes brown very quickly on exposure to light and can be seen to have done so here. The action of the sheep in rubbing the ground—itself a primitive act of markmaking—is paralleled in the deep-brown smudges that form the main substance of the drawing.

Ash Dome David Nash
In this drawing of his sculpture (see p.322), David Nash has used leaf litter from the site to evoke associations with the materials of the sculpture itself.

Sheep Spaces *(1980)*, David Nash
The presence of the sheep is suggested by marks made by materials from the landscape where the sheep rub against the rocks and seek shelter.

Technique

Drawing in the landscape

In "Repens," artist Anya Gallaccio used lawn mowers to create a monumental drawing in grass on the lawns of Compton Verney House, Warwickshire, England. The imagery is taken from a 1670 design by Robert Adam for a ceiling motif in the Great Hall. The Robert Adam design was never implemented and, over 300 years later, it re-emerges in radically different, but no less appropriate, form in the grounds of the estate. The realization of the work involved a digital survey and the construction of aluminum templates to ensure the accuracy of the design. But the work itself has a reflective, settled feel, as if the passage of time and culture has imprinted itself on the landscape.

Repens, Compton Verney *(Aug/Sept. 2000)*, Anya Gallaccio, curated by Locus+
The grand scale of this contemporary work, combined with its elegance and clarity, gives it a relaxed quality and a fine sense of appropriateness in its historical setting.

PAINTING

ALL PAINTING SIMPLY REQUIRES a binding material of some kind to hold the pigment particles together and enable them to adhere to the canvas or panel. The binder might be gum arabic in watercolor, the yolk of an egg in tempera, a drying oil in oil painting, beeswax in encaustic, or an acrylic emulsion in acrylic painting. In each case, the ways of preparing and manipulating the paint are varied. In this section, we explore the materials and techniques associated with most traditional and contemporary painting media.

The Girl with the Red Hat (ca. 1665), JOHANNES VERMEER

This portrait in oil on panel combines boldness, in the soft fluent sweep of the red hat and the blue robe, with great intimacy in the painting of the face. The low-key background with its muted blues and warm browns gives a soft warmth to the painting. The light is centrally focused on the white scarf, which leads directly to the warm fleshtones of the girl's lower face with its parted and high-lit red lips. Much of the rest of her face is in the shadow cast by the red hat, yet her eyes focus directly on the observer.

Painting equipment

THERE ARE MANY TOOLS THAT CAN BE USED TO apply paint, including sponges, spatulas and scrapers, knives, rollers, airbrushes, and spray guns. But the most important tool is the paintbrush. If you want real control over your technique, you should use fine-quality brushes.

Brushes

Brushes for painting fall into two main categories: soft-hair brushes like the red sables, squirrel hair, ox-hair, or synthetic soft-hair types, and the harder bristle brushes that are made from hog hair or synthetic fibers, and that are stiff and resilient. In addition to these brushes, which apply the paint, there are others, such as blenders, which are used to manipulate it once it has been applied to the support.

How brushes were made in the past

Since primitive times, brushes have typically been made from animal bristle hairs bound to a stick, or soft hairs set in a quill. However, in ancient Egypt reed brushes were made by crushing one end of a reed, separating the individual fibers, and binding the reed tightly at the point of separation of the fibers. Other brushes were made by binding twigs of varying thickness.

Italian artist Cennino Cennini, writing in the 1400s, gives detailed instructions for making brushes. For soft-hair brushes, bunches of hairs were selected from cooked minever (rabbit) tails to fit various quills ranging from those of a vulture to those of a dove. The hairs were tied, inserted into the quill, and pulled through to the required length for the tip. A smooth, tapered chestnut or maple stick, about 9in (22.5cm) long, was inserted into the quill to form the handle.

Bristle brushes were made by tying a pound of white hog bristles to a stick, which was then used to whitewash walls until the bristles were supple. This was then untied and bound into smaller bundles of the required sizes. The tip of a stick was inserted into each bundle and the brush bound down half the length of the bristles. This method was practiced until the 1800s, when metal ferrules (the metal band that secures the join between hairs and handle) became widespread. The metal ferrule meant that the shape of the brush could itself be modified to form flat brushes.

Nowadays, brush manufacturers buy hair that has been bundled and dressed by specialist suppliers. In the case of sable hair, this involves cutting the hair in strips close to the skin, removing the tip and the base of the hair, and combing out the soft wool at the base, leaving only the strong guard-hairs. The hair is straightened by steaming under pressure, and dragged out according to the length required.

The manufacturing process The brushmaker places bundles of hair in a cylindrical container called a cannon. Blunt and short hairs are removed. The brushmaker lays a row of hair on the work surface and picks up just enough to fit snugly in the ferrule. The hair is placed in a smaller cannon and tapped down. Then it is gripped, removed, and twisted with the fingers. This twisting forms the shape of the round sable brush.

With long bristle and nylon brushes, the shape of the tip is formed by tapping the hair into a cannon with a shaped base. The hair is snugly fit into the ferrule without tying. Large sable brushes are tied off with cotton using a clove-hitch knot before being inserted into the ferrule and pulled through. The length of the hair out of the ferrule is checked for consistency. Filbert brushes (see p.120) are made like round brushes and the ferrule is flattened with pliers. Flat brushes are made on a flat-bottomed cannon and placed in a round ferrule, which is also flattened with pliers. Prepared ferrules are placed in trays with the hairs pointing down and the handles are glued into place.

Each ferrule is "knurled" on a machine whose three rotating wheels squeeze it, giving it a strong grip on the wooden handle. Any loose hairs are removed by scraping with a blunt pocketknife. The brush is dipped into a weak glue solution to hold its shape.

Egyptian scribes' reed brushes

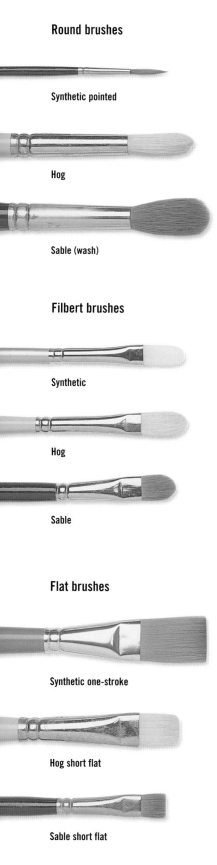

Round brushes

Synthetic pointed

Hog

Sable (wash)

Filbert brushes

Synthetic

Hog

Sable

Flat brushes

Synthetic one-stroke

Hog short flat

Sable short flat

Kinds of natural-hair brushes

The two main categories of brushes each have specific uses and can be employed in a number of ways.

Soft-hair brushes Their precise handling of thin washes of color means that these brushes are used almost exclusively in watercolor painting, but they can be used in the same way with acrylics and oil colors, especially for glazing, and for very precise painting. Other uses include hatching techniques in tempera and fresco, decorative work in ceramics, painting on glass, and areas calling for subtlety and control.

These brushes can hold a good deal of thin paint while retaining their shape. Aside from their use in creating large, spontaneous wash effects in watercolor, they are also used for precise work.

Bristle brushes Bristle brushes are rougher than soft-hair brushes; they have coarse hairs that hold plenty of thick paint and yet retain their shape. They are used extensively in oil painting and with acrylics and are particularly suited to rich, impacted brushwork and large-scale work. They are rarely used in watercolor except when dampened with water for scrubbing or washing off, or with color to give special textured effects.

Bristle brushes are useful for covering large areas with a uniform tone, for blending or graduating thick oil or acrylic color, and for frottage or stencilling effects.

Brush shapes

Within the two main kinds of brushes—soft-hair and bristle—there are two different shapes: round and flat. This characteristic is determined by the cross section of the ferrule. Within these main groups are subdivisions, identified by the length and shape of the hairs.

Round brushes Among the round brushes are the standard pointed rounds. The soft-hair versions taper to a fine point and come in a number of different hair lengths. The shortest are used for miniature painting. In the more standard lengths, the shorter-haired, pure sable brushes cost less than the longer ones. They hold less paint and have slightly less fluent points.

The longer-haired, pointed sables include writers and riggers, the latter being so named after their original use in painting the rigging on pictures of ships. They are used by signwriters, who also use striper brushes—round, long-haired brushes with a "chisel" end—for painting long lines of uniform thickness.

Other round soft-hair brushes include mops and wash brushes, which are usually made from squirrel or imitation squirrel hair and are used to lay large areas of wash or to soak up unwanted paint.

Round bristle brushes have smooth, curved ends. They are tough and hardwearing, with good paint-carrying capacity.

Filberts Between the flats and the rounds are the filbert brushes. Strictly speaking, these are in the flat category, since they have flat ferrules, but in fact they are made as round brushes that subsequently have the ferrules flattened. They have rounded points and combine some of the best features of round and flat brushes. The curved tip allows you to control the brush well when painting up to an irregular edge.

Flats All square-edged brushes set in flattened ferrules are known as "flats." Those with the shortest hair are called brights. Bristle brights were developed for *alla prima* oil painting and are used for applying short dabs of color.

Longer-haired flats made from soft hair are also known as one-stroke brushes. They carry enough color for the artist to make a single, clean-edged stroke across a support of medium dimensions. The thin edge can also be used to make sharp lines. The resilience of the hairs on

a long-haired bristle flat gives a longer, smoother stroke than the bright, but retains the characteristic "rectangular" shape.

The pointed flat is a soft-hair brush that tapers to a point when wet and forms a chisel edge when loaded with color. It is useful both for applying color and for softening edges.

Brush sizes

Within each type, brushes come in various sizes from 00 (the smallest) to around 16 (the largest). The width of the handle is directly proportional to the size, so that a No.6 brush has a thick handle and a No.00 a thin one. The characteristic handle shape, with the wood thickening just below the ferrule, is designed to keep the wet hairs of separate brushes from touching when you are holding and working with several at once.

Brush length has become largely standardized. Watercolor brushes are made 7–8in (17.5–20cm) long and those for oil, alkyd, and acrylic 12–14in (30–35cm) long. Brushes for watercolor are shorter, since the scale of watercolor painting is usually more intimate than that of oils or acrylics. But you must choose the length and size of handle that suits you. Artists often extend brushes by taping them to canes.

Synthetic brushes

Both soft- and stiff-hair types of synthetic brushes have been considerably improved over the last few years, and make a useful and economical alternative to natural hair brushes. However, when used for oil and acrylic painting, no amount of cleaning seems to prevent them from gradually stiffening and accumulating paint in the "heel" above the ferrule. This causes the hairs to splay out and the brush to lose its point. In my experience, they do not last nearly as long as the natural hair brushes. For laying watercolor washes, however, synthetic one-stroke brushes are very effective and seem to be a match for natural hair alternatives.

Technique Obtaining different brushstroke effects

The images below show a similar set of brushstrokes made on damp paper. They are made firstly as transparent washes using a soft-hair brush and secondly, in opaque color, using a stiff-hair brush.

Flat synthetic (soft-hair) brush

Stroke made with flat side of brush

Stroke made with thin edge of brush

Wavy stroke made with flat side of brush at an angle

Stroke made with semi-dry flat side of brush

Stroke made with flat side of brush on damp paper

Stroke made with thin edge of brush on damp paper

Flat hog brush

Stroke made with flat side of brush

Stroke made with thin edge of brush at an angle

Wavy stroke made with upright brush

Stroke made with semi-dry brush

Stroke made with flat side of brush on damp paper

Stroke made with thin edge of brush on damp paper

Mixed-hair brushes

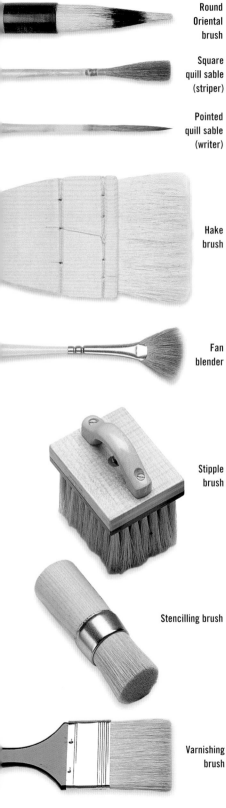

Round
Oriental
brush

Square
quill sable
(striper)

Pointed
quill sable
(writer)

Hake
brush

Fan
blender

Stipple
brush

Stencilling brush

Varnishing
brush

Special-purpose brushes

Aside from the most common brushes, there are various others that perform auxiliary functions.

Oriental brushes Aside from the hake brush—a flat brush used for applying washes or dusting of charcoal—most Oriental brushes are round. They are constructed around a central core of hairs (deer, goat, rabbit, or wolf), to which more are added to establish the shape and size. Even in the largest sizes, most have a fine point.

Quill sables Soft-hair brushes made in the old way, by tying hairs and inserting them into quills, come in a range of sizes relating to the size of the bird from which the quill is taken. Generally available, in ascending order of size, are: Lark, Crow, Small Duck, Duck, Large Duck, Swan, Small Goose, Goose, and Large Goose. Quill brushes are round, long-haired sables with points (writers) or square ends (stripers).

Blender brushes Fan blenders or dusters are flat, fan-shaped brushes, designed to modify paint already on the canvas. They are used dry to soften edges of applied color, to eliminate brushstrokes for a smoothly modelled appearance (on a portrait, for instance), or to blend adjacent tones. Other specialized uses include adding highlights to hair.

Stipple brushes These are made for decorators but are useful for artists. They come in a wide range of shapes from the "shaving brush" type to rectangular brushes used for stippling thick-textured paint.

Stencilling brushes Thick, stubby, round brushes with very stiff hairs and flat ends, used to apply paint through holes cut in a stencil.

Varnishing brushes Flat, wide, long-haired bristle brushes for applying varnish to oil paintings in long strokes.

Technique

Cleaning brushes

With quick-drying media like acrylic, wipe and wash brushes after each manipulation. With a slow-drying medium, clean them after each session. Never use hot water—it may expand the ferrule, causing hairs to fall out, and it can harden acrylic paint on the brush. Use water as a solvent for watercolor and acrylics, paint thinner for oils. Have two jars of solvent. Wipe dirty brushes, then rinse in one jar. Before using a new color, rinse them in the other.

1 Wipe the brush, rinse it in solvent, then rinse repeatedly in clean solvent. Hold the brush under a cold running tap.

2 Rub the brush gently over a block of household soap, then work up a lather in the palm of the hand (it will soon show the color of the last pigment).

3 Rewash the brush in cold water and repeat the soaping until no trace of pigment appears in the lather. Rinse in cold water. Shake off the water, reshape with the fingers, and place in a jar, hairs uppermost.

Other means of manipulating paint

Aside from the huge range of brushes available for painting, there are many alternative methods of applying paint. It can be sponged on, scraped on, rollered on, and stencilled on. It can be applied with painting knives or sprayed using a fine airbrush or a heavy-duty spray gun.

Sponges and pads

Natural sponges come in different sizes and are useful in watercolor work for dampening paper, applying washes, removing color, or for textural effects. In addition, they can be used on a large scale with acrylics.

Synthetic painting pads were developed as an alternative to decorating brushes. The smaller sizes offer some interesting technical effects for artists, including their ability to sustain a band of color of uniform consistency and width over a longer span than a traditional one-stroke brush.

Spatulas and scrapers

The flexible metal spatulas used for mixing colors are not usually used as painting tools, but plastic spatulas or scrapers like the ones used to apply proprietary home decorating fillers are used by artists in various ways. They can be used to apply priming or paint, covering large, flat areas and avoiding brushmarks, or to create textured effects using several colors at once. Small pieces of thin, flexible plastic (such as old credit cards) can be used, or the plastic-edged scrapers used to remove frost from car windows.

A window cleaner's squeegee with its rubber or plastic strip can also create effects that could not be made with traditional painting implements. Scrapers with modelled edges for texture paint effects may also be used.

Paint rollers

There are many types of paint rollers, from pure lambswool to the rubber or plastic types with molded textures that provide specialist finishes for texture paints. Various kinds can be used by artists for applying grounds, particularly when a smooth finish is not required. They are more suitable for work on rigid supports than on canvas, unless the canvas is first stretched against a flat wall or board and subsequently restretched on a stretcher when the painting is finished.

With thin, wet paint, a roller can quickly produce an overall texture effect similar to that created with a sponge. With thick paint, a roller creates a characteristic texture that can be used in a variety of ways for expressive purposes.

When using a roller to cover a very large area rapidly, it is a good idea to attach it to a broom handle. The long handle gives you far greater leverage than the standard length and makes it much easier to distribute the paint evenly over a large surface.

Alternative painting implements

1 Synthetic painting pad
2 Natural sponges
3 Window cleaner's squeegee
4 Car windshield scraper
5 Credit card
6 Plastic decorating spatula
7 Comb-edge decorating scrapers
8 Lambswool paint roller
9 Texture paint roller

Painting knives

Diamond-shape painting knife

Small diamond-shape painting knife

Trowel-shape painting knife

Pear-shape painting knife

Paddle-shape painting knife

Palette knives

Straight palette knife

Cranked-shank palette knife

Airbrushing equipment

Painting knives

Unlike palette knives, these are used for applying paint to canvas. Each has a long, thin, curved steel shank, with a blade at the end. The cranked shaft keeps the blade lower than the wooden handle so that your hand is kept away from the surface of the painting while working. The blades are flexible and springy and come in a wide variety of shapes, lengths, and overall sizes. Common shapes are "diamond," "pear," and "trowel" and a number of effects can be achieved with them.

Palette knives

These are straight- or cranked-blade, flexible steel tools used to move and mix paint on the palette and to scrape it off at the end of the painting session. They are also used to mix ingredients for painting media on a grinding slab before mullering (grinding) and for scraping paint off the edges of the muller (grinder).

Airbrushes and spray guns

These instruments use compressed air to atomize paint and apply it to the support in a fine spray. An airbrush is a miniature, penlike, spray gun that enables you to control the work over a very small area. With a standard spray gun, you can apply uniform or graded tones over large canvases. There are a number of different systems, including the pressure-feed and airless ones. However, the gravity-feed guns (paint container mounted above the gun to allow gravity to feed the nozzle) or the suction-feed

system (paint container below the gun so paint is supplied by a syphoning method) are the systems usually employed by painters with a comparatively small amount of paint to deliver, and who use paints of low viscosity.

The paint should be mixed to a creamy consistency, free of any lumps that could clog the airbrush or gun. It is a good idea to pour it through a nylon mesh or sieve before use. With oil paint and acrylics, it is very important to clean the instrument directly after use. The standard cleaning method is to spray solvent through the system, usually by covering the nozzle of the airbrush or spray gun tightly with a rag and operating it. Accumulated paint deposits from the nozzle bubble back into the reservoir. Repeat until the solvent sprays clear.

It is extremely important to wear an appropriate respirator when spraying paints; atomized droplets of paint and solvent can hang in the air for some time after spraying. (See p.370 for information on working safely.)

Air supply for airbrushes and spray guns An air compressor is usually used to power spray guns and airbrushes—although for airbrushes it is possible (but expensive) to use proprietary cans of compressed air. A good compressor supplies air at constant and adjustable pressure for both airbrushes and spray guns. An air tank helps the compressor to maintain a constant pressure and an even spray.

Gravity-feed airbrush

Gravity-feed spray gun

Respirator

Painting accessories

The well-equipped studio, including choice of easel, is fully explained on pp.362–63. In addition to the features and equipment described there, a number of other items are invaluable to the artist. These include palettes, palette knives and dippers, cloths, and tissues.

Palettes

Hand-held palettes have been used since the 1400s. Originally, they were somewhat small, square or paddle-shaped objects with a handle—at times with a thumbhole set into them. By the 1800s, large, oval- or kidney-shaped palettes with a thumb-hole near the center were fashionable. These were soaked in linseed oil and allowed to dry hard before use, to prevent oil from the paint from being absorbed into the wood and making the paint too lean. Today, palettes are sealed with polyurethane varnishes or cellulose lacquer.

When large wooden palettes were popular, people often painted on a red-brown ground. A mahogany palette showed how the colors would look against this. In the same way, there is a strong argument in favor of using a white palette if you are painting on a white ground. These are made of melamine-faced laminates or other plastic, ceramic, or enameled materials. Nonabsorbent, disposable paper palettes are sold in tear-off pads.

Palettes and dippers
1 White plastic palette
2 Wooden palette
3 Tear-off paper palettes
4 Double dipper
5 Single dipper with lid
6 Tinting saucer
7 Cabinet saucers
8 Divided slant tile

Alternative mixing equipment

Some artists mix their colors on a glass slab laid over white paper, resting on a small table beside the painting. Plates and saucers are useful and old cups, jars, and cans may be used for mixing. They can be covered with plastic wrap between sessions to stop paint drying.

White porcelain slant-and-well tiles and cabinet saucers are excellent for mixing watercolor and acrylic washes. They are heavy, so not liable to spill, and easy to clean. Although expensive, they last indefinitely. Plastic mixing trays are suitable for watercolor, poster, and powder paint.

Dippers

These small containers clip onto the palette and are generally used in pairs —one for solvent or diluent, the other for drying oil or painting medium. Dippers are usually made of tin plate, nickel-plated brass, or plastic, and are open, wide, and shallow. This makes them easy to clean, but the solvent can evaporate quickly, so other versions are available with narrower tops and screw-on lids.

Cloths and tissues

Absorbent tissues or clean cotton rags are an essential part of painting equipment. Wiping paint off brushes before cleaning them in solvent is very important. Cloths are useful for wiping paint off the canvas or making textured effects. Tissues soak up excess watercolor and may also be crumpled for "sponging out" (see p.146).

Working with the mahlstick

This light bamboo or aluminum stick about 4ft (1.25m) long has a ball-shaped end, covered with soft leather. If you are right-handed, hold the stick with your left hand, with he ball end touching the canvas or easel so that your right hand can rest on it while painting. This helps you to work with a steady hand in a particular area.

Mahlstick

Watercolor

VARIOUS KINDS OF WATER-SOLUBLE BINDING material, added to ground pigments to act as vehicles in painting systems, have been used by painters for centuries. But the specific painting medium that is now known as watercolor can be said to have developed and flowered in the English School of the latter half of the 1700s and first half of the 1800s. During this relatively short period, a number of outstanding painters took up the watercolor medium. It had, until then, been largely topographical in approach and was used for the careful filling in with thin color washes of subjects that had previously been painstakingly drawn out in complete detail in pen and ink or pencil. These painters now turned watercolor into art, establishing a new tradition of painting that demonstrated the power and the subtlety of the medium and gave it a most striking immediacy. They each made significant contributions to the development of watercolor painting.

The early watercolor painters

As early as the late 1400s, Albrecht Dürer (1471–1528) was making landscape paintings in water-soluble paints on paper. Among the pioneers of the 1700s were Paul Sandby (1731–1809), who incorporated both transparent and opaque techniques, and J.R. Cozens (1752–97), who used mainly transparent techniques to make paintings with great scale, depth, and atmosphere. In his short life, Thomas Girtin (1775–1802) demonstrated his control of the medium and produced works ranging from sensitive, loosely worked landscape studies to paintings of great precision and detail that still retain a freshness of appearance. J.M.W. Turner (1775–1851) was the first to recognize what Girtin might have gone on to achieve if he had lived. As it was, it fell to Turner to push the possibilities of the medium still further with experimental work with washes, wiping out, scratching out, and the incorporation of body color. John Constable (1776–1837) produced watercolor studies directly

Lake in the Woods *(1495–97)*
ALBRECHT DÜRER
The brooding atmosphere of this famous early watercolor landscape gives it a particularly contemporary feel, with the trees on the left appearing to be blasted by war. The scene is deserted, as if not one human being is alive.

In the Canton of Unterwalden (1790)
JOHN ROBERT COZENS
This work is painted with a great deal of subtlety, particularly in the use of color. Although seemingly a monochromatic painting, it is clear that the grays have been delicately modulated with crimsons and green/blues, giving the work an altogether richer atmosphere. It is also a magnificent example of the artist's ability to give a monumental sense of scale to a relatively small-sized painting. The tiny chalets at the foot of the mountain give a real sense of its massive presence.

from nature that retain the immediacy and spontaneity of the direct response, while John Sell Cotman (1782–1842), one of the greatest artists of the period, demonstrated a control of the medium and a sense of design and order in his carefully constructed works that was unique to his time. David Cox (1783–1859) produced—particularly in his later works—paintings that are almost expressionist in the nervous, turbulent atmosphere they evoke.

The techniques of watercolor

The traditional "transparent" technique of watercolor painting involves the overlaying of thin, transparent color washes that rely on the white of the paper for their effect. This underlying white provides the highlights in the painting, and as more washes or glazes are overlaid, the tone and color deepen as more light is absorbed and less is reflected from the support.

Being water-soluble and, to a greater or lesser degree, resoluble when dry, the color can be modified in different ways by the addition or removal of water and by the use of brushes, sponges, cloths, and tissues.

Watercolor is extremely versatile, and produces results as permanent as those of any other painting medium, provided that permanent pigments and high-quality, acid-free papers are used. Opaque watercolor methods, in which gouache or body color is employed and that rely on white pigment to provide the highlights and pale tones, are discussed in the *Gouache* section of this chapter (see pp.156–59). Mixed methods, in which both transparent and opaque techniques are incorporated in the same work, have been widely used. They usually work best when they are dealt with in a balanced way.

Watercolor paints

Paints for watercolor are made by grinding powdered pigments into a water-soluble binding medium. This medium consists mainly of gum arabic but includes glycerine as a plasticizer, a wetting agent such as ox gall, and, where necessary, a thickener such as tragacanth. Other thickeners include starch, dextrin, or a swelling clay such as Bentone. A preservative that acts as a fungicide and bactericide is usually also added; also, if absolutely necessary for controlling the property of a particular color, extenders (that may produce a white coloration) are sometimes added to the other ingredients.

Each pigment has slightly different requirements if it is to function consistently as a watercolor paint, so greater or lesser proportions of one or more of the ingredients need to be used. Making watercolors is therefore a skilled craft, based on trial and error and years of experience; the home manufacture of watercolors is not recommended. For information on watercolor brushes, see p.131.

Materials Pan and tube colors

Manufactured watercolors come in pan or tube form, each with their specific uses.

Pan colors

These are useful for small-scale work or for outdoor sketching. However, producing mixes can dirty the colors in the box—yellows, especially, may be sullied by touches of other colors and may need to be constantly wiped clean with a sponge.

Tube colors

Containing additional glycerine, these colors are in theory more soluble, although in practice it is not very noticeable. They are suitable for large-scale work because it is easier to mix up larger amounts—of a wash, for instance. The colors are less likely to get soiled, since the required amount of paint can be squeezed from the tube as it is needed. If tube colors are left for a period of time, some separation of pigment and binder may occur.

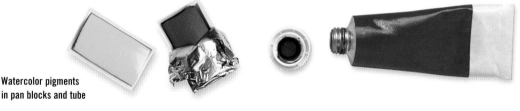

**Watercolor pigments
in pan blocks and tube**

Materials Choosing pigments for watercolors

Most of the permanent pigments approved for oil painters can be used for watercolor. In particular, it is worth noting the synthetic organic pigments, whose brilliance and intensity lend them to the watercolor medium. The very wide range of modern synthetic pigments can make it difficult to recommend a color with a particular name. So, for example, in its original form, "Alizarin Crimson," extracted from the madder plant and popular with artists for its dusky coolness, is not now considered as lightfast as its synthetic counterparts. A Permanent Alizarin Crimson might be made by one manufacturer with an Anthraquinonoid pigment such as PR177, but by another with a mixture of Quinacridone and Pyrrolidone pigments. The sensible thing is to use watercolor paints by reputable manufacturers and look for a high permanence rating on the tube or pan. Paintings in which the Cadmium colors have been used should not be allowed to get damp.

Reds For a limited palette, Cadmium Red (replacing Vermilion) and Quinacridone (Rose) can be used, the first a rich, semi-opaque red on the yellow side, and the second a clean, transparent red on the blue side and useful for color mixing. The synthetic Permanent Alizarin Crimsons have a high lightfastness rating.

Yellows Cadmium Yellow in its various manifestations from Cadmium Lemon to Cadmium

Orange is a strong pigment. For a transparent yellow, many of the modern synthetic versions of the old Indian Yellow are now permanent, and pigments such as Nickel Dioxine PY153 are used in place of the fugitive Tartrazine.

But there are very many clean, permanent, and safe synthetic organic yellows among the Arylamides, the Diarylides, and the Azo Condensation pigments. They vary in permanence according to the particular pigment, so check on the tube or pan for the permanence rating.

Nickel Titanate Yellow is a permanent opaque yellow with a weak tinting strength, sometimes used as a replacement for the toxic barium chromate (Lemon Yellow). It has an attractive, muted tone when used in washes.

Blues Four blues can be recommended unreservedly: Cerulean Blue, Cobalt Blue (excellent in washes), Phthalocyanine Blue (a pure, transparent "primary" color, useful for mixing), and French Ultramarine (a unique bright blue with high tinting strength and a tendency to granulate).

Violets These can readily be mixed from the "red" blues and the "blue" reds. But there are good, clean

Quinacridone Violets and also Dioxazine Violet, which is a transparent violet with a very high tinting strength. Ultramarine Violet is not quite as bright, but is good to use in washes and it also has a high permanence rating.

Greens There is a good range of permanent greens. These include Phthalocyanine Green (a clean, transparent green that can be mixed with earth colors like Raw and Burnt Sienna, or it can be overlaid in washes to produce a wide range of "foliage" greens), Viridian (a similar color, but not quite so intense), and Oxide of Chromium (a rich, opaque, dull green).

Earth pigments All the earth pigments, including the Mars colors, are permanent. Terre Verte is a useful gray/green in thin washes. Raw Sienna and Yellow Ocher belong to the yellows, the former being slightly more transparent and less granular than the latter. Raw Umber is a transparent brown with a yellowish cast. Burnt Umber is considerably darker. Burnt Sienna

is a useful transparent orange/red brown of particular beauty. The iron oxide colors—Indian Red, Light Red, and Venetian Red—are thicker, more opaque colors. Light Red is the most orange, Venetian Red browner, Indian Red more crimson.

The synthetic Mars colors are all suitable pigments, although not extensively used by the manufacturers due to their opacity compared with natural earths.

Blacks and grays Ivory Black is a useful transparent color with a sooty appearance. Charcoal Gray is suitable when a uniform mid-tone is required and gives a quite different look in the same tone to that of Ivory Black. Another permanent gray is Davy's Gray—a pale color, with a greenish cast, made from a particular kind of slate. Paynes Gray, a popular color, is a combination of pigments.

White Chinese White (Zinc White) is the most commonly used white for watercolor, although Titanium White may be used.

Recommended watercolor palette
A personal choice of 24 good, permanent pigments.

Burnt Umber	Raw Umber	Burnt Sienna	Raw Sienna	Indian Red	Light Red
Permanent Alizarin Crimson	Quinacridone (Rose)	Cadmium Red	Yellow Ocher	Nickel Titanate Yellow	Azo (Arylamide) Yellow
Cadmium Yellow	French Ultramarine	Cobalt Blue	Cerulean Blue	Phthalocyanine Blue	Phthalocyanine Green
Viridian	Terre Verte	Oxide of Chromium	Davy's Gray	Charcoal Gray	Ivory Black

Materials Watercolor pigment characteristics

Aside from the obvious differences in color, watercolor pigments work in individual ways, with each one demonstrating its own characteristics. In oil painting, these differences are to some extent evened out by the drying oils, extenders, and stabilizers contained in the paint. But in watercolor painting, the particle characteristics of each of the pigments can be seen much more clearly.

Granulation
Some pigments show a characteristic called granulation, where the way in which the pigment particles settle on the paper creates a mottled effect. Two colors can act very differently when brushed out onto paper, and so can be used for different effects.

Manganese Blue shows the best example of granulation, but sadly, the pigment is becoming unavailable. Cerulean Blue and Cobalt Green show a tendency to settle out into the hollows of the paper. French Ultramarine is another blue pigment that exhibits granulation effects, its uniform, small, round grains producing a more finely divided pigment.

Flocculation
Sometimes, separate pigment particles are drawn together instead of dispersing evenly, giving the same mottled effect of grouping in the hollows of the support as granulation. The cause of flocculation is usually a series of reactions in the electrical charges in the pigment particles themselves, instead of simply the tendency of coarser pigments to settle faster.

It should be pointed out that the grainy effects obtained when using watercolor can have as much to do with the amount of water that is being used for a particular effect as they do with the inherent pigment characteristics of that color.

Particular pigment characteristics
Among the natural earth colors, Raw Sienna and Yellow Ocher appear very similar in hue, but they are very different in feel and use. Yellow Ocher is opaque, has a rich, creamy feel, and a high tinting strength, while Raw Sienna has a much thinner feel and is a particularly useful permanent, transparent yellow. Terre Verte is a natural earth with a very unique color and texture. It is very weak and can have an almost oily feel out of the tube. The two synthetic iron oxides shown here, Light Red and Indian Red, are very different. They are bold matte colors with good tinting strengths. A little of them goes a long way. They can be quite opaque in full strength, but are also very useful diluted in washes. Indian Red, in particular, which is a bluish red, is a unique and delicate color. Another synthetic inorganic pigment is Cerulean Blue, which is a useful blue on the green side. Like Terre Verte, it is a relatively weak color, but one that watercolor painters have in their palette because it is a good "yellow" blue for skies.

The characteristic coarseness of the earth pigments can be seen very clearly in the examples below when compared to the modern, synthetic organic examples such as Permanent Rose and Phthalocyanine Green. With these two, there is no settling out of the pigments into the characteristic grainy look of the earth colors, but a somewhat smooth, almost velvety look—a quality related to the fineness of the pigment particles. They are nonetheless very useful additions to the watercolorist's palette, for their cleanness, their permanence, and their ability to mix physically and optically with other colors. However, some skill is required to produce an even tone in washes because it can be obvious where the brush has been freshly loaded with paint to continue a wash.

Some Phthalocyanine pigments may show "flotation" effects where darker or lighter colors rise to the surface of the wash, resulting in streaks. Manufacturers usually avoid the particular pigments that produce this effect, or are able to counteract it in the preparation of the color.

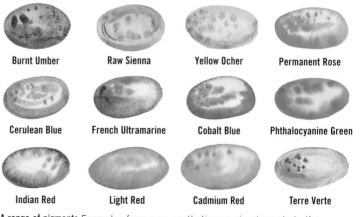

Burnt Umber	Raw Sienna	Yellow Ocher	Permanent Rose
Cerulean Blue	French Ultramarine	Cobalt Blue	Phthalocyanine Green
Indian Red	Light Red	Cadmium Red	Terre Verte

A range of pigments Examples from new, synthetic organic pigments to the natural earths that have been used for hundreds of centuries show the range of pigment characteristics.

Brushes for watercolor

Since watercolor paints are generally used in thin washes, the soft, natural hair brushes including red sable, ox hair, and squirrel have traditionally been the most popular for watercolor techniques. Nowadays, synthetic soft-hair brushes are almost equally popular, being less expensive and with similar characteristics. They are generally made from polyester monofilaments, which unlike the sable hairs do not have the scale structure that gives the sables their paint-holding capacity. They tend to suck up the paint and release it more quickly than the sables.

The harder bristle brushes are not generally used so much in watercolor painting except for special manipulations or effects. They are, however, extremely useful for mixing larger amounts of color for a wash, for example.

Materials The basic brushes

No.3 & No.6 round sable The round Kolinsky sables are essential watercolor brushes. The soft but springy hairs have a scalelike structure that gives them a natural paint-carrying capacity. Well-made, round sables come to a fine point and they can be used for detailed as well as for larger-scale manipulations.

No.12 round sable/synthetic blend The very large pure sables (up to size 14) are excellent brushes, but they are extremely expensive, and so artists often use the cheaper sable/synthetic blends, which give good results for washes and larger-scale work.

No.6 pure squirrel mop The squirrel hair mop is used predominantly as a wash brush. It has a great capacity for laying down areas of uniform tone, since its soft hairs glide easily over the surface of the paper.

No.14b imitation squirrel This soft hair, moplike wash brush is useful for laying down broad strokes of color over large areas.

1in (25mm) flat "one-stroke" wash brush sable/synthetic These are used predominantly for laying uniform bands of color across the paper in order to make a uniformly toned overall wash. It is possible (as shown here) to introduce different colors into the brush before applying it to the paper. This technique can be seen on p.140.

2in (50mm) wash brush synthetic Useful for laying down very broad strokes of color and covering large expanses of paper, this extra-wide wash brush has synthetic fibers with good paint-holding qualities that are excellent for laying washes and controlling the flow of paint.

Japanese brush This is a versatile brush that can be used delicately with the point or in broad, horizontal strokes using the whole side of the brush.

Short bristle filbert This hog brush is useful for mixing larger quantities of watercolor—for a wash, for instance—and for scrubbing-out techniques when you work into a dried area with a damp brush to lighten the tone.

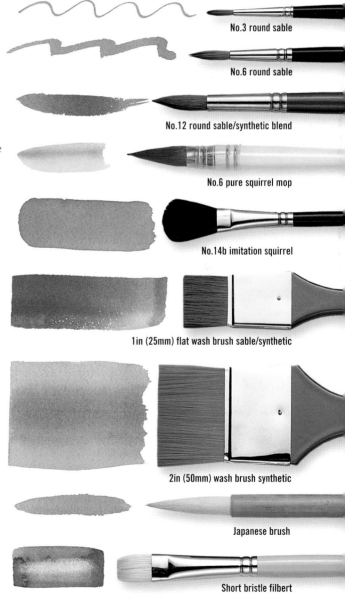

No.3 round sable

No.6 round sable

No.12 round sable/synthetic blend

No.6 pure squirrel mop

No.14b imitation squirrel

1in (25mm) flat wash brush sable/synthetic

2in (50mm) wash brush synthetic

Japanese brush

Short bristle filbert

Mixing colors

One of the chief aspects of watercolor paints that sets them apart from all the other painting media is their ability to reflect the individual particle characteristics of the separate pigments. This has been discussed on p.130 and it is one of the positive aspects of the medium that many watercolorists like to exploit.

Modern synthetic pigments are finely ground and generally produce smooth, similar-looking washes.

In this sense, they may be said to have less character than older, more traditional pigments. On the other hand, they are particularly pure pigments and it is possible, using only a limited selection of colors, to mix an altogether wider range of colors. In fact, using just three modern, synthetic organic pigment primaries—a red, a yellow, and a blue—it is possible to mix as wide a range of colors as you may ever need.

Technique Physically mixing a color range from three primaries

The colors in this range of 48 distinct hues, painted in a mid-tone, are all derived from combinations of Quinacridone (Rose), Arylamide Yellow, and Pythalocyanine Blue. All the colors are obtained by mixing the paint in a saucer before applying it to the paper. In principle, it should also be possible to achieve them optically by superimposing pure yellow, red, and blue transparent washes of the right tone.

The color wheel When the three primaries are painted onto a damp circle, the secondary colors can be seen to form where the colors touch and blend.

Secondary colors The two-color combinations of blue/greens to yellow/greens, of reds through yellow/orange, and of blue/violet through mauve to pink, give a wide range of secondary colors.

Tertiary colors Adding the third primary in each case gives a range of earth colors—gray/greens and blue/red grays that very closely match the color of many of the traditional pigments.

Technique Physically mixing a color range from high- or low-key primaries

Both of these fruit still lifes are painted by mixing three primary colors in a mixing tray before they are applied to the paper. The difference between the two versions is that the top one is painted with strong, "saturated" colors —known as high-key colors—while the bottom one is painted with muted, or low-key colors.

Range of colors produced from high-key primaries

All the colors in this still life are created by mixing just three high-key primaries: Permanent Rose, Winsor Blue, and Cadmium Lemon. These colors produce a large range of lovely hues; the swatches here are just a selection.

Range of colors produced from low-key primaries

This low-key study relies for its effects on mixing Indian Red, Cobalt Blue, and Lemon Yellow Hue. These more muted versions of the three primaries work well in combination, producing subtle ranges of reds, oranges, greens, and grays. The white highlights are created by the actual paper surface, instead of an application of color.

Technique

Color mixing by overlaying washes

In watercolor, colors can be mixed optically by being overlaid in thin, transparent washes. To exploit this fact properly, artists should be aware of the degree of transparency of different pigments and of their resolubility.

Both transparent and opaque pigments are equally transparent in very pale washes, but the difference between them becomes marked in stronger mixes. Similarly, resolubility can be a problem when overlaying colors, and this is generally related to the paint thickness.

Overlaying washes The vertical stripes create secondary colors when overlaid onto the dried, horizontal ones.

Technique Overlaying washes

In this painting of an iris, the violet color of the petals is painted in two stages. The petals are painted first in a cool pink, transparent wash. Once this has dried, they are then overpainted using a thin, transparent, blue wash. The optical effect of these overlaid washes is a violet color that is much more attractive than it would have been if a single violet color had been used.

Two-stage painting The petals are painted first using Permanent Rose (Quinacridone).

Second stage The violet color is obtained by overpainting the pink with transparent Phthalocyanine Blue.

Technique

Solubility and overlaid washes

The problems of resolubility in thickly pigmented washes are discussed on p.133. Although it is rare for watercolor to be used very thickly (except in gouache painting), resolubility can be a problem, even in thin washes. The proportions of ingredients used by manufacturers vary slightly. Some brands are so resoluble they are almost impossible to paint over. Most reputable artist's colormen produce colors that are consistent in this respect and, provided that the artist does not "scrub" while laying on a wash, problems are rare.

For the whole range of watercolor effects to be exploited, the color must be able to be scrubbed, washed, and sponged, but it must also be firm enough to accept overlaid color without dissolving. The correct balance is achieved through experience—another good reason why homemade watercolors are not recommended.

Although tube colors contain more glycerine and so might be expected to dissolve more easily than pan colors, there is in fact very little difference between them in this respect.

Technique

Two- and three-color superimpositions

The circles below show the effects of two- and three-color superimpositions using permanent watercolor pigments. The same set of three colors is painted in a mid-to-light tone and a mid-to-dark tone. Notice how clear and "legible" the color juxtapositions remain in the former; those in the darker-toned version are murkier.

Superimposed color samples Both sets of circles were painted using Venetian Red, Terre Verte, and Cerulean Blue. They show each color singly, and with one, then two colors superimposed.

Technique

The value of overlaying washes

A comparison between two deep tones of Cobalt Blue, the first (left) obtained with one wash of thickly mixed color, the second (center) built up from eight superimposed layers of a pale Cobalt Blue wash (right). The superimposed wash tone has a more pleasing texture and color.

Thickly mixed wash **Superimposed layers wash** **Single pale wash**

Technique Creating subtle colors from optical mixes

The subtle delicacy of colors mixed by the transparent method is one of the most positive and individual characteristics of the watercolor medium. The combination of pale, matte colors with the paper texture establishes an immediate and unique contact between pigment and ground. None of these colors, if mixed in a saucer and applied in one coat, would have the lively delicacy that they show in this form.

The color samples below show sets of subtle reds, browns, blues, greens, and yellows, all mixed using the transparent overpainting method on rough Khadi paper. With one exception, where three colors were used, all the colors are formed from combinations of two other colors. In each case, the first color was allowed to dry thoroughly before the second color was superimposed.

The complementary or near-complementary superimpositions, such as those in which Light Red and Oxide of Chromium and Venetian Red and Terre Verte have been used, are especially interesting. Although the overall appearance is of a warm or cool pale brown, a closer look at the examples reveals both red and green pigment particles creating a lively, vibrant surface. A similar effect occurs with the Viridian/Burnt Sienna and Raw Umber/Phthalocyanine Green combinations. The Cerulean Blue/Venetian Red combination produces a warm, overall pink/gray, although the separating out of the blue means that it retains its characteristic color.

Optical mixes Here, the colors are painted onto off-white, cotton rag, handmade Khadi paper from South India.

1 Cadmium Red/Alizarin Crimson
2 Raw Sienna/Rose Madder
3 Raw Umber/Phthalocyanine Green

4 Phthalocyanine Blue/Ivory Black
5 Raw Sienna/Cobalt Blue
6 Cobalt Blue/Rose Madder

7 Burnt Umber/Quinacridone (Rose)
8 Light Red/Oxide of Chromium
9 Terre Verte/Cadmium Yellow

10 Viridian/French Ultramarine
11 Phthalocyanine Blue/Arylamide
 Yellow/Ivory Black
12 Cerulean Blue/Venetian Red

13 Burnt Umber/Cadmium Red
14 Terre Verte/Venetian Red
15 Raw Umber/Aureolin
 (Cobalt Yellow)

16 Raw Sienna/Indian Red
17 Viridian/Burnt Sienna
18 Raw Sienna/Cobalt Blue

The effects of watercolor papers

It is important to be aware of the enormous range of different papers that is available for watercolor painting and how they affect painting technique. There are three main elements to be considered—weight, absorbency, and surface texture. The weight of a paper ranges from the thinnest of oriental papers to cotton rag papers that are available in boardlike thickness. Clearly, the latter are more durable for painting techniques that involve extensive reworking or special texture effects. The absorbency of the surface varies hugely from one make to another in relation to the kinds of internal or surface sizing used in the manufacturing process.

A waterleaf paper with no sizing will immediately absorb a brushstroke, whereas a paper with strong surface sizing almost repels it. The surface texture will also have a considerable effect on how watercolor behaves. It is more difficult, for example, to obtain a completely uniform wash on a hot-pressed (HP) surface than it is on a surface with some texture.

Technique The impact of watercolor papers on paint techniques

Watercolor papers (see p.49) reveal different characteristics when paint is applied to them. Below are examples of what happens when the three basic paint techniques—wet-into-wet (see p.142), brushstroke on dry paper (see p.148), and masking fluid (see p.151)—are applied to the different kinds of papers.

Wet-into-wet
The damp surface made the wet-into-wet brushstrokes spread. This was not so effective on the HP papers (both machine and handmade) as on the CP and rough surfaces, where the flow of paint was more even and consistent. The tendency of Ultramarine to granulate can be seen where the paper was particularly wet.

HP papers (machine- and handmade)

CP and rough paper

Dry-brush work
The handmade rough paper, with its almost "pneumatic" quality, showed a marked difference—the paint picking up only on the raised areas of the paper's tooth. On the machinemade rough paper, the stroke showed more consistency of tone than on either of the HP surfaces. In general, CP and rough surfaces have the effect of distributing the pigment more evenly.

Handmade rough paper

Machinemade rough paper

Masking fluid
Masking fluid showed up the contrast between the internally sized, handmade paper and the surface sized, moldmade paper. It picked off the surface of both the handmade papers, making further overpainting difficult. If using a lot of masking fluid, choose a surface sized paper or give handmade (internally sized) paper a further protective coat of size before use.

Internally sized handmade paper

Surface sized moldmade paper

Wash techniques

The art of watercolor painting lies to a great extent in the artist's ability to control the application of washes. A wash is a thin film of paint, well diluted with water, which can be applied to the paper in a number of ways. Washes can also be laid one over the other to create a range of different effects.

A wash can provide a continuous, pale tone over the whole area of the paper, acting as a unifying background color for other superimposed washes. Alternatively, it can be graded tonally from light to dark or from dark to light, to indicate, for instance, the lightening tone of the sky toward the horizon. Washes can be modified with the addition of clear water, by sponging and soaking up in various ways, or by being applied over masked-out areas. The appearance of a wash depends on several factors such as the kind of pigment used, the amount of water added to the paint, the method of application, the nature of the paper surface, and whether the surface is wet or dry before the wash is applied.

Technique

Applying uniform tone washes

Washes of an overall uniform tone are generally applied using a series of strokes from either a large, round wash brush such as a No.16 squirrel, a flat, one-stroke brush such as a 1in (25mm) nylon, or a piece of natural sponge. The most important factors in the successful application of an even-toned wash are: speed, control, amount of paint in the brush or sponge, and correct angle to the horizontal of the support. This last factor is managed by sloping the support so that paint can gather along the base of each brushstroke and be picked up by the subsequent stroke, but not at such an angle that it runs all the way down the paper.

Tips for applying washes successfully

- Mix enough paint. Very little can be done if the paint runs out before the area is covered.
- Keep control of the brush. Although speed is a prime factor in laying a wash, control is just as important. The movement should be quick, but not so quick that tiny air pockets form, leaving pinpricks in the finished work.
- Consider the paper surface. The harder the coat of size, the greater the pinprick problem is likely to be. To overcome it, add a drop of wetting agent such as ox gall to the paint, and allow the paint time to cover the surface as the stroke is made.
- Don't push the brush down too hard. If the heel of the brush touches the paper, this causes inconsistencies of tone. The touch of brush on paper must be deft and light but, because it is well charged with paint, full-bodied.

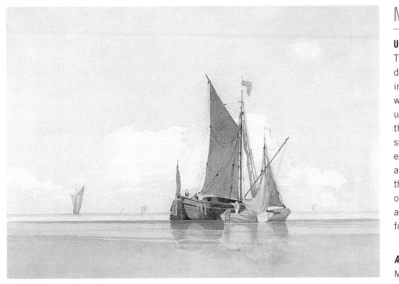

Miles E. Cotman

Uniform tone washes
This peaceful scene demonstrates great control in the application of washes. Notice how the uniformity of tone in the wash for the sky is sustained right up to the edges of the clouds. There are no dramatic sweeps of the brush—just the kind of consummate skill that allows the image to speak for itself.

A Calm (ca. 1840–49), MILES E. COTMAN

Laying a uniform wash on dry paper

In my opinion, a large, overall wash of uniform tone is somewhat more easily laid on dry paper than on paper that has been dampened or wetted. On the latter, variations in wetness on the paper or slight puckering (buckling), even of stretched paper, can produce inconsistencies of tone in the finished wash. Of course, these effects may be desired as part of the expressive nature of the work and can be positively exploited, but for uniformity of tone they are undesirable and working on dry paper is recommended.

Laying a wash is an aspect of watercolor painting that is perfected with experience. Whether you are using a soft round or a flat wash brush, the method is almost the same. Dilute the paint to the required consistency and mix more color than you think you will need to cover the area to be painted.

Remember that a watercolor wash dries considerably lighter than it looks while being applied. The depth of tone can be assessed before the wash itself is laid by trying out a small area on a piece of scrap paper and drying it quickly with a hairdrier.

1 Load the brush with paint. Using the tip of the brush, make a series of horizontal strokes. Paint gathers along the bottom of each stroke and is picked up by the next.

2 The brush should be kept well loaded. As it starts losing its generous charge of paint, dip the brush into the mix and quickly continue making strokes.

Different strokes With a flat brush, make all the strokes run from left to right. With a round brush, the strokes can run from left to right and then back from right to left.

Using a sponge

A piece of natural sponge, well filled with the wash mix, can also be used to make an even, continuous tone and is a quick and useful method of applying a wash over a large area. Grip the sponge between thumb and fingers and push it across and down the paper.

Applying wash with a sponge Apply the wash vigorously with the sponge as if cleaning a window. A sponge is also useful for dampening paper.

Laying a uniform wash on damp paper

If the paper is dampened before a wash is applied, the paint tends to spread naturally. To achieve this, using a wash brush or sponge, wet the paper as if laying a wash. The paper may buckle slightly as you apply the water, making the paint run into troughs, which creates an uneven tone if it is left to dry on a horizontal surface. This can be avoided if the wash is applied in the way shown here.

1 Apply the wash quickly. Note that paint does not gather at the bottom of the stroke on wet paper.

2 When the paper is covered, pick up the drawing board and tilt it so that the paint evens out in all directions.

3 Allow any excess paint to run to one side and absorb it with tissues. The result is an acceptably uniform tone.

Technique Laying graded washes

It is fairly difficult to lay a wash that successfully moves completely smoothly and evenly from dark to middle and light tones. The simplest approach to achieve this is to mix three separate tones of the same color—light, middle, and dark—and set these up in separate saucers. Apply each of the tones in turn, as if for a uniform wash, over the whole of the paper to achieve the graded wash effect.

Working from dark to light

Begin by angling the board at a slight slope. Start laying in the dark tone, work down a quarter of the area, then repeat with the middle tone, then with the light tone, then with clear water. If the paint is applied relatively dry, this will produce a "banded" look since the tones will not run into each other. But if more "liquid" paint is applied, an effect is produced where, at the point of applying a lighter tone, there is a sudden lightening of tone in the wash that then darkens until it reaches the next tonal band where it lightens again. This is a result of the pigment being carried down the sloping board until it gets to the point at which more water is applied in the lighter wash, which acts as a barrier, creating clearly visible lines. To avoid this:

- Move the board while the paint is still wet
- Wet the paper, lay in strokes of pigment, move the board around and, if necessary, using a well-charged brush, add a deeper line of tone at the top.

These methods produce lively, evenly graded, tonal washes.

Laying a light to dark graded wash

The most reliable way to make graded tones is to work from light to dark, beginning with clear water and working down to the dark tones. This sequence shows the use of a very wet No.16 squirrel-hair brush with water and working through three tones of Burnt Umber.

You can mix as many different tones as you like before you lay a graded wash. Or, you may prefer to add more paint to the mix as you go. You have to work fairly rapidly if you do this, but as you get the hang of it, you may prefer this method.

You can use slightly less wet paint and gently work over the whole wash with a damp, clean, flat, one-stroke brush. This completes the blending and ensures an even tonal gradation.

1 With the drawing board tilted, apply some clear water to the top paper.

2 Using the lightest color tone, lay in strokes, letting the paint meet the wet area.

3 Repeat with mid and dark tones. Keep the paint wet to merge it with the previous tones.

4 You can adjust the wash by stroking over it with a damp, flat, one-stroke brush.

Bleeding a wash into wet paper

A technique popular with watercolorists is that of applying a uniform tone wash and letting it meet an area of paper that has been wetted with clear water. The effect is partially random, but can still be very strictly controlled in terms of where and how much the pigment spreads. You can superimpose as many colors as you wish, as long as the underlying color is completely dry. The amount of "interference" between layers can be kept to a minimum if the water and paint are applied rapidly, without repeating any strokes. If you repeat a stroke, the layer beneath will begin to break up and the edges of the stroke will be clearly visible through the diffusing wash.

Bleeding a wash Do not repeat any brushstrokes or the color will be disturbed.

One-stroke multicolor washes

Washes of different colors can be made in one stroke, using a wide, flat wash brush such as that on p.131. Chinese wash brushes are particularly effective for this manipulation. The technique is first to mix all the colors you wish to apply. Then dampen the wash brush and separate the particular section of hairs on the brush that you wish to paint in a particular area. Fill the hairs on that section with color, transferring it to the hairs of the brush with another soft brush. Do all the colors in this way and then stroke the brush across the paper. The multicolor wash will appear. If necessary, you can work the brush back over the same area for a more blended look.

1 Mix all the colors that you intend to use, then dampen a wide, flat wash brush and separate the hairs into sections.

2 Using a small, soft brush, transfer the preferred color for each section onto the appropriate hairs of the brush.

3 Stroke the brush across the page to create the multicolor wash. For a more blended look, work the brush back over the same area.

Indian Red
Cobalt Blue
Permanent Rose

Permanent Rose + Cadmium Lemon mix
Raw Sienna
Cerulean Blue
Cobalt Blue
French Ultramarine

Bleeding water into a wash

Dropping clean water into a color wash can produce some particularly striking results, varying from three-dimensional effects to subtle, cloudlike ones (right). There is a degree of randomness about the result, but the controlling factors are the amount of water you drop into the wash and the density of color and degree of wetness of the wash itself.

1 The wash is applied and water subsequently dripped onto it with a clean brush. The water has an immediate effect on the wash as it creeps into the color. This can be controlled to some extent by moving the board around.

2 Different effects can be obtained with this technique if you delay applying the water over the wash until the wash is damp rather than wet. These effects can also be controlled somewhat with careful use of a hairdrier.

Painting a uniform tone up to a complex outline

Sometimes an area of uniform wash may have an intricate edge or outline. The illustration at the bottom right of the page shows the silhouette of a figure with a dog and other figures by a boat. These shapes are all filled with the same uniform dark tone that is continued below the skyline. To achieve this without unevenness or breaks in the tone, paint the shapes with water, outline them with a fine, soft brush, then fill in with a larger squirrel brush.

Next, drip a fairly thick mix of the color to be used in large blobs into the wet areas. The color will run onto the shapes and flow over the whole area. The board may be tilted to help the paint fill the shapes.

Painting a tone up to an outline This technique is particularly useful when filling a complicated area of uniform tone in the middle of a painting with delicate washes on it already, as shown here in this painting of Santa Maria della Salute.

 1 Paint the outlines and shapes of the figures using clean water and a No.5 round sable.

2 Take a larger squirrel brush and paint in the rest of the area with clean water.

3 Drip a fairly thick mix of Ivory Black and Phthalocyanine Blue into the wet areas.

4 Tilt the drawing board in different directions as necessary to help the paint flow.

Finished painting There is an effective contrast between the watery sky and the clean, clear silhouettes of the land.

Wet-into-wet techniques

Painting "wet-into-wet" means applying color to paper that you have previously wetted—either with water or with an earlier color that has not yet dried. The resulting effects cannot be reproduced in any other medium—with the possible exception of acrylics. Some of the effects have already been explored in *Wash techniques* (see p.137). To wet a sheet of paper, work as if laying a wash with water.

Technique

Laying and blending color washes

Wet-into-wet techniques are often used over large areas to create graded washes (see p.139). They also provide a natural blending method for producing smooth transitions between bands of color. There is no limit to the number of washes that can be superimposed, provided that the surface of the paper has been allowed to dry thoroughly before it is rewetted and repainted. It is possible to obtain a great depth of tone in this way. To control the blending of the colors, move the board or pad around as you work.

Laying color over a wet wash Wet paper with a thin mix of Raw Sienna. Apply Phthalo Green and Phthalo Blue while paper is still wet and allow to blend.

Blending washes Ultramarine Violet, Cobalt Blue, Cadmium Lemon, and Permanent Rose are applied to the wet paper and allowed to run together.

Wet into wet Cerulean Blue and Raw Sienna are painted onto the wet paper and the strokes of Cadmium Lemon then applied.

Superimposing color Ultramarine Violet, Permanent Rose, and Cadmium Lemon are applied and then superimposed while the study is still wet.

Technique Drawing an image wet-into-wet

It is possible to draw images and shapes directly onto damp paper with the fine point of a small, round sable, used very lightly and rapidly.

Drawing wet-into-wet The image is best made with the support kept horizontal. Here, a sheet of CP paper was thoroughly wetted, wiped off, and the drawing made spontaneously into the wet surface with a pointed sable and almost tube-consistency color.

Controlling paint flow

Although wet-into-wet painting produces spontaneous effects, a painting often succeeds according to the degree of control used. The flow and spread of the paint can be regulated in various ways.

- Notice the absorbency of the paper. On heavily sized papers, paint travels further and faster.
- Choose the right paper. The method of pressing used in the manufacturing will affect its suitability for wet-into-wet.
- Mix paint to the correct consistency. Thin paint flows more easily than thick.
- Tilt and lift the paper to make the color move in any direction.
- Try wetting only part of the paper to restrict "free" effects.
- Use a hairdrier to speed up the drying or blow the paint in the direction required.

Technique Spontaneous effects with wet-into-wet

If the paper is well stretched and uniformly wetted, a blob of color from the tip of a well-loaded brush will run evenly outward over the surface. It should feather out attractively, getting lighter in tone toward the edges as the color dilutes. If the paper is too light or not properly stretched, it will buckle when wet and the paint will run into troughs and create unwanted bands of deeper color.

1 Mix the color thickly, because it will diffuse and rapidly disperse across the paper.

2 To retain their individual freshness, keep the colors separate on the paper.

3 To contain the central form, work carefully around the whole central area.

Finished effect This example illustrates the soft, natural diffusion and blending of the colors on the paper.

Emil Nolde

Wet-into-wet landscape painting
Emil Nolde (1867–1956) worked extensively with watercolors throughout his life, often painting outdoors in the winter and allowing the snow and ice to create their own effects on the wet surface of his sketches. His fast and free method of painting gave great scope for wet-into-wet effects in which the colors seem to move and merge over the surface with their own life.

Glowing Evening Sky with Steamer
(ca. 1940), EMIL NOLDE

Technique Wet-into-wet effects

However much you set the conditions for wet-into-wet painting in relation to degree of wetness, amount of color, size of brush etc., there is nevertheless an uncontrollable element about the process that allows the medium to do its own thing on the paper. This gives wet-into-wet a charm and freshness of its own.

Swimmer 1 painted wet-into-wet The paper is given an overall wash of clean water and this is left for a minute or two. The outline is then drawn into the paper using a small, pointed sable and a mixture of Paynes Gray and Permanent Rose—of almost tube consistency. The colors are then touched into the relevant areas with sable brushes for the body (Cadmium Red, very diluted), swimsuit (Cadmium Lemon), and hair (Burnt Sienna). Finally, the Phthalocyanine Blue for the water is touched in around the edge. The complete image is made while the paper is still wet.

Swimmer 2 painted onto damp paper In this version, the shapes for the body, swimsuit, and hair are painted first into damp paper and, subsequently, the blue/greens of the water around them are painted on. All these colors begin to blend on the damp paper. The outline is then drawn in immediately and all the elements merge to form the image.

Washing off

Several watercolor manipulations involve washing off dry pigment that has already been applied to the paper. This produces a variety of effects; results may vary according to the paper and pigment used and the temperature of the water. Most papers respond slightly differently to washing off, as do the various colors themselves. Particular pigments adhere to the paper surface with more or less tenacity.

Technique

Adding tone and dimension

Washing off is frequently used during the process of painting to add tone and dimensionality to a watercolor. It is often done on relatively heavy paper that can withstand constant rewetting, scrubbing, and repainting.

The process is to paint the image in the normal way, applying a full tonal range to the painting. Once this is dry, wet the whole painting and brush over it with a large, clean bristle brush. This is best done by taking your painting (usually stretched on board) to the bathroom and running the cold shower over it while scrubbing it with a large bristle brush. The results you get with this technique are dependent on: a) the kind of paper you are using; b) the make of watercolor paints you are using; c) the temperature of the water; and d) your severity with the bristle brush. So test this out on scraps of painted paper first, before washing off an actual painting (see box below).

The technique has the effect of dislodging the surface color, but leaving all the residual tones in the surface of the paper. This makes the painting look part of the paper itself. It also to some extent softens the edges of areas of color over the painting. The painting is then dried and repainted. This process can be repeated until a rich image with a full range of tones has been created.

 At the initial painting stage, the contrast between the tones is accentuated.

② Following washing off, there is a softening of the tonal contrasts and the texture of the paper becomes visible.

Washing off test

Hold the paper under a hot or cold faucet. Leaving the top cross intact, direct the water at the center cross, while lightly scrubbing the bottom cross with a clean, flat bristle brush.

Finished painting The whole painting is richer and more fully integrated.

Sponging out

Several effects can be achieved by the technique of "sponging out" or "wiping out"—soaking up paint with a piece of sponge, absorbent cloth, or paper tissue while a wash is at various stages of wetness. This is a popular and effective way of creating cloud effects (see below).

Technique Creating cloud shapes

In this cloud study, a uniform wash was laid over the whole paper and allowed to sink in a little. The cloud shapes were drawn into the semi-wet work with a brush and clean water, and soaked up with a sponge. The work was dried with a hairdrier, and then given a lighter wash. The cloud shapes were picked out with a damp sponge, giving a softer, "double-edge" look. If the sponge is too wet, dark patches form at the edges of the sponged areas.

1 Use a sponge to soak up water from the cloud shapes. Stroke it across the lower third to lighten the tone.

2 Dry the work quickly with a hairdrier, and then apply a lighter overall wash of the same color.

3 Pick out the cloud shapes again, using a damp sponge to soften the whole effect.

Finished painting
The double wash with sponging each time adds dimension to the clouds.

Using gum arabic

Incorporating gum arabic in watercolor mixtures has two major effects: it gives a varnishlike sheen to the paint, imparting a depth and luster that some might say is against the spirit of matte watercolor painting, and it greatly increases the solubility of the dried paint film. This makes it more difficult to paint over the film without disturbing it. Also, sponging or blotting effects tend to take the whole film with them, leaving the paper almost bare. This is an advantage if a shape is to be taken out of a dried film: paint the shape in water, leave it on for a minute or two (to dissolve the film), and blot off. Where it remains dry, the paint film will be intact, but the shape will appear as light as the original paper. This is similar to using masking fluid (see p.151). Greatly increasing the solubility of the paint film can endanger color permanence. Adding too much gum arabic can make the paint film very brittle. It is normally sold in a 30 percent solution and, used in moderation, it should not detract from the permanence of a painting.

Straight wash and gum arabic wash dried then overpainted
When lines are painted on in clear water then blotted, the resolubility of the gum film (right) shows up.

Water dripped into a wet straight wash and a wet gum wash
Notice how the "bleeding" effect in the straight wash (left) is absent in the gum solution version (right).

Scratching out

In the past, before masking fluid was invented, the most common method of creating a completely white area or highlight in a "transparent" watercolor was to scratch away the painted surface with a sharp blade to reveal the white paper beneath.

An alternative method is to use opaque white, although this goes somewhat against the idea of the transparent method of painting. The use of masking fluid is actually limited to paintings for which you know in advance precisely where the highlights will come, and also to paintings where you do not intend to do any vigorous scrubbing out that would remove the masking film. So the practice of scratching out is still fairly widespread.

Materials

Tools for scratching out

If the area to be taken off is very small, a utility knife blade is the best choice of tool. To take off a thin vertical line along the branch of a tree, for instance, gently scrape away along the line until the white paper appears. It is important to scratch gently at first and to reveal the white paper by degrees. Using a reasonably heavyweight paper makes the technique safer.

If the area to be scratched out is larger and it is necessary to remove areas of the paper "tooth" (textural ridges), use a rounded pocketknife blade or similar. Fine-grade sandpaper, cut to size for small areas, may also be used for this kind of scratching out.

Utility knife blade

Pocketknife blade

J.M.W. Turner

Scratching out linear detail
Paint has been scraped from the trunks of many of the trees where the light entering at the top left-hand corner makes bright highlights. The individual fronds of ferns have been picked out in the foreground and in both waterfalls, giving a strong impression of water moving in the sunlight. The misty areas of foam are rendered with a combination of scrubbing and scratching out, while the finest lines define the ridge of water.

Weathercote Cave, near Ingleton (ca. 1816), J.M.W. TURNER

Technique

Scratching out a shape

This involves cutting the outline of a shape with a utility knife into, but not through, the paper, then scraping away all the color from inside the shape up to the edge of the line. The detail of gulls flying above a lake (right), picked out against a dark mountain, is a good example of the scratching out technique (far right).

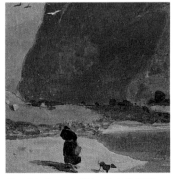

Mountain Scene in Wales (detail) (1810),
JOHN SELL COTMAN

Using a utility knife Cut the outline of the shape, then scrape away all the color within the shape to reveal the white paper beneath.

Softening edges

A major problem for some watercolor artists is the "hard" line that forms around the edge of a painted shape when it dries. This happens most often when a shape is painted somewhat wet onto dry paper. If a hard edge is wanted, there is no problem. If, on the other hand, the artist wants a less abrupt transition from one part of an image to the next, there are various edge-softening techniques that can be employed, all involving the application of water in one way or another.

Technique Methods of softening edges

For this technique, there are as many ways of softening edges as there are brushes and degrees of wetness of the paint. The examples below were all made on the same paper, but you can experiment with effects like these on papers of varying absorbency and texture.

1 With no softening, pigment has accumulated around the perimeter.

2 Using a soft brush dampened in clean water, soften the edge while the paint is still wet. The paper just beyond the paint is dampened by the brush, which then strokes the edge of the paint itself. This runs into the damp paper.

3 Using a slightly larger, wetter area of dampness allows the paint to run more freely and extensively.

4 Painting a very wet, thin band of water outside the edge gives a totally different effect. Water runs

into the pigment instead of the other way around. It is best to let the paint stand for a few minutes after application.

5 A long-hair bristle brush can soften the edges of a wet area of paint. Here, a dampened No.4 filbert was stroked twice along the edge, in a fluent movement.

6 It is possible to soften the edges of a dried area by using a dampened stiff-hair brush. Some artists cut down an old paintbrush to produce a small, stubby brush (see right).

Cutting down an old brush

A worn-out bristle brush is useful for softening hard edges on dried watercolor. Cut down the bristles to make a short, stubby brush.

7 A thin but very wet perimeter of clean water was painted around the edge of the color as it dried. The pigment particles gathered into miniature "mud flats."

8 The paint was allowed to flood into a wide band of clear water applied outside the painted edge.

1 2 3 4

5 6 7 8

Texture effects

The effects created by the granulation of certain pigments have already been demonstrated, but watercolor also lends itself to the creation of other textures. These are generally made by modifying the wet paint film as in blotted effects, or the dry paint film as in sanding effects, or by the introduction of a resist such as masking fluid or wax that prevents the paint from coating certain areas of the support.

Technique

Sandpaper effects

Using sandpaper is a common method of achieving texture effects. The result depends very much on the degree of coarseness of the sandpaper itself and also on the nature of the paper surface.

Fine sandpaper can be used on fine-grain paper to take cloudlike shapes out of a dry wash. On rough watercolor paper, the pigment scraped off will reveal white paper only on the ridges of the rough surface. So unless the rough surface is completely removed, the grain of the paper will be the most apparent feature.

1 Phthalo Blue with Phthalo Green lightly sanded.

2 Add a deeper wash of Phthalo Blue.

3 Sand and add very pale Phthalo Blue wash.

1 Phthalo Green with Cadmium Red lightly sanded.

2 Add wash of Phthalo Green with Cadmium Red.

3 Sand gently when dry.

Sandpaper effects in context

Sanding is normally combined with other techniques that enable it to be incorporated naturally within the painting. It is most often used with the scrubbing out, sponging out, and blotting techniques that are associated with the texture effects that sandpaper creates.

In the landscape study, below right, the light in the sky and the "white" water and foam were created by sanding the surface off the paper in these areas. Sanding on such a rough-grain paper produces a very mottled or grainy texture. This would look odd in conjunction with normal, thin, uniform watercolor washes, and so the effect was incorporated into a style of painting that, with the use of blotting and scrubbing out, retains an overall "texture."

Sanding straight edges

To make the sanding-out more precise, small pieces of sandpaper were folded to provide straight edges or corners that, used with small, circular movements, will take out very accurate areas along irregular contours— as in the join of the furthest hills.

The foam rising from the waterfall was sanded out at its base, but scrubbed in circular movements along the horizontal with a bristle brush and water, then blotted with absorbent tissue. In the sky above the sanded area, a uniform wash of pale Alizarin Crimson was blotted while wet. It appears as a blue/pink mottled area that leads comfortably into the texture created by the sandpaper.

Sanding up to straight edges (detail) Folded sandpaper provides a straight edge for the top of the waterfall.

Finished painting The painting has a rugged surface quality that relates to the landscape itself.

Technique

Blotting paper effects

"Sponging out" and "wiping out" with sponges or absorbent paper are both used to obtain effects like cloud forms (see p.146). For "overall" textures, particularly on rough-grain paper, sheets of blotting paper can be used.

The technique involves applying color and, while it is still wet, overlaying a sheet of blotting paper and smoothing it out over the painting with the side of your hand. When the blotting paper is raised, it lifts color uniformly from the ridges of the paper, creating a mottled effect—an interesting background for subsequent washes.

Tearing the blotting paper

As a further development of this technique, shapes are torn from blotting paper and laid into a wet wash. The torn edges of the blotting paper create softly blurred contours.

Building a painting with blotted washes

Successive overall washes may be laid on to create an atmospheric landscape (as in the example right), building from the sky and background of the picture to the foreground. Blot each wash and let it dry before applying the next. Tear the blotting paper irregularly to produce the shapes of treelines, hedges, and land contours. Use a bristle brush and water to soften any unevenness of line or tone in previous washes.

Blotting paper landscape study In this painting, the use of blotting paper helped create the misty atmosphere of early morning and enhanced the aerial perspective. The receding lines of trees were given blurred outlines by using roughly torn blotting paper, the tones lightening into the distance.

Technique

"Printing" a texture

The standard method of achieving effects of broken color is to hold the brush at a shallow angle to a sheet of rough watercolor paper and drag it lightly over the surface so that paint is deposited only on the high ridges of the paper. When dry, it can be overpainted with another color to provide a two-color texture. This is a straightforward method for thicker paints like oil or acrylic, but with watercolor, it is much more difficult to control the evenness of dragged color. Instead, try painting the required color on a separate piece of paper (use strong paper or thin posterboard). Lay this over the area to be treated, and smooth it

down with a roller or the side of your hand. When the paper is lifted off, a much more uniform result is obtained.

Try modifying the consistency and tone of the paint being applied. You can also use different colors on the printing sheet, or cut the sheet itself into shapes.

"Printing" the color Paint the required color on a piece of scrap paper, lay it face down over the rough paper, and smooth it down with a roller.

Brushed-on and "printed" color The brushed-on sample (top) shows an uneven and erratic texture. In the example below, textural color was laid on much more evenly by "printing."

Technique Using masking fluid

Art masking fluid is a rubber latex solution that can be painted on paper to mask out an area that you do not want the paint to cover. When the painting is complete, the fluid is removed, leaving white paper. One coat is usually enough, but two may be used for extra protection.

Masking fluid can be used before any painting has been done, to ensure that any highlights are kept white throughout. Or it can be introduced at almost any other stage of the painting process. The fluid is generally available in a clear or slightly yellow-tinted form. The latter is useful when working on white paper, to remind you where it has been applied. But if it is used on too absorbent a paper, it will leave a slight yellow stain.

The fluid can be used to paint out an intricate or well-defined shape. This can be drawn out in pencil before applying the masking fluid—use a fairly hard pencil, lightly, so that the outline is as faint as possible. Or, paint just over the edge of the pencil line with the masking fluid so that when it is rubbed off the pencil line can also be erased.

1 Paint out the shape with masking fluid and apply the required washes over the paper.

2 Gently rub away the masking fluid with a clean fingertip or an eraser.

Finished painting The use of masking fluid in the early stages of painting allows the boat to stand out from the background.

Masking out negative shapes

Sometimes you may want to mask out the background that lies around an intricate shape rather than the shape itself. This technique is shown in the example below.

1 Once the outline of the fox has been drawn, the masking fluid is painted carefully up to and loosely around it. When this is dry, the color is applied within the masked-out shape.

2 When the color is dry, the masking fluid can be rubbed off. The areas around the fox left free for touches of paint give a sense of animation to the work.

Masking fluid tips

- Make sure the paper you are using is suitable for latex masking fluid, since this fluid can cause the surface of the more absorbent, internally sized or unsized papers to tear when it is rubbed off. Use it on surface sized paper only and do a test first.
- Allow the fluid to dry completely before painting over it.
- Apply the fluid with an old soft-hair brush. Rinse in warm, soapy water so the heel won't become caked with dried fluid.
- Absorb excess paint from the masked-out area with tissue, to prevent paint puddles from running off the rubber, giving an uneven tone to the wash. Too much dry pigment on the latex may smudge the white area when the film is removed.

Using an old toothbrush Splatter masking fluid off the bristles of a toothbrush and allow to dry before the application of each wash.

Technique Wax resist

Wax repels water, and this is the basis of the wax resist technique. When strokes are made with clear wax and then overpainted with color, the wash only adheres to the paper where there is no wax. Colored wax crayons or white candles may both be used. Candles are usually made from inert hydrocarbon waxes that are permanent as long as they are not subjected to excessive heat.

In representational painting, wax resist reverses conventional procedures by obliging you to begin with the highlights and work back to the shadows.

For textural purposes, it provides a range of grainy effects that rely on the nature of the paper surface.

Modeling a shape with wax resist

The wax-resist method can be employed to paint in a representational and well-rounded way. The technique lends itself very well to subjects such as the apple below. In this example, it is important to work systematically from highlight to deep shadow. In fact, aside from the darkest shadow at the base of the apple and on the stalk, the whole apple has been painted using just overall washes, and all the modeling has been provided by the use of wax.

1 Wax the highlights. Paint an overall wash of Nickel Titanate Yellow.

2 When dry, wax the areas that will appear yellow. Wash with Light Red.

3 Wax areas to appear Light Red. Wash with Quinacridone (Rose).

4 Wax areas to appear Quinacridone (Rose). Add a purplish wash and allow to dry.

Finished painting Using Viridian, paint the dark shadows on the stalk and right-hand base of the apple.

Technique

Examples of wax resist

Here, the use of wax resist gives the effect of substance and texture to the different areas of the scene, including the land, the water, and the side of the boat where the very fine lines of wax are in contrast to the thicker, more vigorous ones in the foreground.

A study after Ravilious The technique can produce a result that is like a cross between a drawing and a painting.

Low- and high-key colors

Watercolor allows the artist to create paintings of subtlety and depth and works that are bright and spontaneous. Working in "low-key" colors can create works rich in tone and atmosphere (see below), while modern synthetic pigments allow artists to explore bright "high-key" possibilities (bottom).

Technique

Tonal depth from overlaid washes

Some of the subtlest effects come from colors applied in thin, pure, overlaid washes. In this painting, the bridge is painted with a thin yellow wash—probably Raw Sienna. Where it is in shadow, a thin blue wash is superimposed. The even-toned wash provides a uniform background for the figure of the horse picked out against it. Similarly, through the arch of the bridge, the pink-brown washes of the land are repeated in their reflections in the water and then overpainted with blue. The general movement from dark to light across the painting is achieved by superimposing color washes in the shadows. The balance of the painting is retained by the large tree in shadow above the right-hand side of the bridge and the boulders in shadow symmetrically below it. Here again, tonal depth is achieved not by mixing a deep tone for one wash, but by the repeated overpainting of thin, pale washes.

Greta Bridge (1810), JOHN SELL COTMAN

Technique

Optical mixing with high-key color

Modern, synthetic organic pigments provide a range of pure, bright, "high-key" colors that can be exploited for their brilliance and clarity. Here, a traditional format landscape is painted using just four of these pigments: Phthalocyanine Blue, Phthalocyanine Green, Quinacridone (Rose), and Arylamide Yellow.

The method of painting was inspired by the appearance of the landscape on a video monitor—which, with its tiny blobs of pure color, inspires a style akin to a synthetic form of impressionism. Strokes or dabs of pure color are painted on with no softening or blending. Tones are built up by superimposing strokes, and the highlights are preserved by the use of masking fluid. The final painting is rich in depth and texture, especially in the foreground.

The painting was made using dots and dashes of yellow, pink, blue, and green with a pink/blue mix—the only physical mixture to be used in the painting—providing a violet for the deep shadows and a basic color for the rocks beyond the shore.

Detail (right) of foreground of above picture Close inspection shows the touches of pure color, laid side by side or overlapping. From a distance, the eye does not discern these colors individually; they become optically "mixed" into more solid areas of color.

Monochromatic underpainting

Great depth and subtlety can be obtained in a work by painting an image in tones of a single color, modeling as if for a finished work, and incorporating techniques such as softened edges and graded washes, and then adding the appropriate colors on top when the underpainting is dry.

Technique

Monochromatic underpainting

This study after Frances Towne, a watercolorist who worked during the late 18th and early 19th centuries, shows the preliminary stages of monochromatic underpainting. The landscape is first drawn in carefully, using a relatively hard pencil (it is best not to use too soft a lead or it will affect the color). Subsequently, the various tones of the image are painted in using just one color, in this case Paynes Gray. If you are going to put color washes on top, you need to keep the tonal range of the grays light.

Building up tones Pale washes, dried and overlaid, rapidly build up to deeper, darker tones.

Painting on toned paper

Painting on a tinted paper can give a unifying tone to a work. As long as the color of the paper is not too deep in tone, you can work with normal transparent watercolor techniques. If you want to put in bright highlights, you will need to use opaque color.

Technique

Painting with watercolor on watercolor paper

Painting on a buff-colored or pale "Turner" blue watercolor paper gives a very different feel to your work. Some of the stronger pigments such as the opaque cadmiums may be relatively unaffected by the color of the paper, but even these colors in thin washes will look very different. In this sketch (right), the sumptuous foliage becomes absorbed into the mid-blue of the paper, creating a soft overall setting for the temple that has been picked out in white "body color"—in this case using gouache paint.

Painting on colored paper The foliage is low-key against the background color, but the architecture stands out in opaque body color.

Mixing watercolor techniques

The various watercolor techniques are rarely used in isolation but more often employed in conjunction with each another. The painting below involves a combination of methods discussed in this chapter; the scarecrow is an example of monochromatic underpainting with superimposed washes.

Project Scarecrow study

1 Paint the sky. Wash off around clouds, deepen sky, add crop shadows, and lighter tones for crops.

2 Add yellow/green wash on field and masking fluid for crop highlights. Lay graded wash.

3 Remove masking fluid and paint hedge. Underpaint figure in tones of Phthalocyanine Blue.

In this watercolor painting of a scarecrow, monochromatic underpainting was used for the figure. Among techniques used were: masking fluid (see p.151), graded washes (see pp.139–41), washing off (see p.145), and softening edges (see p.148).

The image was drawn with a pencil and lightly fixed. Masking fluid was painted over the scarecrow to leave it white while the sky was painted.

A basic graded wash was laid for the sky with other washes added on top. To soften the edges of the clouds, some washing off was done using a brush. Blue pigment was floated in to deepen the sky and redefine the clouds.

Shadows on the crops were painted using tiny dabs of color; paler touches were used for the plants. A pale yellow/green wash was applied over the field; masking fluid was used to protect the highlights. When it was dry, a light to dark green wash was laid from the horizon to below the foot of the scarecrow. When that was dry, the masking fluid was removed. The hedge was painted and its edges softened with a dampened, soft brush.

The scarecrow itself was painted in a range of tones of Phthalocyanine Blue—in the medium to light range, so that the overlaid colors appropriate to the image could be used to give them their full depth.

Finished painting When the underpainting is dry, add the final bright colors for the plastic bags that form the scarecrow's body and paint its wooden support and the piece of string.

Gouache

Gouache colors are popular with many designers and illustrators, who rely on them to provide flat, uniform areas of color. They are also useful for artists who work on a small scale in the tradition of Indian and Persian miniature painting, where particular areas may require "filling in" with flat, opaque color. Aside from these applications, gouache can also be used for highly resolved work on a large scale.

How gouache paints are made

Gouache, or body colors, are manufactured in the same way as transparent watercolors, using similar ingredients. The paint film needs to be thicker and more flexible than that of watercolor, which is used more thinly. So extra glycerine is used in gouache paints, making them more soluble than watercolors. An essential aspect of body color is its opacity. The best manufacturers obtain this through a higher proportion of pigment. With naturally transparent pigments, an opaque extender like barium sulfate or blanc fixe is used. Precipitated chalk is also used as a cheap extender for low-budget versions of gouache colors; the chalk is tinted with the pigment to provide the color. Fine grades of precipitated chalk may be used in this way for the home manufacture of gouache colors.

Another important aspect of gouache is its ability to flow. If it does not brush out to a flat wash using a gum arabic solution as a medium, then dextrin is normally used. Since the paints are often used in airbrushing, they are ground as, or more, finely as watercolors.

Blue Nude (1952) Henri Matisse
Matisse used gouache-coated paper for his cutouts because he was aware of the unique character of its surface. His bold use of matte, opaque gouache helps to give strength and solidity to the forms that make up this sculptural figure.

Materials The character of gouache paints

There is a unique quality to gouache color when used relatively thickly in opaque mixtures. The surface of the paint has an attractive matteness, a "dried earth" quality that brings it close to pastel but without that medium's dusty chalkiness. The matteness gives it a certain weight that transparent watercolor or shiny oil color do not have, and it makes the viewer especially conscious of its pigmented surface.

Gouache tube colors

Using gouache colors

Despite their opacity, gouache colors can be used thinly, in transparent or semi-transparent washes. When used like this, they are usually considered less brilliant than regular watercolors, but among the products of the best materials' manufacturers, and particularly with transparent pigments like Phthalocyanine Blue or Burnt Sienna, there is very little difference between them.

Technique

Adding white

To add opacity to a gouache color, mix it with white. This can help you to paint opaquely with a consistent overall tone. The mixture with white can be diluted for semi-transparent washes, but the examples below show how it will change the appearance of the original color.

"Opaque" wash The white used for added opacity changes the appearance of the original color.

Transparent wash The graduated gouache wash gives a light, transparent effect.

Technique

Using the solubility of the colors

Since they contain more glycerine, gouache colors are more readily soluble when overpainted than are straight watercolors.Softening and blending manipulations between layers are very easily achieved using a damp, clean brush.

If you apply a thin wash over another thin wash, the layer underneath will dissolve more slowly than a thicker one. If you apply a thin wash over a thick, opaque color, it will tend to dissolve the color beneath and begin to blend with it. This can lead to some interesting effects. You can paint a fairly thick coat over a color of similar consistency without affecting it too much, provided that you work very quickly. You can also vary the opacity of colors according to the dilution and the amount of white. This way you can obtain a number of semi-opaque overlay effects that cannot be achieved in transparent watercolor painting.

Thin, transparent wash laid over a semi-opaque wash.

Thin, semi-opaque wash laid over an opaque wash.

Thick, opaque color laid over full-strength gouache paint.

Using toned paper

Being an opaque paint medium, gouache can be used with good effects on gray or colored paper of medium tone. Since the opacity varies with the consistency of the paint and kinds of pigments used, the color of the paper affects the look of the paint either by being faintly visible through it, or by being juxtaposed with it. Note that a painted color loses tone on a colored ground compared to the same color on white.

Technique

Gouache used on white and toned paper

The jug on the left has been painted on white paper, and the one on the right has been painted on paper with an overall mid-tone wash in Burnt Sienna acrylic. As far as possible, the paintings were painted identically. Each has its positive aspects. The colors are clean and bright on the white paper, though the painting does not have the deeper, richer look of that on the toned paper. Here, the underlying color provides a warm matrix under the greens, blues, and yellows of the decorated vase.

Jug painted on white paper This shows crisp, clean colors.

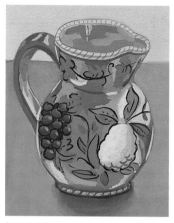

Jug painted on toned paper This has a mellow, rounded feel.

The effects of background color

These examples show the same gouache mixtures applied to white and to orange/brown paper. In each case, the color on the top row is the same as the one immediately below it. The difference the background color makes is marked. Where the paint is applied in a thin wash, as in nos. 2 and 6, and 4 and 8, the influence of the brown toned paper makes a very big difference to the same color seen on white.

Where white gouache is part of the thin mix, as in nos. 2 and 6, the white can still be seen against the brown. Where there is no white in the mix, as in nos. 4 and 8, the color of the transparent wash is transformed against the brown. But even where the paint is used thickly and opaquely as in nos. 1 and 5, and 3 and 7, there are big differences in the tonal appearance of the paint; the chalky appearance of no. 5 looks very different from no. 1, though they are the same color.

Gouache mixtures on white and toned papers

1 & 5 Yellow Ocher plus Titanium White with a touch of Phthalo Green—thick mix.

2 & 6 Yellow Ocher plus Titanium White with a touch of Phthalo Green—thin mix.

3 & 7 Phthalo Green with a touch of Titanium White and Yellow Ocher—thick mix.

4 & 8 Phthalo Green with a touch of Titanium White and Yellow Ocher—thin mix.

Project Apple tree study

This gouache painting shows a contemporary interpretation of a well-used technique for landscape painting, of working on a warm, brown ground. The sky color is painted opaquely through the branches and the paper color acts as a unifying and underlying color throughout. The dark tones of the leaves and branches are thin, blue/brown washes, while the areas in the light are semi-opaque and opaque yellow/green and yellow/white mixes.

1 Make a preliminary drawing in charcoal. Dust off the charcoal to stop it from interfering with the paint. It leaves a residual image.

2 Mix enough paint to paint the sky twice with a mixture of Titanium White and Phthalocyanine Blue.

3 Use Yellow Ocher and Phthalocyanine Green for the hedge. Add Burnt Umber for the dark tones.

4 Paint the darkest twigs and branches in a blue/brown mix. When this is dry, repaint the sky.

5 Paint the lighter tones on the branches in mixtures of yellow, green, and white; add detail.

Finished painting The chalky, green twigs have added presence through the use of the gouache medium.

Tempera

IN TEMPERA PAINTING, A NATURAL EMULSION SUCH as egg yolk, or an artificial emulsion such as a gum or glue emulsion, provides the vehicle for the pigment. The essential feature of an emulsion is that it comprises a stable mixture or suspension of two liquids that do not normally mix—such as oil and water. The emulsions used in tempera painting are normally water-soluble or oil-in-water emulsions, where the oily ingredient is suspended in fine droplets in the aqueous (watery) liquid. However, there are also water-in-oil emulsions, where fine droplets of water are suspended in the oily liquid.

The most common form of tempera painting is egg tempera, which is water-soluble. The egg yolk provides a natural emulsion that, when mixed with pigments and distilled or purified water, gives a fast-drying and highly characteristic painting medium. The medium has traditionally been used in works that are slowly and carefully constructed. It does not lend itself to direct styles of painting in which paint is worked thickly on the surface of the canvas. In egg tempera, the paint is used thinly and superimposed systematically. Its uniqueness is partially due to the fact that many strokes of paint can be superimposed, without the painting losing any of its freshness, than can be done in almost any other medium. Indeed, the color and form of the very first layer of paint applied retain their effect on the subsequent layers.

Egg tempera was the standard medium of European panel painting up to the 1400s, and its characteristics can be seen on most paintings that precede the advent of the more manipulable oil color.

The Wilton Diptych

The Wilton Diptych was painted for King Richard II as his personal, portable altarpiece. Its small scale, fine craftsmanship, and the sensitivity with which it has been painted make it an excellent example of egg tempera painting. The meticulous building up of the image that the technique requires gives each of the participants a quiet gravity. The work has great dignity, but remains fresh and alive, with the choreography of the hands, the rustling of the wings, and the unfurling banner. The combination of ultramarine blue with the gold leaf in the fine gilding is brought alive by the touch of red on the banner.

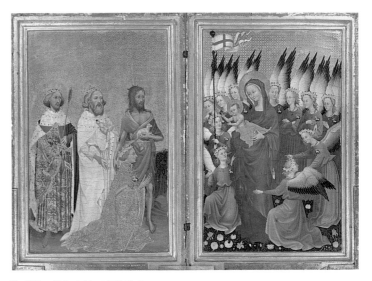

The Wilton Diptych *(about 1395–9)*, FRENCH SCHOOL
Richard II presented to the Virgin and Child
by his Patron Saint John the Baptist and
Saints Edward and Edmund.

The character of egg tempera

Preparing egg tempera paints is straightforward, and the clear and translucent effects that the medium provides are entirely unique. Colors are generally applied on a white gesso ground using round sable or nylon brushes in a series of hatching strokes. In this respect, the painting technique is similar to drawing and could be compared to colored pencils, which build up their tone and color effects through the use of superimposed strokes of color. In egg tempera painting, each stroke retains its autonomy as a shape, since it dries within a few seconds and so cannot be modified by physical blending with adjacent colors.

Egg tempera does, however, differ radically from colored pencil in the luminous clarity that each brushstroke retains. As the painting is slowly built up by cross-hatching, the optical effects of the superimposition of semi-transparent colors provide the richness and subtlety that characterizes the best works in the medium. Egg tempera, when painted on rigid panels, is a particularly permanent medium. Although, when it first dries through water evaporation, the paint film is soft and easily damaged by scuffing or wetting, the oil content slowly begins to harden with time. Eventually, the film becomes a tough, almost waterproof surface that can be buffed with a soft cloth to give it a sheen, or varnished.

In the past, egg tempera was used to provide the underpainting for works that were then glazed in oil color. The final colors were supplied by transparent oil glazes. The advantage of this method was that the underpainting dried quickly, permitting rapid overpainting. Such methods are technically sound.

Different kinds of egg tempera emulsions, including drying oils and resins, have led to debate about the precise painting methods and mediums of certain artists of the past. Some of the claims arising seem speculative in the light of modern scientific analysis.

Technique Tempera emulsions

Since the medium relies heavily on homemade paints, it is not surprising that there should be more recipes for tempera emulsions than for any other paint vehicle. In my opinion, egg yolk by itself is an excellent tempera emulsion. But the whole egg may be used, and many artists have introduced oil or oil-and-resin mixtures into the basic mix to facilitate particular manipulations.

Mixtures that incorporate gum and oil or gum, oil, and resin emulsions are slower-drying and so manipulable for longer. They can be more resoluble to overlaid color. Other emulsions use glues such as casein, emulsified with a drying oil, or, for a less yellowing emulsion, with a resin. Such emulsions are said to be useful for light work on paper. The dried paint film is insoluble.

Selection of ingredients for tempera paints and emulsions
1 Egg yolk
2 Purified (distilled) water
3 Pigment powder
4 Stand linseed oil
5 Dammar varnish
6 Gum arabic
7 Casein

Materials Supports and grounds for tempera

A traditional gesso ground is the ideal choice for tempera, but it can only be properly applied on a rigid support such as a wood panel or composite board (see pp.43–46). A dried tempera film may be too inflexible to withstand the movement of canvas. A gesso ground has the right degree of absorbency to take up the tempera brushstroke sufficiently without absorbing all the binding material. (If necessary, the absorbency can be modified by applying a thin coat of diluted glue size.)

Although a modern, acrylic-primed ground will accept the paint, it does not create the same close bond between paint and ground that characterizes the gesso surface.

Preparing the gesso ground

Gesso grounds are described generally on pp.58–60. For tempera painting, I use a rabbit-skin size prepared in a double-boiler at a strength of 3oz per 1¾ pints (75g per liter) of water. I give all surfaces of the panel a preliminary thin coat, followed when dry by a full-strength coat. You can cover the panel with a thin, loose-weave linen or butter muslin cloth. Once a panel is gessoed, it is just as smooth with or without the cloth, which really just provides a key for the gesso. Apply the cloth to the panel, then brush hot size onto the center, over the cloth, working it out toward the edges and over the back.

When the size is completely dry, the gesso is applied. I use precipitated chalk with Titanium White pigment in proportions of about 9:1. This gives a particularly smooth, white surface. Traditionally, hot glue is stirred into the chalk and pigment until it has a creamy consistency, and the mixture is strained before use.

Scrub the first coat well into the panel and rub it in with your fingers to eliminate any bubbles.

Apply subsequent coats with a flat bristle brush held at right angles, building them up until you achieve a reasonable overall thickness. Allow the panel to dry thoroughly.

To smooth the gesso, the most efficient method is to use an electric orbital sander with a fine-grade abrasive paper (alternatively, sand it by hand). Finally, smooth it again with light, circular movements, using a wad of slightly damp cotton sheeting. Work evenly, without going over the same area twice.

See p.370 for information on working safely.

Materials The tempera palette

Among those pigments that wet easily and are permanent are many of the synthetic inorganic pigments such as:

- Cobalt Blue (grinds well)
- Indian Red (gritty to grind)
- Venetian Red (very gritty to grind)
- The Mars colors (soak up water easily and grind well; they get sticky very quickly).

The natural and calcined earths generally grind well. Raw and Burnt Sienna tend not to be too gritty and grind silkily, as does Terre Verte. Yellow Ocher and Raw Umber are generally very gritty in the initial grinding, but are straightforward to mix and grind.

Other useful additions to the palette that present no great wetting or grinding problems are:

- French Ultramarine
- Viridian (gritty initially, but not too difficult to grind)
- Titanium White (extremely straightforward to wet and grind)
- Ivory Black.

For a reasonably permanent red at the violet end of the range, use a Quinacridone pigment (difficult to wet).

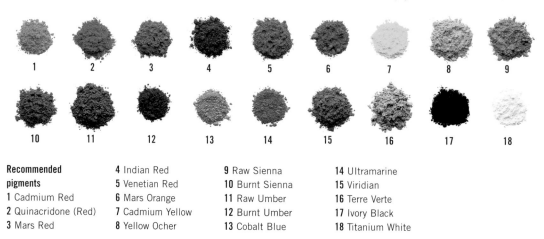

Recommended pigments	4 Indian Red	9 Raw Sienna	14 Ultramarine
1 Cadmium Red	5 Venetian Red	10 Burnt Sienna	15 Viridian
2 Quinacridone (Red)	6 Mars Orange	11 Raw Umber	16 Terre Verte
3 Mars Red	7 Cadmium Yellow	12 Burnt Umber	17 Ivory Black
	8 Yellow Ocher	13 Cobalt Blue	18 Titanium White

Preparation

Grinding pigments

To have a ready supply of usable pigments—at least for egg tempera painting—you should grind these in distilled (purified) water and keep them in tightly closed jars. Working on the relatively small scale normally associated with tempera, you use very little pigment, so you only need to grind enough of each color to fill a small 2fl oz (50ml) jar. This is enough for several paintings.

To use a color, take a small amount of the paste from the jar and mix it with an equal amount of the tempera emulsion (if this is water-soluble). For oil tempera, grind pigments directly with the emulsion medium.

Making the pigment paste

Prior to grinding, work the pigment into a paste with the distilled water (see below). Grinding may be easy or hard depending on the pigment (see below). After a little experience, you will recognize the point when the pigment is well dispersed with the distilled water—the mixture looks and feels very different from the granular paste obtained by simply mixing with the palette knife. Prepared pigment should always be stored under distilled water to keep it moist, and so preventing it from having to be reground.

See p.370 for information on working safely.

1 Place a small heap of pigment on the glass slab. Make a well in it. Pour in some purified water.

2 With a palette knife, turn the pigment into the water, pushing and scraping it until it is wet.

3 Now start grinding the pigment. Use smooth, circular movements of the muller (grinder).

4 When the pigment is ready, put it into a small jar. Fill with distilled water and replace the lid.

Handling "difficult" pigments

Some pigments are very difficult to wet—notably the Phthalocyanine pigments and the Azo yellows, which are so light and fluffy that it takes a considerable time to persuade the water to adhere to them. These pigments also require a lot of grinding—not to break down the particle size, but to ensure even wetting. Adding alcohol to the mix is said to encourage wetting.

It is also possible to obtain aqueous dispersions of modern, synthetic organic pigments, prepared by pigment manufacturers to aid dispersion into vinyl emulsions by paint manufacturers. I have tried these with egg emulsions and they do seem to present a simpler alternative. Pigments have recently become available in a granular form, which is low dusting and disperses well.

Materials

Brushes for tempera

The most suitable brushes for the one-stroke hatching effects that characterize tempera painting are long-haired, round-pointed sables—or their synthetic equivalents. Since the hatching technique involves mixing up the tempera with water, loading the brush, and then partially wiping off the paint to avoid unsightly blobs of color at the end of the stroke, choose a long-haired brush. The hairs retain more color and can be worked for longer than a short-haired equivalent. One characteristic of egg tempera is that a brush-load, even after the partial wiping off (see p.164), lasts for a surprising number of strokes.

Other suitable brushes are quill sables, pointed riggers, and the extra long-haired, round lettering brushes with either pointed or flat ends. These provide traditional effects, but, for creative techniques, many other kinds of brush may be used.

Brushwork techniques

It is important to confine manipulations to one stroke of the brush, whether you are using a fine-pointed sable or a wide, flat bristle brush. If you immediately repeat a stroke, or scrub over it, the paint film will start to clog and disintegrate. Lower layers could be damaged and even the gesso ground might start to soften. Since the medium relies on the "quality" of a single stroke, your brush should be in good condition so that it deposits the paint evenly and with clean edges.

Long-haired, pointed brush

Long-haired, flat-tipped brush

Egg tempera painting

In my opinion, the traditional, pure egg-yolk emulsion is the best medium for tempera painting. It is permanent, simple to prepare, and gives painting a quite unique appearance. If you are interested in the careful construction and build-up to the finished appearance of a painting, the juxtaposition and superimposition of colors for optical effects, and in a crisp, translucent look, egg tempera is ideal.

Technique Preparing egg tempera paints

The preparing and storing of pigments for tempera painting has already been described on p.163. Generally, for egg tempera, the opaque pigments, such as the cadmiums, and the artificial mineral pigments work particularly well. Since they are used thinly and within the egg emulsion, they do not work as completely opaque pigments in this medium but instead as semi-opaque or semi-transparent. This gives the painting body, while retaining its translucency.

Transparent colors may also be used for glazing, although this is still restricted to the single-stroke technique the medium requires (even if a stroke is made with a wide, flat brush).

Mixing the egg yolk and pigment
Use a fresh egg. The color of the yolk is not important since it does not have a lasting effect on the pigment. One yolk is usually enough for a day's painting. Mix the yolk with the pigment paste and with a little more distilled water as described below. Use a plastic palette with indentations or, for larger amounts, use individual china or plastic saucers. Mix up all the colors you will need in this way. Even when the pigment and yolk mixture has been well stirred, the pigment may settle, so stir each mix immediately before use.

As work progresses, the surface of the paint in the palette wells or china saucers may form a skin as it begins to dry. This is not a problem, though you should be careful not to paint any of the "skin" onto the panel.

1 Crack the egg and pass the yolk from one half of the shell to the other to remove most of the white, making sure not to puncture the yolk.

2 Place the yolk on a piece of kitchen towel in the palm of your hand and roll it around carefully. The remaining white will stick to the paper.

3 Hold the yolk sac at the edge of the paper and puncture it with a knife or sharp instrument. Pour the contents into a jar.

4 Take a little pigment paste from the jar. Add about the same amount of egg yolk and a little distilled water. Stir with an old, clean bristle brush.

Technique Egg tempera painting methods

Mix some paint prepared as outlined above with more distilled water so that the mixture is not too glutinous. Load the paint brush and wipe it lightly on an absorbent cloth or paper tissues to remove excess paint—this avoids unsightly blobs at the end of each stroke.

If the paint is of the right consistency and the brush is not overloaded, each stroke is clear and uniform in tone. It dries quickly, allowing rapid overpainting. The brushstrokes should always be laid carefully and never "scrubbed" onto the surface.

Mixing colors
Blending colors on the surface of the ground is impracticable; tone and color gradation are achieved by juxtaposing tones and by crosshatching. Any color mixing is done on the palette. Building up the tones and colors of an egg tempera painting is a slow process and areas will need to be painted again and again. This process is particularly satisfying; the colors seem to retain their freshness and immediacy, even after constant overpainting.

Other brushwork techniques

The emphasis I have placed on the "single-stroke" nature of egg tempera painting does not preclude other kinds of brushwork. You can, for instance, dilute the paint even more and apply thin washes of color with larger brushes over wide areas. It is not possible for the reasons already stated (see p.163) to make uniformly graded washes in the same way as for watercolor, for instance (unless you use a brush as wide as the painting and make the wash in one stroke). However, it is sometimes useful to underpaint a whole area in one thin color, providing an overall matrix beneath traditional hatched strokes. If the underpainted wash is somewhat streaky, this does not show when it is overpainted, and the luminous white of the gesso still shines through the superimposed colors.

Tempera modeling The brilliance of a color is retained (even over a different color) if you use enough strokes.

Project Study in crosshatching and optical color mixing

This small hayfield study painted on gesso over plywood makes a visual connection between traditional egg tempera cross-hatching and the chopped strands of the baled hay and stubble. The painting was made principally with a small, round, pointed soft-hair brush, with a larger, flat bristle brush being used to apply the early washes. French Ultramarine, Viridian, Cadmium Red, Cadmium Yellow Deep, Burnt Umber, and Titanium White were used, all prepared as described on p.162. A modern, synthetic organic pigment, P.Y.109, already dispersed as an aqueous paste, was mixed with egg yolk, and used for the bright yellow.

1 Roughly sketch in the shapes and tones with a thin Burnt Umber mix. If the underpainting is too dark, it will cool down superimposed colors.

2 Paint a thin green wash over the field and hedges at the top, a deeper version of the same color over the first hedge, and a thin yellow wash over the rest of the painting.

3 Work on the hedges and the far field at the top by overlaying thin strokes of various pale and dark greens, blues, pinks, and reds. Add a fine network of Titanium White.

Finished painting Paint the foreground and midground with thin strokes, larger in the foreground for perspective. Make red hatchings in the darkest areas and white strokes in the lightest parts. Gradually add more crosshatched colors (orange, blue, and pale and dark yellow/green). Work up the foreground stubble in similar colors, using vertical and near-vertical brushstrokes. Finally, rework the whole picture to ensure a uniform overall surface.

Technique Traditional egg tempera techniques

The 15th-century Italian artists' handbook *Il Libro dell' Arte,* by Cennini, explains in detail the method of egg tempera painting on panel practiced in the early 1400s. It contains useful information for anyone working in the medium today. Cennini recommends that draperies— curtains and wallhangings—and background be painted before the faces, that the colors should always be tempered with an equal amount of egg yolk, and that they should be "well worked up, like water." An initial drawing should be made on the gesso panel using charcoal, most of which is then brushed off with a feather, leaving a faint image. This is reinforced with diluted (pigmented) ink and a small brush. Every trace of charcoal is removed and a blunt, soft-hair brush is used to shade in some of the folds in the drapery and shadows in the face, with a similar pale wash of ink.

Painting drapery

Cennini's systematic method of painting drapery is appropriate to the medium. First he prepares "dark,"

"middle," and "light" tones of a color. The dark tones are painted in first, then the middle, then the light. Cennini emphasizes that the procedure must be repeated until the tones are perfectly blended.

The next stage is to mix two even lighter tones, followed by pure white, to build up the highlights, and similarly with the darkest tones, finally touching in the strongest darks.

Painting flesh tones

The technique is similar to that used for drapery, except that first an overall wash of Terre Verte with some white is laid over part of the body to be painted. This differs slightly from the description of a similar process on wall paintings, where the face is drawn in first using a *verdaccio* mix of white, dark ocher, black, and red, then shaded with Terre Verte before the warm colors are applied.

Now three values of flesh color are applied in a similar way to the tones of the drapery. Lastly, the lighter tones and highlights are applied before the final dark accents.

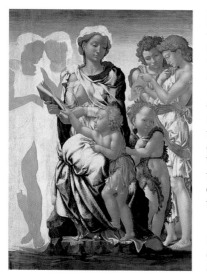

Michelangelo

Stages of painting in tempera

"The Manchester Madonna" demonstrates some of the stages of underpainting practiced in the late 1400s. These include the underpainting of the fleshtones in green Terre Verte, seen in the figures on the left of the painting. In addition, the modeling of the Madonna's blue robe has been left underpainted in black, using a crosshatching technique to build up the dimensionality of the folds of cloth. Cennini describes a similar method of underpainting the blue mantle of the Virgin Mary. He directs the artist to lay in the modeling with a two to one mixture of sinoper (red) and black before putting two or three coats of ultramarine over the drapery and subsequently shading in the folds with a mixture of indigo and black using the tip of the brush.

The Madonna and Child with Saint John and Angels
("The Manchester Madonna")
(c. 1495), MICHELANGELO

Technique Underpainting and overlaying colors

Cennini recommends that the *verdaccio* (see above) used to shade a head be mixed with white for egg tempera panel painting. Since the medium confers a degree of translucency on even the most opaque pigments, any strong tone or color underlying further layers of paint will have an effect on them. So a head underpainted monochromatically in, for example, black, will have a "cool" look, even after warm flesh colors are applied.

The principle can be exploited with, for instance, colors of mid-to-light tone overlaid by darker-toned

complementaries. This allows the white ground to continue to contribute to the translucent quality of the painting. However, the distinction between underpainting and overpainting can be quite arbitrary, especially where a fine crosshatched technique is used, since no overall film of paint is being deposited over another—the technique allows for so many "overpaintings" that it would be difficult to decide where the underpainting stopped and the "top coat" began.

Monochromatic underpainting

If the underpainting is considered an interim stage in the work, it can still take many forms. It may be mono-chromatic (painted in a number of tones of a single color). Different tones may be obtained by gradually diluting the paint with water until it is barely tinted with color, or by slowly adding more white, which produces a richer underpainting. The color chosen has an important effect on the colors used in the overpainting and provides a unifying effect to the finished picture. The range of tones should remain in the mid-to-light area if the superimposed colors are to remain brilliant.

A highly resolved monochromatic underpainting is only worth applying if its qualities remain visible in the finished work. This will only be the case if transparent or semi-transparent colors are used in the overpainting—a bit like tinting a black-and-white photograph. A less resolved underpainting, but with all the main shapes and shadows roughed in, allows for a highly resolved surface treatment in the overpainting. The underpainting does not need to be monochromatic, but each area of shape or shadow may be painted in a color appropriate, by contrast or similarity, to the colors to be painted on top.

Underpainting for a highly-resolved image

The study of a child below uses a crosshatched "drawing" technique to produce a range of tones in the underpainting. The tone of individual lines is relatively consistent, but the paint has been further diluted to produce lighter grays in some areas. The image demonstrates that such a technique may be used in a relatively loose way as in the crosshatching around the limbs, or tightened up to produce a more fully resolved image as in the area of the features, where there is also some stippling with the point of the brush.

The underpainting This was carried out in Ivory Black egg tempera with a crosshatched drawing technique, also including stippling.

Detail of finished image The colored tracery of fine lines, which flow over and help to define the shape of the features, can be seen. When painting the human figure in egg tempera, the use of curved, instead of straight, lines is more appropriate to the soft contours of the image.

Finished painting An overall wash of Terre Verte was applied in single, adjacent, vertical strokes with no repainting and the image was overpainted in color. It remains a bit too cool in tone due to the overly-deep tones of the Ivory Black underpainting.

Technique

Building up in stages

A tempera painting is carefully built up in stages and Ghirlandaio's *Portrait of a Young Woman* (right) is a fine example of the medium. The treatment of the white, gauzy overgarment, which creates a "V" shape at the neck and acts as a translucent veil over the girl's red dress, is of particular interest. If it were an oil painting, this might be painted as an overall semi-opaque glaze, but in egg tempera it is painted in a series of fine, semi-opaque, white lines that model the contours of the red dress.

The following steps show how Ghirlandaio might have built up the depth of color and the detailing in the painting.

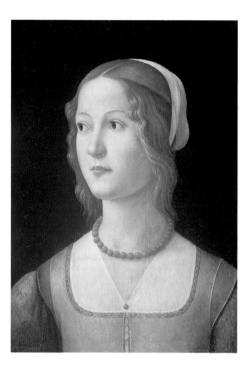

Portrait of a Young Woman
(c.1490), GHIRLANDAIO
This painting has all the hallmarks of an egg tempera painting and it demonstrates the subtle beauty of this translucent medium. The delicacy of the treatment, in the application of the fine, shaded brushstrokes that model and define the form, expresses the sensitivity and composure of the subject.

1 A uniform mid-to-light tone from a mixture of Yellow Ochre, Titanium White (substituting for Lead White), and a touch of Cadmium Red (substituting for Vermilion) is applied rapidly over the shape with a bristle brush.

2 A further uniform but deeper tone mixed from Cadmium Red and Titanium White is also applied rapidly. The combined effect of these two layers is to provide a rich underpainting for the red of the dress.

3 A "glaze" of Cadmium Red is applied in a high proportion of rich egg medium with a soft, long-haired, round brush. The technique is to apply the color rapidly in long, thin, adjacent strokes until the whole area is uniformly covered.

4 The white overgarment is painted with thin strokes of a small, long-haired, round brush. The opacity of the white can be controlled by the amount of white pigment in the egg yolk and the amount of paint on the brush.

5 The green brocade is built up using Terre Verte and Titanium White. This is the most prominent or raised part of the paint surface in the original painting.

Cross section All the layers of the painting can be seen in this cross-section, from the thick band of gesso at the bottom, through the yellow and red layers, to the Terre Verte of the brocade at the top.

Other tempera emulsions

In addition to pure egg-yolk emulsion, there are innumerable recipes – as many as there are tempera painters – which, for one reason or another, incorporate additional ingredients. These include oils, resins, gum arabic, glycerine, and glues. Each recipe produces a paint film of a slightly different quality.

Materials Egg/oil/resin emulsions

The main reason for incorporating oils and resins in tempera is that they slow the drying time, thus rendering the paint manipulable for longer. Another reason is that oils and resins are said to be useful in imparting impasto effects to the paint, presumably by adding flexibility and viscosity. Certainly a pure egg-yolk medium will crack if used too thickly. In addition, egg/oil emulsions are said to aid the adhesion of overpainted oil color (see above).

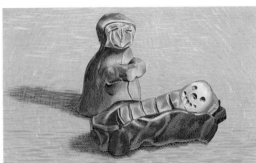

Still life study in egg/oil/resin tempera The study of clay figures was painted using an egg yolk/stand oil/dammar varnish plus water emulsion. Thin color washes were used over the cross-hatched underpainting. The latter provided a unifying matrix for superimposed cross-hatching in color.

Materials

Egg/gum arabic emulsion

The use of egg yolk with gum arabic dates from medieval times when it was used as a medium for working on parchment. The medieval German "Strasburg manuscript" – a treatise on art materials – contains many references to the preparation of colors in a similar emulsion, generally also containing a little honey as a plasticizer, and vinegar as a preservative. To make this emulsion, mix the medium with pigment as for egg tempera painting and use it in a similar way. The presence of the gum arabic makes it act more like watercolor. The dried paint is resoluble by overpainting, and this can be exploited for certain techniques. If, for instance, you overpaint an opaque yellow with a thin red wash, stroking the overpainting carefully and continuously with a damp brush for a short time, the colors will merge to form orange. If you did this in egg tempera, the stroking would result in the destruction of the first paint layer.

In washes, gum arabic makes the paint slightly "sparkly" and gives a somewhat granulated look. Combined with the slightly plastic matteness of the egg film in thicker layers, this makes for an interesting combination. Wet paint of different colors can be worked on the support for blended colors and graded tones. The paint may also be used in a loose and "juicy" manner, running freely into adjacent colors.

Materials

Gum and glue tempera

The gum arabic solution used above may be emulsified with oil or oil and resin to produce a paint vehicle that bears no resemblance to egg tempera. It works best on paper where it can be brushed out well. On gesso it has none of the milky smoothness of egg tempera. It produces a hard film that cannot be scratched when dry, but which is almost immediately resoluble to a damp brush.

Emulsions of this kind, which incorporate oil and resin, are water-soluble given the right proportions, but a stickiness is evident, however well emulsified, and can be felt in the palette and in the hairs of the brush. For vigorous brushwork on paper using bristle brushes, it is a satisfying medium to work with.

Glue tempera

Various glues may be used to make tempera, including glue size and casein. The latter completes its chemical drying process in hours and is completely insoluble when dry. With the advent of vinyl and acrylic paints, casein emulsions are not so common now as they were.

Oil Paints

OIL PAINTS ARE MADE FROM PIGMENTS GROUND in a drying (or semi-drying) oil, such as linseed, nut, poppy, or safflower oil. The use of oils like these as binding mediums gives oil paint its characteristic appearance and its qualities of easy handling. Pigments ground in oil have a distinctive depth and color resonance, and can be used in a wide range of techniques. These encompass transparent and opaque painting and include direct wet-into-wet painting methods, and those that work by building up a painting carefully, layer by layer, according to a prescribed system.

Oil paint can be applied in thin, transparent glazes or in thick, impasted strokes. It can be worked while wet on the surface of the support for much longer than other painting media, allowing scope for particular blending effects and for the safe introduction of fresh colors. This also makes it an excellent medium for landscape painting in the open air. In oil painting, the color laid down wet is effectively the same color when it dries, which makes some aspects of the medium much more straightforward than similar aspects of gouache or acrylic painting.

The history of oil painting

Oil painting dates back to well before the Van Eycks, who have been popularly credited with the discovery of the technique. The German "Strasburg manuscript"—an art treatise of the Middle Ages—gives detailed instructions for the preparation of a cooked and sun-bleached drying oil with which to grind and temper pigments, and also for a cooked oil and resin varnish, three drops of which are added to each color—presumably to aid manipulation. Cennini, in his *Il Libro dell'Arte*, describes fresco and egg tempera techniques, but also includes instructions for the preparation of a drying oil. The use of a drying oil as a painting medium was initially more popular in Northern Europe than in the South. The use of oil-ground color became increasingly popular in Venice during the 1400s, and by the early 1500s, it was the accepted medium for easel painting throughout Italy and the rest of Europe.

Altarpiece: The Crucified Christ with the Virgin Mary, Saints and Angels (probably 1502–3), RAPHAEL
Analysis of paint samples from three areas of this early Raphael Crucifixion show the medium to have been linseed oil in the earth and green robe and nut oil in the sky. The pale nut oil was used for colors that might have been changed by the yellower linseed oil.

The permanence of oil painting

Oil painting is no more permanent than other established painting media. In fact, if the oil painter fails to adopt sound working methods, a number of problems can arise, one of which is that the oil film may crack due to the superimposition of lean (non-oily) paint layers over oily ones. Other problems are caused by overlaying colors of low oil absorption on those of high oil absorption, or by laying too strong a coat of glue size on the canvas before priming. Overbound pigment, with a surplus of oil, causes wrinkling and excessive yellowing, and underbound pigment results in dry, crumbly paint that may flake off the canvas.

Night and Day (1979–82), HOWARD HODGKIN The painter Howard Hodgkin often uses a "proscenium arch" device in his painting. This allows us to move into the space in the painting through planes of color beginning at the outside edges and often, as here, corresponding with a frame that is integrated into the panel. The characteristic bold, sweeping brushstrokes combine with more subtle passages in the interior spaces.

Methods and mediums, past and present

Oil painting need not be the complex undertaking that is suggested by the vast range of recipes for oil painting mediums and varnishes. Perfectly acceptable results can be achieved simply by using unadulterated pigments ground in oils, and diluted with turpentine or paint thinner as necessary, and only painting over a layer of paint while it is still wet or after it has dried. You need to be aware of the potential dangers associated with the use of organic solvents such as turpentine or paint thinner—see p.370 for information on working safely.

Some techniques and effects do require the modification of the straight oil color, but most can be reproduced using the simplest and soundest formulations. Some commentators claim to be able to identify the precise materials used by an artist simply by being able to copy an effect. However, though scientific analysis is now extremely accurate, it can still sometimes be difficult to precisely identify, from small paint samples, the exact nature of the painting medium used. I have therefore decided to show how particular oil painting effects may be achieved, but not to claim that the same methods were used in the past. In many cases, the method will be similar, although the painting or glaze medium used may not.

Oil colors

Oil colors are made by mixing and subsequently grinding pigment powder with a drying oil. (Drying oils are discussed on pp.30–31 and also on p.174.) Linseed oil has been universally popular for many centuries. The less yellowing nut oil has just as long a tradition in painting, particularly for grinding white pigments. Poppy and safflower oils have also been used for this purpose. These are semi-drying oils—often used by manufacturers to slow down the naturally fast drying times of some pigments, or to produce a paint of better consistency for others. They may be used on their own or combined with drying oils. Mixing different oils in this way is perfectly acceptable, since they all contain the same triglycerides (see p.30).

With properly ground pigments, each particle is coated in oil and the paint mixture is sufficiently plastic to be manipulable, but sufficiently viscous to retain the mark of the brush or painting knife. When artists' colormen produce oil colors for the market, they aim to make colors of a similar consistency, which are compatible and that dry within, for example, two to fourteen days. A number of factors are involved.

Preparation Oil absorption

Every pigment requires a different volume of oil to bring it to the desired consistency. The oil absorption of pigments varies considerably and so the phthalocyanines require almost twice as much oil by volume as Titanium White. I stress this point because artists are often rightly advised not to paint in oil colors of low oil absorption over those of high oil absorption, since this results in a badly structured paint film in which lower layers will be more flexible than those superimposed and may cause them to crack.

Extenders and thickeners

For homeground color, the oil absorption tip is good advice. With manufactured oil paints, colormen modify the behavior of their colors, not only by the blending of drying and semi-drying oils and the addition of driers, but also by adding certain pigments (that are transparent in oils) as extenders.

Aluminum hydrate, for example, gives good flow characteristics to certain colors. Blanc fixe is a commonly used extender for strong organic pigments that are considered much too powerful without extenders to fit within the manufacturer's range of compatibility with other pigments. Kaolin (China clay) is also used to control oil color consistency. Such pigments have oil absorption figures of their own that affect the oil content of the tube color. The result is that an oil absorption figure allocated to a specific pigment may bear no relation to the oil content of that pigment in its tube-color form. Other ingredients such as thickeners can also affect oil absorption.

The right approach to oil absorption

Since manufactured colors are made to perform consistently within established limits, the effects of different oil absorptions are to a certain extent mitigated. You may be placing unnecessary restrictions on techniques if you avoid painting in supposedly low-absorption pigments over high-absorption ones.

It is still advisable to avoid fast-drying colors with high oil contents by volume (such as Umbers, Siennas, and Cobalt Blues) in underpainting, since cracking may occur in overlaying layers if these do not contain relatively higher oil contents. Even these colors may be used in underpainting, however, if applied very thinly or in tints reduced with white, or in other admixtures with slower-drying pigments of lower oil absorption.

Approximate drying times of manufactured oil colors

- Fast drying (around two days): Manganese Violet, Cobalt Blue, Prussian Blue, Raw Sienna, Raw Umber, Burnt Umber, White Lead.
- Medium drying (around five days): Phthalocyanines, Burnt Sienna (medium to fast), Cobalt Violet, Ultramarine, synthetic Iron Oxides (medium), Cadmiums, Titanium White, Zinc White, Lamp Black, Ivory Black (medium to slow).
- Slow drying (more than five days): Azos, Quinacridones.

Approximate oil content of manufactured oil colors

It is impossible to provide more accurate figures (see left).
- High (more than 70 percent): Burnt Umber, Raw and Burnt Sienna, Phthalocyanines, Cobalt, Quinacridones, Lamp Black.
- Medium (55–70 percent): Cadmiums, synthetic Iron Oxides, Ivory Black (can be high), Oxide of Chromium, Raw Umber, Chromes, most Azos.
- Low (less than 55 percent): Ultramarine, Flake White.

Materials

Recommended palette

The following pigments are recommended for oil painting. For further information see the Pigment charts on pp.16–29.

Reds
1 Cadmium Red
2 Light Red
3 Indian Red
4 Venetian Red
5 Naphthol Red
6 Permanent Red FGR
7 Quinacridone (Red) (Permanent Rose)
8 Azo Condensation Red

Yellows
9 Arylide Yellow RN
10 Arylamide Yellow 10G
11 Arylamide Yellow GX
12 Diarylide Yellow
13 Azo Condensation Yellow 128
14 Nickel Titanate Yellow
15 Isoindolinone Yellow
16 Cadmium Yellow
17 Yellow Ocher
18 Raw Sienna
19 Transparent Gold Ocher
20 Mars Yellow
21 Naples Yellow

Blues
22 Phthalocyanine Blue
23 Cobalt Blue
24 Ultramarine Blue
25 Cerulean Blue
26 Indanthrone Blue

Violets
27 Quinacridone (Violet)
28 Mars Violet
29 Dioxazine Violet

Greens
30 Phthalocyanine Green
31 Oxide of Chromium
32 Viridian
33 Cobalt Green
34 Terre Verte

Browns
35 Raw Umber
36 Burnt Umber
37 Burnt Sienna
38 Mars Brown

Blacks
39 Lamp Black
40 Ivory Black

Whites (not illustrated)
Flake White (see note on toxicity, p.29.
Cremnitz White
Titanium White
Zinc White

Lightfastness and toxicity

Alizarin Crimson is not included on the *Recommended palette* (p.173) because it does not match the lightfastness of the other pigments. Alizarin Crimson is generally used full strength for glazing; it has poor lightfastness in tints (mixtures with white). So, it is suggested that "permanent" Alizarin Crimson, based on more permanent, synthetic organic pigments such as the Dioxopyrrolloyroles and the Quinacridones, is used. Cobalt colors can cause allergic skin reactions.

The lead content of Flake White, Cremnitz White, and Naples Yellow means they should be handled with care (see p.370 for information on working safely).

Nomenclature of tube oil colors

The names of tube colors often bear little relation to the pigments they contain, and you cannot rely on specialized pigment knowledge from the retailer. With an artists' quality tube color called "Cobalt Blue," for instance, you should be able to rely on the manufacturers using pigments identified by the name, but this is not always so. What appears to be a pure pigment color may be a blend. Some blends are reliable, but others may incorporate unstable colors.

Fortunately, most reputable manufacturers are starting to identify pigments on the tube. If nothing else, they usually publish a list of the composition of pigments, to help you check exactly what you are buying.

Materials

Transparent pigments

The Quinacridone and Phthalocyanine pigments are especially useful in glazing since they are so "clean" and transparent. They provide pure colors that may be mixed to almost any hue. The Azo Condensation Pigment Yellow 128 is similarly effective. Burnt Sienna is a particularly useful orange/brown, while Raw Sienna or Transparent Gold Ocher provide a more low-key glazing yellow. Their high tinting strength also makes these colors well suited to opaque painting methods when used in tints with white or other opaque colors.

Preparation Making your own oil colors

Making oil colors involves grinding pigments and preparing the colors as described in *Tempera* painting (see p.163), except that for oil paints it is a drying oil (usually linseed oil) that is used to grind the pigments and act as the binding medium.

There is, however, a question as to whether anyone really needs to prepare their own oil paints nowadays when there are many reputable manufacturers preparing reliable artists' oil color. If you do wish to make your own paints, you should take careful precautions as outlined on p.371 when dealing with pigment powder, and you should avoid grinding any toxic pigments. (See note after pigment list.)

When you make your own colors, problems such as the separation of oil and pigment in a tube due to over-long storage do not arise and, in general, there is no need to add the specialized ingredients used by manufacturers. It is probably best to avoid pigments such as Ultramarine, which are very difficult to grind into a workable consistency without the addition of stabilizers or thickeners. Adding a little poppy oil may

produce a more acceptable consistency. I have found that pigments said to be difficult to grind in oil, such as Viridian, make perfectly good oil colors if ground for a little longer than usual.

The only additional ingredient that may be added is wax (in small proportions of up to 4 percent). It acts as a stabilizer to stop the color from running out and increases thickness and oil absorption. Add wax to the oil in small lumps and warm the oil until it melts.

Using linseed oil

The kind of linseed oil generally recommended as a grinding medium for most colors is cold-pressed, although a good-quality, alkali-refined oil can be used and is generally used by manufacturers.

Using other oils

Poppy oil, which is slow-drying, may be ground with fast-drying pigments to achieve a more uniform drying time through the range, but it is more important in the grinding of white pigments, since it is pale-colored and less yellowing than linseed oil. Fresh walnut oil is an alternative.

1 Place pigment in the center of a glass slab, make an indentation in the center, and pour in a little oil.

2 Carefully bring the pigment over into the oil and mix with a palette knife.

3 Grind with circular strokes of a glass muller until a buttery consistency is reached.

Vehicles, mediums, and diluents

The "vehicle" is the binding medium (such as linseed oil) that holds the pigment in suspension and attaches it to the support. A "painting medium" is often used to adjust the characteristics of the paint when applying it, as in the application of transparent glazes, for example. The painting medium may simply be a mixture of a drying oil and a solvent such as turpentine. It may also incorporate a resin varnish, although there can be problems associated with this (see below). You generally mix the painting medium to the tube or homeground color on the palette before painting. For many applications, you can simply use a diluent, such as turpentine, oil of spike lavender, or paint thinner, to thin the oil color before use.

Materials Oils as oil painting vehicles

The oil vehicle is generally either linseed oil, nut (walnut) oil, poppy oil, or safflower oil. Both walnut and linseed oils were used extensively from the 1400s, the linseed oil (with its superior drying properties) gradually proving the more popular. Poppy oil became popular in the 19th-century French school.

Linseed oil

This widely used drying oil acts both as a vehicle for grinding pigments and as an ingredient in oil painting mediums. It has been claimed that the "suede effect" (where brushstrokes made in one direction appear different in tone from those made in the opposite direction) is removed by the use of cold-pressed oil. In fact, the effect is not related to the oil but to stabilizers used in the color.

Other forms of linseed oil, such as stand oil (see p.31) and sun-thickened or sun-bleached oil, are used as painting or glaze mediums on their own, or in conjunction with other materials. They are more reliable on their own where they can be diluted to a workable consistency with an essential oil such as turpentine or, for slower drying, with oil of spike lavender. Stand oil is somewhat slower-drying than sun-thickened or sun-bleached oil, but is recommended for its non-yellowing characteristics and the fact that it retains a certain flexibility on aging.

Nut oil

Made from walnuts, this is paler than linseed oil and recommended for use with the paler pigments. In the 1600s, artist and author Henry Peachum recommended it for use in whites for ruffs and linens. "Grind all your colors in Lindseed oyle, save when you grind your white for ruffes and Linnen: then use the oyle of walnuts, for lindseed oyle will turn yellowish."

Poppy oil

This is a slow-drying medium, suitable for direct wet-into-wet painting methods, but should not be used when painting in layers.

Safflower oil

This is used particularly for grinding white pigments. The same care should be taken regarding overpainting as with poppy oil. A paint film with safflower white underpainting and overlaid colors in linseed oil could be unsound.

Cooked oils

Although cooked oils (see below) were popular in the past, they are now considered so unreliable and dark that they should not be used in painting.

Materials

Oil painting mediums

There are many recipes for oil painting mediums that have been popular at different times. All have different qualities, but the safest method of oil painting remains that of using the tube color as it comes, or simply thinned with turpentine, paint thinner, or oil of spike lavender. If necessary, you can simply use a little stand oil thinned with turpentine or paint thinner as a painting medium and for techniques such as glazing.

But painting in oils has a long history, going back well before the latter part of the 1400s, when it became the preferred medium for painters. During that time, there have been countless recipes published for painting mediums, among them the cooked oil/resin varnishes.

Cooked oil/resin varnishes

Cooked oil/resin varnishes are now obsolete for oil painting purposes because of their dark color. They were made by heating a hard fossil resin (such as Baltic amber or copal) with the drying oil, in a proportion of around 3:1, which resulted in a thick varnish, like clear honey. This had good film-forming properties and was strong, durable, and glossy. The *vernice liquida*, as it was called, was a very dark reddish-brown.

Solvent varnishes and oleoresins

Other types of oil varnish incorporated soft resins like mastic or pine resin in nut oil to produce a paler varnish (*vernice chiara*) that could be used with colors such as green and blue that would be affected by the reddish tone of the *vernice liquida*. These varnishes still had a tendency to darken.

Soft resin varnishes, made by dissolving a spirit-soluble resin such as mastic and, later, dammar, in turpentine distillate, became widely used in the 1600s. They were often mixed with drying oils to produce a faster-drying painting medium than could be had with drying oil alone. The balsams or oleoresins such as Venice turpentine, Strasburg turpentine, or Copaiba balsam were also extensively used with drying oils or resin/oil mediums. The resinous ingredients helped to give a lustrousness and depth to a painting through their highly refractive transparency, and to facilitate the handling characteristics of the oil paint for effects such as glazing. Venice turpentine has been most often used (Canada balsam is a possible substitute). Copaiba balsam was used in the past, but is very dark and prone to cracking. For this reason, none of the balsams is recommended. Dammar varnish probably has the best all-around properties, if a soft resin varnish is to be used as an ingredient in a painting medium.

Preparation Making dammar varnish

The dammar resin generally available to artists comes from Singapore, in the form of small, transparent, straw-colored lumps, usually coated with white, powdery, crushed resin.

To prepare dammar (or mastic) varnish, place the resin in an old stocking or a muslin bag and suspend it for several hours in turpentine. Make sure that the container is securely sealed. The resin gradually dissolves, and any impurities remain in the bag. Strain the varnish again through a clean piece of cotton or muslin; it is then ready for use. The proportion should be around 7–11oz (200–300g) dammar per 20fl oz (600ml) turpentine.

If you wish to add dammar varnish to a painting medium of stand oil and turpentine, for example, you should add only a few drops, to avoid the problems of resolubility discussed above.

Materials

Alkyd resin mediums

Several manufacturers make painting mediums based on synthetic alkyd resins. These are believed to be as good, if not better, than those made with natural resins. Although they have been available for 40 years, there appear to have been no long-term investigations with regard to their durability.

The alkyd resin film dries harder than the film produced by a drying oil. It withstands movement, though whether it is more flexible than the oil film is debatable. The drying process of alkyd-based color is much faster than that of oil-based color, and after six months, it is as brittle as an oil film will be after five years. There is some reason to think that it does not embrittle further after that time. As far as yellowing is concerned, the alkyd is itself darker than a refined oil, and the inevitable addition of driers by manufacturers does tend to discolor the film. It does not, however, appear to undergo the progressive darkening of natural resins.

It would be inviting problems if you were to combine the use of traditional mediums with synthetic ones within the various layers of the painting. Alkyd-based mediums, particularly the "jelly" kind, should never be applied on a high-gloss oil surface; they will not adhere.

The problems of using resins

With the more widespread use of resinous ingredients from the 1600s to the 1800s came the problems with darkening, embrittlement, and resolubility of the paint film that have plagued museum conservation departments ever since. Paintings from these periods, where resins are more likely to have been used extensively, have not yet been exposed to the rigorous scientific analysis that might clarify the use of resinous materials in relation to technique and permanence.

The oxidation of resins can cause a severe progressive darkening, which is not generally so pronounced in drying oils. (A few resins—mostly dammars—do not darken to such an extent.)

The brittleness of a dried resin film is another reason for avoiding the excessive use of resins, as is the vulnerability of soft resins to cleaning solvents. On a painting made using just a drying oil as a medium, varnished when dry with a soft resin varnish, the varnish can be removed without affecting the paint film. But if a medium containing a high level of soft resin is used, the colors may be disturbed, even removed, by cleaning. Artists have been known to add finishing touches (to a painting) in a highly resinous medium, only to see them dissolve when the painting is varnished using a similar resin.

These problems have still not been fully resolved. Some artists insist their techniques and effects cannot be achieved without the addition of resinous materials. Others maintain that they can.

Water-soluble oil colors

There is no doubt that there is a strong mood for retaining the flexibility of oil color as a painting medium while getting rid of the dangers associated with the use of organic solvents. This has led in recent years to the introduction of "water-soluble" oil colors. There are two possible methods for making water-soluble oil colors. The first is to load the paint with surfactants. The potential damage associated with this method is that they may not dry, they may not be stable, and they may discolor. The second method is to combine the oil paint with something that is water-soluble at the molecular level, such as polyethylene glycol. But we do not currently know how the paints will react, especially over the long term.

One of the questions raised about water-soluble oil colors is whether or not water gets trapped in the paint film or whether or not it escapes.

Manufacturers are secretive about the composition of proprietary brands. However, it seems clear that as the concept is developed and the products are refined, there will be further moves in the direction of water-soluble oil color becoming available as a mainstream product. This will certainly offer a solution to those artists whose sensitivity to organic solvents means they are unable to use conventional oil colors.

Rigid supports and grounds

Although canvas is the most popular support for oil painting today, rigid supports are in general much more permanent and allow a wider choice of materials. With the right priming, supports like wood panels or honeycomb aluminum provide a much more permanent base than a flexible fabric. However, most artists, including myself, ignore this sensible advice and continue to paint in oils on canvas.

Technique

Using a gesso ground

Gesso (see p.58) is the traditional gypsum/glue size ground used over wood panels for oil or tempera painting. Although it is not strictly accurate, I have also described a ground made using chalk and glue size as a gesso ground since it is so similar. The smoothness and dazzling whiteness of gesso can be used to your advantage when working thinly in oil paint, or in oil glaze over tempera underpainting. Whether or not you are working on smooth or textured gesso, you must seal it before applying any oil paint. A chalk gesso ground is particularly absorbent. Unless it is partially sealed, too much oil from the paint is taken up by the chalk, leaving the paint too lean and causing the chalk ground to yellow. The sealer should not totally shut out the oil paint from the ground, but should allow a degree of absorbency.

Sealers for gesso grounds

Several different sealers may be used over gesso (see also p.60). Proprietary plaster sealers are available, but the simplest choice is a coat of the glue size used to seal the panel and to make the gesso. Dilute this with water to around half its strength; one coat is usually sufficient. There is a marked difference between applying oil color to this treated ground and applying it to an untreated one. On sealed gesso, the strokes are fluent and the paint is manipulable.

A sealer that can only be used on a rigid support (its film is more flexible than that of oil paint) is proprietary acrylic medium thinned with water. Make sure to water it down enough for it not to leave a glossy, glassy film over the gesso.

Sealing gesso Using a flat, wide brush, apply a single coat of glue size over the area.

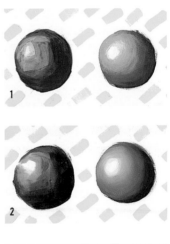

The effect of sealers on gesso In each case, the left-hand sphere is painted transparently in Phthalocyanine Green and the right-hand one opaquely, with Titanium White added to the green.
1 Unsealed panel
2 Glue size
3 Thinned acrylic gloss medium

Preparation Modifying a gesso ground

A thick-textured white ground for oil paint can be created by stirring well-washed sand into gesso before applying it to the panel. Use thick, lathered strokes of a wide bristle brush. The texture allows you to paint economically because it makes the color look more richly worked than on a smooth ground.

Sand-textured gesso ground, sealed with glue size

Oil paint applied over sand-textured gesso The green ground color appears as an overall texture through the brushstrokes.

Incising a gesso ground

Carving into a thick bed of wet gesso with a painting knife and applying oil paint on top creates a textured pattern in heavy relief. Used in this way, the gesso has a very positive role in the painting. Brushstrokes made in different directions trap pigment on "crags" of gesso, causing complex color effects where different colors retain their purity, but work together optically to produce mixtures.

Gesso ground incised with a painting knife

Drawing on gesso with gesso

Liquid gesso poured onto a smooth gesso panel creates a relief outline image. The gesso is ready for pouring a few minutes before it starts to "gel." If it is too liquid, it does not have the body to form lines. For color effects, add pigment to the liquid. Seal the gesso before painting on it.

Dripping gesso with a brush Fill the brush with gesso and drip it over the surface to create a fluid but solid three-dimensional line.

Preparation Other primings for rigid supports

Other more straightforward grounds for oil painting on rigid supports include primers such as the proprietary Titanium White pigmented, oil-modified, alkyd resin primer. In some ways, it is superior to the older White Lead in linseed oil priming, which can yellow and has to be left for some time before painting. The so-called acrylic gesso primers (which are not gesso at all, but pigmented acrylic emulsions) may be used as a ground for oil painting on rigid supports.

Preparation Using unprimed, rigid supports

Several painters have worked in oils on rigid supports without applying a conventional priming, incorporating the color of the panel itself as a kind of toned ground. The oil paint may be applied in touches, leaving parts of the colored ground visible. On a ground like this, an opaque technique must be used if the true color of the paint is to be retained. And to ensure the permanence of the painting, unprimed panels should be sealed. The amount of sealer needed depends on the degree of absorbency of the panel—a medium-density fiberboard, being particularly absorbent, will require a great deal more than a piece of standard plywood, for instance. Glue size, gelatine, or acrylic medium may all be used (see p.180).

Technique
Back painting on glass

Glass is one of the most stable of all supports. Provided that it is properly handled, an oil painting on glass is more permanent than one on canvas. The best glass to paint on is sandblasted on one side to create a slightly matte surface that is perfect for painting on and provides a good key for oil paint. Sandblasting does not affect the transparency of the glass.

Although glass can be used like any other support, a procedure unique to glass is back painting—a reverse of the normal method, beginning with the highlights and working back through glazes and underpainting to the priming, which is the last coat to be applied. As in a normal painting, the primer acts as the light-reflecting backdrop for the colors, and the painting is viewed through the glass from the unpainted side.

Use relatively thick glass (⅛–¼in/ 4–6mm) or even toughened glass, because it is less likely to break. Clean and degrease it with a proprietary glass cleaner before painting. You can use bristle or soft-hair brushes on sandblasted glass. For a multi-layered approach, allow sufficient drying time between coats before overpainting. Remember that opaque color applied to the glass will effectively obliterate any further strokes you may make over it.

To avoid drawing on the painting surface (back of the glass), draw the image on a piece of paper and place it under the glass while you paint. Or draw on the "spectator's" side of the glass in all-purpose pencil, which can be rubbed off when the painting is completed.

1 The face is painted entirely in tones of white. The density of the paint is built up in highlighted areas —the middle of the forehead or down the center of the nose, for example.

2 You can check on the progress of the work by turning the panel over and holding it up against a dark background.

3 Once the face has been fully modeled, the paint is allowed to dry. Subsequently, a coat of Burnt Sienna mixed with a little Titanium White is painted over the whole image.

Finished painting When the opaque Burnt Sienna layer is dry, the painting can be turned over to show the fully modeled face.

Flexible supports and grounds

Canvas is the traditional flexible support for oil painting, although artists have experimented with many other fabrics—both primed and unprimed. Canvas is discussed in *Supports*, pp.52–54. Choice of weave is important, and has a considerable effect on the appearance of a painting. The range of weaves available in linen canvas for artists' use is considerably wider than those in cotton—you can choose from fine or textured surfaces, depending on the painting. However, with polyester, which is more permanent than linen and cotton, you are restricted to an even more uniform texture.

Preparation

Using unprimed flexible supports

If you wish to paint on unprimed canvas, you should at least protect the fibers from the oil paint by sizing. A weak solution of glue size or gelatine (applied hot) provides the traditional barrier between oil and fibers. Another possibility is a solution of carboxymethylcellulose (used for sizing in the textile industry), which does not appear to suffer the expansion and contraction problems of animal glue. Acrylic medium is too flexible to be used below oil color on flexible supports.

Many flexible materials have been used unprimed, including velvet, tarpaulin, and curtain fabric. Their strength and permanence depends on the fiber from which the fabric is made. Polyester sail-cloth does not have to be sized, but it is translucent, and absorbs oil and diluent rapidly. Although the paint moves around easily and can be blended well, it should be used thinly, otherwise a dry pigment deposit will be left on the absorbent surface.

Paul Klee

Painting on unprimed canvas
There are many modern examples of work on unprimed canvas. In this oil painting on jute canvas, the color and rough texture of the jute span the gap between black and white, providing a rich matrix.

W I (In Memoriam)
(1938), PAUL KLEE

Technique

Primings for flexible supports

The priming of flexible supports is discussed on pp.55–57. For oil painting, the priming needs to be flexible enough to withstand the movement of the canvas, but no more flexible than the oil paint film or this may crack. An oil priming should be protected from the canvas fibers by a weak solution of glue size.

Although a traditional gesso ground would be much too brittle on canvas, it is possible to scrape or brush a very thin gesso priming into the interstices of the sized canvas. It is still a good deal more absorbent than a regular oil priming and is not recommended.

Nowadays, oil priming is generally a Titanium White-pigmented, oil-modified, alkyd-resin primer that dries in around 24 hours. Two thin coats should give a uniformly white surface. The more traditional White Lead in linseed oil takes longer to dry. Some painters use household paint for priming. However, none of the household products has been specially formulated for artists' use, and they are probably best avoided.

Thin gesso layer on fine linen

Oil priming on fine linen (left: two coats; right: one coat)

Oil priming on coarse linen

Oil priming on cotton duck

Oil priming on polyester fabric (left: uncoated; right: two coats)

White grounds

When you come to oil painting for the first time, you might assume that a painting is normally made on a white ground. Prepared canvasses usually have a white priming and there would be no particular reason for thinking that the color of the priming might be modified. In fact, white grounds for oil painting only really came back into favor with Impressionism. From around the early 1600s, artists had more commonly and very successfully utilized a ground that was itself colored, or tinted with color prior to painting.

There are, however, very positive aspects to working on a white ground. The reflective white ground shows the purity of individual touches of oil color, especially if they are applied thinly. For the artist there is also a sense of having to cover the whole of the ground, which often leads to a more consistent overall look than painting on mid-to-dark toned grounds. This accounts for the Pointillist or Divisionist style (see p.191), where the whole surface is covered in a series of short brushstrokes.

Traditionally, the white ground has been used to illuminate thin layers of transparent oil color laid over it. With the inevitable increase in transparency over the years of even opaque oil color, painters are advised to incorporate the underlying whiteness of the ground in their work. There are innumerable variations on glazing techniques that incorporate the white ground in some way. They range from working entirely in thin, transparent, or semi-transparent color directly onto the ground, to glazing over various kinds of underpainting. Other techniques include leaving one part of the ground white if you want that part of the image to stand out, and putting a tint over the rest of the ground (see p.186).

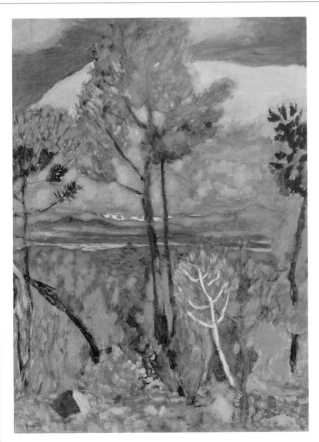

Landscape PIERRE BONNARD

Pierre Bonnard

Using color on a white ground
The positive use of a white ground is exemplified in some of the paintings of Pierre Bonnard, whose fluffy, smudged, and subtle brushwork is consistent over the whole of the white surface of a large canvas. Considerably more actual painting is involved than there would be on a colored ground, where the artist can afford to leave larger gaps between individual touches of pigment. Bonnard exploits to great advantage the juxtaposition of colors such as lilac and pale green, blue and pink, which can be seen in their purity on the white ground. Here, he has utilized adjacent color harmonies, in particular yellow/greens with blue/greens. The brushstrokes are all quite tentative, but strong shapes arise out of them, giving the painting great form.

Colored grounds

Painting on a uniformly colored, mid-toned ground is an economical and efficient way of establishing a complete range of tones from light to dark on your painting. The lighter tones can be painted opaquely using colors in mixes with Titanium White, for example, while the darker tones are often painted thinly with dark, transparent colors such as Burnt Umber.

When describing colored grounds, "toned ground" is used to describe an opaque, colored ground, or one in which the color is incorporated into the priming or added as an opaque layer (or color mixed with white) on top. "Imprimatura" describes a colored ground consisting of a thin, transparent film of paint laid over a white priming so that the luminous, reflecting quality of the white is retained.

Preparation Toned grounds

Nowadays, making an opaque toned ground involves mixing oil color with white (oil) priming. You will need to thin the tube-consistency oil color with turpentine before mixing it into the priming. If your canvas already has a white priming, mix the color with white oil color and paint a thin coat over the priming. Dilute the paint with turpentine or paint thinner, not with additional oil or painting medium. Let it dry before painting over it.

Preparation

Applying imprimaturas

There are three safe ways to apply an imprimatura:
- Mix the chosen oil color with turpentine, paint it over the support and, after a few minutes, rub it off with a clean cotton rag. The result is a transparent stain of color over the primer. This occurs even with an opaque color like Yellow Ocher, since it is spread so thinly. It dries quickly and is generally ready for painting on the next day
- Use a very thin acrylic wash. This can be applied with a sponge. Although painting in oils over acrylics is not to be recommended, the quantity in the imprimatura is so negligible as to make its use fairly safe from the point of view of flexibility and of adhesion
- Apply a thin watercolor stain. This has no adverse effects. Like the acrylic, it dries rapidly, so the oil painting may be started immediately.

Other suggested vehicles for imprimaturas include colored gelatine or glue size, highly diluted shellac, egg/water, a soft resin varnish, or a glazing medium. I do not see any great advantage in these; they introduce resinous ingredients or needless complexity.

Why use a toned ground or imprimatura?
The point of these grounds is to provide an overall matrix for superimposed colors and to give a light-to-mid-tone base over which lighter tones, highlights, and mid-to-dark tones can be worked up. Painters trained to use a white ground are invariably surprised at the economy of method that such a ground brings to their painting.

Opaque toned grounds are mostly used with opaque painting methods, where the reflecting qualities of the white ground are not so important. An imprimatura is more suitable when the transparency of some of the paints is an important factor.

Before wiping off
Here, the white-primed canvas has been painted over with Raw Sienna thinned with turpentine.

After wiping off
The same canvas has been "wiped off" with a rag, leaving the stain of overall color characteristic of an imprimatura.

Technique

Painting on a white and on a colored ground

You can see how the jug on the colored background, painted with Titanium White for the highlights and a Burnt Sienna/Phthalocyanine Blue mix for the shadows, has more substance than the one painted on the white ground.

White ground On a white ground, you cannot add white highlights.

Colored ground The opaque white adds dimension and highlights.

Technique

Painting the preliminary stages on a colored ground

The following images show the first stages of painting on a colored ground. In this case, a mid-tone, Burnt Sienna imprimatura was applied (as above) to the white priming and allowed to dry. Following an optional drawing in of the image in charcoal, which is subsequently brushed off, leaving a faint guide to the forms, the painting is normally progressed either by beginning with the lightest tones and painting them in in opaque white, or sketching in the darker tones first in thin, transparent color. Some artists prefer to sketch out the whole work in thin, dark tones to begin with, adding the lighter tones toward the end of the first stage of painting. Whichever way you prefer to work, you will begin to see a fully dimensional painting after these two preliminary stages.

1 The broad outlines are sketched in charcoal; this is brushed off, leaving the lines visible. (If you brush off the charcoal, it will not contaminate the oil color when applied.)

Finished sketch A Burnt Sienna/ Phthalocyanine Blue mix is used thinly to designate the areas that are in shadow. The result of these three straightforward stages of painting is a well-modeled image to which color and detail can now be applied.

2 Titanium White is painted opaquely or semi-opaquely over the areas that are in the sunlight or are light in tone.

Technique Painting on mid-to-light-colored grounds

Although painting on a mid-to-light-toned ground may result in a slight lowering of tone compared to what might be had on a white ground, the advantages related to fast and accurate modeling of form and to the judgement of tone and color outweigh such minor effects. And with an imprimatura, which is simply a veil of transparent color, the luminous effect of the white ground may still be used to great advantage. Rubens' work shows his expertise in this technique, his paintings show fully modeled forms with rich tone and atmosphere.

Painting on a mid-tone imprimatura

Rubens' technique for painting on a colored chalk/glue ground follows the pattern outlined above. His *Samson and Delilah* in the National Gallery in London is a very good example of thin, transparent darks in the shadows and rich, opaque colors for the lights. Rubens put a warm, yellow-brown imprimatura over the priming in this painting, and if you look through the transparent, mid-to-dark and dark tones, you can see the rapid, striated brushmarks with which the ground was colored.

I have recreated the (5 + cross section) stages by which Rubens might have painted the swag of drapery in the middle at the top of the painting.

Samson and Delilah *(ca. 1609),* PETER PAUL RUBENS
There is an unparalleled economy and fluency in Rubens' technique on a mid-toned ground.

1 The striped imprimatura is made by mixing Raw Umber with Raw Sienna and Burnt Sienna. This is applied vigorously with a wide bristle brush and allowed to dry.

2 The image is then sketched in charcoal. This is dusted off to leave a faint indication of the form. The background is painted in a thin, transparent mixture of earth pigments.

3 The mid-to-dark tones of the drapery are painted in thin, transparent colors. The mixture is used more thickly for the darkest shadows, more thinly for the mid-to-dark ones.

4 The mid-to-light and the lightest tones are painted using Flake White tinted with the purple mixture as above or on its own. This is smoothed and blended with dry brushes.

5 When this is dry, the drapery is reworked with thin, transparent glazes and thicker, opaque highlights.

Cross section The chalk/glue ground with the yellow/brown imprimatura, white highlight layer, and thin, red glaze with grains of blue/black charcoal can be seen in this cross-section

Technique Painting on mid-to-dark-colored grounds

Traditionally, these are used for *chiaroscuro* effects, where the contrast between brightly or partially lit objects and dark backgrounds is emphasized. The best painting method is to work with light-toned, opaque pigment out of a dark ground. Keep the dark background color as thin as possible and avoid excessive oil or resinous components. The increasing transparency of oil colors with age means that colors applied over these grounds should be opaque and painted reasonably thickly.

Jacopo Bassano

Opaque oil color on a dark ground
This small painting illustrates the use of light-toned pigments on a dark ground well. It demonstrates a facility and yet an economy of execution that captures the surprise and immediacy of the moment. It is the work of an elderly artist who needs only to capture the essentials of the drama, but manages to do so with subtlety and assurance.

Susanna and the Elders
(1585), JACOPO BASSANO

Technique

Choosing the color of the ground

The possibilities opened up by the use of colored grounds are so great it is surprising that so few artists use them. Although the most traditional colors have been ocher or umber in the dull yellow to brown range, or red bole or Burnt Sienna in the dull red to orange brown area (with dull greens used to complement warm fleshtones in portraits), there are no color or tone restrictions.

In general, a cool green or blue ground has an overall cooling effect on the painting, whereas an orange/yellow or red warms it up. Such positive colors inevitably have a strong impact on a painting, which is why more neutral colors are often chosen. These do not dictate decisions about color too forcibly at an early stage.

Colored grounds may be chosen from a wide tonal range. If you wish to use very light tones or transparent pigments, however, a light ground such as a pale ocher, mushroom, or gray, is best. It allows transparent pigments to be used thinly while retaining their individual color characteristics; at the same time it allows white to be used for heightening and for adding dimension.

Sir Peter Lely

Portrait on a red ground
From the 1500s to the 1800s, the use of colored grounds of different tones was almost universal in Europe. The favored ground color varied from painter to painter. This unfinished study shows the head and part of the hair painted on an opaque, dull orange/red ground, where variations on pale fleshtones can be worked up more readily. On such an opaque ground, a painter relies heavily on the opacity of superimposed pigments for the lighter tones.

James II when Duke of York
(ca. 1665–70),
SIR PETER LELY

Technique
Painting transparent and opaque colors on a colored ground

The two sets of studies below show different approaches to working on colored grounds. In the first, the images are painted over a transparent Burnt Sienna imprimatura. In the second, they are painted onto an opaque Burnt Sienna plus Titanium White toned ground.

In each case, the bowl of fruit on top is modeled in white only and then, when the paint is dry, glazed with thin, transparent colors, while the bowl of fruit below is painted in premixed opaque colors.

The technique of glazing transparent colors over white underpainting (the top two in the illustrations below), yields a brighter, crisper quality than the opaquely painted versions below them. But the opaquely painted versions give a more mellow, integrated feel to the image. The techniques are not mutually exclusive, however, and are often combined in a work.

Diego Velázquez

Toning parts of the ground

It is a short step from the toned ground that covers the canvas to identifying certain areas of a painting that can be underpainted in particular colors. *The Rokeby Venus* is an outstanding example. After the painting had been slashed by a suffragette, it was found that the white lead priming had been covered with a layer of deep red paint, except under the figure of the Venus, where it had been left white. This gives the figure a notable and luminous presence and dictates a different painting method for figure and ground. The latter is painted with thin glazing colors over monochromatic underpainting, while the figure of Venus is richly painted in opaque colors.

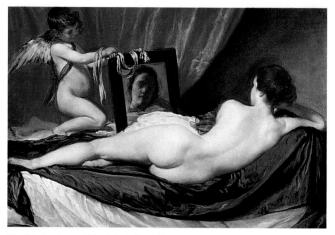

The Toilet of Venus ("The Rokeby Venus")
(1648 or 1649–51), Diego Velázquez

Glazed version 1
On the imprimatura, the fruit is painted white and, when dry, glazed with transparent colors.

Glazed version 2
The same technique is used as in the image on the left, but here it is painted on a toned ground.

Opaque version 1
Here, the colors are physically mixed with white before being applied to the canvas.

Opaque version 2
Compare the difference between the opaque version on a toned ground to that on the imprimatura (left).

Brushes and brushwork

Oil paints are possibly the most manipulable of the painting media, and they can show an enormous variety of effects—from smoothly blended, enamel-like surfaces to thickly impasted ridges of striated color. These effects rely to a large extent on brushwork. Real or synthetic, soft-hair, and bristle brushes may be used in oil painting to create effects with one, or several colors. Brushwork reveals a great deal of the character of its author. The examples of brushwork in this section show the diversity of effects and of the characters that inspired them.

Materials Choosing brushes for oil painting

The kind of brush used depends, broadly speaking, on:
- Viscosity of the paint
- Nature of the support
- Degree of finish required
- Scale of the work
- Style of painting.

For a discussion of the main kinds of brushes for painting, see pp.119–22.

Bristle brushes

With stiff, viscous paints used directly from the tube (for *alla prima* work, for example), bristle brushes should be used to move it around on the support. These can be handled vigorously—for "ladling" on and scrubbing in thick paint, for "push-pull" effects, or for applying dabs of thick color. They are also useful for brushing in large areas of color, to create a smooth, thin, overall tone. They are also suitable for working in broad, tonal areas such as in thin underpainting. On large-scale work, they allow you to work with a speed impossible with soft-hair brushes.

Soft-hair brushes

These work best with a more liquid mix that can be stroked onto the support. They are used for small-scale work—in particular for a smooth finish or detailed modeling. On a small scale, the points of fine, round sables may be "chiseled" between the fingers and stroked down a join between two colors for fine blending effects. Soft-hair brushes, especially sables, do have a certain resilience, and brushes such as red sable filberts can be used to push paint around, with a degree of elastic strength. Soft-hair brushes are often used to apply glazes (see p.198). There are also brushes that are used to modify the appearance of paint already on the canvas.

Technique

Blending oil colors

While many oil paint effects rely on strong brushwork, it is also true that one of the medium's characteristic aspects is that it allows the brushstroke to be made "invisible" by blending, or "sweetening." Just as the marks of the chisel may be erased from a sculpture, so the ridges of paint may be flattened, and adjacent tones and colors merged, allowing an image to express itself entirely independently of the brushwork.

Smooth gradations of tone or color are more easily achieved with oil paint than with any other painting medium. This is because the paint stays wet long enough for a larger number of tones and colors to be put down before being manipulated.

1 The two colors to be blended are applied to the canvas. Where they abut, you can see a sharp line.

2 Using a soft, filbert brush, stroke the join, wiping any paint off the hairs of the blending brush as you go.

Blending adjacent colors

The technique of blending two colors or tones involves taking a clean, dry brush (usually a filbert or flat) and stroking it down the join between the colors to blend the paint on each side. Keep wiping any paint off the blending brush using a dry, absorbent rag or paper towel. A bristle or soft-hair brush may be used depending on the scale of the work.

3 The edge has now lost its sharpness and is a smoothly blended join.

Blending for smooth tonal gradations

If you need to paint an area that moves smoothly and gradually from a light to a dark tone, one method is to mix a series of graded tones and apply these one by one across the area that requires blending. Then, using a dry brush, stroke the joins until they are smoothly blended.

Keeping the paint clean

It is essential to wipe the brush clean after each manipulation so that it does not contaminate the paint on the canvas. In the past, artists kept a stack of clean, dry brushes for this reason. This is important in portraiture, where the colors of a face can be easily soiled by a dirty brush.

Separate tones The columns show parallel and adjacent brushstrokes made in progressively darker tones, from white to black on the left and from yellow to red on the right.

Blending tones Here, the separate brushstrokes have now been smoothly blended or fused where the adjoining tones abut.

Technique

Softening contours or outlines

With oil paints, the shape of an image may be retained and yet softened slightly by blending with an adjacent color. Even the effect of minimal blending in this way is dramatic (see right). This technique is widely used in oil painting, where profiles of objects and figures set against contrasting tones, for instance, may need softening slightly. The amount of blending carried on between two colors can have a great impact on the appearance of a work. This is shown (right) by the yellow shape with a violet shadow against a gray ground.

The degree of softening required dictates the kind of brush you should use. For a minimal amount of modification, a small, round-pointed sable may be used. Its tip should be very lightly moistened with turpentine or paint thinner,

just sufficient to enable the hairs to be chiseled between thumb and forefinger. This is then stroked along the join between two colors to be blended. A flat, soft-hair filbert with its curved tip is useful for softening edges on a slightly larger scale. (Its edge can also be used for smaller-scale work.) On a larger scale still, a bristle brush can be used; again the filbert is useful.

Before blending The colors have been carefully painted into the separate gray, violet, and yellow areas.

Degrees of blending The edges of the yellow shape have been softened, while the violet shape is blended more fully with the gray background.

Technique
Blending a three-dimensional object

Even in comparatively crude, diagrammatic images, the blending or softening technique imparts a degree of smoothness and finish. It also takes away from an image the immediacy and presence of the straight brushstroke, replacing it with something more bland. This is shown by the two cylinders (right), where the softened version (far right) shows how blending generally reduces tonal contrasts. A variety of brushes, from a small-pointed sable to a bristle filbert, was used. Although in this case the image was left alone after softening, it is usual to bring up the darkest and lightest tones with repainting at a later stage.

Cylinder before blending This image shows all the main areas of tone blocked in prior to blending.

After blending The edges of the adjoining tones have now all been blended using a variety of brushes.

Technique Blending in context

In practice, the blending technique is used as much for small, detailed areas of a painting as it is over large expanses of canvas. It can be used where just two colors abut or where a whole range of colors is involved. The two examples below give an indication of this variety.

Initial painting The light and dark areas of the cliff face are painted in two tones. One is a Yellow Ocher and Titanium White mix and the other is a Burnt Umber and Burnt Sienna mix.

Blended version This has been worked with small sable brushes, and immediately gives a softer, more dimensional and realistic look to the cliffs.

Leaves on pond

The advantage of oil paint is that the colors are manipulable for many hours. This allows you to apply a range of colors and tones over a whole painting and leave the blending to the end.

Using a fan blender

The soft-hair, sable fan blender (see p.122), also known as a duster, smooths or blends the surface of a painting. Handled with a light "dusting" action, it completes blending and smooths out ridges in brushwork.

Initial painting Distinct areas of tone and color are loosely painted in over the whole area of the (small) canvas.

Blended version The same after blending. The painting now has considerably more depth and a uniformity of surface that holds the image together.

Frank Auerbach

Expressive impasted brushwork
This painting illustrates all three impasto techniques. Here, color loosely mixed on the palette gives varied striations of color through the stroke. The dark, "defining" lines are painted with extraordinary resolve. Painting wet-into-wet like this is not only difficult technically, but the stroke magnifies and accentuates any uncertainty that occurs during its making. This can be used to your advantage, as in the line of the mouth, for instance, which has a touch of hesitancy.

In the background to the left of the painting, zigzag strokes have been made into the wet paint with a bristle brush. They have their own expressive impact. Finally, the painting demonstrates the stipple effect, seen along the bottom edge of the painting.

JYM.I. (1981), FRANK AUERBACH

Technique Painting impasto

Impasto is the technique of applying paint thickly, so that the brushstrokes are plainly visible and create a textured effect.

Mixing colors on the brush
There is a marked difference between mixing colors completely on the palette and then applying the brushstroke, or putting two or three colors loosely on the end of the brush before applying the color. Where colors are mixed on the palette, an entirely uniform color is produced, despite the thickness of the stroke. Where the colors are only loosely mixed, they work both separately and together in the stroke, giving a lively appearance, with striated colors echoing the lines of the bristles.

Working wet-into-wet
When applying oil color thickly into wet color, the bristle brush must be well charged with paint. To ensure an unmuddied color, paint should be heaped on the toe of the brush, which is then stroked firmly and smoothly, at a shallow angle to the canvas, into the wet paint. Alternatively, the wet color can be partially mixed with the wet color beneath to create further striated color effects.

Stipple (push-pull) effect
By using a bristle brush and viscous oil paint, you can create a "stipple" texture. Push the brush into thick paint (or push thick paint into the canvas), then pull it away.

Technique

Employing other kinds of brushstrokes

The fluency, deftness, or vigor of individual brushstrokes within a painting can give it a particular freshness or immediacy. Brushwork can operate at extremes of wetness or dryness that each give a characteristic look to an image. From the curl of wet enamel from a vertically held brush over the horizontal painting, to the dry touches of stiff pigment stroked over the ridges of a very grainy canvas, the range of possible manipulations is very wide.

One approach is represented by short, chunky strokes of paint, laid down with no blending or further manipulations; each stroke makes its statement as it is placed. Such strokes seem to be just of a length to deposit the amount of thick paint that the charged brush holds; they are direct and abrupt. This kind of stroke characterizes much of the work of Van Gogh.

The impression of movement associated with the direction and vigor of the brushstroke can be exploited for particular effects. Vigorous, strapping brushstrokes can be used in a form of hatching. A series of strong, diagonal strokes may arise out of the natural movement of the arm that pivots at the elbow.

A less vigorous approach can be seen when small, separate touches of color are used; they combine optically (see *Pointillism*, opposite page). The small, flat, bright bristle brushes are said to have been invented for these short dabs of color. These strokes are seen in the late works of Seurat, for example.

Pointillism

The pointillist, or divisionist, method of painting relies for its effects on the juxtaposition of small dabs of relatively pure color. Theoretically, only primary colors need to be used, since mixtures of these produce secondary and tertiary colors. But most of the neo-Impressionist painters who used the technique were more pragmatic in their choice of colors. Such colors combine optically when perceived from a distance, creating fine gradations of tone and color that serve to define the image (see *Color mixing in oils*, p.193).

The technique is not limited to oils, but it was with oil color that the celebrated pointillist painters, Seurat and Signac, created their effects. The technique uses opaque color for the most part; any transparent pigments are generally used as tints with white. Other artists, such as Van Gogh, were influenced by the highly repetitive markmaking that characterizes pointillist painting, but opened it up into a freer, chunkier style of painting.

Georges-Pierre Seurat

Complementary color in pointillism

This is a characteristic example of the build-up of small dabs of color over the whole painting. From a distance, the work can be seen broadly to operate within a middle range of tones. It has a shallow dimensionality. The painting exploits one basic complementary color contrast throughout—between blue and orange/red. In the darkest areas, such as in the bodice by the arm, the colors are used full-strength. In the lighter areas, they are mixed with white. Tonal variation in the bodice, for instance, is achieved with around three tones of blue and three of orange/red. The flesh color is also broken with pale blue.

A Young Woman Powdering Herself (1889–90),
GEORGES-PIERRE SEURAT

Technique S'graffito effects

"S'graffito," the technique of scratching into a wet oil film, can be done with the wrong end of a paintbrush, a sharpened twig, painting knife, or other scraping device. It is effective in defining outlines or details for expressive effects. If there is a contrast in tone or color between the wet paint film and the color beneath, the outline will be distinct. It is excellent for drawing into a wet ground and avoiding the sullying effect of pencil or charcoal.

In this detail, loosely after Rembrandt, the dark color of the jacket below the ruff is painted and allowed to dry. Then a layer of Flake White is painted over the dark color in the shape of the ruff.

The lace design is then scratched through, using the sharpened end of a wooden paintbrush handle. Each time the paint is scraped back, the handle is wiped clean. This is an effective and economical means of creating very complex detail without having to paint each area of white separately.

1 A sharpened paintbrush handle is used to scratch through the wet, white paint on a dry, dark ground.

2 The pattern gradually appears as the white paint is gently scratched off.

3 The image shows a detail of the completed ruff.

Using a painting knife

Painting knives are useful for laying patches of oil color into the wet surface of a painting without sullying the overlaid color. They give a particular shape to the paint laid in, according to the shape of the blade and the method of application. Complete paintings may be made using painting knife techniques; they generally have a scraped and impacted appearance with a somewhat "geometric" look to the strokes, due to the flat edge of most blades. The flexible steel blade can also be used with some precision at the tip, to lay in small dots of color for details, highlights, or texture effects.

Alan Cotton

Controlled painting-knife technique

This small (12 x 12in/30 x 30cm) painting is a fine example of painting knife technique. The sunlight on the sides of the houses with their gray-blue shadows against the golden ocher ground gives a real sense of light and color and makes the composition into a series of fully dimensional geometric planes. The artist has used deft and precise touches of the knife to apply these planes in impasted oil color. Great control is required for this technique at this scale, and yet the painting remains calm and light. The horizontals and diagonals of the hillside architecture are applied with longer, more vigorous strokes of the blade and provide an element of movement in this quiet landscape.

Provence—The Village of Lacoste (1998), ALAN COTTON

Technique Holding and using the painting knife

Like brushes, painting knives come in a range of sizes, for use according to the scale of the painting and the nature of the mark required. The most common blades are pear, trowel, or diamond-shaped, but other knives are available with squared-off, serrated ends (see p.124).

Painting knives should not be confused with palette knives, which are used for moving and mixing paint on the palette and occasionally for laying in large areas of wet color on canvas. Painting knives are designed for more subtle manipulations. Their cranked shaft keeps your fingers away from wet paint while the blade does its work.

Grip for bold effects There are a number of ways of holding a painting knife. For vigorous manipulations, grip the knife handle as you would grip a trowel.

Grip for sensitive effects Hold the knife like the bow of a violin. If rested on the springy part of the blade, the index finger can push the very tip of it into the paint.

Regular grip Between these two extremes, a common method is to grip the wooden handle with the index finger pushing against the steel shaft.

Color mixing in oils

There are three basic methods of "mixing" color in oil painting. First, you can physically mix two or three colors together to get a third color that you then apply to the canvas. Or, you can paint a transparent or semi-opaque color over another dried color already on the canvas, to make a third color. Finally, you can juxtapose small touches of different colors to create the impression of a third color.

Technique
Physically mixing color

Two opaque colors can be mixed to produce a third. If one of the colors is lighter, it is important to mix the colors by adding touches of the darker color to the lighter one, rather than the other way around. An opaque and a transparent color combine to produce an opaque color, and two transparent colors mixed together produce a third transparent color. Note that the physical mixing of colors in this way involves an inevitable lowering of tone and purity. So an orange produced by mixing red and yellow will appear slightly duller than a natural orange pigment. The more colors involved in the mix, the greater is this effect.

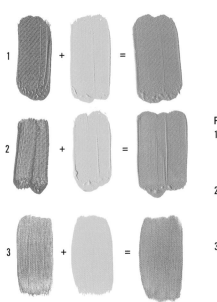

Physical mixtures
1 Cadmium Red mixed with Cadmium Yellow Pale makes opaque orange.
2 Quinacridone (Rose) mixed with Cadmium Yellow Pale makes a similar opaque orange.
3 Quinacridone (Rose) mixed with Pigment Yellow 128 makes transparent orange.

Technique Overlaying color

Glazing
In glazing, a third color is produced by superimposing a transparent film of oil color over another color. The orange produced by glazing transparent red over yellow has quite a different appearance from that produced by physical mixing.

Glazing Permanent Rose has been glazed over Cadmium Yellow.

Scumbling
The technique of scumbling, which is related to glazing, involves loosely brushing a thin film of opaque or semi-opaque color over a second color, which may actually show through in places but which retains an important influence on the surface appearance of the paint.

Scumbling Cadmium Yellow has been scumbled over Permanent Rose.

Technique Juxtaposing color

Small touches of two (or more) colors placed close together appear to combine in the eye of the viewer, to give the appearance of a third color.

Adjacent colors
From a distance, the eye would combine these colors to make orange.

Technique
Using high- and low-key color

The terms "high-key" and "low-key" generally refer to the brightness and saturation of colors. In paintings characterized by low-key color, color is used in unsaturated form in tints and shades. Low-key painting may be subdued rather than bright, but it can also be extremely delicate and subtle. High-key paintings are characterized by the use of bright, saturated colors.

The colors in a high-key painting are invariably applied unmixed, in pure primary or secondary tones, and produce a light, fresh, vibrant quality. This can be enhanced by such effects as complementary color juxtapositions. From the mid-1800s, after the color theories of Chevreul began to be assimilated, the incorporation of these kinds of color contrasts became a conscious aspect of picturemaking (see *Color*, p.345). Such effects are especially appropriate to oil painting, which imparts rich and lustrous luminosity to the colors.

High-key painting

The industry and culture of the 20th and 21st centuries has produced a wealth of high-key saturated color to dazzle the eye and stimulate the brain. The source imagery for the painting below contains the intrinsically high-key color of the costumes and lighting in Latin-American dancing, but the color has been "enhanced" by being viewed through a digital monitor in which the colors have been further saturated. In addition, clean, bright, modern pigments have been used to match the colors on the screen and a further textural quality is added in the rich, impasted brushstrokes.

Gwen John

Using low-key color

Among artists whose strength of purpose is revealed in work that also reflects their retiring nature is Gwen John. Her low-key portraits are made with a quiet care based on penetrating observation. The meditative nature of the work is intensified by a subdued palette. Its "neutrality" gives the restrained colors an extraordinary strength.

Girl in a Mulberry Dress (ca. 1920–23), GWEN JOHN

Saturated color
The depth and saturation of color is a quality that oil paint in particular can bring to a painting. The oil medium imparts a lustrous and rich luminosity to the colors. Here, the complementary contrasts between green and red enhance the effect.

Alla prima or Direct painting

This direct painting method is technically very sound. The reason is that all the paint in any area of the painting is applied in one session, or at least while paint on the surface is still wet. This means there are no problems with different amounts of oil or resin, or different drying speeds between paint layers, since there is effectively only one layer. The method came into favor with the Impressionists who, in order to continue working wet-into-wet as long as possible, often used the "semi-drying" poppy oil as a vehicle, although it is, of course, possible to paint directly in colors ground in any of the standard drying oils.

Technique The principles of *alla prima* painting

In many ways, *alla prima* painting is the most difficult method of working in oils, since it relies so much on every brushstroke being successful, not only in its own expressive terms, but also in the choice of color and tone of the paint that it deposits, and in relation to the color, tone, and form of the brushstrokes next to it. It is, of course, possible to scrape an unsuccessful area off the painting while it is still wet and rework it. Many artists do this, so that what appears as completely fresh and fluent, may actually represent the sixth or seventh attempt. This is perfectly acceptable as long as you get it right eventually.

The ability to observe an image and transcribe it directly in paint on canvas is usually the result of a great deal of practice, usually in more systematic methods of painting. This practice helps you to build up a personal "language" in the use of paint that can be brought to bear on any subject. Achieving fluency in the "language" involves an intuitive ability to judge and prepare on the palette precisely the right tone and color mix for any area, and then to select the right brush and the right painting method. It also involves the ability to make decisions and take risks.

In many ways, *alla prima* painting is best suited to small-scale works that can be completed in one session. It is a good method of producing oil sketches that may later be transcribed into larger "studio" works.

"Systematic" *alla prima* painting

Not all *alla prima* painting is made with an expressive flourish. Some artists paint directly, but work slowly and methodically across the blank canvas until the whole surface is covered, possibly over a carefully drawn, preliminary image in pencil. By using this approach, the essence of *alla prima* is somewhat lost. However, whatever the working method or style adopted by the artist, paintings that are worked up directly with no overpainting share an intimacy and a fresh "surface" quality that the spectator may respond to with equal directness.

John Singer Sargent

Alla prima as an expressive technique
This detail showing Claude Monet at his easel has all the exhilaration of the experience of working *alla prima* outdoors. There is great economy and movement in the loping brushstrokes, and the paint looks fresh from the tube.

Claude Monet Painting at the Edge of a Wood (1888),
JOHN SINGER SARGENT

Technique Painting *alla prima* on a colored ground

Alla prima painting does not have to be made on a white ground. This small, still-life study is painted directly, using opaque colors, on a mid-toned ground. The beauty of this method for direct painting is that the warm brown of the ground shows through in any gaps between adjacent colors, providing a unifying matrix for the painting. The work can be painted with great economy, retaining the *alla prima* look.

1 The lightest tones in the background are sketched in using opaque oil color.

2 The background colors are painted in separately, using clean brushes for each color.

3 The apples are then painted, working progressively from the lightest to the darker tones.

Finished painting The study retains the freshness of color applied *alla prima* and not overpainted.

Technique

Multilayering *alla prima*

There are no definitive boundaries between *alla prima* and multi-layered painting. A rough underpainting can form the basis for an essentially *alla prima* work. Here, the broad areas of a landscape might be roughly underpainted in various tones and colors appropriate to particular areas, then painted directly with superimposed touches of local colors. The underpainting would have an unifying effect, but the painting would retain an *alla prima* character. A more finished underpainting might provide the formal basis for work that is overpainted in a direct way with spontaneous brushwork and use of color.

Tips for successful *alla prima* painting

Keep to a limited palette of around eight colors. Too many are difficult to coordinate, and most of the tones and colors required can be mixed from a limited palette.

- Avoid muddying colors—use several brushes. Keep a brush or brushes specifically for similar tones or colors repeated in the work. Preserve some for pale tints and white; others for the dark tones.
- Charge the brush well with color. This helps to keep the paint that is laid into wet color clean. Hold the brush at a shallow angle to the canvas.
- Avoid complicated mediums—just use color from the tube or thinned with turpentine. This evaporates faster if you are painting outdoors, so keep it in a screw-top dipper.

Oil painting in layers (Indirect painting)

The oil medium may be used to great effect in systematic methods of painting in which transparent, semi-opaque, and opaque colors are overlaid in various combinations to provide paint films of great subtlety and depth. These techniques may be straightforward—such as a simple monochromatic underpainting, colored in particular areas with a single colored glaze—or they may be complex, where many layers of glazes and scumbles are interleaved in a paint film of great complexity. In every case, certain basic rules should be observed to ensure the permanence of the paint film.

Technique

Overpainting in oils

The underlying paint layer must be either completely dry or still wet when it is overpainted. If just a drying oil is used as the medium, this means waiting for up to a few days for the underpainting to dry before applying new paint layers. This explains why artists like Titian are described as working on many paintings at the same time. (The alternative—using an excess of resin and/or driers—is inadvisable, see p.176.)

The "fat-over-lean" rule

Superimposed paint layers should be as, and preferably slightly more, flexible than the layer beneath. Make sure that there is a little more oil in the paint mixture with each succeeding layer. In general, fast-drying, high-oil-content colors should not be used on their own in solid layers for underpainting.

> ### Successful overpainting
>
> - Overpaint when the paint layer beneath is still wet or completely dry.
> - Observe the "fat-over-lean" rule.
> - Use resins or balsams very sparingly.
> - Before overpainting, make sure that the surface is not too glossy, and has not become dirty. If necessary, clean with fresh bread, or cotton balls moistened with saliva.
> - Use paint fresh from the tube; avoid laying continuous films of very thick paint.

Technique

Underpainting in oils

The choice of a method of underpainting depends on the nature of the subject, the method of overpainting, and on the tone and color of the ground.

Monochromatic underpainting

A traditional method is to paint the subject in tones of one color, on a white or colored ground. This allows you to concentrate on the form and tonal values of the subject before having to decide about color. This is sometimes called *grisaille* painting, which means underpainting in tones of gray, although other colors are used, in particular browns.

Generally, there are two methods of monochromatic underpainting, although they are usually used in combination. The first is a form of transparent painting, where, for the halftones, the color is simply diluted more thinly. The second is to paint

Opaque/semi-opaque underpainting White paint is used to model the face on a warm brown ground.

Transparent underpainting Thin washes of Burnt Sienna model the face on a white ground.

opaquely, creating the halftones by mixing the color with white. In terms of surface appearance, the transparent method produces a less "meaty" appearance than the opaque method, and is not as suitable for direct glazing with transparent colors. If painting on a colored ground, you may use the transparent method for the mid- to-dark tones and the opaque method for the mid-to-light ones.

If you are painting monochromatically prior to glazing, (see p.198), keep the painting within a mid-range of tones so that the subsequent transparent glazes can provide the darkest tones and the final opaque highlights the lightest ones.

Technique

Painting a fully modeled monochromatic study

A monochromatic painting can be a finished work in itself. It may often be used as a preliminary study for a larger portrait painting as is the case here. It enables the artist to focus on the essential elements of form and tone.

In practice, combining the thinned, dark paint for the deeper tones and thicker, white, semi-opaque, or opaque paint for the mid-to-light tones is a complex process of reworking and overpainting. It often involves waiting for a layer to dry before continuing.

Modeling tones On the orange/brown ground there is extensive tonal modeling in relatively thinly applied layers of Titanium White. Much of this involves close "dry" brushwork with tube-consistency color worked into the hairs of the brush and applied lightly over the grain of the canvas.

Technique Applying transparent oil glazes

In glazing, you are using transparent colors, so that when you mix a glaze, you need to use a completely clean, fresh brush. If you use a brush that, although cleaned, still has some opaque oil color in the hairs, it will muddy the glaze color.

Applying transparent oil glazes is straightforward, as long as you remember that glazes are not simply brushed on like varnish and left. Glazing is a two-stage process and glazes usually need further manipulation on the canvas in order to give the right degree of color saturation and uniformity of tone.

To make it manipulable, the paint is mixed with a painting or glazing medium, such as stand oil or sun-thickened linseed oil, diluted with turpentine. Use plenty of color in the mixture; do not simply tint the medium, thinking that too much color will obliterate the underpainting. The density of the color is actually controlled by subsequent manipulation with dry brushes and this can often reduce a thick glaze to a mere stain. The underpainting must be dry before any glazing is

done over the top. Remember to apply the "fat-over-lean" rule (see p.197). Different-colored glazes may be applied in adjacent areas, smoothed as below, and fused where they join by blending. For very small areas, use smaller, round or flat, soft-hair filberts.

When you are glazing and especially if you are glazing large areas, you should make sure that there is adequate ventilation and wear an organic solvent filter mask.

Manipulating a glaze

After application, leave the glaze for a few minutes to allow some evaporation of the solvent. Then it can be smoothed to the required finish by dabbing with clean, dry brushes. A shaving brush or any thick, bushy bristle works well over a large area. A clean, tightly bound, cotton pad or a wad of absorbent paper towels can also be used. On smaller areas, the dabbing may be done with any bristle brush; filberts work best. On very small areas, you can use a small, soft-hair brush such as a nylon filbert.

Dab the glaze with the brush. After each stroke, wipe the brush on a piece of paper towel or rag. You do not want any paint to build up on the ends of the hairs. The glazing will not be successful if the brush becomes wet with paint; if this happens, replace it with a clean, dry one. If areas of uniform glaze require further modification, such as lightening for highlights, continue working over the area with smaller brushes (see below). If part of a glaze is to be completely removed, use the corner of a rag or tissue, very slightly moistened with turpentine or paint thinner if necessary.

Technique Opaque underpainting with applied glazing

Opaque underpainting lends itself extremely well to the application of transparent glazes. The tones of the underpainting may be worked up to full strength or kept within a mid-to-light range as shown below. If the tones are kept fairly light, the true depth of tone can be established by the application of colored glazes or scumbles on top. This allows the overpainted color, especially if it is transparent, to work more successfully as a color than it can over very dark tones. The duck has been painted opaquely in tones of black and white. The tones have been kept broadly within a mid-range prior to glazing.

1 Mix the paint with the glaze medium to a soft, mushy consistency. Do not simply tint the medium.

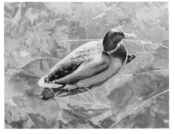

2 The opaque, fully modeled underpainting must be dry before glazing.

3 Brush the glaze onto the dry underpainting with a large, soft-hair or bristle brush.

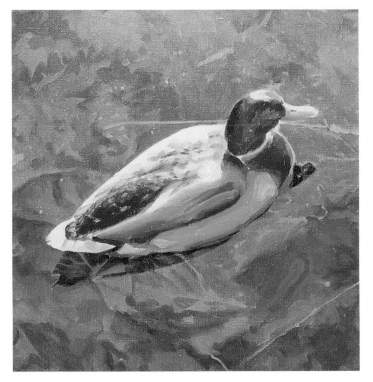

4 After a few minutes, dab the glaze with short strokes of a clean, dry brush. After each stroke, wipe the brush on a piece of paper towel or rag.

Finished glazing on background The warm orange/brown glaze has colored the fall leaves below the surface of the pond, and all the original tonal modeling is retained.

Technique

Underpainting in color

The functions of a monochromatic underpainting have been shown, but paintings may also be underpainted in various other ways, depending on the desired effect.

Underpainting in light tones of the overpainted colors

Deep, saturated color effects can be obtained by underpainting with lighter-toned versions of the colors to be painted on top. For instance, a blue drapery may be underpainted in a pale blue pigment, and then glazed with another deep, transparent, or semi-transparent blue. This exact effect has been noted in pigment analysis of paint samples from the 1400s. The technique gives a brilliance and depth to colors that could not be had by any other means.

Building up layers

This recreation (right) of a detail from a 15th-century painting by Dieric Bouts and broadly based on an analysis by their Conservation Department of a similar work, *The Virgin and Child*, by the artist in the National Gallery in London, shows how the colors of fabric may be made rich and lustrous by carefully building up the underpainting in layers. The combined optical effect of these variously colored paint layers is considerably more effective than a single coat of color would be. Below the red, the artist used a cool yellow on the white priming, then a warm brown. This provides a warm, mid-toned ground on which the lights and darks can be modeled. This is then overpainted in a pale, semi-opaque version of the actual color of the drapery. When this is dry, it is glazed with a transparent and deeper-toned layer of a similar color. The modeling of the forms is achieved by blending the oil paint while it is wet on the surface of the painting.

The Annunciation *(ca. 1465),* DIERIC BOUTS

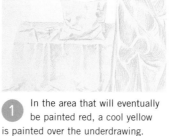

1 In the area that will eventually be painted red, a cool yellow is painted over the underdrawing.

2 A uniform brown is painted over the yellow when dry, providing a warm ground for the red drapery.

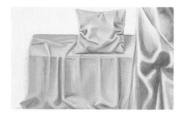

3 The blue drapery is modeled in tones of blue and white. Bouts used azurite pigment for the blue underpainting, saving the more expensive ultramarine for the glazing.

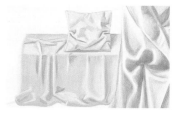

4 The red drapery and cushion are painted by mixing four separate tones, from a very pale pink to a mid-toned red, and applying these in the appropriate areas.

5 These tones are subsequently blended as described on p.187 to produce a fully modeled form. The underpainting is now complete.

6 The glazes are now applied with transparent ultramarine over the blue drapery and a crimson lake color over the red.

Technique Painting in opaque and transparent layers

Each of these two portrait heads is painted on a green (Terre Verte) ground. This was a conventional practice in the early Renaissance; it allowed the warm colors of the superimposed fleshtones to contrast with the cooler greens of the shadows.

Here, all the modeling for the younger man's face and hair has been made in tones of opaque white over the green background color and all the subsequent coloring has been painted using overlaid transparent glazes. The technique gives the painting a particular character

and a feel that is very different to that of the second head. In the second head, the slightly softer green ground has been overpainted using flesh colors mixed opaquely with white. The color becomes integrated into the body of the painting and is much less of a transparent skin. Glazes have been used toward the end of the painting process, but only sparingly, and the result is a more fully rounded image. This portrait was taken from life, whereas the first image was based on a photograph.

1 The face is modeled on the green ground using "dry" brushwork. White paint is used in small amounts directly from the tube and stroked over the canvas, so that the ridges on the texture of the canvas pick up the paint and create a halftone effect. This can be a very effective method of building up a complete range of tones.

2 The effect of the transparent glazing colors can be clearly seen at this halfway stage. In this case, it is not a question of glazing the whole face in one try, but of carefully glazing one part at a time. You then have to wait for the paint to dry completely before applying any further glazes.

Finished image The portrait has come a long way from the first stage, but all the preliminary elements still contribute to the effect of the whole.

1 The green underpainting is still visible and the use of warm fleshtones at this interim stage of the painting already begins to bring the image to life.

Finished image By the final stage, the head is fully modeled in a way that can only be achieved by building up the painting in layers. The sympathetic character of the sitter becomes evident.

Acrylics

THE ACRYLIC MEDIUM, WHICH HAS BEEN developed and refined since the 1950s, represents a significant new addition to the repertoire of permanent painting media. It could be said to have as much significance for painting technique as did the more gradual move from egg tempera to oil painting during the 1400s.

The most important aspects of the acrylic medium are its versatility—it can be used in very pale washes or glazes or thickly impasted with rich textural effects, combined with its permanence—the modern acrylic emulsions are not liable to the continuing chemical changes that an oil film undergoes. The best acrylic emulsions neither yellow nor harden with age. No special techniques are required in the overlaying of colors to ensure that the dried film remains sound and free from cracking and from this point of view, the medium is much simpler to use than oil color.

Since the paint dries quickly, colors can be overlaid more rapidly than in oil painting. However, there is less time for the manipulation of the color on the support, and in this respect, oil paints remain somewhat more manipulable than acrylics. It is also true that, comparing similarly impasted oil and acrylic painting, the former shows a little more crispness and resonance of color than the latter. But acrylic paint is sturdy and flexible; in addition to the more traditional transparent, opaque, and combined painting techniques, it can be scraped, squeezed, piped, thrown, sprayed, mixed with fillers for texture effects, even woven.

Rapid drying

Since acrylic paints dry rapidly and are not easily resoluble when dry, brushes should be washed out carefully immediately after use. This is particularly important for good-quality brushes. What can happen is that dried acrylic color accumulates where the hairs join the ferrule, and this causes the hairs to splay and the brush to lose its shape. Where soft-hair brushes are used, for example, it is probably sensible to use synthetics instead of sables.

I would not recommend acrylics for direct painting outside, especially on a sunny day. No sooner is the paint out on your palette than it will begin to dry, forming a plastic skin over the surface of the paint. Most methods of preventing this are of limited use.

A Bigger Splash *(1967),* DAVID HOCKNEY
There are no human figures in Hockney's sun-filled Californian poolside scene, but the splash indicates a presence beneath the smooth, blue surface of the water.

Materials Acrylic and other resin-based paints

Acrylic colors

The most common forms of artists' acrylic color are based on the polyacrylates and polymethacrylates. These are used in dispersion as the vehicle with which the pigments are mixed. The acrylic polymer emulsion is water-soluble when wet and provides a flexible, waterproof, non-yellowing film when dry. By itself it gives a somewhat soft film, although the addition of pigments makes it a bit harder.

Pigments in acrylics

The range of pigments available in manufactured artists' acrylic color is not as extensive as in watercolor or oil paint. Manufacturers tend to incorporate the newer synthetic or inorganic pigments and to exclude some of the more traditional ones. The result is that the acrylic medium does not exhibit the particle characteristics of the pigments in the same way as watercolors in thin washes (see *Transparent acrylic techniques*, p.206). With the newer pigments, there is generally a high degree of permanence across the range of artist's acrylic colors.

Volatile Organic Compounds (VOCs)

There is an assumption that because acrylics are water-based, there are none of the solvent problems associated with the use of oil color. In fact, some of the coalescing solvents that could be used to make acrylic colors can release volatile organic compounds. These can have a deleterious effect on the environment, and some could also affect the individual's health. Many of the reputable artists' acrylic color manufacturers use formulations that do not contain VOCs. If you are concerned about this, check with the manufacturer.

Permanent pigments in common use in acrylic painting

1 Cadmium Red
2 Quinacridone Red
3 Naphthol Crimson
4 Red Iron Oxide
5 Azo Yellow
6 Cadmium Yellow
7 Yellow Ocher
8 Raw Sienna
9 Burnt Sienna
10 Raw Umber
11 Burnt Umber
12 Phthalocyanine Blue
13 Ultramarine Blue
14 Dioxazine Purple
15 Phthalocyanine Green
16 Chromium Oxide Green
17 Titanium White
18 Ivory Black

PVA colors

PVA colors based on polyvinyl acetate resins are generally found in the cheaper ranges of polymer paints. Most of the PVAs used by artists' material manufacturers are the more straightforward resins that tend to be at the poor end of an ever-improving market where vinylidene chloride copolymers or ethylene vinyl copolymers would provide a superior vehicle on a par with the acrylic resins. Most pigments generally require the addition of a plasticizer to add flexibility to the dried film. The plasticizer can migrate in time, leaving the film somewhat brittle. A PVA film tends to crack at low temperatures. It is probably advisable to use a rigid support for PVA paints.

The lower-quality PVA mediums should not be used for external work where paints can exhibit chalking tendencies (where the pigment begins to "powder off" the surface owing to ultraviolet degradation of the paint film). In addition, pigment permanence should be checked. The so-called "washable" PVA used, for example, in schools may be a PVA (polyvinyl acetate) with dextrin added for solubility, or it may be a polyvinyl alcohol that is resoluble when dry. A polyvinyl acetate is not resoluble when dry.

1
2
3
4
5
6
7
8
9
10
11
12
13
14
15
16
17
18

Materials Iridescent acrylics

Among the relatively recent additions to the range of acrylic colors available are the pearlescent or iridescent colors, many of them in the gold to bronze metallic range. These are made with flakes of mica, coated with titanium dioxide and iron oxide colors. They are highly permanent and have a glistening luster in the right light. They work well when used on appropriately colored grounds. The colored part of the ground here (right) is a Burnt Sienna/Cadmium Red mix.

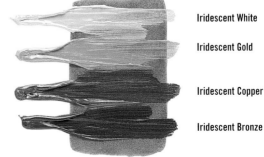

Iridescent White

Iridescent Gold

Iridescent Copper

Iridescent Bronze

Materials Acrylic mediums

Several mediums are sold for use with acrylic colors to produce different effects such as impasto and glazes. Most of these mediums are versions of the same emulsion that is used to make acrylic paint. It is therefore normally fairly safe to intermix them freely with the paint.

Gloss medium

In its simplest form, this is the acrylic polymer emulsion on which the colors are based. For optimum results, it should contain all the additives necessary for good film formation (see pp.40–41). The acrylic polymer emulsion itself is usually internally plasticized to give greatest flexibility and this introduces a softness to the film that may lead to tackiness and dirt retention. In the pigmented color, the pigment itself reduces this and no further modification is necessary. In the medium, however, which may contain very little pigment in transparent glazes, it is necessary to incorporate a harder resin. The term "gloss" is relative, since acrylic gloss mediums will never give the level of gloss found in oil mediums.

Matte medium

If small amounts of acrylic color are added to matte medium, for transparent glazes for instance, the matteness of the color is retained. Matte medium is basically the gloss medium to which a matting agent has been added. This may take the form of a wax emulsion or an inorganic matting agent such as silica. For optimum results, both may be added. The presence of matting agents makes matte mediums thicker than gloss mediums.

Gel medium

This is a gloss medium, thickened by cellulosic or polyacrylic thickeners. It allows the color to be extended or made more transparent without loss to the structure.

Flow improver (water-tension breaker)

These products are simply concentrated solutions of wetting agents. They aid the thinning of acrylic colors for glazes without reducing the color strength by addition of excessive amounts of water. Because acrylics are gelled, they do not thin readily with water alone without losing strength. The addition of the wetting agent helps to break the gel structure.

Retarder

Retarders are used to slow the drying time of the paint. These are usually made from propylene glycol and are available in a gel form or as a liquid. The former is the most useful because its structure holds more water, which keeps the acrylic film open longer. The use of a retarder increases the "wet-edge time" and makes blending easier (see p.209).

No retarder should be used in excessive amounts, because it produces a surface skin with soft color below. This can take days to dry completely due to glycol trapped below the surface of the paint film.

Technique

Tinting an acrylic medium

It is often necessary to tint an acrylic medium for manipulations such as glazing or transparent impasto effects. Add the color to the medium rather than the other way around.

1 Using a brush, add a tiny amount of color to the medium.

2 Stir the mixture thoroughly to achieve a consistency of tone.

Materials Modeling or texture paste

In their range of mediums for acrylic painting, most manufacturers also include a modeling or texture paste. This can be made of marble dust in an acrylic polymer emulsion, though sometimes sand, flint, or polymer flakes or granules are used. It is inert and permanent. In texture, it is similar to the home improvement fillers used around the home to fill cracks in walls, etc. It is only recommended for use on a rigid support, where you can create three-dimensional textural effects using scraping tools or painting knives. The material can be used to make a textured ground for subsequent acrylic painting or it can be mixed with acrylic paint before use and applied as a color.

Rough texture
Thin posterboard placed over texture paste and pulled off.

Combed texture
Texture paste tinted with acrylic color and combed.

Supports and grounds for acrylic painting

Most surfaces are suitable for acrylic painting provided that they are clean, non-oily, dust-free, and provide an adequate "key." On canvas, the permanence of the acrylic paint film is reinforced by the fact that, unlike oil painting, no problematical layer of glue size (see pp.58–59) is required. If the same kinds of paints are used throughout, the vehicle will be identical from primer to final coat, creating a "welded" film unlike the "sandwiched" layers of oil paint that have to follow the "fat-over-lean" rule.

Preparation Priming for acrylic paint

With transparent painting techniques on canvas or board, where the white of the ground is all-important, acrylic primer should be used. This is often called "acrylic gesso primer" by manufacturers, although it does not provide a gesso ground in the conventional sense. Basically, these primers are mixtures of the same acrylic polymer emulsion used as a vehicle for the paints themselves, with titanium dioxide for the whiteness and a coarse extender, such as barytes with magnesium calcium carbonate, to give the primer a degree of tooth. The ratio of pigment to extender is generally about 1:1.

It is not essential to use a primer on canvas if the paint is to be used opaquely, and provided a continuous film is established over the whole area. There are, in fact, examples of work on canvas in which a dark acrylic color has been scraped over the bare canvas to provide the ground for an opaque painting technique (see *Applying a dark ground*, below).

Priming a canvas
When working on canvas, the primer can be brushed on using one or two coats. Another method, particularly useful with very large canvases, is to scrape the primer over the surface. This can be done by temporarily stretching the canvas using masking tape or staples, either flat on the studio floor, or upright onto the studio wall.

With a flat canvas, pour on the primer, then scrape it thinly over the surface using a scraper or window cleaner's squeegee (avoid those incorporating soft black rubber, which may mark the canvas). I use a 12in (30cm) clear plastic ruler with a smoothly beveled edge, screwed into the squeegee handle in place of the rubber strip. It provides a firm, flat, scraping device that forces the primer smoothly into the textured surface of the canvas. Applying the somewhat liquid primer to an upright canvas can be more difficult (see below), but is still far quicker than laboriously brushing the primer onto the support.

Priming rigid supports
With rigid supports, the primer can be brushed on. Two coats are used, depending on absorbency. The first coat can be slightly thinned with water if necessary. For large areas, a very smooth finish can be obtained by spraying the primer on with a spray gun and compressor system.

Priming very absorbent surfaces
On a very absorbent ground, such as a compressed wood-fiber board, a coat of acrylic gloss medium thinned with water and applied before the primer will reduce the absorbency of the support to an acceptable level. If primer is applied to an extremely absorbent surface that has not been sealed in this way, the binder could sink in, leaving a powdery surface. Subsequent coats of acrylic paint would be unable to adhere to this.

Technique Priming a large canvas

You can prime a large canvas either with a decorator's bristle brush or by using a plastic squeegee to scrape on the primer.

Brush Fill a large brush with primer and apply in short, horizontal strokes.

Scraper Scrape the primer into the canvas with the squeegee or scraper.

Technique Applying a dark ground

If dark acrylic paint is being applied to a bare canvas as a ground for an opaque painting technique, the paint itself is considerably more viscous than a primer and easier to apply to an upright canvas. This may be done with a thin, flexible, plastic scraper, such as an old credit card.

Scraping on primer Use the same technique as shown on the left for applying a dark ground.

Transparent acrylic techniques

Acrylic paint is particularly suited to those transparent techniques normally associated with watercolor. Its great advantage is that any number of thin washes can be superimposed without fear of muddying the color beneath, since once each wash has dried, it is insoluble in water. The disadvantage, however, is that by the same token it cannot be modified by sponging or scrubbing, as watercolor can. Acrylic paints dry rapidly, which is an advantage when overlaying colors, but unless the edges of the shapes have been softened with a clean, damp brush or the ground around a shape dampened before it is painted on, they will dry with a crisp, sharp line. This unwanted line is often difficult to soften with water and can only be disguised by being worked over with opaque color.

Technique Achieving watercolor effects with acrylics

As in watercolor, superimposing two transparent washes of different pure colors produces a third, very different color. This new color will have more resonance than if the two colors had been mixed on a palette. Soft-edged, blended effects are possible, so long as you carry out one of the softening techniques described below. Similar effects can be had with an airbrush (see p.214), which can be used either with transparent or opaque color.

It is very possible to paint wet-into-wet with acrylics. To increase the "flow" of acrylic color and help it act more like watercolor, the paint can be mixed with a solution of water-tension breaker, or it can be painted onto a surface already washed with this solution.

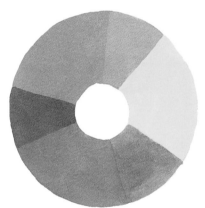

Overlaying transparent washes In this color wheel, where the three primary colors painted in thin, transparent washes overlap, the secondary colors can be seen. This would look the same if painted in watercolor. Each color is allowed to dry before another is painted on.

Wet-into-wet effects In this color wheel, the primary colors painted in thin, transparent washes as before have been allowed to run into each other. The secondary colors can be seen where the primaries mix together on the paper. This, too, is similar to a watercolor effect.

Drawing wet-into-wet In this study, the colors have been applied wet-into-wet, beginning with the yellow and running the blue and green washes up to the yellow. The outline has then been rapidly drawn into the still-wet paint.

Technique Softening edges

An unwanted crisp edge on a dry wash can be a problem with transparent acrylic techniques. Although softening techniques work best with watercolors, crisp edges can be avoided in two ways: either by dampening the paper before the paint is applied, or using an additional brush dampened with clean water.

Dampening the paper Paint a clean water line along the edge to be softened before the paint is applied. Apply just enough water to dampen the paper and make the paint diffuse into the damp area. The edge may have to be worked over with a clean sable brush to absorb excess paint or water.

Using two brushes Alternatively, work with two brushes, one containing paint, one water. Apply the paint and soften the edge immediately by stroking along it with the clean, damp brush. A thin wash of acrylic paint dries rapidly, and so any edge that needs softening has to be reworked quickly.

Technique Painting in transparent washes on paper

When the paint is used in thin, transparent washes, acrylics are very similar to watercolor. Many watercolor techniques can be easily reproduced with acrylic paints, in particular the careful building up of a painting in transparent layers. There is an additional advantage in using acrylics for this technique. Once the paint is dry, it is not easily resoluble, so you can superimpose almost any number of washes, provided that the layer beneath is completely dry before you put on another one. If you do this too much with watercolor, you risk dissolving the paint layers beneath, but with acrylics, the process is more secure. This means you can also build up great depth of tone and color.

If you need to soften the edges of an applied acrylic wash, you will need to do this a little more rapidly with acrylics than with watercolor. This is particularly necessary if, as here, you are painting a face. A harsh edge can ruin the essential softness of the features.

Softening edges in portraits
This painting has been very carefully built up using thin washes of acrylic color on 300gsm, CP watercolor paper. The white of the paper and the palest washes provide the highlights and lightest tones, while the deeper tones are obtained by overlaying different color washes. The edges of the applied washes have been softened, so that the modeling of the features looks smooth. For paintings of this kind, where the white paper illuminates the colors, it is important to work in pale washes and to build up the tones gradually. If you apply tones that are too dark initially, it is nearly impossible to retrieve the image.

1 Initially, the structure of the eyes is painted in a very pale gray wash.

2 A subsequent thin yellow/brown wash brings color to the iris.

3 The modeling of the fleshtones gives the eyes more dimensionality.

Technique

Transparent painting on canvas

On primed canvas with no underpainting, transparent acrylic paints may not work as successfully as on paper since the image can look a little "thin."

One way of dealing with this is to color the priming or apply an opaque, colored ground over the priming before working with thin, transparent washes on top of it. This is particularly useful where there is a "predominant" color in the image being painted. Here, for example, in these details from a painting of foliage, the predominant color was green, and so the canvas was given two coats of a relatively saturated yellow/green opaque color that was allowed to dry. Most of the defining and modeling of the leaves and ferns was then made using a dark, transparent color and soft, synthetic brushes. Individual leaves were then darkened slightly using thinner washes of the same color. Other areas of the leaves and

stems that were lighter in tone were painted using a little opaque or semi-opaque color. This is an extremely efficient and economical method of building up a complex image very rapidly.

For a portrait, the best method is to paint in the features and the broad tonal areas using thin, transparent washes and then to introduce semi-opaque or opaque washes, alternating or combining these with transparent effects. It has to be an "all-over" technique, although the opaque or semi-opaque colors are generally concentrated in the mid-to-light and highlighted areas of the face, with the transparent washes providing the darker areas. The whole image can finally be unified with an all-over glaze or wash of a very thin fleshtone. When this is dry, the highlights or the very lightest tones can be adjusted. This is a slow, systematic technique that involves a great deal of overpainting. It is therefore very appropriate to acrylic paints, which dry quickly and which remain stable and permanent when painted in layers.

Dark foliage The ferns are modeled in dark, transparent colors over the opaque, green ground.

Lights Where the leaves are yellow or catch the light, opaque colors are used. This brings the lights forward as the dark transparent tones of the shadows recede.

Technique

Transparent painting on wooden panels

After the relative absorbency of paper and canvas, it can be difficult to adjust to the nonabsorbency of a wooden panel. With very viscous, opaque colors, the problem is not as great, but with thin washes it can be difficult to cover an area with a uniform tone, since any hint of grease on the primed surface can make the wash separate into beads of color. Even on a grease-free surface, thin paint can fail to "take" properly. If this is a problem, use an airbrush or spray gun to lay the color on initially. If you use a brush, work on small areas at a time, working outward with the brush, which should be damp, not wet, with paint.

Plane The plane was painted in thin color washes, using a brush. Only at the final stage was an airbrush used to reinforce the deepest tones and emphasize white highlights.

Opaque acrylic techniques

In addition to transparent effects, acrylic color is equally well suited to opaque or "body color" techniques, in which the opacity of the pigment, the thickness of the paint, or the addition of white pigment provides colors that, when overlaid, effectively obliterate the color beneath. These techniques are particularly suited to working on a mid-toned, colored ground where the white of the overlaid paint (rather than the white of the ground) provides the highlights.

Compared to similar techniques in oil painting, the main advantage is that the color dries very rapidly and so can be overpainted without risk. This is particularly useful when scumbling or using dry-brush and broken color techniques. The disadvantages are that the rapid drying can leave little time for the smooth blending that is a feature of oil painting, where the paint is wet for long enough to allow the artist to lay in a number of tones before blending them on the surface of the painting. In addition, the color that is applied in oil painting is the same tone when dry as when it is applied.

Acrylic paint dries darker, and this can make it difficult to match tones and colors to a dried surface, especially in portrait painting. To some extent, these disadvantages are exacerbated by relying too much on oil painting techniques.

Technique Opaque color wheel

Compare this wheel to the color wheels painted in the transparent color on p.206. Here, there is no "spontaneous" blending of the colors.

Physical blending An opaque version of the color wheel, in which the primary colors have had white added to make them opaque and they are used more thickly, shows that where they overlap, the colors have to be physically blended to produce the secondary colors.

Technique Blending opaque colors

Keep in mind the fact that acrylic colors dry rapidly, so only paint what you will be able to blend while the colors remain wet on the support.

1 Paint up to the line where the colors need to be blended, leaving a ridge of color at that point.

2 Stroke a clean, damp brush down (or along) the join. This will soften the border between the two colors as shown.

3 For a smoother, more graded blend, move the blending brush from one side to the other of the colors so that there is some physical mixing. This is fairly easy to control.

Technique Overpainting in opaque colors

In this opaque version of the transparent study on p.206, the blue and green tones of the water have been applied in opaque color and blended as above. This blended background color has then been allowed to dry before the shape of the fish is painted in opaque white on top of it. This too is dried and then painted in yellow with a touch of orange. This is then dried before the outline of the fish is painted in on top. This process is typical of an opaque painting technique.

Fish The blended opaque color of the water gives a rich background to the heightened yellow.

Transparent and opaque techniques

There can be an assumption that because a subject is dark in tone, it should be painted using dark-toned color on a light-toned ground. In fact, it can be equally, if not more effective in certain situations, to paint the light tones in and around the subject in light-toned opaque colors on a dark ground.

Technique Painting monochromatic studies

These two images, one using transparent (blue) acrylic on white paper and the other using opaque, white acrylic on blue-toned paper, show two distinctive approaches to the same image. In the first, the darker tones of the image itself are being painted, while in the second, it is the light tones of the spaces around the image that are being painted. (If it were a portrait head against a dark background, for example, the situation would be reversed.) The acrylic medium is well suited to either of these approaches.

Blue on white Acrylic is the perfect medium for monochromatic brushwork sketches of this kind. You can work freely with a fine-pointed sable or synthetic using a relatively dark transparent tone and making the paint slightly "wetter" and more fluent for some areas, such as the branches and twigs, or slightly "drier" for the dry brushwork in the foreground where the paint shows the texture of the paper.

Applying the opaque white The opaque white acrylic is applied thickly over the dark blue ground.

White on blue This is the reverse of the first image. Here, opaque white acrylic is used to paint the highlights and all the lightest tones in the image. The sketch has a very different, less fluent feel than the first. With its more solid surface, it has a thicker, chunkier quality than the original. This technique is just as capable of more complex tonal contrasts and subtle halftones as the first.

Project Bonfire and fireworks

An opaque, monochromatic, acrylic underpainting can form a solid base for one or more transparent, colored, acrylic glazes. It is important that the underpainting is dry before the glaze is applied over the top. A transparent glaze can be applied either with a brush, an airbrush, or a spray gun (see p.214). Note, if you spray acrylic, you should wear a face mask and protective clothing as necessary. You can tint an acrylic medium and make a more viscous glaze that can be applied over a large area with a thin, plastic scraper (an old credit card works well).

As well as being applied over the whole of a painting or large areas of it, a transparent glaze can be applied more selectively to small areas.

This example is worked monochromatically in white acrylic color over a blue/black ground in much the same way as the second tree is painted on the opposite page, although with a little more tonal modeling. Here, the white acrylic color provides the base for the smoke and flames from the bonfire and for the fireworks against the dark sky.

1 The smoke and flames are painted using Titanium White and small sable or synthetic filbert brushes. The lightest tones are painted more thickly than the less light ones, where the paint is thinned with a little water.

2 Thin washes of Azo Yellow in mixes with Quinacridone Red are used to tint or glaze the white underpainting.

3 The fireworks follow a similar process to the bonfire but have more stages. The white underpainting is the first stage.

4 Then a transparent red is painted over the central starburst. When dry, spots of opaque white acrylic are dotted over the red.

5 The spots of white are glazed yellow and the effect of the fireworks is now much more dimensional than it was previously.

Finished painting In the final work, the white underpainting allows the transparent colors to register with vibrant effect.

Technique Glazing a large monochromatic area

This four-paneled painting, "After the Fire" 1987, shows an acrylic version of the oil painting technique of monochromatic underpainting followed by glazing. Each panel is 94½ x 70in (240 x 170cm), so the glazed areas are of considerable size. For some of these, as shown in steps 3 and 4 below, the acrylic was simply thinned with water and applied with a brush. For other areas, as on the far left and far right panels of the finished painting (below), the color was mixed in an acrylic gloss medium and applied with a flexible plastic scraper in the form of an old credit card. Quick-drying acrylic can be glazed more immediately than slower-drying oil color.

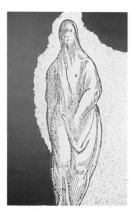

1 The figure is painted in opaque white on a dark-toned ground—dark blue in the case of the background and deep red in the case of the figure. The white is painted in small, separated brushstrokes, creating a textured effect. The color of the ground remains partially visible.

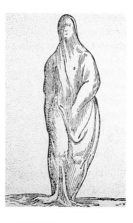

2 Once the white paint is dry, the monochromatic underpainting is complete. It is now ready for the glazing to be applied.

3 The Phthalocyanine Blue glaze is applied to a relatively small area at a time. It is painted on and subsequently dabbed with a dry, round-domed bristle brush or an old shaving brush.

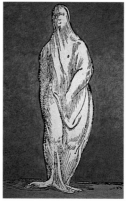

4 The overall blue glaze on the white textured ground allows the figure to stand out clearly from the textured background. A similar red glaze is applied to the ground separating the three main areas of the composition.

Finished painting This painting has been made using opaque, monochromatic underpainting and thin, transparent glazes. The process can be seen in the step-by-step images showing the development of the shrouded figure (second left).

Technique Painting acrylic in layers

Painting in layers, or indirect painting, is a technique particularly well suited to the acrylic medium. This is because acrylic paint, like oil color, is equally capable of being used in thicker opaque or thinner transparent layers but, unlike oil color, it dries quickly, so that you can build up the layers rapidly and efficiently. The following example shows some of the stages of a painting that at first sight may look highly complex, so that if you were going to make a copy of it, you might not know where to begin. In fact, the process is completely straightforward.

The layers of the painting are built up from the back to the front of the work. The background is painted, then some of the fish shapes are painted in white acrylic and colored. Next, the arch and two plants are overpainted in white acrylic and then colored, and so it goes on, adding objects and fish until all are completed. A thin overall glaze in acrylic medium is overpainted at each stage. The process ensures that the colors are kept clean and bright and allows the creation of a very complex image and gives an impression of depth.

1 The background is painted in a watercolor manner in thin, transparent colors.

2 The first few fish are painted in opaque white acrylic. The bodies have three coats to ensure their opacity, while the tails and fins have one or two to give them translucence.

3 The fish are then painted in their blue and red colors.

4 The stone archway is overpainted in white acrylic. Using stippling for texture, the archway is then painted in its true colors.

5 The two plants at each side are painted in white and then in color; subsequently, the plastic diver, frog, and another plant are painted.

6 A detail shows how the orange of the diver is clean and bright over the white underpainting.

7 The final set of foreground fish are painted in white before being colored as before.

Finished painting The study, entitled *Neon Lights*, looks busy and complex, but this has been achieved using simple techniques.

Acrylic airbrush and spray-gun techniques

Acrylic paint can be sprayed through an airbrush or spray gun to provide a wide range of effects, from uniform or graded tones over very large canvases to highlights on highly detailed illustration work. Once it dries, acrylic paint becomes an insoluble plastic film that is very difficult to remove. It is important, therefore, to clean the airbrush or spray gun immediately after every spraying (see p.216).

Technique Spraying with opaque paint

Any mixture of paint that has been diluted with water or medium for airbrushing should be completely free of lumps of partially mixed paint; these obstruct the nozzle and give an uneven spray.

For optimum coverage with opaque color, the thickness of cream is about right. The airbrush is held closer to the support than for transparent color—this gives a good degree of control over effects created and flexibility in spraying. Trigger on the air and begin spraying outside the picture area. Each pass should overlap the previous one for an even tone. Artists who do a lot of spraying will learn the technique of fingering the trigger to increase or decrease pressure and control the amount of paint deposited. This control allows the spray to be deposited in a number of ways so that the instrument can be used as a drawing tool or paintbrush.

Technique Spraying with transparent paint

It is also possible to spray with far more "watery" paint. Thin paint might be used to apply a pale, overall transparent glaze, for example. This is more difficult to apply than thicker paint and the air pressure needs to be a little lower. Do not hold the instrument too close to the painting—about 18–24in (45–60cm) is best—and spray the work in stages, allowing one "mist" of paint to settle and dry on the canvas before applying another. Too much wet paint will start to run down the canvas or form wet blobs on a flat canvas.

Technique Basic airbrushing

You can use cans of compressed air to drive the airbrush, but it is less expensive in the long run to get an electric compressor that can be set to a uniform pressure depending on the material being sprayed. Blow air through the hose before connecting it to the airbrush to get rid of dust. Push down the finger button on the airbrush to open the air valve, then ease it back for an even spray. The further back you pull it, the greater the flow of color. Reverse this process at the end of spraying. Always wear protective clothing, goggles, and a respirator when using an airbrush or spray gun.

Applying a uniform tone Hold the airbrush 6–10in (15–25cm) from the support and keep it parallel during the pass.

Cutting through a mask Lay a piece of masking film over the picture area and, using a utility knife, cut out the required shape.

Spraying through a mask Load the airbrush with color and spray evenly.

Technique Masking out

Stencils can be made to mask out certain areas of the picture before spraying color. A stencil can be made of paper or proprietary masking film (the latter works better on paper than on canvas). Heavy-duty, adhesive-backed plastic works better on canvas. Masking tape is the most efficient way of obtaining a straight edge. Latex masking fluid works very well on acrylic-primed canvas and is one of the best ways of masking out complex areas, so long as the paint is not applied too thickly. See p.370 for information on working safely.

Masking out and spraying

The painting shown below was produced using thin, sprayed colors with various areas of the image masked out at each stage. The masking-out was done using newspaper secured with masking tape. Clear film sheeting may also be used.

Building a painting with thin, sprayed color The brushwork was confined to the reptile and details on the branches. The rest of the painting was made using an airbrush and a spray gun.

Spraying part of a painting

Although there is a tendency to compartmentalize brush and airbrush techniques, the fact is that the limited use of spraying within a "conventionally" worked painting may provide the only means of creating a particular effect.

For example, the problem of representing illuminated colored light bulbs is solved by painting the bulb shapes in white with a brush, then spraying white acrylic paint around each shape with an airbrush to create the diffused effect of the light. The individual colors of the bulbs can then be sprayed on.

Specific use Selected areas (the sky and the light bulbs) were sprayed within a brush-worked painting. The bulb shapes were first painted in white with a brush.

Combining transparent and opaque spray techniques

Spraying and brushwork can both be combined with transparent and opaque acrylic color to create a desired effect. In the painting of the paper airplane below, the opaque background color was sprayed onto the canvas and the "wallpaper" imagery painted in with a brush and transparent colors.

Combined techniques The paper airplane was painted opaquely with brushes; its soft shadow was applied with an airbrush.

Spraying a complete painting

This painting, which was inspired by the sight of planes going in and out of clouds on their flight path along the Thames into London's Heathrow airport, was painted entirely with an airbrush and a spray gun. The primer was stippled to give a textured ground for the sprayed paint. The benefit of this is that you can spray from one direction or another and catch the textured surface from that side. It gives an additional feel to the surface quality of the painting. In a painting of this kind, the building up of a number of layers of slightly varying tones is crucial in giving weight or substance to the image.

Exclusive use The spraying technique is used exclusively in this painting.

Technique

Reducing depth of tone or color intensity

A thin mix of semi-opaque, white, acrylic paint can be sprayed on to reduce tonal depth or the intensity of a color. A decision to reduce the tone of an area in a painting like this normally comes when the painting is well under way. It is likely that foreground areas will have to be masked out. For instance, in the painting below, the background panel with sky, train, and car was too deep in tone; the colors interfered with those in the foreground. So the figure, the plane, and the monster were overpainted with masking fluid and the entire area was then sprayed with semi-opaque white.

To achieve an even tone over such a large area (see right), the spray gun should be held at right angles to the surface and at an even distance, say of about 10in (25cm). The gun should travel in even, horizontal strokes, across and back, the hand making the turning movement outside the frame of the area being sprayed. This is reasonably straightforward, but it is a good idea to practice first.

Spraying on the white evenly Hold the spray gun at right angles to the painting, and about 10in (25cm) away from it. Move the gun across the painting in even, horizontal strokes.

Using sprayed-on white After a semi-opaque coat of white paint was sprayed on to reduce the depth of tone on the background, the masking fluid was rubbed off the foreground figures (see box, below).

Cleaning an airbrush/spray gun

There are two basic steps to cleaning this equipment.

- After using an airbrush or spray gun, spray clean water through the equipment until no trace of acrylic remains. If the cleaning operation is not done thoroughly each time, accumulated deposits of dried plastic paint will eventually clog up the instrument.
- To clean paint from the needle, cover the tip with a cloth or your hand, so that air bubbles back into the reservoir, bringing with it any paint trapped in the equipment. Keep adding and spraying clear water until the airbrush is completely clean.

Tips for using masking fluid

- The surface of the paper or canvas must be primed or have a reasonable covering of paint.
- The overlying paint should not be too thick, or else the fluid will become difficult to remove.
- Remove masking fluid covered with a thin film of paint with your fingertips.
- Remove masking fluid covered with thicker paint by rubbing vigorously with an eraser, against some kind of backing board.

Scraped color techniques

The characteristic viscosity of acrylic paints used direct from the tube or tub makes them particularly suitable for s'graffito techniques of drawing into a layer of wet paint, or "scraped" effects using thin posterboard or plastic, or other spatulalike tools with a thin, flat edge. The acrylic color can be scraped to a uniform thinness over the surface.

Scraping can also be effective in multicolor effects, using paints direct from the tube or diluting them with water or an acrylic medium. Such effects include integrating the image and background color. Scraping can also be combined with "extruded" manipulations (see p.221).

Technique Achieving s'graffito effects

Images can be drawn by laying a light color over a dark ground and scraping into the wet paint with a tool such as a screwdriver (which works well on canvas where there is some flexibility or give in the surface). On panel, you would need to use something less hard, such as the sharpened end of an old paintbrush handle, for example (see also p.191). This study (right) was worked by scraping through a layer of wet, white paint to reveal the black ground beneath.

S'graffito image When the dark ground was dry, a 1–2mm coat of white acrylic paint was plastered on using a flexible piece of plastic. The image was then drawn through the wet white paint with a small screwdriver.

Technique S'graffito in a large painting

All the imagery in this 8-ft (2.4-m) wide painting on canvas was made using the s'graffito method. White acrylic was applied over a black ground (as above) in sections at a time and the image drawn through the paint with a screwdriver. The technique leaves a black-and-white "drawing" visible through the textured white acrylic. Once this is dry, the image is colored by scraping tinted gel medium over the relevant areas. The background is painted in opaque Cadmium Red.

Red Sky in the Morning S'graffito combined with glazing makes a strong graphic image.

Rich surface The detail clearly shows the rich textured effects that can be achieved with this technique.

Technique
Creating scraped acrylic effects

If a number of acrylic colors are applied to the edge of the picture surface and scraped across it using a squeegee or scraper, an immediacy of appearance results that would be hard to obtain without painstaking brushwork.

Colors can either be applied straight from the tube, to create a bright, primary effect, or mixed with a little white before being applied to the edge of the picture. The second method gives a lighter, less color-saturated background, on which additional images can be superimposed using any painting technique.

The examples shown here are small-scale paintings, made by using, as a scraper, a clear plastic, 12in (30cm) ruler screwed into a window cleaner's squeegee. It is possible to apply this method on a much larger scale, by working on smaller sections along the whole length of a canvas, or by making a larger scraper.

On most of the small-scale images, the colors are scraped only once, and thinly, so that the white of the ground gives them their lustrousness and depth. With opaque colors, the color of the ground is not as important.

Tinted acrylic gel medium can be scraped over a painting to enhance colors and add depth to the surface appearance.

Scraper made from a ruler fixed into a squeegee handle.

1 Apply the paint to the picture surface.

2 Pull the scraper across in one fluent movement.

Applying paint at the edge of the support

The bright, high-key color of pure pigments squeezed straight from the tube is retained in scraped images. The pulling action of the scraper has a blending effect when colors overlap, but leaves the purity of the color unspoiled in the middle of the bands. In order for the whole surface to be covered with one pull of the scraper, enough paint has to be applied at the edge. Although this means that a good amount of paint is wasted, the wide range of possible effects may justify this.

Applying paint at various points on the support

Not all the colors need to be applied at the edge of the picture area. A single color can be used on its own at the edge to become the unifying overall background color out of which differently colored shapes appear. As can be seen from the clarity of the colors (right), they are not muddied by the scraping process as long as the scraping is done using just one fluent, firm stroke.

You do only get one attempt at this and you do not want the paint to run out halfway across the stroke, so make sure you put enough of the background color—in this case, Burnt Sienna—at the beginning of the stroke. The scraper should be absolutely clean before you make the stroke and the edge should be completely smooth. Notched scrapers give an entirely different effect.

Applying paint within the picture The blobs of Phthalocyanine Green and Arylamide Yellow were applied at various points.

Technique

Using scraping methods for imagery

The possibilities of scraping can be extended into representational painting if the colors of the image are applied reasonably thickly, before the "background" color is scraped over the support.

The numbers (right) illustrate this technique. The red paint for the 3 and the yellow paint for the 5 were applied with a painting knife but could have been equally well applied through a nozzle. While these colors were still wet, the light and dark greens for the 3 and the light and dark reds for the 5 were added before scraping.

Numerals paintings These small images on white, acid-free cotton paper with a CP surface show the various effects possible with scraping.

More complex work

The scraped technique can be used in more complex ways. Here, for example, the three visible sides of cubes are each scraped separately through stencils to create a three-dimensional effect that is underlined by the use of airbrushed shadows. At each stage, the sections that are scraped have to be allowed to dry before further work can be undertaken, and the cubes must be masked out before the shadows can be sprayed.

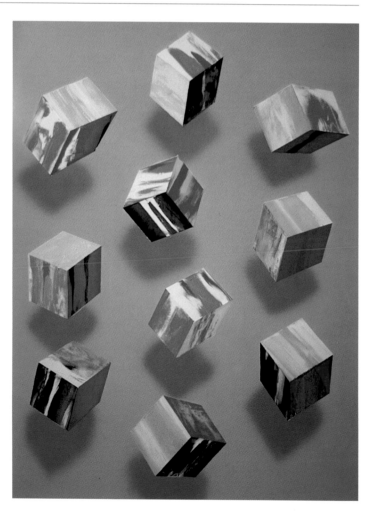

Illusionistic image The faces of the cubes are created using the scraping technique, but the illusion of them floating off the surface is made with airbrushed shadows.

Technique Using stencils and masks

There are various ways of making masks or stencils to create shapes with thick, scraped, acrylic paint. Simple shapes can be cut out of fairly stiff posterboard or thin, plastic sheeting. For more complicated shapes that are to be scraped over a large area, you can use masking tape cut to shape.

Scraping through a mask

Place the prepared mask or stencil over the area of the painting where you want the shape to appear and, if necessary, secure it with masking tape. Apply acrylic paint directly from the tube to the edge of the mask and scrape it across with a flexible scraper. Lift the stencil carefully at one corner and remove it, leaving the image embossed in thick paint on the surface of the ground.

A stencil can only be used for a limited time before paint begins to seep beyond the area to be scraped. When this happens, clean it off and leave it to dry thoroughly before using it again.

1 Design and cut out the stencil and apply thick color to one end of it.

2 Pull the scraper down in one easy movement to retain the clarity of the stencil.

3 Allow the paint to dry thoroughly before applying a further stencil and a different color.

4 Line the second stencil up against the image. Apply the second color and scrape in the same way.

Finished painting You can dampen the surface of the paper before applying the stencil so that the paint bleeds in the damp area, creating wet-into-wet effects that contrast effectively with the thicker, scraped color.

Extruded paint techniques

Acrylic paint possesses remarkable plastic qualities that allow it to be used in ways that other, more traditional paints cannot. In particular, it can be extruded (squeezed) through a nozzle into plastic strands of dried paint that can be pulled off the canvas and knotted, braided, or otherwise manipulated in very unconventional ways.

The paint can simply be extruded through a nozzle onto the canvas as a form of direct painting, or it may be further manipulated while wet by being sprayed with water, for instance, or by being extruded onto a wet or textured ground. It can be extruded with the nozzle touching the canvas, with the nozzle in a horizontal or vertical position, or from above, using various movements to control the curl or twist of the paint. These techniques can be combined with others, such as scraping or spraying. When dry, the ridges of paint formed by extrusion can be overpainted and abraded, using a sander, or sliced back to reveal touches of pure, bright color.

Technique Drawing with a nozzle

Use an icing bag with a plastic or stainless steel cake-icing nozzle for extruding acrylic paint. This is the best method for drawing directly onto the surface of a canvas. Icing bags have the advantage of being able to hold more paint and of allowing you to squeeze them at a more consistent pressure than other methods. Icing syringes are not as good—they are generally too small and not very well sealed. There is an art to working with paint in this way that involves being able to control precisely the amount of paint being extruded, while retaining a fluency about the work.

You need to make sure that there are no air bubbles trapped in the paint, otherwise the line will "pop." After ladling paint into the icing bag, hold it from the base, with the nozzle pointing up, and tap it to allow any trapped air to rise to the surface through the nozzle.

Using an icing nozzle Hold the icing bag firmly and squeeze it evenly while pushing the paint toward the nozzle.

Large-scale extruded line work

Practice is required to make fluent line work using the extruded technique, especially when working on a large scale. You need to squeeze with even pressure to get an even line. It is easier on stretched canvas where there is some give to the surface. This 6-ft (1.8-m) high recreation of a child's drawing required great control. It uses a single, red-orange color against the black ground, but the thickness of the acrylic allows the red to retain its vibrancy. Using paint in this impasted way gives a rich texture to the image against the flat matteness of the ground.

Drawing with extruded paint Here, a white chalk grid drawn on the matte black ground allowed the original, child's drawing to be copied on a much larger scale in extruded red paint.

Dispensing with the support Using red and black paint at the same time, a matrix of extruded paint can be made that creates an acrylic painting with no need for canvas or panel as a support.

Technique Knotting and weaving

An extruded strand of acrylic paint can be laid down on canvas, left to dry, and then pulled up and knotted or braided like a piece of flexible plastic. If it is scraped down into the canvas at one end, it will adhere and support the free-hanging end, which can then be knotted.

Weaving is also possible with short, adjacent, parallel "ropes" scraped down at both ends. When dry, the middle part of each "rope" is pulled up from the support and a separate dried strand woven through. There are numerous variations on these techniques. Different colors can be overlaid when wet to create multicolored strands, or different-colored paints can be placed in a tube or icing bag and extruded in a partially mixed state. The paint may be manipulated while still somewhat wet, although it is easier to work when dry and slightly warm.

Woven acrylic paint using stencils and a damp support

The third of the paintings on the right was created through a stencil directly onto the warm opaque brown on the canvas. The ground had been allowed to dry completely before being wetted just before the stencil was laid over it and the green paint extruded. Once the stencil was removed, the extruded paint flowed outward over the brown ground in wet-into-wet fashion to create the feathery effects at the edges. On the left, you can see a less dramatic version of the same effect with the red paint just bleeding into the warm yellow ground color. The vertical strands in the central work were made by integrating three separate colors while the paint was still wet.

Sealed box frame
The paintings are sealed in box frames.

Woven acrylic paint The dried acrylic paint film is soft in any case, but when it is used in this three-dimensional way, it is much more vulnerable to dirt and dust. The works above were placed in glazed box frames, and I would always recommend framing similar works behind glass to protect them.

Technique

Combining conventional and unconventional methods

In this large painting on canvas, the background shows a decorated ceiling in a derelict country house. This is conventionally painted on a blue-gray, toned ground using thinly applied, opaque white for the highlights and thin, transparent color for the darker tones. This technique has been commonly used for centuries and is a very effective and economical way of modeling a three-dimensional image on a flat canvas. The strange floating figures are made by extruding thick, acrylic color through cardboard stencils onto the horizontal canvas.

Poltimore Poltergeist, 2001 The illusionistic background allows the "woven" image to float off the surface of the canvas.

Encaustic

THE MEDIUM OF ENCAUSTIC PAINTING INVOLVES stirring pigments into molten beeswax and then applying them hot to the surface of the support. Encaustic is one of the most permanent of painting media and some ancient paintings remain as fresh as when painted. Permanent pigments should be used and paintings should not be subjected to the very high temperatures that could melt the surface of the wax.

The advantages of the medium are that it is unaffected by normal atmospheric changes and does not expand or shrink; the wax has no adverse chemical reactions with the pigments or the ground; it has good refractive properties, and displays an attractive sheen after being buffed with a cloth.

Encaustic is capable of a wide variety of effects and may be worked on intermittently and at any time without risk of damage to the paint film. The surface of an encaustic painting should be protected from scuffing. (See p.370 for information on working safely.)

The history of wax painting

The history of encaustic stretches back at least as far as Ancient Greece, although no examples of work from that time survive. Most of the surviving examples of early encaustic painting are the Romano–Egyptian panels known as the Faiyum Portraits, discovered at Hawara (see example, below). These small mummy portraits are painted on wood panels primed with distemper. They are, almost without exception, extraordinarily compelling images, characterized by an immediacy that relates directly to the encaustic painting technique. Encaustic painting continued up to the Middle Ages but was then used only intermittently until its revival in Germany in the latter part of the 1800s.

Mummy Portrait of a Young Man *(detail of face)*
(2nd–3rd century A.D.), EGYPTIAN
The bearded young man in this Romano–Egyptian portrait from a wrapped mummy gazes at the spectator with the vividness that is a feature of such work. The fleshtones are built up to a solid and impacted surface. The dark shadows are characteristically a dull brown/red and the lighter fleshtones are variously pink, orange, or brown tints. There is a hint of green toward the temples, but such cool colors in the face appear to have been largely avoided. The painters of this period probably adjusted and blended the color with a metal tool known as a cauterium—a long-handled spatula with a small spoon-shaped end. This was warmed over hot charcoal before being used to modify the surface of the wax. In this portrait, the top of the moustache may have been blended into the fleshtones in this way.

The clear desire to give a naturalistic appearance to the image can be seen in the care that has been taken in the modeling. Beneath each curl of hair on the forehead is a carefully painted shadow. The encaustic technique is perfectly suited to this bold, yet careful method of painting.

Equipment for encaustic painting

The nature of wax painting means you need certain special tools and pieces of equipment. To keep wax paints hot so that they can be applied with brushes, they are mixed and kept ready on a hotplate or palette. As soon as the brush has made its mark on the cold support, the molten wax solidifies and can be overpainted immediately.

Although the paint is most often applied hot to a support at room temperature, the support can be kept hot during the application of the paint, so that the wax remains liquid and can continue to be worked on the surface of the painting. The solidified wax coating can be reworked at a later stage through manipulation with heated metal tools, or by passing a heat source (such as a heating lamp or hairdrier) over the surface to melt and fuse the colors. In addition, the cooled wax surface can be scraped with blades or incised in other ways to create further effects.

Materials

Keeping the paints hot

Although in the past special heated palettes have been commercially available for encaustic painting, they are no longer common. However, it is fairly straightforward to improvise a homemade alternative, by laying a solid, ¼in (6mm) thick, rectangular, iron or steel plate over a gas burner, or over a flat, electric ring. The metal plate should be supported about 1–1½in (2.5cm) above the heat source, which is kept on a low setting.

A griddle can also be used to supply an evenly heated, flat cooking surface. Since the griddle should be used on a fairly low heat setting for encaustic painting, it is important to buy a model that has a sensitive, easily adjusted thermostat.

Mixing trays

Encaustic colors can be mixed in individual metal trays such as those used for baking small cakes. It is important that the flat base of each tray should be in contact with the hot metal plate. A large single tray with the indented sections incorporated is not suitable because the heat from the plate tends to warp it, so that the central section lifts and is no longer in contact with the plate.

Materials

Heated tools for paint manipulation

Other kinds of equipment for encaustic painting can be used in the subsequent manipulation of the encaustic paint surface. An electric spatula, the kind whose tip can be replaced with various pieces of shaped metal for smoothing or blending the paint, and whose temperature can be controlled, is useful. For the final softening and blending of the paint film, a hairdrier can be used.

Both bristle and soft-hair brushes may be used to apply paint to the support. With soft-hair, the cheaper nylon brushes may "melt"—be careful not to rest them in mixing trays for too long. (The wax has to be kept hot enough so that it does not "drag" when applied to the support.)

Equipment for encaustic painting
Heat is needed for applying and manipulating the paint, so useful tools include a hairdrier and a gas burner. Also shown are beeswax, carnauba wax, and pigment powder in individual trays.

Preparation

Making encaustic paints

To make encaustic paints, a reasonable quantity of suitable wax is melted, then pigment powder is mixed with the wax in small containers.

Opinions vary as to the best kind of beeswax to use. I recommend natural, unbleached, lump beeswax, which has very little coloring effect on the pale pigments, even white. However, if you want the surface of the painting to be harder than that produced by beeswax alone, add about 10 percent of the darker carnauba wax. The paint film produced is considerably more durable than that made solely with beeswax.

There are no hard and fast rules about proportions in the paint mixture, as long as there is enough wax to coat the pigment particles. Individual artists will establish their own preferences. The amount of pigment you use depends on the required opacity of the mix. It is possible, by adding very little color, to create a paint that is something like a transparent glaze—particularly with pigments that are themselves transparent (see box, p.226). If you add too much pigment powder, the paint will be much less manipulable—in fact, it will probably solidify on the brush on the way from the palette to the painting. Pigments vary in their ability to disperse into the wax, but generally the two combine fairly quickly and easily.

Handling the paints

A range of seven or eight colors can be chosen for a painting, and a few containers left empty for special color mixes. In addition, a small, flat tray on one side of the hotplate allows you to mix even smaller amounts of particular colors. Pigments tend to settle in the bottom of the mixing trays if they are left unused on the hotplate for some time; if this happens, simply stir them again before use.

The paint can be applied to a warm or cold support. On a cold support, it solidifies instantly, on a heated one, it can be blended into adjacent colors.

Encaustic painting techniques

Applying hot colors to a cold support is the most common way of working in encaustic. The paint is usually applied in short strokes. The nature of the medium precludes long, fluent strokes, unless a very long-haired brush is held vertically and worked rapidly. Works like the portrait below are characterized by an intensive, all-over treatment, with no single stroke any more important than the next.

Technique

Recreating traditional effects

This copy of an Egyptian mummy portrait from around the second or third century A.D. was made on hardboard primed with white, acrylic primer stained with Yellow Ocher. A range of long-haired, pointed, flat, nylon brushes was used. A relatively limited range of colors appropriate to the image and roughly the same as those in the original painting was mixed and kept hot on a heated metal plate.

The cumulative effect of the short, direct brushstrokes that solidly chart their way around the form is to produce an extremely frank and engaging image. The head gazes at the spectator with an immediacy and honesty that characterizes most of the encaustic tomb paintings of the Romano–Egyptian period (see also p.223).

Building up the portrait

The features were drawn in and the whole head roughly modeled before being heated with a hairdrier to fuse the colors. Use a hairdrier with care because the colors can suddenly melt in just one area and start to run.

Green and blue paints were used in the shadows. Similar mummy portraits sometimes contain a hint of green in the shadows, but these are more commonly designated with a dull red or brown color.

Egyptian mummy portrait After the whole surface was fused, the head was modeled more fully and particular areas, such as the hair, fused with the tip of a warm iron.

Project Tree study

This study was made with hot colors applied to a cold plywood support that had been given a thin, mid-toned acrylic ground—although applying the colors directly to the wood itself would have been just as easy and as permanent. The toned ground helps to hold the painting together.

Glazing in encaustic

To create translucent glaze effects in encaustic, stir a few grains of the chosen pigment into melted beeswax—just enough to tint it. An encaustic "glaze" is, in fact, almost as thick a layer of paint as in any other part of the painting. It cannot, of course, be modified on the surface in the conventional way like oil glazes, but it can be scraped back with a flat blade, held vertically.

Building up the study

The mid-to-dark tones were applied in short dabs of color, followed by the highlights. Next, some areas of foliage were melted with a hairdrier, creating a looser effect (see below).

The contrast between the white highlights and dark shadows was too marked, and so the encaustic equivalent of glazes were applied (see box, above) to localize the colors of the leaves in particular areas—pale yellow, orange, and green. Some scraping back with a blade was done in places. The next stage was to redefine the darkest tones, after which the whole surface was heated again. More attention was paid to the local color, and dabs of oranges, reds, blues, and greens were added. On the ground, dull, dark green and blue were introduced to complement the purple-reds and oranges.

Small areas of wax were scraped away over highlights to bring these forward. Lastly, uniform heat was applied in a final "burning in."

1 The leaves were expressed in a "Pointillist" style, with dabs of thick color.

2 Certain areas were melted aggressively with a hairdrier so that the colors ran.

3 The painting was further developed by some scraping back and adding more detail.

Finished study The addition of more overall glazes such as the yellow on the leaves, along with a final "burning in" with the hairdrier, gives a uniform quality to the finished work.

Multilayered encaustic techniques

The encaustic medium lends itself to the superimposition of layers of color. Opaque and transparent pigments can be juxtaposed and superimposed in various combinations to produce films of great translucency and depth. Surfaces of apparent complexity can be built up by simple means.

Project Underwater study

This fish study shows how a seemingly complicated paint surface can be created quickly and simply with encaustic. The entire painting process was extremely rapid, not merely because this was only a sketch, but because the paint solidifies almost instantly, and can be reworked immediately.

1 The background was painted in mid-to-deep tones of blues, browns, reds, and ochers on the left and bottom.

2 The colors were applied loosely with long-hair, flat, nylon brushes. The work was heated so that the liquefied colors flowed together.

3 When dry, the entire surface was gently scraped with the flat edge of a razor.

4 The first fish were painted, with a pointed, flat, nylon brush, using Titanium White; then overpainted with "glazes" of yellow and with some red.

5 The surface was coated with beeswax tinted with grains of Phthalocyanine Blue and Green pigment. Further scraping adjusted tonal depth.

6 Steps 4 and 5 were repeated twice more with interim "burning in" sessions to make the colors fuse (but not run).

Finished study The multi-layering technique allows for great depth and variety of tone. The surface of the painting becomes intriguing, with shapes and colors floating below it.

Other encaustic techniques

The unique nature of the hot wax medium will suggest various technical possibilities to individual artists. It is possible, for instance, to use a painting method in which an image is drawn and built up by allowing the hot wax color to run through a small aperture in the base of a small-scale, filter funnel normally used for batik work. The wax must be kept very hot and each manipulation made rapidly before it cools in the reservoir. Artists like Jasper Johns have incorporated encaustic with oil and collage techniques, using materials such as newspaper embedded in the protective and impasted wax surface. The linear approach shown below is another encaustic technique with a unique quality.

Project Creating subtle linear effects

It is possible to create an encaustic surface in which a linear work like a drawing is embedded within the paint film. This is done by coating a panel with a relatively thick layer of colored wax (it does not have to be particularly smooth). The image is drawn into this with any kind of scraping device. Then hot wax of a different color and tone is painted rapidly over the drawn lines and left to cool. It is important to lay on the color in single strokes, without overpainting or scrubbing in, otherwise the wax beneath may melt and the image may be destroyed.

The cooled surface is scraped down with the flat edge of a razor blade to reveal the original scratched marks filled with a second color as a drawing within the overall film of wax.

1 A pale yellow bed of wax was laid onto a hardboard support. The sketch was made by scraping into the solid wax coating.

2 Next, hot wax pigmented with Phthalocyanine Blue was painted on rapidly.

3 When the layer of blue was thoroughly dry, it was carefully scraped away.

Finished study Finally, the sketch was given an orange/brown "glaze" that was partially scraped back for a mottled effect.

Drawing with solid wax colors

As soon as the heat source is removed from the encaustic paints, and the metal plate has cooled, the colors solidify in their individual "dippers." They can then be tapped out of the containers and used as "wax crayons." In fact, with their pure pigment and beeswax-carnauba wax formulation, they are considerably more permanent than the low-value wax crayons commercially available.

To make crayons like these, the wax should be well pigmented. Stir the wax color just before it sets. It is possible to make a drawing with the crayons and then expose the work to heat to melt and fuse the colors. Alternatively, the support can be warmed while the drawing is made so that the crayons melt into "paint." Solid wax colors work best without heat on a hard, rough surface where the abrasiveness of the support takes up the pigmented wax.

PRINTMAKING

THERE IS A NATURAL CROSSOVER between painting and drawing on the one hand and printmaking on the other. But although the materials, skills, and techniques of the former are called upon in most areas of printmaking, it can nonetheless be seen as a very self-contained area of art practice with a number of particular disciplines such as intaglio, lithography, screenprinting, or digital printmaking. These each have their own very characteristic materials, equipment, and methods and their own disciples.

Image 1 *(2000), (Collagraph Print)* MOHAMMED FAKRUZZAMAN

A collagraph gives the artist great freedom to create a unique and complex surface for printmaking. The rich textures on the three plates used to make this print were created with sandpaper and PVA on hardboard, combining dry brushwork with marks cut with a knife. The use of the three plates, in Raw Sienna, Alizarin Crimson, and Lamp Black, which vary tonally from mid-to-light to dark, helps to generate a real sense of open space. The eye is led through the sweeping vertical shapes in black, to the right and left in the foreground, to the middle and far distance by means of a curving crimson horizontal. The artist speaks of the "remembered landscape" of his work.

Relief Printing

Relief printing is the oldest form of printing. The ink is applied to the raised surface and an impression is taken of the block or plate. Areas cut away by the artist, or which do not stand out in relief, will remain blank on the printed paper. A wide range of materials can be used to make blocks or plates for relief printmaking. These include stone, wood, linoleum, plastics, metal, cardboard, potatoes, sand, or cloth. The most common forms of relief printing are woodcut, linocut, and wood engraving. Relief printing is closely associated with letterpress and the printing of books, as blocks for woodcut or wood engraving could be made at the same height as type. Letterpress has not been used as a method of commercial printing for decades, but it is still used to make limited editions of artists' books and prints.

At Toilette (1923), MAX BECKMANN
This woodcut celebrates the expressive nature of the marks made by woodcutting tools. The image is stumpy, squat, and vibrant. The direct marks of the gouge can be seen like white brushstrokes in the bodice and skirt of the model. The whole image is animated by the vigor of its bold approach. It rocks on two diagonal base lines as if on a rocking chair.

Woodcut

The ancient Egyptians, Indians, and Arabs used woodblock relief printing methods to stamp or print designs onto textiles. It was not until the seventh century A.D. that woodcut printing on paper began to be adopted in China, where drawing and text were reproduced on the same block. In Europe, the use of the woodcut in the development of printing was not properly established until the late 1300s, because paper had only been introduced there 100 years before. The great German painter and engraver Albrecht Dürer explored and greatly developed the technique and pioneered it as an independent form of art, not merely as a way of printing text. His contemporaries Hans Burgkmair the Elder and Hans Baldung were also involved with the development of woodcut techniques, in particular chiaroscuro, pioneered by Jost van Negker and Ugo da Carpi.

In China and Japan, the art of the woodcut developed toward its great 18th- and 19th-century flowering. The Japanese *ukiyo-e* or "floating world" school progressed through the pioneering color work of Masanobu, through the technical developments of Harunobu, Sharaku, and Utamaro, to the great work of Hokusai and Hiroshige. These prints greatly influenced late 19th-century French artists such as Gaugin. In the early part of the 1900s, the German artists of the Die Brücke ("The Bridge") group took up the medium. Founded in Dresden in 1905, the group was enthusiastic about primitive cultures and, in particular, the traditions of German art. The artists celebrated the direct, expressive power of woodcut in a series of prints that have influenced contemporary artists such as Baselitz, Penck, and Immendorf.

The principle of relief printing This cross-section drawing demonstrates the principle of relief printing. The raised areas of the block receive the ink (shown here in blue) and print, while the areas cut away by the artist do not.

Materials Choosing wood for woodcut

The block for a woodcut is made from plankwood, cut along the length of the grain rather than across it (see *Wood engraving*, p.234). Plankwood suitable for woodcut can come from a number of trees—including cherry (favored by the Japanese), pear, sycamore, apple, beech, plum, chestnut, willow, and maple. It must be hard enough to allow relatively fine lines to be cut. Softer woods such as poplar, pine, or lime may also be used, especially where large areas need to be cut away. These can be coated with shellac and smoothed with sandpaper before cutting.

Large blocks can be made by gluing planks together in the same way as a panel is prepared for panel painting (see p.44). Strips of wood are usually glued to the ends to prevent warping. Old furniture such as desks and bookshelves can provide very suitable panels for woodcut.

Some artists exploit the appearance of the natural grain by rubbing the surface vigorously with a wire brush, by using acid, or by sandblasting. Plywood has a surface that may also be exploited, as has medium density fiberboard (MDF). The latter is easy to work.

The woodcut block Blocks for woodcut prints are cut from plankwood, along the grain.

Technique Transferring the design to the block

Three methods are shown here. Whichever method you use, remember the drawn and cut image will be in reverse when printed.

1 A simple method is to make an Indian ink brush drawing directly onto the block. This method lends itself to woodcut's more direct imagery.
2 A prepared drawing may be traced through white or black carbon paper.
3 A photographic slide may be projected onto the wood.

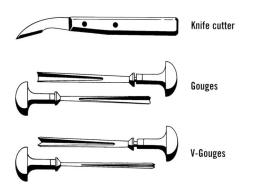

1 2 3

Materials Woodcut tools

The three main tools used for woodcut are the knife, the V-gouge, and the curved gouge. The knife is used for cutting outlines, and the other two are used for scooping out sections of wood. Flat chisels may also be used to remove large areas.

Besides the conventional woodcut tools, many others may be called into service. Metal punches may be hammered into the surface of the wood to create texture effects. A variety of attachments for electric drills can be used to cut, file, and bore.

Knife cutter

Gouges

V-Gouges

Sharpening tools

The importance of using sharp tools cannot be overestimated—almost as much time can be spent sharpening as cutting. Use an oilstone such as the aluminum oxide India stone, which comes in three grades—fine, medium, and coarse. Fine is the most useful, provided that the tools are not allowed to become blunt. A drop of light oil provides lubrication. Blades can be honed further on an even finer natural stone such as Arkansas stone, then polished on a leather razor strap. The burr that occurs on the inside edges of gouges and V-gouges should be taken off with slipstones that are shaped to the curve or "V" of the gouge.

Sharpening a gouge Use a downward, rolling action, turning the gouge from side to side as you draw the edge down the oilstone.

Sharpening a V-gouge Sharpen each cutting edge separately. After sharpening, the "V" should still be symmetrical.

Technique Using the knife, gouge, and V-gouge

The knife is used to cut around the shape of the image. It is held at a slight angle to the cutting line so that the edge slopes out from the printing surface—this is to give strength to the projecting edge of the image and to avoid the inevitable accumulation of ink that would build up if the edge sloped in, and the printing problems that this would bring. Also, another cut may be made at an angle to the first (see below), so that a "V" section is cut around the line to be printed. This enables more wood to be cut away— with the gouge, for instance— without fear of cutting into the edge of the line and damaging it.

The gouge and V-gouge should be used following the grain of the wood. The gouge makes scooped cuts that have a different feel from the sharper, more aggressive cuts of the V-gouge. On a print, the gouge marks are recognizable for the curve that is made at the beginning of each stroke as the tool enters the wood. This gives the marks a certain softness. The V-gouge enters more sharply, and the cut is narrower and deeper than that of one made by a similar-sized, curved gouge.

Using a knife Cut a line across the grain.

Using a gouge With the gouge, cut away from the body, at a shallow angle to the block. The cut has a U-shaped cross section.

Using a V-gouge Handle the V-gouge in the same way as the gouge. It makes a deeper, narrower cut, with a V-shaped cross section.

Gouging Cut up to the knife line.

Technique Using plywood

Plywood has a very different feel to any of the other genuine plankwood blocks used for woodcut. Compared to straight wood, which has a satisfying density, it is light and splintery to cut into. On the other hand, it is very responsive to the gouge and the V-gouge, both of which can be used rapidly, like sketching instruments.

This self-portrait (right) was cut directly from life, with no pre-drawing, using a sharp V-gouge and a curved gouge. The plywood threw up a mass of splinters, so that by the end of the "drawing," the surface of the panel was a mass of sharp, protruding slivers of wood that would have been impossible to ink up properly. A light sanding with an orbital sander restored the smooth surface of the panel and revealed all the incised lines.

Since the areas of wood that the tools remove will not print, for conventional black printing on white paper the cutting should be approached as if drawing on a dark paper with white chalk. This was the approach adopted for this economically made image.

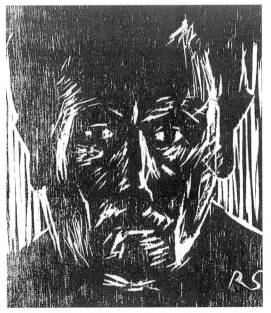

Finished print The print incorporates the natural grain of the plywood, which can be seen particularly in the black areas.

Working back from the highlights The areas of the face that catch the light were cut using both a curved gouge and a V-gouge.

Technique Using alternative cutting tools

Almost any markmaking tool can be used to make indentations into a wood block. Metal punches can be hammered into the wood to create surface textures; and electric drills with a variety of small, abrasive attachments can also be used to incise designs.

Print cut with a soldering iron Using the flat "chisel" tip of an electric soldering iron, the image was slowly burned into a plum-wood block.

Finished print The print creates a negative image of the drawing of houses on a cliff top. It illuminates the lines, as if they are picked out in neon light against a dark sky.

Photographic woodcut (heliorelief)

This method of woodcut printmaking makes use of a rubberized, light-sensitive, polymer coating on a plastic backing. A negative image on film is placed between the polymer film and a light source and the film is subsequently exposed to light. The film is washed out and only remains in those areas that will be printed. The polymer stencil material is supplied with a glue that is used to attach the stencil face-down onto the plank of wood. Up to three coats of the glue are applied, depending on the porosity of the material used for the relief block. The stencil is laid onto the glue while it is still slightly tacky and burnished through the backing paper. It is left to dry for 24 hours, after which the plastic backing is rapidly peeled off. The plank is then sandblasted. The sand bites into the surface of the plank, getting rid of the dried glue, but it bounces off the rubberized coating, leaving it proud of the surface and creating a relief print block. The coating can be left on and inked up or it can be removed, to allow the natural grain of the plankwood to show in the print.

The rubberized polymer material used in heliorelief was originally developed for use on glass (as with most fine art print techniques, it originally had a commercial function) and it can be applied to various kinds of surfaces.

Richard Anderton

Heliorelief print
Here, Richard Anderton exploits the particular "opened up" surface quality that sandblasting a wooden plank can provide. But he also responds to the narrative elements suggested by the grain of the wood. Like the pelican, we are looking over the sea's surface into an illusionistic space. The sense of perspective is heightened by the position of the pelican perched as if high on a cliff. It is wittily appropriate that the image of the bird is taken from a carved wooden figure.

Pelican *(2001)*, RICHARD ANDERTON

Wood engraving

The idea of using copper engraving tools on end-grain boxwood is attributed to the 18th-century engraver Thomas Bewick.

Wood engraving became the standard method of reproducing illustrations for books, and the Pre-Raphaelites produced many designs that were engraved by master craftsmen. However, commercial wood engraving was replaced at the end of the 1800s by photographic methods of blockmaking, and from then on wood engraving became the more specialized field of printmakers working for small private presses.

In the 1900s, the medium was explored and extended by sculptors like Eric Gill and painters like Eric Ravilious. Specialist printmakers publish limited editions of wood engravings as original prints, in the same way as they do with etchings, lithography, and screenprinting.

The Bactrian Camel *(ca. 1785),* Thomas Bewick
Thomas Bewick's mastery of fine line engraving enabled him to depict a full range of tones and minute details. This small example demonstrates his delight in the lumpen shape of the camel within which the variety of textures and movements created by engraved line depict the shaggy coat and the play of light over its surface.

Materials **The wood**

Wood engraving is made on end-grain boxwood blocks (unlike woodcut, which is made on side-grain plankwood). Blocks are usually prepared by an expert blockmaker and are relatively expensive. Boxwood is hard and dense and can be smoothly cut by the sharp engraving tools without leaving the slightest burr. Other suitable woods are lemon, holly, and maple.

The special tools used for wood engraving are known as gravers. They enable the artist to incise lines of great delicacy in the block. Wood engravings are characterized by

their fine detail and careful construction, by crosshatched or parallel-line tonal shading, and by the fact that most of the positive lines in the print are generally perceived as white out of black. They are usually made on much smaller blocks than woodcuts.

The wood engraving block Blocks for wood engraving are cut from end-grain boxwood, across the grain of the wood.

Technique

Drawing out the image

You can draw the image directly onto the block with a soft, fine lead pencil. To prevent the image from smudging, fix it using a proprietary pencil fixative. It can be helpful to darken the block by rubbing in black ink. This means that as you cut it, you can see how the image will look when you print it.

You can draw on the block in white ink, or, alternatively, trace an image using white or black carbon paper.

Materials

Wood engraving tools

Wood engraving tools—gravers, spitstickers, tint tools, and scorpers—are made from fine-quality tempered steel. Each is set into a wooden, mushroom-shaped handle with a flat bottom. They are very sharp.

Gravers
The basic "drawing" tool is the graver, which has the same cross section as a metal engraver's burin (see p.238). This can be square- or diamond-shaped and is set diagonally into the handle so that one of the edges forms the base. At the cutting end, the rod is cut at an angle of between 30 and 45

degrees. The face and the two planes of the bottom "V" section of the square meet at the cutting point. The square graver cuts a slightly wider groove than the diamond-shaped one, which is more useful for fine work.

To sharpen each flat edge, use a circular movement on a fine oilstone with a drop of oil.

Spitstickers

These have a flat, curved cross section and come in a range of sizes. The upward curve on both sides of the point means that they are extremely useful for cutting curved lines.

Tint tools

The tint tools come in a variety of sizes and have a thin, isosceles-triangle cross section. They are used for cutting single straight lines.

Other tools

Similar to the tint tools are scorpers, which are more rectangular in section with a flat or curved cutting edge. They are used for scooping out wider lines. Other tools include the wider chisels and the multiple cutters.

Wood engraving tools (left to right) Diamond-shaped graver, Scorper, Square-shaped graver, Spitsticker, Tint tool.

Technique Handling the tools

Printmakers may devise their own methods, but the essential feature of the grip for wood engraving is that it should be firm and allow the graver to cut at a shallow angle to the block.

Press the handle into the palm of your hand. Your thumb pushes against the steel shaft on one side, counterbalanced by your index finger on the other. Tuck your little finger into the groove of the handle or lay it over the flat. When cutting, rest your thumb on the block to steady the blade at the right height.

The block is traditionally rested and turned on a circular sandbag cushion held by the free hand during cutting. Cut curved lines by moving the block rather than the tool.

Using a graver Push the graver forward at a shallow angle to the cutting surface.

Anne Desmet

Fine line engraving

Anne Desmet has engraved the view from the third floor of her house in east London on separate end-grain blocks of boxwood. The imagery of the print contains all the quiet concentration of its making. It is like holding one's breath on a still, bright morning. The geometry of the walls and the architecture of the buildings create diagonal pathways into the scene. This strong perspective effect takes one right into the heart of the image. The clarity of detail in the morning sunlight increases an air of expectancy in the work. It is a remarkable achievement that a small wood engraving can encompass a world of such scale and atmosphere.

London Gardens—diptych
(1997), ANNE DESMET

Linocut

Effects similar to those of woodcut can be had using linoleum, whose surface is softer, making it easier to work. But, whereas wood is dense, crisp, and dry to cut, linoleum has a thick, almost sluggish feel. Lines cut into linoleum can have the clarity of those cut into wood, but it tends to blunt tools rapidly. If the tools are not absolutely sharp, the edges of the cuts may crumble, producing broken lines in the print.

Materials

Tools and linoleum

To create a linocut block for printing, you need linoleum and cutting tools, which are similar to woodcut tools. Standard lino tools are made from thin pressed steel. They come in a wide range of shapes and are pushed into a wooden handle before use. They can be sharpened on fine grade oilstones or Arkansas stones.

Linoleum for linocut
The thick, heavy-duty range of linoleums with burlap backing is the best kind for linocut. Linoleum may be glued to a wooden block or to plywood to give it more rigidity or to bring it to the required thickness for machine letterpress printing. This is not absolutely necessary and a plain, unmounted sheet of linoleum can be printed on a platen press, or even passed through an etching press if the pressure is adjusted.

Linoleum lends itself very well to multicolor printing. The slight sponginess in the surface, which is squeezed by the pressure of the press, means that flat areas of color print well.

Alternatives to linoleum
Softer synthetic materials, with a grain similar to that of a pencil eraser are now available. These are easier to cut than lino and produce a broadly similar effect.

Mimmo Paladino

Creating a fluid line
This is a fine example of line work in which the contours and features of the drawing, cut directly into the linoleum, appear as white lines out of the dark background color of the block. Matisse was one of the first artists to pioneer this kind of fluency in linocut. In Paladino's print, a rudimentary perspectival space is suggested, on which a complex psychological drama is enacted.

Ulysses (a series of 4 linocuts) (1984), MIMMO PALADINO

Collagraph

In collagraphic printmaking, the artist prepares a thin base plate, the size of the proposed print; this can be almost any sheet substrate, such as a piece of aluminum, thin plywood, plastic, or cardboard, with the edges beveled and with slightly rounded corners.

A unique image is then created as a textured surface on the base plate itself. The textured surface can be created in any number of ways: by scraping acrylic texture paste and carborundum grit onto the plate and scratching into it, or by gluing textiles or other materials, or small objects onto it using plaster and/or PVA. The finished plate looks like a shallow relief collage and is interesting in its own right. It can be inked up as for a relief print, with ink simply rolled over the surface before a print is taken (see opposite page) or as an intaglio print (see p.238) where ink is rolled over but then wiped back so that it goes into the cracks and fissures of the textured surface before a print is taken, or a combination of the two processes.

Monoprint

One of the most straightforward methods of printing is the monoprint. A drawing or painting is made on a smooth, nonporous surface using oil paint, printing ink, or any other medium that will remain wet long enough for you to make the work and subsequently take a print of it. A solid piece of laminate or a piece of acrylic cut to the size that you wish to work to can be printed in a relief press and provides a good, smooth surface to work on.

Printing relief work

For artists working at home without printing presses, it is very possible to print small-scale works by hand simply using a roller and a burnisher. The back of a spoon can be used for the latter. If you have access to a relief press, you have much more control over the quality of your print.

Technique **Printing by hand**

For small blocks with fine lines, a rubber or plastic hard roller and stiff ink is best. A softer roller or runny ink tends to fill in the fine lines, and results in a bad print. For larger, bolder woodcuts or linocuts, a hard or soft roller may be used. Use a soft roller for uneven or textured surfaces. Ink can also be applied with a soft leather dabber or with a brush. The paper used for relief printing is usually thin and absorbent. Interleaving it with damp newspaper before printing ensures a deep, velvety black on the finished print. The paper is laid over the inked block and the impression is transferred by "burnishing."

1 Roll out the ink on a slab, until it forms a thin, uniform layer.

2 Using a roller, dabber, or brush, ink up the block. Then lay a sheet of paper on the block and press down with your hand.

3 Place a protective sheet of thicker paper over the top and rub the surface with the burnisher in a regular, circular motion from the center out.

4 Peel the print away from one side.

Technique **Machine printing**

The block is inked and the paper is prepared in the same way as for hand printing (see above). For home purposes, a simple screw press may be used. The block should be packed on top and the bottom with thick sheets of cardboard or solid rubbering sheet (the "packing"). This ensures a uniform print and protects the block.

The hand-lever letterpress machine is one of the best methods of relief printing, the most popular being the Albion or Columbian platen press found in most art colleges. Relief printing may also be done on etching, flatbed, or cylinder presses.

Before a block is inked up, it should be placed in the press with packing over the top and the impression lever pulled to test the pressure. If the lever pulls back too easily, there is not enough packing. If it does not pull back beyond a certain point, there is too much. Adjusting the pressure on the block affects the quality of the print. The nature of the packing can also determine the quality of the print: harder packing gives a "flatter" print.

Intaglio

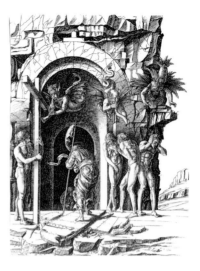

IN INTAGLIO PRINTING, LINES OR TONES ARE engraved or etched into the surface of a metal plate. The plate is inked and then wiped, leaving the grooves filled with ink and the surface clean. Soft, dampened paper is laid over the plate, and both paper and plate are put through the rollers of an etching press. The pressure of the rollers forces the paper into the grooves, so that it takes up the ink, leaving an indented impression of the whole plate on the paper. This impression is known as the plate mark. The two main kinds of intaglio are engraving and etching.

The Descent into Limbo *(ca. 1490)*, ANDREA MANTEGNA
The engraving shows Mantegna's diagonal shading in the rocks around the entrance. The image is seen in harsh light. There is no escape for those condemned to make their descent.

Engraving

Engraving can be traced back to prehistoric man, who used the technique of incising linear markings into resistant surfaces such as stone and rock. The more immediate precursors of copperplate engraving are the armorers and goldsmiths with their surface ornamentations. The silver and gold *niello* work of Italian craftsmen in the first half of the 1400s is an example of this. The first dated example of a copperplate engraving is the German piece *The Scourging of Christ* of 1446, but one of the great engravers of the 1400s and early 1500s came from Italy—Andrea Mantegna. His bold engravings (see above) are characterized by a system of diagonal shading. In Germany, Albrecht Dürer produced engravings that were tighter in style and more deeply tonal. Copperplate engraving soon became the accepted method of reproducing paintings and drawings, but few artists acquired the skills of engraving. Notable exceptions in the 1700s and 1800s were William Hogarth and William Blake.

Materials The plate

In engraving, lines and dots in the plate are cut by hand with a burin or similar tool. Copperplate is the most commonly used surface. It is durable and reasonably soft to cut into. Other metals such as zinc (in its modern zinc alloy form) have been used, but are generally considered inferior to copper. The standard thickness for printmaking is 16-gauge, but the slightly lighter 18-gauge can also be used.

Incised plate In intaglio printing, the grooves cut into the surface of the plate are filled with ink (shown in blue).

Materials The burin and scraper

The basic engraving tool, the burin, has its mushroom-shaped handle set at a higher angle than the main section of the steel blade. This allows it to be pushed along the surface of the copper at a shallow angle.

The blade must be perfectly sharp at all times to allow for smooth cutting. The scraper/burnisher is used to remove the burr on each side of the cut and smooths the edges.

Burin

Burnisher/scraper

Materials Other tools

A number of other tools identical to those used for wood engraving may be used on metal. The scorper, with a rounded or flat point, can be used for broad lines and for removing large areas. The spitsticker or the tint tools may also be used—the medium to large sizes are best for metal; small sizes may break.

Stipple engraving tools

In stipple engraving, tone is built up by a series of tiny dots, rather than with lines as in line engraving. These dots are made with the burin or with a special stippling tool. Various roulette tools may also be used. These have small steel wheels with serrated or roughened edges. Another stippling tool is the mattoir or mace-head punch, which is stamped into the plate leaving small impressed dots.

Engraving in the *crayon* manner

Roulette tools and mattoirs are primarily used for engraving in the *crayon* manner, a way of reproducing the effects of a chalk or crayon drawing.

Although these techniques can be used solely for engraving, they are often also applied to plates through a hard etching ground before being etched in an acid bath (see pp.244–45).

Roulette tool

Mattoir (mace-head punch)

Technique

Making a preliminary drawing on the plate

The technique used for the actual engraving dictates the method of drawing. Some artists prefer to draw in only the most important elements of the image, to allow for subsequent freedom in cutting. A preliminary drawing can be made on the plate in Indian ink, all-purpose pencil, felt-tip pen, or litho crayon. The surface of the plate needs a mirror-polished finish to ensure it will print cleanly. This can be done by using jeweller's rouge with a metal polish. Remember that the print shows the reverse of the engraved image on the plate.

1 To prevent damage to the blankets of the press or the printing paper, file down the sharp edges of the plate, then rub them down with emery paper.

2 If you are not using the expensive mirror-finished engraver's copper, polish the surface of the plate before engraving. Make a preliminary drawing on the copper plate in the drawing medium of your choice.

Technique Line engraving with a burin

The burin should be held in the same position as a graver in wood engraving (see p.235). The burin is only moved forward. To make fluent, curved lines, move the plate, which rests on a leather, sand-filled cushion. If you are using your right hand to move the burin, your left hand will move the plate. A continuous and relaxed action is best, without unnecessary force or pressure. If you hold the burin at too steep an angle, the blade will not travel through the metal. If the angle is too shallow, the blade will not cut effectively.

1 Hold the handle in your palm, with your thumb on the side of the blade, resting on the plate. Cut with a firm, forward action; do not push down.

2 Using the sharp cutting edge of a scraper, cut away the spirals of metal in front of the cut.

3 If you want to add tonal effect and dimensionality to the image, use a roulette with a serrated, steel wheel.

Technique Mezzotint engraving

In mezzotint engraving, the metal plate is pitted with tiny indentations over the surface, which, if printed, produce a deep black. The printmaker works from black to white by scraping out and burnishing sections of the prepared plate. These print as halftones or as white, depending on the degree of scraping and burnishing.

Preparing for mezzotint engraving
The preliminary preparation of the plate for mezzotint involves systematically roughening it with a rocker. This is a broad, flat blade with a curved, chiseled end. One side of the blade is finely grooved, giving the end a serrated edge. The blade is held, or mounted on a pole at right angles to the plate and rocked over the whole surface in many parallel directions to form a grid.

Once a test print has been made, the plate is coated with black wax, or another easily removable medium, so the progress of the work can be seen. The surface is then scraped away. To get back to white, the pitted area must be scraped away entirely and then burnished and polished so that it is unmarked. For darker tones, some of the texture remains. Corrections may be made by regrounding the surface with a roulette and rescraping. The plate is inked using a soft leather dabber and printed through the etching press.

Other methods for overall deep tones
Mezzotint produces denser and subtler tones than other techniques, but it is laborious. Alternative methods are sandblasting or aquatint (see p.244). The sand grain ground technique involves passing the plate repeatedly through the press with abrasive paper over a hard ground, then etching.

Roughening the plate Use the rocker to produce an overall grid surface texture on the metal plate.

Scraping out the texture To scrape out areas, hold the scraper almost parallel to the plate so that it just shaves the surface enough to remove the burr.

Technique Drypoint

Drypoint is a form of linear engraving in which a sharp steel needle, diamond point, or other hard stone tool is used to scratch an image directly onto the surface of the copper plate. The line made in this way is not as deeply engraved as a line made with a burin. It throws up a burr or rough edge that traps the ink and allows the line to be printed. If the burr were removed, the image would not print so distinctly. The surface of the plate is vulnerable to the extreme pressure of the etching press and the burr is quickly worn down by printing, and so unless it is steel-faced by electrolysis, only a limited number of prints may be successfully taken. Of the dry engraving techniques, drypoint is the closest to pencil sketching and is very popular with painters. A small sheet of copper can be worked on with no great technical preparation or skill, other than that of draftsmanship.

Tools for drypoint
The diamond-point drypoint tool produces the most fluent line. It glides through the copper rather than scratching through it as the steel needle does.

The "échoppe" point may also be used to incise lines, which will print thick and dark. For additional, deeper lines, use a burin or the roulette.

Ray Dennis

Mezzotint
The close, painstaking work involved in the preparation of a mezzotint plate is rewarded in the complete range of tones that can be produced from a deep, lustrous black to white. This is well illustrated in this detail. The startled intensity of the girl's face, silhouetted against the evening, and her dramatic pose in the dark landscape demonstrate the atmospheric effects of a mezzotint print.

Playing God (detail) (2000), RAY DENNIS

Etching

The first etchings date from the 1500s, with work by artists such as Albrecht Dürer and Albrecht Altdorfer. By the 1600s, the scope and technical possibilities of the medium had broadened considerably. Etching finds its mature expression in the extraordinary range of work produced by Rembrandt van Rijn. In the 1700s, Giovanni Piranesi produced a powerful series of line etchings, the *Carceri d'Invenzione*. Francisco José de Goya y Lucientes took the relatively new tonal method of etching known as aquatint to masterly heights in series such as the *Por Que Fue Sensible*.

How etching works

In etching, the lines are scratched through an acid-resist ground, then bitten into the surface of the plate by acid. During the process, surface areas that need to be protected from the corrosive action of the acid are covered with a thin film of resist. This is a waxlike substance that can be hard or soft depending on the kind of image required and the technique. It is known as the "ground." The edges and the back of the plate are protected from the acid with varnish.

An etching needle is used to draw the image into the ground, exposing the metal in those areas. The plate is then placed in a diluted acid bath and the exposed metal is etched. The plate can be removed at any time, and the action of the acid on certain lines can be stopped by painting over them with stopping-out varnish.

Once the lines have been etched sufficiently deeply, the plate is taken out of the acid, the ground and varnish removed, and the plate is inked up. An impression is then taken by passing the plate, along with overlaid dampened paper, through the etching press.

Etchings can go through a number of stages of biting, reworking, and rebiting. It is usual for printmakers to take impressions (or "states") of the plate at the various stages to check the progress.

Preparation Preparing the plate

Copper and zinc are the most common metals used for etching. Copper is the best all-around metal, as you can bite it in ferric chloride. This is much safer than other acids and does not give off the potentially harmful fumes associated with nitric or hydrochloric acid, for which it is absolutely essential to have professional extraction facilities.

Iron, mild steel, brass, aluminum, and magnesium may also be used. Iron and steel provide a hard surface. The metal bites slowly and does not discolor inks. The edges of the plate should be beveled with a file so that paper and etching press blankets are not damaged when the plate is put through the rollers.

1 Clean the plate with metal polish. Gently wipe or brush with a paste made from French chalk (or whiting) and water, along with a drop of household ammonia.

2 Rinse the plate under running water to remove all traces of the paste. The water must flow freely over the plate—any rivulets or drops indicate grease on the surface.

Technique Hard ground etching

The ground is the wax-based resist laid onto the plate, through which the image is drawn. Hard grounds can be bought in solid lump or "etching ball" form, or in liquid form. The former is more widely used because it precludes the need to heat the plate, but it can be difficult to control. Liquid grounds are good for selective application and in special techniques such as sugar lift (see p.245).

The three main constituents of a hard ground are beeswax, bitumen, and resin.

- Beeswax provides the basic acid-resist coating for the plate. It is soft enough to be drawn through with the needle, and is modified by the addition of bitumen (asphaltum) and resin.
- Bitumen is also naturally acid-resistant. It colors the mixture and, according to the kind of bitumen used, makes it tough, flexible, or, in excess, brittle.
- Resin hardens the mix and raises the melting point of the ground. Mastic, dammar, or colophony (rosin) may be used. Rosin is the usual choice.

Applying a hard ground

The ball or lump of hard wax ground is applied to the warm plate on an iron hot plate. This can be improvised with a sheet of iron or steel placed over a low-burning gas ring on a domestic stove. The warmed copper plate melts the wax as it is applied in dabs over the surface. It is then rolled flat with a roller. Most printmakers tend to apply the wax ball directly to the surface of the plate, but, strictly speaking, it should first be wrapped in fine silk to trap grit or other impurities that could mark the surface.

The plate should be hot enough to allow the ground to be rolled out very thinly—but not so hot that the ground scorches. The ground will be a translucent brown.

Smoking the plate

Wax tapers are lit and held below the inverted face of the plate. This is hot, so it should be held in a hand vise. The tapers are held at such a distance that the sooty deposits from the flame blend with the still-warm wax and create a smooth, black surface.

Drawing into the ground

The method is also known as "needling," because a steel needle is used to inscribe the lines onto the plate through the wax. The needle should have a slightly rounded tip and should clear the wax ground from the plate, so that the metal shows through clean and shiny. The surface of the plate itself should not be scored; this can result in inconsistent biting or a "foul bite."

Do not rest your hand on the plate—its warmth could disturb the ground and the marks in it. For fine, detailed work, it is helpful to construct a small wooden bridge on which to rest your hand. If the lines are too thick, they will print gray in the middle, so the best way to intensify the width or depth of tone is by repeated or extended biting.

When shading by cross-hatching or with close parallel lines, all lines will print in black, though their appearance—in shiny metal out of the dark ground—is light. If crosshatched lines are drawn too closely, the acid may bite across from one to the other, leaving an undesirable gray area on the print.

Stopping-out varnish

This varnish stops the acid from biting further into a line that has already been etched, and protects other selected areas from the acid. It also coats the back and edges of the plate to protect them from the acid. (You can also protect the back of the plate with adhesive-backed plastic.) There are two main kinds of varnish:
- Bitumen varnish—a solution of bitumen in an organic solvent
- Shellac varnish—a solution of shellac in alcohol (methyl acetate).

Bitumen varnish is dark brown and thickens rapidly as the solution evaporates. It may be thinned for precise applications with a fine brush or pen. The shellac varnishes are transparent or tinted. They cannot be needled without producing a ragged line because they tend to splinter.

The advantage of a near-transparent varnish is that you can compare the biting in various parts of the plate. It has a tendency to spread, but if left on the brush for a while, it will thicken and be easier to control.

1 Dab the ball or lump of hard ground all over the warmed plate so that it melts on the hot metal.

Roll it out to a thin **2** coating, uniformly applied over the plate.

3 Hold the hotplate in a hand vise with the ground facing down. Hold lighted tapers under the plate so their smoke produces a black covering on the ground.

4 With a needle, draw the design on the black surface, through the hard ground.

5 With a brush, apply stopping-out varnish to the back and edges of the prepared incised plate or to any area on the surface where the hard ground may have rubbed off.

Technique Soft ground etching

In soft ground etching, the effects of crayon or pencil drawing can be reproduced in an intaglio print. The hard ground recipe is mixed with up to 50 percent tallow fat or grease. The ground is applied to the plate as before and allowed to cool. A sheet of paper is placed over the ground and the drawing is made with a point on the paper. When the paper is removed, the ground can be seen sticking to it in the drawn areas.

Where the metal on the plate has been exposed, the grainy texture of the paper is retained. The plate is bitten in acid and the textured lines print positively. A weaker mordant should be used than for hard ground etching (see p.245).

This is a very direct method of etching, with a characteristic soft appearance. It can be combined with other etching techniques to produce complex tonal images. The thickness and surface of the superimposed paper and the nature of the drawing tools can be varied, which means that an endless series of different effects can be created. Impressions of textiles, wire, hand, or leaf prints—of anything in shallow relief—can be transferred to the plate, either as overall background textures or within particular areas.

The soft ground can also be directly incised with a round-tipped etching needle or a sharp stick, to produce rich, black lines in contrast to the tonal effects described so far.

1 A photocopy of a drawing is placed over the plate and the drawing is traced through the paper.

2 When the paper is removed, the lines are seen on the ground.

Los Caprichos, Plate 32,
from the **Por Que Fue Sensible** *series*
(1799), FRANCISCO JOSE DE GOYA Y LUCIENTES

Goya

A dramatic aquatint (see p.244)

The bold use of the medium is exemplified in Goya's *Por Que Fue Sensible* series. There is an extraordinary economy of means in these plates, where here, for instance—the contrast between just three basic tones—black, gray, and white—is employed to suggest a fully resolved image. The strong chiaroscuro effect picks out the figure in a cold light against the gloomy interior, producing a powerful intensity of feeling.

Technique Aquatint etching

The aquatint method of etching creates tones of various depths, ranging in texture from coarse to very fine. It can be used on its own or in conjunction with other intaglio techniques such as line etching. A plate is covered in a uniform layer of resin powder—usually rosin (colophony, see p.32) or bitumen—and heated from beneath. The resin melts and adheres. When the plate is etched, the acid eats into the metal around each grain, producing an inkholding surface that gives a uniform tone when printed. By a repeated process of etching and stopping out, an image can be produced in different tones. For the aquatint to be successful, the layer of resin dust on the plate must be finely and evenly distributed. It is best to use an aquatint box (dust box); several kinds are available.

When biting the plate in acid, an aquatint should be checked more frequently than a line etching. Heat is generated more quickly than usual because of the large area of plate exposed to the acid—this speeds up the bite.

1 Agitate the powdered rosin or bitumen in the aquatint box. Allow the particles to settle. Insert the degreased metal plate so that it becomes covered with a dense and uniform layer of dust.

2 Heat the plate by moving a gas burner underneath it, until the rosin melts and the particles stick to the plate. Be careful not to overheat the plate.

3 Seal any areas that are to be white when printed with stopping-out varnish. Etch the plate in acid to eat away at the areas surrounding the grains of rosin. This produces an overall pale tone.

4 Stop out those areas that you want to print in a pale tone and etch the plate again. Repeat the process until only those areas of the plate that need to be very dark are left exposed to the acid.

1 2

3 4

Building up tones in aquatint

1 Stopping-out varnish is applied to the rosin-coated plate. The plate is etched a little.

2 More varnish is applied to enlarge the stopped-out area and the plate is etched some more.

3 More varnish is applied and the plate is etched again.

4 The final printed effect, showing how the area that has been etched most prints in the strongest black.

Other methods of producing grain effects

If a hard ground is laid onto a plate, overlaid with sandpaper, and run through the press, the sandpaper's texture is imprinted on the ground, exposing the metal in tiny dots. This is repeated with fresh sheets of sandpaper until an overall effect is achieved. This is then etched.

A similar effect can be produced by sprinkling salt over the hard ground. When the plate is warmed, the salt sinks into the ground. When it is cooled and placed in water, the salt dissolves, leaving pits in the ground that can be bitten.

Safety points when handling acids

- Wear goggles, protective gloves, and a respirator when using acid or acid solutions.
- Make sure the trays into which the acid bath is poured are placed on a stable surface.
- Always add the acid to the water, not the other way around.
- Use professional extraction facilities in the biting space to draw off the poisonous fumes emitted by nitric or hydrochloric acid.
- Remove the acid from the trays as soon as it is no longer in use.
- Wash off any acid that gets onto your skin immediately, and apply an alkali solution.

Technique Lift ground (sugar aquatint) etching

This is a method of producing positive brush- or pen-line effects on a plate. The image is drawn directly on the plate using a saturated solution of sugar and color. (Dissolve as much sugar as you can in boiling water, then add a little gouache or Indian ink.) When this is dry, apply liquid ground or thinned-down, stopping-out varnish over the whole plate and allow to dry. When the plate is immersed in warm water, the sugar melts, and the brushed or drawn areas emerge out of the ground or varnish. With thin pen-lines, the plate can be etched directly. With thicker lines, the plate is aquatinted as described opposite. These areas will then print positively.

1 Draw the positive image directly onto the plate with a brush or pen.

2 Apply liquid ground or thinned stopping-out varnish.

3 When immersed in water, the sugar melts, revealing the brushed/drawn areas.

Technique The bite

There are two main kinds of acid used for biting: ferric chloride, which is the safest to use, and nitric acid. In addition, hydrochloric acid can be used with extreme care on steel.

Ferric chloride
Ferric chloride can be used on copper, zinc, iron, and steel. It bites evenly and slowly, without fumes. The new acid can be tempered by mixing a little of it with ammonia water in the proportion 1:1. Stir for 15 minutes, discard the liquid, and pour any sediment into the bath. During biting, a sediment will form in the bite. This makes it difficult to observe progress, so the plate has to be removed and checked periodically.

Nitric acid
Nitric acid is the strongest mordant. It attacks edges and undercuts the lines more than the others. For biting copper, mixtures vary from 3:1 to 1:1 water to acid.

When the fresh solution is exhausted, it turns blue. A new solution can be prevented from biting too suddenly by adding a little of the exhausted stock, or by adding copper filings. Bubbles tend to form with nitric acid and these may affect the bite, but they can be avoided by "feathering" the plate (stroking with a feather) in the acid, or by tilting the bath to remove them.

For zinc plates, the acid tends to be used in weaker solution, in a range from around 12 to 6 (water): 2 (acid), although even weaker solutions are not uncommon. Zinc bitten with nitric acid shows a coarser texture than copper. For iron and steel, the solution is around 5 (water):1 (acid). Acid that has been used for one metal should never be used for another.

The biting process
The speed of a bite depends on the strength of the acid and on temperature; in winter or in a cool room, the bath may need warming. There are few rules for the duration of a bite, since conditions vary so much. But it is possible at any stage to remove the plate from the bath, rinse it, and check progress. A needle is a valuable tool for checking the depth of a bite.

Open bite occurs where a line or an intersection of lines is too wide to trap ink when wiped, only the edges will print black and the center will print pale gray. If you do not wish to exploit the soft effects this produces, aquatint the area. Or it can be regrounded or varnished and needled to etch more lines into the gray areas.

Deep etch is an extreme form of open bite; the plate is heavily bitten to produce deep edges to the shapes, which then stand out like islands on the plate and print with great depth of tone. In order to keep edges sharp, several applications of stop-out may be required. Zinc is the most suitable metal.

Plates can be bitten selectively by swabbing with acid in particular areas, or a wall of plasticine or wax can be made to contain the acid. "Creeping bite" involves tilting the bath to clear part of the plate. Agitating the bath avoids a hard edge and creates a gradated effect. Blotting paper can be used to absorb acid in the transitional areas.

Printing intaglio work

At every stage of the platemaking for intaglio printing, you must take a proof on prepared paper to check your progress. Unsized paper needs interleaving with damp blotting paper.

Heavily-sized paper needs soaking in water before being sponged off and must then be stacked between sheets of glass or drawing boards.

Materials Ink and paper for intaglio printing

Printing ink is made by grinding pigment in oil. Its viscosity is determined by the amount of pigment and the kind of oil used, but generally it should have the consistency of thick cream.

Medium-weight, fine-grain, acid-free paper is the usual choice for quality intaglio printing. Deep-etch work will require heavier paper, while aquatint or fine line work may need lighter paper.

Technique Inking and printing the plate

First, the plate is thoroughly cleaned of all stopping-out varnish or ground. It is then placed on the hot plate to warm before inking. Dab ink over the plate, making sure that all the grooves and pits are filled and ink is in the etched areas only. Wipe off the excess with scrim or tarlatan. Some of the excess ink can also be removed by scraping with a piece of stiff cardboard or with the edge of flexible plastic. For a line-only print, rub the side of your hand in whiting and sweep it across the plate.

On the bed of the copperplate press, tape a sheet of paper the same size as the one to be printed and with an outline of the plate in pencil positioned accurately on it. Lay the inked-up plate over the outline and lay the paper to be printed over it. Lay felt blankets over the paper and

pass the plate through the press. The printing paper is generally positioned and then removed with two bent pieces of cardboard held at two diagonal corners to prevent smudging from inky fingers.

After printing, the still-damp paper can be stretched by placing it on a flat surface and sticking it down with gummed tape. This makes sure that it will dry absolutely flat. However, the embossed impression of the plate itself may be lost, so it is best to stack freshly pulled prints loosely between blotting paper. This allows the paper and ink to dry thoroughly. They can be flattened later by redamping, interleaving with tissue paper over the ink and blotting paper, and stacking between drawing boards or glass plates.

1 Apply ink to the plate and spread it with a small rubber squeegee.

2 Wipe off excess ink by rubbing the plate with a bundle of scrim or tarlatan. Use a circular motion.

3 Position the plate accurately on a sheet of printing paper taped to the bed of the press. Lay the printing paper on top to correspond with that on the bed.

4 After printing, carefully lift the print from the plate and allow to dry.

Flexography (photopolymer)

Although flexography is the commercial printing process used for volume printmaking of items such as cereal boxes, it has been taken up by artist printmakers. It involves a light-sensitive, polymer coating on a plastic or metal backing and can make either a relief or an intaglio plate. This material is readily available and simple to use. The plate is exposed to quartz halide or UV light through the artwork on transparent film and washed out with warm water. The result is a photographic relief printing plate. If you put a very fine halftone on it, you can ink it up as an intaglio plate and print photogravure-type etching. You should make negative artwork for relief and positive artwork for intaglio.

Technique The flexographic process

In the world of commercial printing, flexography is used in rotary high-speed printing, so the flexible plate is wrapped around a printing cylinder. In fine art printmaking, it is more common to see the material used in flat sheets as in the example shown, where a proofing press is used to make the print.

1 The thin, steel-backed flexographic plate is created from the chosen image. This is what it looks like after exposure and processing.

2 The flexographic plate is placed on the proofing press, which has an almost "type high" MDF board with a magnetic strip surface, so the plate does not move during printing.

3 Ink is then applied along the large roller and the machine is switched on. The movement of the rollers spreads the ink, which is added until the press is fully inked up.

4 Finally, the paper is attached to the top of the press, the machine is switched on, and the print is taken.

Finished print *Eight Hour View* flexographic print by Tom Sowden. This print is based on a photograph taken by the artist when he had to spend a lot of time lying still on his back in the hospital.

Lithography

THE INVENTION AND DEVELOPMENT OF THE art of lithography took place at the end of the 1700s and is credited to Aloys Senefelder (1771–1834), who founded an institute in Munich where new techniques could be researched and promoted. He was a thorough researcher whose textbook of lithography remains as practical today as it was over 150 years ago. Senefelder was no artist himself, but his invention was soon taken up by artists like Goya, Ingres, and Delacroix. The immediacy of the process and its affinity to straight drawing techniques made it popular among painters such as Manet, Degas, Seurat, and Toulouse-Lautrec—the latter using the technique for the memorable designs on his color posters. Today, lithography has an important role in printmaking.

Tools and techniques for lithography

Lithography, or planographic printing, is based on the mutual antipathy between grease and water. A print is taken from a lithographic stone or plate with a flush surface, in which no area is higher or lower than another. It attracts grease, and therefore the printing ink, in the areas to be printed. In the unprinted areas, however, it attracts water and so repels printing ink.

The damp stone or plate is inked and a sheet of paper is overlaid. It is then put through a press and pressure is applied with a scraper—usually through a thin metal plate or tympan—across the surface of the stone. Lithography was originally practiced solely on limestone slabs, though nowadays specially grained zinc and aluminum plates are also used.

The chemical basis of lithography

The lithographic stone or plate is able to attract or repel grease through adsorption, which is a form of adhesion at a molecular level (see *Glossary*, p.372). Fatty acid molecules (components of the greasy lithographic drawing materials) are adsorbed onto the stone, making the area that has been drawn permanently receptive to grease.

The process is not dissimilar to the chemical action that takes place when the acidified gum arabic is used to etch the plate, except in this case, the gum arabic desensitizes the undrawn areas, which then become permanently resistant to fatty acids.

The adsorbed layers are so thin that they remain imperceptible and do not break up the flat, uniform surface of the lithographic stone or plate.

Materials Stone and metal plates

There are a number of differences between a stone and a metal plate. The main thing to remember is that stone is more porous and feels more absorbent to work with. The effect of this when laying washes is that they will look pale on the stone, but will print darker. It is more difficult to achieve subtly graded tones on metal plates. It is also easier to make corrections to a stone because it can be scraped and re-etched. For this reason, the stone lends itself to litho mezzotint effects, whereas the metal plate does not.

Fine Bavarian limestone of a light yellow/gray color makes the best stone for lithography. It is fine-grained, porous, and softer than gray stone. A light gray stone will require a little more acid in the gum-etch than a yellow stone, and a dark gray stone a little more again. The stones come in various sizes and thicknesses.

Lithographic stone
The image can be retained on the stone by inking, chalking, and gumming it.

Materials Inks and crayons for lithography

Whatever color is used to ink and print the plate, the original work on it is always done in black and white. The medium used to mark the stone or plate must be greasy.

There are innumerable recipes for the preparation of lithographic crayons and inks, but they generally all contain wax tallow fat, and soap in various proportions, as well as the black carbon pigment. A solid ink, ground and diluted with distilled water, can be used. This usually contains some shellac as a hardener. You can also buy proprietary lithographic crayons, ranging from very soft to hard, and "tusche," the ink used for lithography. Tusche is available in slightly different formulations for use with either a brush or pen.

You can use a wide variety of other media for working on stones or plates, including shoe polish, soap, petroleum jelly, oil pastels, and all-purpose pencils. Even ordinary graphite pencils will produce a pale image.

Technique Using a stone plate

The stone must be perfectly flat and grease-free. This can be achieved with a levigator—a heavy iron disk with a handle near the edge and holes in the center. It is used in conjunction with sand and water, to grind down the surface of the plate. The grinding sand is generally used in three grades: coarse, medium, and fine.

If a grainy surface is required (such as for crayon drawing) use coarse-grade sand on its own. Move the levigator around the stone in a figure eight, using equal pressure on the sides, corners, and center. When the sand is pulpy, wash it off and use a new batch. Check the stone's flatness from time to time with the edge of a metal rule. It is important to file the edges of the stone, to make sure that the paper will not be torn when it goes through the press.

Using the levigator With sand and water on the stone, use the levigator in a figure eight motion. Do not neglect the edges and corners of the stone.

Checking the surface From time to time, stop work to wash off pulpy sand and assess the flatness of the stone with the edge of a metal rule.

Drying the stone Dry the stone with a hairdrier before beginning to draw on it.

Technique Using a metal plate

Both zinc and aluminum plates are suitable for lithography. They have to be prepared with a grainy, grease-free surface. This is usually done with a graining machine—a large, flat, vibrating bed or tray.

Place the plate on the graining machine and cover it with glass marbles. Next, throw sand and water into the machine. The marbles vibrate on the sand and plate, which creates the roughened texture needed to hold the lithographic crayon and the water. You can control the roughness of the plate by changing the kind of sand that you use for the graining.

A plate that has been stored for some time, and that may have accumulated grease and dust, can be chemically resensitized with a proprietary mixture such as Prepasol, which contains potassium alum, nitric acid, and water.

Technique Protecting white areas

If you want a white margin around a print, or you want a particular shape to print white, you can mask out the area with a gum or gum-etch solution applied with a soft brush. This protects it from greasy marks that can easily be made while the stone or plate is being worked.

Proprietary gum mixtures are available for working on metal plates. A gum arabic solution can be used if you are working on stone; it leaves a slightly darker mark on the stone or plate, so you can see where it has been applied.

Masking out Apply gum or gum-etch solution with a soft brush or sponge to areas to be left white.

Technique Transferring an image to a stone or plate

The lithographic stone will print the reverse of what you draw, so if you are using an original drawing, view it in a mirror when copying directly onto the plate. If the drawing is on paper, tape it face-down onto a light box, and view it from the back.

When printing a zinc or aluminum plate on an offset-litho machine, which can be a more reliable printing method, it is unnecessary to draw in reverse, because ink is taken from the plate onto a roller before being transferred to the paper and is not therefore a reverse image.

You can also trace an image, using rouge (red chalk) or graphite transfer (tracing-down) paper (see below). This gives a nongreasy image. Another method is to project a slide directly onto the stone or plate.

1 Place the transfer paper, chalk-side-down, on the plate. Lay the original on the transfer paper. Cover it with a thin sheet of transparent acetate for further protection if necessary. Trace the contours with the sharpened end of an old paintbrush or similar instrument.

2 Lift off the transfer paper to reveal the image on the stone or plate. The transfer will generally provide a clear guide to drawing and painting the image on the stone itself, which you now need to do, using greasy lithographic crayons or liquid tusche.

Technique Making lithographic line drawings

When doing any kind of lithographic drawing or painting, always remember that grease will print and gum will not. Any area that has been in contact with grease will leave a mark that will print unless it is physically removed.

One of the best ways of making lithographs is to do a chalk or crayon line drawing on the plate just as if it were a piece of paper. Remember that a hard crayon will produce a lighter tone than a soft one. To keep the chalk or crayon from getting warm and sticky, use a holder. This is particularly important for softer grades of crayon.

Alternatively, you can make a solid black line drawing directly on the plate using tusche or lithographic drawing ink. This is made up in slightly different proprietary forms for brush or pen (zincographic ink). It produces crisp edges and solid lines.

Direct drawing on the stone or plate Drawing with a brush or pen is particularly suitable for lithography, which gives a more subtle and tonal quality to a line than can be had with, for instance, screenprinting.

Making a linear drawing on the stone or plate To ensure there are no smudges on the print, it is important not to let your hand touch the stone or plate.

Linear portrait lithograph This print was made using a soft sable brush and proprietary lithographic drawing ink on a metal plate.

Technique
Creating tonal effects

The natural grain of the stone or plate can be used to create tonal effects: gently rub a crayon across the surface of the stone or plate. The surface texture will pick up the crayon, thus creating a grainy halftone effect similar to that produced by the all-purpose pencil on CP paper (see pp.71–72). You can create denser areas of tone by heavier shading, or shading with a softer pencil.

You can also create halftones by diluting tusche, or by spattering with a toothbrush through a paper stencil. Or try spraying the ink through an airbrush with a spatter cap.

Diluting the crayon
The marks of the lithographic crayon can be diluted by applying a brush dampened with distilled water or paint thinner. Distilled water is preferable, since paint thinner can sometimes have a greasy effect. This technique enables you to create halftone wash effects. It is a good idea to have first mastered the art of gum etching, since it is common for the halftones to go into solid areas of black. The most important aspect of the lithographic process is that the lithographic version of the original will generally reproduce with more tonal contrast.

Producing halftones
Lithographic crayon can be carefully diluted using a brush dipped in distilled water or paint thinner.

Line and tone image This tonal print was drawn up principally in lithographic crayon. Rich tonal effects were obtained by diluting the crayon on the surface of the stone with paint thinner and also by using thin liquid tusche. This was blotted in places for textural effects. Some of the crayon lines were reinforced with brush and ink before processing.

Technique A "mezzotint" form of lithography

A black, greasy ground is laid over a coarsely-ground stone. You can use an asphaltum solution for the ground, or lithographic ink diluted with turpentine. Scrape the image out of the dark ground using flat scrapers, wire brushes, or emery paper for large areas of tone, or pointed scrapers for thin lines that you want to print white.

Toulouse-Lautrec

Lithograph on stone
The lithographs of Toulouse-Lautrec have a lightness of touch, a fluency, and an appropriateness to their subject matter and to the medium that makes them unique in the late 1800s. Lautrec had a gift for drawing that was allowed direct expression by the receptiveness of the lithographic stone. The softness of tone of the crayon and the bold, flat areas of the brush are retained in the stone and expressed in the print.

With Lautrec, there is always the sense of an experience freshly perceived. But there is also a remarkable sense of design that controls the surface and contains the action. Here, the shape of the woman and her profile are held by the surrounding tone.

Aux Ambassadeurs (1894),
TOULOUSE-LAUTREC

Transfer lithography

In this indirect method of lithographic printmaking, the image is drawn with greasy lithographic drawing materials on paper and transferred to the stone from which it is then printed. The paper may be of varying texture or thickness, but before it is used, it should be coated with a weak, water-based size solution or with a water-soluble glue, or gum-based, white paint. This gives a key to the greasy drawing materials but also makes transfer to the stone easier, and ensures that greasy and nongreasy areas separate properly. The surface of the paper should be kept clean of greasy fingermarks that can cause smudges on a print.

Once the image has been transferred, the stone can be processed and printed. Alternatively, you can continue to work on the image directly on the stone.

Technique

Transferring the image to the stone

When you draw an image on transfer paper, you might make the tones slightly deeper than you need, to compensate for the fact that the image can transfer to the stone slightly lighter than the original. If the transfer is not entirely satisfactory or you wish to rework the drawing, you can do so by simply drawing directly onto the stone.

1 Lay the drawn image face-down on the prepared lithographic stone, which should be dry.

2 Lay a sheet of paper on top of the transfer paper and, using a sponge, dampen the back of it evenly.

3 Pass the stone and the paper through the press to transfer the image. Remove the damp paper and peel the transfer paper off the stone.

4 The image will have transferred to the stone. It can now be dried using a hairdrier. Process the stone in the normal way.

Preparing and printing the stone

If the margin around the edge of the image has not been protected with gum, clean it using a snakestone and water and leave to dry. Dust the stone with rosin to protect the greasy, drawn areas from the acidic gum etch and with talcum powder to make sure that the gum etch covers the whole surface.

The first etch

The gum etch comprises a solution of gum arabic to which some drops of nitric acid are added. Phosphoric and tannic acid may also be added to the mix. The amount of acid will depend on the drawing and the kind of stone used (refer to the table on p.254 for proportions).

After it has been etched in this way, the stone will be desensitized to grease in the nonprinting areas. The adsorption, or bonding, of the greasy areas to the stone is also speeded up by the neutralizing effect of the alkali in the soap component of the greasy areas. This "frees" the fats for bonding onto the stone.

Washing and inking the stone

Remove the grease with paint thinner and wash the drawing in an asphaltum solution. This brings up the image in brown, in a light, even tone and helps the nondrying ink, applied after washing the stone with water to remove the gum, to take to the greasy areas.

It would be possible to take a print at this stage, but the image is not yet firmly established on the stone, and so it is best to ink it up with a fatty, slow-drying ink called "press black" or "nondrying black" before "etching" it for a second time. Roll up the ink on a slab and apply it to the stone in a light, smooth, rolling action.

During the application of the nondrying black, keep the stone damp with a sponge. It will take some time for the image to appear in its full range of tones, particularly if it has been heavily drawn with a lot of black.

The second etch

Dry the stone with cold air from an electric fan, or a hairdrier, before dusting it with rosin powder (which adheres to the nondrying black), and then with talcum powder. The stone is ready to be etched for the second time, with a gum etch or water etch solution.

After etching, wash off the etch and gum the stone with gum arabic if you do not intend to make a print right away.

1 Dust the surface of the stone with sieved French chalk or talcum powder (baby powder is suitable) and rosin. Dust the powder on with cotton balls and dust off the surplus.

2 Apply gum etch over the entire surface of the stone. Proprietary gum arabic with nitric acid mixtures may be used. Rub the etch on with a sponge and pat it down. Leave for around 12 hours.

3 After this time, wash the stone with paint thinner to remove any grease.

4 Pour on a little asphaltum solution. Rub this on evenly, with more water.

5 Wash the stone with water to remove the gum.

6 Keeping the stone damp, roll up the ink on a slab, then ink up the stone lightly and fan dry. Dampen a sheet of paper and place it over the stone with some packing paper on top.

7 On a hand-operated lithographic press, lower the metal plate over the bed. Lower the scraper and crank the bed through the press.

8 Lift the finished print carefully off the stone.

Technique Processing a lithographic plate

This method is very similar to processing a stone. The main difference is in the chemicals used for the etch.

The first etch

The plate is first dusted with talcum powder and then sponged with gum etch. This may be a proprietary solution prepared for plate only (a cellulose gum with tannic acid and a phosphate).

The amount of time the plate should be left under the gum etch varies. For lithographic crayon drawings, half an hour is usually enough, but for more delicate work, a considerably longer time is advisable. The action of the gum etch does not continue indefinitely, and plates left over a period of days will come to no harm. The greasy drawing is then washed out through the gum with paint thinner, and then the gum is washed off with water. If the greasy drawing does not come off easily, wet the plate with a combination of water and turpentine. Once the drawing and the gum have been removed, the asphaltum solution is applied to the wet plate as for the stone. The nondrying ink is then rolled up on the wet plate.

The second etch

The plate is dried with the flag drier and dusted with powdered rosin and talcum powder before being given a second etch. The formula of the etch can vary greatly. Gum etch may be used, or pure gum arabic. A potassium/alum/nitric acid and water mix can be used, or a proprietary preparation of tannic acid and water. This is a strong etch and should not be applied for more than 2 minutes. Brush it on with a soft bristle brush and keep it moving on the plate all the time, before washing it off. The plate is fan dried and, unless you are ready to print, gummed and stored.

Technique Making a print

When using stones, the paper is generally dampened as for etching, but for plates the paper is often used dry.

If you are using a hand-operated press, place the paper carefully over the stone or plate with a few sheets of packing paper on top. A thin metal plate is lowered over the bed. A lever is pulled to lower the scraper and the movable bed is cranked through, so that an even pressure is scraped across the entire surface of the plate.

If you are using an offset litho press, lay the plate (with the image not reversed) and paper side by side. An electrically driven rubber cylinder passes over the plate, picking up the ink, which it transfers to the sheet of paper.

Finishing-off

After printing, the plate or stone may need to be saved for further printing, in which case the ink is removed by applying paint thinner through water. The surface is re-inked with nondrying black, then gummed as described above.

A stone may be reground when it is no longer in use. A plate is treated with a caustic soda solution to remove all traces of grease. It can either be reground or resensitized with a proprietary solution.

Etch table

This is a guide to the strength of gum etch required for different kinds of stones and qualities of drawing. Quantities are per 1fl oz (25ml) gum arabic.

	Heavy drawing	Medium drawing	Light drawing	Delicate drawing	Very delicate drawing
Yellow stone					
drops nitric acid	15	12	6	4	0
drops phosphoric acid	5	5	4	3	0
grains tannic acid	6	6	6	5	6
Light gray stone					
drops nitric acid	18	15	10	5	0
drops phosphoric acid	5	5	4	3	0
grains tannic acid	6	6	6	5	6
Dark gray stone					
drops nitric acid	20	18	13	8	3
drops phosphoric acid	5	5	5	4	2
grains tannic acid	6	6	6	6	8

Etch table devised by Lynton R. Kistler, pioneer Los Angeles handprinter
The Tamarind Book of Lithography (1971), ABRAMS, NEW YORK

Photolithography

The ease with which halftone artwork can be created, either by painting and drawing on a grained film such as True Grain, or by producing screened artwork on a computer and laser printing it onto film, means that more artists are making photolithographs.

Technique

Creating a photolithograph on a plate

Positive offset plates can be bought ready for exposure in a UV exposure unit. The artwork is drawn by hand in black film ink onto clear, grained film. The film is placed right reading on top of the plate, the rubber cover pulled down, and the vacuum switched on. The frame is rotated and the UV lights are switched on for around 70–80 seconds—the exposure time varies according to the density of the image. The plate is then placed in a sink and sodium metasilicate positive plate developer applied with a sponge. (Always wear gloves and have the extractor fan on.) The plate is then washed, gum etched, and processed in the normal way.

1 The plate is placed face-up on the rubber vacuum sheet. The film is placed on top, the glass lid is pulled down, and the vacuum switched on. The frame is swung around so that film and plate face down toward the UV lights, which are then switched on for the required exposure time.

2 The plate is put into a sink and developer (sodium metasilicate) is poured onto the plate and wiped evenly over the surface.

3 After the developer is washed off, the image appears on the exposed and developed plate.

4 The plate is coated with a gum-etch solution and processed in the normal way.

5 After processing, the plate is inked up with a roller and the print made on an offset litho press.

Technique

Photolithography on a lithographic stone

A non solvent-based technique, explored and developed by Ben Gamble, is to screenprint a negative halftone image directly onto the stone using gum arabic of molasseslike consistency. The image is then coated with the greasy component such as asphaltum solution. These areas will become the positive areas of the print.

Ways of Escape (detail) *(2002)*, BEN GAMBLE
The large, halftone dot screen gives a sense of nostalgia to the image.

Screenprinting

Screenprinting is derived from the stencil method of painting, where a design is cut out of thin posterboard (or similar material). The posterboard is placed on a sheet of paper or other material and a flat-bottomed brush, held vertically, is used to dab paint over it in the areas that have been removed, thus transferring the design.

Early Oriental handcut stencils were so complex that they had to be held together on a mesh of human hairs. Screenprinting or silk-screenprinting, which emerged at the beginning of the 1900s, is based on a similar idea. A fine, open-weave mesh is stretched on an open frame. The stencil is applied to the mesh and printing ink scraped through it to produce an image. Today, it incorporates sophisticated photographic methods and can produce highly complex images. It is also a simple method of printing that can succeed with very little equipment.

During the last decade, there has been a move away from old screenprinting methods, which relied on the use of harmful and flammable, heavy, organic solvents for washing out screens and mixing printing inks. Now, screenprinting is almost exclusively water-based and conditions in printmaking studios are much healthier. Artists generally no longer work directly onto the screen unless making a monoprint (see p.260), but prepare all artwork separately.

Tools and techniques for screenprinting

The basic printing equipment is a flat bed or base with a batten attached to it. The prepared screen is connected to this with two hinges. A movable bar on the side of the screen is used as a prop while paper is being placed on or removed from the base. Professional presses incorporate a counter-balanced system with a one-arm squeegee operation. Any size of screen can be clamped to the mechanism.

Materials

The screen and frame

The screen is an open-weave mesh stretched on a rectangular frame that may be made of wood or metal, and is usually square-section. Homemade frames may be constructed from any nonwarping wood.

The mesh

The mesh was traditionally made of silk, but synthetic fibers have now replaced this. The mesh should be a tough, uniform, open weave to allow the ink to pass freely onto the paper. It needs to have some flexibility, but must not distort during printing.

Monofilament polyester mesh is almost universally used, although other synthetic fibers such as nylon may also be used, especially where a more flexible mesh is required. For most general, water-based printing purposes, a 120t mesh is used. The 120 signifies the number of threads per centimeter and the "t" signifies a standard thread diameter. A 120hd mesh would have a heavy-duty thread. Nowadays, the diameter of the thread is often referred to in microns, so that a 120t mesh would be 120.34. The finer the mesh, the finer the halftones that can be reproduced, so fine weaves are used for work with a high degree of detail, while coarser weaves are used for simple, bold work that requires a solid layer of ink.

Stretching the mesh

The mesh can be stretched by hand along similar lines to the process outlined in stretching canvas (see p.56). But there are also mechanical methods of stretching the mesh including a roller-bar system that tightens the mesh by turning until the correct tension is reached. A frame is then placed under the mesh and glued with contact adhesive or a two-part epoxy resin. Also available are screw-grip systems and pneumatic stretching machines.

Degreasing a screen

Apply a proprietary degreasing solution to the wet screen, scrub it, and wash it off with a water spray. Dry with a cool air drier.

Materials

Papers and inks

Screenprinting requires a paper that is stable, since it may be overprinted several times, and that remains flat after printing. Water-based inks are generally used for fine art screenprinting so it is best to use a heavier weight of paper, around 200gsm or above, because some inks can make the paper buckle if it is too thin. Screenprinting gives considerable flexibility and can be used on a range of paper surfaces according to the artist's choice. Experiment with your choice of paper before committing to an edition.

Inks

Artists commonly use acrylic paint mixed with a screenprinting medium. The medium retards the drying and reduces the viscosity of the paint. There are also a number of proprietary, water-based screenprinting inks on the market.

Possible ink problems

- If the ink is too runny, it may "bleed" and run into areas of the screen that should be masked out.
- If the ink is too viscous, it may not print in all the smallest areas of the stencil, and it may also cause drying, which effectively blocks the stencil in these areas.

Scrape off excess ink after printing and hose down the screen immediately, otherwise it becomes difficult to remove dried acrylic-based ink from the screen.

Stencils for water-based screenprinting

With the exception of paper stencils, which are directly applied to the screen, most stencils are now created indirectly in the following way. The original artwork is on transparent or translucent film and can take the form of a drawn or painted image, a film cut with a utility knife, or a photographic image. The screen is coated with a light-sensitive liquid emulsion applied with a coating trough. When this is dry, the artwork is held in a vacuum between the screen and an ultraviolet or quartz halide light source in a printing down frame and exposed to the light. After exposure, the areas of the emulsion protected from the light by the opaque parts of the artwork are washed out with cold water. These are the areas that will allow the ink to pass through the screen and create the positive image during the printing stage.

Technique Creating paper stencils

One of the simplest methods of screenprinting is to cut a paper stencil. This is stuck to the back of the screen with some printing medium. Alternatively, place it on top of the paper to be printed in the correct position and lower the screen. It will stick to the screen once the first ink has been squeegeed across it.

Leaf stencils You can see how the leaf shapes will print where the paper has been cut out and removed.

Technique Cutting film for print

Proprietary film is available that has red masking film on a transparent backing sheet. You can lay this film over a drawing or other artwork and, with a utility knife, cut and remove the red film from the backing sheet around the shapes that you wish to print. The film is useful for creating clean, fluent edges.

Cut film Film cut with a utility knife, gives clean edges to simple or more complex shapes.

Technique Preparing images for stencils by drawing and painting onto film

You can prepare artwork by drawing or painting directly, using any medium that will create an opaque image, onto tracing paper, drafting film, or textured film. The matt surface of such film will accept many materials, including opaque black inks, photographic opaque products, or gouache and acrylic paint. The black, all-purpose, or chinagraph pencil has a sticky quality that creates an opaque drawing with a unique quality. These images can be very accurately reproduced as screenprints.

Technique Drawing flat artwork for multicolored prints

Drafting film is particularly useful when the artwork requires a simple hand-drawn outline, for example, which can be made with a permanent marker, or simple flat shapes for a number of superimposed colors. Whatever color is used to print the final image, the artwork for each color must be drawn in an opaque medium on transparent or translucent film. If you wish to make a hand-drawn print in several colors, first draw the artwork on film for the main part of the image and then superimpose a new sheet of film over the artwork when it is dry. Draw the artwork for the next area of color and repeat the process as necessary. The artwork for the second color should slightly overlap the edge of the first all the way around to ensure that in the finished print it will comfortably fill the correct area, since the main part of the image is printed last.

1 Using black ink and a tubular pen nib, the outlines of the angels and balloons (which will print black) are drawn on a piece of translucent drafting film.

2 Artwork for areas that will print blue is drawn on a new piece of film. The same nib is used for outlining, and the shapes are filled with black ink.

3 The artwork for the areas that will print gray is drawn in the same way on a fresh piece of film.

Finished print Stencils are made for each color and the final image is printed in black, blue, and gray.

Technique Using textured film

Ordinary drafting film has a smooth surface that will not allow you to achieve subtle halftone effects. For this, you need to use proprietary film such as True Grain, which have a matte, textured surface. Such film breaks down a mark made on them into a series of fine dots, according to the surface texture of the film, and this prints very accurately. This material avoids having to use photographic halftone methods where hand-drawn artwork is involved.

Many drawing and painting materials can be used on the grainy surface, including soft pencils or graphite sticks, charcoal, compressed charcoal, conté crayon, litho crayons, all-purpose pencils, water-soluble colored pencils, and marker pens. Various black inks, and paints, such as gouache and acrylic, can also be used.

Halftone effects Textured film has the capacity for retaining subtle halftone effects for screenprinting.

Technique Multiple separations

Any or all of the above can be combined on the same print. For example, a flat shape in one color, created either by painting onto drafting film or cutting with masking film, may be overprinted with an image that has been created on textured film. The important thing is to ensure that each piece of artwork carries some form of registration, so that it is printed in exactly the right position relative to what is printed below or above it. The simplest method is to mark crosses in each of the four corners and these can be aligned when the printing is being set up. Other registration systems include the pin bar method, which punches holes into the edge of each layer of artwork. When slotted onto the thin, metal pin bar taped to the screen, each layer of artwork is in register.

Photographic or digital artwork

Whereas in the past photochemical techniques were used exclusively to create photographic artwork on line film for screenprinting, nowadays it is common for this work to be done digitally. These digital methods, relating to screenprinting, are described on p.271.

Technique Using line film

Different kinds of photographic screenprint can be created using line film. For instance, if a black-and-white, continuous-tone negative is projected onto line film, all the halftones will be reduced to solid black or transparent white. But you can still retain a great deal of the image, as shown in the example here.

Line film screenprint A black-and-white photograph was converted to line film and screenprinted. Areas of concentrated tonal contrast reproduce well.

Technique

Posterization

This method involves taking an original, continuous-tone negative and making a series of line positives in which the exposure is increased slightly every time. The resulting series of images will range from overexposure to underexposure and can be screenprinted in different tones.

Technique

Creating photographic halftone effects

To produce a range of halftone effects, the original continuous-tone image needs to be broken up into a series of small dots or lines so that the middle part of the tonal range can be read. To achieve this effect, the negative is projected onto the line film through a halftone screen that breaks up the image into dots or lines.

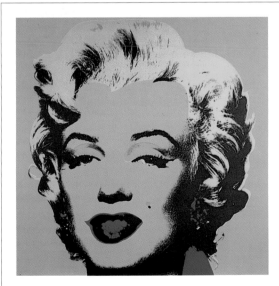

Andy Warhol

Warhol's silk-screen prints
Andy Warhol's portraits of Marilyn Monroe are among the most potent icons of the 1960s. They demonstrate the immediacy and force of the silk-screen medium with the clarity, freshness, and directness that characterizes his work of the time. But they also go beyond a mere brashness of appearance to evoke the personality that lies beneath the transformation and manipulation of surface.

Marilyn (1967), ANDY WARHOL

Technique The screenprinting process

The squeegee is used to scrape ink across the screen, so that it passes through the pores of the mesh onto the paper below. It has a wooden or metal handle, and a strip of flat-bottomed, hard, flexible urethane that acts as the blade. The blade must be sharp and straight and it comes in a range of hardness, known as durometer or shore. Artists generally use blades with a medium hardness of around 70–75.

Most silk-screen presses have a vacuum-pump that holds the paper in position. This ensures that, after it has been inked, it does not stick to the frame when you lift it. You need to mask off the holes on the vacuum bed outside the area of the paper before you print. Silk-screen presses may also have registration or "snap" adjusters to hold the frame off the surface of the paper so that contact is only made when the squeegee is pulled across the mesh. For halftones, this is set at around ⅛in (2–4mm). For solid areas of color, it is set higher, at between ¼in (5–10mm).

1 Tape the image in position on a sheet of paper on the printing table. Move the paper under the frame until it aligns exactly with the stencil when the screen is lowered. Tape it temporarily in place.

2 Tape three thin registration cards to the bed abutting the edge of the paper, one on the left side, and two on the bottom edge. Have every sheet of paper butting up to these before printing.

3 Partially lower the screen into position and pour the ink onto it in a strip around 2in (50mm) wide along the masked-off area, not too close to the open areas of the stencil.

4 Lift the screen and charge it with ink by pulling the squeegee across. Lower the screen and take a print by pulling the squeegee firmly and evenly across the stencil at an angle of around 60°.

5 After each pull, charge the image with ink (this also stops the ink from drying too quickly and losing parts of the image)—push the squeegee back in the opposite direction, tilting it slightly away from you.

6 Raise the screen to reveal the finished color print. Remove the print from the bed and place in a drying rack.

Technique
Using acetate for registration

This method is particularly suitable for detailed designs needing accurate registration. Tape a sheet of clear acetate to the printing table and take a print onto it through the screen. Have the original artwork taped in position on a sheet of paper

as shown left. Slide the paper under the acetate and align the two images exactly. Now position the pieces of registration card, as described above (see step 2).

Technique Screenprinted monoprints

In screenprinting, you can paint directly onto the screen itself to create monoprints, using a mixture of acrylic paint plus printing medium, acrylic screenprinting inks, or watercolor paints. If you use the first two, you need to ensure that the paint or ink you use is still wet when you come to take a print, so you need to work very rapidly. When you have completed the painting, you apply a line of transparent printing medium as if it were normal printing ink and pull the print in the usual way.

If you use watercolor, you should wait for the paint to dry on the screen, because you then flood the screen with printing medium, leaving it for a few moments and allowing it to wet the watercolor before you take a print.

DIGITAL MEDIA AND PHOTOGRAPHY

THE RECENT DEVELOPMENT of digital technology has moved it toward the center of mainstream art practice and it has had a major impact on most areas of work. For many, it is an indispensable tool in preparatory work. For others, it is the preferred medium in its own right. It has also transformed photography, where digital cameras can compete respectably with more traditional formats.

The Scream of Reason *(1980),* GILBERT AND GEORGE

Gilbert and George's encyclopedic exploration of the world takes the form of photoworks, in which large-scale photomontage images are created by the juxtaposition of identically sized framed sections. The images generally feature the two artists and range widely in subject matter, from aspects of nature, including the most graphic macro details, to wider social or cultural concerns. Here, the image of the two artists staring fixedly at each other, with the spiky tree above, is articulated with the legend *The Scream of Reason*.

Digital Image Manipulation

Images can be digitally manipulated and transformed beyond recognition, so that almost any kind of image or object can provide a digital starting point for a work of art that may end up as a painting, a vinyl cut-out, a screenprint, or simply a digital image.

Using computers

Personal computers are an invaluable resource to artists. They allow us to research and develop new ways of gathering material and creating and manipulating images.

Using computers to digitally transform an image to use as a starting point for a later work of art is a radical departure from earlier modes of origination, where an artist might begin by making closely observed sketches of what might later become a fully worked painting or sculpture. The infinite range of options within digital transformation has opened out new possibilities.

To those artists who are used to the slow process of the emerging work, the rapidity with which an image can be digitally modified is staggering. However, although the artist may have a wider range of choices, the often difficult decisions about what works or what does not work have not changed.

Materials A comprehensive basic kit for digital image manipulation

This should include a computer with a high-quality processor, including a CD-ROM drive and a CD writer (or at least a ZIP drive). It should have an internal hard disc drive with a high gigabyte memory and also a substantial working memory (measured in megabytes). It should include a modem for internet access, a mouse and keyboard, a full-color, high-resolution monitor, a flat-bed scanner, possibly a film (slide) scanner, too, and an inkjet or laser printer. Additional items might include a pressure-sensitive pad and pen for drawing and tracing digitally, and a digital camera (see *Photography*, p.272). To this would be added the graphics software, such as Adobe® Photoshop®, which enables you to create or transform images in a wide variety of ways.

Materials Scanners

There are two basic kinds of scanners, a flat-bed scanner for flat artwork or documents and a film scanner for color transparencies or color and black-and-white negatives.

Flat-bed scanners
A flat-bed scanner has a horizontal glass top onto which the drawing is placed face down. A cover is placed over the back of the drawing to keep the light out and the drawing is previewed. This is a preliminary scan that allows you to position the artwork, decide how much of it you want to scan, and adjust how you wish it to be scanned, in terms of resolution, brightness, contrast, etc. Most scanning software has an auto adjustment that will read the image and adjust the scan automatically. For many purposes, this is adequate, since you can make these kinds of modifications later using your image manipulation software. You may wish to establish the resolution in terms of dpi (dots per inch) and scale of the image at the scanning stage.

The image is then scanned. Most scanners use "linear array" CCDs (charge-coupled devices) that travel across the image, taking several seconds to scan it. The image will then appear on your computer screen.

Film scanners
Some flat-bed scanners have transparency tops that replace the normal cover and allow you to scan large-format transparencies just as you would a piece of flat artwork. You simply have to change from the reflective mode of scanning to the transmissive mode.

More common are the separate, small-scale film scanners that have plastic cradles into which you can insert a 35mm slide or a piece of 35mm negative film. The software that comes with these is very similar to that for the flat-bed scanners and allows you to select the part of the image you wish to scan and adjust it in the ways described above.

Digital printmaking

In the sections dealing with traditional print media above and particularly in screenprinting, I have shown how the digital revolution has, to a great extent, been absorbed and subsumed within general printmaking practice. The new technology has allowed some practices, which were time-consuming and difficult, to be streamlined and speeded up, especially in the manipulation of images and the preparation of artwork. Its integration with traditional methods has spawned a new "tradigital" hybrid.

But it is also an autonomous branch of printmaking that can be seen as self-contained and independent of the rest. A digital printmaker can set up a minimum of equipment in the smallest domestic space and originate and complete an edition of fine art prints. At the other end of the spectrum are professional editioning studios with the latest software, archival-quality paper and inks, and large-format printers, where major digital printmaking projects can be undertaken that are independent of traditional models.

Digital creation of the image The image being printed has been created digitally and can be seen on the computer screen.

Large format digital printer This machine makes large-scale prints on archival-quality paper, using UV-lightfast pigmented inks.

Technique Digital printmaking with computer-generated imagery

A growing number of printmakers generate their imagery by using the language of the computer. They are writing their own image-generating software and are producing a new visual language. The possibilities for this kind of work are enormous. Printmaker George Whale has written of his "Evolution of a Mark" series:
"I was interested in the possibility of using the computer to produce families of marks that were quite artificial, different in character from the simulated 'brush marks'

of popular painting software. Following the principles of 'evolution by aesthetic selection' established by Richard Dawkins, Karl Sims, and others, I wrote a program in which the data structure representing the geometry of a mark could be randomly 'mutated' to produce new marks, any of which could, in turn, be selected and further mutated. Starting at top-left and scanning alternately left to right, right to left, each of these pictures traces the evolution of a single mark over one hundred generations."

George Whale

A new language
George Whale writes computer programs that generate "algorithmic" forms. The process creates marks of great precision and clarity, but that are, at the same time, like nothing one has ever seen. As a consequence, looking at the prints is like discovering the pictorial hieroglyphics of a new language. The marks are signs that lead us into new pathways. They invite speculation and seem to suggest that we read them in particular ways. Yet as soon as we feel we are onto something, they change and take on another role. The result is a great richness of form and content.

Evolution of a Mark (ink-jet print) (1996), GEORGE WHALE

Computers and painting

Computers provide artists with the facility to manipulate images freely and effectively. So it is now possible to edit an original photograph or sketch for a painting in such a way that the artist can try out various alternative approaches on the computer before embarking on the painting itself.

This gives the artist a great deal of freedom. It can eliminate what were previously time-consuming errors on the canvas. It can also help the artist to focus on those important aspects of the originating image that he or she feels need to be expressed.

Many artists, for example, use photographs as the source material for a painting. But the photograph can show a wealth of detail that is inappropriate to the style of the painter. Sometimes it can be difficult to weed out the redundant material and simplify the original image. Nowadays, the use of a computer allows the artist to do this with ease.

Computer software such as Adobe Photoshop gives artists the opportunity to just simplify an original image, to reduce it to its essentials. But it also allows the artist to transform an image entirely and in many different ways, up to the point of complete abstraction. In essence, it can bridge the gap between a photograph and a painting. It does this by demonstrating the different possibilities of form, color, texture, and scale, for example, but it also allows elements to be added or subtracted, so that the content of an image can be entirely reworked and transformed before a painting is begun.

Project Blue boats study

These images show the straightforward transformation of digital photographs before beginning a painting—the elimination of unnecessary detail, the modification of tone and color, and the way an image can be cropped and framed to help decide the format for the painting.

The original image of fishing boats on a beach was taken with a digital camera. This allowed for the image to be loaded directly onto the computer. Prints, drawings, or slides can just as easily be scanned into the computer (see p.267).

1 The original photograph shows two boats pulled up onto the beach. The form of the boats is quite strong against the horizon, but there is not a great deal of definition in the sky and there is very little going on in the foreground.

- If you are working from a photograph on paper, place this face down on the flat-bed scanner
- Go to Import–Scanner. Set the size and resolution of the image in true color RGB and scan it. You can save it at any stage in the format of your choice
- Import the image into Photoshop
- Adjust the size accordingly using Image–Image Size
- Enter the values required in the boxes provided

2 Select the central part of the image to form a new composition. This effectively zooms in on the original and gives the fishing boats more prominence by placing them in the foreground rather than in the middle distance.

- With the rectangle Marquee tool, select the central area of the photograph for the composition
- Use the Burn tool on a brush setting of 200 in the mid-tones range and use a 50% exposure to darken the sky, making the cloud shapes more visible
- Use the Dodge tool on the same setting as above to lighten the sides of the boat and the beach in the foreground of the picture

3 Use the Cutout filter to simplify the image. The resulting effect is of an image in which it is possible to see the whole thing in painted form with clearly defined areas designating tone and color. Having established the composition and simplified the image, you can now decide to modify the colors.

- Select the whole image
- Go to Filter–Artistic–Cutout (No. of levels 8)
- Edge Simplicity 2
- Edge Fidelity 2
- You can experiment with the latter to get a more or less complex image

4 Saturate the color to brighten the image. The combined effect of these modifications is to provide a source image for a painting that is easier to read in painterly terms and therefore much simpler to transcribe than if the original photograph had been used unmodified. The main transformation in this case is the use of the Cutout filter, which gives a particular feel to the image while the Saturation filter makes the colors more vibrant.

- Select the whole image
- Go to Image–Adjust–Hue/Saturation (Saturation +38)
- The image will be brighter

Finished work The finished painting shows how useful the manipulation and transformation of the original photograph has been in creating this watercolor painting. Extraneous detail has been removed from the original photograph and it is relatively easy to make a painted transcription, in transparent washes of color, of the simple planes of colors shown in the computer printout.

Technique Transforming television images

In these examples, I have chosen to use "poor-quality" images taken with a digital camera directly from the T.V. screen during a marathon race. The original images are, of course, already hugely transformed from the "reality" of the subject matter. Conventionally, they might seem out of focus, flooded with synthetic color, and possibly of no real interest, but the transforming power of the computer software allows them to become perfect source material for a series of simple manipulations that can retrieve and reinvent them as works that in their own terms are of interest but that might also lead to other kinds of two-, three-, or four-dimensional work.

Pixelating the image

The original photograph gives a sense of one picture plane on which all the action takes place.

By using the pixelate filter, an almost abstract version of the image is produced. It leaves just enough information for the image to be read, but allows the surface pattern of color and shape to be equally important. In this case, I have adjusted the color, making the ground more blue, for instance, by using the color balance command.

Original image Go to:
- Filter–Pixelate–Crystallize (Cell Size 18)
- Image–Adjust–Color Balance, use the sliders to adjust the color

Final image

Cropping and using the Cutout filter

The original photograph has a certain charm, with the runners being framed by the yellow coats of the officials and the two bunches of balloons, but it is the runners and their shadows that will be the focus of the changes made to the image in which flat areas of color create a clean and more abstract version. Begin by cropping, then pasting the image into a new file.

Original image Go to:
- Filter–Artistic–Cutout (No. of levels 7, Edge Simplicity 5, Edge Fidelity 2)
- Image–Adjust–Hue/Saturation (Saturation +40), Filter, Sharpen

Final image

Cropping and using the Texture filter

In the original photograph, the tree and hoardings on the left are a distraction and the vertical barring of the T.V. screen also acts as a constraint on the image. So the runners are cropped vertically to echo the shape of their group and to get rid of the imagery on the left.

The image is altogether more self-contained and with an overall surface quality that gives it more consistency. In addition, the use of the texture filter creates a more animated look with its colorful, grainy pattern.

Original image Go to:
- Crop image (shown on p.264)
- Copy–Paste to a new file
- Filter–Texture–Grain (Grain Type: Contrast, Intensity 40, Contrast 50)
- Image–Adjust–Hue/Saturation (Saturation +100)

Final image

Digitally transforming drawings or paintings

It has now become common practice for artists to scan an original sketch, drawing, or painting into the computer and proceed to develop and transform it using software such as Adobe Photoshop. This method of working suits artists who like the feel of conventional drawing and painting materials but wish to move the image further in ways that could not be achieved traditionally and who may also wish to output their work by digital means. Alternatively, it is a good method of trying out modifications of content, color, or approach that would take a lot longer if done on canvas or paper. Having worked out the possibilities on the computer, you can proceed on the canvas itself to make the changes you have decided on.

Technique Scanning a drawing or painting

Before you can work on your drawing, you will need to scan it into the computer, and there are various ways of doing this (see p.262). Before you do so, you will need to open the image manipulation software from which you can import the scanned image.

Inputting from a digital camera

Some artwork may be too large to fit onto a flat-bed scanner, so a high-resolution, digital photograph of the work may be the best way of getting the image onto the computer. A print or slide from a conventional film camera can be scanned in using the equipment described on p.262.

Examples of the ways in which images can be modified

The following examples are all taken from images that appear earlier in this handbook. The original images have been manipulated using various options on the computer.

Brush and ink: Plants (p.113)
The digital version inverts the tonal contrast of the original sketch and produces an image that shows the plants as dark silhouettes against what might now be an old stone wall. The texture and sepia color give the image the look of an old print. In itself, it seems just as, if not more, interesting than the original drawing.

Original image

- Scan image
- Image–Adjust–Hue/ Saturation (Lower Saturation)
- Image–Adjust– Brightness/Contrast (raise contrast a little)
- Image–Adjust–Invert
- Save As–Select the file format you require

Final image

Oil Pastel: Rhino (p.85)

The original oil pastel drawing has a rich, rough, hand-drawn look, but a simple digital transformation with the Mosaic filter can dramatically change the nature of the image. The mosaic version retains the look of a chunky solid animal, but takes the image into a new "cleaner" realm. From this stage, it could very easily be made as an actual mosaic in vitreous glass.

Original image

- Scan image
- Make sure that the image is in RGB mode
- Filter–Pixelate–Mosaic (Cell Size 38)–Square
- Filter–Sharpen
- Edges–Image–Adjust–Hue/ Saturation (Saturation +60)
- Save

Final image

Conté Crayon: Fishing Boats (p.89)

The more you get to know what your software can do, the more you will recognize how certain kinds of drawn or painted artwork can be modified to positive effect using particular filters. Here, the original image in black and white conté crayon on a mid-toned ground has distinctive tonal contrasts that are picked up and emphasized by using the Photocopy tool. This is another simple transformation, but it makes a radical change to the image, creating a look that seems very separate from the original and is unique in its own way. Here, the impression is more of a woodcut than a soft crayon drawing.

Original image

- Scan image
- Make sure that the image is in RGB mode
- Filter–Sketch–Photocopy (Detail 24, Darkness 50)
- Save

Final image

Pen and Ink: Fish (p.106)

The original image is drawn in pen and ink onto damp paper held at an angle, so that the ink diffuses from the sides and back of the image. It might seem too obvious to use the "Ocean Ripple" option in the Distort filter, but sometimes the obvious is the most effective and here the filter adds movement to the image.

Original image

- Scan image
- Make sure that the image is in RGB mode
- Filter–Distort–Ocean Ripple (Ripple Size 12, Ripple Magnitude 15)
- Save

Final image

Digitally separated artwork for printmaking

Now that artists are more commonly originating work on the computer or scanning drawings, paintings, or photographs and working on them digitally, it has become far easier to create black-and-white line artwork on film or black-and-white, half-tone, photographic color separations on film to make stencils for screenprinting or plates and blocks for other methods of printmaking.

Technique Creating a black and white stencil for printmaking

This digital photograph of a bonsai tree has been modified through a series of simple stages in Adobe Photoshop to show how a single black-and-white image can be created and subsequently printed on clear film as line artwork for transfer to a stencil or block for printmaking. The artwork has to be in black and white, but it can subsequently be printed in any color.

Original image The original photograph of the Chinese elm bonsai tree is in full color. The ease with which the computer can modify full-color images to create black-and-white artwork for printmaking purposes enables the artist to try out a number of different versions on the computer before committing to print. This opens up the potential for a whole new repertoire of images.

Black-and-white image—photocopy filter The color image is converted to black and white. The resulting image is in black and white, but it shows the wide range of textures in the original photograph.

- Filter–Sketch–Photocopy (Detail 24, Darkness 50)
- Image–Adjustments–Threshold (128)

Black-and-white image—half-tone screen Enlarging the dots makes them an important graphic element in the work.

- Image–Mode–Grayscale
- Image–Mode–Bitmap (Resolution 300dpi). Use half-tone screen: Frequency (15 lines per inch)– Angle (45°)–Shape (Diamond)
- Image–Mode–Grayscale

Separating a full-color image into flat areas of color

Screenprinting is an ideal medium for printing flat areas of rich color. Here, a continuous tone, full-color portrait photograph is recreated as a screenprint in three colors and with no halftone.

The process uses the computer software to reduce the image to three areas of flat color, to copy each of these areas as a new file in black and white, and then to print them onto transparent film. The images on film are subsequently used to make the three stencils for the three different colors used to make the print.

1 Scan in the color photograph on which the image is based.

- Go to Image–Mode–Indexed Color–Palette: local (adaptive)– Colors: 9–Forced: Primaries–Options–dither–none
- Put the image back into RGB color by going to Image–Mode–RGB color

| Color 1 | Color 2 | Color 3 |

2 Select each of the three colors in turn, copy them in black into a new file, and add a little width to their outline so there is a small overlap when the colors are printed.

- Use the Eyedropper tool to select the first of the three colors as the Foreground color in the Toolbox
- Make black the Background color in the Toolbox
- Select Color Range (Sampled Colors)

- Next go to Edit–Fill (Background color) then Edit–Copy
- Go to Fill–New–Edit–Paste
- Edit–Stroke (width: 4 pixels, Location: center, Blending mode normal)
- Save this new file and return to the original file where you undo the fill command so the black in the selected areas reverts to its original color
- Repeat the process for the next two colors

3 The first stencil from Color 1 is printed in the chosen color.

4 The second stencil from Color 2 is next to be printed in a deeper tone.

5 The third stencil from Color 3, the deepest tone, creates a finished print.

Four-color printing

Standard four-color printing uses the three subtractive primary colors plus black to create a full-color image. Transparent yellow is printed first, then transparent magenta (red), then transparent cyan (blue), and finally black. The overlaying of these colors gives the whole range of secondary and tertiary colors that recreate the original full-color image.

You can use Adobe Photoshop or equivalent software to separate the original image into the four colors as black artwork on film. For screenprinting, your image should be scanned at a resolution of 150 dots per inch at the size it will be printed.

The basic process is to put the image into CMYK (cyan, magenta, yellow, black) color and then set up the screens for each of the colors in turn.

- Go to Image–Mode (CMYK color, Flatten–Yes)
- Go to Channels (Cyan)

Repeat the following for each of the channels:
- Go to File–Print with preview (Screens)
- Uncheck the box Use Printer's Default Screens
- In the Frequency box, specify the number of lines per inch. This is 47 for all the colors
- Enter the angle for each color. This is to avoid moiré patterns on the print, and for each color it is different
- For Cyan enter 67°, for Magenta 37°, for Yellow 97°, and for Black 7°
- Go to Shape (Ellipse) for each color
- Click OK as you finish with each color
- Go to Page Set Up (Registration Marks)—essential for accurate printing
- Go to Labels (to identify the color of each separation)

- Print each color separation in black onto transparent or translucent film to make the artwork for stencils. You can use matte polyester film designed for use in laser printers or photocopiers. High-quality film positives can also be obtained commercially.

Original image

On-screen Yellow **On-screen Magenta** **On-screen Cyan** **On-screen Black**

Separated Yellow **Separated Magenta** **Separated Cyan** **Separated Black**

1 Yellow is the first color to be printed.

2 The magenta is then printed over the yellow.

3 The cyan is printed over the yellow and the magenta.

4 Finally, the black is printed and the original image is recreated.

Photography

FOR SOME ARTISTS, PHOTOGRAPHY IS THE PRIMARY medium for visual expression. In many ways, this is tied in with technological developments, not least the emergence of high-resolution digital cameras. For other artists, photography has a secondary, but still crucial, importance in documenting work or providing reference material for artworks in another medium.

Photography as art

In the early days of the medium, a photograph was not necessarily seen as a work of art, though the atmospheric images by photographers like Clementina, Viscountess Hawarden, in the 1860s would now be considered so. Similarly, the photographic work of Man Ray in the 1920s or the powerful plant photographs of Karl Blossfeldt in the early part of the last century hold their own against more traditional, fine art media of the time and lead on directly to the more recent work of artist–photographers like Robert Mapplethorpe.

The emergence or perception of photography as a fine art medium is a relatively recent development, but one that has resulted in creative work of great originality and variety.

Styles and subjects

The actual appearance of photographic works is, of course, as diverse as the styles in any more traditional medium. They include multiprint assemblages in works by artists like David Mach, photomontage artworks by Gilbert and George, large-scale transparencies in lightboxes by artists like Jeff Wall, portrait transformations such as those in Cindy Sherman's "Untitled Film Stills" series of 1978, tableaux by Boyd Webb, and photographic works by Richard Long or Hamish

Fulton, which document a walk or trip. Other works like those by Richard Billingham or Nan Goldin fall within a long tradition of intimate images of family and friends, but each has a highly individual approach. The images they produce are straight photographs.

With the development of the digital media, however, the manipulation of slides, prints, or digital photographs, much in the way a painting is developed and modified, but using computer software, has become more common. So in one area, photography has moved closer to painting.

Untitled #21 *(1978)*, CINDY SHERMAN

Materials Equipment and techniques

The photographic techniques adopted for the work described above are hugely varied. For some artists, instant-picture cameras provide images for immediate use. Some prefer to use a 35mm SLR camera, while others choose from a wide range of digital cameras. Many artists still use larger-format cameras in the studio or on location for the highest-quality resolution. These days, a wide range of advanced manipulative techniques including montage and masking effects, multiple printing, and image distortion can be employed.

Cameras

The camera most commonly used by artists is a 35mm single lens reflex (SLR) or an SLR-type digital camera. This allows you to see what you are taking through the lens. Such cameras are extremely versatile and can be used

for original work, reference, and documentation. The film size is large enough to be able to produce images on fine-grain film that when greatly enlarged, retain a reasonable crispness. For digital cameras, the higher the number of pixels (picture cells) the better the image resolution. Most of the standard lenses available on such cameras produce sharp-focus images, and the focus can be accurately adjusted by looking directly through the viewfinder. Good-quality variable focal length lenses are available, which allow you to take wide-angle shots at a setting of around 28mm, or close-up shots of distant objects at between 200 and 300mm and a wide range of possibilities in between. For close-up work, you may need a simple additional lens.

Many SLRs are autofocus and have a range of preset programs for different subjects and conditions. If you choose to use one of these, it makes sense to get one that allows you to manually override any of the functions. Manual focus SLRs give you control over all the camera functions, but they can also have automatic settings that will either take the picture at the correct shutter speed when the aperture has been preset or at the right aperture when the shutter speed has been set.

Film and memory cards

Any of the standard kinds of 35mm film may be used for slides, color prints, or black-and-white prints, depending on your personal choice. Generally, the slower the speed of the film that can be used at a reasonable shutter speed, the better the quality. Digital cameras use memory cards of various kinds. The more memory on the card, the greater the number of pictures that can be stored on it.

The development of digital photography

In recent years, the development of the digital camera and of digital imaging processes has given the artist a great deal of freedom and flexibility in the photographic capture and manipulation of images. As digital photography moves closer in resolution and image quality to that of continuous film format, more artists are moving away from chemical-based photography and into the digital arena.

Digital photography is clean and efficient. Images can be captured, stored, and transferred effortlessly to a computer where they can be manipulated in infinite ways and subsequently output in a variety of printed formats.

Digital cameras rely on CCDs (charge-coupled devices) to record images. There can be millions of pixels or sensor sites on a CCD and these register a varying electrical charge according to their exposure to light. The sensors are grouped in flat rows on the CCDs. They produce analog signals, but these are changed to digital signals by a converter. CCDs employ additive color mixing to create full-color images by means of red, green, and blue filters.

If you want images of high quality, you will need a high-resolution camera capable of creating images of several megapixels. The images can be stored and saved in the computer in a number of different formats depending on end use. For example, a JPEG (Joint Photographic Experts Group) file will allow you to save an image using relatively small memory, while retaining most of the image quality. This is known as a "lossy" file because it can lose image quality when it is compressed. Other popular formats such as TIFF (Tagged Image Format File) support "lossless" compression that retains all the image information.

Boyd Webb

New worlds
The worlds that Boyd Webb depicts are all set up in his studio. In "Lagoon," Boyd Webb makes no attempt to disguise these plastic inflatable flamingos. These kitsch objects are transformed in a work of great sensitivity, which raises fundamental questions about our relationship with nature.

Lagoon (1988),
BOYD WEBB

Photography as reference

The camera is a great addition to the sketchbook in the accumulation of reference material with which to prepare a painting. However, the camera cannot replace the sketchbook, because it is a very different tool. There can be a sense of separateness about a photograph that may require further stages of "processing" before it can be assimilated into a painting. A sketch, even if it is only a few rapidly drawn lines, has vitality and immediacy based on a more prolonged and intensive act of observation.

Technique Photographic referencing

Although the sketch is still a vital source of reference, using a camera can greatly extend the range of subjects that it is possible to record.

Instant referencing

The reference photograph is the only means of swiftly recording elements that might later be usefully incorporated into a painting. An image seen from a train or a plane window, for instance, is not easily sketched, but it is readily photographed. Similarly, a particular cloud configuration or a chance arrangement of figures in a crowd can be recorded before the scene changes.

Compiling a reference library

Many 20th-century artists have incorporated popular imagery from a variety of ephemeral sources in their work. A good method of filing such visual information is to photograph it and keep a record in slide form, or on an image bank in the computer, backed up on a CD. You should be aware of the copyright laws in this respect but, for an image in a poor-quality newspaper for instance, which is going to disintegrate rapidly, it makes sense to photograph it at an early stage.

Two-dimensional source material is not confined to the printed page and it is possible to record imagery from the television screen or video monitor. Such imagery further extends the range of source material available to the painter.

Technique

Recording movement

The camera's potential to freeze a split second of action enables the artist to work with a degree of representational accuracy that was not possible before the advent of sophisticated, fast-shutter-speed cameras. A bird in flight or a running, jumping, or diving figure, for instance, are images that can now be perceived in detail.

2 These rapidly made, small-scale brush drawings are drawn directly from the photograph.

1 Gulls squabbling over food provide an opportunity to capture images that, though not of high quality, would provide accurate references for a painting.

Finished work Image of detail on ceramic tiles.

Technique Working from photographic reference

Photographic reference material can be used selectively. A drawing or painting can be based on all or part of a photographic image that may also be inverted, reversed, or otherwise modified in a number of ways.

Freezing action

This splash image demonstrates very effectively how the camera can freeze a split second of action to allow you to see precisely what is happening and, if necessary, to recreate it in a chosen medium. This would clearly be impossible with any other form of referencing. When the pictures were taken, there was, of course, no way of knowing how the splash would come out. The transformation from black-and-white photograph to soft pencil drawing, along with the modifications made to the inside of the circle and the exclusion of external detail such as the posts and shadows, effects a complete recreation of the original image.

Splash **colored pencil drawing** For this image, a complete 36-exposure roll of black-and-white film was shot as large stones were pitched into a river. The picture used was by far the most appropriate image with its encircling crown of projected water.

Technique

Combining photographs and life

This formal portrait is an example of a painting worked partially from life and partially from photographs. The painting of the figure was made from life over a period of several days, during which most of the time was spent on the head. The background was taken from a separate room in the house from that in which the portrait was painted, and although some hours were spent working on it from life when the light was appropriate, most of the background was worked up from a photograph. Unless a lack of uniformity is a positive aim, it is necessary in work that incorporates painting from life as well as from photographs to achieve the sense of a completely integrated image.

Background image This photograph was used as a reference for the background.

Using photographic reference Each element in this painting has been carefully organized to produce an image that works as a whole, so that there is no apparent discontinuity between the parts painted from life and those from photographs.

Technique Documenting and presenting your work

Almost every situation in which an artist may be professionally involved will require some kind of photographic documentation of his work. The more well-known the artist, the more frequent are the requests for images of work to be reproduced in books and magazines, so it is essential for a professional artist to have good-quality color slides or high-resolution digital images (at least 300dpi at the scale it will be reproduced), and black-and-white prints of his or her work.

A CD with good-quality images or a good set of slides may be enough to persuade the director of a gallery to pay a studio visit. It is certainly essential in any application to an arts association or to the jury in the first stages of an open competition for an artwork

that they should be able to see the work in as presentable a form as possible. If the artist is represented in a solo or group show, it is important for the exhibition organizers to have accessible material that they can show or send out to members of the press, the major art bodies, or museums. In many cases, this will be taken care of by the institution.

But invariably, if such material is not available immediately, there may be too little time to have the work photographed at the last minute. The best policy is to photograph the work as soon as it is completed and to make sure that the photographs or digital images are properly filed. Photographing paintings need not be a complex or expensive process (see below).

Presenting ideas

Reference photography plays an important part in the preparation of proposals for public artworks or for exhibitions (see also pp.364–69). A common technique is to photograph the site (or the gallery space), to photograph the drawing/painting/maquette, and to superimpose the latter onto the former in a (digital)

photomontage so that it can be presented to the commissioning committee as a hypothetical view of the installed work.

Preparation for a sculpture

In this proposal (below) for a freestanding sculpture on an open space in front of a housing development, a model of

the proposed sculpture was photographed with a digital camera and superimposed on a digital photograph of the site. The land had not been landscaped before the proposal was made, so it was necessary to digitally modify the landscape in Adobe Photoshop to give the client a good idea of how the whole thing would look.

Actual site The site before digital enhancement.

Superimposition With the maquette, and modified landscape.

Technique Photographing paintings and drawings

- Position the camera on a tripod. Mount the painting on the wall, or on an easel—absolutely vertical and parallel with the camera's picture plane.
- Place a telescopic stand on each side of the camera, at 45 degrees to the picture plane.
- Fit a flash unit on each stand, facing away from the artwork. The units should incorporate sensors (facing the artwork) to assess the amount of light needed for a perfect exposure. Connect the units to the mains voltage via a transformer.
- Attach an umbrella reflector to the stand so that the

flash will bounce off it onto the artwork.
- Connect an extension sensor from one of the flash units to the hot shoe of the camera and attach a photo cell to the other flash unit so that when the first flash goes off it triggers the second simultaneously.
- Set the camera shutter speed for electronic flash, normally 1/125 of a second, and estimate the aperture from the guide on the side of the flash unit.
- Take a photograph at the correct exposure and at one aperture stop higher and lower.

APPLIED TECHNIQUES

I N THIS SECTION, SOME OF THE TECHNIQUES associated with traditional areas of studio practice are explored on a different scale and in a new context, as in external wall painting, for example. Or they have been applied to more recent materials suited to more robust conditions of use, such as handpainted or printed laminates.

Ginny Housewife (2000), JULIAN OPIE

Julian Opie is an artist who has responded with enthusiasm and commitment to the possibilities offered by more recently available materials and technologies. Here, he is working in an area that has its antecedents in Pop Art, for example, where a large, flat, diagrammatic image might have been painstakingly handpainted. Opie's computer-modified image has been cut and laid in vinyl and it has a very different and immediate clarity. It is remarkable that a work, which on one level might appear bland, with just two black dots for eyes and for nose, should be so compelling and so human. The slight angle of the head adds to the sensitivity of the image.

Mural Painting *Buon Fresco*

THE *BUON FRESCO* TECHNIQUE WAS PRACTICED by early civilizations such as those of the late Minoan period, the Etruscans, and the Romans—who used the technique extensively and to great effect, as evidenced by the celebrated Pompeiian wall paintings of the mid-first century A.D.

But the most celebrated period of *buon fresco* mural painting in the history of art was from the late 1200s to the mid-1500s in Italy, when most of the great artists of the time—from Cimabue to

Michelangelo—exploited the technique in an incomparable series of works. Notable examples are the Scrovegni Chapel frescoes by Giotto in Padua, the Florentine masterpieces of Masaccio, such as *The Trinity* in Santa Maria Novella and the decorations for the Brancacci Chapel in Santa Maria del Carmine, the extraordinarily beautiful and spiritual frescoes of Fra Angelico in the cells of the convent of San Marco, and many other equally inspiring works by great Italian artists such as Ambrogio Lorenzetti, Uccello, Piero della Francesca, Mantegna, Ghirlandaio, Botticelli, and Raphael.

Noli Me Tangere
(1442), FRA ANGELICO
In his fresco paintings for the Convent of San Marco in Florence, Fra Angelico created self-contained worlds in which every single part of the composition seems to breathe with life and devotion. There is an extraordinary tenderness about his work that, coupled with its clarity, makes the moments the painter describes seem all the more significant and real.

Traditional *buon fresco* methods

The *buon fresco* method of wall painting involves the application of pigments ground in water or lime water to a freshly plastered wall. The pigments used should be lightproof, durable, and alkali-proof. They are absorbed by the thin layer of fresh, wet lime-plaster and fuse with it into a permanent, hard, solid state as the lime carbonates. The fact that they do not rely on adhesion to the ground, as do most other methods of painting, but become an integral part of it, makes *buon fresco* one of the most durable mural techniques. Because slaked lime can be hard to find, the *buon fresco* technique is not so common today.

Detail of foliage
Each brushstroke is taken up and absorbed by the damp plaster.

Materials Pigments

Only the most permanent pigments may be used in *buon fresco* painting, especially for exterior work. Not only do they have to be lightfast but, since lime is so alkaline, they must be fast to alkali. They should also be resistant to acids and other pollutants in the atmosphere. No pigments that contain soluble salts should be used, since these may cause a white efflorescence on the surface of the wall (see p.284).

The artificial iron oxide colors (the Mars colors)—which include red, violet, yellow, and black—are excellent pigments for *buon fresco* painting. The blue and green cobalts are equally permanent, as are Cerulean Blue and Manganese Blue. Among the greens,

Oxide of Chromium and its hydrated form, Viridian, are recommended. The slaked lime itself is generally used for white.

The pigments should be ground as finely as possible in water and applied directly to the wet plaster with no additional binding medium added. Natural bristle brushes are commonly used for the application. Distilled water may be used as a precaution against possible adulterants in the tap water. Lime water may also be used to grind pigments, but this can increase their opacity. If an opaque, but slightly lighter-toned effect is required, all the pigments can be ground in a mix of slaked lime and water.

Preparation Preparing the wall

Before plastering, the wall should be completely free of dampness, grease, and dust. Any previous coatings should be washed off, any crumbling mortar raked out, and any projecting or uneven elements chipped back to the level surface. The surface can be hacked to give a key to the plaster but this is not usually necessary. Any surface that has shown signs of mold or algae can be treated with a proprietary fungicidal wash that should be left for the recommended period and then washed off.

The mortar
Traditionally, slaked lime is mixed with sand and/or marble dust of varying particle size, depending on which of the three layers is being applied. The sand should be dry and free of efflorescent salts or other impurities. The sand is inert filler—the chemical change in the drying of the wall being the transformation of the plaster from calcium hydrate plus carbon dioxide to calcium carbonate and water.

Preparation The plastering

There are three basic stages of plastering a wall for *buon fresco*:

- *Trullisatio*
- *Arriccio*
- *Intonaco*

The *trullisatio*

The wall is thoroughly wetted and the first render—known as the rough cast coat, scratch coat, or *trullisatio*—is applied. This mortar is a mixture of lime putty and coarse sand/gravel in the ratio of about 1:3. (Suggested proportions of sand to gravel are in the ratio of about 1:5.)

For interior work on wooden lath or, more commonly nowadays, on an expanded metal screen, less sand or gravel is used in the mix. The application of the first coat is vigorous, with the mortar not smoothed but slapped firmly onto the wall.

The *arriccio*

The second coat—known as the equalizing coat, brown coat, or *arriccio*—is less coarse than the rough cast but not as fine as the final coat. The ratio of lime to sand is about 1:2 or 1:2½, and the sand element can contain a mixture of coarse and fine particles (with the coarse particles predominating). The *arriccio* is also applied vigorously to the thoroughly wetted rough cast and smoothed only to the extent that it will be capable of receiving a painted or drawn outline of the design of the mural. This preliminary outline was named the "sinopia" after the town on the Black Sea (Sinope) from which the red ocher originally used to make the drawing was obtained.

The *intonaco*

The final painting coat, or *intonaco*, is a mixture of lime putty and sand in the ratio 1:1, the sand element often containing some marble grit or dust to add sparkle to the surface of the wall.

Preparation of the wall for *buon fresco*

1 *Trullisatio* Lime putty and coarse sand/gravel in proportions of about 1:3 (around ⅛in/3mm thick)

2 *Arriccio* Lime putty and coarse/fine mix sand in proportions of about 1:2 or 1:2½ (average ¾in/1.8cm thick)

3 *Intonaco* Lime putty and sand incorporating marble grit or dust in proportions of 1:1 (average ¹⁄₁₆–⅛in/1.5–3mm thick)

The plastering of the *intonaco* calls for flowing strokes and floating techniques that bring the surface to the smoothness required for painting. However, it should not be made so smooth that it "closes up" the porosity of the surface.

The *intonaco* is applied consecutively to areas of the wall that can be painted in the few hours between the first stages of drying, when the plaster becomes firm but remains wet, and the second stage, when the actual process of carbonation begins and the pigments are no longer absorbed by the wall. Since this area of the *intonaco* corresponds to the amount of wall that the artist can paint in a day, each freshly plastered section of the *intonaco* is known as the *gionata*. These sections of plaster are usually irregularly shaped, corresponding to shapes such as figures in the imagery of the fresco. Any *intonaco* that remains unpainted because it has become too dry, or because the painter has finished for the day, is hacked off so that it can be replaced with fresh plaster on the following working day.

Technique Transferring the design to the wall

The design for the whole mural should be drawn out on the second coat, or *arriccio*. It is essential to have at least the main outlines of the whole image on the penultimate coat of plaster since it would otherwise be extremely difficult to figure out what should go on each small section of the *intonaco*.

The drawing may be done freehand—with brushes taped to canes, for instance—but it is more likely to have to be transferred from a careful preliminary drawing called a "cartoon," prepared on a roll of thin, hard paper such as detail paper. The cartoon is made the same size as the mural itself, although it is generally drawn in fairly large separate sections. The drawing of the cartoon will have been scaled up using the grid system (see p.358) from a smaller original. It is particularly important that the horizontal and vertical lines should be accurately registered, on both cartoon and wall, so that the result is not lopsided.

Use metal spikes to anchor each end of a length of thin nylon cord. Rub chalk or charcoal along the line and "snap" the taut thread against the wall to leave a marked line.

Dusting or "pouncing"

A traditional method of transferring the image from cartoon to wall is dusting or "pouncing" *(spolvero)* powdered pigment or charcoal through holes pricked along the lines of the cartoon. Perforated wheels may be bought for the purpose. When the paper pattern is removed, pinpricks of pigment combine to form outlines on the wall. This technique may be used on the *arriccio* and later on the *intonaco* sections, where the image will be clearer.

Indenting the outline

An alternative, cleaner method of transferring the relevant part of the design to the *intonaco* is to scratch the outline of the design through the cartoon paper into the damp plaster with a sharp implement.

Drawing freehand within the grid

Another method of applying a less precise, broad design to the *arriccio* is to lay a grid on the wall, using plumb lines and snap lines, and work freehand from square to square, reserving the marking of more detailed outlines for the *intonaco*.

Projecting the image

Nowadays, it is possible to avoid the more time-consuming methods by projecting a transparency of the design, or of relevant sections of it, onto the wall itself. If the wall is so large that the design has to be photographed in sections, the grid superimposed over the drawing must be reproduced precisely to scale on the wall. Also, the same camera lens should be used for each slide, with the camera absolutely parallel to the picture plane and centered on each section of the image. When the slides are projected, the same lens must be kept on the projector, which should remain on a line exactly parallel to the wall and centered on each section of the image, even though this may mean using a scaffold tower.

Technique Painting *buon fresco*

The taking-up of the pigment by the wet wall is similar in a way to that of the absorbent gesso ground in egg tempera painting. There is the same finality about each brushstroke since, once made, it cannot be erased—unless a patch of plaster is physically removed and replaced. In both techniques, layers of paint can be superimposed and a depth of tone and color built up. In the *buon fresco* method, there is possibly even more clarity in the strokes or washes, which stay precisely where they are placed without running.

Diego Rivera

Twentieth-century example

The Mexican artist Diego Rivera (1886–1957) was one of the most committed and productive *buon fresco* mural painters of the 1900s. He used the scale and the directness of the medium to express an often powerful political and social message. In a work that seems fitting for the San Francisco Art Institute, he plays more on the illusionistic aspects of the medium, taking a one-point perspective view and juxtaposing the painted figures in the mural itself with the figures that are doing the painting on their rudimentary scaffold.

The Making of a Fresco (1931), DIEGO RIVERA

"Dry Wall" Mural Techniques

ASIDE FROM THE COMMITTED *BUON FRESCO* specialists, very few artists are eager to prepare a wall by the traditional methods, prior to painting on the wet lime plaster.

In fact, if a mural is commissioned these days, it is very likely that the wall will have been plastered already, using more modern plastering materials. Nowadays, there are more options available, including the development and more widespread use of acrylic-resin-based paints with lightfast pigments.

In the past, the *fresco secco* technique was used on a dried lime plaster wall. The wall was thoroughly soaked with lime water the day before painting started, and again on the morning of painting. A binding medium such as casein, glue size, or egg would generally have been used. *Fresco secco* has now fallen out of use due to the fact that modern plastering materials tend not to accommodate the old techniques that used slaked lime.

External mural painting

The main problems associated with external mural work are dampness, dust and the resulting lack of adhesion of the paint, the effects of the weather, and the acids and pollutants in the atmosphere. Any non-permanent pigments soon fade.

An external wall can be painted in a number of ways, but the most permanent method is probably mineral (potassium silicate) painting. This is a technique where permanent, lightfast, mineral pigments ground in distilled water are applied to a calcined-flint rendered wall that is subsequently sprayed with a fixative. The pigments become chemically bonded with the wall in a way that parallels the carbonation in the *buon fresco* method.

Technique Permanent painting with "Keim" mineral paints

The "Keim" mineral paint system is distinct from other paint systems, aside from the *buon fresco* method, in that it is non-pellicular (filmforming). It was invented in 1878 by Adolph Keim, who decided that a paint system for plaster walls would only be permanent if it was chemically compatible with the wall itself. The major constituent element of the sand, stone, and rocks that provide the plaster was silica and so the system devised was to apply pure, finely ground, alkali-fast, mineral pigments in distilled water to a highly silicious render and then to fix them by spraying on an aqueous solution of potassium silicate. This hardened with the evaporation of the water to form a hard and permanent bond with the plaster, but it left the plaster porous so that water vapor could continue to pass freely through the render. This is the basis of a system that is commercially available from its German manufacturer as the "Keim Artist" paint system.

The Keim method in practice

A normal sand and cement wood float render is applied to the wall to be painted, then a "calcined flint" finishing coat is applied. The calcined flint render is more open to the penetration of the paint than an equivalent sand and cement render would be, though the latter—especially if wood-floated, and with a more open surface—could be used provided that no waterproofing elements such as PVA were in the mix. The "open" surface of the plaster is a crucially important aspect of the Keim system. The proportions of the finishing coat are five parts calcined flint, two to three parts white cement, and one part white lime.

Next, the wall is coated with a proprietary Keim silicate primer that gives a uniform white painting surface; this is not strictly necessary because the system would work just as well directly on the calcined flint render. The plaster is then etched by being given two coats of a proprietary etching fluid diluted with water, which is then washed off. The effect of the etch is to expose mineral particles on the surface of the render and so ensure a good bond with the fixative.

The wall is wetted with distilled water before painting. The finely ground mineral pigments dispersed in distilled water are supplied by the manufacturer. They are painted onto the wet wall in thin, transparent layers. They may be mixed with white and applied opaquely, but the paint layer should not be too thick, or it will not be penetrated by the fixative and anchored to the render. The pigment is so finely ground that it performs like a soluble dye, staining the render wherever it is applied. This is the special characteristic of working with this medium—you use it thin and transparent like watercolor, but it dries like pastel.

Mixing colors

If two pigments are physically mixed to produce a third color, an almost inevitable separation will occur due to the different weights of the pigments, and because they are not bound in a viscous medium. It is better to create third colors by the separate application of transparent layers of two colors, as in the watercolor color-mixing techniques shown on pp.132–35.

Fixing the paint

The silicate fixative supplied by the manufacturers should never be used in its concentrated form. If it were, it would merely "sit" on the surface of the wall. Instead, it is diluted with distilled water in the proportion one part fixative to three or four parts water. The diluted fixative is sprayed over the area that has been painted at the end of a day's work.

Use just enough fixative to stabilize the work, but not so much that the wall is oversaturated. The best method is to use a wad of tissue or absorbent cloth to dab the wall after spraying—it should not be left to dry on the surface. Artists who wear glasses with glass lenses should not wear them while spraying, otherwise the fixative will attach to them, solidify, and ruin the glass.

Several increasingly concentrated coats of fixative can be applied, but make sure that there is still suction to the wall because a painting can be overfixed. Gauging the precise amount is partially a matter of experience.

The effect of the fixative is to transform the mineral pigment into hard silicate. It chemically binds the silicate paint to the silicate of the wall. It leaves the wall highly alkaline with a pH of around 12, so that—to some extent—it is self-protected from attack by acids in the atmosphere. It also leaves the wall porous, preventing the loss of paint due to water vapor.

Preparation of wall for "Keim" method mural painting
1 Sand and cement float render
2 Calcined flint render finishing coat (5 parts calcined flint, 2–3 parts white cement, 1 part white lime)
3 Keim silicate primer
4 Two coats proprietary etching fluid

Detail of painted section The portraits are painted using the Keim technique and represent a series of famous characters from the history of the area.

The Spirit of Soho 1991 FreeForm Arts Trust in collaboration with Alternative Arts The mural in Soho in the West End of London features work in mosaic, ceramics, and concrete in addition to the areas painted with Keim paints.

Preparation

Standard rendering for a brick wall

To give a brick wall a uniform surface for painting, it is generally rendered in sand and cement. The wall must be free of crumbling mortar and dust, so this is generally brushed out with a wire brush followed by a stiff yard brush. Any algae is treated with a proprietary fungicidal wash that is left for 24 hours before being washed off and the wall allowed to dry.

The use of a bonding agent such as "Unibond" or similar PVA-based materials can improve the adhesion of the render. The day before rendering, the wall is painted with a dilute coat. The proportion of PVA to water should be 1:5 or 1:6. Another coat is applied just before plastering, so that the wall is tacky when it is plastered. Washed pit sand is mixed with the cement; this is less likely to cause efflorescence than sea sand. "Sharp" or coarse sand is used for the first coat, in the proportion four or five parts sand to one of Portland cement. It may be mixed with diluted PVA instead of just water, but this is not entirely necessary.

The first coat

This is a light coat that eliminates unevenness in the wall and gives even suction to the second coat. The first coat is scratched to give a key to the second coat that is applied the following day. The strength of a coat of render is in the aggregate rather than in the cement, which is merely the setting agent.

The second coat

The next coat of plaster uses a finer mixture of sand, but it is usually still a medium to coarse mix. The proportion of sand to cement is around 3½ or 4:1. Fine sand used for bricklaying mortar does not have the body for plastering. The second coat is floated and rubbed up to the required finish. As with all finishing for subsequent painting, the surface should not be too smooth. Before being painted, the wall should be left to dry out thoroughly and this may take several weeks.

Efflorescence

Efflorescence is the appearance of soluble salts on a wall's surface in the form of a powdery white substance. This is generally either the result of impurities in the sand and cement mix, or a reaction between materials in the render and the brickwork. Most newly applied render will exhibit some form of efflorescence, especially if the brickwork is also new. If the brickwork is old, the impurities will have come out and the salts weathered off.

Efflorescence is provoked by dampness and, once the wall has dried out completely, it will become inert so that any deposits may be brushed off and the surface painted. But if the surface is painted before it is dry, efflorescence will have a damaging effect on the paint film. There is always a varying degree of moisture in the dry wall and it is for this reason that the paint film should have some degree of porosity.

Rendering other surfaces

A smooth concrete or ceramic tile surface will have been "keyed" in the past with a slurry of neat cement and coarse sand chippings dashed on with a brush, left for 24 hours, and rendered as above. Nowadays, the proprietary PVA adhesives are used instead to establish a bond between the render and the wall.

Wetting the wall before plastering

If a more traditional method of plastering is employed (without the use of PVA), a porous common brick or insulation block wall should be merely flicked with water. It should not be wet, but just slightly damp. No water should be used for engineering brick or a marble block since what is put on will slide off as the wall repels the water.

Large-scale mural

Consistent style

Where a number of artists are collaborating on the same work and the resulting image needs to look consistent, one way of working is to approach the image in terms of a number of "cutout" shapes of flat color. This rationalizes the image and means there are no conflicts of style within the work.

Reunion Rose Conservation Mural, Brixton (1986), MAGGIE CLYDE AND SUSAN ELLIOTT

Technique Painting the wall

The wall will need two or three coats of the chosen base color before the mural is painted. Nowadays, there are durable, lightfast masonry paints in a wide range of colors and it is possible to have particular colors made up specially. If you do this, make sure you have enough of the color you require made up at the same time, since different batches can vary.

Most high-quality, exterior-grade, commercial masonry paints are based on vinyl or acrylic copolymers or ter-polymers. That is, they incorporate up to three different polymers in the emulsion to provide a paint medium with all the characteristics of durability, strength, flexibility, and porosity required for a reasonable exterior lifespan. They are water-thinned and incorporate inert fillers such as quartz aggregate to provide body and strength,

and lightfast, alkali-proof pigments. They have a permeable, microporous paint film that, to some extent, allows the free passage of water vapor. A painting made with acrylic-based paints on an external wall will still have a relatively limited life, depending on the kind of wall, the quality of the paint, and the weather.

The problem with oil-based paints

Oil-based paints are not recommended for masonry surfaces. The reason is that the wall needs to breathe—to allow the free passage of water vapor relating to adjustments in relative humidity and in the moisture content of the wall. An oil film is largely nonpermeable and the build-up of water behind it can cause it to flake off. In addition, such walls are generally highly alkaline, a fact that suits the alkalinity of acrylic paints but is antipathetic to the oil film.

Technique

Constructing a mural

The design for this mural, which relates to a period of local history in an English seaside town, incorporates a number of different elements including a 19th-century drawing and engraving. It was important to establish a sense of continuity of style in the image for the mural, so these different visual elements were remodeled through Adobe Photoshop and made to look more similar to each other in order to produce a design that could be read as a whole.

It was also important that the style of the design was retained in the painting, which was going to be completed by up to four different artists. The answer was to divide the design by means of a grid into manageable rectangular sections. These were put into slide form and projected onto the wall. A single color was chosen for the work and so it was a matter of copying the projected image section by section using relatively small, round, synthetic hair brushes. The scaffolding that allowed the artists access to the high wall had to be screened by tarpaulins in the areas where the projectors were being used, to allow the artists to work from the projected image.

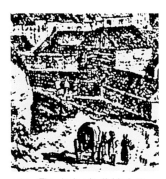

1 The design is divided up and individual sections are projected onto the wall.

2 Artists work on scaffolding below tarpaulin so that they can see the projected image.

The America Ground, Hastings, 2001 The choice of a single color for the mural maintains the effect of a 19th-century engraving, though the design was created in Photoshop.

Internal wall painting

There is a great deal more flexibility in the choice of painting medium for internal mural painting, since most of the established media can be used. Acrylic paints are probably the best choice for work on plaster (see below), although it is possible to work in oils if a plaster sealer is used. Size paints, cellulose paints, egg tempera, and encaustic may all be used; the two former may be best suited to temporary decoration such as scenery, and the two latter, which take longer to build up, to small-scale works.

Preparation Rendering the wall

The following renders are appropriate for internal wall painting. In practice, artists often find that a wall has already been rendered before the client decides that a mural would be appropriate. So there is very little that can be done except to hope that the surface has not been over-troweled or painted with an inappropriate primer.

Sand and cement
Many artists prefer the slightly gritty tooth of a sand and cement render of a wall to that of plaster as a support for interior wall painting. This usually includes a PVA bonding agent and it should not be floated too smoothly. With an expanded metal support, a light first coat is applied, followed by a floating coat and a finishing coat. White cement and a white sand, such as a Derbyshire white spar, can be used for the finishing coat if a white finish is required. Or, when the render is completely dry, it can be given two coats of proprietary white acrylic primer.

Gypsum plaster
The modern methods of plastering internal walls use rapidly setting hemi-hydrates—such as the gypsum/vermiculite mixes (sold in the form of a bonding and a finishing coat). The vermiculite, a lightweight mica aggregate that takes the place of sand and is considerably lighter and more reliable, swells when water is added. It is coarser in the bonding than in the finishing coat. There are two different varieties of vermiculite for different kinds of substrate. If applied to expanded metal, a tight coat about 1–2mm thick is applied to skim the metal. Just before it goes off (sets), it is scratched, and another coat of the same material (same thickness) is ruled in and leveled out. This goes off in 1½–2 hours and is scratched ready for a fine finishing coat.

A similar product made for walls with suction such as brickwork can be applied directly up to ½in (12mm) thick, then given a 1–2mm finishing coat. On concrete, or non-porous surfaces, another version of the same plaster should be applied in a tight 1–2mm first coat and then in a ⅛in (3–4mm) floating coat. This is then given a 1–2mm finishing coat.

Other plasters include the one-coat finish plasters that can be applied directly to the substrate, ruled in, leveled out, and troweled off in one operation.

Plaster is a suitable support for interior mural work, but two factors must be considered. First, the plaster must be completely dry —if there is any moisture in the substrate or in the plaster and a solvent paint system is used, the moisture will be trapped and the paint will come off. Second, when applying the plaster it must not be over-troweled, otherwise there will be poor adhesion between paint and plaster and the paint will fall off.

Suiting the paint to the support
Acrylic- or vinyl-based paints work best on sand and cement render or gypsum plaster. The alkalinity of these surfaces is compatible with that of acrylic paints, but not with the more acidic oil-based ones. It is possible to paint on plaster with oil-based paints, but an alkali-resistant primer needs to be used. Also, the oil film or oil-modified, alkyd-resin film is too impermeable to be safely laid onto a porous substrate that requires the unobstructed passage of water vapor.

Technique Painting on a large scale

Most of the painting techniques described in the earlier chapters of this book may be adapted to large-scale mural work, using larger brushes and tools. Bristle brushes are generally more suitable for a fairly abrasive surface such as a sand and cement render. Artists who work on a large scale are aware of the difference in the feel of an image when scaled up from how it looks in a small-scale study. For this reason, the grid method of transposition from study to wall, which allows little modification of the image, is often dispensed with nowadays in favor of projection systems (see p.281). These can change the size,

position, and angle of the intended image rapidly, allowing a greater degree of flexibility and experimentation. On a large wall, for instance, an image may be viewed from a number of optimum viewpoints relating to the architecture and the space. It is possible to create multi-plane images in which part of the image, for example, when seen from the front may appear as an amorphous, distorted shape, but resolves itself into a normally perceived representation when viewed from a particular angle (see *Anamorphism*, p.357). The effectiveness of such ideas can easily be tested by projection methods and these can help the artist to make sure that every aspect of such a work is appropriate to the space.

For the mural based on children's drawings (right), the position of the imagery was arrived at by the use of projectors, so various images of differing scale were tried out in several different positions until the most appropriate scheme was found.

Mural based on a child's drawings In this mural for a university games room, images were scaled up and painted in acrylic paint on the plastered surfaces of the walls and ceiling.

Technique Painting on a ceiling

This mural is painted onto the ceiling of an anaesthetic room in a childrens' hospital. The idea is to give the children something simple to look at and talk about as they are going to sleep. In a work of this kind, which is characterized by its flat colors and its clarity, you need to make sure that the transfer of the design is made as efficiently and effectively as possible, especially as it may be necessary to use the room at a moment's notice in the case of an emergency.

The design is projected onto the ceiling using a mirror at 45 degrees to the projector lens. This avoids the need to trace or draw out the image first in pencil or charcoal, which could result in making the ceiling dirty.

 The projected image as it appears on the ceiling.

2 The left hand is flat to the ceiling to keep everything steady while the painting hand does the work. The colors have to be painted twice for the required opacity.

Finished painting The completed work is illusionistic and faithful to the original design. The primary and secondary colors used in the design were mixed with a little white to aid opacity and to soften the brightness of the color.

Painted and Printed Laminates

THE USE OF LAMINATES FOR WALL DECORATION has been extensive since the mid-1930s, and architects have been able to specify colors and textures for cladding walls and working surfaces from a wide range of "off-the-shelf" products currently available from manufacturers. The advantages of the laminate surface are that it is tough, permanent, and washable, which makes it particularly suitable for busy public areas. A number of surface finishes are available, ranging from glossy through matt to a rough, uniformly-indented texture. In the past, commercially available laminates have usually been plain colors or imitations of wood grain or material textures. But now the range of designs is much wider.

Many people are unaware, however, that artists can create their own original works in laminates by having them screenprinted, or by handpainting them themselves in acrylic paint on the melamine-resin-impregnated paper normally used to give a color or design to the laminate surface. This is done before the hot-press bonding process that transforms the sheets of resin-impregnated paper into the laminate sheet (see description below).

The laminate process

A cross section of a sheet of laminate shows a brown core with a white or colored facing top and bottom. The facing paper on top displays the color, design, or painted surface of the laminate. A similar facing on the back prevents warping of the sheet. The top and bottom sheets are of absorbent paper impregnated with melamine resin. The middle section, or core, comprises sheets of brown paper impregnated with phenolic resin.

Once the paper has been impregnated with resin and dried, a "sandwich" is made, comprising a protective transparent overlay, the face paper, as many sheets of brown paper as are required for a particular thickness of laminate (up to ½in/12mm), and the backing paper. The sheets are placed in the press between metal plates, the surface of the top plate determining the nature of the surface (matt or glossy) the laminate will have. The plates are pressed together at a temperature of 302°F (150°C). The thermosetting resins melt and fuse and, when cool, form the rigid laminate sheet. The edges are trimmed and the laminate is ready for use.

Laminate is normally bonded to chipboard for use as internal wall cladding, but it can be glued directly to a smooth plaster or wooden wall using proprietary glue and pad methods. It can also be bonded to aluminum and other metals, plastic foams, gypsum, and cement. It is, broadly speaking, permanent in external use.

The "sandwich" A close-up of the "sandwich" before bonding shows the protective overlay, blue facing paper, and brown core paper.

Materials Hand-painted laminates

You can obtain 10 x 4ft (3 x 1.25m) sheets of melamine-resin-impregnated paper from the laminate factory and handpaint them using acrylic paints in your studio. But processing handpainted laminates involves the use of industrial facilities. When your handpainted design is completed, the paper is sent through the factory along the same production line as the thousands of sheets of plain or decorative papers that make up its main output. So there is a certain risk attached to this technique. In my experience, manufacturers are sensitive to this aspect of handpainted laminates, especially if you establish a personal contact with the factory.

Another risk for work of this kind is that the job of fitting the laminate to whatever structure has been

The scale of a full-size laminate sheet The standard size of a sheet of pressed laminate is maneuverable by one person, but if you need to move the resin-impregnated paper during handpainting, you will need assistance since it is so vulnerable at this stage.

designed for it is generally (and sensibly) handed over to expert joiners. They would normally only take on a unique work if the artist is prepared to take the risk of their making a mistake in the cutting or bonding of the laminate to the substrate.

Very rarely after lamination, small air bubbles can appear on the surface of a handpainted laminate. The reason for this has not been established, although it could be the result of some grease or contaminant that has gotten onto the surface of the handpainted paper before pressing. The paper should be kept as clean as possible during painting. You do not want to have to paint the same thing twice, although, as with ceramics, this is a risk you will need to accept.

Supply and delivery of resin-impregnated paper
You can paint on any color of paper, subject only to what the factory can supply. However, the paper is very brittle, especially when it is cold, and must be handled with great care. You should always wear gloves when handling it—dirty fingerprints can easily soil the surface and are almost impossible to remove.

You can make a flat packing case for the supply and delivery of the paper to your studio, but this is somewhat bulky, and an equally satisfactory method is to have sheets sent from the factory (or to pick them up yourself) rolled on a plastic tube with a diameter of at least 8in (20cm)—preferably larger. The sheets should be interleaved with thin newsprint and the width of the roll should generously exceed the width of the paper. The roll should be well protected during transit with bubblewrap or corrugated cardboard and the paper stored flat in the studio.

You avoid the risks associated with sending the paper if you paint at the factory itself. This would need to be negotiated.

Size and format of resin-impregnated paper
Always work on the complete 10 x 4ft (3 x 1.25m) sheet of paper as supplied by the factory. Before starting to draw or paint, attach the sheet to a smooth, flat wall or to the floor of the studio with masking tape. To allow for trimming after bonding, the paper is larger all around than the standard laminated panel size, so the edge is useful—not only for attaching to the studio wall, but also for trying out color combinations before using them. When you have finished painting, do not try to unroll the paper from your studio wall single-handedly. Get someone to help you and work from one end, rolling the paper as you go.

Technique Working on a large scale

If the area of the painting comes within the 3 x 1.25m (10 x 4ft) format, there are no problems with any adjoining edges. For a larger format, two panels can be abutted and painted up to each other. When you send the paper to the factory, stress that only three edges of the facing paper are to be trimmed on each sheet. In this way, the two halves of the image will join up perfectly when the work is assembled.

For an even larger mural painting, a grid system of working square to square as accurately as possible is the only means of ensuring a continuous image through several separate panels. If you know where the joins will come, you can conceive the work so as to make sure, for instance, that half a face does not appear on one panel with the other half on another. This is an important point, since the dimensional stability of the paper can be a problem, with as much as a ⅛in (3mm) distortion over the 4ft (1.25m) width as the paper is run through the drier before bonding. The laminate can, of course, be cut to any size after bonding.

Drawing and painting techniques

The resin-impregnated paper takes pencil, pastel, and charcoal, and retains them after bonding. Pastel and charcoal can be fixed by spraying with an unpigmented acrylic emulsion. The best all-around paint is acrylic, which can be used in a number of ways (see *Acrylics*, pp.202–22). The paper has one particular feature that distinguishes it from other supports—its absorbency. So, when working with thin washes of acrylic color, for instance, a mark made by the brush is almost immediately absorbed into the paper, allowing no time for softening of edges or blending (as is possible on normal, sized paper). This feature may be exploited by the artist (see below). The absorbency of the paper seems to vary according to its color and is particularly marked on white, for which some manufacturers use a slightly thicker paper. Adding thin layers of acrylic paint makes the paper less absorbent.

Technique
Painting in thin color washes

When acrylic paint is thinned to a "watercolor" consistency, each brushstroke leaves its mark on the absorbent paper. The effect of overlaying colors is to create a variegated texture.

The study of Roman portrait heads on the right demonstrates the use of thin acrylic color on white paper. The white paper is too absorbent to use masking fluid effectively, so you have to avoid putting paint on any areas that need to stay white. The watercolor technique on very absorbent paper like this creates a work in which each stroke of the brush is visible in the finished work. So here, for example, very thin washes of three distinctive colors, Phthalocyanine Blue, Quinacridone Red, and Burnt Sienna, were used separately for the background. This creates a more variegated appearance than the gray that would have resulted from physically mixing these colors before application. Once bonded, this "acrylic" watercolor is much more permanent than a conventional watercolor painting.

Painting made in thin acrylics Where the heads are in shadow, deeper tones were made by overlaying more thin washes and drying them with a hairdrier. Three colors were used in the background—Phthalocyanine Blue, Quinacridone Red, and Burnt Sienna.

Technique
Painting with thick acrylic paint

Thick paint can be equally well on resin-impregnated paper. For example, the scraping technique described for *Acrylics* (see pp.217–20) lends itself well to lamination. S'graffito techniques, where lines are scraped out of thick paint, may also form part of a design. Thickly-applied paint is more noticeable after heat-pressing.

Scraped paint technique Here, paint was scraped with a plastic straight-edge over the surface of the paper to a depth of about 1mm. The heat of the bonding process has had no noticeable effect.

Thicker scraped paint Here, thicker paint (⅛in/2–3mm in depth) was scraped through a stencil. The hot press had the effect of "melting" the paint; this is clearly visible in the bleeding around the edges of the fish.

Technique Paintings for public areas

Public areas are particularly suitable for showing original laminate paintings, since the surface is so robust and easy to clean. The following examples were made for the busy emergency room of a general hospital and it was naturally essential that they were strong surfaces that could be easily cleaned.

In the studio The sheets of resin-impregnated paper are shown during painting on the studio wall.

Installed on the walls This latticework of butterflies and flowers, seen here after installation, was painted for a hospital waiting area. It would have been perfect as a screenprinted laminate, but since it only involved three sheets of laminate it was more economical to handpaint it. The clean brightness of the colors was maintained by underpainting in white on the blue, resin-impregnated paper.

Using a spray gun and airbrush This handpainted laminate for a wall uses spray gun and airbrush techniques with acrylic paint to create a sense of space through aerial perspective. The technique is to build up the tonal areas by handpainting with a brush before beginning the spraying. This allows you to get a real depth in the tonal variation, and the spraying serves to soften edges and add to the realistic effect.

Project Laminate wall panel

A main hospital thoroughfare is the site for a work designed to make a feature of a blind bend in the corridor. The work is functional in that it incorporates a mirror to allow people to see whether there are any hospital gurney coming around the bend, but it also adds interest and color to an otherwise plain setting. The idea informing the work is that people walking toward the bend from one direction down the corridor will see something completely different from people coming in the opposite direction. From one side, the image is of leaves, and from the other, of flowers. This is achieved by making a series of thin, vertical, triangular sections around the bend. On one side of the triangle, the leaf image is visible, and on the other, the flowers are visible. The third side of the triangle is flat to the wall.

As a regular handpainted work on panel, this artwork would not be secure or permanent in a busy public thoroughfare. But as a hand-painted laminate, it is durable and can easily be cleaned. The background color for the work is blue. The resin-impregnated paper that is used to make laminate comes in a number of colors and it would be absurd to paint an overall blue background color onto white paper, so the idea uses blue paper as the base color. However, if the yellows, reds, and greens of the image were painted directly onto the blue paper, even in opaque colors, the purity of the color would be lost. So, two coats of white acrylic primer are painted onto the blue paper beneath the leaf and flower shapes. Once the primer is dry, the colors are painted on. They retain their vibrancy when they are painted over the white.

In a work of this kind, which relies on around eight premixed colors, it is important to mix enough color at the beginning to allow you to finish the work. This is particularly true of acrylic colors since they dry darker than they look when wet.

1 A model shows the structure of the work; from one side flowers are seen; from the other, leaves.

2 The image is projected and white primer is applied. The shadows are also painted.

3 Subsequently, the colors are applied, following the contours of the projected image.

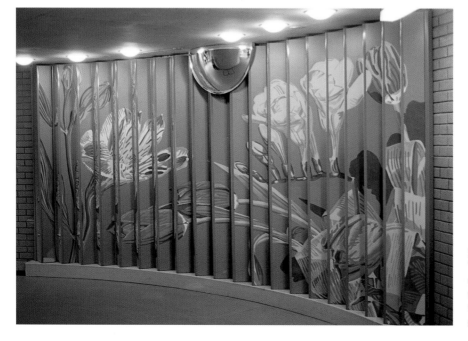

Finished work
This is the completed wall panel seen from one end of the corridor.

Technique Screenprinted laminates

The advantage of screenprinted laminates over handpainted ones is that once the screens have been made, the image can be very easily reproduced, so there are none of the problems associated with the uniqueness of the handpainted laminate as outlined above.

The example shown here, featuring a design for cubicle doors for Armitage Venesta, demonstrates the potential for work of this kind. It uses a relatively simple line drawing and a limited range of clear colors to produce something that is hopefully a great deal more fresh and lively than a plain colored door.

1 The swan sketch is the original drawing for the laminate.

2 Stencils in self-adhesive film are cut and attached to transparent film the size of the laminate sheet. There is a sheet for each color to be screenprinted onto the laminate.

3 Each full-size screenprinted laminate is large enough to carry two of the designs for cubicle doors.

Technique Digitally-printed laminate

It is now possible to create an artwork on the computer and for it to be digitally printed onto resin-impregnated paper before being pressed as laminate. You have to ensure that the digitally-printed colors can withstand the heat of the bonding process and will be lightfast enough not to fade during the lifetime of the work.

Digitally-printed laminate The nursing station under construction for a children's ward incorporates this new technology.

Following installation The image of the houses could have been silk-screen printed, but it would have taken too many screens to create the colors and textures for it to have been economically viable. The digital method, in which colors and tones can be precisely controlled, is immediate and effective.

Ceramic Tiles

CERAMIC TILES CAN BE PAINTED, PRINTED, AND impressed, in many ways and at various stages in the production process. It is possible to create extremely complex images requiring many firings, or more direct, single-process images. Whatever techniques are used, the finished work will have the unique quality of the tile medium and also an extremely high degree of permanence that is difficult to achieve in any other medium.

The manufacture of tiles

Ceramic tiles can be handmade—usually from red or white earthenware clays. Commercially made tiles are manufactured either by extruding plastic clay through dies, by casting from slip (clay and water mixture) in plaster of Paris molds, and by dust-pressing. Dust-pressing allows great control over the consistency of the tiles, and is the method used for most domestic wall tiles. They are dust-pressed from a mixture of ball clay, china clay, calcined flint, and feldspar. Lubricants and binders are then added for the pressing process. They have a white body when fired. Unglazed fired tiles are known as "biscuit tiles."

Materials

Making your own tiles

Clay is bought in blocks, plastic-wrapped to retain around 25 percent moisture. Whatever method is used to make the tiles, the block of clay must first be "wedged," which involves kneading the claylike dough to remove any air bubbles, which would explode in the kiln. The method of rolling and cutting a tile is shown right.

A spring-loaded tile cutter can be used to stamp out the shape, although cutting against a simple straightedge or around a metal template usually gives the best finish. A large slab of clay can be rolled out in the same way, then cut into tiles around a template.

Tiles can also be made in a hand tile press, which can be found in most art colleges. This gives consistent results, the pressure expelling any air remaining in the clay.

1 Roll out the clay with a rolling pin on a piece of burlap (or similar backing fabric) to prevent sticking, between parallel wooden guides nailed to the bench. Coarse sand is sometimes used instead of burlap.

2 Using a knife and a template or straightedge, cut the clay into square tiles. Allow the clay to dry, turning it often to make sure that it dries evenly. When it is "leather hard"—after 2 to 10 days—it is ready to fire.

Technique Impressing relief designs

This is done during manufacture by pressing the tiles into dies that can be cut or cast to the required shape from wooden blocks or resin. In a hand press, a die is made to fit precisely into the bottom of the press. The clay is packed in and the machine then operated. To release the tile, the bottom section of the mold is pushed up by means of a foot pedal and the clay and die can be removed. However, even without a press, any object can be pushed into the clay to make a relief design. For example, a relief image from a linocut or a woodcut can be made by passing the clay and the block through a mangle.

The impressing of designs into the clay is usually combined with other techniques that use slips and glazes to produce a finished image.

Tile shrinkage

When making tiles from plastic clay it is important to allow for the shrinkage that occurs during firing. A rule of thumb is to allow for a 10 percent shrinkage overall (see below for shrinkage guide). The amount of shrinkage can be reduced slightly by adding "grog" to the clay. This is filler—usually a prefired, pulverized clay. It may be the same material as the tiles and is usually added to the wet clay during the wedging.

Smooth red earthenware		Grogged red earthenware	
TEMP °F/°C	SHRINKAGE %	TEMP °F/°C	SHRINKAGE %
1,832/1,000	8	1,832/1,000	6
1,922/1,050	10	1,922/1,050	9
2,012/1,100	12	2,012/1,100	10
2,102/1,150	13	2,102/1,150	10

Technique Coloring tiles

One way of adding color to ceramic tiles is to color the clay itself before it is made into a tile. This is done with body stains, which are refined oxides and are normally used for coloring mixtures of clay and water called "clay slips" or "engobes." If the whole of the tile requires even staining, dry, powdered, unfired clay is mixed with the body stain powder in a percentage ratio, then reconstituted into wet clay with water.

Alternatively, you can douse the body stain with water, then sieve and mix it with clay slip using an electric mixer. This mixture is then sieved again, before being applied to the surface of the tile. The use of a white or colored slip, or engobe, over the surface of the tile is common in a number of decorative techniques such as using stencils, s'graffito techniques, and encaustic tiles.

Decorating ceramics

There is a wide range of methods for decorating ceramics. S'graffito techniques (scratching the design) enable you to draw directly into a layer of slip or glaze on the surface of the tile. You can also apply slip with a nozzle or through stencils. Decorative techniques can create designs that are flush with the tile or in relief, and colors can be painted under, in, or over the glaze.

Materials Basic coloring oxides used in ceramics

The coloring oxides are mixed with water, gum arabic, or oil to form a workable painting consistency, and are then applied to unfired, biscuit, or glazed majolica ware. The raw oxides provide the strongest colors, while the carbonates offer a paler range. The main oxides or raw natural pigments used for coloring purposes in ceramic work are as follows:
- Cobalt oxide gives a range of blues
- Copper oxide gives greens in thin applications, and black when used thickly. It can also give a green-blue or a copper-red in certain alkaline or reducing conditions
- Chromium oxide gives a positive basic green color, but can be used to create reds, yellows, browns, and pinks in particular combinations with lead, zinc, or tin
- Iron oxides give colors from yellow to dark brown
- Manganese dioxide gives a range from pink to brown, with purple being produced in alkaline or tin glazes.

Technique S'graffito technique on slip-coated tiles

This method involves drawing directly into a white or colored slip applied uniformly over the surface of the tile. The slip may be brushed on in a thin film or sprayed on using a spray gun with a suitable nozzle. With a spray gun, it is important to sieve the slip well before application. Apply the slip when the unfired clay has dried to the "leather-hard" stage, when it will have lost much of its moisture but not become too hard.

The slip looks glossy when it is applied, and is still too wet to draw through. As the water content evaporates or is taken up by the clay beneath, it becomes more matte in appearance and an image may then be drawn into it.

Any suitable instrument, such as the sharpened end of an old paintbrush, may be used to cut through the slip to reveal the clay beneath. Once the slip has dried more thoroughly, you can scratch in more accurate details.

A white slip over a terracotta tile would give a dark red or brown "line drawing" through the white. But any combination is possible—the slip could be dark blue or black over a white tile for instance, so that a "scratchboard" effect could be made. Slight changes in the thickness of the slip will give different effects. A thicker slip coat will result in a chunkier effect and a thinner slip will allow finer manipulations.

Technique
Using stencils

Slip can be applied in flat, solid areas of color through paper stencils. Newsprint is particularly good for this purpose. Slip can also be stippled through cardboard stencils, or screenprinted through a coarse mesh. It has a tendency to spread slightly, so it is advisable to limit the technique to nonintricate shapes.

Technique Using slip trailers

Slip can be applied to tiles through a thin nozzle attached to a rubber, slip-filled bulb. The bulb is squeezed between finger and thumb and the slip extruded in a thin line. This is a fluid method of drawing directly onto the tile. It works best when used over tiles laid together as a group.

"Tube lining" is a similar technique in which a thin trail of slip is laid over the outline of an image. The various sections of the image are bounded by these raised outlines and can be filled in separately with underglaze colors or oxides.

Filling inlays The slip trailer is shown here making encaustic tiles.

Technique Making an encaustic tile

This technique—which is completely unrelated to the encaustic method of painting—involves tiles that incorporate an inlay, made by pouring a white slip into an indented image or design in a tile made from clay of a different color. The celebrated decorative medieval floor tiles used this technique. Traditionally, the design is made in white on a red terracotta tile, but there is no reason not to use any other color combination. If you wish, you can also continue working on the finished tile with underglaze and/ or glaze colors (see p.297).

Once a die has been made for the preliminary indentation, the encaustic tile is made by hand. If a die fits the base of a hand-operated tile press (described on p.294), the tile can be pressed and removed before being inlaid. If such a press is not available, you can make a square open mold, whose base forms the die for the inlay. In this case, a thin layer of casting slip is poured over the base of the die and left to dry to a leather-hard state. Plastic clay of a similar kind is pressed into the mold by hand and cut level. The tile is then removed from the mold and the different-colored slip applied.

1 Seal the edges with tape to stop spillage and pour slip to fill and overflow the indented design.

2 Leave the slip inlay to dry, then scrape it back to the face of the tile to reveal the design.

Robert Manners

Small-scale encaustic tiles

The encaustic technique suits simple, stylized imagery and clear, two-color combinations. In this series of nine 2in (50mm) square tiles, Robert Manners has produced semi-abstract designs that have a clarity and freshness within the square format. The combination of light-toned images against a dark ground with dark-toned images against a light ground works particularly well. The dark chocolate color is obtained by staining the clay.

Signs and Symbols (1989), ROBERT MANNERS

Technique Applying underglaze colors

Underglaze colors are special powdered paints that, when mixed with a binding medium, can be applied to unfired (green) clay or to porous, biscuit (fired, but not glazed) tiles. They contain clay, which allows them to adhere to the tile. If onglaze colors (see p.299) were applied to an unglazed tile and fired, they would just flake off, since they do not contain enough fluxing or glassmaking elements to make them stick. Underglaze colors may be sprayed or printed directly onto the tile (see *Printing on tiles*, p.299).

To paint the underglaze colors onto the biscuit tile, they are ground or mixed (depending on their coarseness) with a binding medium. The most common medium is a solution of gum arabic and water, which allows you to manipulate and thin the color as if it were paint, on the surface of the tile. The powdered underglaze colors can also be ground in linseed oil thinned with turpentine. The color can then be used in much the same way as oil paint. The binding medium is not permanent and must be driven off by firing in a ventilated kiln at between 1,112–1,202°F (600–650°C) before the tile is glazed.

The underglaze color should not be applied too thickly, or it will weaken the bond between the subsequent glaze layer and the surface of the tile.

Technique Glazing

A glaze is a glasslike covering layer that enhances the appearance of the tile and reduces its porosity by sealing the surface of the tile. The glaze is applied by spraying, pouring, or by dipping the tile in the glaze. It can also be applied to selected areas of the tile only, depending on the desired effect.

The glaze may be transparent (clear or colored) or opaque (white or colored). Transparent glazes used over underglaze painting or printing or slip manipulations will create richly varied effects.

Technique Painting on the unfired glaze

This technique, also known as "majolica," was developed in Spain. An opaque, warm white glaze is laid over the biscuit tile. When it is dry, the image is painted onto the unfired glaze, using the basic oxides from which ceramic colors are made. (Cobalt oxide produces the characteristic blue on white tiles, and was frequently used in the past because it was reliable and readily available.) The color is mixed with water and applied with a soft brush to the powdery surface of the unfired glaze.

The refinement of the brushwork is limited with this technique, but it is nevertheless an excellent way of working directly with a brush on a large tile panel. Once fired, there is a satisfying fusion of image and ground that can be lacking in the "onglaze" technique (see p.299).

The unfired glaze can be given a harder surface, more suitable for painting, by mixing a little gum arabic into the glaze solution, or by spraying some lightly over the top. This will hold the glaze and make it less powdery.

Using several colors on the unfired glaze A wide range of colors can be applied to the unfired glaze. Until the painted tiles are fired, they have a matte pastel look and the colors are subdued. The surface of the tiles is vulnerable at this stage. Panels are generally painted, as shown, at an angle to the vertical.

Full color The dancers were painted using filbert sable brushes and a range of ceramic colors applied in small repeated touches.

Technique

Understanding fired and unfired colors

When you paint on the unfired glaze, it will take a little experimentation on sample tiles before you get to know how deep the color you are applying is going to be when it is fired. The cobalt oxide is pale and gray before it is fired, but afterward it is a deep glossy blue. It has to be quite thickly applied for a very deep tone.

1 The tail of the whale is gray before firing.

2 After firing, the pale gray color turns a deep cobalt blue. It is usual to lay out recently fired tiles in the workshop to see if any need to be repainted.

"S'graffito" technique The trees are based on an oil pastel drawing. A transparency of the original was projected onto the panel of tiles that had previously been given two deep cobalt oxide washes on the unfired glaze. The white areas were scraped back, using the s'graffito technique, to the blue to reveal the image of the trees. The tiles were then fired.

Technique

Handpainting large-scale panels

It is generally easy to scale up from a preliminary design with a square grid drawn onto it, since this corresponds with the natural grid created by the ceramic tiles themselves. If you are working on a very large wall panel, it is convenient to work on smaller square sections at a time. You can ensure that the design links up as it should by taking slides or digital images of each of the sections and projecting them onto the panels as you paint them. This is how this large ceramic tile painting on the wall of a hospital stairwell was made. The images are each painted with their shadows, so they seem to float off the surface.

Preliminary study This artwork shows the original tile design on a square grid to scale.

Finished ceramic tile painting The completed artwork is faithful to the original design.

Technique Applying onglaze colors

Onglaze colors are applied to a fired, glazed tile. When the tile is refired, the pigments and the glaze fuse. Onglaze enamels, as they are known, are available in fine powder form. They are initially mixed with a suitable binding medium—gum arabic, resin, or oil-based mediums are the most common— and are then applied with a painting implement to the surface of the tile. A wide range of colors is obtainable because the enamels within particular ranges can be mixed.

If onglaze color is brushed on, the smooth, glossy surface of the tile will hold and show the brushmark exactly as applied, with all its ridges and striations. Artists used to painting on absorbent or semi-absorbent surfaces may find the surface somewhat resistant at first.

Onglaze color may also be sprayed onto the tile through stencils, or dusted through a fine, mesh sieve onto a tile that has been coated with ground-laying oil. The color will adhere wherever there is oil. It may also be printed through a silk screen (see below).

Technique Printing on tiles

There are two main methods of printing on tiles: the direct method, and the indirect (or transfer) method. You can print onto the unfired clay or the fired biscuit tile (underglaze printing), or onto the glazed tile (onglaze printing). In the latter case, a further glaze may be applied, in which case the original printing is "in-glaze." With both methods of transfer printing, the medium must be drawn off in a slow preliminary firing in a ventilated kiln.

Direct printing
Screenprinting is the standard method of direct printing (see *Printmaking*, pp.256–60). For best results, a screen with a relatively coarse mesh should be used. You can use any of the binding mediums mentioned above, with the slip, underglaze, or onglaze colors, to enable them to be squeegeed through the screen. Grind or sieve them with the medium to a uniform consistency. You can overprint several colors before firing, so long as you use a quick-drying medium that leaves the color relatively hard.

Most of the methods of stencilmaking may be used (see p.257), but a transfer method is more suitable if a design is too intricate. When direct printing on a commercially made, curved-edge tile, the design should be kept within the flat area of the tile.

Indirect transfer printing
In the indirect method of printing, also known as "water slide transfer," which is best suited to onglaze work, an image is printed on special coated transfer paper.

The coating is a water-resistant membrane onto which the image is printed—usually using a screenprint method, although other printing techniques can also be used.

For unique tiles, a monotype can be made using the ceramic colors on laminate or glass as you would for printing ink or oil color. A print is then taken onto the transfer paper. When the image on the transfer paper is dry, coat it with a proprietary sealer, by silk-screening it on through a blank screen. Leave this to dry. Float the sheet of transfer paper in a tray of warm water. The paper will absorb the water and sink to the bottom of the tray, leaving the transfer floating on its membrane. Pick it up carefully by the top two corners, place it on the (glazed) surface of the tile, and slide it into position. Use a rubber kidney to expel any air or water, working out from the center. Up to three transfers may be overlaid on the same tile. For both methods of transfer printing, the medium should be drawn off in a slow preliminary firing.

Underglaze transfer printing
For underglaze work, it is more satisfactory to transfer a print made on tissue paper by etching or lithography. In etching, the plate is inked up with oxides ground in fat oil. The tissue paper is dampened, then printed in the usual way. The resulting print is laid onto the biscuit tile, and wetted and dabbed with soapy water. The printed image transfers to the tile and the tissue paper is peeled off.

Technique Firing the tiles

Firings begin slowly to allow the work to dry and get rid of any chemically held water. The slow firing is carried out at up to 1,112°F (600°C) with plenty of ventilation. From this point, it rises rapidly to the maturing temperature. There should be no sudden draughts or changes of temperature, and the same amount of time should be allowed for the kiln to cool down as it took to heat up.

Remember that the various layers of the tile—from the body itself, through colored slip, to underglaze colors, glazes, onglaze colors, and lusters (metallic salts that give a metallic finish to a tile)—will require firing at different, progressively lower temperatures. The clay tile itself may need firing at up to about 2,192°F (1,200°C), down through the layers to lusters (about 1,346°F/730°C).

Vitreous Enameling

VITREOUS ENAMELING IS A METHOD OF creating painted or printed images on metal plate. The plate is fired—often several times with different colors—and the resulting image becomes fused to the metal. The enameled panel is permanent and weatherproof, so it can be used for external murals. Vitreous enameled panels have become extremely popular in decorative schemes for busy public areas where a high degree of toughness and resilience is necessary. Small-scale enameling can be done in the artist's studio using kilns similar to those used for firing tiles (see p.302). Large-scale enameling is usually done in conjunction with an enameling factory, which will have industrial kilns big enough for large sections of plate.

Enameling equipment and materials

The most common metal for vitreous enameling is carbon-free steel that can be bought in specified vitreous enameling grades. The steel must be carbon-free because the presence of carbon during firing would cause the enamel to blister and flake.

It is also possible to enamel on copper. This is often used in conjunction with jewelry enamels, which allow the metal to sparkle through. These effects are also possible with stainless steel and precious metals.

Aluminum can also be used. It is conveniently light, but has a low melting temperature, requiring low-firing enamels. There is considerable industrial research being undertaken at the moment on the use of enamel on aluminum.

Materials Kinds of enamels

Enamels are bought in powder form, ground to specific "mesh" sizes. A popular size for artists is 80-mesh; the 120-mesh is more suitable for silk screen purposes. The powder is mixed with another medium before being applied by brushing, spraying, pouring, or printing. It can also be sieved in dry form onto the prepared panel.

Industrial enamels

These traditional enamels are highly resistant to heat and extremely opaque, so it is not possible to create transparent or translucent glazing effects with them. They come in a wide variety of colors and are safe to use and relatively inexpensive.

Jewelry enamels

These are lead-based and therefore potentially dangerous to work with. In factories, the law requires stringent controls over their handling. They are now available in lead-free form in the US and these are recommended. Jewelry enamels can be up to three or four times as expensive as industrial enamels. However, using these enamels is the only way of creating rich, transparent and translucent effects on the metal panel. The glossy, glasslike surface of the fired panel makes these effects very successful in enameling. The price of both leaded and unleaded enamels depends on the metallic oxides used to create the color.

Materials Binding mediums

It is essential that the medium has sufficient binding strength to hold the enamel color together, to stick it to the panel, and to allow overpainting. It should burn off easily in the kiln without leaving a residue, or affecting the color or structural stability of the fired enamel. There are a number of aqueous (water-based) mediums suitable for use with enamel colors.

Gums

A mixture of best grades of gum tragacanth or gum arabic, water, and the enamel color itself will have sufficient binding strength to allow for a range of artistic uses. Gum tragacanth affects the colors less after firing than gum arabic, although there is no chemical reason why this should be so. Very little gum is needed.

Cellulose paste

A cellulose like that used in heavy-duty wallpaper paste provides a good binding medium that will burn out well in firing and is considerably less expensive than the natural gum. It can be used for brushing on the color, but is not so suitable for spraying. Sieving dry color onto cellulose-pasted areas works very well.

Essential oils

Pine oil and clove oil (see p.33) are often used as mediums for vitreous enameling. They allow the color to be freely manipulated on the panel. However, they do not burn off very well in fast-firing kilns and are therefore more suitable for slow-firing.

Acrylic mediums

Methyl-methacrylate-type acrylic resins provide excellent binding mediums for enamel colors. The color is simply stirred up in the medium. They do not have the feel of acrylics since the colors are not fully bound; they are more like a paste. Proprietary water-based emulsions can be used, although in factory conditions these dry too quickly to allow much manipulation.

Acrylics are used extensively in this area because they depolymerize rapidly at about 572°F (300°C). Once this happens, the binder is removed, leaving clean colors with no residue. PVA mediums are not usually used because they do not have good firing properties.

George Stubbs

Enameling on copper

This example shows how complete a range of tones can be subtly and accurately controlled. It is a meticulous piece of work, in which each element has been detailed with precise brushstrokes. Made in the 1700s, it proves the permanence of the medium. The reason for the overall stippling technique is that it is the only method of achieving such fine tonal gradation on the smooth, non-absorbent ground on which Stubbs has painted.

Horse Attacked by a Lion *(1769),* GEORGE STUBBS

Preparation The metal plate

If a large-scale artwork is being prepared—for a public site, for example—you will probably be using enameling steel, and the initial preparation, including the grip coat (see below), will be carried out by the factory. The steel should be at least 1.2mm or 18-gauge in thickness.

The size will depend on what the factory kiln can hold. The largest size available is usually about 8 x 6ft (2.4 x 1.8m), but more usual for easy handling is 5 x 3ft (1.6m x 90cm).

Panels that are to be wall-mounted are constructed with a flange all the way around. Holes can be drilled through the flange and the panel fixed to a metal shoe attached to the wall. A flanged panel needs only a backing grip coat (see below), whereas a flat panel needs the same amount of enamel on the back as on the front to prevent warping. All structural work or welding is done before the metal is prepared for the enameling.

For a fine art or decorative panel, the factory should use the traditional preparation method. First the steel panel is put into the furnace to burn out any grease or accumulated dirt. Then it is placed in a 10 percent solution, hydrochloric acid bath for about 15 minutes. This etches the plate to provide a key for the grip coat. Then the panel is rinsed and neutralized by being

dipped for 30 seconds in soda ash water. Finally, it is rinsed for 30 seconds in borax, to prevent it from going rusty, and then left to drip-dry in warm air.

The grip coat

Once it is dry, the metal panel is ready for the grip coat—the enamel ground coat applied directly to the bare metal, in a spray booth. It is usually dark blue, brown, gray, or black after firing, depending on the particular formulation employed by the factory. The composition of the grip coat can vary greatly, but it generally includes such ingredients as feldspar, silica, quartz, enameling grades of clay, bentonite, and other mill additions. These minimize straining and maximize adhesion in the enamel. The clay makes it stick to the metal. The prepared plate is loaded into the furnace and fired at around 1,580°F (860°C). It is now ready for the cover coat.

The cover coat

The term "cover coat" applies to any enameling applied over the grip coat—for example, a coat of white (or any other color suitable for a ground). For an opaque white, a frit (see *Glossary*, p.372) is prepared by the factory, using titanium. For pastel colors, a less opaque white such as antimony is used in conjunction with industrial enamel colors.

Enameling techniques

Many of the decorative techniques described in *Ceramic Tiles* (see pp.294–99) also apply to vitreous enameling. Colors can be painted on in the traditional way in opaque or transparent mediums. It is important to remember that the ground is nonabsorbent.

As well as using a conventional painting method, you can paint in the design with pure binding medium, and then sieve the dry powder color onto it, so that it sticks only where there is medium. You can also apply the color through stencils, or sieve it onto the dry panel and then spray the medium into the air above it, so that it falls uniformly onto the panel. Silk-screen printing the enamel onto the panels is a common procedure and can be combined with handpainting. Trichromatic screenprinting is well developed with computer-separated artwork and a seven-color process replacing the four-color system. Transfer printing is a popular method of working in vitreous enamel, as it is with tiles.

Technique Applying enamel colors

The enamel can be applied to the prepared metal in many different ways, provided you observe certain points. If too little color is applied, white spots can come through from the ground coat. This is more likely to happen if the panel is fired at a high temperature. If the color is too thick, the medium may not be able to burn off through the enamel, which would cause flaking and cracking.

It is possible to print several layers on top of each other, allowing each to dry before reprinting, then giving the panel a single firing. It is best not to apply more than two or three colors at a time—some artists prefer to fire one layer at a time. With a work that includes several panels, remember that the color will change slightly with each firing. So, even if the panel does not have a color that is later applied to another, it should still be refired along with the second, to ensure color consistency throughout.

Technique Firing enameled work

There are two kinds of fast-firing factory kilns: the box kiln in which the panels are fired flat, and the tunnel kiln in which panels are fired vertically. The former produces slight variations in heat at the front, center, and back of the panel, whereas the latter gives a more uniform heat distribution. Results from both are equally satisfactory.

For smaller pieces of work, electric front-loading kilns are available for home or studio use, with different internal kiln sizes.

Craft kiln for small-scale enameling A small electric kiln (left) is suitable for firing small pieces of work on metal plate and for jewelry work. These kilns can fire at temperatures of up to 1,832°F (1,000°C) and have electronic temperature control.

Elizabeth Turrell

Scratching out linear detail
This panel features vitreous enamel on perforated, reclaimed, pre-enameled, industrial steel with additions of enamel, gold foil, and graphite drawing. It demonstrates the rich variety of surface effects that can be had with the medium.

W is for War (1999), ELIZABETH TURRELL

Technique S'graffito

The s'graffito technique that features throughout this manual is particularly well suited to the vitreous enamel medium and can be seen in this work by children.

S'graffito technique (children's drawings) These vitreous enamel tiles were created by children from a preschool, by scratching the image through the unfired white ground in a straightforward s'graffito technique.

Technique Stenciling

This detail from a donor panel for a children's hospital was created by applying color through a series of hand-cut stencils. The images were based on children's drawings. The work has a clear, fresh, diagrammatic quality but is still full of life. It owes much of its inspiration to "tree of life" stencil images from India. The work has a lively and fresh character.

Stenciled tree shapes Stencils can create clear, crisp images.

Technique
Stenciling and collage

The semi-abstract shapes in this work were based on images in a paper collage in vitreous enamel using sheet copper and copper wire cloisonné. The colored, raised shapes have a strong tactile quality that combines with bold color and a range of tones.

Multi-material vitreous panel The detail demonstrates the depth of color that can be obtained in vitreous enameling. The imagery was built up by sifting the colors onto the plate through a series of stencils.

Stained Glass

IMAGES CAN BE CREATED ON GLASS BY PAINTING or "staining" with pigments or by etching with acid. Glass itself is made by heating silica (in the form of siliceous sand, quartz crystals, or flint pebbles) with a flux (such as soda ash) to aid the fusion process, and a stabilizer (lime) until it is dissolved. The molten glass mixture is then shaped and cooled.

Glass painting

When painting on glass, the contours of the image are usually defined by strips of lead. These enclose separate pieces of glass that are painted to define the features and three-dimensional form of the image.

Traditionally, features are defined with opaque black lines and halftones, and shadows by "matting" (see opposite). The painted glass is "fired" in a kiln, causing the paint to melt with the glass.

Materials The glass

The best glass for stained glass work is known as antique, or "soft," glass and is made by hand. It is formed from a bubble of molten glass that is blown into a long, sausage-shaped balloon. The molten glass may be colored by the addition of metal such as manganese, cobalt, copper, or iron oxides. The two ends of the cylinder are cut off and the shape cut along its length. It is cooled at a regulated temperature and flattens out to form a sheet.

Glass paint
Paints used for painting on glass are a mixture of glass dust and iron oxide with a flux incorporated. "Cathedral" colors, which come in a range of blacks and browns, are finely ground and are worked with a spatula and distilled water on a slab for a few minutes before they are ready to use.

Transparent enamel colors
Enamel colors are applied in the same way as glass paints but are fired at a lower temperature (around 1,022°F/550°C). They can have a "painted-on" look, but if fired at high temperatures, a more fused look is created; though colors can change and become lighter. They can be screenprinted when mixed with a medium such as gum arabic and water. There have been recent developments in the production of transparent glass enamels that have produced much stronger colors. They are available ready-mixed in mediums that suit handpainting, airbrush, or screenprinting and they come in a range that can be fired at lower or higher temperatures for different applications.

Screenprinted enamel color The example shows blue and yellow printing onto clear glass.

Materials Binding mediums

The binding medium used for glass painting is burned off in the heat of the kiln. It serves only to hold the paint together and give it temporary adhesion to the glass. To a certain extent, it can inhibit resolubility and allow further manipulation of the paint on the unfired glass.

Gum arabic
The most common binding medium for glass paint is gum arabic. In powdered form or in solution, it can be mixed with pigment powder and distilled water. The pigment powder may also be ground in oil if a more viscous mixture is required for manipulations that involve working the paint for longer than the gum mixture allows.

Acetic acid
Acetic acid is also used in a 40 percent solution added to the paint mix. If this is unavailable, vinegar—which is a weaker version—may be used. Its function is to harden the paint layer, so that subsequent layers may be applied before firing without disturbing the layer beneath.

Technique Painting on glass

The basic design of the image is first outlined on a pattern called a "cut line," where all the shapes are drawn to size prior to any painting, staining, enameling, or etching. The cut line shows each piece of glass within the overall design, with a gap between them of the same thickness as the core of the lead that is used to join the pieces together. Each piece of glass is cut well within the line of the pattern. If it were cut over it, the whole design could move out of shape, which would be disastrous when working within the dimensions of a specific window frame. If the glass is cut accurately, the leading will be accurate, too. The paint is applied with the glass laid on the surface of a large electric lightbox.

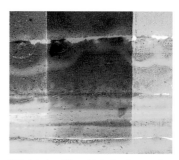

Staining glass The striated yellow and orange is fired silver nitrate.

Painting opaque lines

The best brush for painting simple, solid lines is a round, long-haired brush such as a rigger or striper (see p.120). The paint should be quite liquid but rich in pigment, like liquid poster paint. The brush should be well filled and a "river" of paint pushed along the glass. If the stroke is made too quickly, it will become too light and, when fired, lose even more opacity. Mixing glass paint with a drying oil thinned with paint thinner allows a rich, dark tone to be made for a trace line. When this is dry, matting (see below) can be done in a water-based medium over the top without affecting the original line.

Matting

The method of achieving a halftone or a graded tone effect is known as "matting," where a thinner overall tone of paint (the matte) is applied.

If glass is to have both line and tone on it, the line work is painted first, and acetic acid may be used to harden it. Then the matte is applied. Practically any brush can be used to apply this very liquid paint. For large areas, a bristle brush is preferable to a soft-hair one, because the paint can be moved around more effectively.

However carefully it is applied, the paint will look uneven because the glass has no porosity or texture to hold the pigment particles in place. If a graded tone is required, more pigment can be laid into the deeper-toned areas. For the even-toned effect, the paint has to be modified after application, in much the same way that oil glazes are

blended or adjusted with dry brushes. So, the next stage is to "whip" or "flog" the matte, using a dry soft-hair brush in a light, sweeping movement across the glass. The brush hardly touches the surface at all, but it creates a beautifully smooth gradation or even tone across it.

Stippling

In the warm atmosphere of the studio, water in the paint evaporates and the paint film dries out. If the tone still has inconsistencies in it, or if a different kind of tonal effect is required, the brush may be used vertically in light dabbing strokes to produce a stipple effect.

S'graffito

The matting technique described above may be adapted with a slightly thicker paint mix to produce an evenly opaque layer of paint on the surface of the glass into which imagery may be scratched or scraped. Any tool may be used, including needles, nails, screwdrivers, steel combs, brushes, steel wool, and fingernails. The fingertips can also be used to gently rub away the applied color. While the paint layer is wet, various textured materials may be pressed into it so that an impression is formed in the glass.

Spray painting glass

The glass painting pigments are ground finely enough to allow them to be sprayed through conventional spraying equipment. It is possible to use an airbrush, although more

consistent effects can be achieved with a larger gravity-feed spray gun, which allows both uniform and graded mattes to be achieved to almost any depth of tone.

Staining glass

The only true glass stain, as opposed to glass paint, is silver nitrate. This actually permeates the glass in a way that glass paints do not. It is yellow in color and stains in when fired at 1,148°F (620°C). The higher it is fired, the more orange and red it becomes. It is available in powder form, and is mixed with water.

Sandblasting

Sandblasting, using a special machine, is a quick and relatively safe method of permanently frosting or matting areas of glass.

One kind of sandblasting machine is much like a vacuum cleaner, with an inner nozzle that blows out grit and an outer nozzle that sucks it up at the same time. Around the head of the nozzle is a skirt in the form of a stiff brush. The nozzle is held close to the glass in the area to be sandblasted, or, for larger areas, passed over the surface of the glass in smooth, horizontal movements. A fine abrasive, such as emery powder, is generally used on glass.

Suitable masking-out materials for sandblasting are "Fablon" and heavy-duty Scotch tape. Scotch tape or masking tape holds out better than Fablon for sandblasting. A double layer of the former is advisable when a more heavy-duty sandblast is required.

Technique Firing glass

The pieces of glass to be fired are placed on metal trays containing a ½in (12mm), even layer of dry plaster powder. This allows the glass to move slightly in the kiln without risk. The trays are preheated in the warming chamber of the kiln at a temperature of at least 1,148°F (620°C). If a number of trays are to be fired at the same time, they should be transferred to the kiln as rapidly, but as carefully, as possible.

Once the kiln has reached the desired temperature, the firing only takes a few minutes. If the temperature is raised to over 1,292°F (700°C), the glass may begin to melt at the edges and the opacity of the paint may

be fired away, but the paint will really begin to look like part of the glass itself.

After firing, the trays are transferred to the annealing (cooling) chamber as quickly as possible. The glass should be allowed to cool for as long as possible, preferably overnight. If it is cooled too rapidly, the thermal shock will cause the glass to crack. This method is suitable for small pieces of glass, but for larger pieces multiuse, speed-burning gas kilns are available that fire up quickly and allow all the painting to be fired together on the bed of the kiln. These kilns are suitable for firing paint and slumping glass (see p.309).

Acid etching glass

As well as painting on glass, images can be created by etching the surface of glass with acid. A hand-made form of glass known as "flash" or "flashed" glass is often used for this technique. This is white or colored glass that has a coating of a different

color on one or both of its sides. It is made by dipping a bubble of molten glass into a crucible containing molten glass of another color. The glass is etched in a solution of hydrofluoric acid to partially or wholly remove the colored surface layer.

Materials The acid

A solution of between 33 and 47 percent hydrofluoric acid in distilled water is generally used in etching glass (the acid is added to the water, not the other way around). With flashed glass, the formation of a colored scum on the surface shows that the acid is biting. The glass can be taken out of the acid, rinsed off, and checked periodically. At the end of the etch, it should be thoroughly washed. Generally, for flash glass, a mix of one part acid to three parts water is appropriate, but a stronger acid mix is required where some colors— green and turquoise, for example— are harder than others. It depends also on where the flash glass has come from. French glass usually carries a relatively thin flash and the 1:3 mix is sufficient. For German glass, however, which has a harder, thicker flash, you may need a 1:1 mix. If the mix is warm, it will bite more rapidly than if it is cold. See p.370 for information on working safely.

Materials Acid resists

In order to define the etched image, areas of the glass must be covered with an acid resist, or "barrier medium," a substance that will not be affected by the action of the acid and that will leave the glass beneath unmarked. There are two main kinds of resist, and these may be used to create a variety of etching effects.

Stencils
Sheets of adhesive-backed plastic sheet (the heavy kind) can be used to make stencils for use on flashed glass. The plastic can be stuck onto the glass that is itself placed over a design that has been drawn in black ink on white paper. This can

be easily read through the glass and the plastic can be cut and removed with a utility knife. Adhesive-backed plastic sticks well to degreased glass and the acid tends not to creep into the design. However, the artist is limited to "hard-edge" shapes.

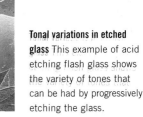

Tonal variations in etched glass This example of acid etching flash glass shows the variety of tones that can be had by progressively etching the glass.

Barrier varnish

Proprietary barrier varnishes can be used on degreased glass to create a wider range of tonal effects than are possible with plastic.

A single stroke made with a stiff bristle brush can be used to make a striated line in the glass that will etch in the areas where the barrier varnish has "missed." It is also possible to stipple on the varnish to produce a more controlled tonal image.

Proprietary barrier varnishes can be somewhat brittle and liable to chip off the glass. Many stained glass artists use waterproofing bitumen paint, which is generally available in the roofing department of hardware stores. This can be thinned down with paint thinner. Proprietary car body underseals in spray cans provide a version of this material that allow the artist to create various stipple effects.

A barrier mixture of one-third beeswax, one-third tallow, and one-third paraffin wax is said to respond well to techniques including fine line work, textures, and stippling.

Many artists find that tallow on its own is oily and sticky enough without the addition of beeswax. The liquid latex paste masking fluids may also be used, but they are not generally so reliable, especially for etches that take a long time to complete.

Silk-screen etching

Another method of using the resist is to put a halftone (dot) screen onto a silk-screen and squeegee the barrier through the mesh onto the glass (see page 260).

Technique Acid etching

The standard method of acid etching is to use an acid resist to retain defined areas of colored glass, as described above. Variations on this technique include using hydrofluoric acid on white glass to produce a subtle etch. If a "frosted" effect is required in the etched areas, then white (ammonia) acid can be used. More straightforward, though, is the sandblasting technique described on p.305.

It is also possible to achieve a washlike gradation of tone from one area of the glass to another by having the acid bath at a slight angle, so that there is more acid at one end, placing the glass plate in the acid with the tongs, and rocking it gently so that acid washes up it intermittently. This should be done through a glass-sided extractor unit, so that only the gloved arm holding the tongs is actually in the cabinet.

1 Here, the glass panel is made with turquoise on clear flash glass. The image is blocked around the background to the flower shape, so that the turquoise dissolves in the acid, leaving the flower shape clear. The clear glass is then stained using silver nitrate and fired to produce the yellow color.

2 The same process has been applied, but to a blue-on-turquoise flash, so when the blue dissolves the flower is left turquoise. Here, there is no yellow stain.

Acid-etched flash glass This work, for a nondenominational prayer room in a children's hospital, balances the large shapes of the flowers with the linear tendrils of the lettering. Two hues of blue predominate—one on the blue side and one on the red side. As if to echo this, panes of yellow are juxtaposed with the blue on that side of the spectrum while the red glass relates to the deeper red/blue. This balance allows the artist to make a work that is rich and strong in color but that also maintains its calm poise.

Technique

Leading up

The pieces of fired glass are pieced together with strips of lead in a process called "leading up."

The cut line is taped to a wooden work bench and a right-angle of wood is nailed to the bench at one corner of the design.

With the use of a curved-blade lead cutter, the lead is then cut into strips of appropriate length and fitted to the edges of the pieces of glass. The corner-piece of the design is packed firmly into the right-angle of wood on the bench. Other pieces of glass are leaded up and the design built up from that corner.

Soldering and cementing

After leading up, the glass must be secured by soldering together the individual strips of lead and cementing them firmly in place. The lead should be cleaned with a wire brush or steel wool before soldering with a gas or thermostatically controlled electric soldering iron. A tallow flux is generally used with blowpipe solder—ordinary plumbing solder will not do.

When one side of the panel has been soldered, it is turned over and the other side is done. It may then be cemented. The cement mix is made from whiting, a little plaster, and linseed oil. Paint thinner can be added if the cement needs to be a little more liquid.

Leading up and soldering The strips of lead are shaped like an "H" when seen in cross section. Different sizes are made to accommodate various widths of glass (left). The joints between the lead strips are soldered together (right).

Securing the leaded glass The mixture should be pushed right around each strip of lead with a scrubbing brush so the whole panel will be solid (top). The excess cement is wiped off, scraped, and cleaned when dry (bottom).

Technique Combining methods

This modern piece of stained glass demonstrates several of the techniques described above. Strong shapes and tonal contrasts in the basic design of the panel allow these techniques to work together harmoniously.

Combining different techniques The designs at the top were painted on acid-etched, blue flash glass. The yellow shading is silver nitrate stain. The water area was masked then etched to leave the fish. Glass paint applied in the blue area was rubbed and scratched for varied tones.

Technique Bonding variations

For artists who do not want to use lead to join pieces of glass together in a panel, there is a move toward new bonding techniques. In this method, the separate pieces of colored glass that go together to form a panel are physically bonded to a sheet of clear, toughened glass. The size of each completed section is limited by weight, and stained glass artists should take advice from specialist glass manufacturers or structural engineers.

The bonding process involves the use of a two-part silicon resin. This resin retains a certain flexibility that allows for expansion and contraction between the glass layers.

The float glass onto which the colored glass is bonded is laid horizontally and a shallow wall is created around the perimeter. This can be made from strips of float glass and plasticine. The wall prevents the liquid resin from dripping off the edges of the glass.

Meanwhile, the top surfaces of the colored pieces of glass are painted with a latex rubber solution and this is allowed to dry. Resin is poured into one corner of the supporting glass sheet and the first piece of colored glass is floated onto the glue. As the glass is pushed down onto the glue, bubbles are forced out at the edges. The next piece of glass is laid onto the panel in the same way and the resin seeps up at the join where the pieces are butted together. This is why the glass panels are protected by the rubber solution, because when the glue has dried the rubber solution is rubbed off the surface of the glass and the dried glue is removed with it, leaving the surface of the colored glass clean. There is an element of risk when this work is

undertaken, since you have to get it right the first time. Consequently, many artists leave the fabrication of their bonded glass works to specialist studios with expertise in major projects.

On a much smaller scale, where an artist might wish to bond very small pieces of glass to a larger panel, the clear silicon that is commonly used for sealing and waterproofing joints can be used. This material is too thick to push out bubbles of trapped air.

Where completely flat surfaces such as float glass to float glass need bonding, another bonding material is available in the form of thin liquid glue. This material cures when subjected to ultraviolet light and creates an invisible bond. It is not suitable for antique glass.

Patrick Heron

Large-scale bonded glass

A series of bold, simple forms in strong, saturated colors creates a powerful effect as you enter the Tate Gallery in St. Ives, England, where this large-scale work in bonded glass is installed. The work plays on the juxtapositions of adjacent color, as between the orange/red shape floating down from top left and the blue/red triangle that rises from the bottom edge. Between these two are the deep red/blue of the background with the contrasting yellow/blue shape between.

Tate Gallery St. Ives Window
(1992–93), PATRICK HERON

Technique Putting stained glass into storm windows

Nowadays, it is common practice for glass artists to create storm windows incorporating the stained glass panels created for a commission in a new building. The energy efficiency standards of the building require the fine art aspect to conform to the standard of the rest of the work in this respect.

It is a relatively simple matter to make a "sandwich," comprising two pieces of clear float or toughened glass (as specified) with the decorative glass panel in the middle. The size of each unit corresponds with that of the panels in the window frames designed for the building.

For each panel, a frame is assembled approximately ¼in (7mm) in from the external edge of the glass panel, using proprietary aluminum, internal glazing bars. This is stuck to the glass with double-sided tape. The decorative glass panel is laid inside the frame, and the top sheet of glass is laid over it and then stuck with double-sided tape. The ¼in (7mm) gap between the internal glazing bars and the edge of the glass panel is filled and sealed with proprietary filler. Now the decorative glass is safely sealed within the storm windows and each unit can be handed over to the glaziers to be incorporated into the window frames.

Technique Slumping (melting) glass

One way of creating a rich variety of textured effects in a slab of clear glass is to make a smooth ⅛in (2–3mm) layer of plaster on the bed of the kiln, to subsequently create a texture in the plaster, and place a piece of, for example, ⅜in (10mm) float glass over it.

The kiln is then fired to 1,472°F+ (800°C+) and allowed to cool very slowly. The glass will take on the form of the texture in the plaster.

Texture effects In this example, a leaf shape created in plaster has been reproduced in the clear glass panel.

Laser/Water-jet Profiling

THE CONTINUING EXPANSION OF TECHNOLOGY in systems and methods of fabrication enables artists to make use of specialist facilities. In the past, an artist who wished to cut complex shapes from flat sheet materials would probably have done so using hand tools. This was time-consuming and labor intensive. Nowadays, the profile would be created digitally on a DXF or IGES file, for example, and the profiling cut by laser or water jet.

Technique

Laser cutting

A powerful laser-profiling machine is not the kind of equipment an artist would have in the studio. It is industrial machinery and it can cut very small-scale, fine tracery work or profiles on a much larger scale. The technique uses "excited" light, created by adding gases such as carbon dioxide, nitrogen, or helium to a beam of laser light. The light is focused and concentrated through a series of mirrors and a lens so that where it emerges through the cutting nozzle, it is as hot as the sun and can cut easily through hard steel. An assist gas is used to blow the molten material away from the cut and keep it clean.

The cutting is done on a flat bed under a canopy with light guards and the whole area is fume extracted. In the last 20 years, the power of laser cutting has increased ten times.

Mild steel up to a thickness of ⅞in (20mm), and stainless steel up to a thickness of ⅝in (15mm) can be cut with a smooth edge and in any kind of intricate shape. MDF can be cut up to a thickness of 30mm (1⅛in), and acrylics and PVCs up to around 1⅛in (30mm). Certain materials, such as polycarbonates or nylon, cannot be cut by laser because they produce toxic fumes. The glues in plywood make it unsuited to laser cutting. Such materials are generally cut by water jet (see below), which is a cold-cutting process.

Laser cutting The powerful laser beam creates a clean, rapid cut.

The cut itself is known as the "kerf." The kerf thickness in laser cutting is around 0.3mm. The kerf thickness can be added to the dimensions of a shape that is set into another one, so the two shapes interlock perfectly with no gap between them.

Technique Water-jet cutting

Water-jet cutting is more expensive than laser cutting, but it can cut hard materials of far greater thickness, such as 3⅛in (8cm) armor plating. It can also cut soft materials like rubber or foam sheeting. It is a cold-cutting process, which does not alter the chemical properties of the material it cuts, so it can safely cut those that would be unsuited to the heat of laser cutting. It can cut to the same tolerances as for laser cutting, although the kerf thickness (or width of the cut) is bigger at 0.8mm.

In water-jet cutting, water is pressurized to around 55,000psi (pounds per square inch). The water travels through a tiny tube from the pressurizing machine to the cutting machine, where it comes through a 0.8mm-diameter hole in a sapphire set into the end of the nozzle. Water comes through this nozzle at a speed of mach 3. Soft materials such as foam or rubber are cut with water alone. For harder materials, such as steel or

Water-jet cutting The "water-knife" slices easily through most materials.

stone, the stream of water is dosed with fine-powdered garnet. This abrasive powder is what does the cutting and the water is simply the vehicle for the abrasive.

A whole range of artistic possibilities is opened up by the use of water-jet cutting. For example, it is particularly suited to the use of hard materials such as glass, marble, and stone. Intricate fretwork imagery can be created in these materials to a substantial thickness. The use of water-jet cutting is also the best means of creating inlaid work for marble-clad walls.

Technique Repetitive elements

Laser or water-jet profiling is particularly appropriate when your artwork involves repetitive elements, as the unit cost goes down the more you have cut.

Preliminary drawing

Laser or water-jet cutting can be made from simple diagrammatic profiles or complex, freehand brush-and-ink drawings. The former can be created directly on the computer using CAD or similar software and the latter can be scanned in and redrawn by copying the profile using a vector graphic system.

The laser-cutting company will be able to nest the image for the most economical use of the sheet material. If you have no access to a computer, the company will probably be able to digitize your drawing. In this case, an accurate, single black line drawing to scale showing the complete profile and appropriate dimensions will be required. As in any cut-out work, you have to ensure the integrity of the structure by making sure that the various elements of the drawing are connected to each other where necessary.

On this and the following page are examples of how you can transfer your artwork for use as wall, window, and floor decoration.

"Cutouts" for walls

In this work, a fluent brush-and-ink drawing of a swift was recreated as a profile, digitized, and laser cut out of polished stainless steel for an artwork on an external wall. In this case, stainless steel rods were welded to the back of the profile to allow the work to be attached a little way forward of the wall. This allowed the profile to cast shadows on the wall in different lights.

1 An original drawing is scaled up in black ink on white paper.

2 It is then accurately reproduced in ⅛in (3mm) laser-cut mild steel with a black polyester powder coat finish.

Finished artwork
The birds have been laser cut in polished stainless steel.

"Cutouts" for windows

Security grilles don't have to be prisonlike bars. Here, a laser-cut metal grille takes the form of a flower. The grille remains functional, but is considerably more attractive than plain steel bars. The vigor of the original drawing is retained in the steelwork and the distinct colors help to mediate the flatness of the steel plate.

Laser-cut metal grille Two-pack polyurethane color gives a durable finish.

"Cutouts" for floors

In this example, school children made rapid charcoal drawings of animals and insects. These drawings were reworked to enable them to function as cutouts.

The new drawings were then digitized and cut out of marble agglomerate slab. The cutouts were cemented into the floor and infilled with terrazzo. The surface was subsequently ground and polished.

1 For this project, the final floor design is based on children's charcoal drawings such as this one.

2 The drawings are simplified, digitized, and laser cut from slabs of marble agglomerate. Above is the final marble cutout before being cemented to the floor (shown below with tail).

Detail of the marble figure cutout

Laser-cut marble floor panel The aerial view of the floor shows the cutouts in place following terrazzo infill, grinding, and polishing. Above is a close-up on a single figure.

Technique Preliminary maquettes and limited editions

Laser profiling can be a useful and relatively inexpensive way of making models or maquettes for proposed artworks, or for making limited editions of an artwork.

Here, a simple sketch drawn in a matter of seconds provides the source material for a downtown sculpture.

The sketch is reworked and recreated in a limited edition as a maquette 27½in (70cm) high in painted laser-cut steel. This enables the client to see almost exactly how the figure will look when it is made 23ft (7m) tall in plasma-cut, 2⅜in (60mm) painted steel plate.

 The original drawing, around 2in (50mm) tall.

2 The laser-cut maquette, around 27½in (70cm) tall.

Finished work The final sculpture stands at 23ft (7m) tall.

Vinyl and Linoleum

ARTISTS ARE ALWAYS ON THE LOOK OUT FOR new materials and techniques, because these may point a way forward for their own work. Most new materials are naturally developed for commercial purposes, but they can extend the range of possibilities for artists.

Among the materials that have become popular with artists in recent years is vinyl, which has now almost universally replaced handpainted text and images for commercial vehicles and for other signs.

It was only a matter of time before artists incorporated this into their repertoire of techniques, and a number of artists have produced substantial bodies of work with this material. Among them is Julian Opie, whose drawn and computer-generated diagrammatic portraits and still-life images are created in vinyl on aluminum or on wooden stretchers.

Opie celebrates the physical realization of a computer image that is unique to vinyl: "Vinyl gives a completely flat, even color that translates the look of a computer screen into reality. I first used it in a light box, but found that the unlit vinyl is more even and beautiful. Although it has been around for a while it has a completely super-modern quality that allows me to get away with using quite traditional images."

Still Life (2000), JULIAN OPIE
The combination of the scale of this work—almost 12ft (4m) in length—in the gallery, with the perfect computer-cut line of the vinyl and its unique surface quality, makes a traditional still-life painting into something completely new. It is as if still-life painting has been given a spring clean. The work is like a billboard with a powerful, inescapable, yet encrypted message.

Tools and techniques

At the simplest level, all you need in order to work with this material is some colored, self-adhesive vinyl film, a clean surface on which to apply it, some backing film, and a pair of scissors. For more complex work, you can use a computer to control the design and the cutting.

Materials Adhesive-backed vinyl film

In the past, signwriters painstakingly drew up and painted text and images after a long apprenticeship, but now artwork is drawn up in vector form on a computer and the images and lettering are cut by plotters out of colored, adhesive-backed vinyl. This is easy to apply and is available with guarantees as to its lightfastness and durability. For artworks, use a good-quality cast vinyl, rather than the cheaper polymeric vinyl. The latter is calendered through rollers and will always try to get back to its sheet state, whereas the former is floated out onto glass plate in the manufacturing, which means it has no memory and is more stable however it is positioned.

Technique Using vinyl

If the vinyl has been cut commercially, it will come sandwiched between a top sheet (through which you can read it the right-side-up) and the backing sheet. The backing sheet is removed before the vinyl is positioned. The vinyl can be wet-applied to appropriate substrates. You put a drop of enzyme-free, dish detergent or baby shampoo into a spray bottle of water and spray the surface on which you plan to stick the vinyl. This allows for repositioning and makes it easier to squeegee out trapped air bubbles. When you squeegee out the water and air bubbles, work from the center out. Having done this, allow another 15 minutes before you unpeel the carrier sheet.

The vinyl can also be dry-applied where a substrate cannot take water or when a job has to be done rapidly. The only drawback to the dry application method is that you only have one chance to get it into the right position and it is harder to get rid of all the air bubbles.

Technique Cutting and applying by hand

The vinyl may be "computer" cut by knife plotter as mentioned above, or it can be cut and applied by hand. The cutting can be done with a utility knife or with scissors. The safe scissors that school children use are perfectly good for cutting vinyl film. The process is straightforward. The first stage is to cut the shapes required for the image from the colored vinyl film. At this stage, the backing paper is left on the film. The shapes are then arranged in position and a sheet of low-tack carrier film is placed over them. This holds the shapes in the correct position and the backing paper is then pulled off.

The sheet of low-tack film with the colored vinyl shapes on it is lowered onto the substrate and rubbed down. The low-tack film is pulled off, leaving the colored vinyl shapes sticking firmly to the substrate.

1 The children make self-portraits out of different shapes in vinyl film. After cutting out the shapes, each child builds up the image on a banner.

2 The freshness and immediacy of each of the children's work is maintained in the bright colors and clear shapes associated with this material work.

Finished project The banners are installed from one side of the street to the other.

Technique
Cutouts with vinyl colors

In this work, created in collaboration with children for a children's hospital, I recreated and scaled up a number of small drawings in the computer. The images were lasercut in MDF. These were then black-lacquered and the colors applied in self-adhesive vinyl. This gives the work a particular clarity and freshness.

Cutouts The matte vinyl colors work well against the glossy black-lacquered shapes.

Technique Creating images in vinyl and linoleum flooring

The development of heavy-duty vinyl flooring and specialist aqua-jet cutting has meant that artists can now create complex images in the vinyl flooring itself. This can also be done in linoleum. If this aspect of a scheme is properly and professionally cut and laid, it will be as durable as the rest of the flooring.

There are two limitations to this work. First, the palette is restricted to the colors in a manufacturer's range. In fact, the color range is usually sufficiently varied to encompass most ideas (although in this work for the Bristol Royal Children's Hospital we were able to persuade the vinyl manufacturer to create four new colors for the scheme).

Secondly, the design has to be created so that it can be cut, like jigsaw pieces, in flat, interlocking shapes of the selected colors. The manufacturer will need to create the computer program that instructs the cutting machine and will generally be content with a digitally created or a hand-drawn line drawing from the artist. The scale will need to be correct and the more accurate the line, the better the resulting image will be. The manufacturer will make a copy of the original drawing and the artist should check it and make sure that modifications are made if necessary. Once this has been done, the manufacturer will cut and supply the material to the company who has been instructed to lay it.

Red level The leaves act as "stepping stones" in the lobby of the children's hospital.

Yellow level A ribbed sand effect is created in the vinyl floor with starfish and their shadows.

Geometric designs
Simple triangles in lighter or darker tones were used to produce this illusionistic design. The figures in the floor can just be seen echoed in the design around the desk at the top of the picture.

Technique Subtle links

Vinyl can be used in very subtle ways. Here, for example, vinyl cut with a wave-form pattern has been used to soften the junction between the floor and the wall along the length of the hospital corridor. The design breaks down the angular geometry normally found in this setting and gives a more rounded feel to the space. (For this to work successfully, it needs to be installed by skilled craftsmen.)

Flowing lines
The wave-form vinyl appears to flow along the corridor.

Mosaic

THE MOSAIC TRADITION COULD BE SAID TO stretch back to the third millennium B.C. and decorative terracotta cladding in Sumerian architecture. But the earliest examples of the technique that we would probably recognize as mosaic are in floor decorations made from pebbles of different colors. There are examples of these from the eighth century B.C. in Turkey that show geometric patterning. Possibly, the most striking early examples are the fifth-century B.C. Macedonian mosaics in Olynthos. These are made from river pebbles and they show mythological scenes surrounded by intricate geometric patterning. The sophisticated and yet rugged combination of material and design is particularly effective.

By the late fourth century B.C., floor mosaics had moved on from river pebbles in terms of the variety of materials used and the nature of the design. At Pella, the capital of Macedonia, there are works of great beauty and elegant sophistication that incorporate materials such as glass tesserae and semiprecious stones.

The Romans explored and expanded the mosaic technique in floors and wall panels of great diversity in both design and purpose and ranging from the functional, including decorative, monochromatic floor mosaics in black and white, to more complex polychromatic, mythological, and religious works around the fourth century A.D.

This period is the beginning of a Byzantine mosaic tradition that gives visual expression to the Christian faith over the next millennium. The technique was extended and further expanded in works that completely covered interior walls in cathedrals such as the great domed basilica of the Hagia Sophia in Istanbul. The influence of Byzantine mosaic decoration can also be seen in the sumptuous gilded mosaic interior of the Basilica of Saint Mark in Venice.

Doves at a drinking bowl *(fifth century A.D.)*
This fifth-century mosaic from the Mausoleum of Galla Placidia in Ravenna, is a reference to an earlier work by a famous mosaicist called Soros, who created extraordinary trompe l'oeil mosaics in Pergamum during the second century B.C.

Materials and techniques

The nature of the mosaic is such that an artwork is generally created with patient care and attention in small sections over a long period of time. There is something ultimately satisfying about the realization of a work in the most permanent of materials that will outlast work in almost any other medium.

Materials Basic materials for mosaic

Mosaics can be made in a range of materials from vitreous glass or ceramic tesserae in standard sizes, to ceramic, marble, or smalti glass in variable or freely cut sizes. Some materials, including colored stones and pebbles, can be used directly in their natural state to make mosaic images.

Vitreous (glass) mosaic
This is the standard mural material. It comes in an extremely wide range of colors and these can be deep and lustrous. There are tesserae that are beautifully striated with metallic ores or have gold leaf sandwiched within them. The glass has a flat surface and a ridged back. The size of tesserae can vary, but the standard size of a single tessera for artistic panels is around ⅞ x ⅞in (20 x 20mm) (depending on the manufacturer) and ⅙in (4mm) thick. It used to be available loose in boxes or bags, but nowadays, it comes pasted to paper in 12½ x 12½in (315 x 315mm) sheets.

Vitreous glass tesserae These come in a wide range of colors.

Marble
Another main material for mosaic, marble can be supplied with various surfaces from polished, which is flat and glossy, to riven, which is matte and textured. It is often combined with smalti (see right).

Unglazed ceramic
This is flat, opaque, and the easiest mosaic material to cut. It is the material of choice when the cut is important to the design. If you want to create a rhythm in the cut, you can see it much better in the finished work in ceramic mosaic than you would in vitreous mosaic, where the reflective surface tends to conceal the grout line. The mattness of the ceramic mosaic shows the patterning in the cut. This material is better underfoot and is often used for exterior paving work. Ceramic and vitreous mosaic are often combined in the same work since they are a common size.

Ceramic panel
Unglazed ceramic mosaics have a characteristically restrained, "low-key" quality, which can make them very attractive.

Smalti
Thicker than the vitreous tesserae (left), smalti is a glass material that is nonuniform in size. It is generally inset into cement without being grouted. It comes handmade in large, thick, circular plates, which can be supplied in cut form from the factory at a certain size. The artist can consequently cut the pieces more according to the chosen design.

Smalti Boxes of precut smalti show their characteristic glossy opacity.

Technique The process of making a mosaic

There are two principal methods of making mosaics: the direct and the indirect method. In the direct method, the mosaic pieces are stuck directly onto the substrate. In the indirect method, the mosaic pieces are glued face-down onto sheets of paper and subsequently attached to a rendered or screeded surface. The paper is then washed off. The indirect method is the most common professional method.

The direct method

This method is suitable for small, portable panels, in which a material such as marine plywood is used as a baseboard and mosaic tiles are stuck to it with proprietary adhesive. It would also be possible to use a stone substrate that can be set into the ground, for example, along with others, to make up a complete work.

The indirect method

If you are making a mosaic according to a regular grid pattern, known as Opus Regulatum, it is customary to use a jig. This allows you to make one large square of the mosaic design at a time. A jig is effectively a compartmentalized plastic tray around 12½in (315mm) square into which the individual mosaic pieces are placed. When the jig is full, a sheet of strong brown paper is stuck to the surface of the tesserae. When the glue is dry, the paper with the tiles attached is lifted off the jig and the tiles are ready to be stuck to the wall or floor.

Manufacturers now supply vitreous mosaic glued to sheets of paper and it is becoming increasingly difficult to get hold of jigs. For Opus Regulatum, the tesserae manufacturers often prepare and supply the mosaic mural to the artist's design.

If you are making a mosaic using irregularly shaped tesserae as in Opus Vermiculatum, where the contours of the image are defined by (wormlike) rows of tiles, or Opus Palladianum, where all the tesserae might be irregularly shaped, you will need to draw out the design on kraft paper. This is strong brown paper that can hold a good weight of mosaic without breaking. The image is then constructed by cutting and pasting the mosaic onto the paper, face-down, using water-soluble PVA. The paper with the mosaic is cut into manageable sections along the line of a contour. These sections are later fixed to the wall or floor.

1 The mosaic is assembled in small sections. The lines of the design are drawn onto the kraft paper as a guide to the image and the artist builds up the mosaic by cutting and gluing each small piece of glass onto the paper.

2 This is one small section of a much larger work, but the movement in the work is already evident in the fluid lines of the background and in the positions of the heads and beaks of the oystercatchers.

Technique Fixing the mosaic

Before fixing, it is important to have made a key drawing, like a jigsaw, which shows where each of your irregularly shaped pieces of mosaic panel will go. The mosaic is applied from the top of the panel down. This is to make sure that each section of the mosaic is self-supporting, that the adhesive is stiff enough, and that there are no air pockets. First of all, the top section of mosaic (if it is vitreous glass or ceramic) is pregrouted from the back. Grout is rubbed into the interstices between the tesserae and then the back is cleaned off with a sponge, so there is no grout on the back of the mosaic. A proprietary adhesive such as Ardurit 5000 or X7 is troweled onto the rendered wall using a ⅛in (3mm) notched trowel, and the top section of the panel is placed onto the adhesive. The section is then tapped repeatedly with a flat bed squeegee or rubber trowel to ensure a good bond. The next stage is to wet the paper and leave it to absorb the moisture for around 10 minutes before peeling it off. The process is repeated for each section of the mosaic panel. When the adhesive is dry, the surface of the mosaic is cleaned and the whole panel is subsequently grouted.

For a mosaic in smalti, a thicker adhesive mix is applied to the wall because the smalti is not grouted.

Emma Biggs

Mosaic panel
The artist has described her mosaic in vitreous glass as an experiment in tone and the intensity of color. It was influenced by tapestries from the Bauhaus and explores the subdivision of spaces, juxtaposing balance with surprises. The central horizontals in yellow and white beam out between the more solid verticals on each side. The movement in tone and color of the verticals at each end of the panel bends the rectangular shapes into three-dimensional space. The effect is to play on the contrast between surface and internal space in the work.

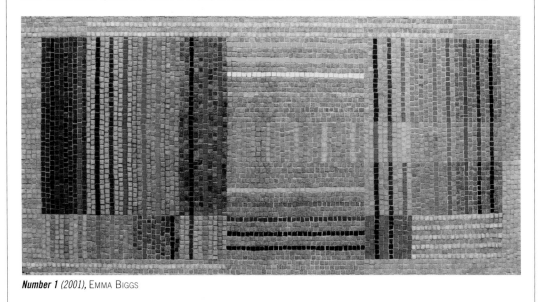

Number 1 (2001), EMMA BIGGS

Technique Using natural stone

A mosaic work is not limited to work with glass or ceramic tesserae. A number of artists make mosaic using natural stone. In this example, I used the dark "interior" surface of knapped flints to define the bird shapes on an external wall, while paler Scottish beach cobblestones were used for the spaces in between. The arc of each bird's wing was used as a guide to the layout of the cobblestones. In order to get the stones in the correct place on the wall, the original artwork was photographed in slide form and projected onto the wall at night. The image was drawn out in paint as a guide for the stonemason.

Using flint and cobblestones
Stones of contrasting kind and color allow the images to be read across the wall.

Planting

THE EXPANSION OF ART PRACTICE FROM THE EASEL and the studio and out into a wider domain can be seen in exterior work using natural materials in the cityscape or in the landscape. For many artists, the ideas that apply to small-scale work in one context can be translated into ideas that work in different materials and on a larger scale in a very different context. The planting project, for example, could simply be seen as painting with flowers. This may simply be a question of recognizing an opportunity or a way of working with new materials, but it can move an artist forward creatively, renewing the work and keeping it fresh.

David Nash

Ash Dome *(1977)*, DAVID NASH

David Nash's "Ash Dome" was planted in March, 1977 on his own land at Cae'n-y-Coed (the field in the trees) in North Wales, in the UK. The work has been evolving over the last quarter of a century. The original concept was clear and simple: to plant 22 ash trees in a circle, then to cut and bend them over at five-year intervals until they created a dome space. The artist originally made drawings of how the artwork might look when a dome had been achieved. The drawings are prescient works in themselves and yet what is particularly satisfying about the Ash Dome is how nature has added its own richness and depth to the concept as the work has become powerfully tangible.

Early Days The beginning of the project shows the young trees in 1980 having been planted and secured to stakes at the chosen site.

Mature Work Twenty years later, the maturing work shows the trees after fletching, a process in which they are cut and bent and allowed to grow in a particular direction.

Winter The seasonal effect of the work is such that there are striking variations throughout the year. The branches have a crisp clarity in the snow.

Drawings The work is the source of numerous drawings in which the artist can explore the process and the effect of his work. Each has its own mood and atmosphere.

Project Fall leaves planting

For this project, I was invited to make a planting work on a series of roundabouts and other sites. There were opportunities to look down on the sites from the windows of office buildings and the scheme was temporary, for one season of summer bedding plants.

In situations like this, a single informing idea can enable you to carry a major work through all its many stages without finding at the end of it that the result is completely different from what you expected. Holding onto the idea in this way seems to give the resulting work a clarity or strength.

Here, the object was that by looking down onto the roundabouts, you would see one large fall leaf on each, and each leaf would be different. An essential feature of the idea was that you would also see the leaf's shadow. This would give a crucial sense of illusion or dimensionality to the leaf, and so it was not just a flat pattern on the ground but somehow a real object.

1 The preliminary outline is drawn on a grid, each square of which represents a square yard of site.

2 The gardeners need to plant the flowers in specific areas. So, the artwork must outline shapes representing only the colors that can be achieved with plants.

3 The leaf shape is cut into the ground and created as a large, empty flowerbed. A new system is used to draw out the shapes for the different-colored plants. A plastic watering can with a modified spout allows fine, dry sand to be the medium for drawing on the soil.

4 The gardeners use the sand outlines as a guide to planting. The flowers are planted closely together so that the different areas of color are clearly defined.

Finished works Each leaf is remarkably close to the original design. The original concept has worked, but it has been enriched and transformed by the scale and by the natural materials. There is something satisfying about the fact that it is only a temporary work and that before the fall the leaves will fade and disappear.

Light and Lighting

IN RECENT YEARS, THE WIDENING SCOPE OF FINE art practice has led artists to work in ways that they might not previously have considered or that might not have been available. One such area is the development of the use of light as a medium for art. Among those who use natural light is James Turrell, who has made installations that open up the roof of a gallery or alternative space to a rectangle of sky. This kind of work can only be experienced firsthand but, like all good art, it has the extraordinary effect of enabling participants to feel they are experiencing a part of the world for the very first time. Where artificial light is concerned, there are a number of lighting technologies that are available to artists, including fluorescent light, taken up as an art medium in the 1960s by Dan Flavin, neon tubing, celebrated in work by Bruce Nauman, video projection, and the recent fiber-optic technology that offers new scope for lighting artworks.

"monument" for
V. Tatlin (1969),
DAN FLAVIN

Installations in the urban environment

Artists have increasingly found scope for lighting artworks within the built environment. These can range from the subtle transformation of the architecture of a building at night using artificial illumination of various kinds, to video or film projection on the sides of buildings or within them. There are powerful light sources available, including 5kw xenon projectors that can project 7in (18cm) square transparencies for temporary works, creating a 32½yd (30m) image size at night.

Esther Rolinson

Video projection
A temporary video installation from the British Council UK Day, Berlin, in June 2002. Over a 6-minute period, digitally manipulated video reveals an abstract passage through the thin skin of the building, traveling through layers of corrugated steel, undulating mesh, framework, dust, and billowing air.

Supple Solid (2002),
ESTHER ROLINSON

Technique Metal-halide light

Metal-halide lighting combines a high light output with a long bulb life. It is extensively used in all kinds of exterior lighting, where it gives a cooler hue than that obtained with orange/yellow sodium lamps. It also provides bulbs for projectors of many kinds, including those used for fiber-optic lighting (see p.326). The work below was commissioned as a temporary artwork, but several years after installation it is still fully-functioning.

Inside Out
In this nighttime lighting sculpture, around 30 powerful metal-halide floodlights have been installed under a seaside pier to reveal, from close-up, a vast concrete and steel structure stained by seaweed greens and iron oxide browns and ochers. The lighting creates a unique atmosphere that changes with the mood of the sea as it slaps or roars against the concrete. Viewed from the distant cliff top, the metal-halide light creates a cool, bluish phosphorescent glow. A work of this kind has to conform to the strictest health and safety requirements.

Technique Fiber optics

The development of fiber-optic technology has provided artists with a new medium for lighting artworks. The technology is really very straightforward but there are many ways of using it.

The principle of fiber-optic lighting is simply the transmission of light, by means of a projector incorporating a light source, along a fiber-optic cable. The cable, which varies in width, can be solid or is made up of a bundle of smaller translucent/transparent plastic fibers within a clear sheath. This is known as side glow or side-emitting cable because it glows along its length. The side-glow cable can be used to "draw"

lines of light of varying complexity in almost any internal or external situation, including under water. As long as the light source is kept protected, the cable itself, which is simply inert plastic, can go anywhere.

The stronger light that glows at the end of the cable is known as end glow or end-emitting, and some fiber-optic cables are used exclusively for end-glow effects, so there is an opaque, black plastic sheath surrounding the fibers in these cables. End-glow cable can be used to illuminate areas where it would be difficult to install the electricity supply required for conventional spotlights.

Projector with fiber-optic cables: clear filter

Projector with fiber-optic cables: green filter

Projector with fiber-optic cables: pink filter

Making Waves
In this large-scale fiber-optic lighting sculpture, there are 22 spans showing a series of wave forms through four main streets in a seaside town in Devon, England.

Each set of waves comprises three ⅝in (16mm) side-glow fiber-optic cables attached to a fine stainless steel catenary structure above the road. These cables are lit by two wall-mounted projectors, one on each side of the street. Each projector has a rotating four-color wheel, so that the

span can have up to eight separate colors pulsing in a spiral through the fiber-optic cable. The color changes are nonsynchronous, but in each span, they gently shift and modulate in adjacent harmonies as the spans move broadly through the spectrum along the length of the street.

The slow pulse of the color change through the wave gives an echo of the movement of the ocean beside the town, but the waves also refer to the wavelengths of colors within light itself.

CONSERVATION AND FRAMING

ARTISTS CAN LEARN MUCH from the work carried out in the conservation departments of major museums and galleries. This includes finding out how paint can be built up in particular layers, or how certain colors can be mixed, in order to achieve a desired effect. Also, by seeing the damaging effects of unsound painting practices in the past, we can learn how to avoid them today.

Suzanna Beckford *(1756)*, SIR JOSHUA REYNOLDS

This ornate frame is not strictly contemporary with the portrait, but it works magnificently, particularly when seen as one of a pair with Reynold's portrait of Suzanna Beckford's husband. It does so because the portrait itself is a strong, sumptuous image, which is in no way intimidated by the molding. Suzanna Beckford's pose is upright and proud, and her perfectly fitting dress sparkles off the canvas. In addition, the dark background creates space around the figure, allowing her to be seen with clarity. Reynolds used some experimental techniques and impermanent materials in his paintings, including the use of nondrying bitumen, and unfortunately many of his paintings have suffered as a result.

Conservation

Research in the area of conservation has identified the various ways in which paintings deteriorate and many of the reasons why this deterioration occurs. Picture restorers now have increasingly efficient methods of reducing or even eliminating many of the harmful effects brought about by the aging process. These findings also provide artists with a great deal of practical information about sound working methods, indicating the techniques and materials that should be employed—and those that should be avoided—if the durability of the artist's work is to be ensured. In this section, some simple techniques are described, such as using saliva on cotton balls to clean oil paintings, or preventative measures, such as using a backboard to protect the back of paintings. You do not need to be trained in conservation or restoration to do these things. However, the more specialist techniques described here should be left to the experts.

Factors that affect deterioration

Paintings deteriorate in two main ways: the painting materials themselves can change—so that pigments may discolor or varnishes may yellow; and the structure of the painting itself may change—that is, the layers that are bonded together become weaker due to differential movements or stresses contained within the layers. Several factors are involved.

Light

The most obvious cause of discoloration and fading in pigments and varnish is the action of light. The more light to which the painting is exposed, the greater the adverse effect. In strong sunlight, the effects are greatly accelerated because of the presence of the ultraviolet (UV) element. Artists are therefore encouraged to hang and store paintings in areas where the light is shaded. This is particularly important for works on paper in a medium such as watercolor. These are more vulnerable because the pigments are not surrounded by a protective medium and because paper itself is relatively unstable, particularly as an exposed support.

In museums, ultraviolet filters are employed to eliminate UV light and light levels at the picture surface are strictly controlled.

Landscape with Sportsmen and Game (detail)
(1665), Adam Pynacker
This detail is a dramatic example of the effect of light on a painting. Originally, the leaves in the foreground were green, but the artist has used a fugitive yellow pigment in combination with the blue to make the green. The yellow has faded over time, so that just the blue remains visible now.

Relative humidity

The biggest factor contributing to changes in stress in a painting is relative humidity (RH), which is the percentage of moisture present in the atmosphere. The drier the conditions, the bigger the stress in the paint and ground layers (for the effect of this on the size layer see *Supports*, p.43, and *Grounds*, p.58).

The worst conditions occur in the winter, when cold air from outside is brought in and heated up by dry forms of (central) heating. These can reduce the RH to levels as low as 30 percent, and this creates huge stresses in paintings.

In museums, a range of humidity of between 50 and 60 percent is adequate for the painting to remain stable. In practice, this means that artists and their patrons should use humidifiers to maintain their work in prime condition. The inexpensive "ultrasonic humidifiers" are very efficient and suitable for this purpose.

In very humid climates, damp can be a major problem, but in temperate climates, it can be overestimated, since paintings prefer slightly damp over dry conditions.

Heat

Allied to the effect of light is that of heat. If a painting is hung in direct sunlight, it will get very hot—especially under glass, where temperatures of 104–122°F (40–50°C) can be reached on the surface of the painting. This accelerates the oxidation reactions within the paint and varnish and also within the cellulose fibers of canvas supports, causing considerably faster physical degradation of the painting. Therefore, the colder it is, the slower the rate of deterioration will be. In practice, however, paintings cannot be enjoyed at uncomfortably low temperatures (museums generally keep the temperatures of their galleries at around 68°F/20°C).

The structure of a painting

Whether paintings are made on wooden panel or on canvas, the structure of the paint layers is broadly similar. The support has one or more ground layers on which there may be a preliminary drawing, followed by a number of paint layers, and a layer of varnish.

Varnish

Paint layers

Drawing

Ground layers

Canvas

Wood

Canvas

Panel

Problems with paintings on wooden panels

The main problems associated with traditional wooden panels are warping, splitting, and flaking paint.

Warping can be the result of a differential of expansion between the back and front surfaces of the panel. The front is sealed by the paint layers but the back is more susceptible to gaining and losing moisture. This unequal swelling and contracting compresses the wood cells on the back and causes the panel to warp. It is more sensible to leave a panel with a slight warp than to attempt to constrain it, as happened in the past when the wooden cradling or battening designed to prevent the panel from warping only succeeded in compounding the

damage to the paint surface. A cushioned backboard may sometimes be used to help support the panel and protect the back. Where an old panel has dried out and warped considerably, it is stabilized under controlled humidity in a humidity chamber.

When preparing a wooden panel, the artist can help maintain its dimensional stability by applying a similar ground to the back and edges of the panel as applied on the front. Splits and breaks are glued together.

Museum conservation departments have panel-joining tables that allow them to align the joins with complete accuracy, applying pressure both horizontally and vertically.

Consolidation of cracking or flaking paint

Loose-flaking paint known as "cleavage" is consolidated by the introduction of weak adhesives between the paint and the ground and the use of warm spatulas to press down the flaking area.

The main factors to be taken into account when establishing the kind and use of adhesives are:
- How easily the material will penetrate into the crack
- How much deformation needs to be corrected
- Whether the surface of the paint is going to be affected

by the carrier of the adhesives—some paints, for instance, are blanched by water or affected by solvents. Broadly, the paint needs to be re-adhered and made flat without changing the surface in any way. Weak gelatine solutions have traditionally been used where an aqueous adhesive helps to flatten the paint or soften the ground. Wax has also been used because it flows well beneath the surface of the paint. Otherwise, the newer synthetic resins in solvent or the acrylic dispersion adhesives have added further possibilities.

Problems with paintings on canvas

Paintings on canvas exhibit a tendency to structural collapse considerably more rapidly than those on panels. Canvas is vulnerable to changes in humidity and to impact. The stress on the canvas at the edge of the stretcher bar and on the tacks, which may also rust, often results in the face of the painting detaching from the frame.

The strain imposed by stretching is not limited to the tacking edge, but affects the whole canvas. The deterioration caused by years of tension can cause serious puckering over the surface of the work. The fibers of a traditional canvas made

before the 1800s might be degraded by oxidation, but the fabric will often be relatively stable. However, the machinemade canvases of the 1800s are so much more tightly woven and with a thick glue size layer that any humidity can make them shrink, causing the paint layers to detach from the support.

Relatively minor damage, such as bulges and even small holes in the canvas, can usually be dealt with reasonably successfully by the artist. More serious damage that results from the aging process can only be rectified by highly trained restorers using specialized equipment and techniques.

Repairing small holes

Occasionally, a new painting might suffer structural damage such as a hole being torn in the canvas. Although artists might be best advised to leave such a major repair to a trained conservator, most would probably attempt a repair themselves.

In this case, the canvas should be prepared by moistening the back of the wounded area slightly and flattening it using weights. This allows the damage to be assessed more easily and any wounded areas to be brought together. Any loose threads or frayed edges of canvas should be cut off neatly. The procedure is to cut a patch of canvas larger than the area of the hole. Feather the edges of the patch to assist its invisibility when seen from the front. Attach the patch to the back of the canvas using BEVA adhesive. This adhesive is available as a thick, viscous liquid or in film form.

If a hole is evident from the front, it must be filled to the level of the rest of the canvas with a proprietary, fine-surface filler paste incorporating PVA, which gives flexibility. This can be sculptured to the texture of the surrounding canvas and primed and painted by the artist to match the rest of the work.

Removal of surface deformation

It may sometimes be necessary to remove depressions in the paint film (known as "cupping") or other dents, which can occur when a large canvas has been stacked next to a smaller one that has pushed against it.

Artists tend to sponge water onto the back of the canvas in the area affected. This has the effect of shrinking it and pulling out the bulge. However, modern canvases woven on power looms have a very tight weave and are therefore prone to shrinkage, so too much water on the back of the canvas will shrink it to the point where, ultimately, the ground will begin to flake off. The answer is to use moisture as sparingly as possible. The canvas may be dabbed with a moist "squeezed-out" sponge only.

It may be helpful to place a book under the horizontal

canvas up to its surface level where the bulge has been treated and put another book on top to help flatten the bulge. Before you do this, however, protect the surface of the painting by laying a sheet of clear film.

A low pressure lining table (see also *Lining* opposite) is a metal table with small regular holes drilled in it through which air is sucked, creating a low vacuum. This is commonly used by professional restorers to relax and flatten canvases that have become deformed.

Using a backboard

Attaching a backboard of thin plywood or acid-free poster-board is a simple and effective way of providing additional protection to a painting on canvas (see p.57). It is a physical barrier to the blows and water spillages that canvases seem

prone to, and to the accumulation of dirt, which greatly accelerates the degradation of the canvas. In addition, it creates a barrier in terms of moisture changes, which greatly reduces their harmful effects on the paint film. A backboard therefore prevents the need for major repairs, as well as keeping the picture clean.

Before attaching a backboard, it may be necessary to clean the back of the painting by blowing off dust with compressed air or vacuuming it off with a soft, clean brush on the end of a vacuum cleaner nozzle.

Technique Repairing the paint film

The lining table is helpful when consolidating loose or flaking paint layers on a canvas. The process is just as described for panels opposite (see *Consolidation of cracking or flaking paint*).

Repairing Van Gogh's Wheat Fields Small amounts of refined sturgeon's glue were used to stabilize the detaching paint from Van Gogh's *A Wheat Field, with Cyprusses*, seen here on the low pressure lining table providing suction, humidity, and warmth during the process.

Lining

The most common treatment for a very degraded and weakened canvas is full or partial lining. This involves sticking it to a new piece of stretched fabric that takes over the strain that the old canvas can no longer sustain. Relining is a similar process, but here an old lining is removed before a new one is attached.

Traditional lining methods

Traditional methods of lining have attempted to deal with the following three problems in the same operation:

- The replacing of a weak support with a new one
- The removal of unwanted surface deformation on the painting. This may be in the form of open cracking and/or cupped paint (the depressions that may occur inside a network of cracks)
- The general consolidation of the layers that make up the structure of the work.

Glue/flour or wax/resin mixes, traditionally used for these operations, are no longer recommended, and the current philosophy is to deal with these problems separately if possible.

Modern lining methods

More recent lining techniques have concentrated on refining the individual aspects of the process. The problems of cleavage and cupping are, to a greater or lesser extent, dealt with before lining as described above. Whereas formerly, the whole canvas might have been relined, now, since a weak canvas may only be weak around the edges where there is stress at the edge of the stretcher bar, only the edges are strengthened. This is known as "striplining" and it does not involve any major treatment to the center of the painting.

The lining itself is carried out with synthetic adhesives that will not impregnate the support but merely establish a "nap-bond" between the lining and the back of the original canvas. The most common modern method is described below.

Lining with heat-seal adhesives This method uses an ethylene vinyl acetate copolymer adhesive—incorporating microcrystalline waxes, such as BEVA 371. A lining that uses such an adhesive requires heat and is normally applied on a flat, heated metal surface known as a hot table.

The painting is prestretched, as is the lining material, which may be the traditional linen, a glass fabric, or polyester sailcloth. The BEVA adhesive is available as a thin, uniform film that can be peeled away from its backing sheet and placed between the back of the painting and the lining material. The hot table activates the adhesive and a vacuum pressure brings the surfaces together.

In the early years of the process, too much pressure was used, resulting in paintings with a corrugated texture. Since this was first noticed, the pressures have been considerably reduced.

Relining

The front surface of the painting is faced with tissue paper and glue to protect it. In the case of relining (where the old degraded lining has to be taken off the back of the canvas), this facing is essential for its cushioning protection. It also holds the paint in the correct place on the painting in the event of it delaminating.

An old lining is removed by being pulled off by hand in narrow strips. All traces of the old glue are removed from the back of the old canvas, either by very careful washing with warm water or by scraping with a utility knife.

Cleaning and restoration

The cleaning of a painting is a progressive process. In its simplest form, it concerns the removal of surface dirt from the painting. It also involves the removal of varnishes that have disused over time, and the removal of repainted areas by previous restorers.

The judicious use of distilled water or saliva on white cotton balls is normally the best method for removing surface dirt. The cleaning medium should be applied with small balls on small areas at a time, so it is possible to look at the ball and see if color as well as dirt is coming off. If this is the case, the cleaning should be stopped. Great care should be taken not to put contaminated balls in the mouth. They should be disposed of and not reused.

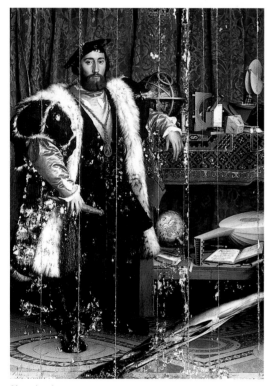

After cleaning A detail from *The Ambassadors* by HANS HOLBEIN THE YOUNGER, shows where the paint has become detached along the lines where the planks that make up the panel abut.

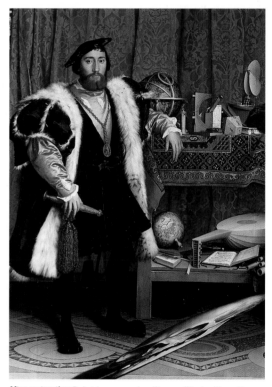

After restoration Paint losses and splits are filled with putty and subsequently given a coat of dammar varnish before being deceptively retouched using Paraloid B72 with powder pigments. All this work is reversible.

Cleaning oil paintings

For oil painting, cotton balls dampened with saliva will remove a great deal of the accumulated dirt. Paint thinner may also have to be used in very small quantities where the dirt is greasy, being careful not to dissolve the varnish. This can be a problem on a relatively recently completed painting, but an older work that has been coated in dammar or mastic varnish will be unaffected by the paint thinner. In any case, the swab should be only slightly dampened in paint thinner and tried out on the perimeter of the painting first.

Cleaning egg tempera and encaustic paintings

When it has hardened, an egg tempera film is very stable and very resistant to dirt. It is also one of the most permanent of all paint films. The encaustic paint film may be more attractive to dirt if beeswax alone—with its relatively low softening point—is used, and less susceptible if a harder wax such as carnauba wax has been incorporated to raise the melting point. Both egg tempera and encaustic can be rubbed with slightly damp cotton balls and buffed up with a piece of silk.

Cleaning acrylic paintings

An acrylic paint film from acrylic dispersion paints is relatively soft, which makes it very attractive to dirt. The reason for this softness is that, when the water has evaporated off, small droplets of polymer are left that need to be soft to coalesce and enable a film to be formed. In effect, the convenience of water as a diluent is therefore balanced by the softness of the resin that attracts dirt. The best way of dealing with this is to frame the painting behind glass. The problem of varnishing acrylic paintings is discussed under *Varnishing*, p.334.

Conservation cleaning techniques

The use of saliva or distilled water on cotton balls, and of solvents to remove surface grease has already been discussed. For conservators, however, the cleaning process invariably involves removing layers of old yellow varnish. This is felt to be necessary to reveal, in their original splendor, the colors the artist actually used and intended to be seen. In some cases, the colors have faded or changed in time, while other (more permanent) pigments on the same painting have remained relatively unchanged.

Such changes are difficult to quantify, and conservators vary in their approach to the problem of varnish removal. The conservators at the National Gallery in London, for example, prefer to remove all the varnish and any later acretions of paint down to the original paint film, while those at the Louvre in Paris try to leave a thin layer of the original varnish over the whole surface of the painting.

At the Metropolitan Museum in New York, the amount of varnish removed in any area is adjusted according to the conservator's idea of the balance of tone and color in a work.

Using solvents

Old, yellowed varnish becomes gradually less soluble with time, so that the disparity between its own solubility and that of the paint film is reduced. The problem is to find the correct solvent or solvent mix for the so-called "solubility gap" between the two, so that the varnish can be dissolved safely without affecting the paint film beneath.

In an ideal example, a painting might have a 100-year-old dammar varnish that has oxidized as far as it will go. The paint will have been bound in linseed oil or nut oil with no additional resinous ingredients and the gap in solubility between varnish and the paint film will therefore be large. In such a case, a number of solvents may be used. Whichever solvent is chosen, the problem of toxicity should be taken into account. Conservators are very aware of the accumulated chronic effects of exposure to organic solvent vapors, and take sensible measures to protect themselves.

Specialized cleaning agents

"Solvent gels" and "resin soaps" are now widely used for the cleaning of paintings. These are highly controllable because they are chemically tailored to the particular material that is to be removed from the painting. A 100-year-old dammar varnish, for example, will have a resin soap made specifically to remove it.

The solvent gels contain just the right amount of solvent to remove material previously identified by microchemical analysis. These are painted on, left for a minute or two, and then washed off.

Removal of repaints and retouchings

Very often the solvent used for the removal of varnishes will also remove the retouchings. This can result in the exposure of old damage to the paint film. Occasionally, the old repaints have

become hard and insoluble and the only way to remove them is with a sharp utility knife. The process of cleaning will have left the surface of the painting somewhat dry and chalky, so a thin coat of synthetic "isolating" varnish is applied before the holes in the surface are filled and sealed with the same varnish.

Filling and retouching

Traditionally, a chalk and gelatine mixture has been used to fill gaps in the paint film and it is still used on panel paintings.

Proprietary fine-surface fillers incorporating PVA are used for paintings on canvas. The filler is scraped on with a spatula and then taken down with a swab and water or saliva, and may be indented to match the weave of the canvas; it can also be sculpted when dry.

Once the painting has been cleaned, the losses exposed, and the holes filled, it is given an isolating layer of varnish. The retouching of the actual paint film is always made over varnish so that it can be removed if necessary. The modern synthetic resins used by conservationists for varnishing are removable and have excellent resistance to cross-linking.

The approach to retouching paintings varies from one country or institution to another. At the Courtauld Institute and the National Gallery in London, for example, deceptive or "illusionistic" retouching is practiced. This is barely distinguishable from the original paint, even when examined at close quarters.

In Italy, on the other hand, a number of retouching systems are used that are not noticeable from a distance, but are quite obvious when examined closely.

After retouching, using watercolor paints, or modified synthetic resin-based paints, the painting is varnished. All this work is fully documented and reversible.

Varnishing

A VARNISH IS A THIN PROTECTIVE LAYER BETWEEN the paint film and the atmosphere. It should be transparent and colorless and should form a good bond with the dried paint film but be removable without affecting the paint in any way. A varnish is a solution of resin in solvent and is applied when the paint film is thoroughly dry.

Protective requirements of a varnish
The varnish should protect the paint film from dust and dirt in the atmosphere and from abrasion. If a varnish is too soft (see *Varnishing acrylic paintings*, opposite page), it will, in fact, pick up dirt. Some thermoplastic resins have low glass transition temperatures, which means they can soften at relatively low temperatures, and therefore attract dirt.

The varnish provides some measure of protection from the effects of oxygen and moisture; this varies according to its permeability. The varnish must be sufficiently elastic to prevent cracking as the canvas expands and contracts. It must place the minimum stress on the paint layer. The addition of ultraviolet absorbers to the varnish may act as a filter, protecting the paint from the light, but, in practice, these are rarely used.

Varnish deterioration
Varnish can deteriorate both physically and chemically. The former shows itself in cracking, chalking, shrinkage, and wrinkling. Chemical degradation is a result of oxidation, both of the resin and, occasionally, of the solvent. Linear polymers deteriorate by chain-breaking and cross-linking (which leads to insolubility). The deterioration of the varnish layer is one of the principle problems faced by conservators.

Varnish solvents
Solvent-type varnishes dry by solvent loss, or evaporation. The varnish film becomes touch-dry before all the solvent is lost. If the varnish forms a gel with considerable solvent still present, it will tend to flow into the irregularities of the paint surface. If this solvent is easily oxidized and discolors, it may lead to the discoloration and faster deterioration of the paint film. This is one of the reasons for not applying varnishes before the paint is completely dry. Solvents must be carefully and correctly balanced in a varnish formulation to achieve the right gloss and a satisfactory drying rate.

Varnish resins
The type of natural or synthetic resin from which the varnish is made will affect its durability and gloss qualities.

Dammar The natural resin dammar is relatively nonviscous when dissolved in turpentine, which means that it brushes easily and wets the surface well. This makes it very glossy and enables it to saturate colors, especially dark ones, giving them greater depth. The alcoholic and ketonic components in the dammar cause gradual oxidation; impure resin discolors more quickly.

Synthetic resins The synthetic alternatives in common use in proprietary artists' picture varnishes are the polycyclohexanone or ketone resins, which are as non-viscous as dammar and which give a similar intimate bond with the paint surface, brushing easily and wetting well.

Conservation varnishing
Although most paintings that are restored are given a coat of varnish, some are not. These include some Impressionist and Cubist paintings where the artist clearly did not wish to use an overall gloss. In some paintings by 20th-century Spanish artist Juan Gris, for example, there are areas that are specifically shiny and other areas that are matte.

There is no ideal varnish, and the best a museum can hope for is that the surface quality of the varnish will be appropriate aesthetically, that it will not discolor for around 40 years, and that it will be easily reversible.

The polycyclohexanones handle well and give a slightly glossy surface, but they comprise short-chain resins that break up under stress. So, although they are easily reversible, they are nonetheless very brittle.

Probably the most stable of the synthetic polymers is B72. This is an acrylic co-polymer extensively used in conservation, but it is not available on the retail artists' material market. Such polymers are "long-chain" high viscosity resins, which means that the long strands of polymer that make them up inhibit the mobility of the varnish. For this reason, they do not intimately wet the surface to which they are applied, and therefore give a lower gloss. B72 is nonyellowing and does not change its solubility as do most other resins over a long period of time, so it is always reversible. It produces a slightly plastic-looking

surface. It is impossible to brush it on because it has the consistency of molasses, so it is usually sprayed on in a 2 percent solution. The solvent is toxic, so this has to be done under rigorous health and safety conditions.

Dammar varnish is still well regarded for conservation varnishing. It has a good surface quality, is easy to apply, and is sufficiently reversible. The best highly refined dammar is used and it is accepted that it will have to be replaced after a few decades.

Technique Varnishing oil paintings

The chapter on oil painting has pointed out the dangers of using excessive amounts of resin varnish in the painting medium. An artist who has done so may find, for instance, that detailed work on the surface of the painting is dissolved and dispersed by brushing resin varnish on top. This is because the resin in the paint layer is redissolved by the solvent in the varnish. Such an effect may also occur many years later when the old yellow varnish comes to be removed, and the solvents used to do so can disturb the original paint.

The answer is to rely on drying oils and diluents alone when manipulating the oil paint. This makes for a wide (and therefore safe) solubility gap between the dried paint film and the varnish (see above). Any of the resin varnishes discussed above are suitable for oil painting. Dammar is the traditional choice, giving high gloss. Ketone is a modern and probably less yellowing alternative.

Technique Varnishing acrylic paintings

The solubility gap between paint layer and varnish can be very small where acrylic paints are concerned so that problems can occur if a varnish needs to be removed. One obvious answer might be to use a solvent-based resin, but this makes the acrylic resin swell. In addition, such resins are not perfectly stable, they oxidize and become less and less soluble and would end by requiring solvents for their removal that would almost certainly dissolve the acrylic paint film.

Proprietary, water-soluble, acrylic varnishes tend to be variations of the acrylic dispersions that form the binding medium for the paint itself. The ingredients that enable the acrylic resin to be dispersed in water remain in the film when it is dry, often giving a milky look to the varnish. The matting agents used to reduce the natural gloss of the acrylic dispersion can also give a milky effect. Since the acrylic film is soft and liable to attract dirt, it may be sensible to have the painting in a glazed frame.

Technique Applying varnish

Varnishing should be done in a clean, warm, dry, ventilated room. The painting should be clean, grease- and dust-free, and the paint must be absolutely dry.

The painting is normally laid flat and the first coat of varnish applied thinly with a flat, wide, hog-hair brush. A varnishing brush should be kept for this purpose alone; it must, of course, be absolutely clean. More than one pass is made with the brush. In fact, with the short- chain varnishes, such as the ketones and dammar, continued brushing can give a semi-matte appearance, with the brush just breaking up the surface as the varnish begins to dry. Such effects are not so possible with the less mobile long-chain polymers, but these are less glossy anyway.

The second coat can be brushed or sprayed on (it is possible to spray both coats, but brushing is generally thought to provide a better bond between varnish and paint film).

1 If absolutely necessary, clean the painting carefully with cotton balls moistened with saliva.

2 Using a varnishing brush, apply the first coat of varnish, brushing in one direction, parallel with the edges of the picture.

3 Once dry, apply a second coat, using the brush or a spray gun to give a fine, even film. Make the strokes at right angles to the first coat.

Technical Examination of Paintings

IN A MUSEUM, THERE ARE CERTAIN STANDARD WAYS of examining pictures that tell us about how they are painted and what has happened to them since. This information is of particular interest to artists because it gives us considerable practical knowledge about how paintings can be made. There is an enormous amount to be learned from this about the juxtaposition and superimposition of color and about the performance of specific pigments in particular binding materials. We are given clear images of the precise stages of building up a painting, so that something that from a normal vantage point may look impossible to achieve proves easily and practically accessible.

In addition, techniques that are revealed can prove useful when we are using painting materials that were not available to painters in the past. Some of the new lightfast, synthetic organic pigments developed for the automotive industry, for example, are such clean, pure colors that when used in the kinds of layer structures we see in 15th- or 16th-century paintings can produce quite different results.

Kinds of examination

So much of today's technology can tell us about how paintings were made and what has happened to them since they were painted, without actually affecting the painting itself. Of the six methods of examination described here, including the use of X rays and special photography, five are noninvasive.

Examination through a microscope
Examination of a painting through an optical microscope is non-invasive and gives information about how the layers have been built up and whether there has been any restoration or repainting. Photomicrographs give very clear images of the way small touches of paint have been applied.

Scanning Electron Microscopy (SEM) also enables you to look close up at the surface, but this time again under huge magnification so that the smallest grains of pigment look like tennis balls.

Surface detail A macro detail shows how the paint has been built up in a ridge below the mordant gilding.

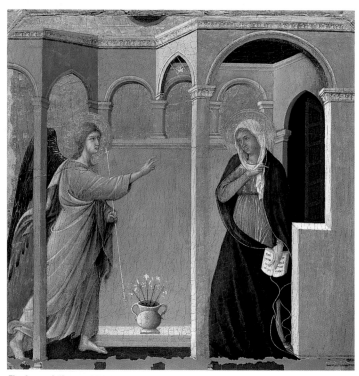

The Annunciation (ca. 1278), Duccio

Paint cross sections

Tiny fragments of paint, taken from the damaged edges of a panel or canvas, are embedded in clear resin, sliced, and viewed in a microscope. The flat cross sections give a clear image of how the paint layers in the picture have been built up.

A paint cross section also allows the layer structure to be examined by microchemical analysis using gas chromatography, mass spectrometry (GC-MS), and Fourier-transform infrared microspectrophotometry (FTIR). This enables scientists to analyze the precise pigments used in the painting and also the components of the painting media. So, for example, it would be possible to establish the kind of drying oil or whether an egg or a casein binder was used.

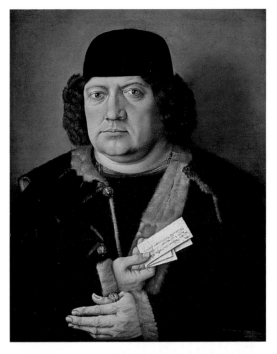

Portrait of Alexander Mornauer (ca. 1464–88), MASTER OF THE MORNAUER PORTRAIT Before the technical examination of the painting, it was assumed that the blue background and the size of the hat were part of the artist's original scheme.

Paint cross section This examination revealed the layer of Prussian Blue that was not available to artists until 200 years after the original painting was made.

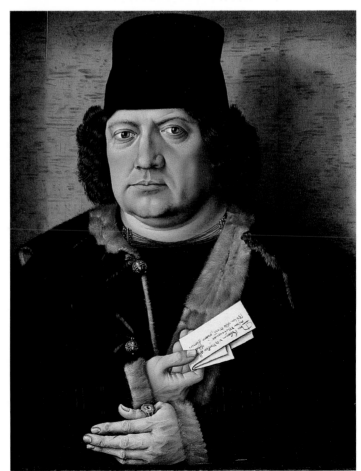

After restoration Following the discovery that the blue background was a much later overpaint, the painting was restored to its original state. This has a much greater feeling of uniformity and appropriateness.

X-ray detail In the X-ray detail, you can see clearly how the artist originally painted Venus looking down toward Cupid rather than looking out to engage the eye of the viewer.

X-ray analysis

X rays penetrate the whole structure of a picture and show everything. So, if it is on canvas, the stretcher can be seen, including the nails holding the canvas to the frame. X rays also pick out the dense pigments, especially lead white, but also vermilion and lead-tin yellow. Since the features are generally built up using lead white, it is possible to see changes the artist made when producing the work. X rays are also useful for looking at the condition of the work since they often show areas of damage or heavy restoration.

Venus with Mercury and Cupid (The School of Love)
(1494), CORREGGIO

Infrared photography

This photography uses an infrared sensitive film in a conventional camera. Infrared radiation penetrates the top layers of a painting and reveals the layer just below the visible surface. This is particularly useful in ascertaining whether there is any preliminary drawing under the paint layers. It often shows the artist drawing out a number of different possibilities on the canvas or panel itself, before firming up on the composition or on details for the finished work.

X-ray detail The number of different positions shown in the underdrawing for Giovanni Arnolfini's hand shows just how important it was for Van Eyck to get precisely the right position in the finished work. There is more of a sense of calm or repose in the final version of the hand, seen, as it is, practically from the side, than in the earlier version with the more exposed palm, which we see in the underdrawing. Many other areas of the underdrawing show Van Eyck trying out slightly different versions of his subject matter.

The Portrait of Giovanni Arnolfini and his Wife Giovanna Cenami ("The Arnolfini Marriage")
(1422), JAN VAN EYCK

Infrared reflectography

Infrared reflectography is an extension of the same principle as X-ray photography. But instead of using X-ray film as above, a light-sensitive, infrared detector in a T.V. camera is used. The camera is connected directly to a monitor and the system works in real time. The range of infrared reflectography is greater than that of infrared photography. The latter cannot penetrate blues and greens, for instance, but infrared reflectography can. This method has largely replaced infrared photography in museums.

Ultraviolet analysis

Photographing a painting under UV light has the effect of making different materials on the paint surface fluoresce in different ways. In practice, this is a guide to the condition of the painting. It means that later varnish shows a different tone to that of the original varnish and the same is true for later retouchings as compared to the original paintwork. So this kind of analysis is an extremely useful guide to the conservator.

Framing

ONCE A PAINTING OR DRAWING IS COMPLETED, it is usually mounted and/or framed. It is relatively easy for artists to frame their own work, but the way in which a finished artwork is framed has an inevitable effect on how it is viewed, so the choice and construction of frame is an important factor in the presentation of the work.

Functional aspects of framing

For delicate or vulnerable artwork, framing is an essential part of the process of protection. The sooner a pastel drawing is framed behind glass, for example, the better its chances of survival. The same could be said for acrylic paintings, which can have a soft surface that is vulnerable to dirt.

The history of framing

The early Renaissance practice of preparing and painting on a panel with a gesso ground often incorporated the molding and gilding of the frame as an integral part of the work as a whole. But as the practice of making paintings on canvas developed, the frame became a separate component that was attached to the canvas after it was finished. The frame was an important and expensive decorative feature designed to display the work to advantage and, in itself, to demonstrate the skills of the wood carver and the gilder. This "dressing-up" of the painting produced some extraordinarily elaborate and some extremely beautiful frames, but the frame often had very little to do with what was going on in the painting.

Contemporary trends

In the late 1800s and throughout the 1900s, there was a move among most painters to return to the earlier concept whereby the painting and frame were more integrated. Artists such as Van Gogh and Seurat, for example, often painted their frames in a style akin to the works themselves. Seurat applied small dabs of the same colors used in the painting to the frame. An alternative has been to dispense with the frame altogether or simply to protect the canvas with a thin strip of plain or painted hardwood.

Among contemporary painters who have explored and furthered the notion that the frame is an absolutely integral element of the painting itself, are Howard Hodgkin and Mimmo Paladino; the former in work in which the frame and painting merge almost imperceptibly, and the latter in work that introduces new motifs in the painting of the frame to enrich and expand the narrative of the painting itself.

Howard Hodgkin often uses recycled hardwood as a support that is already framed in some way. In some cases, the frame becomes emphasized as a proscenium arch that allows us to look through to a usually vibrant world beyond. In other paintings, he appears to ignore the frame, painting over it as if it were not there. Between these extremes is a range of approaches that shows an instinctive awareness of how the notion of a frame can truly signify in a work.

Dinner at Smith Square *(1975–79),* HOWARD HODGKIN
Here, the frame has become an entirely assimilated part of the artwork and the painting would make no sense if it were removed. It is an active container.

The framing process

The construction of a rectangular picture frame is straightforward. It simply involves cutting four lengths of molding with accurate 45-degree angles at both ends of each piece, and gluing and pinning these together (see pp.342–43). In practice, artists who attempt to do this with no equipment other than a saw, glue, hammer, and nails invariably find it practically impossible to get a perfect angle.

If you envisage doing a lot of framing, it is worth investing in a few basic tools—some form of miter cutter is certainly essential.

Materials Choosing the molding

Proprietary picture frame molding is widely available in a huge range of sizes, styles, and finishes. Many of these moldings are designed for the cheaper end of the market—for the framing of supermarket prints or photographs, for example—and may not be of interest to artists. In addition, many are designed for work of a limited size—for glazed work on paper or prints, for instance—and may not be appropriate for larger paintings on canvas. However, if you do find a satisfactory molding within the commercial range, you will save money by buying it in 100ft (30m) batches, with the molding divided into 8–10ft (2.4–3m) lengths. For the larger-scale canvases, a limited range of moldings is available in plain pine or ramin.

Plain wooden moldings like these can be gessoed and stained or primed and painted in any way felt to be appropriate to the painting. This may be the only satisfactory way of ensuring the permanence of a colored frame, since commercial colored molding can darken quite drastically. Gesso is considered by many to be the most satisfactory preliminary coating on a molded, wooden frame. Its thick, white, matte surface softens the sharp edges of the molding. It is the perfect surface for applying red bole and subsequently gilding or for simply staining.

Making moldings

If a suitable molding cannot be found, the artist can sketch the required design and have it professionally manufactured in wood. If the proposed molding profile is a reasonably straightforward shape, this need not be an expensive business, especially if a large amount of molding is commissioned.

Technique Cutting the miter

Assuming the frame is rectangular, the molding will require cutting at an angle of 45 degrees. The cheapest method of doing this with any degree of accuracy is to buy a wooden miter box made of hardwood, into which the molding is placed. The blade of a tenon saw is placed between the guide cuts in the two vertical sides of the box and the molding is sawed. In practice, the accuracy of the wooden miter box lasts for only a short time as the action of the saw inevitably widens the guide cuts; a metal box is better. But for artists who are going to continue to make frames, a moderate investment in a miter cutter makes a lot of sense. These are simple cast-iron stands with a framework and saw attached, to enable cuts to be made at specified angles.

The best makes of cutter are extremely long-lasting and reliable, with the only maintenance required being the occasional sharpening of the saw blade. The blades on some machines are thin and, if the sawing is forced and not made uniformly, you may find that they do not cut completely vertically. This can be a problem when you come to glue and pin the corners together.

Another, but considerably more expensive, machine is the guillotine miter cutter, which most picture-framing workshops use. This comprises two sharp knives set at right angles at 45 degrees to the molding so that they can cut both corners of a miter at once. These are usually operated by compressed air or with a foot pedal. They are not generally capable of cutting moldings whose width is in excess of 3in (8cm). The reason that they are preferable to any of the sawed methods is that the problem of sawdust is eliminated. With sawed moldings, the dust must be removed before gluing and pinning.

Whichever method is adopted, the lengths of the molding will have to be accurately measured so that the painting fits. Measure the height and width of the painting and add to those measurements enough to allow a gap between the edge of the rebate and the painting itself of between ⅛in (3mm) and ¼in (6mm) all around, depending on the size of the canvas and of the rebate. This measurement will represent the shortest (inner) side of each piece of the frame.

Technique Gluing and pinning

The established method of gluing and pinning is to put a spot of fast-drying, white wood glue on the cut face of the pieces of molding to be joined and to position them in corner clamps. The two pieces of molding are pushed gently together and the clamps tightened. Excess glue, if any, visible at the join should be wiped off with a damp cloth. Using a small hammer and panel pins, the corner is then side-pinned. A nail gun should finally be used to hammer the heads of the pins into the wood so that the holes can later be filled and made good. The corner comprising two sides of the frame should be left in the clamp to dry. Two halves are glued and pinned at a time so that, when they are dry, the other two halves may be put together in a similar way and the frame completed. When the frame is dry, the pin holes can be filled with a wood filler or with a white powder filler mixed with a little PVC glue and water. When this is dry, it can be retouched to the color of the frame.

Some framemakers simply put one piece of the frame in a vise and hold the other piece to it with one hand, while banging a nail in using a hammer with the other.

A more professional method is to use an underpinning machine. The two pieces of molding are given a spot of glue as above and placed on the machine. A right-angled piece of metal is fired up into the corner of the frame from underneath. This allows the underpin to hold the frame together while the glue sets. A complete frame may be made rapidly in this way and there are none of the problems associated with unsightly holes in the side of the frame.

Technique Putting a painting in a frame

If the painting is being placed into a frame without mounting or glazing, it is generally held in place with cork or balsa wood slices. These allow the painting to fit snugly in the frame but also to move a little if necessary.

The inside edge of the rebate can be covered with a soft material such as velvet ribbon to protect the surface of the painting where it touches the rebate. To prevent the painting from falling out, it has been customary to nail panel pins into the back of the frame next to the canvas and bend them over the stretcher frame. This is not a very sound method, since it creates stress on the canvas at the point where the nail is bent over; also, the nail may start to rust. A better way of securing the painting is to screw proprietary, nylon angle brackets or mirror plates onto the frame that lip over the back of the canvas and hold it in place. The painting may then be taped up at the back using brown gummed paper.

In order to keep a stretched painting on canvas in good condition for as long as possible, the use of a hardboard, plywood, or even cardboard backboard to keep out dust and dirt and to act as a buffer against atmospheric changes is strongly recommended.

If it is a relatively small picture, a couple of screw eyes with rings are screwed into the back of the frame and picture wire is strung between them. A larger painting will require more heavyweight hardware, with substantial hooks and a metal chain. Or it can be screwed to the wall using mirror plates (see p.343).

Technique Framing drawings, prints, and paintings on paper

Drawings, prints, and paintings on paper are all framed in the same way, but have to be protected by glass. In turn, their own surface must be protected from abrasion with the glass itself, so they are generally "window mounted" in cardboard, or a fillet is introduced between the glass and the mounting board. In addition, there is a backing board to protect the back of the work. There may also be an impermeable sheet of inert plastic film between the backing board and the back of the mount.

The glass

Picture glass is generally as thin as the size of the frame will allow. This is to enable the image to be seen as clearly as possible and without risk of distortion or any latent color in the glass affecting it. Glass is cut with any steel or diamond-wheel glasscutter. It should be cut right to the rebate to prevent the risk of dust or dirt getting in from the front. The cut is made smoothly and in one go against a wooden or metal ruler held against the glass as a guide. To snap a piece off, put the ruler under the glass along the line of the cut and push down on one side while holding the other steady. The glass should be cleaned and degreased with a small amount of proprietary glass cleaner. It should be polished with a lint-free duster.

Cleaning Make sure the inside face of the glass is thoroughly clean.

The mounting board

Since the original has been made, one imagines, on the best acid-free paper or board, it would make no sense to use a highly acidic, wood pulp mount since it would soon contaminate the artwork. The best and most expensive mounting board is known as museum board or conservation board and it comes in an extremely limited range of white and off-white colors, but it is acid-free and therefore reliable.

The most primitive method of cutting a window mount is with a utility knife, such as a Stanley knife, against the bevel edge of a heavy metal rule. Holding the angle of the bevel along the length of the cut is extremely difficult, so most artists opt for a relatively inexpensive, handheld, mountcutter. This holds the blade at the required angle while it is drawn across the board against the edge of a metal rule. On a professional mountcutter, the length of the cut can be preset so that complete accuracy is maintained.

Attaching the work to the mount

A work on paper is traditionally attached to a window mount with a pair of hinges made from thin Japanese paper and stuck with a flour and water or cellulose paste. The use of tape or drafting film is not recommended, as these can discolor the artwork. The window mount itself may be hinged in a similar way to a piece of the same museum board so that the artwork is securely held as the "filling" in the sandwich. For a work on handmade paper, for instance, in which it is necessary to see the whole of the sheet—including the deckled edges—a window mount is inappropriate, but a system of paper hinges can still be used, one on each corner of the paper, and pasted to the conservation board beneath. In this case, the frame will have to incorporate a fillet to ensure that there is a space between the paper and the underside of the glass.

The backing board

A loose sheet of Mylar or equivalent inert plastic may be placed between the mounting board and wooden (hardboard or plywood) backing board to ensure the mounting board

Taping it up Seal the back of the frame with strong, brown tape.

is not contaminated by acidic elements in the backing board. This is not generally considered necessary, however. The backing board should be cut tight to the frame and is generally secured with a point driver or glazing gun that fires diamond-shaped, flat points into the edge of the frame to ensure that dirt does not penetrate the gap between backing board and frame. Strong, brown, gummed tape is secured around the back of the frame as an added precaution against dirt.

Finally, a pair of screw eyes with rings are screwed firmly into the frame between two-thirds and three-quarters of the way up on each side and picture wire or nylon cord is strung across. This ensures that the painting leans forward slightly from the wall. The framed picture is now ready for hanging; if it is very large, it may be better to screw it to the wall (see box below).

In the frame Place the mount in the back of the frame.

Mounting the work Mark the correct position of the work in pencil on the back of the mount and attach it using paste and paper hinges or proprietary archival tape.

Hanging a very large painting

A very large painting may be too heavy or cumbersome to hang from normal picture wire. A secure method of hanging such a painting is to attach one or two mirror plates to the back of the frame on each vertical edge so that they protrude when seen from the front. These can then be screwed from the front into the wall.

Disguising the fixture
When the picture has been attached to the wall, the visible part of the mirror plate can be made less obtrusive by painting it to blend in with the wall.

APPENDICES

So far, the subject headings have dealt with the materials and techniques of art as they relate to specific areas of art practice, including drawing, painting, and applied arts. The appendices contain information about topics such as color and perspective that may be generally useful in all these practical areas. They also provide broad information on exhibiting studio work or working to commission in the area of public art.

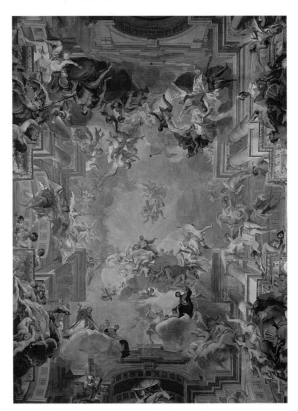

The Glory of St. Ignatius (1691–94), PADRE ANDREA POZZO

In order to be able to transfer his design accurately, Pozzo had to construct a grid on the barrel vaulted ceiling of the Church of St. Ignatius in Rome. He first constructed a horizontal grid using cord on the level of the springing of the arched ceiling. He then took a line using cord from the viewpoint on the floor of the nave through the intersections of the cord grid, to a corresponding point on the ceiling. The points on the ceiling could then be joined up to provide the required grid into which the drawing for the mural could be accurately transcribed.

Color

OUR PERCEPTION OF COLOR IS ENTIRELY
determined by the action of light on
the objects we perceive. In the latter part of
the 1600s, Sir Isaac Newton demonstrated that
colors were integral components of white
light. He did this by allowing a beam of white
light to fall on a glass prism. The light was
dispersed into a band of separate colors from
red through orange, yellow, green, blue, and
indigo to violet (the colors of a rainbow).
Then, when he allowed the colored rays of
light to pass through a converging lens and on

through a second prism, they were reconstituted
into white light. This demonstrated that the
colors were constituents of light itself.

Dispersion of white light As white light passes through the dense
prism glass, it is dispersed into the colors of the spectrum.

The constituent colors of light

The colors that make up white light were revealed
to Newton by the fact that light of different
wavelengths is refracted to a greater or lesser extent
when it passes from one transparent medium
(air) to another dense one (glass). The rays of red-
orange light pass more rapidly through the denser
medium and so are bent, less than the blue or violet
rays. This is why light from the sun is seen as red-
orange at sunrise and sunset, when the oblique

angle of the rays means they have to penetrate
more of the atmosphere.

The range of wavelengths of visible light is
a very tiny proportion of the electromagnetic
spectrum—from around 390 nanometers for
violet to 760 for red. Beyond the red are infrared
rays, and beyond them radio waves. Beyond the
violet are wavelengths of ultraviolet rays, X rays,
and gamma rays.

Additive color mixing

Newton's experiments showed that
if the colored rays produced by
dispersing white light were added
together again in the manner
described above, they would be
reconstituted as white light. This is
known as "additive" color mixing
because more light is being added
with each additional color.

The additive primary colors In
order to produce white light from
colored light, just three colors have
been shown to be necessary. These
are the primary colors for light.
They are:
● Blue (blue/violet) for the shorter
 wavelengths

● Green for the middle wavelengths
● Red (orange/red) for the longer
 wavelengths.
The additive primary colors
correspond to light-sensitive
substances found in the cones
of the human retina where three
main kinds have been shown to
be sensitive to blue, green, and
red light respectively.
 If three white-light lamps are
covered with red, green, and blue
filters respectively, and the lamps
are directed onto a white panel so
that the lit areas overlap, the area
where all three overlap will be
white (see right). Where the green
and red lights are superimposed,
they produce yellow light. Where

the green and blue lights are
superimposed, cyan blue light is
produced; where blue and red are
superimposed, magenta light results.

The additive primaries A projection of
the three light primaries, red (large
circle), blue (smaller circle), and green
(triangle) onto a white surface. The
production of white light is visible
where all three overlap, and cyan,
magenta, and yellow can also be seen
where each pair of colors overlaps.

How we perceive the color of objects (selective absorption)

We have seen how white light can conveniently be split up into three primary colors—orange-red, green, and blue-violet—and that these colors correspond with photochemical-sensitive substances in the cones of the retina of the eye.

Whether light is reflected from a colored surface or transmitted through it, only the colors perceived will be reflected or transmitted. The other colors will be absorbed by the materials. A white surface will reflect all three colors that together constitute white. A matte black surface such as carbon black pigment will absorb all these colors. An object we see as blue/violet will have absorbed the green and orange/red rays of light.

Looking at a yellow object A yellow object will absorb the blue/violet light, but the green and orange/red rays will be reflected or transmitted since the additive combination of these two colors is yellow.

Subtractive color mixing

This is of particular importance to painters as it is concerned with pigments and dyes or with overlaid films of color viewed under a single light source. The principle notion is that the addition of a further color diminishes the amount of light that is reflected or transmitted to the viewer. This can be seen when, for instance, a transparent colored filter is placed over a white light. A red filter will absorb the green and blue light and will only transmit the red. More colored filters will subtract even more light. The subtractive primaries are red (magenta), blue (cyan), and yellow.

Subtractive color mixing for painters When physically mixing colors for painting, each new pigment that is added will make the mix darker and the color less pure. For example, Cadmium Yellow, which contains a lot of orange, when mixed with a reddish Ultramarine Blue will give dirty gray/green mixtures because they are almost complementary colors (which in subtractive mixtures produce dark gray or black).

Nowadays, with the very pure colors that can be had from synthetic organic pigments such as the phthalocyanines and the azo condensation or benzimidazolone pigments (see pp.12–15), it is possible to mix secondary and tertiary colors of remarkable purity (though the subtractive principle still applies). For instance, a brighter green can be had with an Azo (lemon) Yellow or Cadmium Lemon and a Phthalocyanine Blue.

This is also true of glazing, in which you first put one transparent film of color onto the canvas, then another on top of it, and so on. As you do so, the tone deepens and less light can be transmitted from the surface of the priming or the paper.

The following swatches of color give examples of the kind of "primary" colors you need to mix to get clean secondary ones.

Gray green Cadmium Yellow mixed with French Ultramarine gives a somewhat gray green.

Bright green Cadmium Lemon mixed with Phthalocyanine Blue gives a clean, bright green.

Gray violet Cadmium Red mixed with French Ultramarine gives a somewhat gray violet.

Bright violet Permanent Rose (Quinacridone) mixed with Phthalocyanine Blue gives a clean, bright violet.

Trichromatic printing The principles of subtractive color mixing are the basis of all three-color (trichromatic) printing. The positive plates that make up the image are printed in transparent yellow, magenta, and cyan inks respectively, on white paper. The combination of the yellow with the red gives the range of yellow through orange/red to magenta and the subsequent superimposition of the cyan produces the rest of the spectrum. There is usually an additional plate printing black to add depth and dimension to the images. This is known as four-color printing.

The sequence in *Digital image manipulation* on p.271 shows the subtractive effect of overlaying layers of transparent color.

Testing color

The "purity" of color of a pigment can be established by a spectrophotometer, which measures the amount of light absorbed by the pigment from within the visible spectrum and records the results on a graph called a chromaticity chart. This can be done by transmitting white light through a thin layer of the pigment and measuring what comes through the other side—i.e., white light minus the color absorbed. Alternatively, the light reflected off the surface of a sample of the pigment can be measured.

A very "pure" color has an absorption band that is very sharp or narrow at a particular wavelength. The higher the peak, the brighter the color will be. If the curve is broad, it means that the pigment is absorbing wavelengths from either side, and that the color is "dirtied," or at least less pure.

Working with complementary colors

From the above, it can be seen that whatever color or colors are absorbed by the material the light rays strike, the remaining colors are reflected or transmitted. Thus, a yellow object absorbs the blue/violet light and reflects the green and red. So yellow (a combination of green and red light) and blue-violet can be said to balance or complete each other since a combination of them in light (additive mixing) would produce white, and in pigment (subtractive mixing) would produce black. They are known as complementary colors, and they are of great importance to artists and designers.

The complementary colors are:
- Green and magenta
- Blue/violet and yellow
- Red/orange and cyan (blue).
 (The designation of the precise hues of complementary colors has varied a little from one color theorist to another.)

These complementary colors are so important in painting because they are the colors of greatest mutual contrast and they are used in a variety of ways to enhance, enliven, or subdue the appearance of a painting. Also linked to this are the theories expounded by Chevreul of simultaneous contrast, successive contrast, and mixed contrast (see p.348).

Exploiting complementaries One of the first things that an awareness of complementary color teaches artists is that a color may be broken or dulled very effectively with a touch of its complementary color, in physical mixtures rather than by adding black, and that the high key of a glaze color, for instance, may be reduced by a very thin glaze of its complementary color—a practice, it appears, that was already being used by Italian artist Cima in the 1400s. These effects are not found on even the most complex color spheres or color trees since they can, of course, only concern themselves with a single opaque hue of a certain tone and brightness.

Color mixing

Physically mixing each of these pairs of colors together produces black, as seen in the central part of the swatch, in each case.

Cyan blue This is the complementary color of orange/red.

Green This is the complementary color of magenta.

Yellow This is the complementary color of blue/violet.

The theories of Chevreul

Although the conscious use of complementary colors in European painting can be seen to good effect in early egg tempera panel paintings, for instance, where colors such as pink and green are juxtaposed in fleshtones, it was not until the 18th and 19th centuries that theories about the nature and application of complementary colors were articulated.

Perhaps the greatest theorist, whose attention to the practical aspects of his ideas revolutionized the ideas of many painters, was Michel-Eugène

Chevreul, who in 1839 published his great work on the principles of harmony and contrast of colors, *De la loi du contraste simultané des couleurs.* Chevreul's ideas about color effectively transformed the nature of European painting. They did so because they expressed clearly and in practical ways some of the notions of color that artists had possibly until then only been aware of in a vague and empirical way. Chevreul defined the three simple laws of simultaneous, successive, and mixed contrast.

Employing simultaneous contrast

The law of simultaneous contrast states that if different tones of the same color are placed side by side in strips or if different colors are juxtaposed in the same way, the contrast between them will appear much greater than if they are viewed separately. Chevreul identifies a tonal change at the point of contact between the areas of color in addition to a color change if two separate colors are involved. "In the case where the eye sees at the same time two continuous colors, they will appear as dissimilar as possible, both in their optical composition and in the height of their tone." He demonstrates that strong color such as red will show a tendency to irradiate the surrounding space with its complementary color (green) and that this will affect the appearance of the color with which it is juxtaposed. In terms of "simultaneous" contrast, this is an effect that happens as soon as the eye perceives the tonal or color juxtaposition.

It can be extremely useful for the artist to have a developed awareness of these aspects of the juxtaposition of colors when making practical choices about the design and application of tones and colors in any work of art. It can often explain why things work or do not work.

Simultaneous contrast of two tones When two separate sections of tone, one light and one dark, are viewed separately, they will not appear to be as contrasted as they will when viewed side by side. This is because at their point of contact—which is the point of maximum contrast—the tone of the darker piece looks even darker.

Simultaneous contrast of complementary colors With two adjacent complementary colors such as yellow and violet, the complementary of the first will affect the look of the second, so that the violet looks more violet and the yellow more yellow. Thus the effect of simultaneous contrast is to greatly emphasize the contrast between complementary colors.

Simultaneous contrast of gradated tones When a number of uniformly toned strips of increasingly greater tonal depth are juxtaposed, the maximum point of contrast along the edges gives the flat area of tone a fluted or channeled look. The importance of this visual effect to practicing artists cannot be overstressed, and Chevreul points out that to avoid this consequence, the edge of the adjacent darker tone must be painted in a lighter tone to give the appearance of a smooth gradation.

Simultaneous contrast of similar colors With two similar colors juxtaposed, the same rule applies—that is, the complementary color of each will affect the other. But, here, the effect is different: if red is placed next to orange, it will look like a more violet red by the blue cast the orange induces. If the same red is placed next to violet, the red will look more orange due to the yellow induced by the violet. Where the area of one color is considerably smaller than the other, the effect of this irradiation is greatly pronounced.

Employing successive contrast

The law of successive contrast is similar in many ways to that of simultaneous contrast except that, where the latter is immediate, the former concerns itself with after-images. So that if the eye observes a color fixedly for a while and then looks away, an after-image is formed in a color complementary to that originally observed. Such effects are of particular interest to painters when considered in conjunction with Chevreul's third law—that of mixed contrast.

Employing mixed contrast

This is the phenomenon of the after-image effect described above being changed in color by the influence of the color of another object in view. If, for example, you stare at an area of orange/red and then immediately at an area of yellow, the yellow will appear green since it mixes with the blue after-image of the red.

The notion of mixed contrast relates very directly to large-scale paintings or mural artworks that are viewed "successively" and in which there are generally clearly delineated areas of strong, saturated color.

Chevreul's ideas on complementary color

Chevreul's laws of contrast pay particular attention to the use of complementary color. He pointed out that in his "harmony of contrast" the use of complementary colors was superior to other assortments. The three main complementary pairs are, however, different from each other in respect to their tone values.

"Red and Green are the complementary colors most equal in height: for Red, under its relation of brilliancy, holds a middle place between Yellow and Blue, and in Green, the two are combined."

"Blue and Orange are more opposed to each other than Red and Green, because the less brilliant color, Blue, is isolated, whereas the most brilliant (Red and Yellow) are united in Orange."

"Yellow and Violet form the most distinct assortment under the relation of height of tone since the lightest or the least intense color, Yellow, is isolated from the others."

The implications are clear to painters. For instance, the fact that yellow is most pure at a high level of brightness compared to violet is a good reason for using yellow for lights and violet for shadows. The former are pushed forward on the picture plane by the latter.

Color notation systems

The notion that each color has its own complementary color that balances or completes it meant that a system of color notation would allow the artist to find the complementary of a color rapidly by simply referring to what was basically a chart. This was developed from the idea of the color wheel on which the colors are arranged in complementary pairs across from each other. The simplest color wheel is one that shows magenta across from green, violet opposite yellow, and orange/red across from cyan. More complex wheels show many more hues.

Chevreul constructed his chromatic circle with 72 separate hues, obtainable from the three primaries—red, yellow, and blue. In addition, each hue was represented in tints to white and shades to black in 21 steps from white to black. The color hemisphere that Chevreul developed was similar to the three-dimensional system devised by Runge earlier in the century in the form of a sphere and in which the three distinct qualities of a color could easily be perceived. These are:

- Hue—the color itself (red, blue, green)
- Saturation or chroma—the intensity of the color. The degree of saturation depends on the amount of white (tint) or black (shade) with which the color may have been mixed. In practice it might be less saturated by being applied in a very thin transparent film over a white or toned surface
- Value or relative lightness—the degree of lightness or darkness (usually in relation to a fixed gray tonal scale).

The German Ostwald and the American Munsell, both working in the latter part of the 1800s and early 1900s, each developed a separate system of color notation in which a hue of particular saturation and value could be precisely identified and reproduced. Such a system may be of no more than academic interest to painters.

Applying Chevreul's theories

Chevreul was well aware that complementary colors could be used both to enhance each other's effect in situations of simultaneous contrast and also to neutralize the colors that each comprises. In the latter case, when discussing the combination of colored threads for tapestries, Chevreul warned against including complementary colors in mixtures that were intended to make brilliant colors.

On the additive principle of color mixing, adjacent touches of red and green, blue and orange, or yellow and violet merely give an impression of a neutral grayish color. The important point here is the size or scale of the color in relation to the whole. For the painter, the range is from the intimate physical mixing of pigment particles, in which neither color is distinguishable, through small adjacent dots of pure color that read as neutral from a distance, to larger areas of adjacent color that may show an aggressive contrast or a harmony and balance depending on how the color is used. The intensity or the saturation of the color also comes into play here, so that where equal amounts of red and green that are similar in tone might give a balanced effect, different amounts of yellow and violet would be required to give a similarly balanced effect, since pure yellow has a higher level of brightness than violet.

Juxtaposing similar colors In the close juxtaposition of two separate colors to give the impression of a third, the best way of avoiding the neutralizing or graying effect is to use colors that are similar. Chevreul, for instance, when discussing the mixing of red and yellow tapestry threads to produce orange, recommends the use of a red inclining to orange and a yellow inclining to orange. One of his "rules of harmony" states that different but similar colors can be "agreeable" when juxtaposed. It may certainly be more lively in certain cases to use two separate colors to give an impression of a third, rather than physically mixing it. In the juxtaposition of similar colors, Chevreul recommends the lowering of tone of one to make the other appear more brilliant.

The effect of color on different grounds

Chevreul points out that ". . . every recipe for coloring compositions intended to be applied upon a ground of another color must be modified conformably to the effect that the ground will produce upon the color of the composition." Every painter knows that this is so—indeed, Leonardo had pointed out the same thing centuries before —but Chevreul was the first to itemize these effects in relation to his theories of contrast, which stated that a red shape tends to color the surrounding space green, yellow makes it violet, blue turns it orange, and vice versa. This interaction between colors relates as much to tone and shape as to the color itself. The effect of a white ground is to make the color more brilliant or deepen its tone through its complementary color being added to the white. On black, the combination of the complementary color with the black may lighten the tone of the color unless the other is a brilliant, saturated color (see *Isolating colors with black or white*, below). According to Chevreul, the proximity of gray makes all the

primary colors gain in brilliance and purity. A gray image on a brightly colored ground will, of course, take on the complementary color of the ground, and by doing so will intensify the ground color.

Isolating colors with black or white

Any opaque color superimposed on another color will be affected to a greater or lesser extent by irradiation—the effect of the color's proximity. This can be avoided by isolating the color with black or white. Chevreul pointed out that stained glass windows were beautiful because they showed a simple design with well-defined parts that could be seen without confusion from a distance. But the

most important aspect for him was that, because it was surrounded by black, each color was able to be seen in all its purity and brilliance. The idea of isolating colors with black outlines is characterized in the paintings of Georges Rouault (1871–1958) and Fernand Leger (1881–1955), both of whom recognized the rich and resonant effects produced, especially with primary colors.

An alternative technique, which gives a very different effect, is to use a white contour (anticerne). This is easily done by painting separate strokes of color onto a white ground. Both techniques are most effective with flat areas of color.

Colors isolated with black and white The contrast between the effect of isolating the areas of bright color with black (left) and white (right) is marked. Out of black the colors glow; against the white they are deeper in tone.

Colored light on colored surfaces

Another of Chevreul's "harmonies" was the unifying effect of a number of different colors seen through a colored glass. He discussed at some length the effect of colored rays of light on the colors of material objects, pointing out that red rays on white made the object appear red, on black purple/black, on deep green red/black, and on light green red/gray (complementary effects). Red-on-red produced a considerably deeper and more

brilliant red than that perceived under a white light.

These ideas are of interest to painters, not only because they demonstrate the color changes that are brought about by different-colored lights, but because they also demonstrate the kinds of color changes that are brought about by superimposing a transparent glazing color of similar hue on a painting. Glazing a painting is similar to superimposing a colored gel over the white light used to illuminate it.

Perspective

NATURAL PERSPECTIVE MAY BE CONSIDERED AS the way our eyes perceive the spatial relationships between the various objects we have in view. This perception is extremely complex, since when moving around—as we do most of the time—we are constantly shifting and adjusting our point of view and focus. As we move around within a space, for instance, we are processing images of many different views of the same object to enable us to register a fully three-dimensional image within its three-dimensional setting. Even with our eyes fixed on a single point, we are aware of a field of vision that radiates from that point, encompassing much more of the space that we inhabit than we usually see in paintings.

The history and use of perspective

The Ancient Egyptians were able to represent their world quite satisfactorily in one impacted plane without recourse to perspective. Figures varied in size according to their importance in the scheme of things. They could be seen either face-on, from the side, or in a combination of both viewpoints. This system was coherent, organized, and direct. There were no problems of distortion associated with later, more complex systems. This correlation between size of image and emphasis filters through the centuries and also finds expression in Byzantine art with its flat, anti-illusionistic images.

The Pool in Nebanum's Garden *(ca.1400 B.C.)*, EGYPTIAN FRESCO
The ancient Egyptian method of representation showed the scene from above, from the side, and from the front at the same time. This opening out and flattening the space gives an extremely clear view of the subject. The different views are all shown on one plane.

Greek and Roman developments

The Greeks were the first to explore the notion of the recession and projection of images. According to Roman architect Vitruvius, who wrote his *de Architectura* around 25 B.C., the notion of projecting radii from a fixed vanishing point in order to give the illusionistic appearance of buildings in painted stage scenery was being developed over four hundred years earlier by the Greeks Democritus of Abdera and Anaxagoras.

The theoretical treatise that had the most significant effect on the development of linear perspective was Euclid of Alexandria's *Optica* of around 300 B.C., in which the laws of geometry were applied in an investigation of the process of seeing. Euclid introduced the notion of straight visual rays entering the eye at the apex of a visual cone. This work led to the first practical account, by Leon Battista Alberti in around 1435 in his treatise on painting, of its application for artists in constructing images with linear perspective.

Among the theorists who developed Euclid's work was Ptolemy, whose *Optica* of around 140 A.D. introduced the idea of the central visual ray (see p.355) and whose *Geographia*, which was not to reach the West for another 1,250 years, was the first account of how perspective may be used in mapmaking to make a two-dimensional version of a three-dimensional (spherical) form.

Illusory space In the meantime, the development of the use of perspective in practice can be seen in examples of Greek and early Roman art, where a form of axonometric projection, in which the sides of an object perceived in depth are angled but do not converge, was used in conjunction with an empirical parallel perspective to give a degree of spatial realism. The "Room of the Masks" in the House of Augustus on the Palatine in Rome of the mid to late 1st century B.C. is an excellent example of the attempt to create a convincing architectural setting on the two-dimensional wall.

In most examples of this kind, the art of representing an illusory space seems to be seen as an art in itself, rather than as the means of making what actually happens in the scene more convincing. John White, writing on perspective in 1957, points out that the later development, leading up to the Renaissance, is no mere secular

decoration as is found in Pompeii, but a commitment to the convincing expression of religious history. In fact, after the Roman period, the use of perspective died out for almost 1,000 years.

The Room of the Masks (mid to late 1st century B.C.) The shallow dimensionality of the painted architectural elements makes the illusionistic effect particularly striking.

The revival of perspective

The "disappearance" of perspective in art is paralleled in the theoretical writings by a similar gap. The important Arab work on optics, *Perspectiva*, by scholar Alhazan of around 1000 A.D., which was to reach Europe in the 1100s, brought together most of the early writings and introduced new ideas relating to the passing of light rays through the eye to the curvilinear shape of the cornea. The revival of interest in optics, especially in relation to Christianity, became significant in the 1200s with the writings of English scientist Roger Bacon in his *Opus Majus*. His ideas were disseminated in the popular *Perspectiva Communis* of fellow Franciscan John Pecham and a century or so later in Italy by Blasius of Parma (*ca.* 1345–1416).

Toward a central vanishing point
In art itself, the move toward a single vanishing point, central-linear perspective system was gradual. The Italian artist and architect Giotto (1267–1337) was one of the first artists to bring a sense of spatial unity to his compositions in a way that was recognized by his contemporaries as being completely innovatory. At around this time, the development of vanishing axis perspective, in which separate vanishing points were used to create a symmetrical arrangement of parallel edges linking on a central vertical or horizontal, allowed the "interior" rectangular space represented in a painting to be slightly flattened, or opened out so that more of the sides, top, and bottom could be seen.

Ambrogio Lorenzetti

A developing sense of perspective

This townscape section from a fresco from the Sala del Nove, in the Palazzo Pubblico in Siena, shows a profound empirical, if not scientific, sense of perspective in its treatment of architecture.

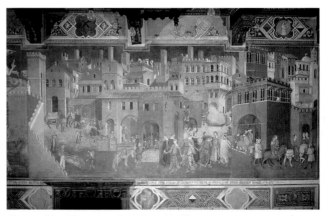

Allegory of Good Government in the Town (detail) (1337–39), AMBROGIO LORENZETTI

Brunelleschi's experiments with central perspective It was not until 1425 that Italian artist and architect Filippo Brunelleschi demonstrated a central perspective system in which all the orthogonals converged to a central vanishing point that depended on the fixed viewpoint of the spectator. His panels, depicting the Baptistry and the Palazzo Vecchio in Florence, were designed to be seen in a mirror through a peephole in the panel corresponding to the vanishing point of the painting.

The idea of central perspective caught on rapidly among the painters and relief sculptors of the day, and Masaccio's *Trinity* fresco in Santa Maria Novella of around 1425 (see right) is one of the finest examples of a work whose structure is entirely planned according to artificial perspective. Here, however, the figures are not drawn in strict accordance with the perspective of an architectural structure that does conform to a single viewpoint. This is a feature of many works of the time where it was clearly much easier to establish the geometry of perspective with architecture than it was with the human figure.

By 1436, the application of linear perspective in the making of paintings was ready to be formalized in the treatise of Florentine architect Leon Battista Alberti, whose method of constructing perspective is shown on p.354.

The conventions of central perspective With a single central vanishing point, the problem of the position of the viewpoint becomes critical. For a square interior space, for instance, if the scene is pictured from too close, then the width of the "walls," "ceiling," and "floor" will be too dominant. If viewed from too far, they will barely show in the painting. An average and commonly used distance from the picture plane is around one and a half times the width of the image. The newly discovered system, articulated by Alberti a decade or

Masaccio

Using artificial perspective
This is an outstanding early example of artificial perspective in which Massacio uses a central vanishing point at eye level to open up the vaulted architectural space behind the figure of Christ.

Trinity Fresco, Santa Maria Novella, Florence (ca. 1425), MASACCIO

so after Brunelleschi's experiments, meant that for Renaissance artists, the illusion of space could more tangibly be represented on a two-dimensional surface than ever before. Since the eye of the spectator would inevitably be drawn in by powerful orthogonals, it was possible to make this a more subtle process by intercepting it with the undistorted frontal planes that work so well in this system. These could be placed at various carefully designed stages to guide the eye around and into the depth of the painting. The vanishing point might be concealed behind an object toward the front or at the back of the image. It might be set behind the face of a figure looking directly back at the spectator, or it might simply be on the distant horizon visible through the architecture of the painting.

The conventions of central perspective were both liberating and, to some extent, restricting. Liberating because, for the first time, painters could articulate an utterly convincing illusionistic space within which the religious drama could be enacted and this gave considerably more credence to the depiction as a "real" event; but restricting because, to work effectively, the system demanded

a fixed viewpoint that was often not the one from which it was, in practice, possible to view the work. In addition, as Leonardo was later to point out, there were anomalies in a system that took no account of vertical or lateral convergence.

The new Renaissance system, however, placed the individual at the center of a new world of objective truth—a world that could now be accurately depicted according to a simple system of measurement and proportion.

How artists approached central perspective Contemporary artists approached artificial perspective with some pragmatism. They incorporated it when useful to do so but were prepared to be flexible. John White says of Florentine Renaissance artist Paulo Uccello, for instance, that he continued to use shifting vanishing points long after he had mastered artificial perspective. It is ironic that Uccello, who was much occupied with the theory of perspective, should have created works like the fresco of *Sir John Hawkwood* and the *Deluge* in Santa Maria Novella—both based on careful and accurately drawn perspective but containing elements not compatible with the scheme.

The treatise of Alberti

Alberti postulated a pyramid of visual rays from the object to the eye. The central visual ray—"the prince of rays"—passed to the eye through the center of the pyramid at a given distance. What was pictured on the intersection was exactly proportional to the objects seen according to Theorem 21 of Euclid's *Optica*, which states that if a straight line intersects two sides of a triangle (at any point) and is parallel with the third, then the two triangles will be in direct proportion. Thus all shapes that are parallel with the picture plane can be accurately represented with no distortion and in perfect proportion.

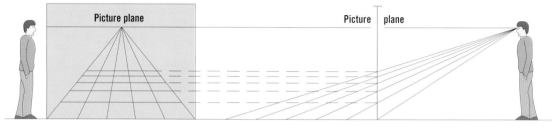

Alberti's principle The method of constructing perspective in a painting was to draw a rectangle for the picture area (the picture plane) and decide how large a figure was to be relative to it. The height of a man was to be divided into three parts proportional to a *braccio*—one *braccio* was about 23in (57cm). Having established what the scale of a man was to be on the painting, the base of the painting rectangle was marked off in *braccia*. A central vanishing point, called a "centric point," was established in the center at the height of a man's head (three *braccio* up, to scale) and lines (orthogonals) were drawn to this point from the points on the subdivided base line.

The positions of the receding transversal (or horizontal) lines could be established by taking a side view of the picture plane, establishing the height and distance of the eye from it, and drawing lines to the divisions in *braccia* of the pavement on the ground plane. Where the lines intersect with the picture plane marks the height of the horizontal transversals.

Making perspective drawings

The first of many books to deal with the practical construction of perspective drawings, *de Artificiali Perspectiva*, was published in 1505, by Jean Pelerin (or Viator). He introduced the idea of both central and diagonal vanishing points, the latter being used to accurately position objects that were at an angle from the picture plane. In 1600, Guido Ubaldo del Monte wrote that the vanishing point of any line on a plane could be determined by drawing a line parallel to it from the eye to the picture plane. Any number of vanishing points could then be used as required. In 1636, French writer Girard Desargues in his *Manière Universelle* introduced the idea of a vanishing trace or axis from which vanishing points could be determined for the different sides of a sloping surface on a single plane. So by the mid-1600s, a three-point perspective system had been developed that enabled any object with a plane surface at any angle to the picture plane to be accurately depicted from a fixed viewpoint. By the end of the century, the use of perspective had become so confident that it was possible for a brilliant perspectivist like Padre Andrea Pozzo to produce his quite astonishing *The Glory of St. Ignatius* (see p.344). The task of transferring the accurate scale drawing to a barrel vault of such a size was extremely arduous.

Linear perspective and other systems

Our experience of natural perspective can be compared to the more limited vision of space in the application of artificial or linear perspective. The rules of linear perspective limit the viewpoint to that of one fixed eye. They are based on the idea that objects of similar size appear to get smaller in proportion the further away from the eye they are.

An image is created as if drawn on a flat sheet of window glass (the picture plane) set up between the artist and the subject. This "window glass" concept of an intangible, yet psychological, barrier introduces a notion of separateness that underlies the conventions of linear perspective, so that for the observer, there is a sense of "looking in," rather than of "being in" the projected space.

Moreover, the geometrical constructions upon which it is based limit the representation of all horizontals and verticals parallel with the picture plane to straight lines, whereas, in reality, they are experienced with varying degrees of curvilinear distortion.

The synthetic, or curvilinear, system was articulated in his writings by Leonardo da Vinci, and many artists before and since have used it in varying ways as an approach to the more encompassing depiction of space (see p.356). A number of orthographic, axonometric, and isometric projection systems are commonly used by architects and are recognizable in a more primitive form in most arts from the periods before the development of linear perspective. These are not strictly perspective systems at all, since they do not set out to show objects receding into infinite space, but rather to give as much clear information about a three-dimensional object as can be projected onto a single plane. This more conceptual method of organizing space has found favor with many modern painters.

Possibly the single most important practical advance in recent years has been the computer software systems that enable artists with little knowledge of geometry or mathematics to make complex perspective drawings for their work, using any of the above systems.

Linear perspective—some basic concepts

One way of illustrating the basis of linear perspective is to imagine that a spectator is looking from a fixed position at a fixed object through a rectangular window—this "window-pane" is known as the picture plane. The windowpane corresponds with the surface of the drawing or painting. Rays of light from the object converge on the eye, passing through the window at points that could be plotted. If these points were joined up, an accurate image of the object could be obtained. The basic terms described below are based on this premise.

Basic terms The bottom edge of the picture plane is the ground line that marks the closest edge of the ground plane that stretches to the horizon line. The position of the horizon line corresponds to the eye level. If you were standing on top of a cliff, the horizon line would be higher up the picture plane than if you were standing at the foot of it.

The position of the eye is known as the station point, and from that point the central visual ray or center line of vision is an imaginary line to the horizon at 90 degrees to the picture plane. It intersects the horizon line on the picture plane at the center of vision.

The diagrams below illustrate the principle of rays of light traveling in straight lines from an object to the eye of the spectator. The point at which the rays of light pass through the picture plane establishes the position of the image on a drawing or painting.

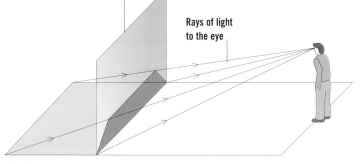

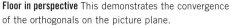
Floor in perspective This demonstrates the convergence of the orthogonals on the picture plane.

Position of picture plane The picture plane can be moved closer to the subject or to the spectator. This will change the size of the subject in the drawing or painting.

The rules of linear perspective

The three main rules are:
- Any plane parallel to the picture plane retains its shape without distortion and only diminishes in size. Thus vertical lines remain vertical and horizontal lines parallel to the picture plane remain horizontal
- All parallel horizontal lines converge to vanishing points on the horizon line. Those at right angles to the picture plane converge to the center of vision.
- A line drawn from the eye or station point parallel with any line or set of parallel lines on the subject will locate the vanishing point for that line or lines at its point of intersection with the picture plane.

Establishing vanishing points

Linear perspective relies on the simple fact that objects appear to diminish in size in direct proportion to their increasing distance from the picture plane. With a simple object like a box, which has two sides parallel with the picture plane and two sides at right angles to it, the two sides at right angles will appear to converge at a point on the horizon known as a vanishing point. Any line that recedes in any direction and on any plane can have its vanishing point established.

A vanishing point can be used to determine the relative size of an object anywhere behind the picture plane and, in addition, to measure distances along lines that travel to a vanishing point. To establish such distances along a particular vanishing line, a measuring point can be marked by describing an arc, using the vanishing point as center and taking a radius to the station point (the eye). This will cut the horizon line at one side of the center of vision. A line from this point to measured points on the ground line (or picture plane) will cut the vanishing line at the appropriate places.

One-point perspective Allows you to put a cube in perspective when one of its planes is parallel to the picture plane. All lines converge to a central vanishing point.

Two-point perspective Allows you to put a cube into perspective when two of its planes are at an angle to the picture plane.

Three-point perspective Allows you to put a cube into perspective when three of its planes are at an angle to the picture plane.

Where an object has planes at oblique angles to the picture plane, on ascending or descending axes, for instance, it is possible to locate their vanishing points, not on the horizon line, but on vanishing traces or axes above or below it. Lines may then be projected from these ascending or descending vanishing points.

Leonardo da Vinci's curvilinear system

Leonardo da Vinci was the first to point out the anomalies of the grid system of constructing a perspective (*Costruzione Legittima*, as outlined by Alberti). He drew a diagram of the plan of three cylindrical columns along a straight line parallel with the picture plane, and showed that if lines were drawn from the edges of these to the eye on the picture plane, the two outside columns would appear wider than that in the center.

Leonardo went on to develop a system of perspective that attempted to allow for the fact that images received by the eye were subjected to a curvilinear distortion. His synthetic perspective system represented a departure from the tenets of artificial perspective in a number of ways. It

suggested that natural perspective was more accurately represented as being curvilinear in all directions from the point closest to the eye on the plane surface. Rather than the size of objects diminishing in direct proportion to their distance from the eye, the size in fact depended on the visual angle—the wider the visual angle the greater the distortion. As with the earlier system, all orthogonals converged to the vanishing point in straight lines.

It seems that Leonardo never put his system into practice. It remains, however, one of the more interesting alternatives to most of the systems that rely on straight verticals and horizontals and it conforms more accurately to the natural experience of perspective.

Leonardo's illustration of curvilinear perspective On the plan of three columns on a line parallel with the picture plane, lines drawn from the edges of the columns to the eye show that the two outer columns will look wider than the center one. But if the rays from the columns are drawn on an arc centered on the eye, each is the same width.

Implementing Leonardo's system

As an experiment, try making a drawing of everything within your field of vision, even those areas at the very edge. This includes your hands and the drawing board. What generally emerges is a drawing that, in order for everything to be included, has the appearance of a photograph taken with a wide-angle or fish-eye lens, in which vertical and lateral convergence bends and distorts what we think of in the abstract as being straight lines. More than any other approach, this gives the impression of the observer being drawn in, or being part of the scene represented.

There are obvious problems in this system, the main one being that if you are working within a conventional rectangular format, it may be awkward to relate the image to the frame. Some artists who appear, at least empirically, to have adopted a more curvilinear approach to perspective, have solved the problem with specially shaped canvases.

In natural perspective, the curves are very gentle, so that, generally, observers are only made aware of them when an unusual or unexpected image is perceived. An excellent example given by writer Laurence Wright is the image of the contrails of squadrons of fighter planes, whose straight flight paths, seen from below, gave the impression of a "domed birdcage."

Wide-angle view This simple sketch encompasses an extremely wide angle of vision. This can generate a real sense of involvement and of place.

Other aspects of perspective

Among the many other aspects of perspective of particular interest to artists are the changes in tone and color brought about by atmospheric perspective—the corrective adjustments (counter perspective) that allow for the effect of perspective when making large-scale wall paintings that are viewed from the ground—and anamorphism, a form of perspective designed for oblique viewing angles.

Atmospheric perspective

Atmospheric or aerial perspective describes the lightening of tones and the cooling of colors as they recede toward the horizon. We have all seen how, on a slightly misty morning, a landscape appears to recede in a series of flat planes of reducing tone and bluish color. Artists need to be aware of these effects in order to give a sense of depth to their work.

Counter perspective

Of particular interest to artists who may be commissioned to work on large vertical walls is the notion of counter perspective. This is brought into play to counteract the fact that images painted the same size up a vertical wall will look progressively smaller, since from a fixed viewpoint the same angle of vision will take in more of the subject as the view is directed upward.

The most famous and often-quoted example of counter perspective applied to architecture is the Campanile of Santa Maria del Fiore in Florence, designed by Giotto. Each section of the tower as it rises is built taller than the section below it, so that the effect from a fixed low viewpoint is of balance and symmetry rather than of acceleration. In practice, of course, the further from the image the spectator can be, the less perspective correction would need to be applied. But from close up, the amount of correction needs to be quite dramatic.

Accelerated perspective

This is the opposite of counter perspective. It is used to increase the effect of perspective rather than diminish it—often in the theater, where an illusion of great depth needs to be sustained in a relatively shallow space. The combination of an upward-sloping stage and inward-sloping scenery, following a skilfully coordinated artificial perspective system with illusionistic painting, allows the audience to enjoy a convincing illusion.

Anamorphism

An image drawn from an extreme oblique angle to the picture plane will, when viewed from a central position, have an elongated and very distorted appearance. It may only be seen correctly from the original oblique viewing angle. One of the most celebrated examples features in *The Ambassadors* by Hans Holbein the Younger, where a strange shape at the bottom of the painting only resolves itself into a skull when the spectator stands at one side of the canvas and looks across it (see p.332).

Transferring an Image

MOST ARTISTS KNOW THE SYSTEM OF measuring angles and distances between areas of a subject that involves aligning the pencil at arm's length with the subject, turning it to get the correct angle, and measuring with the thumb along its length. This "rule of thumb" method of getting correct proportion and scale is surprisingly accurate. There have, over the centuries, been many other methods of helping the artist to make a faithful representation of the subject. These have ranged from simple cardboard finders to digital projection systems.

Painting and drawing aids

Observational drawing from life is integral to the work of most artists, but there are times when all you need is to get the outlines of an image as simply as possible onto a painting surface. This may be the transfer of an existing drawing or it may be an image from life. There are a number of ways of doing this, ranging from simple tracing or grid systems to more complex mechanical or electronic methods.

Tracing

To transfer an image from a drawing to a canvas of the same size, it can simply be traced. If the original drawing has a fragile surface (chalk or charcoal, for instance), a sheet of acetate can be placed over it before the tracing paper or film is laid on top. The original should be taped to a flat board and the tracing paper or film taped down on top. Matte drafting film is dimensionally more stable than tracing paper, but more expensive. A harder pencil can be used on drafting film than on tracing paper, because it is so receptive to the graphite lead.

In order for it to appear the right way around, the image will have to be redrawn on the back of the tracing paper before being traced onto the canvas. If the original image is on thin paper, this can be avoided by using a light box (see below).

If the tracing is being transferred to a panel or stiff support, the lines will show after tracing, but on a stretched canvas, this can be more difficult. You can either stretch the canvas on a flat wall in order to trace onto it or, if it is already on stretchers, you can insert a piece of hardboard between the back of the canvas and the frame while tracing.

Tracing on a light box

Place the original face down onto the light box. You will be able to see the image in reverse through the thin paper. Place the tracing paper or drafting film on top and draw the outlines in the normal way. Your tracing is a reverse image and so can be rubbed down immediately onto the new support and without having to be redrawn on the back. (You can make a reverse image copy of an original drawing in some photocopiers or by scanning it and reversing it in a computer.)

Using a grid

This is a time-honored method of transferring the outlines of an image to whatever scale is required onto a new support. Squared grids are drawn both on the original drawing or reference image and on the support on which the copy is to be made. If the copy is to be smaller, the grid is diminished in size, and if it is to be larger, the grid is enlarged. If you do not wish to draw a grid directly onto the original image, you can draw a grid onto a sheet of transparent acetate using an indelible felt-tip pen and then tape the acetate over the original. You then refer to the grid on the original sketch or reference image and plot the outlines of the original, square by square, by means of the grid on the new support. This can be done either loosely by eye or by marking the crossing points of lines on the perimeters of the squares and subsequently joining them up. To facilitate the drawing, the squares may be lettered down one edge and numbered along another in the same way on both the original and on the new support.

To transcribe more closely worked areas of the original, the grid can be subdivided in these particular areas.

Technique Using framing devices

A framing device establishes the boundaries of the image to be represented and it is remarkable what an immediate difference this can make in enabling you to see what goes where on the canvas. Such devices are usually rectangular, though they could be made in any shape as long as it corresponds to the shape of the canvas.

Cardboard viewer and finder

The simplest method of locating a subject within the rectangular frame of the canvas or paper is to cut a similar shape to that of the canvas out of the middle of a small piece of cardboard or stiff paper. This is then held at an appropriate distance from one eye and a composition is established. It is a straightforward matter to mark off on the edges of the cardboard viewer or "finder" the height or distance of parts of the subject. These marks can be simply transferred to the edges of the painting and the composition can be more easily drawn out. It can be referred to through the finder and the progress of the drawing assessed. Such small devices are easily made, though they have in the past been commercially available as "sight measures" with one moveable edge to establish the correct proportion of the canvas or paper before it is held up in front of the subject.

Portable grid

The portable grid, or "screen frame," is an open frame on which a grid latticework of thin black wire has been stretched. The frame is set up on a couple of strong, vertical poles pushed into the ground. The artist works on a support that has the same proportions as the frame and with an identical grid of vertical, horizontal, and (two) diagonal lines drawn onto it. The subject is viewed through the frame and its features are drawn into the corresponding areas on the grid on the drawing surface. Albrecht Dürer used such a device, as did Van Gogh, who had such a frame made for him by a blacksmith and illustrated its use in a letter to his brother.

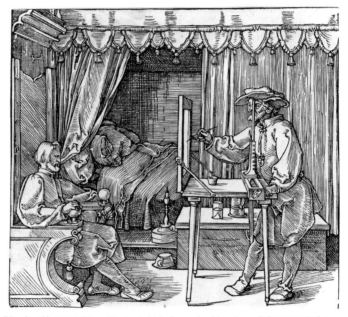

Dürer's grid system Dürer illustrated his framed grid system. It incorporated a vertical sighting rod to establish a fixed viewpoint. The artist looked from this point with one eye through the grid toward the subject and transferred what was seen to the drawing.

Tracing frame

In a variation of the apparatus described above, a pane of glass is set up in front of the subject. By keeping to the same, fixed, one-eye viewpoint, the artist is able to draw the image directly onto the glass screen. This should be done using a waxy or fatty material, such as all-purpose pencil, that will stick to the glass. The image on the glass can then be transferred to a canvas or paper support by tracing, by the grid method, or by applying a sheet of damp paper onto the glass.

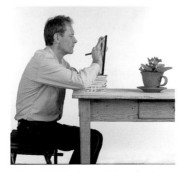

1 Hold the framed glass firmly. It should not move while you are drawing. Look at the subject with one eye only.

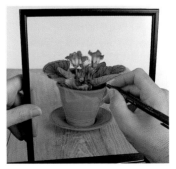

2 Using an all-purpose (wax) pencil, trace the outlines of the subject onto the glass. Then transfer the image to your paper or canvas.

The Claude glass or reducing glass

One method of framing an image or arriving at a suitable composition, which was widespread in the 1700s and 1800s, was the use of the Claude glass—named after the 17th-century painter Claude Lorraine. This was a small, tinted, convex mirror that reflected a reduced image of the landscape. The mirror could be held, hung from a tree, or stuck in the ground and the reflected image could then be drawn. Landscape artists would effectively be painting a scene with their backs to it. The Claude glass with its dark, monochromatic tint had a significant and not altogether beneficial effect on landscape painting. John Ruskin reviled the predominantly brown color of French landscape painting in the 1850s, which, he said, showed the pernicious influence of the Claude glass.

Claude glass is not so common nowadays, though mirrors continue to be used in the studio. One reason for having a mirror is to look at the progress of a painting in it from time to time. This was an excellent tip that Leonardo da Vinci gave in relation to portrait painting.

You do not realize just how much you can get used to an image while working on it and how you are unable to see it with fresh eyes until you look at it for the first time in a mirror. Then you immediately know which areas need adjusting.

Technique Drawing from projected images

There are various long-established methods of projecting images that enable the artist to trace them directly onto the paper or canvas. Devices such as the camera obscura, the camera lucida, and the graphic telescope were very popular with 19th-century artists, although they were often somewhat clumsy and difficult to use. Nowadays, electrical or digital forms of projection, such as slide projectors or digital projectors, are most commonly used.

The camera obscura

In his recent history of the camera obscura, John H. Hammond describes how the creation of an inverted image by means of a pinhole in a screen was recorded as early as the fifth century B.C. by the Chinese philosopher Mo ti, and how in the fourth century B.C. Aristotle noted during an eclipse how images were formed when rays of light passed through tiny apertures—in this case, the spaces between leaves on a tree. But it was not until the 1500s that inverted images produced in darkened rooms by the "pinhole camera" effect began to be explored by astronomers. In fact, the earliest recorded image of a camera obscura is by the Dutch astronomer Reinerns Gemma Frisius, who illustrated an eclipse of the sun at Louvain on January 1st, 1544, in his book *De Radio Astronomica et Geometrico* (1545) (British Library). It was not long before lenses were being exchanged for the pinhole, and portable screens for viewing the image, which could be moved into focus, were set up. In addition, the use of mirrors was developed to make the image upright. By the 1600s, there were many portable camera obscuras in existence, and by the 1700s, they were widely known and used by artists. Sir Joshua Reynolds, who owned a portable book form of the instrument, considered that looking at Dutch painting was like looking at life through a camera obscura.

Later versions By the late 1700s and early 1800s, there was a great vogue for the instrument and home boxlike versions were constructed on the sedan chair principle. Also, tent varieties were very popular because they were so portable. The artists could set up the camera obscura in any situation and, provided that the interior was kept very dark, an accurate and focused image of the scene would be projected onto the paper or canvas. Right up to the 1800s, camera obscuras were referred to as philosophical instruments, giving instruction on sight and on the nature of the association between the eye and the brain. They were also, of course, extremely useful to artists. Their limitations were that they usually needed a great deal of light to work well, but that they also needed to prevent light from getting in. They were generally not particularly portable and there was a limit to the size of paper that they would take.

Toward the end of the 1700s, camera obscuras had been developed with lenses that were able to concentrate the light on the projected image. The 18th-century English writer Horace Walpole wrote with great enthusiasm about a camera obscura provided by English instrument maker William Storer, which apparently worked as well by candlelight as it did in the full light of day.

Camera obscura
This was concealed in the shape of a book.

Camera obscura
The tentlike variety allowed the artist full access.

The camera lucida

The camera lucida—the most widely used drawing aid in the 1800s—was invented by English scientist Dr. W.H. Wollaston in 1806. It dispensed with the necessity for total blackout. It was a simple prism on a stand with an additional lens to control short or long sight. An eye piece over the prism enabled the eye, from a fixed position over it, to look down a small hole rather than at the whole face of the prism. The artist could see the subject of the drawing directed down onto the paper and the outlines could then be traced. The method is precarious and it is easy to lose sight of the image, and the pencil moves tentatively, giving a somewhat tenuous line quality. Basil Hall, a naval officer who traveled in North America in the late 1820s, used a camera lucida to make drawings from which etchings were made and published in 1830. They have an extraordinarily real but very dull feel. Indeed Basil Hall made the point that if someone did not have an aptitude for drawing, the use of the camera lucida would not improve their skill.

Camera lucida
However elegant it looked, the camera lucida was a tricky instrument to use.

The graphic telescope

In 1811, English artist Cornelius Varley invented his superior system of projecting the image of a subject onto the drawing surface. As with the camera lucida, the eye piece deflects the image down onto the drawing table but, by the expert use of good lenses, a far clearer image than that obtained with the cameras obscura and lucida was had and, in addition, a far greater range. By using lenses of different focal length "any person, who can make a good outline, may draw, correctly, all kinds of objects, the most distant, as well as near, magnified to any scale, from five to twenty, forty, or sixty times their apparent size."

Portraits could be drawn, or the instrument could reduce, enlarge, and reverse a drawing for the engraver.

The development of photography meant that the use of such instruments declined, to be replaced by photographic sources of reference if such were required. Nowadays, there are a variety of machines the artist can use to project an image onto the canvas.

Graphic telescope Varley's instrument was a great improvement on the camera lucida in allowing the artist to change the scale of the subject.

Episcope or epidiascope

This projector allows flat artwork to be placed under a glass and projected up to any size, depending on the distance of the projector from the canvas (the instruments usually have fixed-focus lenses). Like the camera obscura, which it resembles, it does not have very good illumination and has to be operated in a darkened room for the image to be seen at all. In addition, even the best machines only allow a small original image to be seen at once, so that a medium-sized drawing on 11 x 13 inch paper, for instance, would generally have to be projected a quarter at a time.

Slide projector

A solidly constructed slide projector is a very efficient and versatile device for projecting a transparency of an image or an original study for a painting onto the canvas itself. The variable focal length zoom lenses that allow an image to be enlarged or reduced with the projector in the same spot are extremely useful. In a cramped space where a large image is required, a wide-angle lens may also be used. The projector will allow the image to be reasonably clearly seen in a shaded room without the necessity for blackout facilities. It should be kept on a solid base to avoid losing the correct position of the image. If the image moves, it is difficult to return it to the right position. The canvas, too, should be rigidly supported. When drawing out an image in this way, the artist should stand to the right or left of the image so as not to obscure it.

Digital projector

A digital projector allows you to project an image directly from your computer, so if you have scanned in a drawing to work on it, or originated the image digitally, you do not have to go through an additional stage of making a slide in order to project it onto your canvas. Digital projectors are expensive but versatile. They are essential for artists making art in projected image form or in time-based media. There are different technologies, the most common being liquid crystal display (LCD). The most recent technology is digital light processing (DLP), which gives a brighter, clearer image. The quality or resolution of the image is determined by the number of pixels (picture cells) and the brightness in lumens.

The Studio

THE IDEAL ARTIST'S STUDIO WOULD BE LARGE, warm, and suffused with north light from a high window. A high light source prevents unwanted shadows and the northern orientation prevents direct sunlight from beaming awkwardly across a painting. Large paintings can be moved in and out with ease and stored in a separate area.

Making the best of the conditions

In practice, most artists have to work in far from perfect conditions. Even so, certain criteria should be considered when setting up a studio. These include the physical appropriateness of the space for your work and how it is lit, heated, and ventilated.

Light

The type of light in which a painting is viewed has a great influence on its appearance, so this must be considered when the picture is being made. Natural light allows colors to be perceived with clarity in their true value, but when the painting is sold it may well be displayed in artificial light, which would transform its appearance.

Unfortunately, there is usually no way of knowing in what conditions a finished work is likely to be displayed. Ultimately, you must decide the type of light by which you prefer to work, though this may, in part, be dictated by imposed factors. The many artists who like to work on into the night have no choice but to rely on artificial light.

If working by daylight, you may need to make some adjustments. If a studio lets in shafts of sunlight, the best method of diffusing it is to install thin, white, translucent roller blinds that can be pulled down easily when necessary. A less expensive alternative is to tape translucent drafting film over the window panes. Tracing paper or tissue paper could also be used in this way. Thin curtains will only partially diffuse the light.

If using artificial lighting, the best kind for a constant and uniform studio light is probably the standard fluorescent tube. The "color temperature," measured in degrees Kelvin (K), designates the warmth or coolness of the color. "Artificial daylight" lamps are available with a color temperature of 6,500K that corresponds to that of natural light. In practice, however, these lamps give a somewhat cold, gray atmosphere to a studio and also to a museum, where conservators have opted instead for a lamp of intermediate color temperature, between daylight and tungsten light, of around 4,000K.

Tri-phosphor or multiphosphor lamps are particularly efficient. The amount of light these give out at various wavelengths stays stable for around 6,000 hours. Furthermore, the amount of light they supply per watt of electricity (lumens/watt) is particularly high, which means they are very economical.

Tri-phosphor and multiphosphor lamps are also particularly suited to studios in which the artist is making large-scale works and requires a constant overall light level. There are, of course, artists who work on a very small scale—making wood engravings or painting miniatures, for instance. Here, a small spotlight on an adjustable bracket will give a pool of light within which the piece can be worked. Indeed, such a set-up can greatly assist concentration if the rest of the studio is kept in relative darkness.

Heat

It is very difficult to work in cold conditions, but a large, badly insulated space is expensive to heat and it is often better to concentrate the heating close to the working area. Portable paraffin and gas heaters provide a good localized source of heat. You should be fully prepared for the fire risks associated with such heating. For studios with large ceilings, toward which the heat escapes, a ceiling fan set at a slow speed will recirculate the heat quite substantially. Installing insulation will also have a positive effect.

Ventilation

Any artist who works with organic solvents such as turpentine or paint thinner should be aware of the health risks that arise from their misuse and should always observe sensible safety precautions (see p.370). Aside from using only very small quantities at a time, and keeping containers sealed as much as possible, the room in which they are being used should be well ventilated, to allow any accumulated solvent vapor to disperse. You should have an extractor fan set up where you are using organic solvents.

Walls and floor

Most artists prefer to paint all the studio walls in a neutral color, such as white or gray, which does not unduly affect the appearance of the color on the canvas.

Artists who work on very large canvases often stretch the canvas on a studio wall and paint it there rather than stretching it directly on a wooden frame. Most studios have a "painting wall" on or against which most of the work is made. A fake wooden wall may be made by attaching a horizontal/vertical framework of wood to the wall and screwing sheets of ½in (12mm) plywood to this. This gives a uniformly flat surface to which canvas may be stapled. With a plastered wall, a stretched canvas has to be attached with masking tape. This is not very effective.

The floor should be kept swept if the studio is being used for painting, since dust will stick to wet paint and varnish films. Flat wooden floorboards provide a suitable backing if you wish to stretch canvas on the floor. However, if you prime and paint the canvas on the floor, any gaps where planks abut can cause lines to show on it.

Sink and draining board

A sink and draining board are essential for cleaning items such as brushes and for cleaning up after working. Bear in mind that any excess paint should not be washed down the sink into the main drains, but cleared away separately.

Storage

Ideally, the storage of paintings and the storage of equipment should be in separate areas and should themselves be separate from the painting area. You may also wish to have a separate drawing area or an area for smaller works. Dividing up the studio in this way increases the efficiency of the space and makes clearing up much easier. In practice it is never so easy to keep these areas apart.

Storing materials and equipment

If possible, every piece of equipment should be allocated a particular space on a wall, shelf, bench, or in a cabinet. The best method of protecting the hairs of brushes is to store them upright in jam jars or brush vases. Painting mediums, and especially organic solvents, should be kept in a high metal cabinet and well away from the reach of children. All bottles should be kept tightly closed at all times.

Storing paintings, prints, and drawings

A separate area may be designated as a storage space. Large paintings should be protected from dust by being wrapped with plastic—not just over the paint surface, but over the back as well. The corners should be protected with corrugated cardboard or proprietary corner protectors. These enable three or four similar-sized paintings to be stacked against each other.

Storage systems

A relatively simple wooden structure can be built to stack large paintings. This comprises a series of upright pieces of wood from floor to ceiling around 2½ft (75cm) apart, against which a small number of paintings rests. Another series of uprights a further 2½ft (75cm) in front of these can provide another stacking area. Between the two sets of uprights along the floor, some pieces of 2 x 2in (5 x 5cm) wood are bolted to ensure that the bases of the paintings are held off the floor. This assists ventilation and helps avoid dampness. If the ceiling is high, cross-timbers can be installed to provide further racking space for smaller paintings above the larger ones.

For paintings, drawings, and prints on paper, a plan chest with large, shallow drawers is ideal. Each drawing can be protected from the one above by being interleaved with an acid-free tissue paper. Or, a simple structure can be made with pieces of wood constructed in a similar way to pallets and stacked on top of each other.

Easels

Unless you paint your pictures against a wall, an easel is an essential piece of equipment, because it provides a secure platform for the canvas while you are working on it. Easels are available in two main kinds: studio easels and sketching easels. The former are large, heavy, and support large canvases. The latter are light, fold into compact, transportable pieces of equipment, and are designed to take smaller canvases and drawing boards. They can be used outside. Radial easels are strong enough to support relatively large canvases, but do not take up too much space and are easily packed away.

Exhibiting Work

However many times an artist's work is exhibited, the experience of seeing it properly presented, within the clear and ordered space of a gallery, is always exciting for an artist, as it enables the limitations and strengths of the work to be seen with great clarity, often for the first time. Most exhibitions are in galleries, though other venues for showing work are sometimes found, often by artists or groups of artists. Public art commissions also provide new opportunities for getting work seen by a wide audience in many different settings (see p.366).

Gallery exhibitions

It is a major achievement for a would-be professional painter to have a solo exhibition in a reputable gallery. Indeed, once an artist's work has been shown, further exhibitions become more likely. This is because the art world is relatively small and news of what is considered to be exciting new work travels rapidly around the circuit, so other galleries become eager to show the work, too. At any one time there are a number of galleries in the major cities around which there is a buzz of excitement and a sense that this is the place to see and to show new work. You may not consider that your work fits into this category, in which case you would need to find the kind of gallery that you think might be interested in the kind of work you do. Gallery directors each have their own methods of deciding which artists to show.

How work is chosen

Current enthusiasms in the art world play a part in determining which artists are shown. In addition, gallery directors are often guided by the recommendations of colleagues and other artists, or—much more rarely—they will decide to exhibit on the basis of a set of slides sent to them unsolicited by an artist. Galleries do occasionally get in touch with artists and request a set of slides or a CD, so it is vital that a good record of all work is kept (see p.276). If they are interested, they will probably suggest a studio visit, and if this is successful, an exhibition may be forthcoming.

Many young emerging artists have discovered that the most successful way of attracting attention to their unique work is simply to be around the contemporary scene, making art and mixing with other artists, critics, curators, and collectors.

Complementing the space A series of 60 "same-size" paintings, identically framed and equidistantly spaced, complement the long, elegant curve of the gallery wall.

One way of getting work seen is to submit it to important national open submission exhibitions. Although, statistically, there is only a small chance of being selected—it depends so much on the makeup of the selection panel—good work will always stand out. Such shows are seen by large audiences, they are reviewed, and they often go on tour, so an application is well worth considering. They also generally include a well-designed catalog featuring the work in color.

Kinds of galleries

There are very broadly two kinds of galleries: the privately owned and run commercial galleries and the state-sponsored public galleries. Artists may well begin their careers by showing in either one of these sectors and as they become more well known, move across to encompass both. The world of contemporary art is international and successful artists exhibit in galleries all around the world.

Independent/commercial galleries

Some artists become attached to commercial galleries who act as their agents. Such galleries may take a large percentage of the sale price of a work in commission, but they manage all aspects of the business side, including transportation, framing, and storage of artworks, publicity and exhibition costs, negotiations with prospective clients, invoicing, and accounts. They are professional dealers who understand the market, who know the collectors, and for whom the promotion of an artist's work is also in their own financial interest. Such an arrangement is ideal for many artists, enabling them to concentrate on their work without external pressures. Other artists like to remain independent, preferring to maintain their own control over their business.

State-sponsored galleries

Showing in museums or other state- or regional arts association-funded galleries is a different matter. The gallery may take a (much lower) percentage of the sale price and will generally take care of transportation, insurance, and publicity. It has responsibility toward the exhibition, and may organize a tour of other galleries, but the contract between artist and gallery ends with the return of the work.

Doing it yourself

Young artists often get started by finding venues of their own and curating their own group shows.

Such venues include empty office buildings or warehouses that the owners agree to be used for a short renting period. The artists take on the responsibility for all the publicity and marketing and they target key figures in the art world.

A number of artists, who have later become well known, have been taken up by commercial galleries following exhibitions of this kind. Such events are usually held in major cities where access is straightforward.

Planning an exhibition

If the exhibition is a group show, the hanging of individual pieces of work will generally be left to the selectors/curators or organizers. This is true for exhibitions of paintings or other portable works, though if the artworks are a series of installations for particular spaces in the gallery, the artist will take on the responsibility of setting it up, albeit with help from the gallery staff. For a one-person show of paintings, the artist usually decides on the distribution of the paintings within the available space. One-person exhibitions are generally planned well in advance—at least a year and often considerably longer—so that the artist has a

chance to get to know the space and decide on which works to include and where to put them. The effect of juxtaposing two paintings that use a very different range of colors can be detrimental to each and there are many aesthetic decisions to be made at this stage of the process. In many cases, the artist will create a work or a series of works with the particular gallery space in mind.

In both cases, it is customary for the artist to be given a ground plan of the gallery, drawn to scale. There may also be sets of elevations of the gallery walls. Such plans enable the artist to mark out existing or projected work to scale within the space. This can be particularly useful in giving an idea of the likely appearance of the show and of how the works will be perceived. Hence, the nature of the pictures is often determined, to some extent at least, by the features of the gallery in which they will be displayed. Some artists go to the trouble of making a small-scale model of the gallery into which miniature versions of their work, also to scale, can be tried out. This demonstrates the importance that artists attach to the influence of a particular space on their work.

Working to size This single work, which combines commercially printed photographic murals with painted and framed recreations of sections of them in acrylic on canvas, has been made to precisely fit a wall in a museum.

Public Art

THE AREA OF ART PRACTICE THAT DEALS WITH art associated with public spaces and the built and wider environment has come to be known as "public" art, though it could just as appropriately be called "commissioned" art. Public art has been known to carry with it the association that it is somehow a less rigorous form of art practice, which may be compromised by the constraints or the bureaucracy that seems to surround it.

At worst, it has been associated with the "add-on" or "afterthought" art that is added at the end of a development in order to satisfy a statutory planning obligation. But at its best, public art allows artists to bring a special vision and focus to a new set of circumstances. It enables artists to work creatively in areas that open up opportunities in almost every kind of practice. It allows art to breathe.

The practicalities

Although ideas and schemes may be developed to a certain extent within the self-contained world of the artist's studio, there is a great deal to attend to as regards the practicalities of working to a public commission. In the following pages, I have outlined some of the stages and the processes involved.

Sites
The range of sites for commissioned art is boundless and artists have created work in hugely varied settings, ranging from disused chapels to new hospitals, from extinct volcanoes and land reclamation sites to inner city developments and the tops of trees.

The artist as a member of a professional team
Art thinking has also come to be accepted as integral to major public schemes—in urban regeneration projects or environmental schemes, for example. The artist is an increasingly regular member of a professional team that includes architects, planners, developers, landscape architects, and engineers. The input the artist can have in such a situation can be significant and far-reaching. It is at the ideas stage that the artist very often has the kind of intuition that can take a scheme into new territory, helping to find a coherent vision that can inform and underpin a major project. With this role comes a professional responsibility and a commitment to a process that may at times seem arduous and nonproductive, but that will ensure that ideas are protected and developed appropriately at each stage of realization.

An important aspect of working in a team is recognizing that each member of the team has particular professional skills and expertise that you do not have, but that, through their contribution, allow your part of the work to proceed smoothly. For an artist used to working alone, this can be an extremely positive and helpful arrangement.

The selection process
The selection of artists for public art projects takes many forms. There may be an open competition on a national or international scale, from which a short list is drawn up. In many cases, there is a limited competition. The client will have been shown images of work by a number of artists preselected by a public arts agency, for example, and will then choose which artists to short-list. Once an artist has been short-listed and invited to make a proposal, it is up to that artist to demonstrate to a jury or panel the ideas and expertise that will convince them to make the right choice.

Submitting preliminary proposals
There are a number of ways of giving your proposal its best chance. The ideal way is to have a good idea and to present it well.

If the proposal is more in the way of a general concept or approach to a large-scale scheme, for example, it is extremely helpful to produce some specific examples of the concept in practice.

If the proposal is for a three-dimensional work, a three-dimensional maquette, or model, may well be more appealing than a two-dimensional representation of it. It is even better if the maquette can be made in the materials you are proposing to use for the artwork itself, or if you can take samples of the materials with you.

You can take digital photographs of the site and of your model, load them into the computer and, with basic image manipulation software, give an accurate representation of what the work will look like once it is installed. (See *Photography*, p.272.)

Many artists will be used to making sketches and paintings of their ideas, and this traditional method is still very attractive to many selection panel members, who may find the digital approach somewhat impersonal. Another danger about presenting a proposal with "photographic" accuracy is that it may limit your ability to modify the artwork while you are making it—though this depends on the nature of the work proposed.

If the proposal incorporates a technology that may not be well known to the panel, it is helpful to bring a working sample to the interview, provided that you can set it up with the least possible inconvenience.

Whatever the makeup of the jury, it is likely that there will be those who are less responsive to your ideas than others. Whatever the outcome, you need to speak to the strengths of your proposal as you see them and to be open and straightforward, especially if you are being given a hard time.

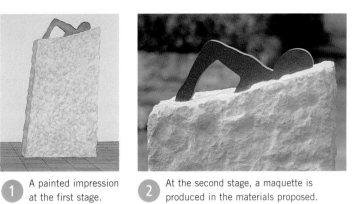

1 A painted impression at the first stage.

2 At the second stage, a maquette is produced in the materials proposed.

On the Crest of a Wave The completed sculpture in white Portland stone and sea green Kirkstone is sited at Dover Harbor, England.

Contracts

There is only space to make some broad observations here. For specific advice, you should consult your lawyer.

Once you have been awarded the commission, you will need to come to a written agreement with your client about roles, responsibilities, rights, and fees. The most important thing is not to rush into signing a contract because you are anxious to get the first stage payment. You may be presented with one of a number of "standard" contracts. None of these may be appropriate to the specific nature of your particular job. So before anything is drawn up,

it is sensible to meet the client and for each of you to draw up a list of all those things that you consider should be included in your agreement. When setting down conditions for a contract, you should not just consider your own position. You do need to protect your own interests, but you should also consider the arrangement from your client's point of view. It may be a new enterprise for them and there may be quite natural anxieties to deal with. You should clarify, clearly and specifically, what each of you expects of the other. As far as possible, you will need to assess the risks that may be attached to

the project. This will help you to avoid or transfer them.

Terms and rights Your agreement needs to give you a clear view of your obligations and you need to know that they are achievable and realistic within the timespan of the proposed project. You should not take on responsibilities and liabilities that you are not equipped to deal with, either professionally or financially. You need to be able to focus on what you do best and it is remarkable how certain responsibilities can be adjusted if you voice your concerns straightforwardly at the outset.

If you are dealing with the realization of work on a very large scale, for example, this may involve the commissioning of fabrication from a specialist company. If you are a solo artist and your client is a big organization, used to dealing with major contracts, it may be in your interest and in that of the client if the client commissions this aspect of the work directly from the fabricators rather than from you. During the process of fabrication, you would continue to make all the ongoing aesthetic decisions about the work in progress. This would be standard practice where the artist is a consultant member of the professional team including architects and engineers, working on a major new building, for example.

There are certain rights that you should retain. For example, you may sell the work itself, but you should retain your intellectual property rights in the work. That is to say, you should retain your copyright. If you do not do so, the client could be able to make physical reproductions of your artwork at will (as long as the copies are accurate in all detail). The last thing you want to see are clones of your original and, as you thought, unique, artwork appearing all over the place without your agreement. You would, of course, protect your client's ownership of your original work by agreeing not to make a copy of the work yourself and you would no doubt include a clause giving the client the right to photograph the work for promotional and other purposes. You would also need to retain your legal rights to be acknowledged as the creator of the work. It is not in your professional interest that the work itself should become universally known, while you, the artist, remain anonymous.

The work

There are various issues and responsibilities associated with the fabrication and installation of a permanent new artwork in a public place and artists need to be aware of these in thinking through the stages of a new commission.

Maintenance You need to ensure that once the work is completed it can be maintained to the same level of finish during its projected lifetime. This is one of the first things you need to look into at the outset of the project, to ensure that the specification is of a sufficiently high standard to withstand the conditions of use. You want the work to be worry-free for yourself as well as your client and you should always over-specify rather than leave yourself and your work exposed.

Allow for the unexpected In the area of public art, the artist is continually creating one-off original artworks for specific sites. So in many ways, every project involves a new prototype. In normal manufacturing operations, prototypes are tried and tested before a production line is set up. For the artist, the prototype is the work itself. There is clearly an element of risk in this and you need to give yourself some room to maneuver when you are putting together a budget for the work. Allowing for the unexpected relates to all aspects of the commission. During the course of a recent sculpture commission, for example, it rained heavily for a month before installation, leaving the normally hard ground so spongy that we had to have an expensive metal trackway installed to get the sculpture and the crane to the installation site. No one had anticipated this expenditure.

Consultation and progress It is essential that proposals for any major intervention in public areas should go out to consultation and that the local community and other interested parties should be able to express their views.

There seems to be more of a problem about this where new art is concerned. Indeed, there have been major arguments throughout the centuries, about proposals that may have initially attracted loud and bitter criticism, but have, after a period of time, been celebrated by and taken to the hearts of the very communities that began by despising them. There is no simple answer to this. Many fine artists who have worked at the height of their skills and with the best of intentions in the public domain have had their work reviled at one time or another. In itself, this is no reason for artists to change their way of working. The argument that art takes time to filter through is no justification for bad art, but there is a language of art that serious contemporary artists at any period of history are developing and it does take time to become absorbed into a culture. This is true of any major discipline. In the case of art or architecture, however, the results are particularly visible and cannot be ignored. But you cannot look over your shoulder when you are making art. You have to do the very best you can for yourself, with all the conditions surrounding a commission in mind. Your intuition, training, and experience tell you what it would be right to do and what you might need to hold out for, in order to protect an idea. These things also help you to carry your ideas forward to a community. This often involves countless meetings and a good deal of patient discussion, but there is some satisfaction in carrying an idea through to fruition often over a number of years and eventually to some sense of community celebration for what has been achieved.

Fabrication On many of the more major schemes with which an artist is involved, much of the work will be fabricated and installed by others. In such cases, it is never just a question of releasing a set of designs and waiting for the completed work to be installed. It is essential that the artist is available at all stages of fabrication and installation to assess one aspect or other of the work and

to make all the many specific decisions that are required during an often long and complex process. The difference this attention makes can certainly be influential in the success or failure of the work. Those involved in the fabrication are not going to be interested in someone throwing their weight around, but they are going to be able to tell if the work really matters to the artist. Where they are involved in something out of the realm of their normal work, it can be a matter of pride to do a great job and it is useful to have someone on hand with a clear image of the work in mind.

Installation In areas such as specialized external paving, vinyl flooring, or the incorporation of designs into a brickwork façade, for example, the process of installation is gradual and artist and public alike can accommodate to the emerging artwork. But for large-scale, external sculptures, for example, the work tends to be craned in on a single day. For the artist, this is a tense and exciting moment, as it is immediately obvious whether the position, scale, and finish of the work is appropriate to the site. You can have made as many computer visualizations as you like, but the reality is always quite different and special.

Celebration After a long, complicated, and sometimes difficult process toward the completion of a major project and one in which very many different people have been involved, it is good to mark the completion with some kind of celebration. This may be a long-planned event involving specialist community project teams, or it may simply be a ribbon-cutting exercise with a speech or two. A passing moment of congratulation is no bad thing, but you should then be prepared to field questions from a potentially hostile press.

Dealing with the Press

Art in public spaces has never had a smooth ride. There can be many reasons for this. It may be because it simply takes time for the public to catch up with a new idea or that the artist is caught in a crossfire in a political battle between two sides of a local or city council. Whatever the reason, you need some resilience when you find you are being called at all times by reporters who would like you to say something that might damn you,

the project, or someone associated with it. You simply have to be on your guard. Even if you are, you can find quotations ascribed to you in the national press although you did not say them. It is important to weather any such storm, and it is interesting to note that in the majority of cases what may at the outset have been hugely controversial, invariably ends up by being celebrated and protected.

Associated activities

Artists should be aware that at any one time there are certain ideas that are favored by funding bodies. So any commissioning agency or other applicant may be required to incorporate those ideas in their proposals in order to satisfy the requirements for funding. As a result, artists can often find qualifications attached to their brief.

These qualifications vary, but can often include the active participation of schools and local communities in the design process, or the mentoring of younger artists, for example. You need to establish and to be comfortable with your responsibilities in this respect before committing yourself to a commission.

Involving a local community

Problems with a local community most often occur where it is felt, often quite justifiably, that they have had no say in what has been, as they perceive it, foisted upon them. Where, for example, a straightforward single commission for a piece of sculpture has been proposed, there should be representatives from the local community on the selection panel. If four artists have been short-listed for this work and invited to prepare a maquette, it is good practice to exhibit the proposals locally, in order to keep the community informed, and to invite views and comments. The selection panel invariably works independently of this public voice, but it can provide helpful information. It is also helpful to establish a forum in which the community can be kept informed about the progress of the work at all stages.

Collaborating with children For this sign in a hospital, children drew objects that had a similar shape to certain letters. A banana became a "c," a spotted giraffe an "h," a fried egg with a vertical piece of bacon on its right a "d," and so on. The children had to use a method of creating imagery that could be translated into a new material for a permanent exterior work. So they were asked to make them as colored paper cutouts. This meant that these flat colors could easily be reproduced in the new medium.

HEALTH AND SAFETY, THE ENVIRONMENT AND THE ARTIST

Artists' materials from reputable companies should not present a risk to health when handled in the expected and correct manner.

However, health and safety commands an increasing level of interest and understanding. Art materials are chemicals and, as such, their manufacture, sale, use, and disposal are governed by constantly changing legislation, as more information becomes available. Unfortunately, there is no worldwide harmonization of legislation and this can lead to misunderstandings.

Labeling of Hazardous Art Materials Act (LHAMA)

The Labeling of Hazardous Materials Act (signed into law in 1988) requires that all art materials be reviewed to determine the potential for causing a chronic hazard and that appropriate warning labels be put on those art materials found to pose a chronic hazard.

The term "art material" includes "any substance marketed or represented by the producer or re-packager as suitable for use in any phase of the creation of any work of visual or graphic art of any medium." (The law also applies to many children's toys and other products used by children to produce a work of visual or graphic art.)

Which "art materials" are affected by the LHAMA?

The United States Consumer Product Safety Commission has identified the following general categories as art materials:

- Products that actually become a component of the work of visual or graphic art such as paint, canvas, inks, crayons, chalk, solder, brazing rods, flux, paper, clay, stone, thread, cloth, and photographic film.
- Products that are closely associated with the creation of the final work of art such as brush cleaners, solvents, ceramic kilns, brushes, silk screens, mold or mold-making material, and photo developing chemicals.

For more information on the requirements for art materials, contact the U.S. Consumer Product Safety

Commission (CPSC), Division of Regulatory Management, Office of Compliance and Enforcement, Washington, DC 20207, telephone: 301-504-0400 or go to www.cpsc.gov.

Art & Creative Materials Institute (ACMI)

Recognized as the leading authority on art and craft materials, the Art & Creative Materials Institute (ACMI) is an international organization dedicated to assisting its members in providing the public with art and craft materials for children and artists that are non-toxic. All products in the program undergo

Conforms to
ASTM D 4236 Conforms to
ASTM D 4236

extensive toxicological evaluation and testing before they are granted the right to bear the ACMI certification seals. ACMI recently began the launch of two new certification seals (AP and CL, see above) for use on newly authorized products and also on products previously authorized when their packages change.

Always read the labels

As raw materials improve, companies are sometimes able to replace hazardous materials that were not replaceable in the past. Consequently, you may find a product that has a warning now will appear without such a warning in the future. Because it is common for artists and retailers to retain products for a considerable time, you should read each label, rather than associate a particular hazard with a certain color or product name.

Routes into the body for harmful chemicals

To cause a serious problem, the harmful material has to enter the body via one of the routes listed below:

- Ingestion
- Inhalation
- Skin contact
- Eye contact

There are very few artists' products that qualify for a toxic label. The most common are the lead whites in oil color.

Spontaneous combustion of oil colors and linseed oil

In combination with certain pigments such as Raw or Burnt Umber, or in combination with driers, linseed oil can present a risk of spontaneous combustion when left on paper, rags, or other easily combustible material in a confined space. As the linseed oil dries, heat can be generated to the extent of igniting the rags, etc. It should be noted that as the volume of waste increases in a confined space, so too does the fire risk.

See under *Storage and disposal* on the opposite page for information on how to discard of oily palettes and rags.

Art materials and environmental legislation

The environment is of increasing concern to the world and as artists we have a responsibility, particularly with regard to the materials we use. The term "environment" relates to the world ecology, but also to an individual's working conditions.

Ideally, for the environment, a state of zero-risk is desired. In artists' materials, as in any area, the only way an individual can ensure zero-risk to their environment is not to participate! So one has to choose what is the least damaging or the most controlled use of a resource. For example, clay is not a renewable source, so should the world stop using it? If yes, what should be used instead—wood? plastic? Each material and process has relative pros and cons and a choice has to be made. The working practice of you as an artist should be:

1 Understand and make use of the legislative system designed to protect you, others, and the environment.
2 Use your common sense to help you decide your own personal choices and decisions.
3 Don't waste your materials, more will have to be made to replace what's been wasted.
4 Understand that ensuring a healthy alliance between safe materials and working practice becomes progressively more difficult the further one moves into unconventional materials.

Solvents

Solvents will normally be the most hazardous chemicals the artist will encounter. A solvent is a chemical that dissolves another chemical. Water is a solvent; in fact, it is a universal solvent as most chemicals are to some degree soluble in water, even if only to an almost immeasurable degree. Artists come across solvents in many guises, solvents dissolve resins, solvents dilute mediums and varnishes, solvents thin colors, and solvents clean brushes.

Except for certain specialist colors, the solvents most commonly encountered will be paint thinner or low-aromatic alternatives and turpentine. If it were not necessary to modify oil colors with mediums, oil colors would be among the most solvent-free products used by artists, and one of the safest.

The hazardous effects of a solvent are felt in two ways:
1 Health hazard from inhalation, ingestion, or skin contact.
2 Environmental hazard from disposal or evaporation into the atmosphere.

Not all these hazards apply to every solvent, and in each case there are degrees of severity.

Using solvents safely

- Open windows to allow free movement of air.
- Use an extractor fan to remove harmful fumes.
- Apply barrier creams to protect your hands.
- Wear a respirator to prevent the inhalation of toxic gases.

Governments can legislate to both inform the user and reduce the amount of solvent emission, and manufacturers can use less hazardous solvents, but after that it is up to the user.

Legislation can also control the release of solvents to the environment. Volatile organic solvents (VOCs), which can build up in the atmosphere, and solvents that affect the ozone layer are restricted and in some cases banned. Although paint thinner and turpentine now require labeling as Dangerous for the Environment, it is the aquatic environment that is affected should these get into watercourses, not the atmosphere through evaporation.

Aside from turpentine, most solvents encountered by the artists are derived from petroleum. They may be fairly pure substances such as xylene or more complex mixtures as in paint thinner. These mixtures contain aromatic and aliphatic hydrocarbons; the former are the more hazardous, but they are also more effective solvents. Low-odor solvents are petroleum hydrocarbon mixtures that have had almost all of the aromatic components removed. This makes them safer to use and they are not classified as Dangerous to the Environment.

The water-based paint market, particularly in industrial and decorative sectors, has been affected by the need to reduce VOCs, as well as the fact that water-based paints are seen as poor performers in relation to solvent-based paints. The major art materials' manufacturers should be producing acrylic colors without VOCs.

Pigments

Artists' colors, or at least those that have the required degree of permanence expected by artists, can never be completely environmentally friendly because of the source and manufacturing process of many of the permanent pigments. Artists should therefore ensure that any waste pigment is disposed of responsibly.

When airbrushing or using powdered pigments, make sure that you are properly protected from pigment dust—wear an approved mask and work in adequate ventilation to avoid inhalation of airborne particles. An exterior-vented extraction system is recommended. Gloves and eye protection should be worn. Only work with small quantities of pigments and do not have matches or a naked flame nearby as any powder in the air can catch fire. Don't put pigment in or near your mouth, and don't wash pigment down the sink. The pigments should be stored in a well-sealed container well away from a heater.

Storage and disposal

Store all materials, particularly solvents, in tightly capped containers when not in use. Do not pour out more solvent than is necessary for your current painting session, it will only evaporate into the room. Avoid exposure/inhalation of solvent vapors. If paint or solvent is splashed into the eyes or on the skin, wash thoroughly with water. Clean up all spills. Don't leave solvent-soaked rags around as the solvent will evaporate into the studio. At the end of the painting session, dispose of unused solvents, oily and paint-soaked rags in a fireproof, airtight, solvent-proof container or soak them with water, tie them up in a plastic bag, and place them outdoors in a metal garbage can away from buildings. Ensure the regulated disposal of waste products.

Do not wash discarded color into the drains. Wash hands, including your nails, thoroughly at the end of your painting session. Do not use solvent to wash color from your hands. Use a hand cleanser instead.

Working with acids

- Wear gloves and goggles to protect the hands and face.
- Always wear an appropriate respirator to avoid inhalation of acid fumes.
- Have an acid antidote cream on hand whenever you are working with an acid.
- Always use an extractor fan to dispel the noxious fumes given off by the acid. If this is unavailable, the process should take place outside.
- Use tongs to place materials into the acid.

Good working practice

- Read the product labels in case there are any hazard warnings. Remember to be especially attentive to the suitability of any products you wish to use that are not sold as artists' materials. Contact the manufacturer to check that the product is suitable for your use.
- Keep artists' materials out of reach or contact with children, animals, and foodstuffs.
- In the studio, ensure plenty of fresh air, ventilation, and circulation. Do not expose artists' materials to naked flames or excessive heat sources.
- Do not eat, drink, or smoke when working, due to the risk of ingesting a product.
- Avoid skin contact, particularly with solvents.
- Do not place your brushes in your mouth; paints are not made for human consumption.
- Do not apply color directly with your fingers. Use a barrier cream or surgical gloves when painting with your hands.

Glossary

Absorption (light) All substances absorb incident light at different wavelengths. Their color depends on the wavelengths reflected.

Acid A substance that liberates positive ions characteristic of the solvent. In aqueous solution this would be the hydrogen ion H+.

Acrylic Synthetic resin commonly used in an emulsion for preparing acrylic colors or in a solvent-based system for varnishes and in restoration.

Additive mixture The superimposition of colored lights to produce a third (lighter) color. The mixture of orange-red and blue-violet light will produce magenta. This is the principle of the color television screen.

Adsorption A molecular or electrostatic attraction between the surface of two molecules.

Aerial perspective Deals with the effect of the atmosphere on objects, lightening them in tone and cooling them in color as they recede toward the horizon.

Aggregate Groups of pigment particles held together by attractive forces.

Aliphatic Organic compounds that do not contain a benzene ring structure.

Alkali An aqueous base, see *base*.

Alla prima painting Also known as "direct painting," this is a one-layer painting technique in which the painting—usually painted from life—is completed in one sitting or while the paint remains wet.

Amorphous Noncrystalline.

Anhydrous Without water.

Aqueous Water-based.

Aromatic Organic compounds containing a benzene ring structure.

Autoxidation Slow oxidation by oxygen in the atmosphere.

Base (i) A substance that liberates negative ions characteristic of the solvent. In aqueous solutions this would be the hydroxyl ion OH- (ii) An inert pigment on which a lake is formed.

Binder The substance that holds the pigment particles together in a paint formulation and which attaches them to the support, e.g., linseed oil, egg yolk.

Bit A binary digit, like an on/off switch. The basic unit of data in a computer.

Bitumen (or Asphaltum) A tarry compound soluble in oil or paint thinner. It is no longer used as a painting pigment but continues to be widely used in the processing of lithographic stones or plates.

Blanching The whitening of an emulsion film after drying due to the absorption of moisture. Also the discoloration of a dried paint film or varnish after a solvent is applied.

Bleeding Migration of a dye or pigment dyestuff through a superimposed paint layer in which it is slightly soluble.

Blending The physical fusion of adjacent colors on a painting to give a smooth, often tonally graded transition between areas of color.

Bloom Cloudiness in a varnish which takes place after it is apparently dry—usually due to atmospheric contamination.

Blue Wool Scale An internationally recognized measure of lightfastness, expressed upward from 1–8. Each successive figure represents double the lightfastness of the last.

Blush Clouding of a varnish during drying due to the condensation of atmospheric moisture which may precipitate components of the varnish.

Body color (i) Opaque watercolor paint (i.e., gouache). The opacity may arise from mixing white with a colored pigment. (ii) More generally, any painting technique which uses opaque rather than transparent color.

Broken color Color that has been dulled by mixing with another color or affected optically by the juxtaposition or superimposition of another color.

Byte 8 bits.

Casein A glue or binding medium prepared from skimmed milk.

CCD Charge-coupled device for recording images in digital cameras or scanners and comprising batches of pixels or sensor sites that register electrical charges according to their exposure to light.

Chalking Powdering of the paint surface due to breakdown of the binder usually caused by ultraviolet radiation.

Chiaroscuro Technique used in painting to explore the often dramatic tonal contrasts between light and shade.

Chroma The degree of saturation or intensity in a color.

Chromatic pigments Colored, as opposed to white, gray, or black (achromatic) pigments.

Cissing The break-up of a wet film on a surface due to poor wetting or lack of adhesion.

CMYK color The three subtractive (pigment) primary colors (Cyan, Magenta, Yellow) plus Black used in four-color printing to make images in full color.

Cockling The deformation of a sheet of paper when wetted.

Colloid Dispersion of minute particles of one substance (the inner phase) in another (the outer phase).

Color temperature The measurement of color in degrees Kelvin emitted from a light source.

Complementary color The complementary of a primary color, for instance, is the combination of the two remaining primary colors. Thus, in subtractive color mixing, the complementary of blue (cyan) is orange/red—a mixture of red (magenta) and yellow.

Condensation (i) Deposition of moisture from the atmosphere. (ii) A reaction between two chemicals which involves the elimination of a third, often water.

Continuous tone In photographic film, an image that shows a complete range of tones without having had to be converted into dots or lines by a halftone screen.

Covering power A measure of the amount of color or medium needed to cover a given area.

CP (cold pressed) Artists' paper with intermediate texture between smooth (hot pressed) and rough.

Cutting Dissolving a resin in solvent.

Deckle The irregular edge of a sheet of handmade paper.

Dextrin Substance obtained by heating dry starch. A cheap alternative to gum arabic, can be used as a binder in watercolors.

Dichroism The phenomenon of a colored pigmented film appearing differently colored when viewed in different circumstances.

Diffraction The scattering of light—usually by an aperture or the edge of a solid—producing a series of dark and light bands or a spectrum.

Diluent Liquid used to thin the consistency of a prepared color, e.g., paint thinner for oil paint, water for watercolor and acrylic.

Direct painting (see *Alla prima painting*).

Disperse To produce a homogenous suspension of solid in liquid.

DPI (Dots per inch) A measure of the resolution of an image. The higher the number of DPI, the clearer the detail.

Drier A chemical substance, usually a metallic salt, which accelerates the drying process of a paint film by absorption of oxygen.

Dry-brush technique A method of painting in which paint of a dry or stiff consistency is stroked across the canvas.

Efflorescence Crystalline deposit on the surface of paint produced by the migration of soluble compounds.

Emulsifying agent A surfactant that assists in stabilizing an emulsion by holding the particles in suspension by electrostatic forces.

Emulsion A stable mixture of normally nonmiscible components such as oil and water. Egg yolk is a naturally occurring emulsion.

Enamel (i) Term to describe a high-gloss coating. (ii) Colors that are painted or printed onto steel plates, ceramics, or glass and subsequently fired.

Encaustic (i) A painting technique involving the application of pigments bound in hot wax. (ii) In ceramics, a form of inlay tile decoration involving clays of different color.

Enzyme A protein that acts as a catalyst for a specific chemical reaction.

Epoxy resin Powerful synthetic resin used in the preparation of two-part adhesives and paints, which set by chemical reaction rather than by evaporation of solvent.

Extender A pigment that has a limited effect on a color. It may be added to control the properties of a paint or to reduce the cost. Examples are chalk and China clay.

Fat Containing a large amount of oil.

Fat-over-lean The rule that applies to oil painting in layers. Each superimposed layer of paint should have a little more oil in the medium than the one beneath.

Ferrule The metal tube from which the hairs of a brush protrude.

Firing Baking clay, glass etc. in a kiln.

Fixative A surface coating which prevents the dusting of pastel, chalk etc.

Flash point Temperature at which the vapor above a liquid will ignite if a source of ignition is applied.

Flocculation The aggregation of pigment particles in suspension.

Fluorescence Light re-emitted while an object is exposed to radiation (especially ultraviolet radiation).

Flux A substance incorporated with the raw materials of glass, clay bodies, and glazes to facilitate fusion.

Formalin An aqueous solution of formaldehyde.

Format A system for storing digital information. There are different formats suitable for different kinds of image, e.g., JPEG files for bitmap or pixel-mapped images, or EPS files for vector images.

Frits Mixtures of lead or other metal compounds with silica and other materials that have been melted at high temperatures, cooled in water, and ground to provide a basic component of glazes for use in ceramics and vitreous enameling.

Frottage Taking an impression of an image in relief by rubbing with a (wax) crayon onto thin paper laid over the relief work.

Fugitive (pigment) Impermanent, of poor lightfastness.

Gesso Painting ground for rigid supports, usually made from gypsum and glue size.

Gigabyte (GB) 1024 megabytes.

Glaze Film of transparent color laid over a dried underpainting. Glossy, impermeable surface coating for fired clay.

Gouache Opaque watercolor (body color).

Grain The texture of canvas (e.g., fine grain), or of wood.

Grisaille Monochromatic painting in various tones of gray.

Ground The surface on which color is applied. This is usually the coating rather than the support.

Gum Water-soluble secretion from certain trees, e.g., acacia.

Halftone In printing, a method of giving the appearance of lighter and darker tones when painting in a single tone (e.g., black) by converting the original image into a series of small dots or lines.

Hardware Computer equipment.

Hiding power The ability of a coating to obliterate the underpainting—a measure of opacity.

Highlight The lightest tone in a painting (usually white).

HP (hot pressed) Artists'-quality paper with a smooth surface.

Hue (i) Spectral color. (ii) Often used by artists' materials manufacturers to indicate the use of a substitute pigment (e.g., Cadmium Yellow Hue).

Humectant Hygroscopic additive (e.g., glycerine) to watercolor paints, to keep them moist.

Hydrolysis A chemical reaction involving decomposition by the addition of water, usually in the presence of an acid or base.

Hygroscopic Absorbing moisture from the air.

Impasto Painting technique with thick paint in which paint is heaped up in ridges to create a heavily textured surface.

Imprimatura A very thin transparent stain (or "veil") of color laid over the white ground before the painting itself is begun.

Infrared Thermal radiation beyond the red end of the visible spectrum.

Inkjet printer Makes prints by spraying ink through tiny nozzles onto (specially coated) paper.

Interface The boundary between two surfaces.

Interfacial tension A more accurate term for surface tension, since the interface between a gas and a liquid is involved.

Internal sizing Method of reducing the absorbency of paper by sizing at the pulp stage rather than "surface sizing" after the paper has been formed.

Intimate mixture A completely homogenous mixture, e.g., a thoroughly wetted and dispersed mixture of pigments.

Iodine value A measure of the saturation of an oil.

Ion A charged atom produced by dissociation in solution (e.g., H+, OH-).

Ionization Dissociation into ions, usually in gases.

Isotropic Having the same properties in all directions—liquids are isotropic.

Key A painting is said to be "high key" when the colors and tones are bright and "low key" when they are dark or somber. Also used to describe a surface to which paint will adhere readily.

Kilobyte (KB) 1024 bytes.

Laid Type of paper made by lifting pulp against a characteristic horizontal and vertical mesh of "laid" lines and "chain" lines.

Lake A pigment formed by the precipitation of a dye on to a white base.

Levigate To grind into a powder with water. Separation of pigment by particle size, usually by sedimentation in water.

Lightfastness The performance of a pigment when exposed to light.

Local color The actual color of a subject as seen in even, diffused light, although it may look quite different in different lights.

Loomstate canvas Canvas that has had no "finishing" treatment.

Mahlstick A long stick with a soft pad at the end, used to steady the painting hand and hold it off the surface of a painting.

Maquette Preliminary model (of sculpture, etc).

Marouflage A method of attaching a painted canvas to a wall or other rigid support.

Masking (or "masking out") The protection of areas of the support from the applied paint.

Medium An additive used to control the application properties of a color. Also the vehicle in which the pigment is dispersed.

Megabyte (MB) 1024 kilobytes.

Metamerism The phenomenon in which two color matches may appear to differ under changed illumination. This is due to the different composition of each color.

Micelle Aggregation of molecules in a colloidal solution.

Micron Unit of measurement used to gauge size of pigment particles (one micron = one-thousandth of a millimeter).

Mineral Naturally occurring inorganic compound.

Miscibility Measure of mixing capability.

Modeling In painting technique, indicating the three-dimensional shape of an object by the appropriate distribution of different tones.

Molecule The smallest entity into which a compound can be divided without losing its chemical identity.

Molecular weight Mass of one molecule of a substance relative to that of carbon 12.

Monochromatic underpainting Preliminary painting in tones of one color.

Monomer Single chemical compound, the unit of a polymer.

Moldmade paper Artists'-quality paper made on a cylinder mold machine.

Oleoresin (or balsam) Mixture of essential oil and resin exuded from coniferous trees.

Opaque painting The opposite of transparent painting. Here, lighter tones are not produced by thinning, but by using white.

Optical mixing The perception as a single color of two or more different colors in juxtaposition.

Organic Relating to living compounds.

Oxidation Addition of oxygen.

Palette (i) Portable surface for mixing colors. (ii) The range of colors an artist chooses to work with.

Particle size The diameter of a pigment particle, usually described as a particle size distribution since pigments are of variable diameter.

Perspective Prescribed method of representing the three-dimensional world on the two-dimensional surface of the support.

pH A measure of acidity related to the hydrogen ion concentration in aqueous solution. A pH of 1–6 us acidic, 7 is neutral, and 8–14 is alkaline.

Pigment Solid-colored material in the form of small discrete particles.

Plasticizer An additive that imparts flexibility to a binder.

Polymer A chemical produced by combination of monomer units.

Porosity The degree of absorbency of a substance.

Precipitate A solid produced from solution by chemical reaction.

Precipitated chalk High-grade artificially made chalk.

Primary color Light: red/orange, blue/violet, and green. Pigments: red (magenta), blue (cyan), and yellow.

Primer Substance that provides a suitable prepared surface for painting in terms of adhesion and color and isolates the paint film from the support.

Protein A basic component of living matter whose structure is based on a polymer of amino acids.

RAM (Random Access Memory) A computer's working memory.

Rectification Purification of a solvent.

Reduction (of color) Mixture with white.

Refraction The bending of light by a surface.

Refractive Index A measure of the degree of refraction.

Relief printing (or letterpress printing) A form of printing in which the ink is applied to the raised surface of the block or plate.

Resin A hard, noncrystalline substance with an amorphous structure. Either naturally obtained from the secretions of trees or synthetically produced. Widely used in varnishes and (in the synthetic forms) in the binding mediums for paints such as acrylics.

Resist A protective layer applied to a painting, screen, or metal plate in printmaking to define an image by preventing paint, ink, or acid from affecting certain areas.

RGB color The three additive (light) primaries (Red, Green, Blue) used in TV screens and monitors to create images in full color.

Rough The most heavily textured grade of artists' paper.

Saturation (i) The intensity of a color. (ii) The presence of only single bonds in a molecule.

Scanner Device that scans drawings, paintings, or photographs and converts them into digital images for use on a computer.

Scumbling A painting technique in which semi-opaque or thin opaque colors are loosely brushed over an underpainted area so that patches of the color beneath show through.

Secondary colors Light: red (magenta), blue (cyan), and yellow. Pigments: green, orange-red, blue-violet.

S'graffito A method of drawing or painting in various materials by scratching through a layer of one color or tone to reveal a second.

Shade Color mixed with black.

Siccative (see *Drier*) Also, traditionally a rapid-drying, varnish-based medium used to accelerate drying.

Size Material such as glue or gelatine used to prepare canvas prior to priming or to reduce the absorbency of paper. It can be used as a binding medium for painting.

Slake To combine chemically with water.

Slip A liquid clay.

Software Applications or programs run on a computer.

Solution A liquid containing a dissolved solid as distinct from a suspension or a colloid.

Solvent Any liquid in which a solid can be dispersed to form a solution.

Squaring (or "squaring up") A method of transferring the contours of an image to the canvas. A grid of squares is superimposed over the original study.

A similar but larger-scale grid is fixed to the canvas or wall and the image drawn in, square by square.

Starch Substance synthesized in plant cells from carbon dioxide and water during photosynthesis. It is used as an adhesive and as a binding material.

Structural formula A formula that indicates the spatial arrangement of atoms in the molecule.

Stump Tightly rolled paper or leather cylinder used to smooth charcoal and pastel on a drawing.

Substrate The material on which the painting ground is supported.

Support The structure (wood, paper, metal, etc.) on which the painting is made.

Surface sizing A method of decreasing the absorbency of a material like paper by coating the surface with size.

Surface tension The intermolecular forces that reduce the surface area of a boundary. The effect can be seen in the curved meniscus on a liquid in a tube.

Surfactant (or water tension breaker) Substance which increases the flow of a paint over a surface, e.g., ox gall.

Tacking edge The edge of the stretcher bar to which the canvas is attached by tacks or staples. Nowadays, artists tend to staple to the back of the stretcher bar rather than the outside edge.

Tempera Tempera painting generally incorporates a water-soluble emulsion that dries to a hard film.

Thermoplastic Softening under heat.

Tincture Color or the addition of color. A color intended to be used for tinting.

Tint Color mixed with white.

Tinting strength A measure of the ability of a pigment to tint a white.

Tone The degree of lightness or darkness of a color.

Toned ground An opaque imprimatura in which the color is mixed with white to give a uniform opaque ground.

Toner Organic pigment based on a metallic salt.

Tooth The slightly rough surface of a priming or paint film, which allows a subsequent layer of paint to grip and bond.

Top tone (mass tone) The color of an undiluted pigment.

Tortillon Small paper stump used to manipulate a drawn surface.

Traction Movement of one paint layer over another, usually giving rise to cracking.

Transparent painting Uses transparent colors and relies for its effects on the whiteness of the ground or on the various tones of the underpainting.

Trompe l'oeil Illusionistic painting that deceives the observer into thinking that the objects depicted are real.

Ultraviolet Radiation beyond the violet end of the visible spectrum.

Undertone The color of a pigment as it appears in thin transparent films.

Value The extent to which a color reflects or transmits light.

Vehicle The binder, or medium in which pigment is ground.

Viscosity A measure of the flow characteristic of a color or medium.

Vitreous enameling Method of decorating prepared metal panels by applying enamel colors and firing at high temperature.

Volatile Capable of evaporating from solution.

Wet edge time The time for a film to become unworkable—often equal to the time taken for a solvent to evaporate— particularly in viscous films.

Wet-into-wet Method of painting in which wet color is applied into or on top of wet color already on the support.

Wetting agent An additive which aids the wetting of a pigment by a binder or the surface of the substrate by the medium.

Wove Paper that is made against a "woven" metal mesh, giving it something of the appearance of canvas—as opposed to "laid" paper.

Index

Acknowledgments

Author's acknowledgments

Revised edition

I would like to thank Christopher Davis and the excellent team at DK, including Andrew Heritage, Mary Thompson, Maxine Lewis, Polly Powell, Carole Ash, Caroline Hunt, Heather McCarry, Mandy Earey, Caroline Hill, Barbara Dixon, and Kelly Meyer.

I am most grateful to David Bomford at the National Gallery, Alun Foster at Winsor & Newton ColArt, and Steve Hoskins at UWE Bristol, for sharing their expertise and experience. Thanks also to all the artists, colleagues, and friends who contributed towards this revised edition, including Barnaby and Ros Adams, Richard Anderton, Ian Barrington at the United Bristol Healthcare Trust, Matt Benton, Bronwen Bradshaw, Emma Biggs, Maggie Bolt, Stefania Bonelli, Phil Bowden, Nicola Cottell at P. H. Coate & Son, Alan Cotton, Maggie Clyde, Andy Crawford, Ray Dennis, Anne Desmet, David Downs at Formica, Susan Elliott, Andrew Evans, Glyn Forbes, Freeform Arts Trust, Ben Gamble, Jerry Hardman-Jones, Malcolm Hatcher, Thomas Jenkins, Catrin Jones, Herman Lelie, Richard Long, Jon Bewley at Locus+, Henry Lydiate, Robert Manners, Richard Mathers at Ciba Speciality Chemicals, Imi Maufe, David Nash, Christian Needs, Carol Ormsby, Lyndall Phelps at Compton Verney, Lord and Lady Renfrew, Esther Rolinson, Catriona Smith, Emily Smith, Jerry Sohn, Tom Sowden, Mick Taylor, David Tee of the Cumberland Pencil Company, Paul Thirkell, Faculty of Arts and Education, University of Plymouth, Dominic Trent at Armitage Venesta, Elizabeth Turrell, Boyd Webb, George Whale, Willamette Europe Ltd.

Original edition

I am most grateful to the following for sharing their expertise and giving so much helpful advice during the preparation of this book. Also, to some for allowing pictures to be reproduced or for sitting for them: Roger Ackling, Hugh Adams, Simeon Adams, Dr. Helena Albuquerque, George Warner Allen, Sr. Francisco d'Almeida, T.E. Anderson (Hercules Ltd.), Philip Bale (Hercules Ltd.), John Beardsley, Maria-Clara Pinto Beça (Aleluia), B.T. Bellis (The Leys School), Oliver Bevan, Ian Biggs (Conté U.K. Ltd.), Professor Lewis R. Binford, Constance Boggis-Rolfe, Robert Boyd (Russell and Chapple), Geoffrey Burnham (Burnham Ltd.), Les Caird, Dr. Colin Campbell (Ciba Geigy), David Carter (Blythe Colors Ltd.), Peter Chadwick, Michael Chaitow, P.H. Coate & Sons, L. Cornelissen & Son, Dr. John H. Coy (Ciba Geigy),

John Dale, Jake Davies, Richard Dixon-Wright (St Cuthbert's Mill), Mike Dodd (Pittard Group plc), Simon Draper, Brenda Drayton, Geoff Eley, Brenda Fawcett (Perstorp Warerite), R.R. Franck (International Linen), Amal Ghosh, Mike Goodall (Southampton City Art Gallery), Mary Greaney, Simon B. Green (Barcham Green & Co.), A. Greenwood (Pecket Well Mill), Dr. E. Hartley (ICI), Richard Hayward & Co., Tim Head, Gerry Hedley (Courtauld Institute), Martin Hill (Thorn EMI), Sarah Hocombe, Chris Hollings (D. & J. Simons & Sons Ltd.), Dave Holt (Silvermans), Lisa Hughes, F. Hugh Howarth, Derek James (Chelsea Art School), Jason Jefferies (Faber Castell), Richard Jobson, Stephen Johnson (Norsk Hydro), John Keel (Rowney Artists' Brushes Ltd.), Ken Kellaway, Dr. Peter Laight (Pittard Group plc), Mark Lancaster, Bill Latham (Deancraft Fahey Ltd.), Dominic Lawson, Claude Libeert (Libeco S.A.), The Lisson Gallery, Richard Long, Henry Lydiate, Dr. J. McAllister (Ciba Geigy), Jane McAusland, Alan McWilliam (Chelsea Art School), Medite of Europe, Steve Meredith (Hoechst (UK) Ltd.), Louis P. Miles (International Institute for Cotton), John Mills (National Gallery, London), R. Murray (Blythe Colors Ltd.), David Nash, Sr. Eduardo Nono, John van Oosterom (Falkiner Fine Papers), Alan Oswald (Ciba Geigy Bonded Structures Division), Philip Preston, Dr. M. Pidgely, The Public Art Development Trust, Helen Reid (Rexel Ltd), Professor and Doctor A.C. Renfrew and family, Robert Ritson (Chelsea Art School computer department), Sr. J. Rocha e Melo (Aleluia), Desmond Rochfort, Ashok Roy (National Gallery, London), Kirsten Salén, Richard Shone, Camilla Smith, Henry Smith, Dr. Peter Smith, Dr. Umberto Sozzi, Marianna Stamp, Sundeala Ltd, Richard Sweetman, David Tee (Rexel Ltd.), Steve Thorpe, Mr. Varkey (K.T. Textiles), M. Vickey (Rowney Artists' Brushes Ltd.), Caroline Villers (Courtauld Institute), Boyd Webb, Bernice Weston, Raymond White (National Gallery, London), Roger Whitney, Ron Wright (Perstorp Warerite).

Special thanks to Alun Foster, my scientific adviser, who provided a great deal of information for the "materials" section and the glossary and who checked the manuscript. Also, to Jonathan Leslie for assistance with research. I should like to thank Barbara Thomas, my typist, for so patiently, accurately, and promptly transcribing so much handwritten text.

Finally, my thanks to the Directors of Dorling Kindersley and to the editorial and design team, Caroline Ollard, Mark Richards, Tim Hammond, and Joanna Martin, who worked so hard on this project.

Publisher's Acknowledgments

Dorling Kindersley would like to thank Andy Crawford for photography, Mike Taylor at Paupers Press, Richard Bird for the index, Julian Gray for editorial assistance, Jo Grey for design assistance, Jane Myers for proofreading, Mike Grigoletti for recreating the chemical formulas on pp.16–29, Franziska Marking and Sarah Duncan for additional picture research, Margaret Parrish and Christine Heilman at the Americanization Unit, and Caroline Ollard, Mark Richards, Tim Hammond, Joanna Martin, Alan Buckingham, Peter Chadwick, and Alun Foster for helping to create the original edition.

Picture Credits

a: above; b: below; c: center; l: left; r: right; t: top

2: Robert Manners (bl); **5:** Oliver Bevan (c), Catrin Jones (tc); **8:** Bridgeman Art Library, London/New York/Bibliotheque Nationale, Paris, France; **36:** Winsor & Newton (br); **42:** Bridgeman Art Library, London/New York/Diego Velasquez/Prado, Madrid, Spain; **62:** Bridgeman Art Library, London/New York/Jean-Baptiste Simeon Chardin/Louvre, Paris, France; **64:** Derwent Cumberland Pencil Company; **87:** The Royal Collection © 2002 Her Majesty Queen Elizabeth II/Leonardo da Vinci (tr); **90:** Bildarchiv Preußischer Kulturbesitz/Thomas Gainsborough (bl); **94:** The Baltimore Museum Of Art/Henri Matisse/© Succession H Matisse/ DACS (Designers And Artists Copyright Society) 2002. The Cone Collection, formed by Dr Clairibel Cone and Miss Etta Cone of Baltimore, Maryland BMA 1950.12.50/DACS (t), Magnum/Robert Capa (c); **103:** Courtauld Institute Gallery, Somerset House, London/ Rembrant van Rijn/ Princes Gate Collection (tr); **107:** The J. Paul Getty Museum, Los Angeles/Vincent Van Gogh (cl); **108:** © The British Museum/ Wang Dongling, (OA ref. 16461); **112:** Bridgeman Art Library, London/New York/Fitzwilliam Museum, University of Cambridge (tc), Fitzwilliam Museum, University of Cambridge, UK (tr); **114:** Lisson Gallery, London/Sol LeWitt; **116:** Richard Long, photographer Walter Klein (c), Jerry Sohn (tr); **117:** David Nash (c), (cr), A Compton Vernay Commission © Locus+ Archive www.locusplus.org.uk (b); **118:** Corbis/ Andrew W Mellon Collection/Photo Francis G. Mayer; **119:** British Museum; **126:** Bridgeman Art Library, London/New York/ Albrecht Dürer/British Museum, London, UK; **127:** Courtauld Institute Gallery, Somerset House, London/John Robert Cozens; **137:** Gallery Oldham/ Miles E Cotman/Charles Lees Collection; **143:** Bridgeman Art Library, London/New York/Emil Nolde/Private Collection/© Nolde-Stiftung Seebüll (b); **147:** © The British Museum/Jospeh Mallord William Turner (cr), Norwich Castle Museum and Art Gallery/John Sell Cotman (bc); **153:** Bridgeman Art Library, London/New York/John Sell Cotman/ Norfolk Museums Service (Norwich Castle Museum) UK (cr); **156:** Bridgeman Art Library, London/New York/Henri Matisse/ Musee National d'Art Moderne, Paris, France/ © Succession H Matisse/ DACS 2002; **160:** Bridgeman Art Library, London/New York/National Gallery, London, UK; **166:** National Gallery, London/ascribed to Michelangelo; **168:** Calouste Gulbenkian Museum, Lisbon, Portugal/ Domenico Ghirlandaio (tc); **170:** National Gallery, London/ Raphael/ Mond Bequest, 1924; **171:** Anthony D'offay Gallery/Howard Hodgkin; **180:** Galerie Beyeler Basel/Paul Klee/© DACS 2002 (c); **181:** Bridgeman Art Library, London/New York/Pierre Bonnard/Christie's Images, London, UK/© ADAGP, Paris and DACS, London 2002; **184:** Bridgeman Art Library, London/New York/Peter Paul Rubens/National Gallery, London, UK (tr); **185:** Bridgeman Art Library, London/New York/Jacopo Bassano/ Musee des Beaux-Arts, Nimes, France (tl), National Portrait Gallery, London/ Sir Peter Lely (br); **186:** Bridgeman Art Library, London/New York: Diego Velasquez/National Gallery, London, UK (tr); **190:** Bridgeman Art Library, London/New York/Frank Auerbach/Southampton City Art Gallery, Hampshire/The Artist, Courtesy of Marlborough Fine Art; **191:** Bridgeman Art Library, London/New York/George Seurat/ Courtauld Institute Gallery, Somerset House, London (cl); **192:** Alan Cotton (cl); **194:** Bridgeman Art Library, London/New York/Gwen John/ Southampton City Art Gallery, Hampshire/© Estate of Gwen John 2002. All Rights Reserved, DACS; **195:** © Tate, London 2003/John Singer Sargent; **196:** Robert Manners; **200:** Calouste Gulbenkian Museum, Lisbon, Portugal/

Dirk Bouts (t); **202:** © Tate, London 2003/ David Hockney; **223:** Bridgeman Art Library, London/New York/Fitzwilliam Museum, University of Cambridge; **229:** Mohammed Fakruzzaman; **230:** DACS /Max Beckmann (tr); **233:** Richard Anderton (bl); **234:** Dover Publications, Inc. New York/Thomas Bewick (tr); **235:** Bridgeman Art Library, London/New York/Anne Desmet (bl); **236:** Alan Cristea Gallery/ Mimmo Paladino; **238:** University of Michigan Museum of Art/Zoan Andrea after Andrea Mantegna/ Museum purchase made possible by the Friends of the Museum of Art 1979/1.159 (tr); **240:** Ray Dennis (br); **243:** Bridgeman Art Library, London/New York/Goya/On Loan to the Hamburg Kunsthalle, Hamburg, Germany (bl); **251:** © Christie's Images Ltd/Toulouse-Lautrec (bl); **255:** Ben Gamble (br); **259:** Bridgeman Art Library, London/New York/Andy Warhol/Phillips, The International Fine Art Auctioneers, UK; **261:** Bridgeman Art Library, London/New York/ Gilbert and George/Leeds Museums and Galleries (City Art Gallery) U.K.; **263:** George Whale; **272:** Metro Pictures/Cindy Sherman/Courtesy of the artist and Metro Pictures; **273:** Boyd Webb; **277:** Lisson Gallery, London/ Julian Opie; **278:** Bridgeman Art Library, London/New York/Fra Angelico/ Museo di San Marco dell'Angelico, Florence, Italy; **279:** Bridgeman Art Library, London/New York/Fra Angelico/Museo di San Marco dell' Angelico, Florence, Italy; **281:** San Francisco Art Institute /Diego Rivera/ © 2002 Bank of Mexico Diego Rivera & Frida Kahlo Museums Trust Av. Cinco de Mayo No. 2, Col. Centro, Del. Cuauhtemoc 06059, Mexico, D.F. San Francisco Art Institute, gift of William Gerstle, photo: David Wakely; **284:** Maggie Clyde, Susan Elliot/London Wall; **296:** Robert Manners, (tr), (br); **301:** © Tate, London 2003/ George Stubbs; **302:** Elizabeth Turrell (br); **304:** Catrin Jones; **305:** Sarah Hocombe © Chelsea School of Art; **306:** Catrin Jones; **307:** Catrin Jones; **309:** Tate, London 2003/© Estate of Patrick Heron. All Rights reserved, DACS 2002. Medium: Coloured Glass 460 x 420cm. Designer: Feary and Heron Architects. Client: Tate Gallery St Ives/Friends of the Tate/CCC. (t); **310:** Courtesy of Jet Edge, www.jetedge.com, St Michael, MN, USA (tr), (br); **314:** Lisson Gallery, London/Julian Opie; **316–317:** Jerry Hardman-Jones; **318:** Scala Group S.p.A./ Mausoleo di Galla Placida, Ravenna, **321:** Emma Biggs (t); **322:** David Nash; **323:** Air Fotos Ltd; **324:** Collection Walker Art Center, Minneapolis: Gift of Leo Castelli Gallery, 1981; **325:** Esther Rolinson, Photographer Monika Schürle; **327:** © Tate, London 2003: Joshua Reynolds; **328:** Dulwich Picture Gallery/Adam Pynacker/By Permission of the Trustees of Dulwich Picture Gallery; **331:** National Gallery, London; **332:** National Gallery, London/Hans Holbein the Younger (l), (r); **336:** National Gallery, London/Duccio (bl), (br); **337:** National Gallery, London (tc), (cl), (br); **338:** National Gallery, London/ Corregio (br), Corregio (detail) (tl), (tr); **339:** National Gallery, London/Jan Van Eyck (cl), Jan Van Eyck (detail) (tc), (tr); **340:** © Tate, London 2003/ Howard Hodgkin; **344:** Bridgeman Art Library, London/New York/ Church of St. Ignatius, Rome, Italy; **345:** Oliver Bevan (b), Exploratorium, www.exploratorium.edu (t); **351:** © The British Museum; **352:** Bridgeman Art Library, London/New York/ Palazzo Pubblico, Siena, Itlay (detail) (b), Scala Group S.p.A./Casa di Augusto (Palatino) Rome (t); **353:** Bridgeman Art Library, London/ New York/Santa Maria Novella, Florence, Italy; **359:** Warburg Institute/ University of London (t); **360:** Science Museum (b), (t); **361:** Science Museum (b), (t);); **367:** Ian Pleeth; **370:** The Art & Creative Materials Institute, Inc (c), ACMI (c), International Labour Organization (ILO) (cl), (clb), (bl); **371:** International Labour Organization (ILO)

DK images: 4t; 9t; 11; 12; 30; 33; 36; 37; 51; 52; 53; 56; 57; 63; 65; 92; 97; 103b; 104cl; 119; 131; 157tr; 174; 231, 232t; 235tr, cr; 237; 239c, b; 240c; 241; 242; 243tr; 244; 245; 246; 247c, bl; 248; 249; 250t, bl; 252; 253; 255t, c, bl; 260; 357br; 359bc, br; 360; 361. For further information see www.dkimages.com
All other artworks © Ray Smith